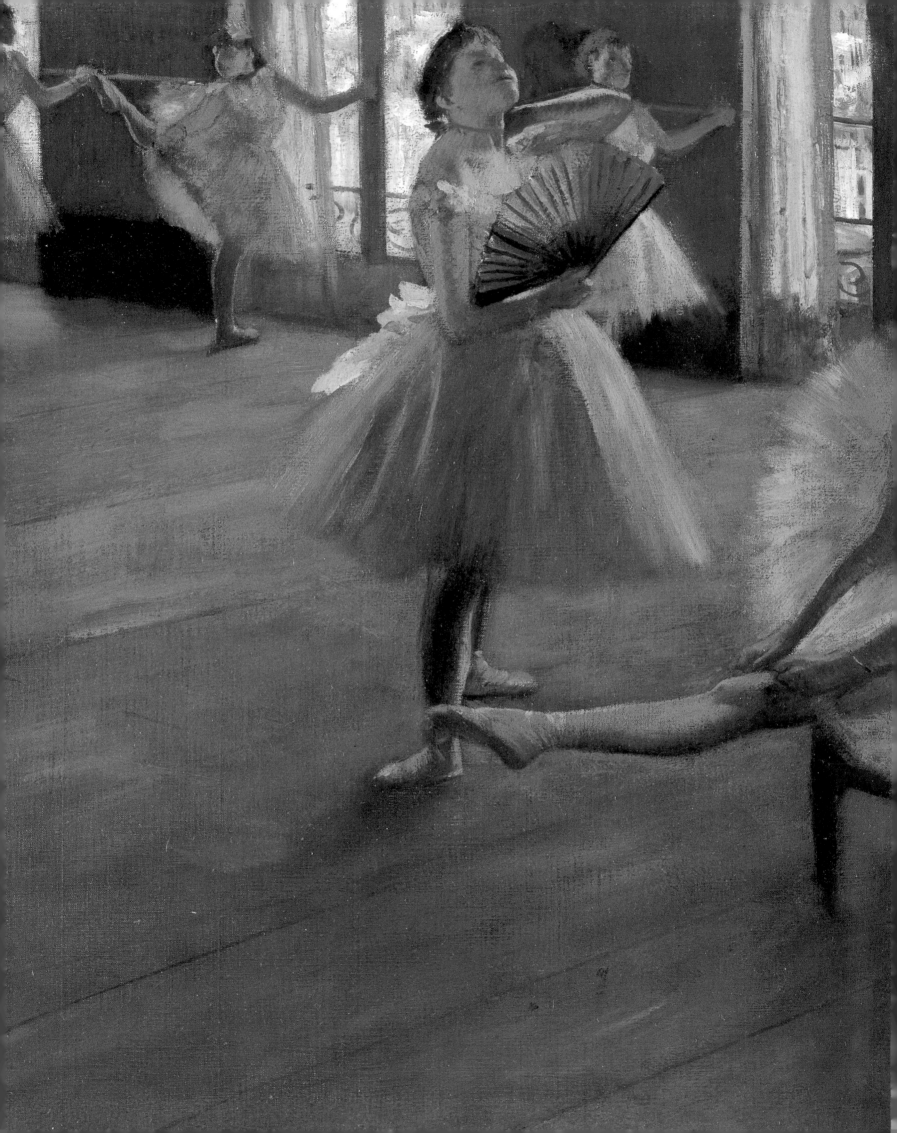

Jill DeVonyar and Richard Kendall

DEGAS AND THE DANCE

HARRY N. ABRAMS, INC., PUBLISHERS
in association with the American Federation of Arts

This catalogue has been published in conjunction with "Degas and the Dance," an exhibition organized by the American Federation of Arts, The Detroit Institute of Arts, and the Philadelphia Museum of Art.

Established by an act of Congress in 1909, the American Federation of Arts produces art exhibitions, publications, educational programs, and professional conferences to benefit the museum community. The AFA's mission is to enrich the public's experience and understanding of art.

For the AFA:
PUBLICATION COORDINATOR: Michaelyn Mitchell

For Harry N. Abrams, Inc.:
PROJECT DIRECTOR: Margaret Kaplan
EDITOR: Sharon AvRutick
DESIGNER: Lindgren/Fuller Design
PRODUCTION CONSULTANT: Shun Yamamoto

Library of Congress Cataloging-in-Publication Data
DeVonyar, Jill.
 Degas and the dance / Jill DeVonyar and Richard Kendall.
 p. cm.
 Published in conjunction with an exhibition held at the Detroit Institute of Arts, Oct. 20, 2002–Jan. 12, 2003 and the Philadelphia Museum of Art, Feb. 12–May 11, 2003.
 Includes bibliographical references and index.
 ISBN 0–8109–3282–2 (hardback) — ISBN 1–885444–26–5 (AFA: pbk.)
 1. Degas, Edgar, 1834–1917—Exhibitions. 2. Degas, Edgar, 1834–1917—Criticism and interpretation. 3. Ballet dancers in art—Exhibitions. I. Degas, Edgar, 1834–1917. II. Kendall, Richard. III. Detroit Institute of Arts. IV. Philadelphia Museum of Art. V. Title.
 N6853.D33 A4 2002
 759.4—dc21 2002018230

Printed in Japan

10 9 8 7 6 5 4 3 2 1

American Federation of Arts
41 East 65th Street
New York, N.Y. 10021
www.afaweb.org

Harry N. Abrams, Inc.
100 Fifth Avenue
New York, New York 10011
www.abramsbooks.com

Abrams is a subsidiary of

LA MARTINIÈRE
GROUPE

Exhibition Itinerary

The Detroit Institute of Arts Philadelphia Museum of Art
October 20, 2002–January 12, 2003 February 12–May 11, 2003

FRONT COVER: Edgar Degas, *Three Dancers in Yellow Skirts* (detail), c. 1899 (plate 318); BACK COVER: Edgar Degas, *Dancer Stretching* (detail), c. 1882–85 (plate 132); PAGE 1: Edgar Degas, *The Dancing Lesson* (detail), c. 1880 (plate 168); PAGES 2–3: Edgar Degas, *The Dancing Lesson* (detail), c. 1880 (plate 168); PAGE 5: Edgar Degas, *The School of Ballet* (detail), c. 1873 (plate 146)

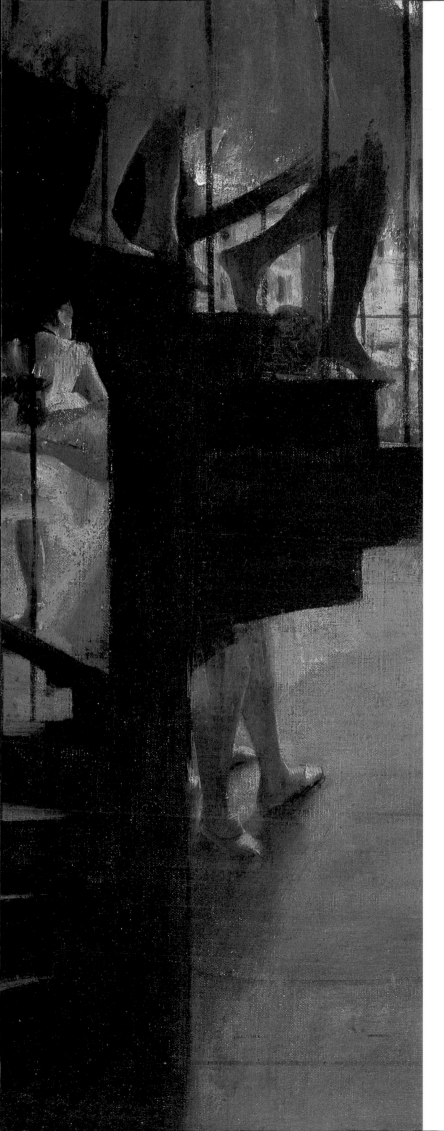

Contents

Preface

What a delight! After years of waiting and of hoping, an exhibition of Degas dancers has at long last been assembled, and by two devoted and knowledgeable people, the choice of whom could hardly have been bettered. Richard Kendall has worked on this giant of an artist for so many years that in 1996 he was able to demonstrate—and at the same time to remind us—that Degas' working graph rose brilliantly and ever more penetratingly over the years as his age increased, and this despite the terrifying threat of total blindness that beset him as early as the mid-1880s and of which he was entirely aware. It would almost seem that Richard, wishing to share his discovery with us, and perhaps to endorse his own suspicion, threw himself with the zest and fine judgment it merited, into the organization of the truly memorable exhibition "Degas Beyond Impressionism," which London was privileged to mount in 1996. As the title implies, the show comprised work produced by Degas during the latter half of his active life when his vision was becoming relentlessly impaired. In this non-compromising selection of works created through the diverse media of oil paint, pastel, charcoal, and bronze, Degas was seemingly challenging fate to do its worst—and to an amazing degree he succeeded.

Jill DeVonyar, herself a former dancer and teacher, has, through her research, been able to uncover much that might otherwise have remained hidden concerning the story of ballet in France during the latter part of the nineteenth century. It was a period, one must admit, of no great acclaim, for the renowned Romantic ballet had already reached its zenith around the time when Degas was born. When he first became interested in that branch of art at the end of the 1860s, ballet had gone into a steep decline; its stars had retired through old age or illness, while the public—always fickle—had lost its great interest. Degas would not have known or cared about this, for inside the Opéra, before and after its closure due to the Franco-Prussian war, he painted four most original canvases from the front row of the stalls. In all of these, the compositions are sharply divided between the dark figures in the orchestra pit and the gas-lit figures on stage. The first of the four shows no interest in ballet; it is a fantasy group-portrait of some of Degas' friends, all but one under the guise of musicians, while the tutu-clad figures at the top of the canvas are no more than suggested. The second composition is even more adventurous, for over half of the canvas is occupied by the enlarged dark mass of hair and shoulders of three men, but now with rather more focus upon the dancers behind them on stage—the soloist taking her bow being Degas' first acknowledgment of a dancer as such.

The two paintings of the ballet from Meyerbeer's *Robert le Diable* follow—one actually dated 1872. I believe this ballet to have been of the utmost importance, the key to all the wonderful studies of ballet dancers that were to come. It also added visually to the history of ballet, for *Robert le Diable* had originally been produced in 1831, choreographed by her father with Marie Taglioni in "La Valse Infernale" leading the troupe of half-crazed ghostly nuns, in the wildest of postures, across the stage as they were emerging from their tombs. It was during this scene that Taglioni narrowly escaped serious injury when a piece of scenery fell from above, just missing her legs as she was lying below. I could imagine that of all the ballets Degas subsequently saw, none was as dramatic and as painterly as this, the earliest of them all. It is very likely the reason why, in the ensuing years, he attempted so few compositions of classical ballets *sur la scène*. Such would have been too charming and two sweet for him—*La Sylphide* would not have been "up his street." Degas from then on became enamored of ballet. Through it he discovered what was to become an ever-growing passion—the variety of movements of which the body (always female) is capable and which could scarcely be found in any other human activity.

This thrilling exhibition follows the dancers from their tentative beginnings in the classroom until, after years of vigorous training, they emerge onto the stage for rehearsals or performance. With his lively and inquiring mind Degas needed to know how an aspiring dancer would be trained, so he obviously attended classes with such regularity and understanding that it would not be at all surprising to come across a snapshot of him in tights and working with the juniors at the barre. With my particular background (and I feel sure that Jill would join me), I especially warm to those early drawings of a child at the barre trying to assume some position or other that was quite beyond her ability. Degas has seized upon her particular mistakes and has written tacit corrections on the page, which in their truth always make me chuckle.

Over the years the dancers have grown sturdy—far too heavy by today's slender standards; mostly they are standing in the wings or resting, and although their tutus have so often been discarded, these nudes are grand and impressive but still quite obviously dancers.

LILLIAN BROWSE

Acknowledgments

This publication and the exhibition it accompanies bring new insights into Edgar Degas' lifelong passion for the dance, a subject that inspired the artist to create many of the masterpieces of late-nineteenth- and early-twentieth-century art. Degas created pictures of the ballet in a variety of media over five decades; in fact, more than half of his work is devoted to this compelling subject. Degas and the Dance is illuminating therefore not only for what it tells us about Degas' ballet work but for the critical light it sheds on the artist's overall achievements. It is difficult to believe that a major exhibition on Degas' paintings of the ballet—in which the works are set in a historical context—has not been undertaken until now. The American Federation of Arts is thrilled to have the opportunity, together with our guest curators and coorganizers, to bring these exquisite works together, many of them familiar and beloved, and make them available to a wide audience.

Our thanks begin with our extraordinary guest curators, Richard Kendall and Jill DeVonyar, for working with us to develop this project with such intelligence, imagination, and untiring commitment, and for the important and fascinating new scholarship they bring to the subject. Their accomplishment is prodigious in many respects, and working with them has been an enormous pleasure.

We wish also to warmly acknowledge our esteemed partners, the Philadelphia Museum of Art and The Detroit Institute of Arts, with whom we have had the great pleasure of organizing this project. In particular, we would like to thank the directors of these institutions, Anne d'Harnoncourt and Graham W. J. Beal, respectively. Thanks also go to David Penney, George Keyes, Iva Lisikewycz, Tara Robinson, Pam Watson, and Kimberly Brinker in Detroit; and Joseph Rishel, Adrienne Deitch, Suzanne Wells, Gail Harrity, Irene Taurins, and Sara Detweiler Loughman in Philadelphia.

On the AFA staff, numerous individuals have been critical in the organization of "Degas and the Dance." Thomas Padon, Deputy Director for Exhibitions and Programs, not only provided invaluable oversight throughout the organization of the project but, together with former AFA Curator Suzanne Ramljak, initiated the discussions with Richard Kendall that led to the development of the exhibition. Ms. Ramljak, in fact, deserves special thanks for her key role in defining the exhibition's premise. Kathryn Haw, Curator of Exhibitions, guided every aspect of the exhibition's organization with intelligence and aplomb. Working with her counterparts at Harry N. Abrams, Michaelyn Mitchell, Director, Department of Publications & Design, adeptly oversaw the editing, design, and printing of this impressive book with singular grace, skill, and patience. Other AFA staff members who share credit for the success of this project include Amy Poll, Curatorial Assistant, and Anne Palermo, Editorial Assistant, both of whom scrupu-

lously attended to innumerable details over long hours. Kathleen Flynn, Head of Exhibitions Administration, offered expert guidance in negotiating the complex details of this project; Diane Rosenblum, Registrar, coordinated the logistics of traveling the exhibition; and Nina Callaway, Media Representative, oversaw the promotion and publicity for the project. The mammoth task of managing the loan list and compiling images for the exhibition catalogue could never have been accomplished without the patient assistance of former editorial assistant Beth Huseman and intern Emily Guggino. Ann Helene Iversen researched the provenance of each work in the exhibition over many months and with unparalleled diligence. Finally, our tireless volunteer Doris Palca employed the most creative means to secure the most elusive photographs.

We are delighted to have joined forces with Harry N. Abrams and wish to single out Margaret Kaplan, Editor-at-Large, for her unflagging enthusiasm and much-appreciated support; Deborah Aaronson, Editor, for her attention to myriad organizational details; and Sharon AvRutick, for her editorial skills. We also want to thank Laura Lindgren and Celia Fuller of Lindgren/Fuller Design for their sensitive design of the catalogue.

To the many lenders who so generously allowed us to borrow some of the great jewels from their collections go our warmest appreciation. Without them, a meaningful exploration of Degas' fascination with the ballet would have been impossible.

The success of this project would not have been imaginable without the advice and assistance of many friends and colleagues, and for their kind efforts on our behalf we wish to thank Carol Acquilano, Charlotte Ahlgren, Joseph Baillio, Guy Bennett, Laura Bennett, Mark Brady, Calvin Brown, Olivier Camu, Carson Chapin, Stephane Connery, William Darby, Robyn Deutscher, Douglas Druick, Jean Edmonson, Christopher Eykyn, Walter Feilchenfeldt, Laura Giles, Anika Guntrum, Per Hedström, Teri Hensick, Rory Howard, Kimberly Jones, Henry Joyce, Dragana Kovacic, Jan Krugier, Lori Kutscher, Nicholas Maclean, Joan Michelman, Leta Ming, Charles Moffett, A. G. Nevill, Britta Nilsson, David Norman, Nancy Norwood, Stephen Ongpin, Pascale Pavageau, Judith Pineiro, Eliza Rathbone, Simon Ray, James Roundell, George Shackelford, Karin Sidén, Harry Smith, Roderic Stein, Richard Thune, Gary Tinterow, Hans Verbeek, Pierre Vidal, Fay Werbel, Aaron Young, and Ruth Ziegler. Finally, Harriet Stratis offered invaluable counsel on the conservation of Degas' pastels, and thus made possible the loan of several very important works in the exhibition.

JULIA BROWN
DIRECTOR
AMERICAN FEDERATION OF ARTS

7

Acknowledgments

Degas made his first pictures of the dance in the 1860s and his last almost half a century later. He was a complex and frankly obsessive individual, the greatest obsession of his long career being the ballet dancer in almost all her manifestations in both public and private modes. A central aim of this book and the exhibition it accompanies is to present the wide range of Degas' principal creative project in a critical and original light; not just as it evolved from decade to decade, but as it followed radically new directions and departed from its original premises. By bringing together the perspectives of ballet history and art history we have attempted to ask fresh questions about well-known works and assess less-familiar objects, while situating them in the historical circumstances in which Degas' dance art was made. Often assumed to be self-explanatory, these images turn out to be endlessly startling and contradictory: in his mid-twenties, for example, we find the young Degas making previously unidentified sketchbook studies of the Paris stage and turning to cheap engravings and photographs for inspiration; as he became more familiar with the dance world, there is new evidence of visits backstage and of his remarkably sophisticated knowledge of dancers and their techniques; paradoxically, pictures that appear realistic are now revealed as synthetic creations, while many scenes of ballet performance are identified as specific responses to the Paris Opéra repertoire; and in his last years, we encounter yet another set of priorities, as Degas united classical poise with vivid, explosive color.

The scale and ambition of this study of Degas' art has depended on the practical support and the generous advice of many hundreds of people over a period of five years. At its inception, Suzanne Ramljak, Thomas Padon, and Serena Rattazzi persuaded us that it should happen and remained unfailingly loyal to our vision. Subsequently, we have been rescued and assisted on a daily basis by Amy Poll, Anne Palermo, and Meg Calvert, all of whom deserve our warmest thanks; Michaelyn Mitchell, who has calmly guided us through the production of the catalogue with unusual forbearance; and central to the team, Kathryn Haw, who has been a tireless coordinator, sympathetic colleague, and source of endless encouragement. Many colleagues have helped us in a hundred different ways, but we have been continually inspired by the example and affection of Lillian Browse, and have enjoyed the patient scholarly advice of Theodore Reff, George Shackelford, Jean Sutherland Boggs, and Sandra Noll Hammond. Our research has depended crucially on specialist libraries and collections of dance materials, principally the Performing Arts Division at the New York Public Library, the Harvard Theater Collection, and the Bibliothèque de l'Opéra in Paris. We are immensely grateful to the staff of these institutions, notably Annette Fern at Harvard and Pierre Vidal and his consistently helpful colleagues at the Bibliothèque de l'Opéra. Special thanks are also due Martine Kahane for revealing to us the heights and depths of the backstage world of the Palais Garnier, where so many of Degas' encounters with the dance took place.

Our profound debt to those who have loaned works to the exhibition is acknowledged on a separate page, but we wish to single out those individuals who have made many of these loans possible, or who have contributed to our research and to the catalogue in other ways: Gotz Adriani, Charlotte Ahlgren, Christina Anderson, Eve Arnold, Sharon AvRutick, Maxine Bartow, Guy Bennett, Giovanna Bertzzoni, Bojana Boric-Breskovic, Charles Bradstock, David Brenneman, Rick Brettell, André Bromberg, Sara Campbell, David Carpenter, Marjorie Cohn, Stephane Connery, Salvatore Cordaro, Laura Coyle, James Cuno, Catherine Curran, William Darby, Barbara Divver, Douglas Druick, Ann Dumas, Adrian Eeles, Sondra Eisenberg, John Elderfield, Walter Feilchenfeldt, Peter Findlay, Jay Fisher, Richard Francis, Flemming Friborg, Marianne Frisch, Jim Gantz, Ivan Gaskell, Laura Giles, Gloria Groom, Vivien Hamilton, Per Hedström, Lee Hendrix, Rory Howard, Colta Ives, Jennifer Jones, Henry Joyce, Sarah Kianovski, Dragana Kovacic, Lori Kutscher, the Marquise de Lillers, Henri Loyrette, Barbara Mathes, Suzanne McCullagh, Joan Michelman, Leta Ming, Charles Moffett, Linda Muehlig, Edgar Munhall, John Murdoch, Britta Nilsson, David Norman, Martin Peretz, Anne Pingeot, Emily Pulitzer, Richard Rand, Eliza Rathbone, Sue Reed, Chris Riopelle, Joe Rishel, Helen Row, Janet Salz, Barbara Shapiro, Christie Stubbs-French, Dick Thune, Gary Tinterow, Ernst Vegelin, Caroline Villers, and Fronia Wissman. For their help in examining pictures and invaluable advice on their safe transport, we are especially grateful to a number of conservators, principally to Harriet Stratis for her enthusiasm and expert guidance, but also to Dare Hartwell, Teri Hensick, Tim Hinton, Anne Maheux, Ann Hoenigswald, and Rosamond Westmoreland. Finally, we wish to thank our families and friends for their encouragement and forbearance throughout this protracted project.

JILL DEVONYAR
RICHARD KENDALL

Presenter's Statement

Known in his lifetime as the "painter of dancers," Edgar Degas explored the world of the ballet in drawings, prints, pastels, painting, and sculpture throughout his career. Thanks to the generosity of many museums and private collectors, "Degas and the Dance" offers visitors a "back-stage pass" to this world and the opportunity to experience, through the eyes of the artist, dancers in performance, practice, and repose. The Detroit Institute of Arts is pleased to be a part of this extraordinary exhibition, which presents Degas' favorite subject in great detail. It is with great pleasure that I acknowledge the major corporate support of the DaimlerChrysler Corporation Fund, which enables us to share "Degas and the Dance" with our public, as it has a number of major DIA exhibitions in the recent past.

An exhibition of this scope would not have been possible without the talents and contributions of many institutions and individuals. Our deepest thanks go to the American Federation of Arts for organizing this groundbreaking exhibition, particularly Serena Rattazzi, former Director; Julia Brown, Director; Thomas Padon, Deputy Director for Exhibitions and Programs; and Kathryn Haw, Curator of Exhibitions. We are especially grateful to Richard Kendall and Jill DeVonyar, independent scholars and the organizing curators, for providing such a bold and interesting reinterpretation of Degas' associations with the ballet of his time. Their exhaustive research into the archives of the Paris Opéra has unearthed many startling and revealing discoveries that will enable us to experience Degas' work in new ways.

We have developed a close working relationship with our fine colleagues at the Philadelphia Museum of Art and gratefully acknowledge their sustained contribution to this joint effort between our museums. We are particularly indebted to Anne d'Harnoncourt, the George D. Widener Director and Chief Executive Officer; Joseph J. Rishel, the Gisela and Dennis Alter Senior Curator of European Painting Before 1900; Suzanne Wells, Coordinator of Special Exhibitions; and other members of the museum staff who have contributed so substantially to the success of this ambitious undertaking.

In the European Paintings Department at The Detroit Institute of Arts, I would like to acknowledge George S. Keyes, Elizabeth and Allan Shelden Curator, and Iva Lisikewycz, Associate Curator, who have overseen the realization of this exhibition with exceptional skill and professionalism. We are deeply indebted to Tara Robinson, Curator of Exhibitions, who has worked with so many colleagues in the complex task of bringing "Degas and the Dance" to Detroit. The project was elegantly realized here by exhibition designer Elroy Quenroe.

Finally, I want to acknowledge the dedication of the entire staff of The Detroit Institute of Arts. They have worked especially hard to present this important exhibition at a time of tremendous dislocation and change in the midst of the museum's renovation. Their enthusiasm and commitment have enabled the DIA to maintain a high profile within our community at a critical time in the new millennium.

GRAHAM W. J. BEAL
DIRECTOR
THE DETROIT INSTITUTE OF ARTS

DAIMLERCHRYSLER

DaimlerChrysler Corporation Fund

9

Presenter's Statement

Since 1936, when the youthful Henry P. McIlhenny organized for the Philadelphia (then Pennsylvania) Museum of Art the first great Degas exhibition in the United States in, as his mentor Paul Sachs put it, "the native state of his only pupil, Mary Cassatt," the museum has benefited from a close association with some of Degas' most passionate admirers. That exhibition included not only *The Ballet Class*, shortly to be purchased by the museum, as well as Mr. McIlhenny's own *Interior* and *Little Dancer, Aged Fourteen*, now stars of his bequest, but also *After the Bath (Woman Drying Herself)*, the daring late picture that the great Degas scholar Jean Sutherland Boggs was to covet for years and finally acquire for Philadelphia during her brief but distinguished tenure as director in 1980–82. The museum is delighted with the opportunity afforded by this brilliant examination of a crucial aspect of Degas' work to bring his genius to our twenty-first-century public.

We salute our colleagues at the American Federation of Arts as prime movers of this ambitious project, who have seen it through with enormous energy and skill: Julia Brown, Director, and her predecessor, Serena Rattazzi; Thomas Padon, Deputy Director for Exhibitions and Programs; and Kathryn Haw, Curator of Exhibitions. We are particularly grateful to Richard Kendall and Jill DeVonyar, who have brought such fresh and revealing insights to what might have seemed (but never is with an artist of Degas' stature) familiar territory. Our collaboration with The Detroit Institute of Arts, as in the recent case of the van Gogh portrait exhibition in 2000, could not be more agreeable. Now, as then, they have preceded us on the calendar, and therefore have had to take on the lion's share of the organizational details. Graham W. J. Beal, Director; George S. Keyes, Elizabeth and Allan Shelden Curator; and Tara Robinson, Curator of Exhibitions, have proven once again to be model colleagues and friends. For this we are extremely grateful.

In Philadelphia the exhibition is sponsored by ATOFINA and The PNC Financial Services Group, both old friends of the museum who have come in at an unprecedented level to make such a far-ranging and complex show possible. The Pew Charitable Trusts has been a constant source of invaluable funding for our exhibition program for many years; we hope that they will derive a great deal of satisfaction from contributing to an exhibition that will surely delight not only our visitors who love the visual arts, but also the vast and enthusiastic audience for dance in this city. We are also enormously grateful to The Annenberg Foundation and its newly granted endowment in support of major exhibitions that will help us present "Degas and the Dance" as the first of many ambitious projects to come. Our debt to all of them is immeasurable. We can only hope that the success of the show will equal the weight of their generosity.

In Philadelphia, the principal responsibility for this exhibition has fallen to Joseph Rishel, the Gisela and Dennis Alter Senior Curator of European Painting Before 1900. His greatest debt is to Adrienne Deitch, who took on with lightly worn efficiency all the daily organization of the show and the coordination with the many other departments in the building that quickly joined in to take full advantage of such a choice opportunity. Public relations, the development department, information services (with an admirable website especially created for the exhibition), and the education and public programs departments all, early on in the planning phase, thought hard about how to best engage as broad a public as possible in the exhibition and sought to make its point come across. Irene Taurins and her skilled team of registrars handled all the complex details of insurance and shipping. The handsome installation is the creation of Jack Schlechter and his colleagues in our installation design department.

Degas has long been an extremely popular artist whose works are in nearly constant demand for a great variety of exhibition projects. It is a great compliment to the AFA as a whole and to Jill and Richard in particular that we have been able to come so close to the initial and extremely demanding "wish list" of works for this show. But finally, it is to the lenders themselves, often parting with some of the most important and cherished objects in their collections, to whom we must express our deepest gratitude. Colleagues from museums as far afield as Belgrade (who truly thrilled us with their initial response to our rather ambitious loan request) and as near as the Metropolitan in New York (which thanks to the Havemeyer bequest is particularly rich in Degas) responded generously, as did a remarkable number of private collectors who, unlike large public institutions, cannot substitute an (alas, often lesser) work from their depots to fill the temporary gaps made by their loans. This exhibition would simply not have been possible without the support of all our lenders, and we are deeply in their debt.

ANNE D'HARNONCOURT
THE GEORGE D. WIDENER DIRECTOR AND C.E.O.
PHILADELPHIA MUSEUM OF ART

ATOFINA **PNC**
The PNC Financial Services Group

In Philadelphia, the exhibition is made possible by ATOFINA and The PNC Financial Services Group.

Additional support has been provided by The Pew Charitable Trusts and The Annenberg Foundation.

Lenders to the Exhibition

The Art Institute of Chicago
The Baltimore Museum of Art
Bibliothèque nationale de France
Brooklyn Museum of Art
Chrysler Museum of Art, Norfolk, Virginia
Cincinnati Art Museum
The Corcoran Gallery of Art, Washington, D.C.
Courtauld Institute Gallery, Somerset House, London
Dallas Museum of Art
Denver Art Museum Collection
The Detroit Institute of Arts
Fine Arts Museums of San Francisco
The Fogg Art Museum, Harvard University Art Museums, Cambridge, Massachusetts
Fondation Beyeler, Riehen/Basel
Free Library of Philadelphia
High Museum of Art, Atlanta
Hirshhorn Museum & Sculpture Garden, Smithsonian Institution, Washington, D.C.
The Hyde Collection Art Museum, Glens Falls, New York
Isabella Stewart Gardner Museum, Boston
The J. Paul Getty Museum, Los Angeles
Kimbell Art Museum, Fort Worth, Texas
Hamburger Kunsthalle, Hamburg
Memorial Art Gallery of the University of Rochester
The Metropolitan Museum of Art
Musée du Louvre
Musée d'Orsay, Paris
Musée des Beaux-Arts, Lyon
Museum Boijmans Van Beuningen, Rotterdam
Museum of Fine Arts, Boston
The Museum of Fine Arts, Houston
The Museum of Modern Art, New York
Nasjonalgalleriet, Oslo
National Gallery, London
National Gallery of Art, Washington, D.C.

National Gallery of Scotland, Edinburgh
The National Museum, Belgrade
The National Museum of Fine Arts, Stockholm
The New York Public Library
Ny Carlsberg Glyptotek, Copenhagen
Philadelphia Museum of Art
The Phillips Collection, Washington, D.C.
The Art Museum, Princeton University
Smith College Museum of Art, Northampton, Massachusetts
Solomon R. Guggenheim Museum, New York
Städtische Galerie im Städelschen Kunstinstitut, Frankfurt am Main
Statens Museum for Kunst, Copenhagen
Sterling and Francine Clark Art Institute, Williamstown, Massachusetts
Tacoma Art Museum
Tate London
UCLA Hammer Museum, Los Angeles
Trustees of The British Museum, London
Trustees of the Victoria & Albert Museum, London
Von der Heydt-Museum, Wuppertal

André Bromberg
Charles and Jane Cahn, New Jersey
Gregory Callimanopulos
Mr. and Mrs. Nico Delaive, Amsterdam
James and Katherine Goodman, New York
J. Kasmin, London
Dr. Morton and Toby Mower
Janet Traeger Salz, New York
Mr. and Mrs. A. Alfred Taubman
Andrea Woodner and Dian Woodner, New York
and other private collections

Colnaghi, London
Galerie Berès, Paris

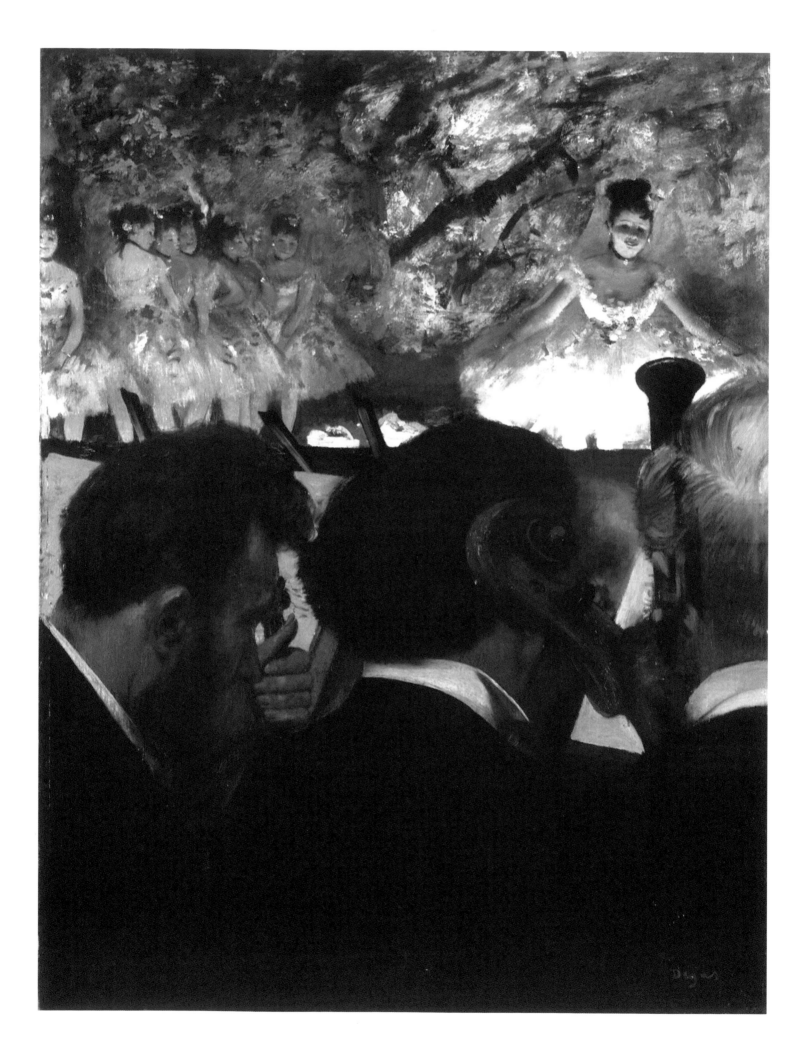

1. Degas at the Paris Opéra

I hear he's becoming the painter of high life.

—EDOUARD MANET, REFERRING TO DEGAS IN 1868[1]

Their legs savagely cut by the edge of the stage, their coral and silver dresses suppressed by shadow or ablaze with light, the background figures in *Orchestra Musicians* (plate 1) were among the very first dancers to be painted by Edgar Degas. It was a startling debut for an obscure thirty-five-year-old, one of a cluster of ballet scenes he began around 1870 that were soon to launch his career as "the painter of dancers."[2] As early as 1874, a critic at the first Impressionist exhibition noted that "the dance foyer has become his predilection" and the writer Philippe Burty could assert, "There is as yet no-one who has made such portraits of the dancer, the coryphée, made of gauze and bone."[3] *Orchestra Musicians* was a manifesto-like composition in other ways: if the upper register gave notice of visual audacities to come, the rest of the canvas was almost old-masterly, its somber hues describing in meticulous detail a group of Degas' musical friends in the orchestra pit. Here he presented some of his more orthodox credentials, at the same time informing his Parisian audience that this dramatic image came from the heart of their city. As with the closely associated *Orchestra of the Opéra* in the Musée d'Orsay, the location would have been recognizable to most of them as the auditorium of the Paris Opéra, a resemblance underlined by Degas' inclusion of portraits of such long-serving Opéra instrumentalists as the cellist Louis-Marie Pilet, the bassoonist Désiré Dihau, and the violinists Lancien and Gout.[4] Even more pointedly, Degas chose a viewpoint almost embarrassingly close to the performers, effectively painting himself into their company: the Paris Opéra, he seems to tell us, is where he belonged.

To an extraordinary and still underestimated extent, Degas' ambitions developed under the roof of the Paris Opéra, and the materials of his dance art derived from its stage, its rehearsal rooms, and the activities of its personnel. The Opéra, or the Académie Royale de Musique as it was formally known, was the home of the national ballet and the national opera, the twin companies habitually appearing together in the same elaborate productions. The Opéra ballet was nationally and internationally renowned: in France, only the Opéra maintained a permanent corps de ballet of nearly two hundred individuals, and it was only in its auditorium that dancers could be seen several nights each week throughout the year.[5] In various parts of the Opéra building most of

1. *Edgar Degas*, Orchestra Musicians, *c. 1870–71. Oil on canvas, 27⅛ x 19¼ in. (69 x 49 cm). Städtische Galerie im Städelschen Kunstinstitut, Frankfurt am Main (SG237)*

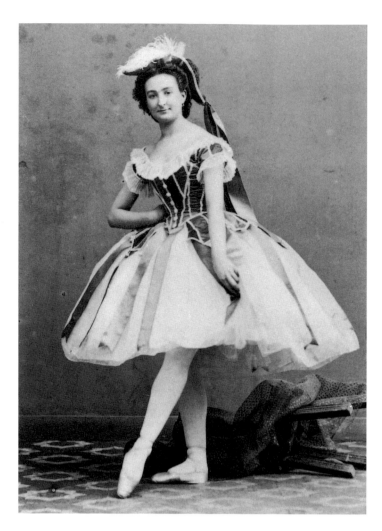

2. *Elise Parent in* L'Etoile de Messine. *Bibliothèque nationale de France*

these ballerinas had been trained as children, drilled as members of the corps, instructed in their roles, and finally celebrated in the footlights, and it was to precisely these activities that Degas turned for his pioneering dance pictures.

At times Degas' engagement with the routines of the Opéra can appear encyclopedic and his advertisement of this fact almost shameless. As well as studies of the orchestra pit, he chose the setting of the backstage classrooms at the Opéra for dozens of works, such as *Dance Class at the Opéra* (plate 19) and *The Rehearsal* (plate 88); the distinctive décor of the Opéra's proscenium appears in several early canvases, among them, *Ballet Rehearsal on the Stage* (plate 61); many of the Opéra's popular successes of these years, like Delibes' ballet *La Source* and Massenet's *Le Roi de Lahore*, featured in Degas' compositions; and scores of identifiable personalities from the company are shown in his drawings, prints, pastels, and oil paintings, from the elderly teacher and former Opéra star Jules Perrot (plate 230), to the almost forgotten ballerina Elise Parent (plate 2), who appeared in *La Source* and in the role of Mother Superior in Meyerbeer's *Robert le Diable,* and "probably posed for the dancers" in *The Orchestra of the Opéra.*[6]

3. Edgar Degas, Sketch of Three Musicians. *Page 10 from Notebook 24. Bibliothèque nationale de France*

The interweaving of Degas' personal life with that of the Opéra and its varied employees is a matter of record. Among his long-standing friends were Count Ludovic Lepic, balletomane, amateur artist, and lover of the prominent dancer Marie Sanlaville; and the popular librettist and author Ludovic Halévy. Ludovic was the nephew of the even more illustrious Fromenthal Halévy, the composer of one of the Opéra's great successes of the previous generation, *La Juive,* and a founder of the family's cultural and political dynasty in Second Empire Paris.[7] Both Lepic and Halévy were introduced to the Opéra as children, the former advancing to a modest career as a costume designer for ballets such as *Les Jumeaux de Bergame* (the apparent subject of several Degas pastels), the latter exploiting his backstage experiences in a scurrilous bestseller about two imaginary ballerinas who appeared on the Opéra stage, *La Famille Cardinal* (for which Degas produced a number of illustrations).[8] Thumbnail sketches of the early 1870s allow us to visualize the artist at work among his colleagues, recording glimpses of musicians (plate 3), the apparatus of the proscenium, and the architecture of backstage rooms (plate 83), the latter suggesting Degas' intriguing proximity to dance classes and rehearsals.[9] In 1876, he exchanged letters with Jean-Baptiste Faure, the renowned baritone who created several roles at the Opéra. One message refers to the Opéra ballet master Louis Mérante, ending rather cryptically, "You are singing tonight I believe. Do not forget to remind Mérante about the photographs he offered me yesterday. I am eager to see them and to work out what I can make of this dancer's talent."[10] It was Faure who commissioned *The Ballet from "Robert le Diable"* (plate 53), which featured among its audience the figure of another Opéra habitué, Albert Hecht, who later bought pictures by Degas and helped him gain access to an Opéra dance examination, leading him "in person to the feet of Mon. Vaucorbeil," the Opéra director at the time.[11] And in 1886, Degas sent his congratulations to the newly appointed Opéra director, Eugène Bertrand, reminding him, "You have favored me so exceptionally, that I feel myself a little attached to your fortunes and that I am getting to be, as they say, one of the household."[12]

Degas' links with the Opéra's dancers themselves are documented over four decades, in reports of social encounters; in accounts of modeling sessions in his studio with ballet pupils, members of the corps,

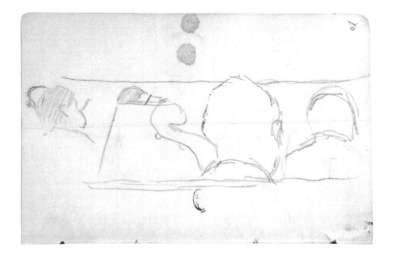

and occasional Opéra stars; and in evidence of private infatuations and innocent friendships with many of these individuals. By the mid-1860s, for example, he was close enough to the sensational Eugénie Fiocre and the obscure Joséphine Gaujelin to draw and paint them on several occasions and in a surprisingly intimate manner (plates 49 and 48, respectively). On his visit to New Orleans in 1872, Degas wrote personally to the dancer Mlle Simon, greeted several of her colleagues at the Opéra, and enquired about the new *première danseuse*, Rita Sangalli, while asking the bassoonist Dihau to give his regards "to our friends of the orchestra."[13] In the following decade, he was sufficiently well acquainted with two of the Opéra's most glamorous celebrities, Rosita Mauri and Marie Sanlaville, for them to visit his studio with their entourage: Degas made drawings of their heads, we are told, but their "movements were posed by the pupils."[14] As the years passed, the names of other dancers who worked with him—Mlle Hugues, Melina Darde, Nelly Franklin, Alice Biot, Julie Subra, Zina Mérante, Suzanne and Blanche Mante, and the three van Goethem sisters— continued to range through the Opéra hierarchy. He used his connection with Ludovic Halévy to urge the case of the dancer Joséphine Chabot, who felt she was underpaid, and one of his models in later years was the ex-ballerina Yvonne, who posed for some of his final wax sculptures.[15] So complete was Degas' identification with the Opéra dancers that he was repeatedly caricatured as one himself, most memorably by his friend Michel Manzi (plate 4).

New evidence in this volume emphasizes and extends Degas' attachment to the Paris Opéra, rooting it in the earliest years of his career and pushing it into the late decades. In fragmentary notebook drawings made between 1860 and 1862, for example, we find suggestive echoes of contemporary dance and opera productions, such as Saint-Georges' *Pierre de Medicis* and Gounod's *Faust*, proposing a first response to the Opéra stage a full decade before the painting of *Orchestra Musicians*. One of these studies even appears to record a plan for an ambitious frieze-like ballet composition, conceived but never executed at this surprisingly early date. Another pattern emerges among the patrons for his dance pictures, who were often familiar figures at the Opéra: the purchaser of *Orchestra Musicians* was again the singer Jean-Baptiste Faure, the first owner of *Orchestra of the Opéra* was Degas' bassoonist-friend Désiré Dihau, while later collectors included the critic and ballet admirer Charles Ephrussi; the Opéra subscribers Nissim de Camondo, Camille Groult, Albert Hecht, Hector Brame, Charles-Frédéric Dietz-Monnin, and Paul-Arthur Chéramy; and members of the Clapisson, Barthelemy, Boussod, Petit, and Bernheim families.[16]

The real possibility arises, therefore, that Degas was making dance pictures for a select, informed clientele who recognized his subjects and understood their specific nuances and allusions. Important here are the indications that as many as a hundred of Degas' pictures from his middle years were related to ballets in the Opéra repertoire that these individuals would have known, ranging from Donizetti's *La Favorite* and Mozart's *Don Giovanni* to Métra's *Yedda* and Lalo's *Namouna*.

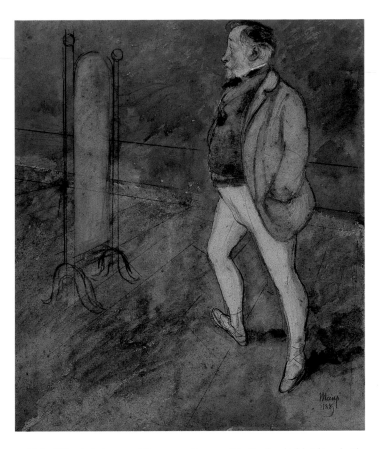

4. *Michael Manzi,* Caricature of Degas as a Dancer, *1885. Pencil and ink heightened with gouache and watercolor, 20⅞ x 17⅜ in. (53 x 43.6 cm). Private collection*

Analysis of these works and their preparatory studies has also highlighted Degas' knowledge of the dancers' craft and their backstage milieu, strengthening the case for his having had access to restricted parts of the Opéra building. From the end of his career, links with additional members of the Opéra's ranks—such as the dancers Berthe Bernay, Mlle Bouissavin, and Cléo de Mérode—have amplified the list of his subjects and occasional models, advancing Degas' active involvement with the corps de ballet into the 1890s and perhaps beyond.

As our sense of Degas' participation in the life of the Opéra clarifies, his response as an artist to his chosen subject becomes increasingly paradoxical. From the beginning of this encounter, as *Orchestra Musicians* has demonstrated, he preferred the fragment to the whole and the teasing glimpse to the instructive panorama, often adopting motifs, structures, and viewpoints that were subversive of visual—and certain kinds of social—convention. By comparison with the language of contemporary theater illustration, for example, as seen in a wood engraving of 1873 showing the auditorium in which *Orchestra Musicians* was set (plate 5), Degas' pictures seem willfully strange. However knowledgeable about the ballet or the Paris Opéra he was, his pictorial engagement was neither passive nor merely documentary, just as his other preoccupations of the day—with the cabarets, cafés, laundries, hat shops, and brothels of the city—were marked by a radical reinvention of current visual modes. The more we learn about Degas' familiarity with the Opéra and its dancers, the more ruthlessly selective his

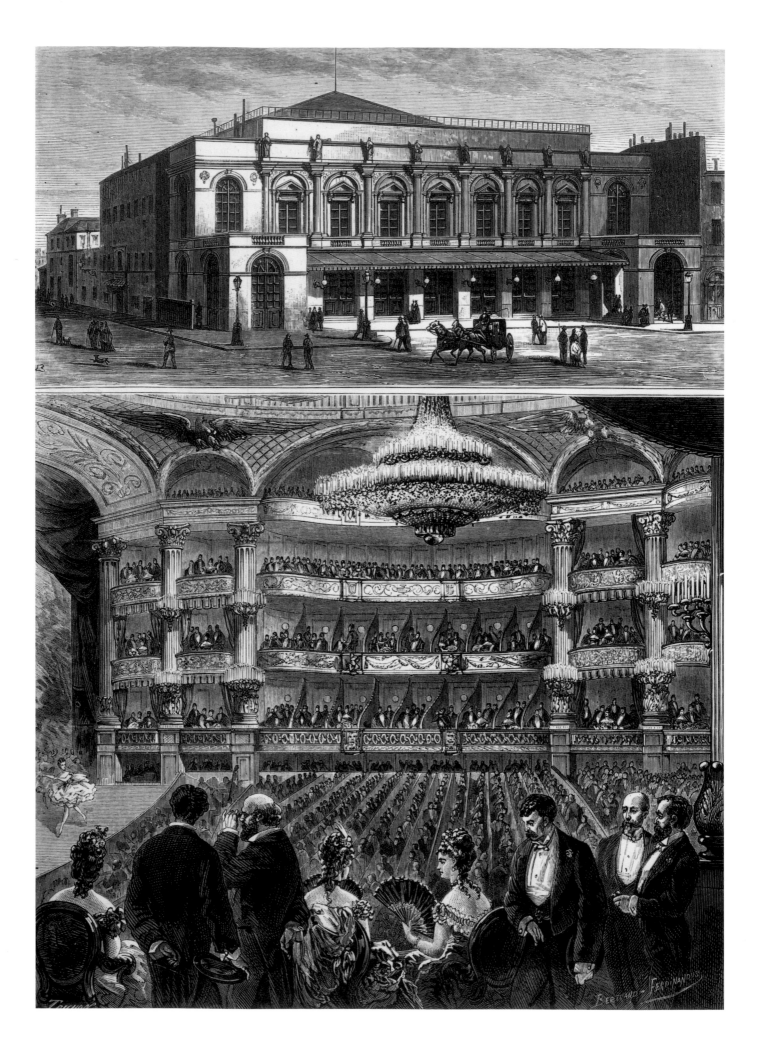

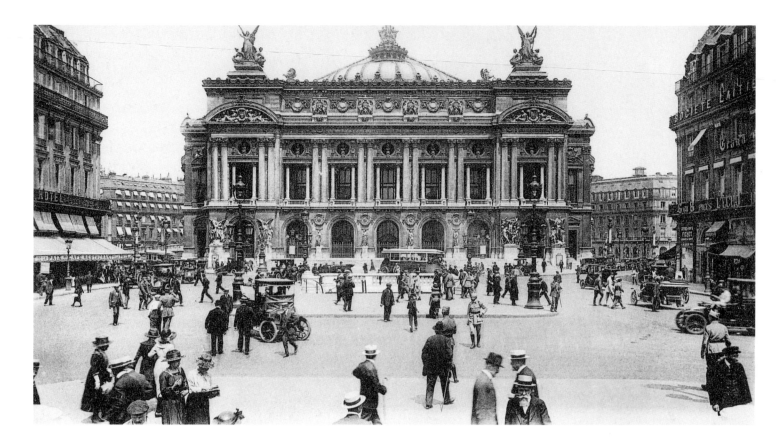

6. *The Paris Opéra (Palais Garnier), c. 1900*

vision appears to be. Inverting the assumptions of his predecessors and peers, whether painters, engravers, or photographers, he showed almost no interest in the architectural grandeur of the Opéra itself or the elegance of its clientele, and little more in the legendary glamour of its ballerinas. To an almost perverse degree, Degas favored the backstage classroom over the performance and the bare corridor over the glittering crowd, developing pictorial techniques appropriate to his novel priorities. Degas' theater perspectives plunge and soar, his framing often separates performers from the settings that give them meaning, and his planes of focus isolate details at the expense of the larger scene. Structures known to have been long demolished reappear in his pictures, and existing rooms find themselves remodeled to suit his pictorial whims, while elements that failed to engage him— such as the Opéra's celebrated scenery—were drastically edited from his field of concern.

The significance of Degas' questioning and highly personal vision can only be gauged against its original context: the rooms, personalities, training routines, and social semaphores that made up the phenomenon of the Paris Opéra. In his lifetime, the Opéra occupied not one, but two successive buildings: the old structure on the rue Le Peletier, whose exterior and interior are seen in the 1873 engraving, and the elaborate new edifice that replaced it in 1875 and is still in vigorous use today, the Palais Garnier (plate 6).[17] Each theater had its separate history and character, and each dominated a major chapter in Degas' career as a dance artist, though—as we shall discover—the

narrative that joins them was often far from clear. In his early years, the rue Le Peletier Opéra had already become a site of pilgrimage as the birthplace of the Romantic ballet, arousing strong sentiment in the older generation and a stubborn attachment in the young. There are clear indications that Degas shared this loyalty and found means of expressing it in his art. He was born almost within sight of the building's squat and unlovely façade, and it was in this auditorium that he probably saw his first dance performances and conceived new kinds of pictures that would soon make his name. When the elderly theater was destroyed in a terrible fire in October 1873 (plate 60), the site of Degas' youthful pleasure and the source of his distinctive imagery were violently taken from him. Professionally, personally, and symbolically the loss was to disrupt his life for years, perhaps haunting him until the end of his working career.

At the time of the fire, the long-awaited replacement for the rue Le Peletier Opéra—the huge, lavish, and massively expensive building designed by the architect Charles Garnier—was nearing completion less than half a mile away. When it opened in January 1875, the majority of performers from the previous establishment, and many of the surviving stage sets and costumes, were once more on display, in programs that emphasized both the continuity and the novelty of the new Opéra's offerings (plate 7). Though Degas' views on the new structure are not specifically recorded, the testimony of his letters and other documented accounts indicates that he soon transferred his balletwatching activities, if not his full affection, to the Palais Garnier.[18] From 1875 to the decline of his attendance in the 1890s, this was to be the

5. *The rue Le Peletier Opéra, 1873; Façade on the rue Le Peletier and view of the auditorium. Bibliothèque nationale de France*

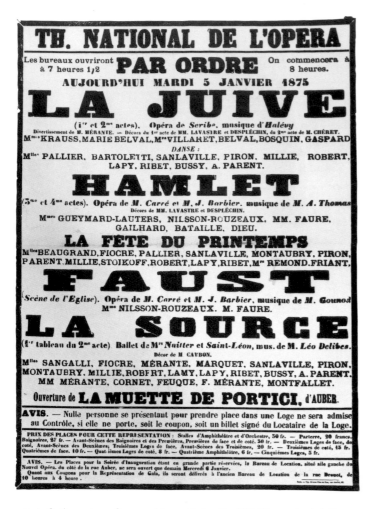

Through good management and some good fortune (the archive survived the 1873 fire), the Paris Opéra is one of the most richly documented institutions of its kind in the world, preserving within its walls many of the architectural plans and early photographs, the musical scores and autograph production notes, and—most spectacularly—the original stage and costume designs of the late-nineteenth-century repertoire.[20] Featured only sporadically in the Degas literature, this material conjures up a Vatican-like city-within-a-city, a "vast industry"—as one chronicler described it—that employed around seven thousand individuals in the creation of visual and orchestral splendor on a monstrous scale.[21] Account must therefore be taken of the Opéra's own organic evolution, not only as a functioning theater but also as a showcase for the changing tastes, and rising and falling standards, of music and dance in the French capital. Parallel to these developments was Degas' own idiosyncratic progression, from intense involvement with the Opéra in his early years to an effective retreat in his final phase. At no point, therefore, can the relationship between painter and edifice be taken for granted. While Degas clearly needed the raw material of stage productions and dance training, just as he nourished himself on fierce observations of horse races, circus artistes, and milliners, the pictures he made from these subjects grew out of a teasing and often oblique relationship with his experience. With the Opéra, the depth of his knowledge appears to have urged him to visual extremes, authorizing persuasive reports from the wings and the rehearsal floor, as well as flights of whimsy and moments of free invention. At times these procedures resemble an elevated and unsparing game, played

principal arena in which Degas experienced the ballet and encountered new productions and new generations of dancers. Somewhat puzzlingly, however, only one case has been identified where Degas unequivocally reflected the design and ornament of Garnier's building in his pictures from these years. This is in the misleadingly titled *Dance Rehearsal in the Foyer of the Opéra* (plate 116), a much-repainted canvas begun in the mid-1870s and reworked two decades later, which shows the distinctive round windows of the practice room above one of the wings of the Garnier Opéra, where rehearsals continue to this day. More puzzling and more significant for his art is the contrary case: far from neglecting the rue Le Peletier building after its disappearance in 1873, Degas continued to depict certain of its formal structures and backstage spaces in the months and years that followed, in a bizarre exercise of nostalgia or commercial opportunism that has yet to be fully deciphered. In the pastel-over-monotype *Dancers at the Old Opéra House* (plate 8), for example, we encounter the cornices, pilasters, and uniquely decorated boxes of the older auditorium, yet we know the picture cannot predate Degas' invention of the monotype medium around 1876.[19]

8. Edgar Degas, Dancers at the Old Opéra House, c. 1877. Pastel over monotype on laid paper, 8⅝ x 6¾ in. (21.9 x 17.1 cm). National Gallery of Art, Washington; Ailsa Mellon Bruce Collection (1970.17.26)

by one of the acutest visual intelligences of the age according to his own rules, and taking as its subject the question of depiction itself.

"THE GREATEST THEATER IN THE WORLD"

By centering his art on the Paris Opéra, Degas chose to identify with one of the grandest and most culturally resonant establishments in France, whose dancers claimed descent from the court entertainments of Louis XIV and Louis XV. Not only was the structure itself "the greatest theater in the world," according to contemporary rhetoric, but it had long been one of the glories of the capital and a symbol of the vitality of the French nation as a whole.[22] This status was implicitly recognized by successive governments, which variously underwrote the Opéra's massive costs or monitored its administration, while including the theater among its most sumptuous ceremonial arenas. An early-nineteenth-century director, Louis Véron, records that his contractual duties included "maintaining the Opéra in a state of pomp and luxury appropriate to the national theater," and it was to the Opéra that visiting potentates were driven in state and sometimes taken backstage. At the beginning of Degas' career, it welcomed Queen Victoria in 1855, the Russian Czar in 1867, the Sultan of Zanzibar (plate 9), and the Lord Mayor of London in 1875.[23] The decoration of the two Opéra buildings openly celebrated the history and the sophisticated appetites of France in emblems of Imperial and later of Republican power, and in displays of murals, mosaics, sculpture, and ornamental art by French practitioners. Marble figures of the seventeenth-century French composer Jean Baptiste Lully ("the inventor of ballet") and the eighteenth-century dancer Marie Guimard, for example, reminded visitors of the ballet's national traditions, and ceiling paintings and wall panels demonstrated the progression of French dance—somewhat imaginatively—from Roman and Greek prototypes: "It is only with us," Théodore de Banville loftily claimed, "that a true classical school exists."[24]

Belief in the preeminence of the Opéra extended to its choral and its choreographic achievements. In 1860, as Degas was probably beginning his adult attendance at the rue Le Peletier auditorium, a critic in the popular journal *Le Monde Illustré* could announce that the Opéra was "an institution whose splendors are as intimately linked with the history of Paris as they are with that of art. Our leading stage has always been the center from which the most glorious masterpieces of music have radiated."[25] Implicit here are the author's—and many of his older readers'—memories of the "golden age" of the Romantic opera and ballet, the period of two decades that followed the sensational first appearance of such works as *Robert le Diable* and *La Sylphide* in 1831 and 1832, respectively. Dominated by the extraordinary talents of the dancers Marie Taglioni, Carlotta Grisi, Fanny Elssler, and Fanny Cerrito (plate 10), as well as those of the young Jules

Perrot, the unchallenged greatness of the ballets of this era haunted the second half of the century. Intriguingly, the teenage Degas could have seen some of these great stars before they retired, but he certainly came to maturity in a world where their superiority was often invoked and the standards of contemporary ballet were endlessly debated. In 1845, Théophile Gautier had been able to write in *La Presse* of a young Russian ballerina, "An artist who has not obtained the approval of Paris cannot be sure of her talent," explaining that the individual in question, Elena Andreyovana, had made the journey from her homeland to perform at the Opéra, "merely to have the opinion of Paris on her dancing."[26] In Degas' later years, the situation was almost reversed, but not long after he painted his *Orchestra Musicians*, the music critic Albert de Lasalle could still announce in *Le Monde Illustré*, "One dances only at the Paris Opéra."[27]

As its name implies, the principal attractions of the Paris Opéra were its sumptuous and internationally famed productions from the operatic repertoire, drawing on masterworks from the past, as well as a substantial proportion of scores from the current century. In earlier decades the building had seen such historic first performances in Paris as those of Gioacchino Rossini's *Guillaume Tell* and Giacomo Meyerbeer's *Les Huguenots*, and in Degas' maturity those of Richard Wagner's *Lohengrin*, Giuseppe Verdi's *Aïda*, and Camille Saint-Saëns' *Samson and Delilah*. Degas was a deeply musical individual and a discerning admirer of opera who once traveled to Brussels to hear the singer Rose Caron and wrote from New Orleans in 1872 "the lack of opera is a real privation here."[28] His documented tastes ranged across the works of Cimarosa, Gluck, and Mozart to his friend and contemporary Ernest Reyer, though he is known to have resisted the popularity of Wagner.[29] Detailed record books from the 1880s and 1890s still preserved at the Paris Opéra show the regular pattern of Degas' visits, including his devotion to certain productions, such as Gounod's *Faust*, Verdi's *Rigoletto*, and Reyer's *Sigurd*, which he saw eleven, fifteen, and thirty-seven times, respectively.[30] For reasons that remain unexplained, however, Degas never aspired to become "the painter of singers," representing

9. *Bertall,* Visit to the Opéra, *from* L'Illustration, *July 31, 1875. Wood engraving. Free Library of Philadelphia, Literature Department*

the opera choruses, soloists, and settings he knew so well in just a handful of pictures. Among the exceptions are the pastel-on-monotype *The Chorus* (plate 178), based on Mozart's *Don Giovanni*; the larger but technically similar *Aria After the Ballet*, probably showing a scene from *Faust* (plate 209); studies in several media from Reyer's *Sigurd* (plate 199); and a superb portrait of Rose Caron.[31]

Audiences of many kinds were drawn to the Opéra by its "glorious masterpieces of music" and by the renowned attractions of its stage. Opéra productions boasted scenarios derived from writers ancient and modern—Shakespeare, Goethe, Gautier, de Musset—and great epic and historical spectacles, accompanied by the sensory delights of hundreds of singers, dancers, costumed extras, and occasional live animals. Celebrities from many walks of life flocked to dress rehearsals and grand openings: both Giuseppe Verdi and Jean-Dominique Ingres were present at the premiere of the ballet *La Source* in 1866, and *Namouna* was inaugurated in 1882 by the French president, flanked by senators, deputies, ambassadors and "Tout-Paris mondain, littéraire et artistique."[32] For many of these individuals, as well as more modest citizens who competed for seats on everyday occasions, the Opéra ranked among their principal public entertainments and provided a real or vicarious center for their social world. Attendance on several nights each week was not uncommon, though visitors might arrive late and stay for a favorite scene or two from the current production, before leaving to dine or chat with fellow spectators. The Opéra ledgers reveal that Degas, too, visited the building three or four times a week at certain periods: in May 1886, for example, he saw all or part of *L'Africaine* on Wednesday the fifth; *Le Cid* on

11. The new Opéra: the dance foyer, c. 1875. *Bibliothèque nationale de France*

Friday the seventh; *L'Africaine* for a second time on Saturday the eighth; and *Guillaume Tell* on Monday the tenth.[33] As the pages of the present volume show, events at the Opéra were widely reported in the daily and weekly press, from lengthy reviews by leading literary figures to banal illustrations and disrespectful caricatures of celebrities, while a cult of personality flourished around its leading performers that has plausibly been compared to that of movie stars today. The glamour, as well as the ambiguous reputation of the institution, reached a peak at the annual Bal de l'Opéra, when the auditorium was transformed into a vast public ballroom and thousands of masked or disguised Parisians, from students to aristocrats, danced and flirted through the night.

Prominent among the Opéra spectators were the annual subscribers, or *abonnés*, representatives of the city's leading families who were wealthy enough to reserve a seat or an entire box throughout the year, often for decades. For the exclusively male *abonnés*—accompanied by their wives, mistresses, and friends—the Opéra combined business, social display, and a variety of physical pleasures, apart from and sometimes irrespective of the production itself. Crucially, a subscription for three nights a week allowed its owner to go backstage during the intermissions in a performance, to mix with the cast in the exclusive *foyer de la danse* (plate 11) and to pursue his private and professional intrigues in corridors and dressing rooms (plate 12). Several power blocs intersected at the Opéra, from the worlds of politics and high finance to such rarified bodies as the Jockey Club and the diplomatic corps, and its bars and corridors were notorious for deals, cabals, and liaisons of many kinds. Much mythologized in the past,

10. T. H. Maguire, after A. E. Chalon, Carlotta Grisi, Marie Taglioni, Lucile Grahn, and Fanny Cerrito in "Pas de Quatre," 1845. *Lithograph Jerome Robbins Dance Division, The New York Public Library for the Performing Arts, Astor, Lenox and Tilden Foundations*

12. Edgar Degas, Conversation: Ludovic Halévy Speaking with Madame Cardinal, c. 1876–77. *Illustration for La famille Cardinal. Monotype in black ink heightened with pastel on paper, 8½ x 6¼ in. (21.6 x 15.9 cm). Private collection, courtesy James Roundell, London*

the holders of *abonnements*, or subscriptions, have been brought into sharper focus in an important publication by Frédérique Patureau, whose analysis of the five hundred names listed for the 1892–93 season divides them into broad categories by profession. Patureau argues persuasively that the Opéra audience in general "corresponded to an elite of wealth and elegance" in the capital, but that the "*abonnés* represented an elite within an elite."[34] The cheapest *abonnements* were a little under a thousand francs a year for a single seat one night a week, while a much-coveted *loge* in the *avant-scène* cost almost 30,000 francs each year.[35] Around a quarter of the subscriptions were held by major financiers and two out of every five belonged to members of the nobility, while other groups included industrialists and commercial magnates (9 percent), the liberal professions (21 percent), and public officials (10 percent).[36]

Incomplete records have made it difficult to pin down Degas' engagement with the *abonnement* system through his career, though his status at the Opéra has frequently been misrepresented. The lack of comparable documentation from the 1860s and 1870s, for example, does not preclude the possibility that he owned or shared a one-night subscription during some of this period, though the expense may well have deterred him in his youthful days. The fact that Degas includes himself among the *abonnés* in several seminal paintings, such as the orchestra scenes of 1870–71, should also be considered. Fixing his viewpoint in the seats closest to the stage, Degas metaphorically occupied not just a location that was the envy of the rest of the house, but a row associated with the most senior *abonnés*.[37] This might be read as wishful thinking, as a territorial claim by a new arrival, or as a gesture of solidarity with his confreres, but at the very least it suggests a familiarity with their position. Without being too literal, we should also note that Degas might have been among the many visitors to the Opéra who took occasional advantage of the *abonnements* of friends—in his case, Lepic, Halévy, Emmanuel Chabrier, and Paul Valpinçon all had places at this time, for different reasons—and thus enjoyed their superior vantage point and borrowed prestige.[38] Contrary to legend, Degas was not a wealthy man and lived modestly, working hard to produce and sell his artistic output (Paul Valéry remembered him as "labor incarnate") and to repay the debts left by his father, an unsuccessful banker.[39] In a much-cited letter of 1882, we find him scheming to use his personal connections at the Opéra to secure a full subscription— "a seat for three days"—and proposing to share the expense with friends while reserving for himself "the right to go behind the scenes."[40]

When an *abonné* went backstage, he passed through the strictly guarded *porte de communication* where his name was recorded in dated lists. While it is misleading, as some have done, to see this as an account of an individual's attendance at performances (*abonnés* could also, of course, visit the auditorium *without* going behind the scenes), it is equally important to remember that only a subscriber with three weekly seats normally had the right to this access. Henri Loyrette has pointed out that Degas' name appears in such records between 1885 and 1892, which seems to imply that the artist's initiative of 1882 took three years

to come to fruition, by no means an unusual experience.[41] But Degas' letter leaves us in no doubt that he had been a subscriber for some while, perhaps for several years: "I shall take Mondays *as I always have done*," he wrote rather pointedly in 1882.[42] This situation has been confirmed by Patureau's discovery that Degas' name was already included in the roll call of *abonnés* published in 1882, among the numerous holders of single seats.[43] Patureau, Kahane, Terrier, and others describe a number of variations and abuses of the Opéra rules, including the practice of subdividing an *abonnement* mentioned by Degas—which was technically illegal—and the possibility of an *abonné* nominating a friend to go backstage in his place.[44]

The Opéra subscribers, who accounted at different periods for between one third and two thirds of the total seats, and a corresponding proportion of the institution's income, wielded significant power over its repertoire.[45] It was already a cliché that many came principally to watch the dancers, in an age when flimsy clothing and athletically displayed female bodies could not be seen elsewhere in polite public entertainments. The curious mixture of voyeurism and solemn dedication among these men was given visual form in their short-lived periodical *La Gazette des Abonnés*. One issue (plate 13) had on its cover the beginning of a review of a new opera, *Roland à Roncevaux*; portraits of those responsible (including the conductor, Georges Hainl); and an engraving of the stage, showing the emperor in his *avant-scène* box and two dancers displaying their legs, while an inside page included a scene in the wings during the current production (plate 14). Opéra administrations in the nineteenth century went to some lengths to accommodate both these serious and more brazen tastes. Short ballet interludes were routinely and sometimes brutally inserted into the majority of operas, either as divertissements between acts or as danced sequences in the principal narrative. These might be loosely linked through costume and choreography to the drama on stage—in a production of Degas' early years, for example, pastoral dancers appeared in the chateau gardens in *Don Giovanni*—but at times they would be frankly arbitrary. Contemporary illustrations show that ballerinas in modern tutus also graced Don Giovanni's apocalyptic descent into hellfire in Act Five of the opera; mingled with ancient Egyptians, and performed *en pointe* against Gothic architecture (plate 15) or on a Breton beach. If these anomalies could irritate the experts, they seemed to attract the uncritical loyalty of many subscribers, who expected the appearance of the dancers in each evening's program and at clearly specified moments. One of the reasons for the notorious failure of *Tannhauser* at the Opéra in 1861, when it was booed off the stage by the Parisian audience, was Wagner's resistance to the traditional introduction of the ballet.[46]

Contrary to widely held and frequently reiterated belief, however, the ballet in Degas' day was not just an adjunct to the opera. Though ballets continued to be interpolated in choral works or used to lighten a ponderous evening, they were also regularly presented as independent productions of one, two, and three acts on the Opéra stage. In the 1860s, critics actually complained that too much time was devoted to

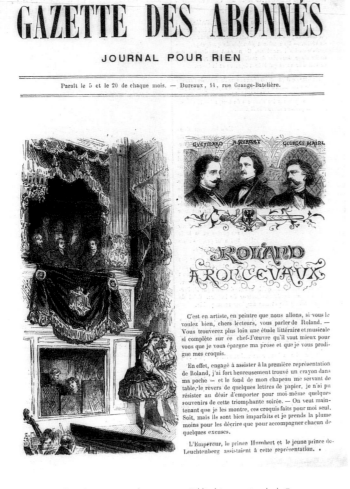

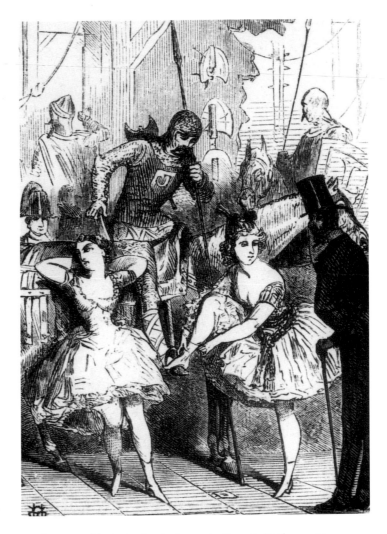

13. La Gazette des Abonnés, *October 20, 1864. Bibliothèque nationale de France*

14. The Wings of the Opéra, *from La Gazette des Abonnés, October 20, 1864. Bibliothèque nationale de France*

the dance, one arguing after a presentation of *La Source* that "two hours of *ballonnées*, of *jetés-battus*, of gracious poses…seem to me enough to satisfy anyone" and another protesting about a three-hour performance of the ballet *La Maschera* in 1864.[47] A typical compromise, in an age when the evening's entertainment might last many hours, was to combine a ballet of some forty or fifty minutes' duration with one of the shorter operas in the repertoire, or a single act from a longer one, which might additionally contain its own passages of dancing. On certain occasions, an entire program would be divided between favorite sequences extracted from both operas and ballets, as at the grand opening of the Garnier building in 1875 when the poster listed significantly more dancers than singers (plate 7). But combinations of two productions was the rule rather than the exception: in May 1870, for example, the first performance of Delibes' two-act ballet *Coppélia* took place at the Opéra, with Berlioz's opera *Le Freischutz*—complete with third-act dancers—acting as a "curtain-raiser."[48] A decade later, when Degas himself had become an *abonné*, records show that he attended double bills in which *Coppélia* was twinned with one of a range of operas, such as Verdi's *Rigoletto*, Donizetti's *La Favorite*, and Verange de la Nux's *Zaire*.[49] Other independent ballets seen by Degas during these years, paired with various shorter operas, were the one-

act *Les Jumeaux de Bergame*, two-act productions of *Les Deux Pigeons* and *La Korrigane*, and the three-act works *Yedda*, *La Farandole*, and *La Tempête*.[50] Confronted by such examples, it is time to lay to rest the myth of the occasional nature of ballet in Degas' experience and to adjust our perceptions of his subjects accordingly.

Where Degas can be connected with the life of nineteenth-century ballet—through letters, documents, attendance registers, sketchbooks, paintings, and anecdotes—the trail almost invariably leads back to dancers and other personalities at the Paris Opéra. But throughout his career, dance performances of various kinds and degrees of sophistication were available on stages across the city, from the crudest burlesques to productions that rivaled those of the Opéra itself.[51] Lacking full-time companies, these theaters relied on dancers who had trained elsewhere or had left the Opéra, typically because they failed to meet its standards (at least three of Degas' early ballet models, Joséphine Gaujelin, Melina Darde, and Mlle Hughes, are recorded as part of this traffic).[52] Other individuals or entire troupes were imported from abroad, such as the company from La Scala, Milan, presented amid controversy at the Eden Théâtre by Eugène Bertrand, before he became the director of the Opéra in the 1880s.[53] Degas is known to have enjoyed public entertainment of many kinds, from cabarets and vaudeville to the most select

music recitals.[54] It is highly likely that he saw occasional dance performances outside the Opéra: in New Orleans in 1872, he noted that he had seen a "Mlle Winke" who was formerly "a dancer at the Français," and on his return made hasty notebook sketches of actors or ballerinas at the Théâtre du Chatelêt.[55] Though technical standards were widely acknowledged to be inferior to those at the Opéra, many Parisians clearly preferred the relaxed manner and lighter tone of these performances. In Félicien Champsaur's erotic novel *L'amant des danseurs* of 1888, which is very loosely based on Degas, the painter-hero Decroix bemoans the "traditional gestures and stereotypical smiles" of the Opéra's ballerinas, comparing their "mechanical and lifeless" presence unfavorably with "the voluptuous odor" of dancers at the Eden Théâtre.[56]

Faced with this vigorous and seductive competition, as well as with high production costs and a fluctuating artistic reputation, the Opéra moved from decade to decade in a state of continuous near-crisis. State control in the early part of the century was briefly replaced in the 1830s by private finance under the formidable directorship of Louis

Véron, who is said to have become extremely rich on the proceeds.[57] Later administrators attempted to balance government subsidies with revenue earned from a popular repertoire, but controversy and the abrupt arrival and departure of new officials characterized the Opéra's history throughout Degas' life. Running through these years were two preoccupations that could at some times be complementary, at others in open and painful conflict. The first was with the maintenance of technical standards in music and ballet on the national stage, in full awareness of the glories of the past but equally of the need for innovation and fresh talent. To this end, great emphasis was placed on the training and rehearsal of the Opéra's professional ensembles of singers, dancers, and musicians, much of it taking place in the classrooms and rehearsal spaces within the huge complex of the building itself. The Opéra dance school, for example, was famed for its rigor and its orthodoxy, and much importance was attached to attracting the finest teachers from France and beyond. In addition to established works from earlier years and more recent revivals, a steady flow of new productions was commissioned each year to display the Opéra's talents. During the life of the rue Le Peletier building, from 1821 to 1873, a total of ninety-eight different operas and sixty-four ballets were presented, most of them newly written for the Opéra stage and all needing

15. La Korrigane, Act I, Paris Opéra, from L'Illustration, December 11, 1888. Bibliothèque nationale de France

elaborate combinations of sets and costumes, made by the theater's own teams of resident specialists.[58]

At the beginning of the nineteenth century, the repertoire of the Opéra had been widely considered an embarrassment. Ballet had "degenerated to the level of a purely acrobatic spectacle," according to one modern authority, and in the 1830s (the decade of Degas' birth) musical works by the great figures of eighteenth-century classicism—such as Gluck, who was later claimed by Degas as his favorite composer—had not long left the contemporary roster.[59] Arguing in 1825 that Gluck's *Alceste* was now outmoded and tedious for modern audiences, the contemporary historian Castil-Blaze pointed to the solution: "Our great lyric stage cannot regenerate itself except with new compositions, written in the modern style."[60] Within a few years, the impact of Romanticism in all the arts had begun a process that would soon fulfil Castil-Blaze's vision, not just in music but in the allied professions of the scenario writer, the choreographer, the scene painter, and the costume designer. Scores "in the modern style" flowed from the pens of Rossini, Weber, Donizetti, Meyerbeer, Gounod, and Berlioz, many of which became wildly successful productions at the Opéra, while an equally revolutionary school of prima ballerinas—led by Marie Taglioni (plate 16)—emerged to do justice to the drama and lyricism of their music. To the growing discomfort of the Opéra hierarchy and of Parisians generally, however, these legendary dancers also belonged to a long line of foreign, principally Italian, figures who dominated the national stage for years to come, just as the roll call of triumphant composers during the same period remained resolutely un-French.

The second preoccupation of the Opéra was thus with nationality, and with the need to enrich the French musical and choreographic heritage. Native composers, such as Daniel-François Auber, Fromenthal Halévy, Jules-Henri Saint-Georges, Ambroise Thomas, and Adolphe Adam, contributed substantially to its production of operas and ballets, but much of their output was roundly criticized, even derided, and soon left the repertoire. The school of dance, despite radical changes under reformers like Véron, seemed fated to turn out superbly proficient performers rather than the charismatic stars who excited the Opéra's fickle audience. Parisian dancers were famed for their adherence to traditional technique and their restrained style, which in turn allowed local supporters to pronounce on the correctness or otherwise of visiting foreigners. But time after time, French ballerinas found themselves consigned to secondary roles or to the corps de ballet and directors in search of celebrity were obliged to send their emissaries abroad, to rival establishments such as the famous dance school at La Scala in Milan. Véron himself traveled to London to persuade the Austrian Fanny Elssler (plate 267) to join his company; the French ambassador in Saint Petersburg was instrumental in securing the services of Martha Muravieva in 1862; two dancers known person-

ally to Degas, the distinguished Rosita Mauri and the obscure Nelly Franklin, began life in Spain and England, respectively; and, in desperation, the Opéra director Alphonse Royer was said to have dispatched his secretary to scour the teaching establishments of Italy, armed "with a pocketful of contracts."[61]

While they delighted in the skills and the allure of their imported prima ballerinas, and the music of Italian and German composers, French commentators smarted under this continuing humiliation, Castil-Blaze arguing that for the finest theater in Europe to be "reliant on foreigners" was "undignified."[62] In 1862, when Degas was twenty-seven years old, a Parisian critic at the premiere of Gounod's *La Reine de Saba* observed that this opera revealed the composer "in all his melodic impotence," and found himself "in despair at French music."[63] A generation later Maxime du Camp took up the cry, recalling in 1879 that the Opéra had been partly founded to "develop French music"

16. Jean-Auguste Barre, Marie Taglioni in "La Sylphide," 1837. Bronze, 17⅝ in. (44.8 cm). Carnegie Museum of Art, Pittsburgh; Leisser Art Fund (92.114)

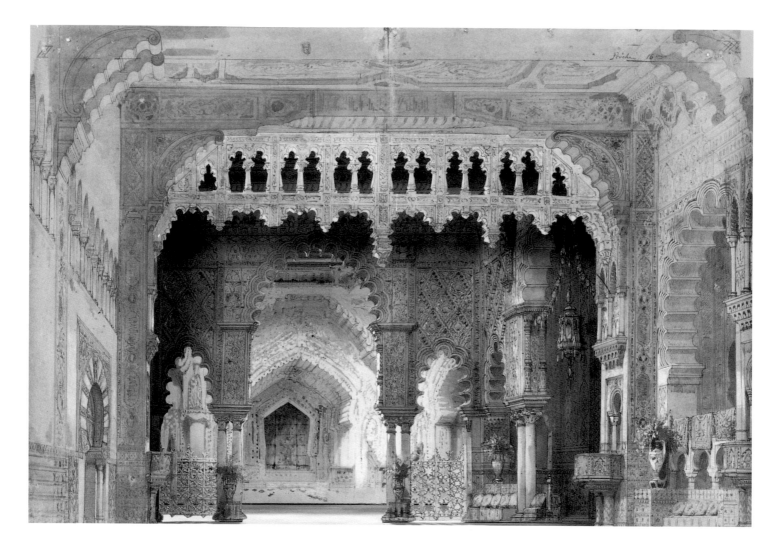

17. *Maquette for La Favorite, Act III: "The Palace of Alcazar," Paris Opéra, 1875. Designed by Charles Cambon. Bibliothèque nationale de France*

but that it now relied very heavily on foreign composers.[64] For some of their compatriots, the insult to the art of ballet—"which speaks so eloquently to the French people"—was especially pointed, encouraging them to monitor every sign of burgeoning talent under the Opéra's own roof.[65] A bruised nationalism was evident in the mourning that followed the violent and untimely death of the dancer Emma Livry, an exceptionally gifted Parisienne who took the city by storm in the early 1860s, and in the praise heaped on certain of her successors.[66] The homegrown Léontine Beaugrand, a principal dancer from 1861 to 1880, was explicitly admired for her "French" modesty and precision, qualities that attracted the attention of Théophile Gautier.[67] Noting that Beaugrand was "a child of the house, and has risen through the ranks," Gautier continued: "There are several dancers of that rank who are very talented and quite as good as the exotic celebrities who are brought to Paris at great expense."[68]

One source of unequivocal French pride was the Opéra's supremacy in mise-en-scène, the integration on an enormous scale of light, color, perspective, and scenic effects to produce a "phantasmagoria of magnificently impossible things" on its celebrated stage.[69] From the 1830s onward, a catalogue of exceptional designers and scene painters that included Ciceri, Cambon, Philastre, Thierry, and Despléchin prided themselves on the sweep of their Assyrian panoramas, the intricacy of their cathedral interiors, and the majesty of their Spanish palaces (plate 17), while audiences regularly applauded the latest spirit-filled glade or Mediterranean vista.[70] Even when complaints about musical standards were routine, there was rarely a production whose appearance failed to delight the most skeptical critics. As the newly translated Rossini opera *Sémiramis* opened to great acclaim in 1860, for example, Lasalle voiced his concern about this latest Italian arrival but left no doubt of its sensory impact. "As always the administration has paid the costs of the décor and costumes…never have costumiers and decorators dressed and installed a more magnificent queen than Queen Sémiramis," he wrote, referring to the exotic setting for the regal figure visible at right on a contemporary music score (plate 18). Reporting that the advice of the history painter and expert on archaeology Eugène-Napoléon Flandin had been sought, he added, "this scene equals in splendor and daring any extravagance that imagination and history could dream of."[71] The following week he returned to his theme, claiming that the Opéra now had "the right to claim the title *Imperial Academy of Decorative Painting*."[72]

In an age when large-scale visual spectacle was in short supply, directors of the Opéra and its rival Paris theaters understood that their audiences could be boosted by sheer theatrical novelty. Thunder and

lightning, mist-filled forests, exploding volcanoes, and plunging waterfalls spread the fame of the latest production, and the still-exotic resources of gas and electricity were used to evoke moonlight, sunrise and sunset, and a variety of ghostly presences. Hundreds of machinists were required to produce these effects on the Opéra stage, where stunts like flying fairies (in *Giselle*), disappearing principals (in *La Sylphide*), and a full-size storm-tossed ship in cross section (in *L'Africaine*) were contrived by ingenious systems of wires, mirrors, trapdoors, and other machinery. In the Renaissance setting of *Pierre de Medicis*, for example, which the young Degas may have seen, a much admired vista revealed "the Campo Santo at Pisa, illuminated by electric light" (plate 40), while another scene in the same opera included a fully operative "fountain with running water."[73] Such innovations could verge on the bizarre, as in the sequence in Halévy and Meilhac's *Néméa* of 1864 in which dance pupils performed "with miniature oil lamps attached to their foreheads," or when the opera *Le Prophète* was enlivened by the introduction of two professional English roller skaters.[74] Other productions could be frankly grandiose: during Massenet's *Le Roi de Lahore* of 1877 (plate 185), which prompted several pictures by Degas, the sets included the interior of an Indian temple, a broad plain overrun with soldiers, and a scene in Paradise, and at one point up to four hundred people were said to have been on the stage. The critic of the London *Daily Telegraph* found in this occasion "the scenic and terpsichorean splendours which are the speciality of the Paris Opéra, the theater *par excellence* of lavish and tasteful magnificence," though other voices had long since expressed their doubts about these developments.[75] In 1860, the critic Charles Bauquier protested: "We see horses on the stage, interminable processions, entire regiments parading with superb equipment, immense perspectives, crowds, swarms of dancers, shipwrecks, burning towns. Soon we will be present at a battle, a naval engagement...."[76]

The extent to which Degas' art was formed by, or made in opposition to, these currents of nationalism, technical display, and popular distraction has never been critically explored. Saluted by the leading historian of the French dance, Ivor Guest, as "one of the greatest painters who was ever attracted to the dance," whose "penetration into the mysteries of ballet has never been surpassed," Degas was also highly selective and implicitly critical of much that he saw.[77] It has often been remarked, for example, that Degas the painter preferred backstage scenes to the glamour of the performance, but it has rarely been added that his many extant pictures of the stage virtually ignore the large-scale exoticism that so appealed to his countrymen. While later chapters reveal the still-underestimated extent to which he depicted specific productions at the Opéra, we find him habitually

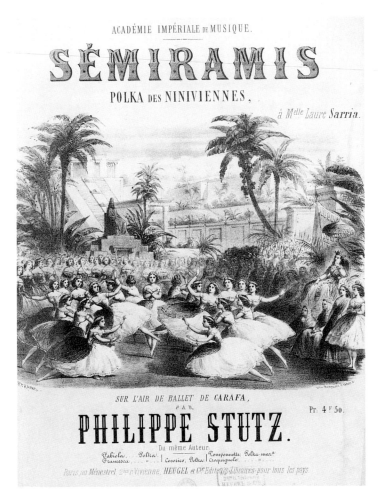

18. Sheet music cover for *Sémiramis*, c. 1860. Bibliothèque nationale de France

omitting the architectural detail and scenic extravaganzas that were the admiration of contemporary audiences and the staple of theatrical illustration. Surrounded by images of the dance in other contemporary modes, among them, the magazine plate, the popular print, and, increasingly, the photograph, Degas knowingly distanced himself from them and the information they contained, even as he mastered their codes and occasionally mocked their pretensions. In these and many other respects, Degas' engagement with the ballet at the "greatest theater in the world" was profoundly polarized, dependent on his privileged consumption of a refined spectacle on the one hand, yet endlessly subversive in his disregard of its priorities on the other. What is beyond doubt, however, is Degas' place at the center of this milieu, in the "household" of the Opéra and among the personalities and the lives of its dancers. It was within this intricate world that Degas evolved his new visual language, and it is by understanding more of the cultural topography of the rue Le Peletier Opéra and the Palais Garnier that we better grasp his achievement.

2. The Rue Le Peletier Opéra

*Here are qualities of observation on the one hand,
and the most remarkable qualities of color on the other,
within an absolutely new theme.*

—ERNEST CHESNEAU ON DEGAS, 1874[1]

If there was a time and place when Degas' vocabulary of the dance was formed, it was in the last three or four years of the life of the rue Le Peletier Opéra, before its destruction by fire in 1873. This is true in a strictly historical sense but also on a number of more personal and perhaps symbolic levels that have rarely been considered. In an extraordinary burst of inventiveness between the late 1860s and the early 1870s, Degas produced fifteen or more oil paintings of ballet subjects that are, quite literally, fundamental to his achievement. Here are his earliest portraits of contemporary ballerinas, in both their offstage and onstage finery; the first dancers at the barre, exercising against the geometry of bare walls; in pictures such as *Orchestra Musicians* and *Ballet Rehearsal on the Stage* (plate 61) the star moves into the footlights, glimpsed across the heads of the audience or surrounded by insubstantial scenery; and in *Dance Class at the Opéra* (plate 19) and other classroom views, we meet the corps de ballet with their instructors, gathered in mysterious, idiosyncratic rooms. These are astonishingly original pictures, mastering new kinds of spaces and a bold vocabulary of pose and gesture in a way that seems effortless. Together they spelled out—and have continued to define—Degas' professional identity for many of his admirers, demonstrating his prodigious accomplishments as well as his ambitions as an artist of modern urban experience.

Degas' first ballet scenes also had a remarkable long-term significance for the development of his own art. Much of the output of his subsequent career grew out of a selective recapitulation of these themes, in some cases even the same compositions and figures. The pose of the *Little Dancer, Aged Fourteen* (plate 130), for example, first appeared in the corner of *Ballet Rehearsal on the Stage* around 1874, while the distant ballerinas at left of center in *Dance Class at the Opéra* are clearly the precursors of those in *Dancers at the Barre* (plate 320), painted almost thirty years later.[2] If certain early motifs—such as the looming orchestra and the crowded audience—were soon abandoned and others gradually introduced, Degas stayed remarkably loyal to his first visualizations of the Opéra. An element of personal sentiment may well have played a part in this attachment, especially

19. Edgar Degas, Dance Class at the Opéra, 1872. Oil on canvas, 12⅝ x 18⅛ in. (32 x 46 cm). Musée d'Orsay, Paris

in its more curious manifestations. As we have seen, Degas was strangely reluctant to abandon the forms of the rue Le Peletier theater after its tragic demise, stubbornly including its stage and proscenium in works of the mid and late 1870s, and even beyond. Equally intriguing is his commitment to the classrooms from the same building, which reappear in canvases painted throughout the decade (to be examined in detail in Chapter Three). Extraordinary in a different way was the elderly Degas' habit of reworking certain earlier canvases, taking up images of the rue Le Peletier building still in his possession around 1900 and partially or wholly repainting them in the acid colors and bold brush marks of his late manner. Both *Ballet Scene* (plate 316) and *Dancers Practicing in the Foyer* (plate 91) are vivid examples of this anarchic retrospection, which carries Degas' identification with the old theater into uncharted and increasingly turbulent realms.

The more Degas' pioneering ballet paintings are examined, the more calculated their chosen location and subject matter appears to be. In every case, Degas took pains to spell out the link with the rue Le Peletier Opéra, often in ways his contemporaries would immediately have understood. Each of the pictures—without exception—has either an architectural setting that is unmistakably that of the Opéra, or a number of depicted personnel who were conspicuous among the Opéra staff, performers, or regular audience. In certain works, such as *Mlle Fiocre in the Ballet "La Source"* and *The Ballet from "Robert le Diable,"* Degas used the title of the picture to underscore its association with a much-talked about current production at the Opéra, while in others—such as *Rehearsal of the Ballet on Stage*—he specified views of the Opéra proscenium known to thousands of Parisians. Contrasting sharply with the vague titles and anonymous spaces of his later work, these images were part of a wider tendency to localize his first dance motifs. In an almost heavy-handed way, for example, Degas insisted on his familiarity with the theatrical personalities he portrayed at this time, from the near-infatuation expressed in his studies of the popular idol Eugénie Fiocre, to the presumptuously intimate depiction of the instrumentalists in *Orchestra Musicians*. In the Musée d'Orsay's version of this latter subject, Degas transformed the scene into a reunion of his friends from the Opéra world, while in *Dance Class at the Opéra* he personalized both the left-hand dancer, Mlle Hughes, and the ballet master, Louis Mérante, who was one of the most distinguished teachers of his day.[3] Even the room in which these latter figures appear would have been recognizable to certain of Degas' peers, including those who bought and wrote about his paintings, as a backstage foyer at the Opéra.

Degas' early ballet scenes presuppose—almost demand attention to, with a young man's *gaucherie*—an intimacy with the rue Le Peletier Opéra that speaks of first-hand knowledge. When and how he originally came by this knowledge has long been a matter of speculation, especially concerning his access to restricted backstage areas where classes and rehearsals took place. Specific information about Degas'

presence at the Opéra as a young adult, as with so many aspects of his life at that period, is still lacking: the 1860s are among the most sparsely documented years of his career, recorded in a mere handful of circumstantial accounts and barely represented in his surviving correspondence. Our principal sources of information in this decade are twofold: a dozen or so densely used notebooks, which have been somewhat overlooked in the context of his dance and theater art; and the drawings, paintings, and prints that emerged alongside them. Both sources confirm that Degas began his professional career around 1859, when he returned as a twenty-four-year-old from an extended tour of the galleries and monuments of Italy and from visits to his Neapolitan grandfather and Florence-based aunt. Back in Paris he established his first studio in Montmartre, working on ambitious portraits and large history paintings, such as *Sémiramis Building Babylon* (plate 42) and *Young Spartans Exercising* (plate 270), and planning to display his newfound erudition at the annual Salon. In parallel with these ventures, Degas made tentative inroads into a surprising range of current themes, among them the modern portrait, the landscape, and the racetrack, while his sketchbooks contain jumbled studies of the street, fashionable faces, objects in the Louvre, and half-formed ideas for future pictures.

A photograph of Degas taken around this time (plate 20) shows him conventionally attired in the uniform of his class, as he joined

20. *Anonymous photograph of Edgar Degas, c. 1860–65. Modern photograph printed from glass negative. Bibliothèque nationale de France*

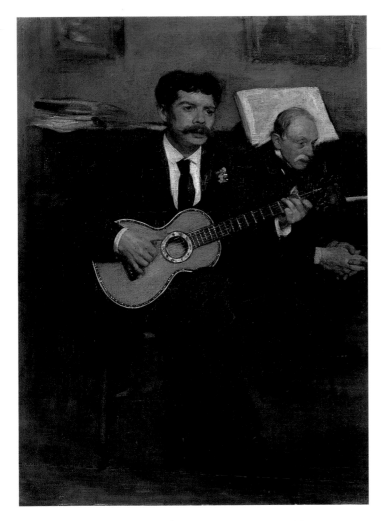

21. *Edgar Degas*, Lorenzo Pagans and Auguste De Gas, *c. 1871–72. Oil on canvas,
21¼ x 15¾ in. (54.5 x 40 cm). Musée d'Orsay, Paris (RF 3736)*

thousands of young Parisian males in their search for entertainment and advancement. What we know of his origins suggests that Degas, along with his early attachment to the visual arts, was markedly predisposed toward an involvement with music in general and to an identification with the rue Le Peletier Opéra in particular. He grew up in a cultured home, where his mother and younger sister sang Neapolitan songs and Gluck arias, and his father, Auguste, invited performers to occasional musical soirées.[4] One such evening was immortalized in the dual portrait *Lorenzo Pagans and Auguste De Gas* (plate 21), which features the Spanish singer and guitarist who was also included, quite anomalously, among the gathering of Degas' friends in *Orchestra Musicians*.[5] Degas himself is said to have had a good singing voice and to have taken up the violin briefly, but soon abandoned it in frustration.[6] In these circumstances, it seems rather likely that the young Edgar would have been introduced to public performances of music and opera by his parents, and perhaps exposed to the ballet for the first time in their company. His later predilection for certain classical composers—notably Cimarosa and Gluck—can almost certainly be

22. *Edgar Degas*, The Violincellist Pilet, *c. 1868–69. Oil on canvas, 19⅝ x 24 in.
(50 x 61 cm). Musée d'Orsay, Paris (RF 2582)*

traced to his upbringing, as can a number of stories from his final years. One of his models tells us that Degas sang Neapolitan melodies to her as he worked in his last studio, and Daniel Halévy describes a discussion with the aged artist on the merits of playing Gluck's *Orfeo e Eurydice* in the open air.[7]

In the second half of the 1860s, Degas' love of music found a creative outlet in a series of paintings of acquaintances with their instruments, forming a direct bridge between his earlier, more formal portraits and the canvases of orchestral players and accompanists in dance classrooms that soon followed. Works such as *Mme Manet at the Piano*, *Mme Camus at the Piano*, and *Violinist and Young Woman Holding Sheet Music* again recreate the atmosphere of domestic music-making and reverie, while studies of practitioners directly related to the Opéra carry us into professional terrain. The piano-playing Marie Dihau, the subject of one of these paintings, was the wife of the bassoonist at the Opéra, Désiré Dihau, who appears alongside his colleague Louis-Marie Pilet in *Orchestra of the Opéra*. Pilet and the Dihaus both lived close to the rue Le Peletier, as we know from Degas' notebooks, where the former's name is noted down alongside the address of Mlle Hughes, the ballerina at the right of *Dance Class at the Opéra*.[8] Painted around 1869, *The Violincellist Pilet* (plate 22) takes us to the heart of the rue Le Peletier institution, to encounter the controversial musician "seated in his office at the Opéra," as Theodore Reff has shown in a brilliant analysis of the composition. Evidently using his picture to take sides in a dispute between management and members of the orchestra, Degas also depicted on Pilet's wall a lithograph of contemporary composers, poets, and performers, the intricacies of which say much about Degas' engagement with French music at this contentious moment.[9]

As so often with Degas' art, local topography is also significant. He was born in 1834 on the rue Saint-Georges and christened at the neighborhood church, Notre-Dame-de-Lorette, just two or three streets away from the rue Le Peletier Opéra, in an area of lower Montmartre where he eventually spent most of his adult life. Though

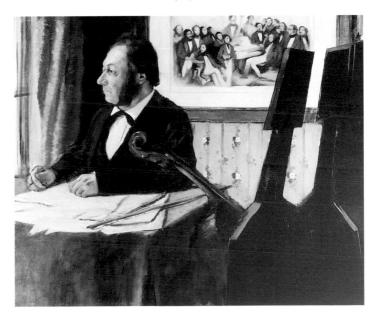

the family moved to another part of Paris in his youth, Degas chose to rent his first studio on the rue de Laval, half a mile to the north of the rue Le Peletier, and thereafter occupied a succession of apartments in the immediate vicinity. In another curious act of nostalgia or symmetry, he returned to live and work in the same street—now called the rue Victor Massé—throughout his last two decades.[10] It was an intensely artistic quarter, famed for its painters' and sculptors' studios, small galleries, auction houses, and suppliers of art materials, and for the ready availability of models. Several of Degas' acquaintances lived nearby at different times, from such colleagues of his early years as Renoir and Moreau, to Forain, Cézanne, Puvis de Chavannes, and Toulouse-Lautrec in later life, while Cassatt and Van Gogh both occupied buildings on the rue de Laval itself during their Paris sojourns. Parallel to the rue Le Peletier was the rue Laffitte, the "street of pictures," where many of the city's leading dealers had their premises and young artists gathered to study the work of their seniors.[11] From the beginning, Degas' career as a dance artist revolved around this area: it was in 1871 at Durand-Ruel's gallery—almost in the shadow of the Opéra—that he showed one of his first ballet pictures, *Orchestra of the Opéra*; most of the early Impressionist exhibitions, where his paintings, pastels, and drawings of the dance achieved their first wide currency, were held in galleries on the rue Laffitte and on nearby boulevards; and in later life Degas would stroll down the hill each evening from the rue Victor Massé, inspecting the stock of dealers like Vollard and Durand-Ruel who now competed for such works as *Two Dancers* (plate 258) and *Dancers* (plate 264).[12]

Today, the site of the old Opéra is occupied by offices, while the rue Le Peletier itself is a small and somewhat unprepossessing street crossed by the much busier thoroughfares of the rue La Fayette and the boulevard Haussmann. But in the 1860s it was one of the cultural hubs of Paris, surrounded by notorious cafés and famous restaurants, visited by art collectors, and frequented by tourists, fashionable pleasure seekers, and the Opéra's glittering audiences. The surrounding area was as popular for the accommodation of musicians and dancers as it was for artists, as a scattered survey of Degas' circle demonstrates. On the rue de Douai, near his first studio on the rue de Laval, lived Degas' close friend Ludovic Halévy, sharing the address with his collaborator on such works as *Carmen*, the composer Georges Bizet.[13] Further along the rue de Douai in the 1870s could be found the van Goethem family, with their three daughters who danced on the Opéra stage, among them, the model for the *Little Dancer, Aged Fourteen*.[14] Suzanne and Blanche Mante, the principal subjects of *The Mante Family* (plate 237), are said to have occupied an apartment in the same building as Degas around this time, along with their father, Louis-Amédée Mante, another cellist in the Opéra orchestra.[15] The great Opéra choreographer Arthur Saint-Léon spent his last years on the rue de Laval, where Degas' musician friends the Dihaus also resided,

while the legendary ballerina Emma Livry was born on the rue Laffitte and christened in the same church as Degas.[16]

Degas thrived in this rich cultural terrain throughout the 1860s, inevitably passing the rather grim façade of the rue Le Peletier Opéra on occasion as he walked from the rue de Laval toward the center of the city. A fascinating glimpse of his links with this institution can be found in a photograph taken between 1869 and 1873 (plate 23), where a small poster for the current attraction can be made out on the distant wall at right. Just visible is the word *Faust*, advertising the highly successful opera by Gounod that finally appeared here in 1869 after extensive runs at other theaters.[17] During its relatively brief season on the rue Le Peletier stage, this production of *Faust* involved several individuals already well known to Degas, or who were soon to feature in his life: the baritone and collector of contemporary art Jean-Baptiste Faure, playing the role of Mephistopheles; the conductor Georges Hainl, referred to simply as Georges in Degas' notebooks; and the "irresistibly seductive" dancer Eugénie Fiocre, who created one of the leading roles in the newly interpolated ballet sequences.[18] In an entry in his journal for June 12, 1869, Ludovic Halévy mentioned that he, too, had called in at the Opéra while *Faust* was playing, and within months he had written the first of his Cardinal Family stories, which begins backstage during the same opera.[19] Around 1870, if not before, Degas planned or executed his first orchestra and classroom paintings, which celebrated

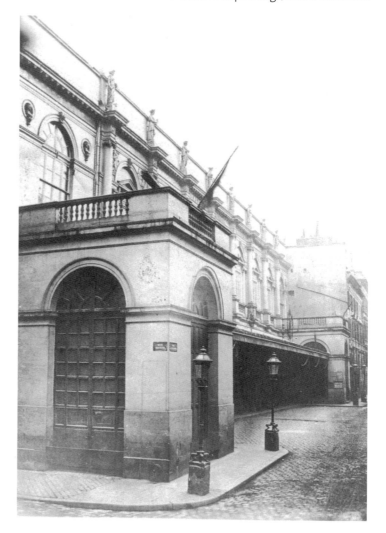

23. *Anonymous photograph of the rue Le Peletier Opéra House, c. 1870. Bibliothèque nationale de France*

the stage on which Fiocre and Faure were performing, the rostrum Hainl occupied, and the setting of Halévy's text. Somber though it seems, the exterior of the rue Le Peletier Opéra concealed an extraordinary spectrum of artistes and images that already animated Degas' creative life.

THE THEATER OF DEGAS' YOUTH

The rue Le Peletier Opéra known to the young Degas was already a dilapidated and obsolete structure, increasingly in the shadow of its planned replacement. The design and internal furnishings of the building had been widely criticized from the outset, and early references to its "rare elegance, and magnificent appearance" had given way in mid-century to remarks about "the poor taste of its facade, and the disgraceful appearance of its other sides."[20] Built in haste in 1821 by the almost forgotten architect François Debret, largely of elements recycled from the previous theater and from impermanent materials such as wood and plaster, it had been intended as a provisional home for the nation's opera and ballet while a grander edifice was devised.[21] If Debret is remembered at all, it is for his much-criticized restoration of the historic Gothic abbey of St. Denis, but it was his commitment to an "intransigent" classicism that defined the new theater.[22] As it transpired, his Opéra was to be used for more than half a century, entering into legend as the birthplace of the Romantic ballet and generating a flood of private memoirs and public documentation. Literally hundreds of monographs, pamphlets, prints, handbooks, and souvenirs described the institution and its personalities, recording with greater or lesser detachment the controversies that surrounded it through much of its existence.

Many of the characteristics of Debret's theater have a direct bearing on Degas' dance art, which was fundamentally conceived in its spaces and against its decaying fabric. From the beginning, for example, there were complaints about poor visibility in the auditorium and the obtrusiveness of spectators in the avant-scène. Visitors behind the scenes encountered the crowded dressing rooms and glamorous foyer that feature in Degas' Famille Cardinal monotypes (plates 81 and 82) and the classrooms recorded in such works as Dance Class at the Opéra (plate 19), both areas teeming with rats, as the young dancers were affectionately called. The backstage chaos was notorious, likened by one English writer to "a skein of thread tangled by the paws of a kitten, from the number of staircases and corridors which cross each other in all directions like a labyrinth."[23] As the years passed, Debret's "cage of plaster" was increasingly slighted and demands for its replacement became more vociferous, resulting in an atmosphere of uncertainty throughout much of the artist's association with the building.[24] An official competition for a new Opéra house was announced in 1860 and Garnier's winning design was chosen the following year, with construction on his massive project continuing for more than a decade. In the interim, records show that it became necessary to remodel or

redecorate the rue Le Peletier interior at frequent intervals, including a partial overhaul in the early 1860s at about the time Degas returned to establish himself in the city.[25] The somewhat threadbare look of fittings and upholstery in such canvases as Orchestra of the Opéra seem to reflect this history, along with the abraded wall surfaces in several of Degas' classroom pictures, among them, The Rehearsal (plate 88) and The Rehearsal (plate 84).

Debret's 1821 design for the Opéra followed many of the conventions of his day, establishing a huge, cube-like stage and a lavish auditorium at the center, then clustering the theater's social and technical amenities around them as the site allowed (plates 25 and 79). The photograph of around 1870 that disclosed the poster for Faust shows the much-denigrated main façade, behind which was the Ionic entrance foyer known to us principally from a lithograph and an unfinished painting by Eugène Lami (plate 24). Engravings illustrate the extent to which the severe exterior was offset by the richly carved and gilded décor of Debret's auditorium (plate 5), where the novel installation of gas lighting and a massive central chandelier heightened the glamor of the "greatest theater in the world," as a later admirer described it.[26] The stage at the rue Le Peletier was famously capacious, stretching almost a hundred feet into depth to allow for the architectural illusions and scenic extravagances beloved of its audiences, and catering to its teeming crowds of performers, managers, and technical staff. An elevation (plate 25) displays the huge block of the stage to the right of center, with the auditorium and entrance foyers at left. Above and below the stage we see the ranks of wooden structures that raised and lowered backcloths and other scenery elements through the ingeniously slotted boards, both from the "flies" above and from the lower depths. At this date all such maneuvers were muscle-powered, requiring armies of stagehands to be on duty during performances. Finding himself in the wings on one such occasion, the journalist Albéric Second recalls how he became "stupefied at the large number of machinists I saw bustling about in every corner of the theater, as if in an anthill," while another witness likened the scene to "a battle."[27]

Also discernible in the elevation is the four-degree slope of the stage surface, designed to increase the visibility of the action throughout the theater, and the controversial presence of boxes in the avant-scène. The latter owed their origin—in Charles Garnier's words—to "an ancient and barbaric usage, where gentlemen of the court placed themselves on the stage, side-by-side with the comedians."[28] These boxes were the province of wealthy or distinguished guests, among them the emperor himself in the Imperial loge (at the left of the proscenium), associates of the theater director, and in the uppermost tier, dancers from the company who wished to watch the performance.[29] At the lowest level a dark rectangular opening led to the notorious loge infernale, an exclusive vantage point from which groups of influential balletomanes had once greeted their favorites loudly or hissed at unpopular productions, though this practice was in decline by Degas' day.[30] Because of their proximity to the action, these boxes and loges attracted the attention not only of the audience but of generations of

24. *Eugène Lami,* Leaving the Opéra, *1842. Watercolor. Bibliothèque nationale de France*

caricaturists, who relished the opportunity to lampoon the celebrities who occupied them and their variously affected relationships with the performers (plate 26). Such distractions affected both dancers and spectators, giving rise to much debate about the theater's design. When Debret drew up his original plans, a decision to "suppress the boxes in the avant-scène" was applauded by the public, but this arrangement was soon overruled by higher authority and vested interests.[31] Garnier, too, weighed the merits of the system, judging it harshly but settling for a compromise in his new building.[32]

Before moving on to consider Degas' first pictures of the rue Le Peletier interior, it is instructive to note the ruthless, single-minded selectivity of the artist's approach to his chosen subject. Though Degas clearly frequented the sumptuous auditorium, the elegant public foyers, and other reception areas at the Opéra, these features are almost absent from his dance imagery. Ranks of spectators, fashionable parties in boxes, events in the *avant-scène*, flirtations during the intermission, and the thronged entrances that appealed to illustrators like Lami and Doré are equally scarce in his work, and even the sweeping arch of the proscenium itself is glimpsed only briefly and partially. When the audience makes a rare appearance in Degas' dance paintings, for example, in *The Ballet from "Robert le Diable"* (plates 53 and 58) its members tend to be shrouded in semi-darkness, and on the few occasions when the *loge infernale* is depicted—as in *The Orchestra of the Opéra*—it is either empty or confined to the very margins of the picture. From

his earliest days as a theater painter, it seems, Degas largely rejected the social and architectural spectacle in favor of more haphazard, even eccentric targets. In one of his most radical compositions of this period, *Ballet Rehearsal on the Stage* (plate 61), Degas chose a moment when the Opéra auditorium was conspicuously and resoundingly empty. Turning his back on the gilded *loges* and fabled chandeliers, he showed a group of disconsolate dancers as they yawned, scratched themselves, and awaited instruction, rendering the whole scene in bleak monochrome. Though we must continue to visualize him regularly—at times obsessively—presenting himself at the rue Le Peletier Opéra, Degas' painterly interest in the proceedings was exceptional in its severity and its aloofness from conventional taste.

The practical arrangements in the rue Le Peletier auditorium were much the same as those of a modern theater, though with greater disparities between inferior and superior accommodation, and more subtly nuanced social codes surrounding their use. Five levels of seating were available, from the cheaper, cramped quarters beneath the ceiling (the *paradis*, or *poulailler*) to the three tiers of private boxes or *loges* below them, with the *parterre* or stalls at ground level, all visible in the stylized plan of the period (plate 27). *Loges* had private access from the adjacent corridor and ranged from modest, partly screened groups of seats to spacious lower balconies, like those occupied by the foreground spectators in the engraving of 1873 (plate 5). A position opposite the stage gave the best views, and the lowest registers were the most expensive and prestigious. The *parterre* consisted of parallel rows of separate seats, with a smaller raised section at the rear known as

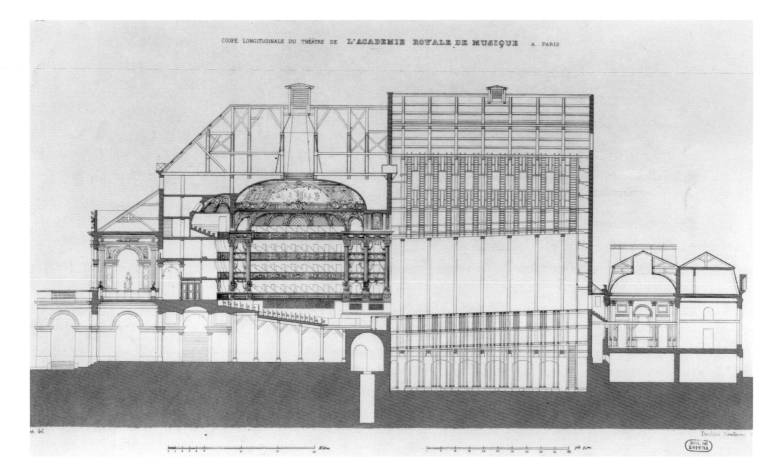

25. *Elevation of the rue Le Peletier Opéra House from Clément Contant,* Parallèle des principaux théâtres modernes de l'Europe, *1859. Jerome Robbins Dance Division, The New York Public Library for the Performing Arts, Astor, Lenox and Tilden Foundations*

the *amphithéâtre* and the exclusive *orchestre* area near the stage, an all-male preserve set aside for regular subscribers, or *abonnés*.[33] In a very visible sense, therefore, an individual's location in the auditorium was eloquent of his or her status, gender, and personal wealth. An artist like Degas, in his turn, was free to translate some of these inflections into the structure of his pictures, in the implied height or angle of his viewpoint and its proximity to the action. At one extreme, a composition predicated on a spectator near the center of the theater with a horizontal view, as adopted in *Orchestra Musicians* and *The Ballet from "Robert le Diable,"* placed the consumer of both performance and painting among a group of much-sought-after *parterre* seats that were forbidden to women or to members of the general public: at the other, the vertiginous sight lines of *L'Etoile* (plate 180) or *On the Stage* (plate 179) corresponded to the higher level, and therefore cheaper, *loges* above.[34]

The audience at the rue Le Peletier was considered to be diverse, with tickets and *abonnements* theoretically open to all, but Catherine Join-Diéterle's claim that "everyone went to the Opéra" must be treated with considerable caution.[35] In practice, the system of annual subscrip-

tions for individual seats and for entire *loges* came close to turning the Opéra into a private club, for "those privileged by fortune...the aristocracy and the rich bourgeoisie," in Frédérique Patureau's more recent phrase.[36] At full capacity, around nineteen hundred persons were accommodated in Debret's theater, with as many as three-quarters of the tickets for any given performance set aside for subscribers or distributed without charge by the director.[37] These were perpetually unavailable to the wider populace, while entire blocks of seats—in the front of the *orchestre* and the two lower registers of *loges*, for example—were permanently reserved for *abonnés*.[38] *Abonnements* were jealously guarded and passed down from one generation to another,

26. *Gustave Doré,* Les Rats de l'Opéra, from La Ménagerie Parisienne, *1854. Lithograph, 10¼ x 13⅜ (26 x 34 cm). Jerome Robbins Dance Division, The New York Public Library for the Performing Arts, Astor, Lenox and Tilden Foundations*

and when one was surrendered it was eagerly competed for among the elites of Paris: "the military, churchmen and lawyers" who favored the second *loges* and the "businessmen and officials" who were found in the third, according to Agnès Terrier.[39] Seats were expensive—twice the price of those at the Comédie Française—beginning at four francs in the *paradis* and advancing to twelve francs for the coveted places in the *avant-scène*, with individual tickets in the *orchestre* at six francs.[40] At a time when the humblest members of the corps de ballet were paid 300 francs a year and a workman earned between one and two francs a day, a large part of the citizenry was effectively excluded from the theater, while middle-class enthusiasts might aspire to an occasional visit.[41] Other factors conspired to limit spectators: formal dress was required in the more expensive sections; women were confined to the *amphithéâtre* and the boxes; and semi-clandestine ticket dealers manipulated the market.[42]

DEGAS' PRECURSORS AT THE OLD OPÉRA:
PAINTERS AND CARICATURISTS

The deeper origins of Degas' pictures of the ballet on stage have been little studied. His initial adoption of this subject, however, and his formulation of a new painterly language with which to articulate it were among the most radical departures of his working life. Around two thirds of his early dance scenes dealt with the performance rather than with events backstage, compared to less than a quarter in the works of later years. Predictable though this choice of theme might now seem, it cannot be sufficiently stressed that Degas embarked on these experimental canvases in something like a painterly vacuum. At the beginning of his career, there was effectively no viable tradition of theater painting with which to identify and no current exponents of the genre on which to model himself. We search almost in vain, for example, for contemporary performance and dance scenes in the Salon catalogues of the 1860s, and equally for depictions of the wings and the ballet rehearsal. A number of reasons can be offered for this extreme state of affairs, among them, the mid-nineteenth-century attitude of moral disapproval toward the theater in general and the world of the ballet in particular, and the association of such spectacles with lowlier art forms, such as caricature, souvenir lithography, and cheap illustration. This taint pursued Degas' imagery, however inappropriately, throughout his early years: at the first Impressionist group show in 1874, one of the artist's critics argued that his pictures of the dance showed "women in their opulent nudity" and accused him of bringing "an entire harem into the exhibition."[43]

Some illuminating exceptions will be examined in due course, but the extraordinary fact remains that the operas and ballets of the Romantic tradition and its aftermath failed to attract the major pictorial talents of the epoch, as well as most of their followers. The para-

dox was particularly acute for an artist like Degas, who was well aware that a genre of precisely this kind had flourished in the previous century, a period he much admired. While still in his early twenties, he had made several studies from prints by William Hogarth, an Englishman renowned for his abrasive scenes of the London stage and for his overtly theatrical social narratives.[44] Hogarth may well have been in Degas' mind when he designed some of his first ballet-class interiors, a possibility suggested by an astute British critic in 1876.[45] On both sides of the channel, the production of lively and sometimes risqué caricatures of dance subjects was well established in Hogarth's day, exploiting a series of visual devices that had lost none of their bite when re-used a century later. The art of eighteenth-century France was represented on the walls of the Degas family home, where a portrait by Jean-Baptiste Perroneau—who executed pastels of ballerinas and was famed for "frequenting the wings of the Opéra"—appears to have hung beside a Quentin de la Tour portrait of Gluck himself.[46] Both originals and engraved reproductions would have introduced Degas to pictures of dancers by Jean-Baptiste Pater, Antoine Watteau, and Nicolas Lancret, whether in concerts-champêtre or in such idealized settings as Lancret's "stage" paintings of the ballerina Camargo (plate 28).

Nearer his own times, Degas could look back to just a handful of immediate precursors who had tackled the theater and the dance, typically in isolated or idiosyncratic canvases. Eugène Delacroix, a profound influence on his early formation in many ways, was arguably even more preoccupied with music than Degas himself and went regularly to concerts, private musical soirées, and choral events. He even shared with Degas a particular taste for the operatic works of Gluck, Cimarosa, and Mozart, writing of "the grace, tenderness, simplicity and strength" of Gluck's Iphigénie in Aulis.[47] In his journals, Delacroix recorded his reactions to a succession of operas from the 1820s until shortly before his death in 1863, many of which would have been accompanied by dancing, while during a presentation of Robert le Diable he made several drawings of the singers on stage.[48] Yet in spite of the coincidence of Delacroix's mid-career with the heroic age of Romantic ballet and his documented visits to dance performances—which included personal attention to the great Marie Taglioni—as a painter he remained studiously indifferent to the choreographic arts. Taglioni, Elssler, and their colleagues make no appearances in the pages of his journal or in his sketchbooks, drawings, and paintings, with the obscure and solitary exception of the formal portrait of M. Simon, maître de ballets à l'Opéra.[49] This absence is more puzzling when we take into account Delacroix's well-known use of painting and graphic techniques to respond to themes from opera and drama. His lithographs of episodes from Goethe's Faust (plate 29), for example, were suggested by a production of the play in London, and he completed several canvases in the early 1860s that have been linked to current performances of Gluck.[50]

Delacroix's Duel of Faust and Valentin (plate 29) exemplifies one of the most widespread conventions for the representation of the stage

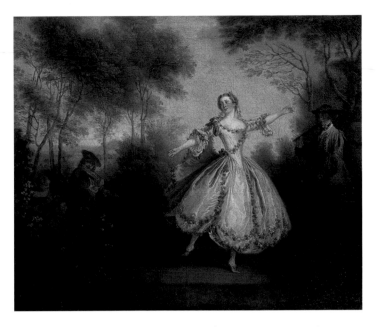

28. Nicolas Lancret, Camargo Dancing, c. 1730. Oil on canvas, 17¾ x 21¼ in. (45 x 54 cm). Musée des Beaux-Arts, Nantes (634)

in the early- and mid-nineteenth century. Despite the exaggerated poses, heightened effects of light and shadow, and stylized decor of the Romantic drama, the scene is offered as a plausible event taking place in real space, not on the boards of a theater. Crucially, no reference is made within the composition to the proscenium arch, the footlights, curtains, prompter's box, or adjacent loges that were part of every play-goer's experience. The arena of depicted action is thus presented as continuous with that of the spectator, governed by the same visual language and the same range of emotions. In this categorical sense, Delacroix colluded in and perhaps intensified the viewer's temporary suspension of disbelief, urging us to see the moment from Faust in similar terms to his painted landscapes and his other real or imagined images of the external world. This same formula—the theater scene without the theater—was ubiquitous in the rare and often undistinguished stage paintings of the day. It is found, for example, in Courbet's solitary excursion into the genre, the large Portrait of Louis Gueymard based on the opera Robert le Diable, and in the work of the long-forgotten François-Gabriel Lépaulle, whose "prodigious fecundity" extended to religious, military, and genre subjects.[51]

More telling, perhaps, is the example of Camille Corot, who has recently been unmasked by Fronia Wissman as a lifelong lover of the ballet. Corot's contemporaries saw him making drawings at Paris theaters and the artist himself talked about his procedure for rapidly capturing "the ballets and décors at the Opéra."[52] Among his rapid studies of the stage made over half a century are numerous representations of dancers (plate 30), singers, musicians, and scenery annotated with the names of current productions, such as the Opéra's La Favorite of 1840, La Filleule des Fées of 1849, an early production of Faust, the perennial Robert le Diable, and an 1859 staging of Gluck's Orphée at the Théâtre Lyrique.[53] But Corot, like Delacroix, Courbet, and

29. *Eugène Delacroix,* The Duel of Faust and Valentin, *1828. Lithograph, 8 15/16 x 11 3/8 in. (22.7 x 29 cm). The Metropolitan Museum of Art; Rogers Fund, 1917 (17.12)*

Lépaulle, never chose to paint the auditorium of the Opéra as such, preferring to absorb the splendid rural stage sets of Despléchin, Cicéri, and their colleagues into his canvases of the sylvan landscape and transforming his sketched ballet dancers into nymphs and dryads. Intriguingly, in a large-scale Salon picture like *Les Plaisirs du soir; danse antique,* Corot seems to come full circle, turning the artifice of the modern stage designer back into nature, even into the classical past. As his notebooks show, Corot's close engagement with theater and ballet continued into the early 1870s, and both his reputation and the regular appearances at the Salon of his Opéra-related canvases may well have encouraged the young Degas—a lifelong admirer of Corot's art—at this formative time.

The glorious exception to this rule of the "theater-less theater," as to so many others, was another central figure in Degas' evolution: Honoré Daumier. Several of his brilliantly inventive but undated oils and watercolors of dramatic scenes, which are thought to have been made in the 1860s, divide their attention equally between the per-

formance and its physical context. The critic Arsène Alexandre was among the first to summarize this crucial aspect of his achievement, pointing out that "Daumier was the spectator par excellence, because he simultaneously captured the events in the auditorium, on the stage and in the crowd."[54] Apparently executed some years after his precisely dated lithographs of ballet dancers, singers, and tragedians, Daumier's paintings dealt frankly with the delights of the spectacle in its sometimes prosaic surroundings. The principal subject of *At the Theater* (plate 31) is the multi-layered artificiality of visual experience, articulated in the separation of the actors' fictive space from that of the craning, tumultuous onlookers. By comparison with Delacroix's *Faust* scene, we feel that Daumier has suddenly pulled back from the moment of drama, revealing its synthetic and slightly absurd actuality. Where Delacroix's characters appear in a gothic townscape, those in Daumier's melodrama stand on a wooden floor against rudimentary scenery, their cardboard antics contrasted with the physical presence of the spectators and, by extension, ourselves. Other paintings by Daumier are set in grander theaters and show gilded, ornamental *loges* and stage appointments like those of Debret's Opéra, where Daumier is known to have been an occasional visitor.[55] Common to all

30. Jean-Baptiste-Camille Corot, Woman in Loge and Dancer, c. 1845–55. Pencil on paper. Musée Carnavalet, Paris (D 3594)

of them, however, is the shift from dramatic illusion to contemporary fact: these are pictures about spectatorship, not disembodied visions of the past.

The example of Daumier—and that of his fellow caricaturists and illustrators—was arguably the single most important factor in the emergence of Degas' dance vocabulary. Lacking a painterly precedent and remote from the pictorial mannerisms of previous generations, Degas was able to turn to the lithographs and engravings of these "sublime hooligans," as Gérôme called them, and to a visual vernacular that was still in the rudest health.[56] Widely available in print shops, in cheap bound volumes, and in the pages of daily and weekly newspapers, the huge output of Daumier and his peers—among them Lami, Gavarni, Doré, Marcelin, Grandville, Cham, Grévin, de Montaut, and de Beaumont—combined irreverence with extreme perceptual and formal license. Many of these draftsmen were attracted to the theater, where the structures of the stage and the wings encouraged their suggestive pens and their ironic asides, their montages of fashionable types, and their swooping, candid exposés. The resurgence of stage painting in Degas' day can often be traced to their work, pointedly developing among artists with a strong link to graphic procedures. Daumier's own canvases and panels self-evidently depended on it and were clearly designed to cross the genre divide, though they remained largely unknown until shortly before his death in 1879.[57] Isolated theater pictures by Edouard Manet and Adolph Menzel were either directly indebted to Daumier's prints, as in the former's Lola de Valence (plate 47), or to new currents of illustrative realism, such as the remarkable product of Menzel's visit to Paris in 1855, The Théâtre du Gymnase.[58] If the young Degas was almost certainly unaware of Daumier's and Menzel's paintings, he was sufficiently well informed about Daumier's lithograph L'Orchestre pendant qu'on joue une tragedie to adopt its bipartite design for his two experimental orchestra canvases of 1870–71.[59] Several of Degas' later performance scenes were

ill-disguised acts of homage to the prints of his great predecessor, while many more were the progeny of Daumier's selective eye, his compositional daring, and his famously dry humor.

Two very different strategies for the representation of ballet performances were available to Degas in the graphic modes of the 1860s: the caricature and the engraved stage panorama. His near-reverence in later life for the caricatures of Daumier, Gavarni, and certain of their followers is well attested, though his debt to them may still be underestimated.[60] Often overlooked is the immediate significance of these lithographs for Degas and other artists working at the rue Le Peletier theater. Large numbers of contemporary prints on ballet or musical subjects were implicitly or explicitly set in Debret's Opéra, a location underscored in their titles, in representations of familiar performers, and in details of décor. Daumier's Afficionados' Row: View Taken at the Opera (plate 32) is one of hundreds of examples where the site is specified, while most of his drawings on dance themes would automatically have been understood to refer to the Opéra stage. The setting of Danses de la Haute Ecole of 1853 (plate 33), for example, may appear somewhat generalized, but it probably recalled one of the numerous ballets or ballet divertissements that premiered at the rue Le Peletier in this same year, and perhaps the current controversy over "ugly" and attenuated male dancers at the Opéra.[61] But there can be little doubt that the horizontal format and dramatic lighting of Daumier's print were in Degas' mind when he created his justly celebrated Three Ballet Dancers (plate 34) a quarter of a century later, along with its implicit Opéra setting. Replacing lithography with the more up-to-date but somewhat sympathetic technique of monotype, Degas gave his performers a similar weightlessness and just a hint of the jovial angularity of Daumier's stick-like troupe. Ironically, on this occasion it was Degas who omitted the references to footlights and prompter's box in

31. Honoré Daumier, At the Theater, c. 1860–64. Oil on canvas, 38³/₈ x 35½ in. (97.5 x 90.4 cm). Bayerische Staatsgemäldesammlungen, Neue Pinakothek Munich (8697)

his predecessor's design, secure in the knowledge that the theatrical context would have been recognized by all.

When Degas took his seat in Debret's parterre, he knowingly placed himself—figuratively, and presumably on occasion, literally—in the most exalted graphic company of his seniors. Daumier, Gavarni, and many of their generation were still actively plying their trade in the 1860s and publishing drawings of the Opéra and associated themes in illustrated papers, albums, and individual prints. Their impact on the young artist can be vividly summarized in a study by a relatively minor exponent of the genre, Cham (plate 35), which is typical of dozens of works of this period. Cham's drawing incorporates a remarkable, even disconcerting range of elements associated with Degas' first dance pictures: a narrow field of vision that includes both stage and audience; an isolated dancer engaged in inscrutable action, detached from her historic or sylvan background; a glimpse of an *avant-scène loge*; the cropped figure of a musician in the orchestra pit; and looming foreground spectators, armed with opera glasses. The revelation is complete when we discover that Cham's study was published in April 1860, the very month Degas returned to settle finally in Paris and exactly a decade before he adopted these devices in his own painting, in such works as *Orchestra Musicians*.

Cham's drawing was printed in *L'Illustration*, one of a number of weekly journals and daily newspapers to feature topical cartoons, humorous vignettes, and larger satirical caricatures on ballet and opera themes. These publications were part of an immense output of printed, illustrated material at this date that generated a number of theatrical genres, from pictorial music covers (plate 18) to posters (plate 7), from tinted lithographs of the stars produced in their tens of thousands (plate 10) to bound collections of prints (plate 26). One pervasive format, often appearing in the same periodicals as the work of the caricaturists, was the pedantically detailed wood engraving of a current

32. *Honoré Daumier, Afficionados' Row: View Taken at the Opera, 1852. Lithograph, 9⅞ x 8½ in. (25 x 21.4 cm). Fogg Art Museum; Gift of W.G. Russell Allen and Paul J. Sachs (M8813)*

33. *Honoré Daumier, Danses de la Haute Ecole. Poses D'Une Ecole Encore Plus Elevée, 1853. Lithograph, 8½ x 10½ in. (21.6 x 26.7 cm). Philadelphia Museum of Art; Gift of Lessing J. Rosenwald*

production at one of the city's musical theaters, with—once again—a strong emphasis on the Opéra itself. Executed by obscure or anonymous craftsmen, such prints relied on a set of descriptive conventions at the opposite extreme from those of Cham, Daumier, and Gavarni. In place of the telling gesture or the impudent close-up, the engravers repeatedly showed the full span of the rue Le Peletier stage, with a consequent emphasis on painted architecture and illusionistic landscape at the expense of individual singers, dancers, and spear-carriers. A large amount of visual information was included, while neutrality in handling and the adoption of a level, frontal viewpoint were standard expectations. Finally, no reference was made—as in the oil paintings of the Romantic era—to illusion-destroying structures beyond the edges of the proscenium arch. Wood engravings of *La Korrigane* (plate 15) and *Sapho* encapsulate the type (plate 268), reminding us forcefully of the cultural priorities and visual constraints of the day. In both cases the ballerinas in their exotic settings are dwarfed by the spectacle around and above them, reduced almost to ciphers in a drama that barely concerns them and in a landscape bizarrely remote from their tutus and fashionable Parisian coiffures.

Daumier's lithograph, Cham's sketch, and the scenes from *La Korrigane* and *Sapho* stand for the dominant but contrasted modes of theatrical depiction as Degas began his career; the first two examples scurrilous and selective, the last mechanically all-inclusive. The significance of both for his nascent vocabulary was enormous, whether as models to be emulated or knowingly cited, or as over-determined patterns to be resisted. Important studies by Joel Isaacson, Beatrice Farwell, and others have brought to our attention the pervasive role of journalistic illustration in the art of the Impressionist generation. In

Degas' oeuvre, Isaacson has discovered case after case where the artist "borrowed" or made witty reference to a pictorial formulation of the theater already current among caricaturists, some enjoying "the status of a running gag" by the time he used them.[62] Other examples show Degas' adoption from the popular press of specific formal devices, such as "cropping" and high vantage points, but Isaacson acknowledges that Degas habitually went further, achieving "a greater leap, a greater adventurousness and daring beyond what the illustrators, including Daumier, offered."[63] Illuminating though they undoubtedly are, simple appropriations of imagery from one register to another—from a newspaper to a canvas, for example—are only part of a larger and necessarily more elusive story. What Degas ultimately owed to his graphic predecessors was his artistic liberation, not just from a limited range of subject matter and stultifying convention, but from the idea of restraint itself.

In the 1860s, the impact on Degas of caricature and illustration, as well as such related forms as the newly fashionable Japanese print and the ubiquitous photograph, appears to have been traumatic. The solemn young man with a top hat recorded soon after his return from Italy (plate 20), with one artistic foot still planted in the Renaissance, was assailed from several directions and rapidly gave ground. The uncertain success of his large classical and biblical canvases was accompanied by small-scale forays into more local themes, but by mid-decade his priorities had definitively shifted. The complex and tormented *Scene of War in the Middle Ages*, which was accepted at the Salon of 1865, became the last painting of its kind to emerge from Degas' studio: in 1866, his submission was the aggressively modern *Fallen Jockey*, followed in 1867 by his portrait of a questionably talented Opéra ballerina, Eugénie Fiocre. It is a remarkable fact that these new themes, as well as the others that now dominated his art—beach scenes, laundresses, bourgeois interiors, and, of course, orchestras, musicians,

34. Edgar Degas, Three Ballet Dancers, c. 1878–80. Monotype on paper, 14 x 19⅛ in. (35.6 x 48.6 cm). Sterling and Francine Clark Art Institute, Williamstown, Massachusetts (1955.1386)

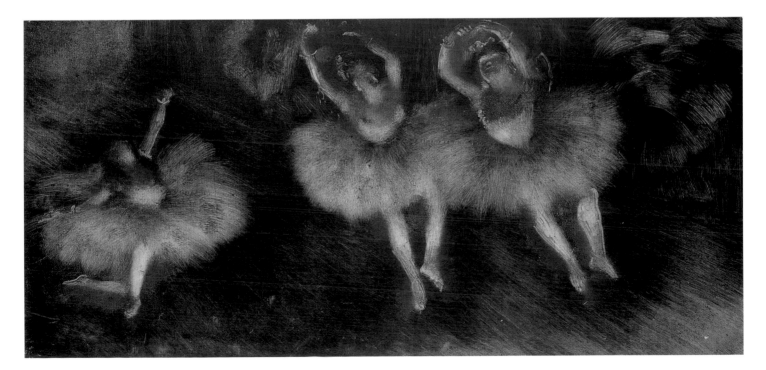

35. *Cham*, Les Lorgnettes, *from* L'Illustration, *April 21, 1860. Bibliothèque nationale de France*

and dancers—all had a vital currency in the popular graphic media. Given his starting point, Degas' progress toward the demotic was an extreme case of personal and artistic reinvention. Now keeping company with Manet, Tissot, Fantin-Latour, and Morisot, Degas was sharply stimulated by their urban iconography, their acerbic ideas, and by a shared taste for unorthodox images, among them, cheap prints and cartoons. By 1870, this transformation was almost complete, and Degas was to place the language of Daumier and his disciples at the center of a new professional project: a contemporary art of the dance.

DEGAS' BEGINNINGS AS A THEATER ARTIST

The earliest—and among the least noticed—images by Degas of an identifiable theater scene were made when he was an art student in his early twenties, shortly before leaving Paris in 1856 for his three-year sojourn in Italy. They consist of a series of sketches of an actress and various ancillary figures and were made on the tiny pages of three pocket notebooks (plate 36).[64] Modest in scale and execution, these studies are disproportionately vivid, both as accounts of specific performances and as precocious models for the stage compositions and theatrical passions of his later years. As Jean Sutherland Boggs first established, they record the renowned Italian actress Adelaide Ristori, who appeared in two of her most celebrated roles at the Théâtre des Italiens on successive visits to the French capital in 1855 and 1856.[65] The young Degas was clearly enraptured by the sight, thrilling to Ristori's white-blond hair and delicate gestures: "Her hands so fine, so beautiful!"

36. *Edgar Degas*, Scene from "Medea." *Page 11 from Notebook 6, 1856. Bibliothèque nationale de France*

he wrote in his notebook, "When she runs, she suddenly has the movement of the 'Victory' from the Parthenon."[66] In response to the earlier performance, when Ristori starred in Schiller's *Mary Stuart*, Degas completed just one rather cramped drawing of the richly robed queen, her attendants, and a hint of the stage set.[67] The following year his excitement overflowed on to a dozen pages, where hasty lines document Ristori in scene after scene of Legouvé's *Medée*, often side by side with written notes and further exclamations: "on Tuesday 15 April I saw the most adorable figure from a Greek vase, speaking and walking."[68]

Everything about these studies suggests immediacy, as though they were furtively begun and perhaps completed during the production itself. Almost as striking—and certainly as indicative of things to come—is Degas' close attention to such scenery elements as decorated walls, a large altar, and a row of classical columns, which situate the figures effectively but economically within the space of the stage. While there is a danger of over-interpreting these faint traces, we might note that Degas has approached Ristori's performance as an essentially theatrical event, complete with notes on the color and pattern of her costume, details of her hairstyle, and excerpts from the play's text. His involvement with the spectacle and his empathy with Medea's plight are almost palpable in the cinematic sequence of the drawings, which follow her tragic progress as she arrives in Corinth, gathers her children to her in the face of the mounting drama, and later threatens to kill them. So infatuated was Degas by Ristori's talents that he went to see her in the same role in Rome in 1857 during his Italian visit, making one further notebook study of figures and

THE RUE LE PELETIER OPERA

37. *Edgar Degas, Scene from a Play. Page 137 from Notebook 18, c. 1859–64. Brown ink on paper. Bibliothèque nationale de France*

décor.[69] His care with the details of the scene is confirmed in both contemporary engravings and photographs, leading us to speculate about the purpose of the young painter's industry.[70] By this date, Degas had already begun to make his own distinctive if youthful works of art, from ambitious portraits to more tentative studies from the urban landscape. Poised for the next step in his career and enthralled by the sight of Ristori, both timeless in her role and strikingly actual on the stage, could Degas have considered an even more daring venture: a small, precocious canvas of the Paris theater?

Exactly ten years later, Degas was again swept up in an obsession with a glamorous, charismatic female performer, this time on the stage of the rue Le Peletier Opéra and with a prominent ballerina, Eugénie Fiocre. In his preparations for the portrait of Fiocre shown at the 1868 Salon, he once more made hurried notebook sketches during an acclaimed contemporary production and executed a set of drawings—now on a larger scale—that focused on her gestures, exotic costume, and bodily expression. But between these echoing encounters there is considerable mystery, with little documentary evidence of Degas' response to drama, opera, and ballet, and no known painting that deals unequivocally with these themes. Previously overlooked in this period, however, are numerous more modest indications of his presence at the theater and firsthand attempts to visualize this experience. As with the Medea drawings, it is Degas' notebooks that bring us

closest to his thinking: the range of studies they contain during the intervening years is immense, broadly illustrating the young Degas' cultivated but unpolished appetite for musical entertainments of many kinds. From the mid-1850s, for example, we find figures playing instruments, such as the violin and cello; groups in historic dress who strut and gesture; and occasional glimpses of the dance.[71] If specific depictions of the ballet have yet to appear, there is a suggestive foretaste in swirling antique maenads and elegant ballroom couples, bucolic jigs, and folkloric merrymaking in several registers.[72]

The notebooks produced after Degas' Italian visit are more specifically theatrical and operatic in tone. Between 1860 and 1863, we encounter dozens of characters in the costume of earlier centuries; spectators in theater boxes, actors declaiming, and putative scenes from drama; more musicians and instrumentalists; and faces in crowds and audiences.[73] Some studies described by Reff as "fantastic" or "invented" architecture may equally reflect an interest in theater scenery, while a previously unremarked picture of figures in a shadowed interior appears to show a contemporary play in mid-performance (plate 37).[74] With its unmistakable line of footlights in the foreground, this ink-and-wash scene is surely taken from the Paris stage and is thus the earliest such image in Degas' mature career, anticipating by almost a decade the ballet and cabaret compositions of the Impressionist years. Further groups of sketches depict mannered—perhaps operatic—individuals caught in the act of singing, some accompanied by musical notation, and dancers in social or other settings.[75] Significantly, perhaps, these same pages reveal Degas' growing curiosity about

38. *Edgar Degas, Dancer. Page 57 from Notebook 14, c. 1859–60. Pencil on paper. Bibliothèque nationale de France*

39. *Edgar Degas, Opéra Scene. Page 11 from Notebook 18, c. 1859–64. Pencil on paper. Bibliothèque nationale de France*

caricature itself, which he often applies in an experimental manner to the very stage and theater subjects under discussion.[76] Most intriguing of all, in a notebook used from 1861 to 1862, we discover a previously unheralded male figure in tights, full-sleeved blouse and laced doublet, the first surviving drawing of a ballet dancer—and a rare male performer—in Degas' entire oeuvre (plate 38).

The likelihood of Degas' attendance at performances of opera and ballet in the first half of the 1860s has already been established in our examination of his personal background, his familiarity with some of the Opéra personnel by mid-decade, and his residence near the rue Le Peletier. To this can now be added the witness of his sketchbooks: among hasty scrawls of street characters, urban faces, and rural horse-riders, a gesticulating figure in doublet and hose or a singer in Renaissance finery cries out for explanation. Such a figure was often to hand on the stages of the French capital, and more specifically in the documented repertoire of the Opéra. Close inspection of Degas' drawings shows that a number of his subjects are not only historically precise but demonstrably close to the antiquarian productions in vogue at the Opéra during these years. A cluster of hasty sketches on pages used between 1859 and 1864, for example, catalogued as men and women "in eighteenth century costume," actually shows them wearing the distinctive breeches, tall hats, and high wing collars of the Directoire style,

current between approximately 1795 and 1805.[77] The only place Degas could have seen such outlandish characters was at the theater, in a play or in a ballet like Petipa's 1861 *Le Marché des innocents*, which was set in exactly this period and featured several Directoire "incroyables."[78]

Another page in the same notebook (plate 39) presents a vista of late Gothic or Renaissance ecclesiastical buildings, spires, and a bridge-like structure, arranged behind its appropriately costumed and sword-wielding protagonists. Here Degas has sketched an incident directly comparable to that in Delacroix's *Faust* lithographs or Daumier's *At the Theater*, but favoring the essentially credulous manner and fantastical space of the former. Tales of swashbuckling conflict amid crenellated architecture were not uncommon at the rue Le Peletier at this time, in operas such as Saint-Georges' *Pierre de Medicis* of 1860 (plate 40) and Mozart's *Don Juan*, and in early presentations of Gounod's *Faust* at other Paris theaters.[79] Degas' drawing resembles scenes in each of these productions, yet incomplete records of their performance limit our ability to identify its source precisely. What is beyond question, however, is Degas' exposure to a theatrical ambience of this kind and to its colorful actors, singers, and associated ballet troupes. On such occasions, he must already have been watching several dancers who were to become the friends and models of his mature world. The cast lists for the ballet divertissements in *Pierre de Medicis* and *Le*

Marché des Innocents, for example, reveal the names of Elise Parent, who posed for *Orchestra of the Opéra*; Marie Sanlaville, Mlle Malot, Jules Perrot, and Louis Mérante, all of whom he would paint in later years; Mlles Simon and Ribet, both mentioned in his letters; Louise Fiocre, the less renowned of the sisters (plate 41); and the subjects of his two earliest dancer portraits, Joséphine Gaujelin and Eugénie Fiocre herself.[80]

Most of the early drawings of the stage in Degas' notebook are focused on individuals or small groups, at the expense of the broader view. In this and in other respects—such as their cursory graphic manner—they favor the tradition of the caricature rather than that of illustration or conventional painting. A tantalizing exception is a scene in pencil and sepia wash (plate 42), which occurs among a group of theater-based drawings from the early 1860s, an image vividly characterized by Reff as a "dramatic episode in an opera or play, showing a ship at the right and a maiden being abducted in the center."[81] Here Degas has adopted the wide format of the newspaper engraving, albeit in summary form, implicitly situating his viewer in the audience as the action unfolds across the breadth of a stage. Uncharacteristic in its painterliness and lack of detail, the study nevertheless allows us to add to Reff's itinerary a colonnade at left with figures behind it, and a male presence at right in tall hat, greatcoat, and long boots. Despite its vagueness, therefore, this is a distinct narrative set in a specific location at a particular moment, which again finds echoes in the current offerings at the rue Le Peletier. Among other candidates, a two-act ballet first performed at the Opéra in 1861, Gabrielli's *L'Etoile de Messine*, culminates on a Sicilian harborside with figures emerging from a church at left, a frenzied dancer collapsing into the arms of her brother at center, and a somewhat sinister male hovering in the foreground, though surviving designs indicate that it was originally set in a more crowded, rustic context.[82] Whether we imagine Degas recasting Gabrielli's idiosyncratic drama in heroic mode or recording another current production, however, such pages speak irresistibly of a theater artist in the making.

The position of this drawing for an unrealized painting of a "dramatic episode in an opera or play" immediately beneath a draft for

41. *Louise Fiocre in* Sémiramis. *Bibliothèque nationale de France*

Degas' large history picture *Sémiramis Building Babylon* (plate 43) invites a number of conjectures. Using not just the same page and the same ink-and-wash medium but a rhyming horizontal frame for the two studies, Degas could hardly have been unaware of their affinity and may have envisaged them as a pair of canvases on twinned ancient and modern themes. One of the modes he was currently exploring in both contexts was the panorama or frieze, linked for centuries to wall painting and to the lateral unfolding of pictorial action, such as that associated with dramatic narrative. In his notebook studies, Degas skillfully orchestrated two compositions of this kind, distributing a succession of clustered figures, columns, spatial intervals, and billowing forms (foliage in the former, sails in the latter) across their tableaux-like surfaces, and in adjacent pages we see the same principle at work. Crossing a wide foreground plane, there are processions of horse-drawn carriages and bystanders in contemporary dress, and arrangements of actors and domestic figures, often bizarrely interspersed with sketches for his history paintings—notably *Young Spartans Exercising* and *The Daughter of Jephtha*—depending on the same transverse dynamism.[83] Degas was to return to these experiments in the following decade, for the extraordinary series of frieze-like dance classroom pictures (plates 121, 125, and 168) that were to become one of his most distinctive inventions as a ballet artist. It is not entirely fanciful to see the hand

40. Pierre de Medicis, *Act III, Paris Opéra, from* Le Monde Illustré, *March 17, 1860. Bibliothèque nationale de France*

of a stage-manager-in-waiting behind these earlier works, as Degas timed his entrances and exits within the proscenium of the picture frame, and directed his motley cast of Greeks and Old Testament heroes, costumed extras, and wilting ballerinas.

Degas is thought to have begun *Sémiramis Building Babylon* in 1860, the year Rossini's grand opera *Sémiramide* returned to the rue Le Peletier stage, where it had first been produced in 1825.[84] Often linked with Rossini's opera (which included a ballet in the second act) this picture has thus been claimed as Degas' first fully realized response to a theatrical theme. Recent opinion has shifted, however, from Browse's belief that "Degas took his subject" from Rossini to the now pervasive view that it "was not in the least inspired by" the 1860 production, but the coincidence of Degas' timing cannot be so easily dismissed.[85] Degas chose to base his composition on an aspect of the Sémiramis story that is only implicit in Rossini's drama. Where the opera concerns violent passions and court intrigue, his painting presents the mythical queen as the founder of Babylon, looking calmly over austere terraces and accompanied by her retinue and ornate chariot. Many of the engravings of the 1860 production, by contrast, show massive architectural interiors and crowded, palm-filled vistas—such

42. *Edgar Degas,* Study for "Sémiramis Building Babylon" *and an unidentified stage scene. Page 223 from Notebook 18, 1861. Pencil and brown wash on paper, 10 x 7½ in. (25.4 x 19.2 cm). Bibliothèque nationale de France*

43. *Edgar Degas,* Sémiramis Building Babylon, *c. 1860–62. Oil on canvas, 59½ x 101⅝ in. (151 x 258 cm). Musée d'Orsay, Paris (RF 2207)*

44. *Anonymous, Scene from "Sémiramis." Lithograph. Bibliothèque nationale de France*

as the courtyard scene in Act Two (plate 18)—and recall the city's famous hanging gardens. For Henri Loyrette, the surviving drawings for these scenes show that Degas "deliberately distanced himself from the Babylonian sets designed by Cambon and Thierry" in his much-reworked canvas, even though the artist's preparatory studies tell a more complex story.[86] Some of Degas' drafts show vegetation framing the scene and blocking parts of the sky, with more extensive groups of figures and a greater general animation throughout, bringing his first conception closer to the Opéra decor and its documented action.[87] A previously unnoticed lithograph from *L'Artiste* (plate 44), for example, tells us that the Sémiramis of Rossini, like that of Degas, processed across the stage in a splendid chariot, her horse led by a servant in a manner close to a Degas study.[88] We should surely follow Geneviève Monnier in acknowledging that Degas' choice of subject was not a chance event, as if he could have been oblivious to a major operatic production taking place at this moment. More plausibly, his painting can be seen to grow out of a complex dialogue with a topical theme, perhaps offering a rebuke to the excesses of the Opéra and its extravagant characterizations. Though he resisted the opportunity to draw the dancers involved in this staging, such as the young Louise Fiocre (plate 41), his painted queen offers a dignified, Ristori-like alternative to Rossini's full-blown star Carlotta Marchisio.

A mysterious and little-known piece in the jigsaw of Degas' earliest dance pictures is the exquisite fan design *Spanish Dancers and Musicians* (plate 46). Presented by the artist to Berthe Morisot, reportedly between 1867 and 1869, the fan and two others associated with it have been assumed to date from this same period, despite their anomalous appearance when compared with other works by Degas from the late decade.[89] Several technical and circumstantial factors, however, link these delightful fans with his earliest excursions into stage imagery, not least an old description of one—whose location is currently unknown—as "representing the hanging gardens of Babylon

(perhaps Sémiramis)."[90] Both the Washington fan and its companion, *Spanish Dancers*, were painted with considerable delicacy in pen-and-ink and watercolor on paper, highly unusual techniques for Degas in his maturity but not uncommon in his immediate post-Italian years. The absence of studies for any of the figures raises the extraordinary possibility that they were improvised directly on to the paper, though certain notebook sketches of about 1860–61 may shed some light on their origins.[91] Most intriguing are the subjects of the known pair, which have no counterparts in the Opéra repertoire of the 1860s and may derive from more informal entertainments, such as one at the Opéra ball (plate 45) or the kind that inspired the 1862 *Spanish Dance* by Edouard Manet, whom Degas met at precisely this date.[92] Manet's drafts for his canvas were made in ink and watercolor, a medium he greatly favored for such studies, and it is hard to imagine that his larger project had no impact on Degas' designs. Like Manet's portraits of actors and his painting *Lola de Valence* (plate 47), they seem to belong among the achievements that first drew Degas to his rival and soon formed part of their competitive exchange.

Ironically, the first painting of a dance subject that Degas unquestionably intended for public consumption was based on one of his humblest sitters: the poignant *Madame Gaujelin*, dated 1867 (plate 48). Joséphine Gaujelin was a dancer—in Lillian Browse's words—"of no importance, who would probably never have been heard of" without her connection to Degas, leaving few traces in the critical or photographic archives.[93] Her name has recently been discovered, however, among the troupes of "20 huntresses" and "80 *luminais*" in the 1860 production of *Pierre de Medicis*, and in a paragraph of theatrical gossip in *Le Monde Illustré* of October 1865.[94] This mentions "Mlle Gaujelin" as part of the "desertion" to other theaters by a group of Opéra dancers; we know from a note on a later drawing by Degas (plate 223) that her move was to the Théâtre du Gymnase, where she became an actress. Nothing is known of Degas' private relationship with Gaujelin, though he favored her as a model over at least six years: apart from the 1867 portrait, which implies Degas' presence in her dressing room, there are two further oil paintings and around half a dozen works on paper showing the dancer in a variety of modes, while her figure has been

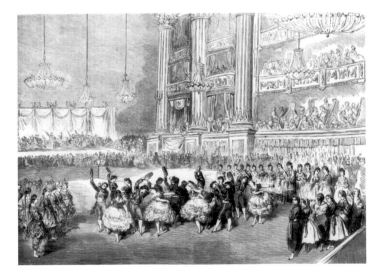

45. *Annual ball at the Opéra: Scene of Spanish dancers. Engraving. Bibliothèque nationale de France*

identified in several early ballet pictures.[95] For Degas she provided the perfect intermediary subject, linking his paintings of family and friends at the beginning of the decade to his first portraits of performers, and beyond to the pictures of dancers in their classrooms. The wistful, Ingres-like woman in the Boston canvas seems almost petite and perhaps a little oppressed by her professional experience, an unsung heroine of Degas' formative years enjoying a moment of attention.

The turning point for Degas in his career as a dance artist was undoubtedly the rich, subtle, yet curiously hybrid composition *Mlle Fiocre in the Ballet "La Source"* (plate 49). Begun in 1867, this large oil painting carried him irrevocably beyond the theatrical sketches of the early 1860s and brazenly announced his claims on the Opéra and one of its newest stars. Remaining unsold at the Salon the following spring, it attracted some critical comment from Emile Zola, Zacharie Astruc, and others, and the dubious—if oddly appropriate—accolade of a caricature in *Le Journal Amusant* (plate 50). The next year, 1869, Degas attempted to consolidate his position by showing the earlier dancer

46. *Edgar Degas, Spanish Dancers and Musicians, c. 1868–69. Watercolor, pen, and black ink on wove paper, arched, 20¼ x 10¼ in. (51.4 x 26 cm). National Gallery of Art, Washington; Woodner Collection (2000.25.3)*

47. *Edouard Manet, Lola de Valence, Spanish Dancer, 1862–67. Oil on canvas, 48½ x 36¼ in. (123 x 92 cm). Musée d'Orsay, Paris (RF 1991)*

48. *Edgar Degas, Madame Gaujelin, 1867. Oil on canvas, 24⅛ x 18 in. (61.2 x 45.7 cm). Isabella Stewart Gardner Museum, Boston (P1e4)*

49. Edgar Degas, Mlle Fiocre in the Ballet "La Source," 1867–68. Oil on canvas, 51½ x 57⅛ in. (130.8 x 145 cm). Brooklyn Museum of Art; Gift of James H. Post, A. Augustus Healy and John T. Underwood (21.111)

portrait, *Madame Gaujelin* (which was largely ignored), and within months had embarked on his groundbreaking ballet performance scenes.[96] He was never again to attempt a work like the Fiocre painting, and it remains a hauntingly transitional creation: still dependent on an earlier tradition of stage imagery, it aspires to be aggressively topical; evolved through sketches, figure drawings, and oil studies in the academic manner, it flirts with the tonality of Whistler and the brusque textures of Courbet; and, crucially, it leaves its subject suspended, occupying neither reality nor the world of poetic illusion, uncertain whether to please or to shock its Salon audience.

A central mystery behind this youthful masterpiece remains largely unaddressed: how did the unknown thirty-year-old Edgar Degas come to paint one of the most talked-about personalities on the Opéra stage, already fabled for her glamour and pursued by some of the richest men in Paris? In these same months, Fiocre had agreed to sit for the fashionable portraitist of European high society, Franz Xaver Winterhalter (plate 218) and was soon to be immortalized in bronze and marble by Jean-Baptiste Carpeaux (plate 51).[97] It may be that a more personal motive lay behind her collaboration with Degas, but tales of a romantic attachment and of connections between the artist's and dancer's families lack a documentary foundation, despite evidence of a prolonged acquaintance.[98] Fiocre must have cooperated with Degas to a certain extent, though he may have used photographs to master her likeness before making several meticulous drawings and pastels of the dancer herself, in both costume and social attire. Our new awareness of Degas' early activity in the Paris theater world goes some way to explain this intimacy, as does his probable familiarity with Eugénie and Louise Fiocre in their earliest roles, in such works as

THE RUE LE PELETIER OPERA

They were equally polarized on the subject of Fiocre herself, who seemed "without grace or talent" to a writer in *Le Monde Artiste*, but was "quite the prettiest blond houri" for Théophile Gautier, and "delicious to watch" for one of his colleagues.[105] It was already a commonplace that Fiocre was applauded as much for her "charming body," as Gautier described it, as for her dancing skills, and there were several complaints when the enveloping "pantaloons" and "voluminous blue mantle" of her costume failed to show her figure "to advantage."[106]

It was into this contested and salacious arena that Degas stepped in the months following the ballet's premier. His first ambition was apparently to paint a more conventional portrait of Fiocre, somewhat like that of Joséphine Gaujelin, beginning with two elegant, frontal drawings of Fiocre's face that are unrelated to her stage appearance.[107] Hasty sketches in a pocket notebook suggest that a visit to the Opéra soon presented an alternative and altogether more novel way forward. In the principal sketch, Fiocre is seated with her head propped on her hand, surrounded by landscape forms, an attendant figure, and the live horse that accompanied her on the stage, all elements that appear

Sémiramis, *Pierre de Medicis*, and *Le Marché des Innocents*. Among a number of individuals who may have brought them together was Marie Sanlaville, who danced beside Fiocre in these same productions and is said to have become the mistress of Degas' close friend Ludovic Lepic around the time of the premier of *La Source*.[99] Just two years younger than Fiocre, Sanlaville rose through the ranks with her and appeared in such key ballets as Meilhac and Halévy's *Néméa* in 1864, when Eugénie first caught the eye of the Opéra audience. Known by mid-decade to Halévy, Lepic, and perhaps Achille Degas (the artist's brother and Lepic's riding companion), Sanlaville also starred as the imp Zaël in *La Source* and was thus close to Fiocre at the critical moment.[100]

The three-act ballet *La Source* opened at the rue Le Peletier Opéra on November 12, 1866, its early performances augmented by sections of Rossini's opera *Comte Ory* and Gluck's *Alceste*.[101] The convoluted libretto—"never has a ballet been less intelligible," wrote one critic—has often been summarized, but its story of thwarted love in exotic terrain provided the occasion for much vaguely oriental dancing.[102] In Act One, for example, Eugénie Fiocre as the Princess Nouredda rested with her attendants beside a mountain spring (the "source" of the title) and was entertained by the music of an oriental instrument, the guzla, only to leap up and perform an energetic "pas de guzla" before resuming her journey. The critics were confused and divided, some finding it "too long," and "feeble in invention, feeble in choreography, feeble in execution," while others delighted in its improbabilities and its wealth of scenic effects.[103] Hippolyte Proust, writing on the front page of *La France politique, scientifique et littéraire*, saw Act One through a "vaporous atmosphere" that was "no longer of this world": "nature appears as if through a prism of uncertain color," he effused.[104]

in his final design.[108] Fiocre evidently went along with this surprising turn of events, allowing Degas to draw her as if in performance and repeating her distinctive pose for his benefit. At a stroke, therefore, Degas moved his broader artistic project on to the contemporary stage, competing with the theater painters of the past and attempting a radical restatement of the modern Opéra-goer's experience. Invoking the close-up portrayals of Lépaulle, Courbet, and others, Degas rejected most of the orthodoxies that had sustained them: his picture shows a ballet where no one dances, an image of mid-action that is neither heroic nor graceful, and a portrait of a voluptuous popular star who is almost concealed by her outfit. Other features hinted at the implicit challenge in Degas' manner, from the trompe-l'oeil water that fools the horse yet fails to dampen the squatting maidservant, to the pink dancing slippers discarded on a bank that distinctly resembles an oriental rug.

Where the music critics had been perplexed by *La Source* itself, the Salon opinion-makers of 1867, as Henri Loyrette has pointed out, were now divided about the meaning of the painting. Zacharie Astruc applauded the fact that Degas had "left reality for dreams" and Louis Leroy saw the work as "a riddle," but both were contradicted by Zola, who insisted that it was "well observed" and proposed the more down-to-earth title "A Halt Beside the Water."[109] It can be argued that all these readings were justified in Degas' picture, which repeatedly juxtaposed and sometimes inverted the plausible and the bogus, without finally opting for either. His painted rocks, for example, which on the stage were made of wood and fabric, have all the moss-encrusted conviction of a real cliff face, such as the one he carefully recorded at Bagnoles-de-l'Orne around this time, presumably with his Salon entry in mind.[110] One of the few existing images of the 1866 production, a lithograph from a music score cover (plate 62), recalls the stylized nature of the Opéra set in its own mannered way, while revealing a further complexity of Degas' response. Unnoticed by earlier commentators, the print shows Fiocre in the awkward reclining position—albeit reversed—that became the defining motif of Degas' painting.[111] Here, it seems, the artist chose to be "faithful to fact" (as Browse points out), depicting not "a pause in a rehearsal" as many have suggested, but an already canonical moment in the rue Le Peletier performance that he integrated into his factitious scene.[112] In their different ways, Degas' contemporaries—the cartoonist Bertall, the Salon critics, and perhaps Fiocre herself (who failed to buy the picture)—all seemed to sense his irresolution: after this bravura excursion into both reverie and pragmatism, decisiveness was needed.

Dissimilar though they are in several respects, the natural successors to *Mlle Fiocre in the Ballet "La Source"* were the dance rehearsal and orchestra-dominated scenes of the early 1870s. Each is centered on a populous event beneath the rue Le Peletier proscenium, each implies the proximity of artist and *dramatis personae*, and each is emphatically of the moment. Even more conspicuously, all these works offered a confident new vision of theatrical reality that owes more to caricaturists like Daumier than to a century of fine painting. For Degas, the

52. *Sheet music cover for* La Source, *c. 1866. Bibliothèque nationale de France*

portrait of Fiocre was thus the first and last of its breed, a modern performance picture that still clung to the possibility of illusion. Despite its elements of mischievous novelty, the space it occupied was much like that of Delacroix's *Duel of Faust and Valentin*: there is little in Degas' composition to reveal its origins among the ropes and pulleys of the modern stage and even less to locate it in Debret's rue Le Peletier auditorium. The Opéra habitués who first saw the painting, of course, would have recognized the star of *La Source* in her notorious role, but for other spectators and for posterity it is only the picture's elliptical title that distinguishes it from an exotic pictorial fantasy. By locating it in its original context, however, we can deduce that Degas' vantage point would have been shared by a somewhat elevated member of the Opéra audience, perhaps in a second-tier *loge* and implicitly using opera glasses to narrow the visual frame. The result of this maneuver was to suppress the wider and more informative panorama, and consequently to heighten its ambiguity. It is unmistakably significant that all the stage images made by Degas in the years immediately after the Fiocre painting were to abandon this conceit, insisting on their location with a cartoonist's frankness and spelling out the nature of the architecture, interior decoration, and practical arrangements of the rue Le Peletier building.

In *The Ballet from "Robert le Diable"* (plate 53), dated 1872 but perhaps begun as early as 1870, Degas again mixed past and present though now with notable self-assurance. Meyerbeer's five-act grand opera *Robert le Diable*, which had already inspired drawings or paintings by Delacroix, Lépaulle, Courbet, Corot, and others, was a standard fixture in the Opéra's repertoire. Still lingering through most of Degas'

53. *Edgar Degas,* The Ballet from "Robert le Diable," *1872. Oil on canvas, 26 x 21⅜ in. (66 x 54.3 cm). The Metropolitan Museum of Art; H.O. Havemeyer Collection, Bequest of Mrs. H.O. Havemeyer, 1929 (29.100.552)*

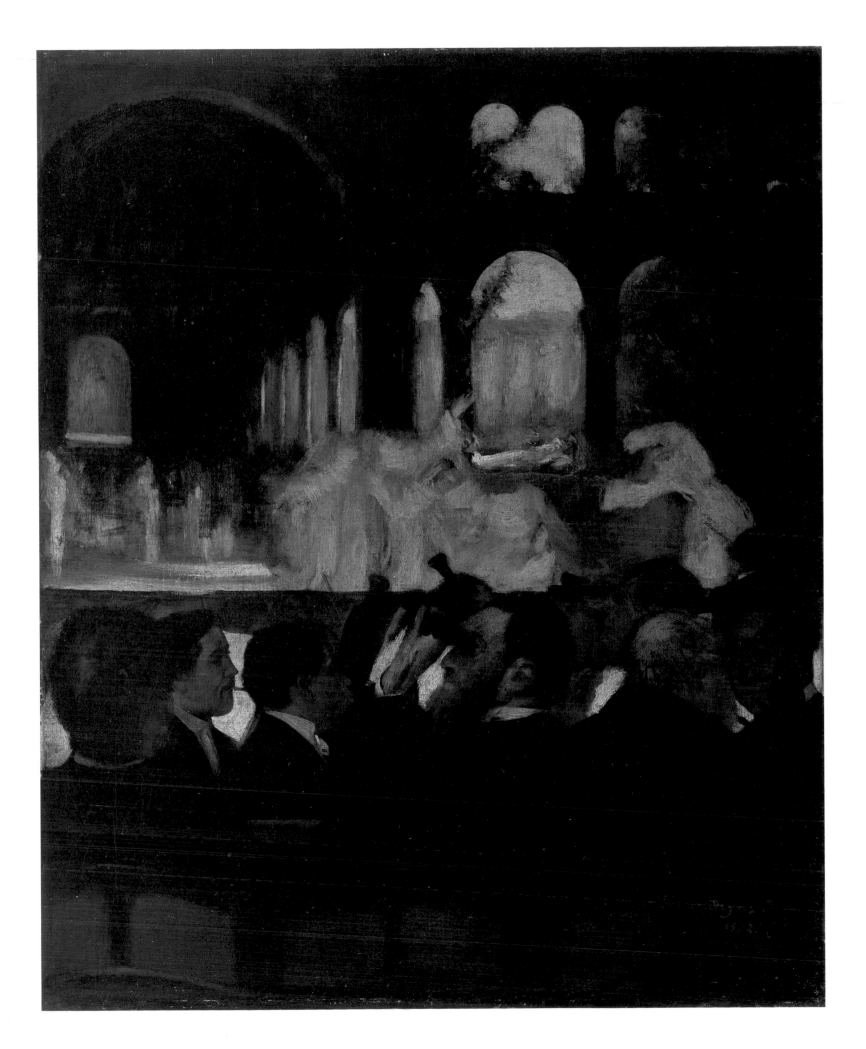

career, the opera had made a profound impact when it premiered at the rue Le Peletier in 1831: "Those who did not see the first performance of *Robert le Diable*," declared Théophile Gautier, "can have no idea of how novel this great work appeared at that time."[113] Building directly on the success of his orchestra paintings and a well-tried Daumier formula, Degas divided the vertical rectangle of his canvas into two distinct zones, one fantastic and the other quotidian. In the upper band he painted the most famous scene of all, the Act Two "ballet of nuns," choosing an image—as with *La Source*—that may have been reinforced by one of many popular prints in circulation (plate 54).[114] This strange, demonic sequence concerns the medieval duke of Normandy, Robert, who has been informed by his father, Bertram, that he will triumph only "if he snatches the green bough from the altar of Saint Rosalie," an event that takes place in "the ruined cloister of the saint, where Bertram conjures up the spirits of apostate nuns to tempt Robert to perform his sacrilegious deed."[115] In one of his last theater reviews, the aging Gautier wrote of the 1870 revival of the opera—the production that inspired Degas' painting—"A bright beam of light, produced by an electric burner, shoots its brilliance through the arches, picking out in the shadows female forms moving beneath the white pallor of their shrouds with deathly sensuality. The scene is admirably composed: the groups are well arranged, and the soft lighting does not divest those dancers of the tomb of their poetry and their mystery."[116]

Faced with this curious relic of Gautier's youth, Degas' depiction of the ballet was a shrewd mixture of respect and skepticism. Again following the pattern of the Medea drawings and his Fiocre portrait, the onstage scene was based on pencil sketches made in the theater, mixing details of the cloister and the audience with Degas' verbal descriptions of light effects. Using dilute brown oil paint on larger sheets of paper, he also executed five studies of the "well-arranged" groups of nuns (plates 55, 56, and 57), transforming the cadaver-like dancers of the famous print into billowing, animated forms. Degas' mastery of these unusual figures is impressive, both in his brush drawings and in the final painting, and we might surmise that he persuaded Elise Parent—who played the role of the Mother Superior around this time—to pose "for the figures of the dancers," as she had recently done for *Orchestra of the Opéra*.[117] In the lower zone of the picture, however, the tone shifts from carefully restored history to brash modernity, from the supernatural female to the awkwardly contemporary male. Here the black-coated spectators are gathered in a fractured mass, one swinging his opera glasses across the upper *loges* and others staring to right and left, seemingly oblivious of their privileged view of the stage. The now-familiar introduction of Degas' close friends at the rue Le Peletier—Dihau playing the bassoon, Albert Hecht with his lorgnettes—stresses the immediacy of the foreground, while the shadowy figure at extreme right might be turning to acknowledge Degas himself. As we have seen, this formulation of the audience had also become a cliché of the age, a link the artist appears to encourage in his caricatured profiles and flattened space. His prose is

also appropriately and bluntly un-Romantic; referring to the conductor Georges Hainl, he wrote in his sketchbook, "bowstring brightly lit by the lamps, head of Georges in silhouette, light red shadows, flesh tones."[118]

It is tempting to see *The Ballet from "Robert le Diable"* as Degas' leave-taking from the Romantic ballet and the laborious conventions that surrounded it. By the time he painted Meyerbeer's opera, it was already regarded as "superannuated" by the younger generation, who attended performances only to make "an affected departure from their seats after the ballet."[119] It is disputable whether Degas was "particularly fond" of *Robert le Diable* as has been claimed, but there is equally no evidence that he shared the dismissive views of some of his companions, such as Ludovic Halévy.[120] Apart from the second version of the same composition (plate 58), Degas never again returned to the depiction of elderly Opéra triumphs or lingered so patiently on the minutiae of scenery, lighting, or eccentric costumes. But the circumstances in which these pictures were made suggest some of the conflicting emotions that may have surrounded the artist's project. When he began his first canvas of the Opéra around 1870, Garnier's new building was visibly nearing completion less than half a mile away, and the demise of the rue Le Peletier theater was considered imminent. The burden of nostalgia in Degas' painting was therefore enormous, both in his image of the doomed interior and in his selection of Meyerbeer's youthful masterpiece. Whatever his personal views, he undoubtedly chose to record *Robert le Diable* at a poignant moment in its history and at a time of unusually heightened susceptibility for the Opéra's older habitués.

The demands of Degas' still-dormant career and his need to identify a personal iconography may also have been factors in his choice of subject. By including the art collector Hecht in *The Ballet from "Robert le Diable,"* Degas perhaps hoped to find a new patron, though the picture was soon bought by a different kind of regular at the rue Le Peletier, the singer Jean-Baptiste Faure. For unexplained reasons, Degas decided he was dissatisfied with the canvas and arranged for Faure to return it, delivering a second variant to him some four years later.[121] Faure had been a friend of Meyerbeer's and was a recently converted admirer of contemporary painting, amassing a distinguished collection of works by Manet and the Impressionist generation that eventually included twelve pictures by Degas. He bought boldly and well, commissioning two ballet canvases from Degas around 1873— one of which was *The Dance Class* (plate 127)—as well as owning both *Robert le Diable* pictures at different times. The later of these, now in the Victoria & Albert Museum in London (plate 58), is a dense and technically complex composition, larger and significantly broader in format than the first. Here we see one of the most panoramic of all Degas' stage scenes, almost a theatrical genre picture that does equal justice to setting, dramatis personae, and contemporary audience. The Romanesque décor and dancing nuns follow the earlier painting closely, though Degas seems to have discovered even more detail and sculptural vigor in his sheets of figure drawings. It was clearly the fore-

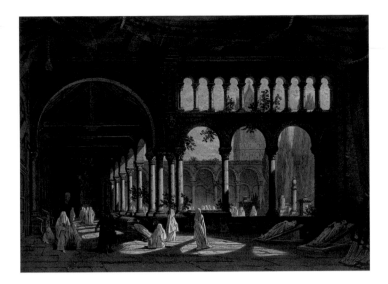

54. The "Ballet of Nuns" in Act III of Robert le Diable, 1832. Bibliothèque nationale de France

ground that most troubled him, now cut near shoulder level and more insistently tied to the view among the *abonnés*, where Hecht has been moved across to the left and a superb glancing profile of a hirsute Lepic introduced at right, alongside a squarer head with an improbable resemblance to Ingres. Close scrutiny of the paint surface and unpublished X rays show that much of this lower register was modified before the picture was finished, obliterating one or more large heads and revising numerous details elsewhere.[122] Eventually, Degas was able to strike a brilliant balance between the shocking nearness of the Frankfurt *Orchestra Musicians* and the relative passivity of the New York *Ballet from "Robert le Diable,"* juxtaposing the Parisian melee beneath with the quaint theatrics beyond.

Degas' newly confident paintings of the ballet proved popular and were to play a large part in establishing his name. Most were sold within a year or two of their completion and several must have been scarcely dry when they joined the collections of Gustave Mulbacher, Henri Rouart, Edouard Brandon, and Faure himself, or entered the galleries of young dealers like Paul Durand-Ruel in Paris and Charles Deshamps in London. Early in 1873, in a largely overlooked initiative that might have changed the course of his career, Degas planned to submit his *Dance Class at the Opéra* (plate 19) to the annual Salon, only to discover that it had been purchased from Durand-Ruel by Louis Huth.[123] When the first Impressionist exhibition opened in April 1874, four of his ten catalogue entries were concerned with ballet rehearsals, classrooms, or the wings, all of them ostentatiously listed as belonging to private collectors. The critical response was overwhelmingly positive, dwelling on the artist's novelty of vision and his attention to a largely unexplored subject. One writer noted with approval that Degas was the most admired of the group and described his ballet pictures as "morsels for the gourmet," while another recommended them to "those who lovingly study the undulations of hips, and the serpentine curves of movement."[124] More thoughtfully, Ernest Chesneau wrote, "He draws precisely and exactly, with no other purpose than scrupulous exactitude, all the twisting legs and dislocated hips

that are demanded by the rigorous practice of the dance," adding that Degas' preoccupation with "the theater, this aspect of modern life which has until now been completely overlooked by painting" constituted "an absolutely new theme."[125] Soon afterward, the artist planned to capitalize further on his reputation, scribbling down a poster design for a one-man show (plate 59) to be entitled "Degas: Ten Works on Dance at the Opéra," an intriguing but otherwise undocumented scheme that was again overtaken by events.[126]

Degas' progress from obscurity to professional acclaim was remarkable in itself, but it becomes scarcely comprehensible when viewed against the national trauma that erupted during these two or three years, and the personal crises that accompanied it. After a period of mounting international tension, France declared war on Prussia in July 1870 and soon suffered a series of crushing military encounters, followed by the surrender of Emperor Napoleon III and abject capitulation. During the war, Paris was besieged for four grim months and was subsequently swept by insurrection and the terrible bloodshed that followed the declaration of the Commune. Degas, Manet, and certain of their colleagues enlisted in the National Guard during the siege but saw little action, though the less fortunate Frédéric Bazille and Degas' sculptor friend Joseph Cuvelier were both killed in skirmishes. Garnier's unfinished Opéra was commandeered as a storeroom and as a temporary hospital, and in the freezing winter of late 1870 most normal activity in the city came to a standstill. It was also at this period that Degas began to confront a threat that would haunt the rest of his life, that of blindness. When applying for the army he discovered a serious weakness in his eyesight, a problem that seems to have become exacerbated by the conditions of the siege: in a letter of 1871, Degas told the painter James Tissot that his affliction had left him "unable to read or work or go out much, trembling all the time lest I should remain like that."[127]

Almost as soon as he launched his new series of ballet paintings, it seems, Degas found his world in turmoil and many of the verities of his former existence—musical and artistic life, the art market, his robust health—at risk. During the siege he painted little and afterward retreated to the Normandy home of his friends the Valpinçons, but before the end of 1871 he was evidently back in his studio. Even at the height of the Commune, arrangements were somehow made to show his *Orchestra of the Opéra* in the city of Lille, and some months later the same picture appeared in Durand-Ruel's gallery close to the Opéra on the rue Laffitte.[128] In October he visited London ("Give me some idea how I too could gain some profit from England," he asked Tissot), where his dance pictures would soon attract favorable attention and where the first version of *The Ballet from "Robert le Diable"* was exhibited in the summer of 1872.[129] At this same time, the artist was visited in Paris by his brother René, who heard Pagans sing at Degas' apartment and saw his latest creations, among them, perhaps *Dance Class at the Opéra*: "Right now, he is painting small pictures, which are what tires his eyes most," René noted, "He is doing a dance rehearsal that is charming."[130] Still in search of rest and distraction, Degas decided

to accompany René when he returned to his cotton export business in New Orleans in the fall of 1872, staying there for five months and again complaining about his fragile sight. He also discovered how much he missed Paris, writing to inquire about several members of the Opéra corps de ballet, considering the submission of his *Dance Class at the Opéra* to the 1873 Salon, and confessing to the artist Lorenz Fröhlich, "I need music so much."[131]

Returning to France in early 1873, Degas threw himself into the rebuilding of his professional life, not least as a promising "painter of dancers." He labored anxiously to complete paintings for Faure, Durand-Ruel, and Deschamps and joined in discussions about a possible collective exhibition with some of his colleagues. In late October, however, he suffered another blow to his equilibrium when the central subject

of his latest initiative—the rue Le Peletier Opéra itself—was consumed in a massive fire (plate 60). Though Degas' immediate response is not recorded, the words of his friend Ludovic Halévy may evoke something of their shared sense of loss: "The Opéra! My old Opéra! The theater where I spent my life, where I know by heart all the nooks and crannies," Halévy wrote soon after the conflagration. "How we roamed its corridors! How many hours I passed on the red velvet banquettes in the *foyer de la danse*, surrounded by this miniature population of swirling, swarming *petits sujets* and coryphées!"[132] Like Halévy, Degas had lost the institution where his love of ballet had been formed and where the proud tradition of Romanticism still lingered. Some of the practical consequences of this loss will be examined in the next chapter, but there are immediate signs that Degas' identification with the ballet survived unscathed. In February 1874, for example, he was visited by one of the leading arbiters of Parisian literary and artistic taste, Edmond de Goncourt, who noted in his diary: "Yesterday I spent the whole day in the studio of a strange painter called Degas. Out of all the subjects in modern life he has chosen washerwomen and ballet dancers…it is a world of pink and white, of female flesh in lawn and gauze, the most delightful of pretexts for using pale, soft tints."[133]

Within two months of Goncourt's visit, Degas was a leading participant in the first exhibition of what we now call Impressionist art, held on the premises of the photographer Nadar just a stone's throw from Garnier's still-unfinished Opéra. One of the four oil paintings he submitted was *Ballet Rehearsal on the Stage* (plate 61), neither a true performance scene nor a glimpse backstage, but positioned somewhere between the two. It depicts an unflinching view from the rue Le Peletier auditorium, complete with orchestra pit, *avant-scène loges*, footlights, shadowy wings, subtly individualized dancers, and a seated male official on stage. Almost certainly begun before the fire, the picture's setting was partly based on sketchbook drawings of the proscenium arch, adjacent *loges*, and decorative detail, all of which correspond closely to the documented features of Debret's building.[134] After the Opéra's catastrophic demise, the resonance of this image must have been overwhelming for the rather modest number of Parisians who saw the exhibition. Several critics admired Degas' "exact" or "finely observed" images of the old theater, and Jean Prouvaire noted sympathetically of one of Degas' pictures, "when passing this work, old habitués of the opera foyer smile and sigh."[135] *Ballet Rehearsal on the Stage* had been sold before the opening to a collector of eighteenth-

55. Edgar Degas, Nuns Dancing, Study for the Ballet from "Robert le Diable," 1871. Essence on buff laid paper, 22¾ x 31 in. (57.7 x 78.7 cm). Trustees of the Victoria & Albert Museum, London (E3688-1919)

56. Edgar Degas, Nuns Dancing, Study for the Ballet from "Robert le Diable," 1871. Essence on buff laid paper, 22¾ x 31 in. (57.7 x 78.7 cm). Trustees of the Victoria & Albert Museum, London (E3687-1919)

57. Edgar Degas, Nuns Dancing, Study for the Ballet from "Robert le Diable," 1871. Essence on buff laid paper, 22¾ x 31 in. (57.7 x 78.7 cm). Trustees of the Victoria & Albert Museum, London (E3686-1919)

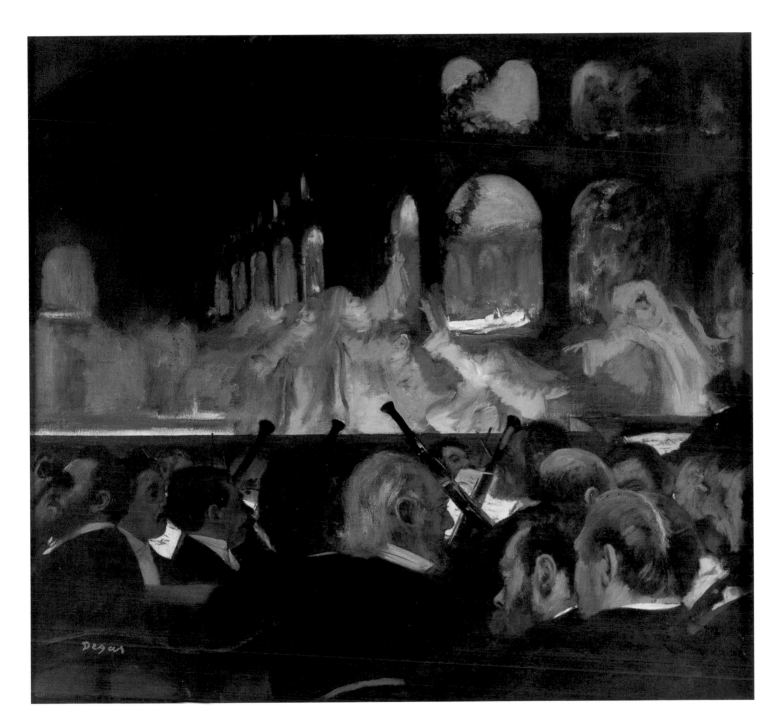

58. *Edgar Degas, Ballet Scene from Meyerbeer's Opera "Robert le Diable," 1876.*
Oil on canvas, 29¾ x 32 in. (76.6 x 81.3 cm). Trustees of the Victoria & Albert Museum,
London (CAI.19)

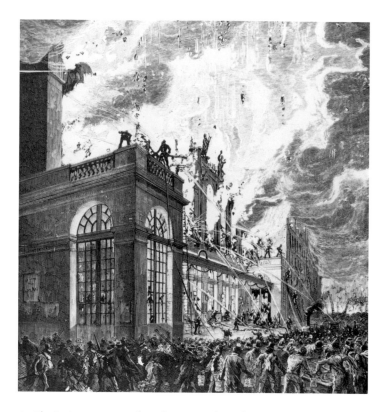

59. Edgar Degas, Three Studies for an Exhibition Poster. *Page 204 from Notebook 22.*
Pencil on paper, 9⅝ x 7⅞ in. (24.5 x 20 cm). Bibliothèque nationale de France

60. The Opéra on Fire, View from the rue Le Peletier, *from* L'Illustration, *November 8,*
1873. Wood engraving. Free Library of Philadelphia, Literature Department

century art, Gustave Muhlbacher, and two other versions of the same composition—both executed on paper and now in the Metropolitan Museum of Art—also found buyers within a short time. Degas, too, seems to have been satisfied with his creations and recognized their historic potential. One of the New York variants (plate 62) began life as a delicate pen-and-ink drawing, which he sent to the *Illustrated London News* as the suggested basis for an engraving, though its subject was considered unseemly and the work was rejected.[136] This curious story helps to explain the monochrome medium used in the Musée d'Orsay canvas, which was apparently undertaken as a tonal exercise of a kind traditionally made in the preparation of reproductive prints. The two works on paper originally shared this bleakness, not just in their tonality but in the complete absence of verdant scenery at the right of the stage and fewer defined branches and leaves at left.[137] When his drawing returned from London, Degas enriched both studies with complex layerings of gouache, watercolor, pastel and oil paint, adding to their subtlety as well as their salability, and creating his first series of theater scenes.

In *Ballet Rehearsal on the Stage* and its two companions, Degas had "arrived" as an utterly original painter of the dance. If certain details linger from earlier pictures—the tiny central figure of Joséphine Gaujelin, a dancer at left who looks like Elise Parent, the bass scrolls of *Orchestra of the Opéra*—these pictures are unprecedented in their marshaling of deep space and in their bold, intrusive viewpoints. Degas has presumptuously adopted a position in the region of the first-level *avant-scène loge* at the left of the stage, a primary location at the Opéra that was traditionally reserved—as the cover of the 1864 *Gazette des*

Abonnés shows (plate 13)—for the emperor or for leading dignitaries.[138] Like these elevated individuals, he was thus above the dancers yet close enough to see them in all their particularity, while commanding a view across the boards and into the suggestive gloom of the wings beyond. One commentator noted how the "artificial lighting" added to the sense of novelty, as the stark upward beam of the footlights bleached the bodies of the corps de ballet, yet plunged other areas into obscurity.[139] Such visual impertinence could only have its roots in popular graphics, an affinity acknowledged by Degas in his audacious approach to the *Illustrated London News* and recognized by critics of the moment, who likened his pictures to works by Daumier and to "illustrated newspapers" and "fashion plates."[140] Some of the visitors to the 1874 exhibition—presumably the very people who read the popular journals—were shocked to find these devices in a more refined context, finding them "curious," "strange," and "bizarre."[141] Rich though its sources were, however, *Ballet Rehearsal on the Stage*—unlike *Orchestra of the Opéra* and *The Ballet from "Robert le Diable"*—depended on no single image by Daumier, Gavarni, or Cham; and unlike his portrait of Eugénie Fiocre, no competing modes disrupted the unity of his three latest compositions. Degas had achieved a new resolution, assimilating a cacophony of pictorial dialects into a vibrant whole, and finding an eloquent, entirely modern voice.

This seminal trio of pictures marked a consolidation of the artist's practice at a number of levels. Technically, they emerged from a process that was to dominate his next two decades: each was largely composed from a series of drawings that Degas had patiently executed from individual dancers, subsequently scaled-up or reduced, and then

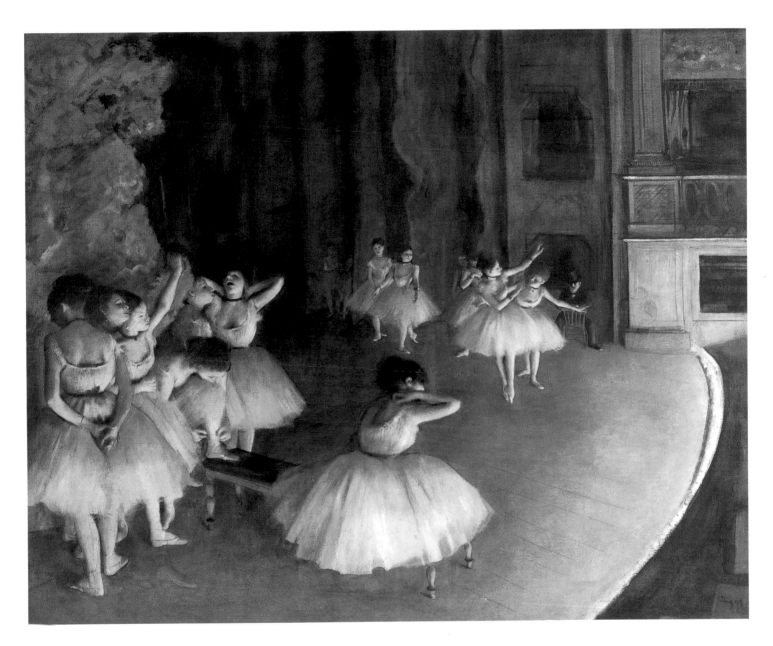

61. *Edgar Degas, Ballet Rehearsal on the Stage, 1874. Oil on canvas, 25⅝ x 31⅞ in.*
(65 x 81 cm). Musée d'Orsay, Paris (RF 1978).

62. Edgar Degas, The Rehearsal of the Ballet on Stage, probably 1874. Oil colors freely mixed with turpentine, with traces of watercolor and pastel over pen-and-ink drawing on cream-colored wove paper, laid down on Bristol board and mounted on canvas, 21⅜ x 28¾ in. (54.3 x 73 cm). The Metropolitan Museum of Art; H.O. Havemeyer Collection, Gift of Horace Havemeyer, 1929 (29.160.26)

progressed through several stages and were subject to numerous protocols concerning costume, the use of theater lights and instrumentalists, and the presence of outsiders. As many witnesses explain, practice sessions for the leading roles were conducted in backstage classrooms and foyers, while larger gatherings of the corps de ballet were held on the rue Le Peletier stage.[142] Some of these procedures changed with the decades: at mid-century, Véron enjoyed the "highly comical scene, worthy of a painter's brush" of a rehearsal at the Opéra, where dancers chatted, ate, sewed, and read novels.[143] In the late 1860s, Albert Vizentini also evoked the cheerful onstage chaos, with "Mon. Petipa, the ballet master" shouting instructions and advice to those under his charge, while in June 1871 Ludovic Halévy watched a rehearsal and noted the "white tarlatan dresses lighting up the semi-darkness of the theater," bringing to mind the pictures of "my friend Degas."[144] In 1873, as Degas was actually working on his rehearsal pictures, the authority on stage matters, Georges Moynet, pointed out that dancers in these circumstances would often rehearse in "classroom outfits" or even "street clothes," adding that the theater lights and heating would not normally be turned on.[145] Paul Mahalin published further details

integrated into his larger design. Originating in academic teaching and already explored by Degas in his earlier canvases, this procedure allowed a high degree of control over the composition and the possibility of re-using certain figures from the same drawings, sometimes in different groups or situations, in later pictures. This sequence of events often resulted in families or complete dynasties of images that can be traced back—almost literally—to the crucial period of the early 1870s. Conceptually, too, the same ritual was to define Degas' middle years, clarifying the division between observation and artifice that lies at the heart of his ballet oeuvre. A sensuous, animated drawing such as Study of a Ballerina (plate 63), for example, seems to take us to the heart of the ballerina's world, yet it was almost certainly posed in the neutrality of the artist's studio, by a dancer paid to hold this attitude for several hours. The contrivance was continued into the finished picture, when Degas used this study to draft a distant figure in The Dance Class (plate 229), alongside images of other dancers she may never have met or—conversely—who may also have been posed by the same woman. Degas' method allowed him to depict these figures as formally, or as extravagantly relaxed, as he wished, in working circumstances that would have been inconceivable at the Opéra itself. Though, as we shall discover, he probably saw such feline stretching, scratching, and yawning rather frequently at the rue Le Peletier, other sheets of drawings show how calculatedly his "scrupulous exactitude" was arrived at elsewhere.

The synthetic nature of Degas' creativity was, of course, vividly mirrored in the making of a ballet itself, as the different elements—musical, scenic, and choreographic—were studied and refined, and brought together in a final ensemble. Ballet rehearsals at this date

63. Edgar Degas, Study of a Ballerina, c. 1876. Charcoal heightened with white on buff paper, 19¼ x 11¾ in. (48.9 x 29.8 cm). Private collection

of a *répétition ordinaire* held behind closed doors in 1887, contrasting the "frightful depths" of the empty auditorium with the colorful appearance of the set, where dancers' hats and coats were hung on the scenery and music was supplied by "two violins."[146] Something of this atmosphere is captured in an earlier wood engraving of a rehearsal for *Néméa* (plate 64), the ballet with a scenario by Halévy and Meilhac that starred Eugénie Fiocre as *L'Amour* (here seen standing on her pillar). Other literary and graphic accounts describe the dress rehearsal, or *répétition générale*, which increasingly became a semi-public event where the costumed cast, complete décor and lighting, and full orchestra were assembled in the presence of an invited audience of celebrities and members of the press.[147]

Remote from *Ballet Rehearsal on the Stage* in almost every way, such elaborate occasions alert us to Degas' willful banality and to his determination to get beneath the anecdotal surface of the Paris Opéra. His rehearsal pictures are closer to the routine, private sessions described by Moynet, perhaps showing a small-scale practice for ballet corps members when two or three were being coached for a modest solo role. The air of work in progress is heightened by the presence (in the two Metropolitan pictures, but not in that of the Musée d'Orsay) of a distant trestle or gantry, which can now be identified as part of a scene-painter's equipment at this period (plate 65). As in the two works on paper, the Paris canvas formerly boasted a black-clad dance teacher— probably the formidable Mon. Pluque—to left of center and an additional male figure on stage who appears to be a director or administrator, both of whom were painted over before the composition was complete.[148] A slight increase in the transparency of the paint through the years has revealed numerous similar modifications, adding to our understanding of this early masterpiece as a pictorial arena in which Degas tested and refined his "absolutely new theme." Further experimentation included the mining of his own pictorial riches in a series of smaller works based on the same composition, most thrillingly perhaps in the Courtauld Institute's *Two Dancers on a Stage* (plate 173). Just as the literary outsiders Vizentini and Mahalin recorded rehearsals they

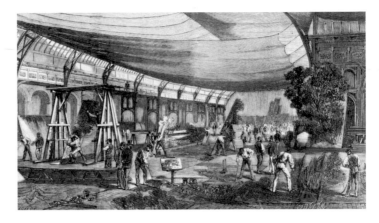

65. *Set painting studio for the new Opéra, from L'Illustration, September 26, 1874. Free Library of Philadelphia, Literature Department*

had seen at the Opéra, so we must imagine Degas insinuating himself into the rue Le Peletier auditorium some time in 1873, conceivably during a routine practice for the ballet divertissement in Mozart's *Don Juan*.[149] Beginning his pictures before the fire in October, or drafting them rapidly from memory immediately afterward, he appears to have completed them within months. Aware of the topical potential of his material, Degas released the resulting images to a London magazine, to the English and French art markets, and to the puzzled crowd at the first Impressionist exhibition, and over time saw each work acquired by a distinguished collector. Their originality seized the imagination of his peers: it is hardly a coincidence that the rehearsal pictures were among the most widely reproduced works of Degas' lifetime, and that artists as astute as Paul Gauguin and Walter Sickert coveted one of the series and acquired another.[150]

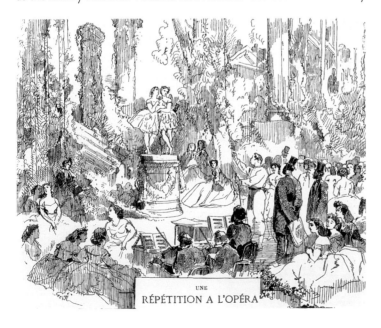

UNE
RÉPÉTITION A L'OPÉRA

64. Rehearsal at the Opéra of "Néméa" or "Love Avenged," *from La Vie Parisienne, July 16, 1864. Bibliothèque nationale de France*

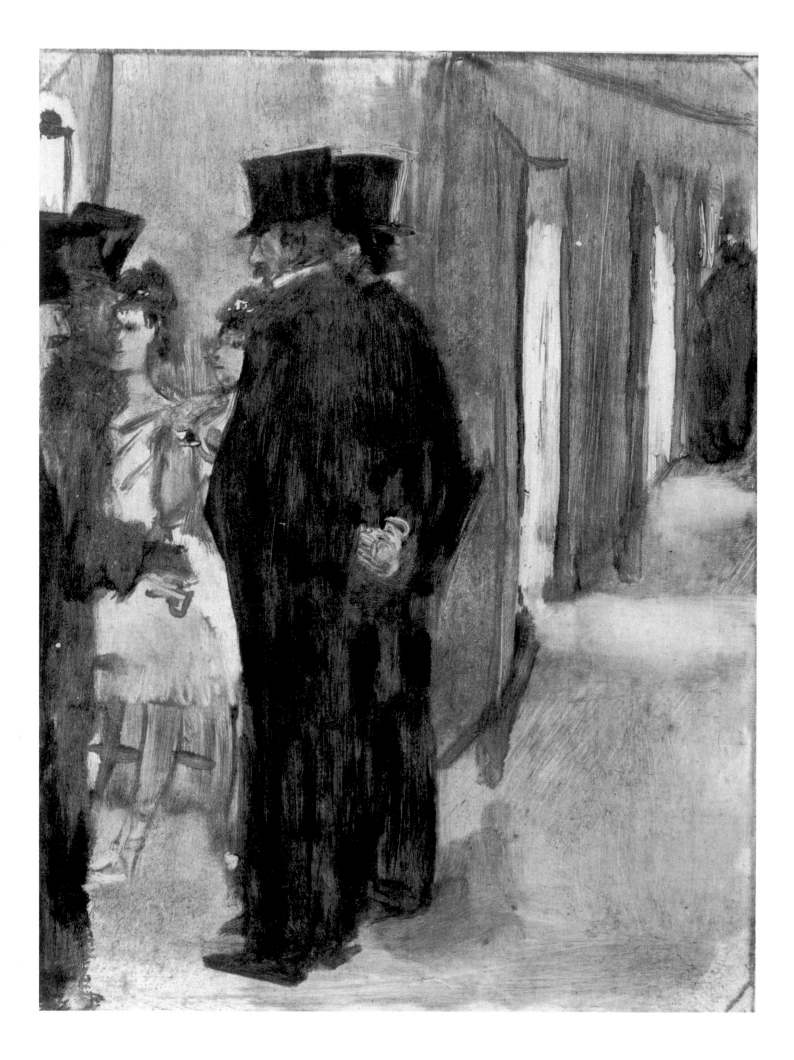

3. Degas Backstage

He knows and depicts the backstage world
of the theater like no-one else, the dance foyers,
the essential appeal of the Opéra rats
in their bouffant skirts.

—JULES CLARETIE ON DEGAS, 1877[1]

Degas' activities as an artist of backstage life are among the most mythologized and misunderstood features of his career. Around three-quarters of his enormous output of dance images are concerned with events beyond the public gaze, yet they have rarely been evaluated against the documented rituals and physical circumstances that brought them into being. In the 1870s, a major but neglected sequence of oil paintings took Degas' viewers to the heart of the Opéra's teaching system, to the ballet classrooms represented in *The Dance Rehearsal* (plate 87) and *The Rehearsal* (plate 88). During the same years, the very different *Famille Cardinal* monotypes showed the private corridors, staircases, and dressing rooms of the labyrinthine Opéra building, where the fictional dancers of Ludovic Halévy's stories laid wait for, or were ambushed by, their male pursuers (plate 66). While these monotypes have been repeatedly invoked in studies of the artist, their status as a tiny, atypical aspect of his iconography still awaits recognition. Both of these themes were overtaken in subsequent decades, when the theater wings became Degas' principal obsession, resulting in hundreds of pastels of lonely ballerinas waiting behind the scenery (plate 297) or sinking into monumental torpor beside their colleagues (plate 264). All these works prompt a series of interrelated questions that have been imperfectly tackled. Where precisely at the Opéra did the depicted events take place, and who had access to such locations? What did the "backstage world of the theatre" actually look like, and how faithful was Degas to this observed reality?

The claims of contemporaries like Jules Claretie, who was a novelist, dramatic author, art critic, and admirer of the ballet, that Degas was unusually well informed about these matters are long overdue for critical consideration.[2] Prominent among the obstacles in this task are the over-fabulized nature of the dancer's existence in the nineteenth century and the elusive backstage geography of the opera houses known to both men: the old rue Le Peletier Opéra and the Palais Garnier. Ironically, the theater whose internal structure Degas recorded the least—Garnier's building—still survives in its virtually unrestored glory, with a full complement

66. Edgar Degas, Pauline and Virginie Conversing with Admirers, c. 1876–80. Illustration for La famille Cardinal. Monotype on paper, sheet 11³⁄₈ x 7½ in. (29 x 19 cm). The Fogg Art Museum, Harvard University, Cambridge, Massachusetts; Bequest of Meta and Paul J. Sachs (M14295)

of *foyers*, dressing rooms, hallways, and practice rooms largely as the artist knew them.[3] Though there is much to be said about his relationship with this architectural complex, the most testing topic for Degas scholars has always been the edifice that preceded it. Now vanished and known principally through architectural plans, engravings, caricatures, and verbal descriptions, the old Opéra can be visualized only with a considerable effort of the imagination. But this was where Degas first saw ballerinas at the barre, watched *rats* in the *foyer*, and became acquainted with the *coulisses* (wings), and it was here that his dance vocabulary was essentially formed. The key to Degas' articulation of such subjects lies in this poorly researched backstage milieu, beneath layers of legend and a century of scholarly neglect. Our initial aim, therefore, is to re-animate these intricate areas, exploring the internal appearance of both theaters and populating them again with plausible men and women.

The writings of Ludovic Halévy (plate 67) are an exceptional resource in this endeavor, not just as accounts of "the theater where I spent my life," as he described it, but as a formative influence on the popular image of backstage existence in the late nineteenth century.[4] Halévy was the same age as Degas and went to the same school, becoming one of his closest friends in middle life. He was a complex, multi-talented individual, as fascinated by politics as he was by literature, and subject to bouts of melancholy that recall Degas' own. In the 1860s, he sud-

denly became rich from his collaborations with Meilhac, Delibes, Bizet, Offenbach, and others in creating popular musical works for a number of Parisian stages, and later found fame as a best-selling author.[5] Halévy's notebooks of this period are studded with personal reflection and metropolitan gossip, gleaned from company that included the philosopher Hippolyte Taine, the politician Henri Rochefort, the art critics Albert Wolf and Jules Claretie, the illustrators Cham and Marcelin, the painter Gérôme, and the two dancing Fiocre sisters. As a contributor to the Opéra repertoire he was granted special privileges there, attending rehearsals and regularly visiting the *foyer de la danse*, where in November 1863 he spotted "Sanlaville, Montaubry, Fiocre...Parent" among a group of "twenty-five coryphées."[6] His greatest literary success, somewhat to his chagrin, was the wry and hastily written book *La famille Cardinal*, a compilation of short stories that began to appear in 1870 and were first collected into a single volume in 1883.[7] Based partly on real conversations and tales heard backstage, they sold in the tens of thousands, summarizing for an entire generation the ambitions of families of modest means who sent their daughters to the Opéra, hoping for a lucrative liaison with a wealthy *abonné*.

In Halévy's first story, *Madame Cardinal*, we hear that her offspring Virginie and Pauline are thirteen and fifteen respectively, then follow her comical but hypocritical negotiations with the Marquis Cavalcanti, already Virginie's lover, throughout which the mother insists on the respectability of her household.[8] Much of the appeal of Halévy's stories comes from their matter-of-factness, less supercilious and lewd than the texts of Vizentini, Champsaur, and Mahalin, yet always more indulgent than judgmental in tone. His manner might be said to occupy a place between the wittiest of Degas' sketchbooks and the least sentimental of his paintings, combining economical description with a hint of caricature. Degas clearly admired them, making almost forty separate monotypes in the mid-1870s that may have been intended—like his ballet drawing for the *London Illustrated News*—as publishable illustrations.[9] A few of these prints, such as *Conversation: Ludovic Halévy Speaking with Madame Cardinal* (plate 12), were developed in color and given the character of small, brilliant pastels, but the majority were left as monochromes. Due to differences between the two men or to practical problems in translating the monotypes into printable form, Degas' images did not appear in the lifetime editions of Halévy's text, which were accompanied by banal illustrations by Maigrot, Morin, and Mas, and later by Albert Guillaume (plate 68). Very soon, however, the names of the writer and artist were publicly linked, as when Claretie introduced Maurice Magnier's 1885 *La Danseuse* with a reference to "the little modern chorus-girl, the little Cardinal of Ludovic Halévy, the little turned-up face of Degas' Parisienne."[10]

Some of Degas' monotypes re-create the broader milieu described by Halévy, while others are unquestionably close to his narrative: where a scene like *Group of Four Men and Two Dancers* (plate 69) might be

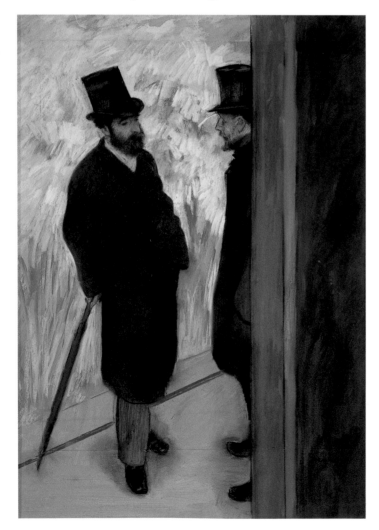

67. *Edgar Degas*, Ludovic Halévy and Albert Boulanger-Cavé Backstage at the l'Opéra, *1878–79. Pastel on beige paper, 31⅛ x 21¾ in. (79 x 55 cm). Musée d'Orsay, Paris (RF 31140).*

DEGAS BACKSTAGE

68. *Albert Guillaume,* Madame Cardinal in the Wings. *From Ludovic Halévy,* La famille Cardinal, *1907 edition. Private collection*

used to flesh out the spare printed saga at several points, *Ludovic Halévy Meeting Madame Cardinal Backstage* (plate 73) corresponds precisely to the opening sequence of the story *Madame Cardinal*. Once again, however, we find Degas taking his cue from an existing graphic mode, recalling in his superb *Pauline and Virginie Conversing with Admirers* (plate 66) such hackneyed engravings as Dumont's study of the wings of 1864 (plate 14), but translating its laborious handling into the brush marks of his experimental new technique. The incident depicted tallies with a moment in the tale of *Les Petites Cardinal*, where the author evokes a visit to "the poor old Opéra" in the company of an unnamed painter and other friends, when they "trapped" the Cardinal sisters in one of its "delicious old corridors… badly lit by smoky lamps."[11] Such details gave authority to both Halévy's texts and Degas' prints, the monotypes revealing busy passageways and wall-mounted lights, along with the crowded *foyers,* shadowy *loges,* and predatory *abonnés* mentioned elsewhere in the book. When several works from Degas' series were exhibited in 1877, Claretie announced "they are life itself. He is the equal of Gavarni and Goya," adding that they showed "everyday life in Paris, its varied faces, its surface and its depths."[12]

Certain features of the backstage anatomy of the Opéra known so well to Halévy and, apparently, to Degas, can be established at the outset. At both the old and the new theater, the majority of training and preparation for the stage took place in the Opéra building itself, not just for the corps de ballet but for the youngest recruits and the most highly paid stars. These were complex, business-like premises, formally arranged for the use of many hundreds of individuals and subject to continuous surveillance. As in theaters today, entrance from the street to areas behind the stage was denied to the general public, though with a draconian strictness that became legendary. At the old Opéra, we are told, the ferocious Madame Crosnier and her successor Madame Monge kept constant vigil in their *conciergerie* at the rear doorway on the rue Grange-Batelière, dispensing soup to undernourished dancers but ejecting interlopers who lacked the necessary credentials.[13] Security was maintained by separating the theater itself from the backstage zone beyond and denying access between the two, except through a single door for those with authorization. The door in question, the *porte de communication,* was either kept locked or formally guarded by an Opéra official who maintained a written record of all who used it.[14] Rules governing these entrances were applied rigorously, some endorsed by government decree and others modified in the Opéra's statutes as the years passed. The national archives show that foreign dignitaries, journalists, traveling celebrities, artists, and others frequently made applications to breach these defenses, but they were by no means always accommodated.[15]

Once past this *cordon sanitaire,* performers and visitors entering the private realm of the Opéra by either door were confronted by several floors of administrative offices, workshops for making costumes and props, storerooms, and even a library, as well as facilities for the singers and orchestra. For the Opéra dancers, there were four quite separate territories that dominated their routines, each with its specialized function and each circumscribed by its own regulations and behavior. Degas' art touched on all of them, some to an almost comprehensive extent, others only tangentially, but the differences between these areas had an immediate and measurable impact on his imagery. A conspicuous case is the dance classroom, painted on dozens of occasions by Degas himself yet almost unknown to most of his contemporaries. Central to the lives of the Opéra ballerinas, the classrooms were large, dreary chambers where the hard work of exercise and regular teaching took place for several hours a day, six days a week. In *The Rehearsal* (plate 84) and other such classroom canvases, we encounter members of the corps at their least glamorous, dressed in plain practice tutus and random accessories, waiting idly for their teacher or laboring until they were "exhausted, almost dead, puffing like a steam engine," their faces "multicolored" with exertion.[16] These observations were made by Charles de Boigne, an Opéra enthusiast who had evidently witnessed a ballet class himself, but otherwise such accounts are rare in both the texts and illustrations of the period. By comparison with the freshly costumed and exquisitely coiffed dancers on the stage or in the *foyer,* it seems that few visitors were attracted to the weary women who went through their exercises in these near-squalid spaces.

69. *Edgar Degas*, Group of Four Men and Two Dancers (The Cardinal Sisters Talking to Admirers), *c. 1876–77. Illustration for* La famille Cardinal. *Monotype in black ink on white paper, 10³/8 x 7½ in. (26.3 x 19.1 cm). Musée du Louvre, Departement des arts graphiques, fonds Orsay (RF 30021)*

At the opposite extreme was the *foyer de la danse*, the most lavishly appointed of all backstage rooms and the most eagerly frequented by *abonnés* and others who went behind the scenes (plate 80). Much drawn and painted by socially aspirant artists like Lami, Gavarni, and de Montaut—and later at the Palais Garnier by Béraud, Forain, and Seguin-Bertault—the mirror-lined and ornately decorated *foyer* was specifically designed as a meeting place between dancers and male members of the audience: writing about his new building, Charles

Garnier explained that "above all, the Foyer is intended as a setting for the charming swarms of ballerinas, in their picturesque and coquettish costumes."[17] By long-established custom, dancers of coryphée status and above would present themselves here before and after their stage appearances, ostensibly warming up for their roles but as often mingling with the distinguished company. Rigidly denied to the general public, the right to visit the *foyer* was one of the cherished privileges of an *abonnement*, though this right applied only on the evenings of performances. During the day, the same superior spaces were used at various periods for the advanced instruction of "the majority of *premiers sujets*" (or leading dancers) for the teaching of "pantomime" and for rehearsing the stage roles of the Opéra's stars.[18] Something of the

complexity of Degas as a dance artist is summarized in his attitude to the *foyer de la danse* at both theaters. Despite countless assertions to the contrary, his documented presence at this most popular of locations is hardly reflected in a single substantial work of art, and the refined decoration of Debret's and Garnier's *foyers*, and the human transactions that took place there, are completely absent from his oeuvre outside the *Famille Cardinal* monotypes.

A more utilitarian feature of the dancer's backstage existence was the dressing room, allocated according to her status in the Opéra's hierarchy. Between ten and twenty-five members of the corps de ballet might share a crowded room at the rue Le Peletier, one of which Albéric Second recalled as "dirty" and "crudely furnished," with vulgar caricatures of prominent dancers scribbled on the walls.[19] Vizentini describes how the same girls would "laugh, cry, fight and embrace" as they dressed themselves, adding that "the only man admitted among these women was the coiffeur."[20] Unsurprisingly, perhaps, this was another area that attracted few outsiders, making such communal spaces almost as rare as classrooms in the iconography of the day.[21] As dancers rose in the hierarchy, they commanded individual dressing rooms, or *loges*, of increasing comfort, progressing from those remembered as "small, dark and inconvenient" by Mahalin to one "hung with muslin, and the sofa and armchairs covered with richly embroidered silk," and another ornamented with "a complete collection of illustrations of the dance past and present."[22] When the curtain came down, the stars would receive their honored guests and faithful followers in these shrine-like boudoirs, giving rise to a subgenre of illustration and anecdote that often had blatant erotic undertones.

Degas responded to the brilliance, the squalor, and the suggestiveness of the dressing room on a number of occasions, demonstrating—or implying—his familiarity with both shared and individual spaces. A sketchbook drawing for his oil painting *Madame Gaujelin* (plate 48) shows the dancer's mirror, dressing table, and toilet articles, a documentary aspect of the *loge* further explored in a number of experimental prints. The small monotype *L'Intimité* includes an elderly *habilleuse*, or personal dresser, a performer adjusting her makeup, and a male companion, while the etching *Actresses in their Dressing Rooms* reveals two young women attending to their hair and costumes.[23] The latter, one of Degas' most visually complex prints, exploits the play of shadow, texture, and overlapping spatial planes to suggest a tunnel-like sequence of untidy boudoirs. The title is almost certainly spurious—there is little evidence of Degas' intimate acquaintance with actresses—and the image can be more plausibly compared to such backstage scenes as those of the *Famille Cardinal* series. One of Halévy's early stories, *Monsieur Cardinal*, is recounted to the author in a shared dressing room at the Opéra, represented by Degas in his monotypes as a chaotic chamber festooned with tutus.[24] On a different scale and in a contrasting medium, a group of pastels executed around 1880 introduces us to the

elegantly furnished quarters of the *étoiles*. The magnificent example in Cincinnati (plate 70) is highly specific in its inventory of hair adornments, discarded red stockings, and other paraphernalia, again reinforcing a sense that Degas—like Halévy—had observed such places himself.

The fourth aspect of the dancer's habitual terrain combined elements of all the previous three. The theater wings marked the point

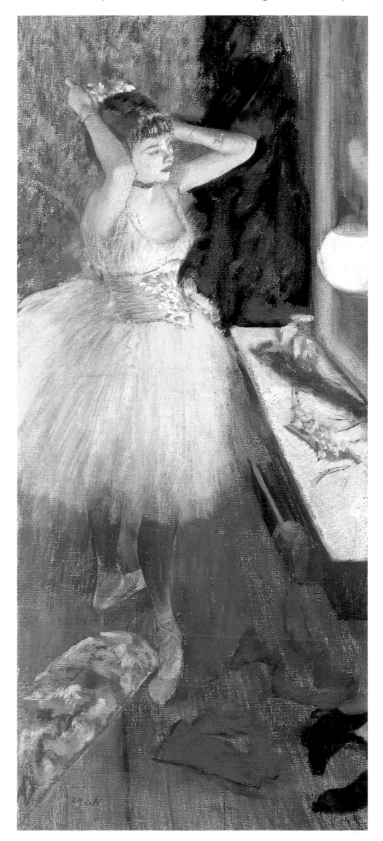

70. *Edgar Degas, Dancer in Her Dressing Room, 1879. Pastel on canvas, 34⅝ x 15⅞ in. (87.9 x 40.3 cm). Cincinnati Art Museum; Bequest of Mary Hanna (1956.114)*

where the warren of smaller, secluded backstage rooms and connecting passageways met the large, sumptuous auditorium, when every feature of the ballerina's private toilette and every practiced move of her body was made available to public scrutiny. In hundreds of popular engravings, lithographs, and etchings, dancers in the wings become the playthings of their admirers and the objects of prurient curiosity. In Valnay's drawing of the Opéra from 1875 (plate 71), we see the canonical moment between scenes at a performance, when backstage life spills on to the stage itself. Parading the stock types of his craft, Valnay presented the dancers surrounded by adoring *abonnés*, the confident soloist at right who converses with a follower, and around them a melee of stagehands, firemen, and assorted officials. In contrast to their sanctuaries in the depths of the building, this was less controlled and selective terrain for such young women, popularly associated with chance encounters and the making of assignations. In theory at least it was still a restricted area, where the fictional dancer

Virginie Cardinal could be fined for allowing her mother to wait during performances.[25] But the number of journalists, authors, *abonnés*, caricaturists, and artists who displayed a detailed knowledge of the subject, to say nothing of the composers, stage and dance directors, chaperones, machinists, dignitaries, and firemen (visible in their helmets at left), seems to indicate a greater laxity on occasion.

As an *abonné* himself in the mid-1880s, if not before, Degas must have legitimately witnessed such spectacles at close quarters, though nothing like Valnay's assorted crowds and technical confusion were to appear in his work at any point in his career, early or late. The extent to which he edited out the mechanical and anecdotal life of the coulisses from his countless depictions of the subject deserves further emphasis. The wings were principally a theme of his middle and later years, but even the examples manifestly located at the old Opéra show a narrative restraint that borders on austerity. The chaos recorded by Valnay was a favorite topic of the day, not just with illustrators but also among gossips, newspaper columnists, and novelists: a few years earlier, the Goncourt brothers had been enraptured by a view behind the

71. Valnay, The Wings at the New Opéra, 1875. *Bibliothèque nationale de France*

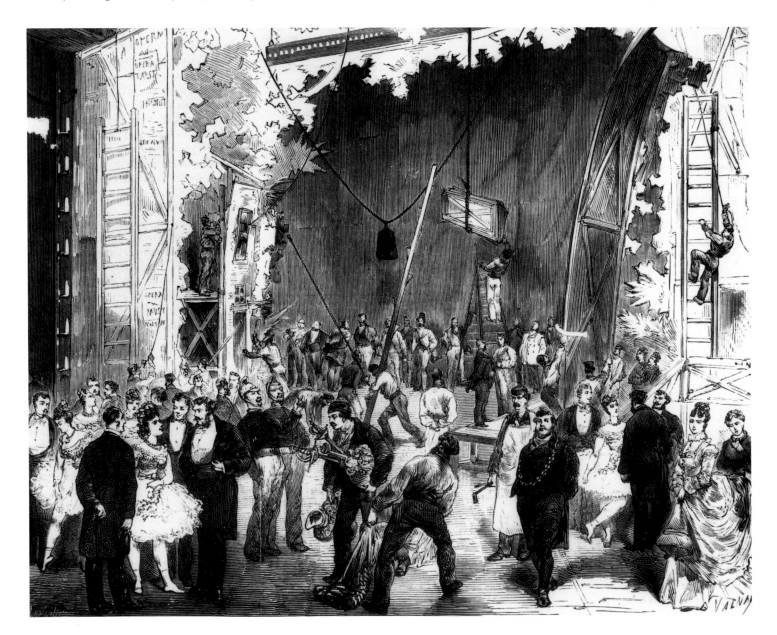

DEGAS BACKSTAGE

72. Edgar Degas, *The Curtain*, c. 1880. Pastel over monotype, 10¾ x 12¾ in. (27.3 x 32.4 cm). Collection Mr. and Mrs. Paul Mellon

of his own monotypes, and that of the daily press. If the date of 1872 proposed for this work can be sustained, it is also among the most precocious of all Degas' canvases of the wings, both in its *Famille Cardinal*-like subject and its bravura manner.[27]

Significantly distanced from this formula is *Yellow Dancers* (plate 76), a complex oil painting exhibited by the artist at the Impressionist exhibition of 1876. This is an astonishingly prescient work, apparently the first *coulisses* scene shown by Degas in public and the compositional template for scores of canvases and pastels made over the next three decades. Asymmetrically placed within the rectangle, their torsos merged and their skirts dissolved in a single mass of color, these dancers are simultaneously united by their craft and their femininity, yet utterly self-absorbed. The challenge of interlacing their limbs while allowing each figure its muscular identity clearly fascinated and tested the artist, who repainted the canvas extensively before signing it for the 1876 show. Recent X rays have identified his changes in the scenery, in the witty, cartoonish line of legs at left—which recall *The Curtain* (plate 72) of the same date—and the dispositions of all three ballerinas.[28] Compressing motifs and experiments from several works of the early 1870s, Degas must have resolved this design around mid-decade and soon progressed to related canvases in other colors and formats.[29]

In subsequent years, as Degas adopted pastel as his principal medium, he was to return again and again to the dense grouping of the Chicago canvas in variants based on brilliant reds, mineral greens, or contrasted corals and blues that remain among his crowning achievements. But in 1876 the reviewers saw his pioneering scene in more prosaic terms, one merely pointing out that the dancers were "cut by the frame at the knee" and another noting "the pink tights of the corps-de-ballet beneath the scenery," slyly acknowledging the artist's proximity to his subject and its potential for sexual frisson.[30] A much less well-known canvas, *Dancers in Red Skirts* (plate 77), traditionally dated to the following decade, clearly belongs to this same moment and once resembled the initial draft of *Dancers Preparing for Ballet* more closely. It too involves a tightly knit group at the right edge, here balanced by two less crowded figures in muted coral outfits and the brightly lit girl in the distance. Shadow and illumination dominate the narrative, throwing an audacious screen of indistinct forms across the foreground and allowing only partial glimpses of the action beyond. Again cropping the scene rather severely and implying intimacy, Degas suggested the obscurity of life in the wings as well as its occasional glamour. Evidently content with his invention, he signed the picture and soon released it on to the market, where it was owned in succession by three distinguished patrons, the critic Théodore Duret, the dentist Georges Viau, and the Danish collector Wilhelm Hansen.[31]

Yellow Dancers draws our attention to another critical feature of Degas' scenes of the wings: the presence or absence of dark-suited male figures, who have generally been assumed to be *abonnés*. This painting, like most of Degas' theater works in oil or pastel, lacks these ominous presences, which have become so central to discussions of the artist's backstage imagery. A detached look at his oeuvre in its

curtain during an interval, recording in their diary "the domesticity of the stage, the comings and goings of this army of coryphées, stagehands, walk-on roles," and "the scenery rising slowly from the floor."[26] If a work like *The Curtain* (plate 72) could almost be an illustration of their account, however, in Degas' wider oeuvre the endless movement of technicians, décor, and costumed extras noted by the Goncourts is conspicuous by its absence. In another overt act of homage to Daumier, the monotype *Ludovic Halévy Meeting Madame Cardinal Backstage* (plate 73), Degas seems to look back to a simpler age and a less frenetic theater. As in Daumier's canonical *The Singer's Mother* (plate 74), Degas blocks out much of the action with a shadowed, featureless flat, here almost obliterating an "army of coryphées" in order to emphasize the lurking presence of his adult protagonists. Even more than Daumier, and in stark contrast to Valnay and Dumont, he avoids the ropes and pulleys, the gaslights and ladders, and the bizarre anachronisms of backstage existence in favor of graphic economy and gentle characterization.

Still pursuing a dialogue with his caricaturist predecessors, most of Degas' early images of the wings were executed in a graphic medium or on a small scale. The postcard-size etching *Dancers in the Wings* (plate 190) is a case in point, though here—strictly speaking—we look through the scenery from the wings at a scattering of the corps de ballet already on the stage. Again, the trappings of backstage life are omitted, as they are in the tiny but richly sensuous canvas *Dancers Backstage* (plate 75). In this painting the spectator feels part of the intermission melee described by Valnay and the Goncourts instead of a voyeur lurking behind the scenes, but the sense of intrusion into an unaccustomed space is acutely captured. By cropping the dancer's legs at ankle height and interposing a shadowy male figure, Degas brings us close to their encounter and perhaps to the coarser comedy

73. *Edgar Degas, Ludovic Halévy Meeting Madame Cardinal Backstage, 1876–77.*
Illustration for La famille Cardinal. Monotype on paper, 6³⁄₈ x 8³⁄₈ in. (16 x 21.3 cm).
Collection André Bromberg

74. Honoré Daumier, The Singer's Mother, 1856. Lithograph, 8 x 9¼ in. (20.5 x 23.5 cm). Private collection

broader setting leads us to invert many of the assumptions now current in such debates. As previous examples in this volume have shown, the lurking, top-hatted, and oddly attenuated *abonné* was already a stock character in the graphic art of mid-century, in the work of caricaturists such as Gavarni, Cham, de Beaumont, Valnay, and Dumont that Degas would have known since his youth. Even in largely descriptive engravings, such as those illustrating the *foyer* at the rue Le Peletier (plate 80) and the Palais Garnier (plate 11), *abonnés* monotonously fawn over members of the corps de ballet or leer at their favorites. Significantly, the very limited number of Degas' own stage pictures that feature such individuals tend to be small and are frequently graphic-based: they include some of the Cardinal Family monotypes; several pastels executed over prints, like *L'Etoile* (plate 180) and *The Star* (plate 103); and a cluster of sketch-like canvases, among them, *Dancers Backstage* (plate 75) and *Three Dancers in the Wings* (plate 106). But the *abonné*-cipher in the background of a work such as *In the Wings* (plate 78) seems like a gesture to a faded tradition, where the artist's principal concern is with the overlapping forms and psychologically contrasted characters of the dancers themselves. In his lithograph, of course, Degas uses the darkly indicated figure in the distance to inflect the surrounding atmosphere, but it would clearly be absurd to see this remote and slightly ridiculous observer as the defining element of the scene.

The more we confirm the prevalence of *abonnés* in the Opéra wings and the undoubted rapaciousness of their behavior, the more meaningful is Degas' exclusion of them from the great majority of his theater subjects. If we set aside the *Famille Cardinal* monotypes, which

75. Edgar Degas, Dancers Backstage, 1876–83. Oil on canvas, 9½ x 7⅜ in. (24.2 x 18.8 cm). National Gallery of Art, Washington; Ailsa Mellon Bruce Collection (1970.17.25)

were conceived as illustrations for a pre-existing text, the number of pictures in which the artist introduced male observers of various kinds into his narratives amounts to around twenty. When account is taken of the documented presence on the stage of directors and administrators, stage managers, and music and dance directors—such as those depicted in his three *Ballet Rehearsal on Stage* pictures—most of whom were required to wear top hats and formal dress on duty, the total of unquestioned representations of *abonnés* in Degas' theater scenes dwindles to a mere handful. What is truly remarkable about Degas' oeuvre in contemporary terms, in other words, is how *little* attention he pays to the *abonné* and how insignificant these figures are in most of his pictures. Once again, it appears, Degas distinguished himself and his art by first studying the energetic visual modes of his day, absorbing what suited his purposes, and then distancing himself from their more banal manifestations.

IN SEARCH OF DEGAS' BACKSTAGE SUBJECTS

Degas almost certainly made his first contact with the four principal aspects of the dancer's backstage existence—the classroom, the dressing room, the *foyer*, and the wings—in the notorious maze of rooms behind the scenes at the old Opéra. So eccentric was this building and so curious its history that it is necessary to disentangle its significance for Degas' art with some care. In their hurry to find a location

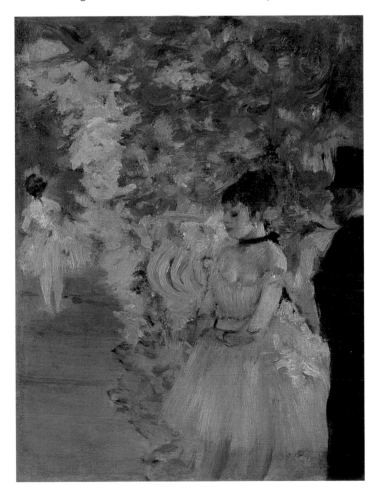

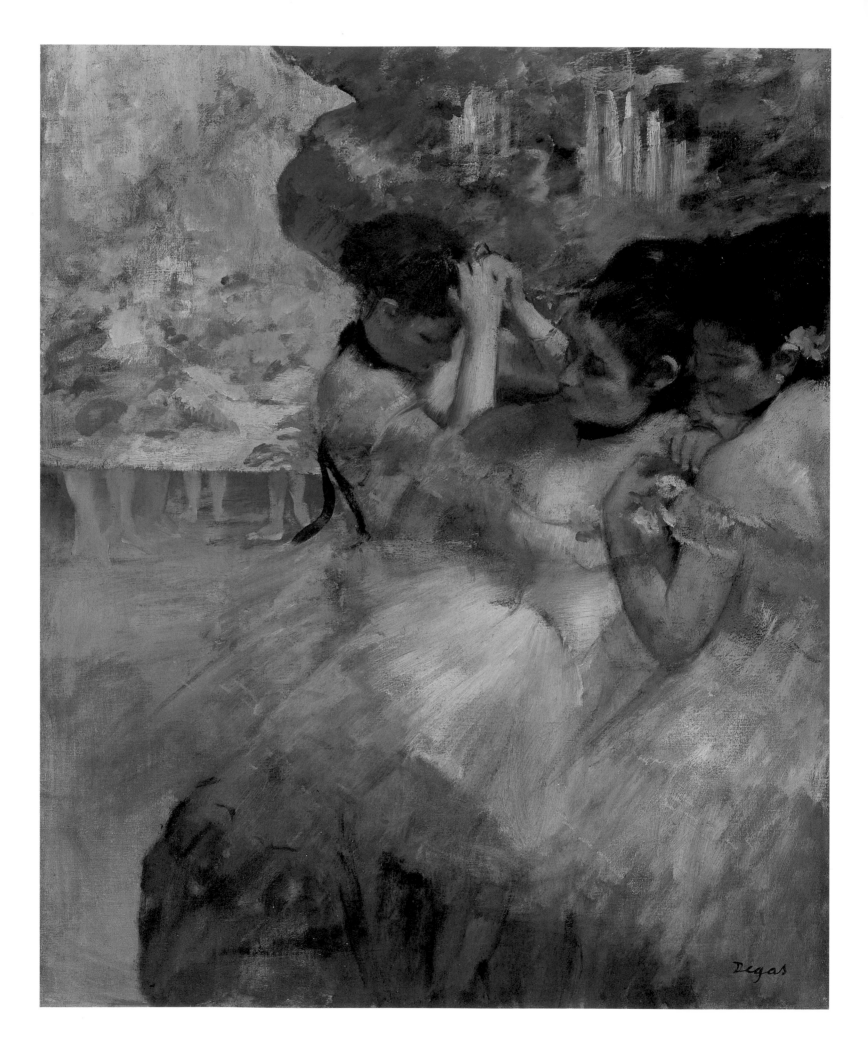

DEGAS BACKSTAGE

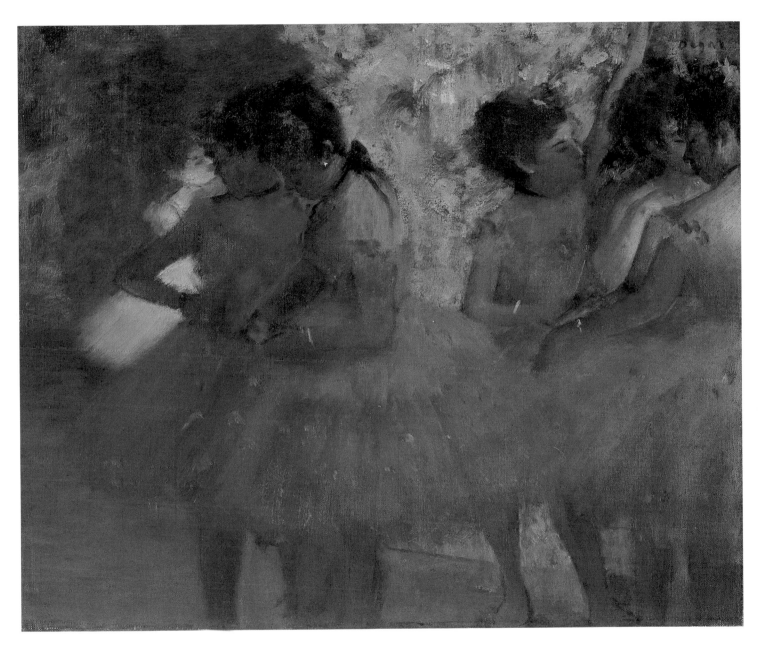

77. *Edgar Degas, Dancers in Red Skirts, c. 1884. Oil on canvas, 15 x 18 in. (38 x 44.5 cm). Ny Carlsberg Glyptotek, Copenhagen*

76. *Edgar Degas, Yellow Dancers (In the Wings), 1874–76. Oil on canvas, 29 x 23⅜ in. (73.5 x 59.5 cm). The Art Institute of Chicago; Gift of Mr. and Mrs. Gordon Palmer, Mr. and Mrs. Arthur M. Wood and Mrs. Bertha P. Thorne (1963.923)*

78. Edgar Degas, *In the Wings*, c. 1879–80. Crayon lithograph (from transfer paper), 14 x 10 in. (35.5 x 25.4 cm). Private collection, courtesy Ruth Ziegler Fine Arts, New York

for Debret's design in 1821, the authorities had commandeered the house and gardens of a grand eighteenth-century residence, the Hôtel de Choiseul, situated at the junction of the Boulevard des Italiens and the rue Le Peletier (plate 79).[32] This hôtel had enjoyed a momentous past as the home of the Duke de Choiseul, the long-serving foreign minister of Louis XV who is said to have installed "the entire Court" there during his Paris sojourns and turned it into "the veritable political and literary center" of the capital.[33] The duke and duchess entertained in style, receiving their guests in "an immense gallery, remarkably well heated in winter and lit by thousands of candles," while in adjoining salons they could enjoy "billiards, reading and intimate conversation."[34] Extraordinarily, it was this monument of French history that Debret absorbed into his plans, joining the new theater directly on to its principal façade and using the older building for most of the necessary backstage facilities. Since the revolution, the hôtel had fallen on hard times, its rooms occupied by various government agencies and stripped of some of their furnishings. But it was the once glittering salons and reception areas of the Duke de Choiseul that were now transformed into classrooms, *loges*, and *foyers* for the Opéra's dancers, and, even more bizarrely, it was these same spaces—where Louis XV's ministers had once dined by candlelight—that provided the setting for Degas' first backstage paintings.

Few aspects of Degas' early engagement with the ballet are as tantalizing as the historic rooms of the Hôtel de Choiseul. While earlier commentators have suggested that certain paintings by Degas depict this reconstructed backstage area, almost no information has been available on its appearance or on the location of specific rooms within the hôtel itself, and its decorative scheme seems to have escaped the attention of earlier engravers. To confuse matters further, Debret made extensive modifications to the internal arrangements and other changes were introduced as time passed, recorded only in imperfect designs and verbal accounts.[35] When the bold—and no doubt economical—decision was made to integrate the structure into the new Opéra, staircases and doorways were built to connect the former hôtel to the rear of the newly planned stage area. This arrangement is clearly evident in the elevation (plate 25), though here it is only the main body of the hôtel that is shown as the lower structure at right. The full extent of the latter is better appreciated in the ground plan of the ensemble (plate 79), where the clusters of subsidiary rooms flanking the main courtyard, and the rear entrance on the rue Grange-Batelière—where Madame Crosnier later ruled—can also be seen. It was in the ground floor and basement of this ancien régime complex that Debret situated most of the administrative functions of the Opéra, leaving its two upper levels to the needs of dancers, singers, and musicians.[36]

Where exactly did ballet classes take place at the rue Le Peletier Opéra, and what was the appearance of these spaces in Degas' day? The conventional response has been to cite the *foyer de la danse*, one of the few rooms consistently marked on plans of the building (see "Danse" at the center of plate 79). The titles traditionally given to many of Degas' early classroom pictures situate them here, despite wide variations in their architectural schemes and in the activities of their dancers: *Dance Class at the Opéra* (plate 19), for example, was once confidently labeled *Dance Foyer at the rue Le Peletier Opéra*, while having little resemblance to the painting still sometimes known—again erroneously—as *The Dance Rehearsal* (plate 87).[37] Yet as we have seen, the *foyer* was a highly specific domain with a unique décor and a largely ritualistic function. It was also the only room in the former Hôtel de Choiseul described in some detail by contemporary artists, writers, and illustrators. In the watercolor of 1841 by Eugène Lami, which was reproduced in several popular prints around mid-century (plate 80), we see the dance *foyer* in its golden age. At this date, Louis Véron explains, "*abonnés*, ambassadors, deputies and ministers" would gather to enjoy the company of the Opéra's celebrities, as well as that of the lightly clad *étoiles*: a key on Lami's painting indicates the dancers Fanny Elssler, Adèle Dumilâtre, and Célestine Emarot; the composers Daniel-François Auber and Fromenthal Halévy; the poet Alfred de Musset; and the Opéra directors Nestor Roqueplan and Véron himself.[38]

Debret had gone to some lengths to create an appropriate setting for such ensembles, basing his *foyer* in the "grand salon" of the

79. *The rue Le Peletier Opéra, ground plan, 1820*, from Alexis Donnet, Architectonagraphie des théâtres. Bibliothèque nationale de France

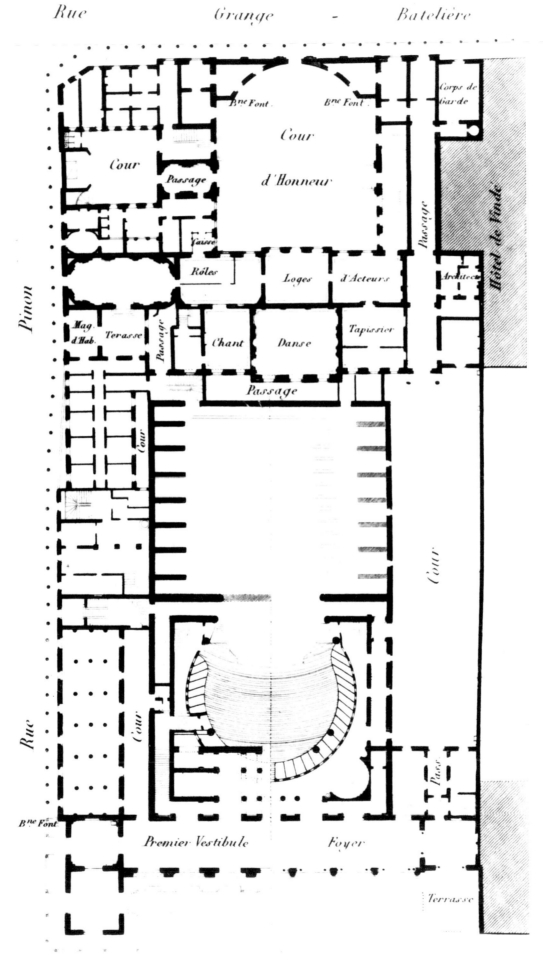

Rue Grange - Batelière

Pinon

Hôtel de Vende

Cour

Cour d'Honneur

Passage

B.ne Font. B.ne Font.

Corps de Garde

Passage

Caisse

Rôles Loges d'Acteurs Architecte

Mag. d'Hab. Terasse Passage Chant Danse Tapissier

Passage

Cour

Cour

Cour

Cour

Passe.

B.ne Font.

Premier Vestibule Foyer

Passe.

Terrasse

Rue Lepelletier

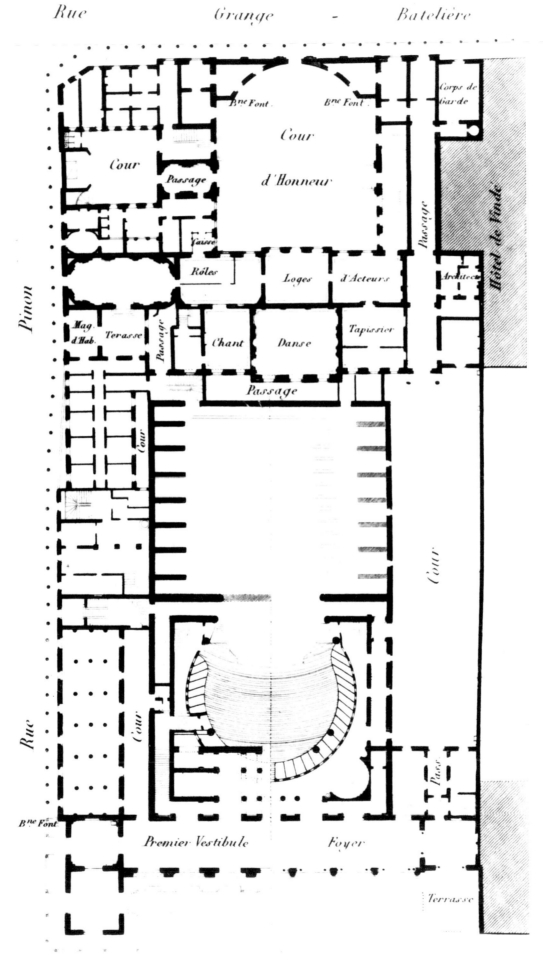

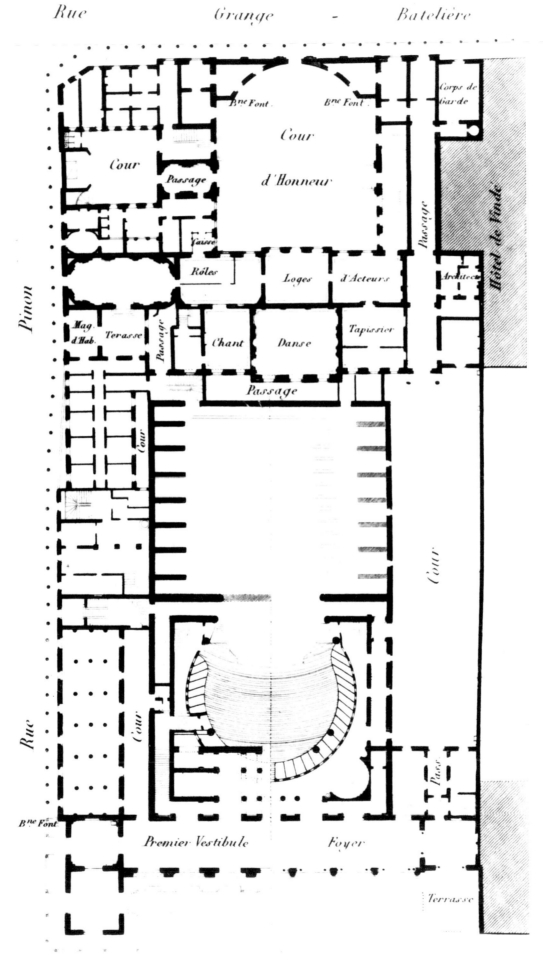

Hôtel de Choiseul, situated behind its principal west-facing façade, a room once "decorated in the Corinthian order in carved wood, after the designs and under the supervision of Clérisseau, painter to the King."[39] From the ground plan it appears that the space was some thirty feet wide by forty feet long, with three deep-set windows along one side. Visitors extolled the "gilded" décor of the *foyer*, with "a great expanse of beautiful mirrors," numerous "banquettes of velvet," "traditional barres for exercise," a chandelier, and a marble bust of the eighteenth-century dancer Guimard.[40] Debret contrived the room by dividing the "grand salon" horizontally with a new floor, supported on columns that are clearly indicated in the elevation. The effect, visible in Lami's print, was a curious truncation of the salon's massive Corinthian pilasters and an emphasis on the heavy arches surrounding the windows, which seem disproportionately heavy in such a low chamber. A further drawback was its close proximity to the recently built theater, preventing daylight from reaching the windows and making the room dependent on gas and oil lamps. Despite its reputation as the "Temple of Voluptuousness," the *foyer de la danse* was also allowed to deteriorate over the years, in both its fabric and its social status. By mid-century, *abonnés* were complaining about "smoke-stained walls," "dirty ornaments," and "poor lighting," and in 1868 Albert Vizentini claimed that the *foyer* had "lost all its prestige, all its gaiety, living on

80. After Eugène Lami, The Foyer at the Opéra, 1841. Bibliothèque nationale de France

memories of the past."[41] Adding insult to injury, Paul Mahalin later compared it unfavorably to the Palais Garnier, remembering that the old *foyer* was neither "as spacious, nor as comfortable, nor as magnificent" as the new one.[42]

When Degas began his backstage paintings, the *foyer* at the rue Le Peletier was a somewhat faded, architecturally eccentric space, with a distinctive inventory of fittings. In any painting of the subject from this period, therefore, we should expect to see these well-documented features, along with an evening gathering of *abonnés* and costumed stars, or a daytime class for a few *premier sujets*. Not a single canvas by Degas fulfils these criteria. The exaggerated Corinthian capitals and barrel-vaulted ceiling of the Hôtel de Choiseul are nowhere to be found in his paintings and pastels, and neither are the central chandelier, marble bust or "great expanse" of mirrors mentioned by his seniors.[43] Furthermore, a glance at such works as *Dance Class at the Opéra* (plate 19), *The Dance Rehearsal* (plate 87), or *The Dance School* (plate 93) shows that their undecorated spaces are illuminated by daylight, with several members of the corps de ballet taking class under the eye of a single instructor, unwatched by *abonnés* or other male visitors. None of these pictures can thus represent the legendary room, either as a nighttime gathering place or as a site of instruction in lavish surroundings. Mutely alerting us to this situation, Degas himself refrained from using the word "foyer" in all the titles he gave to his own pictures.

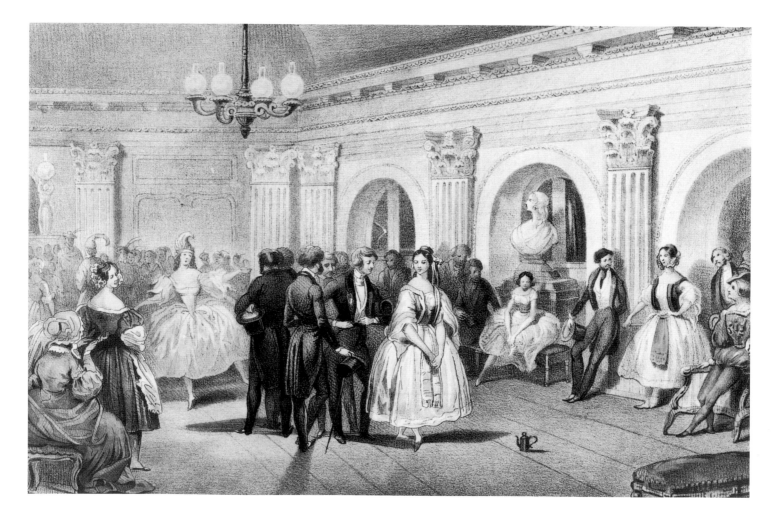

Only two options appear to remain open: that Degas chose not to depict the *foyer* at all or that he never saw it. In actuality, a third explanation exists that is both consistent with his known tastes and vividly endorsed by a group of his pictures. It was characteristic of Degas, especially during these years, to restrict the treatment of certain themes to a specific medium: the nude and the cabaret, for example, are almost entirely confined to pastel and print, while the brothel scenes of this same period exist uniquely as monotypes. It appears that Degas also chose the intimate scale and sensuousness of monotype for his response to the Opéra *foyer*, lending the works something of the secretive quality of the brothel pictures and suggesting a reluctance to deal with his delicate subject in a grander mode. The result was a set of half a dozen prints that are small enough for their historic significance to have been largely missed, yet sufficiently precise to leave no doubt of the artist's purpose. All the prints are broadly linked to the *Famille Cardinal* saga, and each includes clusters of black-suited *abonnés* paying court to dancers, manifestly at night or by the light of lamps or chandeliers. Though the monotype medium hardly lends itself to exactitude, among its subtle touches of black, gray, and silver we also find traces of most of the definitive elements in Debret's *foyer de la danse*, leaving no doubt of Degas' acquaintance with this aspect of the rue Le Peletier Opéra.

Titled after the artist's death—like all this group of *foyer* prints—the subtly evocative monotype *The Foyer* (plate 81) shows one of the "banquettes of velvet" against a paneled or mirrored wall, as well as a chandelier suspended above the formally attired company. These details are even more emphatic in two similar proofs, both currently of unknown whereabouts, where the elegant expanse of the *foyer* and the presence of "traditional barres for exercise" is further apparent.[44] Architecturally more explicit is another unlocated image, *Talking to Admirers*, which incorporates one of the unmistakable semicircular arches of the former "grand salon" at the Hôtel de Choiseul, and other monotypes in the group hint at the pronounced "fluting" in the *foyer*'s giant pilasters.[45] Though they register almost subliminally, the bold vertical strokes in the background of *In the Foyer* (plate 82) are clearly a memory of this carved decoration—ordained by "Clérisseau, painter to the King"—for which there is no equivalent in the *foyer* at the Palais Garnier (plate 99). This magnificent monotype summarizes both the solemnity and the casualness of the traditional *foyer*, where a knot of be-suited male subscribers (surely portraits of individual *abonnés* known to Degas) sit on the corner benches and attempt to distract an awkward coryphée. Offering evidence of a more personal kind, this print and a number of less specifically contextualized monotypes argue for the implicit presence of the artist throughout the sequence. Despite its blank background and its literary theme, *Group of Four Men and Two Dancers* (plate 69) presents a persuasive image of *foyer* life, with an abrupt, close-up viewpoint that suggests both proximity and familiar-

ity. We should not forget, however, that these prints were necessarily retrospective and perhaps pointedly nostalgic, having been made at least two years after the burning of the entire rue Le Peletier site. But there can now be little doubt that such accurately detailed images were derived from Degas' firsthand experience of the old *foyer*, preserved in his famously tenacious memory and retrieved for the creation of the Halévy illustrations.

By adding the visual testimony of this sequence of monotypes to other evidence from his early career, we can considerably clarify the vexed issue of Degas' backstage access. The difficulty of getting behind the scenes was a constant theme among writers and journalists of the period, many of whom took pleasure in revealing that they, exceptionally, had achieved this feat. Albéric Second in the 1840s, and Roqueplan and Véron in the 1850s, spoke of the thrill of a first private invitation to the *foyer*, and their colleagues in Degas' day showed that special favors or a brazen manner still allowed the rules to be circumvented.[46] Most of the intimate descriptions of the wings by individuals such as Vizentini in the 1860s, du Camp in the 1870s, and Magnier in the 1880s were written by enthusiasts who had a questionable right to be there, among whom was Claretie himself, grandly announcing in 1885 that he had "never liked the reality of the *coulisses*."[47] To this company we should add the many painters and illustrators who have already been mentioned, who effectively placed themselves and their viewers behind the scenery and occasionally in the classroom. Though

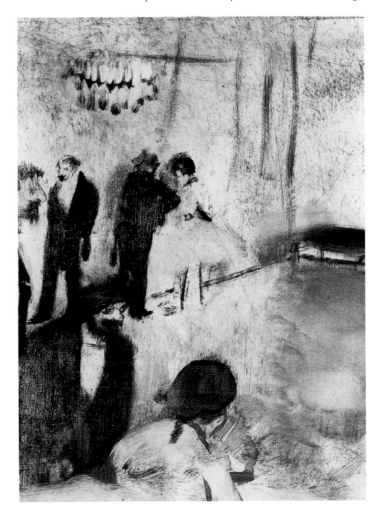

81. *Edgar Degas,* The Foyer, *1876–77. Illustration for* La famille Cardinal. *Monotype in black ink on white laid paper, 6³⁄8 x 4⁵⁄8 in. (16.2 x 11.9 cm). Collection André Bromberg*

some, no doubt, took advantage of the imagery of their more authoritative colleagues, it is crucial to note that several artists were documented in the *foyer* and elsewhere by their contemporaries. De Beaumont, Lami, Isabey, and Gavarni were listed by Mahalin as backstage habitués, and Halévy remembered a visit to the Opéra's corridors in the company of an anonymous painter in *La famille Cardinal*. Again, arrangements were made in 1866 for the sculptor Jean-Baptiste Carpeaux, accompanied by the dance master Petipa, "to observe the ballerinas practicing in the Foyer de la danse," resulting in many remarkable drawings.[48] And after the move to the Palais Garnier, such disciples and imitators of Degas as Renouard, Forain, and Carrière-Belleuse paraded their own detailed familiarity with the private world of the Opéra in large numbers of their works.

In the 1860s, long before he obtained the *abonnement* that automatically gave him access backstage, Degas was unusually well placed to benefit from the various rights of access enjoyed by his acquaintances at the rue Le Peletier. Composers and writers who had written for the repertoire enjoyed the right to go behind the scenes, and members of the Opéra orchestra had been known to extend this privilege to their friends.[49] Several of the subjects of Degas' early portraits fell into such categories—Dihau, Pilet, and Chabrier among them—while his contact with stellar performers like Fiocre and Faure, and with such senior Opéra figures as Gard, Hainl, Perrot, Mérante, and Vaucorbeil, must have increased the likelihood of an impromptu invitation. More specifically, toward the end of the 1860s Degas is thought to have renewed his childhood acquaintance with Ludovic Halévy, scion of one of the Opéra's most illustrious families and himself entitled to go backstage as the author of the 1864 ballet *Néméa*. Henri Loyrette has established that Degas first accompanied Halévy on one of these visits in 1871, though this was not necessarily the artist's introduction to the Opéra's backstage areas.[50] Perhaps on this occasion, however, and certainly around this date, the artist completed a modest sketchbook drawing of an arch with surrounding pilasters and entablature (plate 83), which was used rather loosely in his small canvas *Dance Class at the Opéra* of 1872. Carefully inscribed with the names of the structural materials—"marble," "stucco"—the décor in this study and its associated painting is subtly distinct from that of the *foyer de la danse* but remains entirely consistent with an eighteenth-century interior such as that of the Hôtel de Choiseul.

As we increasingly encounter Degas' knowledge of backstage structures at the rue Le Peletier—which already include the *foyer* and the unnamed practice room of *Dance Class at the Opéra* and will soon extend to the principal classroom—the case for his occasional contact with the dancers' private world at the Opéra in the early 1870s

becomes irresistible. By the same token, certain of the paintings loosely linked to the building in the past take on new authority, and our search for their locations acquires an additional urgency. Though his sketchbook study of the arch remains unique, Degas' painted representations of the interior fabric now appear increasingly evocative of the faded glories of the Hôtel de Choiseul. In *The Dance Class* (plate 229), begun in 1873 as a commission for Faure, we see high ceilings, deep moldings, and rich marble-and-gilt pilasters that broadly follow the style of his drawing, though here the golden ochre walls of the smaller Paris painting are replaced by Rococo jade. Its near-twin in the Metropolitan Museum of Art (plate 127) reflects a more modest chamber with a lower ceiling and less ornament, perhaps one of the rooms in the dormer story. Its elevation is signaled in the rooftop view reflected in the large mirror, which also situates us provisionally on the eastern side of the courtyard, though allowance must always be made for the artist's rearrangement of such effects on his canvas.

The near-miniature panel of about 1871 in the Metropolitan Museum, also called *The Dancing Class* (plate 143), is apparently set in a humbler corner of the same suite of rooms, where ambiguous doorways and mirrors allow distant views of sunlight entering through tall windows, and yet more green and gold walls. Close scrutiny of these paintings reveals that Degas often modified their perspective and their architectural logic as he progressed, reminding us yet again of his limited interest in description for its own sake. Whatever his contact with the hidden life of the Opéra, there are no indications that he made accurate drawings of these spaces, just as there are no such studies of the laundries, café-concerts, and shops that fill the backgrounds of other current works.[51] In the backstage paintings, Degas' habitual fusion of observation, memory, and whimsy seems to be in operation, but the particularization of features like doorways, mirror frames, and lightly paneled wall surfaces, and the inclusion of such items as bulletin boards and framed Opéra posters, speaks forcefully of localized contact with the Hôtel de Choiseul's historic rooms.

82. *Edgar Degas, In the Foyer: Men and Dancers, 1876–77. Illustration for La famille Cardinal. Monotype in black ink on vellum paper, 8⅝ x 7⅜ in. (21.9 x 18.7 cm). Collection André Bromberg*

83. *Edgar Degas, Study for "Dance Class at the Opéra." Page 135 from Notebook 22. Pencil on paper, 9⅝ x 7⅞ in. (24.5 x 20 cm). Bibliothèque nationale de France*

THE CLASSROOM PAINTINGS

The principal achievement of Degas as a backstage artist in this early period might be summarized as his fecundity: the sheer range of scale, medium, and subject suggests the excited exploration of still-novel territory, as well as the staking out of certain themes that would sustain him in years to come. Some topics—notably the wings—were to stay with him into old age, while others—among them, the dressing room and the anecdotal encounter behind the scenery—barely survived the decade. One of his major creations, however, which has not previously been identified as such, is a formidable sequence of some twenty oil paintings of the ballet classroom that are both strongly individual and compellingly linked. Not a continuous series in the sense that was to become central to his later art, but including two tightly related families of pictures, this extended project is redolent of complex, private significance.[52] The majority of works were laboriously prepared, emerging from an intricate process of drawing from life and subsequent transfer to canvas, often followed by modification of the image on the painted surface. In several cases, the composition was partly or wholly scraped down and then reworked, with new figures added and old ones removed, and major elements of the architecture entirely revised. As much a restless, educative venture as an opportunistic gambit, these pictures appear almost perversely concentrated on one of the least enticing aspects of backstage life. Spartan in appearance and unwelcoming to strangers, then as now the classroom was the raw underpinning of the ballet world, the brutal training ground for new recruits, and the haunt of the exhausted and the idle.

What is immediately striking about Degas' cycle of dance class paintings is that almost half of them appear to be set in the same room. In at least eight of these works we see a strongly characterized, lofty space, its bare walls unrelieved except for a trio of tall, round-topped windows along one side. All these features are conspicuous in *The Rehearsal* from the Frick Collection (plate 84) and are equally visible in pictures from the Fogg Art Museum (plate 88), the Shelburne Museum (plate 93), the Ny Carlsberg Glyptotek (plate 91), the Portland Museum of Art, and a private collection (plate 87), and in other combinations in works at the Corcoran Gallery of Art (plate 146) and the Burrell Collection (plate 165). Though none of them carry a date, the earliest can be traced back to the months before the fire of 1873 and the remainder appear to have been finished in informal succession over several years.[53] As such, they mark a consolidation of Degas' activities as a painter of the dance and a new claim to consistency, authority, and historical seriousness. This suite of unfolding variations also provides an unusually specific example of Degas' painterly retrospection, from his first canvas of the subject to the moment when it literally went up in smoke, and beyond to its recapitulation. The final paintings in the group, which may conceivably have been begun before the fire, were inevitably completed from memory and at least one was first exhibited as late as six years after the event.[54] Degas' reasons for perpetuating the sequence and the strategies he followed remain somewhat puzzling. Though he

84. Edgar Degas, The Rehearsal, c. 1873–79. Oil on canvas, 18¾ x 24 in. (47.6 x 60.9 cm). The Frick Collection, New York (14.1.34)

returned again and again to the lost classroom, for example, and faithfully recorded the exercises that once took place there, he reinvented its architecture so freely that its location and character are still a matter of dispute.

The identity of Degas' large classroom can finally be resolved from information found in two sources. The first is the mass of ground plans, elevations, and other architectural drawings of the old Opéra, accompanied by published accounts that sometimes illuminate the building's configuration. Apart from the *foyer de la danse*, this material indicates that large unobstructed spaces were scarce in Debret's modified structure: an enormous hall-like space at the left of the theater façade appears to have been an exception, but this turns out to be a subdivided "magasin des décorations" where scenery and other stage properties were temporarily stored.[55] Among the many surviving plans, some carry indications of the current function of backstage areas—"Chant," "Roles," "Tapissier," etc.—while others, supported by anecdotal testimony, make it clear that these uses changed over time.[56] By far the strongest candidate for Degas' dance paintings is the room marked "Loges" on the 1839 plan, immediately above that labeled "Danse" on the central axis of the theater. It evidently measured some thirty by twenty-five feet and had three large, deep-set windows in its eastern wall, overlooking the courtyard of the old Hôtel de Choiseul. Debret had originally intended this area as a workshop for the Opéra's costume makers, but twenty years later it was set aside for the *loges d'acteurs*, presumably dressing rooms for male singers and extras.[57] There were also schemes to divide it horizontally, as in the dance *foyer*, but by the late 1860s it appears to have become the Opéra's principal classroom, corresponding to what Albert Vizentini called the *foyer de jour*, "a very high salon" where "ensembles, partial rehearsals, certain ballet classes and preliminary *mises-en-scène*" took place.[58]

A second source of information is both more lucid and more dramatic, consisting of a number of largely unpublished photographs

of the old Opéra, some taken in its final hours. The day after the 1873 fire, at least two photographers and a number of news illustrators made hasty images of the remaining wreckage, in certain cases while it was still smoldering.[59] These show that most of Debret's theater had been destroyed, though the shell of the eighteenth-century mansion was left intact. By a startling coincidence, one of the photographers involved was Louis-Amédée Mante, a cellist in the Opéra orchestra and the father of the two young Opéra ballerinas who posed for a pastel by Degas (plate 237), as well as a technical pioneer of early color photography.[60] A grim view taken by Mante (plate 85) shows at left the great charred basement that once supported the auditorium and stage of Debret's "cage of plaster," and at right the heat-blistered western façade of the Hôtel de Choiseul where it formerly abutted the theater. In the center of this façade are the three imposing windows of the grand salon, in the upper arched portion of which Debret had constructed the *foyer de la danse*. As we look at this photograph, we confront a dispassionate record of the arches and moldings known from Lami's famous watercolor, and peer dimly into one of the hallowed shrines of the Romantic era.

Other photographs taken by Mante from a lower angle provide views into and through the blackened interior of the building, while a solitary print reveals its rear façade (plate 86). It is this unassuming image, apparently taken before the fire, that brings us to the end of our quest for Degas' classroom.[61] Showing the elevation of the eastern face of the Hôtel de Choiseul, with the courtyard in the foreground, it represents a unique external view of the backstage world known to Halévy, Claretie, Degas, and many others. On the ground floor, painted signs on the walls announce the *Concierge du théâtre* at left and the entrances to the library and the office for *abonnements* to the right of center. Above them, various rooms can be associated on the ground plan with the Opéra administration, dancers' *loges*, and other practical activities, and at the heart of the principal story we find the *foyer de jour* seemingly referred to by Vizentini. Here, almost concealed by the courtyard trees, is a row of conspicuously tall, round-topped windows,

their distinctively heavy transoms and square panes instantly recognizable from Degas' canvases. It was the central group of three windows in this façade that illuminated the classroom in question, and it is the foliage on these very same, inconveniently placed, trees that appears in the background of works such as *The Rehearsal* (plate 88) and *The Dance School* (plate 93). Also remembered with affection by the flaneur Mahalin, several details of the courtyard fixed themselves in Degas' memory and recurred in his pictures, among them the tall chimney pots, tiled roofs, and—most curiously—the small barred windows at upper right, which are minutely repeated in at least three of his classroom views (plates 84, 88, and 93).[62]

In the deep umber and gold *Dance Rehearsal* (plate 87), which Degas originally and more accurately titled *Salle de Danse*, we look out from the classroom toward the rear of the courtyard, just able to make out the adjacent buildings at left, with rooftops and sky beyond. Morning sunlight from the east-facing windows filters through the pale curtains, reducing several dancers to near-silhouettes and emphasizing the massiveness of the surrounding architecture. Knowing the location of the room, we can now imagine the even more penumbrous *foyer de la danse* behind us, and perhaps the sound of voices tuning up in the singers' *foyer* nearby, while visualizing the corps de ballet making its way to class through adjoining staircases and corridors. The events depicted in Degas' painted room must have been typical of a thousand such sessions. At left, a dark-suited instructor begins to put a dancer through her paces, demonstrating a *dégagé en avant, croisé*, watched by the two who will shortly take her place; against the wall, another girl warms up at the barre, while a group of her intimates exchange the day's gossip; and at right, an inert coryphée awaits the arrival of friends from the floor beneath. In the more formal Frick *The Rehearsal* (plate 84), the class has progressed along lines still followed today, with the dancers now engaged in center floor exercises against the same high wall, and a glimpse of the barred window insistently present at upper left.

In *The Dance Rehearsal*, as in so many of his classroom scenes, Degas has woven together the elements of the composition with such skill

85. *Louis-Amédée Mante, The Ruins of the rue Le Peletier Opéra House, c. 1873. Bibliothèque nationale de France*

86. *Louis-Amédée Mante, Courtyard of the Hôtel de Choiseul, Opéra House on the rue Le Peletier, c. 1873(?). Bibliothèque nationale de France*

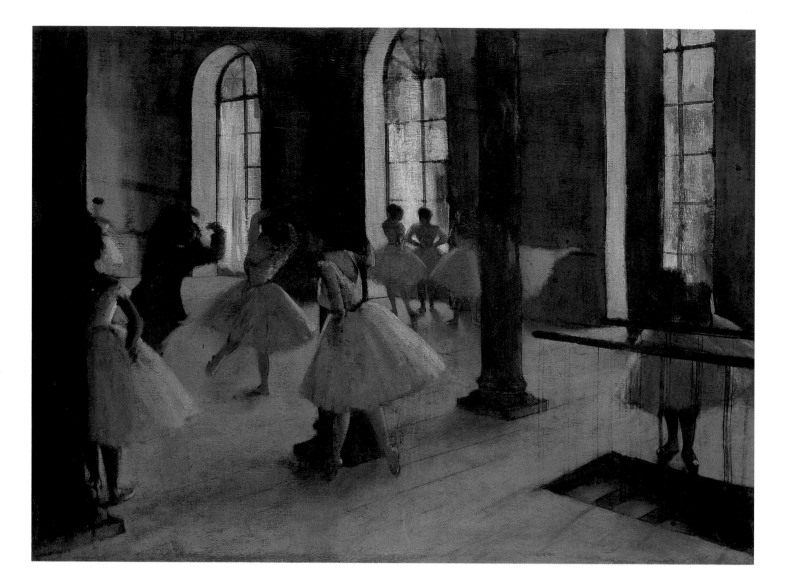

87. Edgar Degas, The Dance Rehearsal, c. 1873. Oil on canvas, 16 x 21½ in. (40.6 x 54.6 cm). *Private collection, courtesy The Phillips Collection, Washington, D.C.*

that we find ourselves seduced by its plausibility, evaluating it in the same documentary terms we might use for a photograph, such as those taken by Mante. When the painting was shown at the 1876 Impressionist exhibition, several critics treated it in precisely this way, one assuming that the artist had included a photograph of a picture in his installation, a practice Degas is known to have used.[63] Others approved of the work's sense of actuality, its "well observed indications of movement and disposition of groups" and—in the words of Emile Zola— the painter's "profound love of modernity, of interiors and human types from everyday life."[64] Our knowledge of the circumstances in which *The Dance Rehearsal* was made, however, and of its links with the later classroom canvases, obliges us to sharpen our analytical skills. While these paintings extend our admiration for Degas' originality of perception, we become increasingly conscious of the elaborate visual games he chose to play and the means by which he played them. With the exception of the girl leaning on the balustrade, for example, each of these human forms was first pondered in a known drawing, often in relation to a pose he had used elsewhere. In their turn, certain of

characters from *The Dance Rehearsal* were repeated in later statements of the same theme: the partly concealed dancer at the barre, for example, first occurred in *Dance Class at the Opéra* in 1872 (plate 19), then reappears in four subsequent classroom paintings; and the timid figure half-hidden by the left-hand column occurs in a similar position in all three versions of *Ballet Rehearsal on the Stage*. Already, it seems, we are meeting a familiar cast, the pawns, queens, and occasional knight who will continue to do battle in Degas' pictorial chess problem.

If it comes as no surprise to find Degas moving his human chess pieces from game to game, it is almost shocking to discover him—in effect—redesigning the board itself. As he explored the visual potential of different moments in the dancers' day, Degas began to modify not just the details of the classroom but its proportions and even its structure. In *The Dance Rehearsal*, for example, we are made aware of the height and narrowness of the windows, the prominence of their glazing bars, and the way the floorboards run from this wall toward the left. Several elements that may relate to Debret's refurbishment are also evident, from a dark stairwell and surrounding handrail occupying the right-hand corner, to a conspicuous row of heavy, round-sectioned columns across the foreground. When we turn to what was almost certainly the second canvas in the group, *The Rehearsal* in the Fogg Art

Museum (plate 88), we find that almost all these features have changed or disappeared. While in this instance the windows retain much the same shape (in later works they are squatter), their jambs are noticeably shallower and the details of their fenestration are almost invisible; the lines of the floor now run in the opposite direction, into the depth of the room: and, most startling of all, both colonnade and staircase have vanished. Yet this is self-evidently the same classroom as that in *The Dance Rehearsal,* and there is no possibility of architectural modification during the sequence, given that the building was demolished in 1873.

The comparison of these distinctly similar, but subtly varied, images of the rue Le Peletier classroom lays bare the artifice of Degas' realism. We have already discovered the artist's lack of pedantry when it came to depicting buildings, acknowledged in later life when he admitted to only the most rudimentary grasp of perspective.[65] The case of these two paintings, however, is clear-cut: one of them, at least, and perhaps both, must represent a willful transformation of reality as Degas knew it, radically altered for artistic rather than documentary reasons. Any lingering doubts are set aside by recent technical analysis of *The Rehearsal* at the Fogg Art Museum, which has revealed parts of an earlier version of the same scene beneath the present paint surface (plate 89). X-ray and infrared examination shows that a similar line of columns and a stairway like that in *The Dance Rehearsal* once dominated the Fogg composition, only to be partially scraped out as Degas changed his conception. Still partly visible to the naked eye, these ghostly presences are accompanied by the vestigial figures that were formerly associated with the same structures, such as the dancer holding the central column in *The Dance Rehearsal* and her colleague leaning on the baluster.[66] Degas' drastic simplification of the Opéra classroom, in other words, took place directly on this canvas; having begun with a near-replica of the earlier design, he now chose to reject its dramatic chiaroscuro and its crowded, fractured space. Obliterating much of his first draft, he cleared large areas of the floor, swept all his players to the left-hand side, and flooded the room with warm, rational light.

The apparent serenity of the Fogg *Rehearsal* is thus founded on an even greater contradiction between verisimilitude and invention than its predecessor. But by acting so decisively, Degas opened up his classroom playground and clarified the nature of the *foyer de jour* as a practical arena for the Opéra's corps de ballet. Now the emphasis is on group movement rather than eccentrically occupied individuals, with a cohort of dancers working in unison as they go through their center-floor exercises to the music provided by a seated violinist. Executing a *battement* or *developé à la seconde,* a standard element of their daily training, these girls are clearly not engaged in the rehearsal specified in the picture's current title, but in a routine class. The same ritual becomes the subject of the classroom scenes in the Frick Collection (plate 84) and the Shelburne Museum (plate 93) but is unexpectedly abandoned by Degas thereafter. Despite the uniformity of the dancers' actions, which might have tempted a lesser artist to repeat

a single pose with only slight variations, Degas has taken pains to give each woman her own physiological and temperamental identity. The tall, slim brunette at the head of the phalanx, for example, was carefully drawn in charcoal and white pastel, then her image was transferred to the repainted surface by means of a superimposed grid (plate 90), the evidence of which can still be seen—rather puzzlingly—on the Fogg canvas. As many as a dozen works on paper record her immediate companions and the other personalities animating the scene, from the solitary ballerina at the barre to the much-reworked juxtaposition of musician and dancer at left.[67]

These human exchanges and spatial shifts were multiplied in several of Degas' other classroom images, apparently within a short space of time. An initially perplexing canvas now in Copenhagen once presented an intermediate case, boasting an emphatic line of supporting columns that divided the picture rectangle into populated and unpopulated sectors (plate 91). Over-painted by the artist at the end of his career in an extraordinary palette of oranges, ochres, and pinks, the original composition can now be identified in an unpublished lithograph by George William Thornley, a printmaker with whom Degas worked in the 1880s (plate 92).[68] In both print and painting, a solitary dancer engages in her *battement* exercises, while a cluster of smaller figures chatter in the distance behind a row of pillars, which have now become aggressively square in section. Several of these individuals are instantly recognizable from previous permutations, while others—such as the newly revealed standing dancer at extreme left—were first established in a separate drawing. In this earlier design, therefore, the artist had again reinterpreted the evidence of his eyes, carrying the process a considerable stage further in his reworking of 1900 or later. As X rays have confirmed, the tall dancer at left was painted out at this time, along with a great deal of architectural detail, compensated for in the introduction of three energetic and entirely new dancers in the opposite corner.[69] The wild brushwork of Degas' last years contrasts violently with the delicate forms of the earlier lithograph, but the Fauve-like frenzy of these additional ballerinas remains almost as remarkable as it must have seemed in the early twentieth century.

Degas' appetite for the playful transformation of his tall-windowed classroom was still apparently unsatisfied. Other versions include a large work on paper with a single column and a single performer; two near-replicas of the subject and the space depicted in the Fogg canvas; and two idiosyncratic designs, each dominated by a spiral staircase.[70] The latter pair, in the Burrell Collection and the Corcoran Gallery of Art (plates 165 and 146, respectively), will be examined more fully in Chapter Five, but the sheer audacity of Degas' insertion of massive, serpentine staircases into these pictures, whether they existed in Debret's theater or not, deserves comment here. Such improvised means of access between floors may well have been part of the revised accommodation at the old Hôtel de Choiseul, though no fixtures of this kind are indicated on plans of the exercise areas. There are enough similarities between the Burrell and Corcoran rooms and those already studied, however, to argue that they all derive—with a characteristic degree

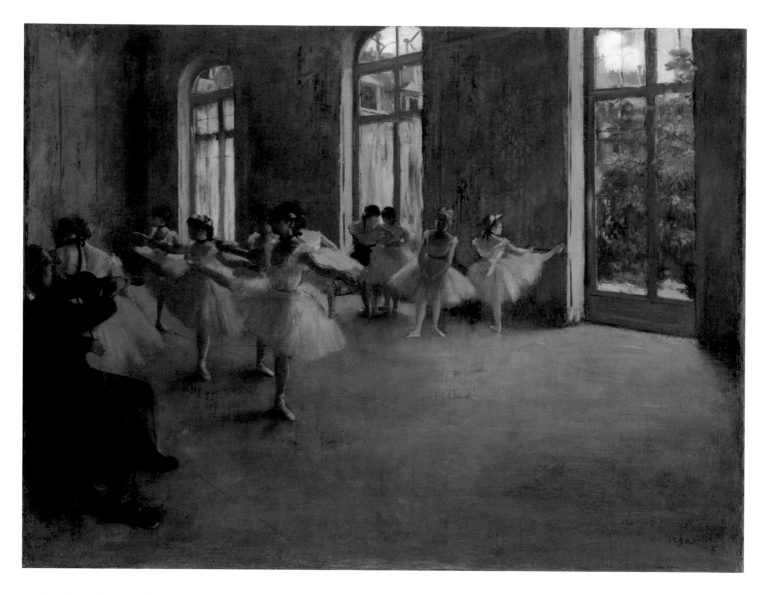

88. *Edgar Degas,* The Rehearsal, *c. 1873–78. Oil on canvas, 18 x 23⅝ in. (45.7 x 60 cm).*
The Fogg Art Museum, Harvard University Art Museums, Cambridge, Massachusetts;
Bequest from the Collection of Maurice Wertheim, Class of 1906 (1951.47)

89. The Rehearsal (plate 88), with dotted lines indicating alterations to the composition evident through infrared examination (white) and x-ray examination (black). Larger diameter points indicate obvious visible outlines; smaller diameter points indicate areas where the location of the underlying elements is more hypothetical.

of latitude on the artist's part—from the same source: only the much-revised Corcoran painting has a previously unencountered space, in the area opening into depth at right. Edmond de Goncourt noted Degas' use of the "little staircase" against a window to create a "curious silhouette of dancers' legs," when he saw the Burrell work in 1874, but tells us nothing about its origin.[71] The possibility that Degas simply invented the staircases and dropped them into place in his pictures, using for guidance an engraving from a perspective manual or a wooden model he is known to have owned, has been suggested.[72] Whatever their origin, the visual drama of these structures—as Goncourt recognized—is beyond question. Providing a vertical accent in a horizontal narrative and juxtaposing hurried, fragmentary movement against the relative stasis of the ballerinas beneath, they combine memories of Renaissance mathematics with nineteenth-century technology, modern ironwork with the frantic pace of urban life.

After his opening gambits with columns, balustrades, and staircases, and the analysis and reanalysis of subsequent canvases, Degas' final variations on the foyer-de-jour theme were confident and uncluttered. The Dance School in the Shelburne Museum (plate 93) is a direct revisitation of the revised Fogg Art Museum painting, celebrating the same open spaces and an even more relaxed, summery atmosphere. Blue sky, pink brickwork, and yellow-green leaves shimmer outside (where the curious grids of the high windows beyond can again be seen), while inside the room warm light picks out echoing tints of peach, gold, and cerulean in the dancers' costumes. By now, many of the personnel seem like old friends, though Degas has reshuffled such

characters as the girl in center distance with a black ribbon down her back, who once occupied the left foreground in the Fogg work. Exceptionally for this series, the Shelburne picture was carried out on canvas in water-based paints rather than oils, demanding rapid execution and leaving few opportunities for the artist's second thoughts.[73] The resulting freshness is almost palpable, underscored by a scattering of forms at left where a dance-master's profile, a bending ballerina, the rear view of a violinist and a passing tutu (in the lower corner) cheerfully coexist. In the Frick oil on canvas (plate 84), the corresponding element of disarray is supplied by a flurry of legs and fabric at the right-hand edge, which the artist mischievously contrasts with the solemn faces of the assembled coryphées. Again, warmth floods the three-windowed room, though now we find ourselves positioned at its center, among the dancers and alongside—or in place of—the instructor himself.

The artist, his friends, and contemporary critics all sensed the importance of the larger cycle of classroom canvases. At each of the Impressionist exhibitions from 1874 to 1879, two or three variants on the theme were regularly included by Degas among his submissions, proving immediately popular with collectors. Perhaps the highest compliment came in purchases of these works by fellow-artists of

90. Edgar Degas, Dancer Rehearsing: Study for "The Rehearsal," c. 1874. Charcoal heightened with white on gray paper, 17¾ x 11⅛ in. (45.1 x 30.2 cm). Norton Simon Art Foundation, Pasadena, California (M.1977.05.D)

varying persuasions, ranging from Edouard Brandon, Jacques-Emile Blanche, and Henri Rouart to the printmaker and illustrator Michel Manzi, who owned no less than three of the canvases—some with supporting drawings—at different periods.[74] In the group exhibitions, the series-within-a-series of *foyer de jour* variations was consistently prominent, released by Degas over the years as if to mark their slow evolution or to announce his latest solution to a complex pictorial conundrum. Though the precise dating of these pictures is beset by problems and there is some doubt about the identity of the works that were actually shown, the sequence in which they were set before the public can be reconstructed with some accuracy. For the 1876 show, two pictures called *Salle de danse* were listed by the artist in the catalogue, one almost certainly *The Dance Rehearsal* (plate 87) currently on loan to the Phillips Collection, the other chosen from the closely related *Dancers Practicing in the Foyer* (plate 91) or *The Rehearsal* (plate 88).[75] The following year an *Ecole de Danse* appeared, widely thought to be *The Rehearsal* (plate 165), and in 1879 the classroom scenes in both the Frick Collection (plate 84) and the Shelburne Museum (plate 93) were displayed in the same installation.[76]

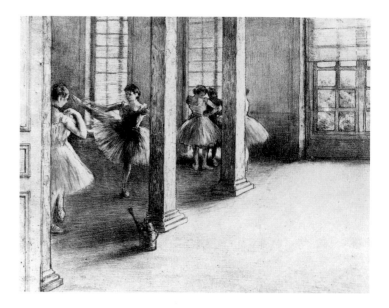

92. *George William Thornley, The Dance Class, c. 1888. Lithograph, 9⅜ x 12⅛ in. (24 x 31 cm). Private collection*

91. *Edgar Degas, Dancers Practicing in the Foyer, c. 1875–1900. Oil on canvas, 28 x 34⅝ in. (71 x 88 cm). Ny Carlsberg Glyptotek, Copenhagen*

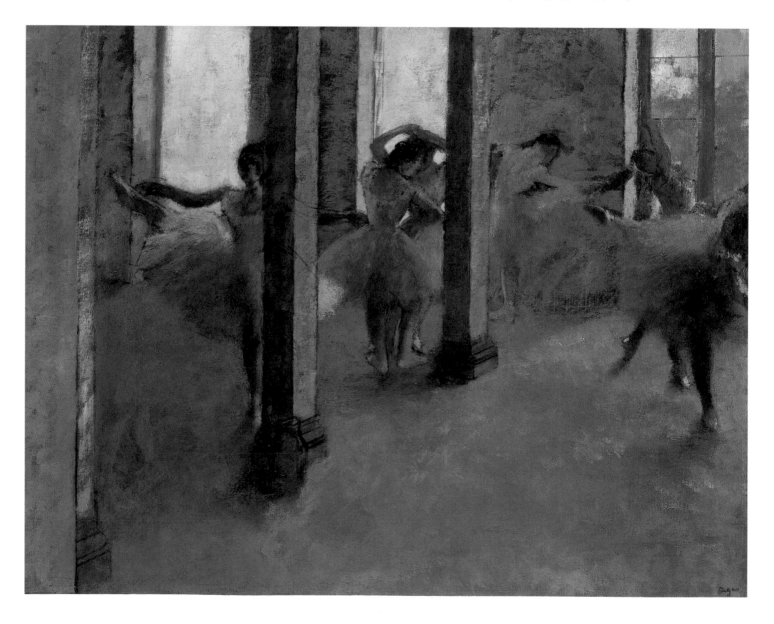

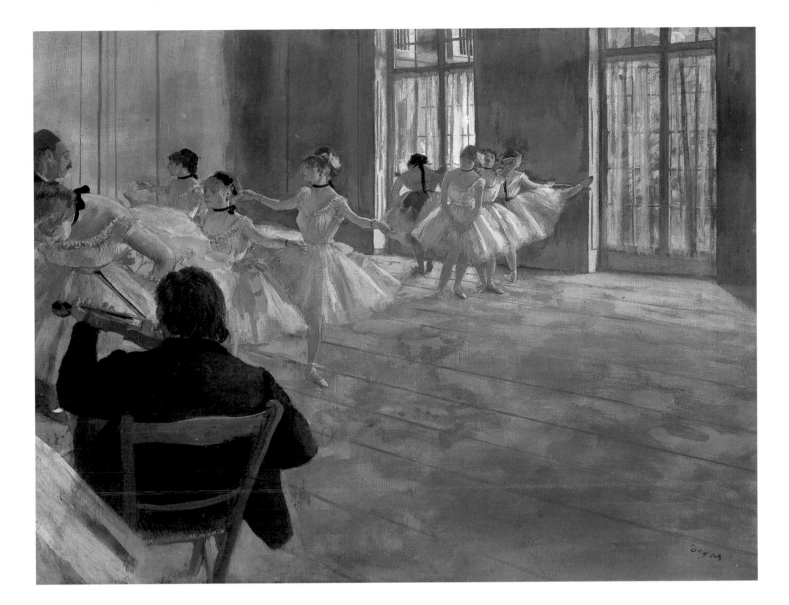

93. *Edgar Degas, The Dance School, c. 1874–78. Oil and tempera on canvas, 18½ x 24⅛ in. (47 x 61.3 cm). Shelburne Museum, Shelburne, Vermont (27.3.1-35)*

The press was almost unanimous in its praise, seeing these paintings as proof of Degas' maturity and—in the opinion of some—his superiority over many of his Impressionist colleagues. Other writers noted his broader links with the group, singling out the modernity of Degas' subjects and referring repeatedly to the "truth" of his light effects. At the 1879 exhibition, for example, Armand Silvestre saluted the arrival of "a new *Leçon de danse*," explaining how Degas showed "a theater *foyer* in broad daylight, lit from outside by windows overlooking a garden, allowing beautiful showers of light to pass through the curtains and fall across the wooden floor."[77] In a mainly derisive review, the Salon favorite Jean-Léon Gérôme managed to admire the minor painters and neglect the figures we esteem today, while suggesting that "there is much spirit, much observation and much ability in the painting in which M. Degas has depicted little dance students taking class."[78] But it was arguably the published remarks of Philippe Burty, print specialist and dedicatee of one of Degas' monotypes, that best defined the claims to seriousness of these formidable works. Repeating the word "science" three times in a single sentence, with its implications of skill as well as theoretical command, Burty evoked the laboratory-like intensity and the sheer mental commitment of Degas' project. In works like the "two *Ecoles de danse*," he observed, Degas showed his "delicate science of drawing, his precise knowledge (science) of the colors of clothing, his extraordinary mastery (science) of interior light."[79] Marking a new phase in the public acceptance of Degas' backstage imagery, his statement continued with the suggestion that such pictures should now have their place in the national collection of contemporary art. "It is most regrettable," wrote Burty in April 1879, "that this eminent, exceptional, spiritual and solemn artist should not be represented in the Luxembourg."

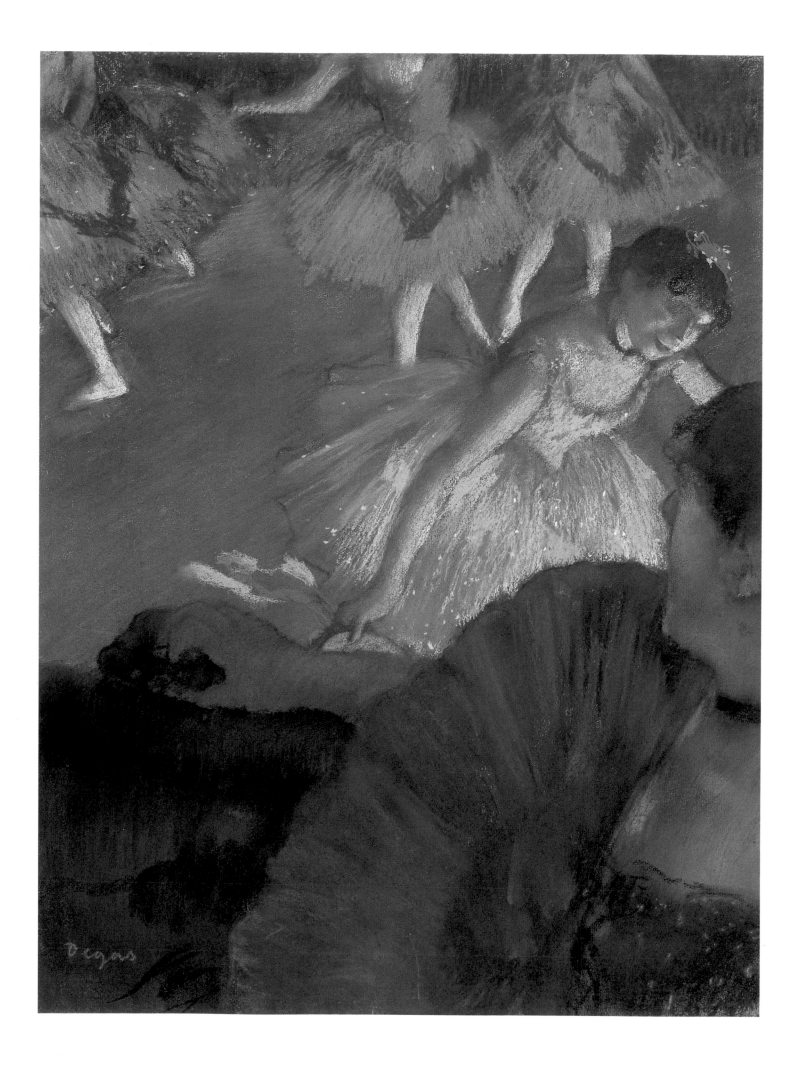

4. The Palais Garnier Years

When an auditorium has a fine appearance and a beautiful structure, the works performed on its stage should be in sympathy with the splendor of the architecture, and the impression they make should be the continuation of the first impression suggested by the architectural decoration. The character of the production can nevertheless be diverse, because art can be great and beautiful in many ways: ballet as well as singing, comedy as well as drama, even décor and costumes have their nobility.

—CHARLES GARNIER, 1871[1]

The new Paris Opéra, designed by Charles Garnier in 1861 and finally inaugurated on January 5, 1875, represented the public face of the ballet throughout Degas' middle and later life. He was to remain both an intimate of the Opéra and a skeptical onlooker, variously stimulated by its performers, loyal to its productions, and engrossed by the theatrical experience itself, yet typically at odds with its grandly stated values. Degas' thrilling pastel of the early 1880s, *Ballet from an Opera Box* (plate 94), gives visual form to this contradiction: like many of his pictures of the Palais Garnier stage, it implies a socially elevated view of the spectacle, though its broken forms and dizzying perspective can hardly have expressed the "nobility" the architect had in mind. Garnier's reflections on the nature of the auditorium were published several years before the opening of the new building, at precisely the time Degas was painting his first canvases of its elderly predecessor on the rue Le Peletier. Nothing is recorded of the artist's view of Charles Garnier or his "palace," except that Degas, like the rest of the audience from the destroyed theater, soon relocated his encounters with dance to the new establishment. As the years pass, we read in Degas' letters of plans to meet his friends at the Opéra, such as the art critics Charles Ephrussi and Gustave Geffroy; of "a little soirée at the Opéra, a soirée of connoisseurs" to see Gounod's *Faust*; and of other social outings to see rehearsals of Reyer's *Sigurd* and Lajarte's *Les Jumeaux de Bergame*.[2] Surrounded by the "splendor" of Garnier's architecture and sometimes present—as the Opéra records show—at

94. *Edgar Degas*, Ballet from an Opera Box, *c. 1884. Pastel on paper, 26 x 20 in. (66 x 50.8 cm). Philadelphia Museum of Art; The John G. Johnson Collection (J 969)*

two or three performances of "ballet as well as singing" in a single week, Degas found himself the informal chronicler of the grandest and most talked-about institution in Paris.

For Garnier himself, the dance was clearly a secondary attraction at the Opéra. The few references to the ballet in his 1871 book, *Le Théâtre*, follow more extensive and solemn considerations of the demands of "great music and great dramatic literature," and were largely concerned with its challenges for the stage designer.[3] Though his building (plate 95) made full provision for the most extravagant ballet productions the public might demand, Garnier reflected an attitude of condescension toward its dancers that was common among his contemporaries. For the previous generation, the claims of the ballet to serious attention had been eloquently summarized by Théophile Gautier, who argued that it should be experienced as "mimed poetry, dream made visible, the ideal rendered palpable, love translated into images, grace given rhythm, harmony condensed into shapes, music transmuted from sound to sight."[4] Ranged against him were the champions of the choral repertoire, who could claim that dance performances were "long, slow, heavy and boring to the point of extinction" and pointed to their insubstantial, purely sensual appeal.[5] In 1868, the year Degas exhibited his painting of Eugénie Fiocre in the ballet *La Source*, the critic Charles Yriarte had asked, "What is a dancer? A dancer is a white, blond and pink apparition, something shimmering, pearly...enveloped in waves of gauze."[6] Another rarely mentioned detractor was Degas' artistic

idol, Jean-Auguste-Dominique Ingres, who watched the premiere of *La Source* and was initially rumored to have provided its inspiration.[7] Though Ingres had often painted and drawn dancers in a classical mode, his view of their modern successors was scathing: "What can I say about this thing we call *divertissement* or *ballet*? We see wretches disfigured by their efforts, red, inflamed with fatigue, and so indecently strapped-up that they would be more modest if they were naked. They caper about like acrobats, making leaps and pirouettes without end.... It is even worse when there are male dancers. Oh! I have no way of expressing the disgust they inspire in me: and so I propose quite simply the total abolition of their stupid profession."[8]

The persistence of these violently opposed attitudes was evident in the reception given to *Sylvia*, the first new ballet to be presented at the Palais Garnier. The production opened in June 1876 and starred the Italian Rita Sangalli, who had specifically been invited to the Opéra "to lead the ballet to greater accomplishments at the start of the Third Republic."[9] With a meandering story of love among nymphs, shepherds, and Greek gods, the three-act spectacle was received warmly by certain members of the press. In the *Journal des débats*, Clément Caraguel described how "the curtain rose at a quarter to nine on one of those Elysian landscapes such as the painter Corot has sometimes seen 'with the eyes of a dreamer.'" Approving of *Sylvia*'s clear and comprehensible plot, Caraguel admired the costumes "in the purest style, in the best taste" and tells us that Sangalli was "much applauded," while other colleagues hailed the ballet as "fresh" and "original."[10] But the same premiere provoked outspoken and often contradictory criticism.

95. *Cross-section of the Opéra (Palais Garnier), 1875. Bibliothèque nationale de France*

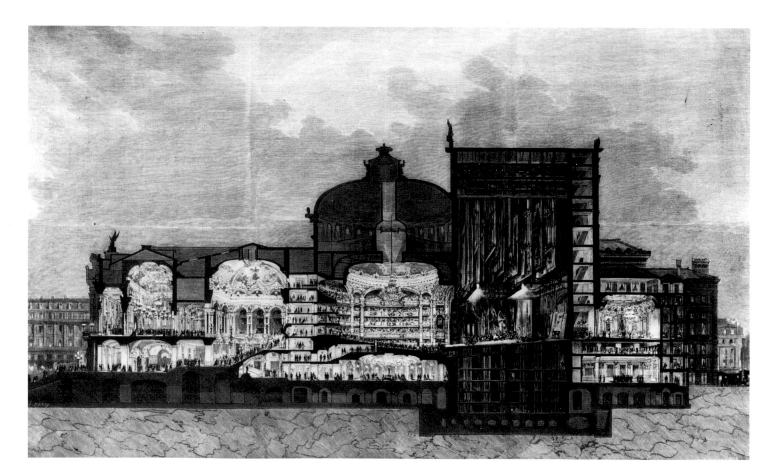

The correspondent of *Le Français*, Adolphe Jullian, summarized the story as "insipid" and the choreography as "banal," and a writer in *Le Gaulois* complained that he needed the *livret*, or printed plot summary, to follow the action.[11] Charles de Rounat in *Le XIXe Siècle* mocked the idea that "ballerinas balancing on their pointes" could articulate the sentiments of "characters wriggling on the boards" and suggested that the spectators' intelligence could be safely left at home.[12] Even Sangalli was not immune from their taunts, Victor Wilder in *L'Opinion* noting that she had to compensate by hard work and "clownishness" for her "somewhat massive build and rather immobile physiognomy," a theme taken up by a cartoonist in 1881 (plate 96).[13]

Degas' personal reactions to *Sylvia* and most other ballets of this period are not known: what is strikingly apparent from the pictures examined in later chapters, however, is that—as an artist—he immediately began to respond to events on Garnier's stage. After 1875, Degas made pastels and paintings of many existing works in the repertoire, such as *La Favorite, Faust, Don Juan*, and *L'Africaine*, and of almost every new dance production and many new operas that followed in successive years. After *Sylvia*, we can identify imagery related to *Le Roi de Lahore* and *La Fandango* of 1877, *Yedda* of 1879, *Namouna* of 1882, *Sigurd* of 1885, and *Les Jumeaux de Bergame* of 1886, leaving only the ballet *La Korrigane* of 1880 unaccounted for. The consistent nature of Degas' engagement with the Palais Garnier's dance output comes as something of a revelation, though we should note that it is often traceable only through cryptic details in his pictures or peripheral documentation. Despite his loyalty to the Opéra's programs, Degas' project was as remote as ever from descriptive illustration, heedless of its scenic extravaganzas and oblivious to the exquisitely Baroque décor of *Don Juan* (plate 97), for example, and to the exotic settings of *Namouna*. Degas' attendance at *Sylvia* is documented in 1892, though he must surely have seen this popular success when it first appeared: characteristically, however, the Corot-like antique vistas of the production that so charmed Clément Caraguel were among scores of historical settings that found no place in his art.[14]

Over the decades, Degas remained a discreet presence at the new Opéra, leaving few traces in its archives and attracting no official recognition from successive administrations, though his letter of 1886 to the director, Eugène Bertrand, in which Degas described himself as "one of the family," indicates a degree of preferential treatment.[15] His professional reticence and the Opéra's artistic conservatism may have contributed to this obscurity. Degas had been young and unknown when a group of painters was commissioned to decorate Garnier's emerging structure in the 1860s, and it was such established figures as Paul Baudry, Elie Delaunay, Isidore Pils, Gustave Boulanger, and Félix Barrias who covered its walls with insipid allegories of music and dance. Even in later years, Degas' own pictures of ballerinas probably remained puzzling to most of the Opéra management, the "disgraceful poses," "angular and dislocated limbs," and "clown-like movements" seen in them by an 1880 critic offering a challenge to the "great and beautiful" creations that graced the national stage.[16] Stubbornly attached

96. Caricature of Rita Sangalli in Sylvia, after a painting by P. Chassaignac at the Salon of 1881. Bibliothèque nationale de France

in his art to the now-vanished rue Le Peletier Opéra, Degas also distanced himself from other aspects of the newly completed building, whose flamboyance contrasted so markedly with the classically severe theater of Debret and the romantic shabbiness of the Hôtel de Choiseul. Where Degas had gone to some lengths to celebrate the earlier site, his new pictures—like *Ballet from an Opéra Box*—seem designed to avoid the gilt moldings, sculpted *loges*, mirrored and chandelier-hung halls, and massive proscenium of Garnier's masterpiece.

A color photograph of the *foyer de la danse* taken twenty years after the opening of the Palais Garnier (plate 99) illustrates this chasm of taste at its widest. Apart from the trite presentation of the dancers (at the center of whom is "Mlle Parent," presumably a younger relative of Elise who posed for *The Orchestra of the Opéra*), we see part of Boulanger's banal wall-painting *Danse Bacchique*, the fanciful Second Empire reliefs and the neo-Baroque columns that stood for everything Degas abhorred. In such a context Degas might be considered the anti-Garnier, intensely knowledgeable about the ways of real dancers and the events that took place in these rooms, yet—as an artist— perversely determined to *separate* them from the "impression suggested by the architectural decoration." He was only nine years younger than Garnier and had followed a surprisingly similar early career, converging once more in their adult lives at the Paris Opéra. Both began their tuition at the Ecole des Beaux-Arts and studied extensively in Italy, Garnier completing his formal attachment to the French Academy at the Villa Medici in Rome in 1854, just two years before Degas began his more casual attendance at the same institution.[17] When Garnier's submission to the 1861 competition for the new Opéra brought him overnight fame, Degas was still courting recognition within his own

discipline, working on a succession of mural-scale canvases for the official Salon with very limited success.[18] Subsequently aligning himself with the "Indépendents," as the Impressionists first called themselves, Degas effectively turned his back on state patronage and the rhetoric of conventional taste. But on his regular visits to Garnier's monument, Degas must have reflected on his own chosen path and those of their former colleagues at the Villa Medici. It was Jean-Baptiste Carpeaux, a school friend of Garnier's and briefly a contemporary of Degas' in Rome, who had been given the task of carving the figure of *La Danse* for the Opéra façade, and it was Degas' comrade from the Villa Medici, Elie Delaunay, whose pictures now graced the walls of the Opéra's Grand Salon.[19] By choice and through force of circumstance, it seems, Degas had become an artistic outsider.

Appearing in 1875 soon after the opening of the "vast and grandiose edifice," Charles Nuitter's authoritative *Le Nouvel Opéra [Garnier]* is a trove of statistical information on the new building. Listing by category the 2,156 places for spectators, compared to the 1,771 at the rue Pele-

tier, Nuitter briefly felt obliged to defend this relatively modest increase in the size of the new auditorium.[20] Amply evident from his tables, however, is the enormous area covered by the Opéra itself, at 11,237 square meters almost two and a half times larger than any theater in the world at that date.[21] Plans show that much of this additional area was taken up by ceremonial and social spaces (plate 98), from grand staircases and loggias to public foyers and reception rooms, with one entire wing notionally set aside for the emperor and another for *abonnés*. The purpose of the Opéra was openly civic, aspiring—in Ernest Chesneau's phrase—to be "worthy of the greatness, the luxury and the arts of the new Paris."[22] Conceived toward the end of the Second Empire, the structure became "the most perfect expression of an epoch that placed pleasure and spectacle above everything," ornamented almost without regard to expense and completed after repeated transfusions of state capital: another contemporary, Georges d'Heylli, estimated that the entire project had exceeded one hundred million francs.[23] But Garnier, too, was a modernizer in his way, leaning toward more democratic access to his theater and contriving a "marriage of science and art" that concealed iron frameworks, advanced heating and ventilation systems, and electric lighting beneath his massive and costly masonry exterior.[24]

97. Maquette of set for Don Juan, Act II, Scene 2, Paris Opéra, 1875. Designed by Jean-Baptiste Lavastre and Edouard Despléchin. Bibliothèque nationale de France

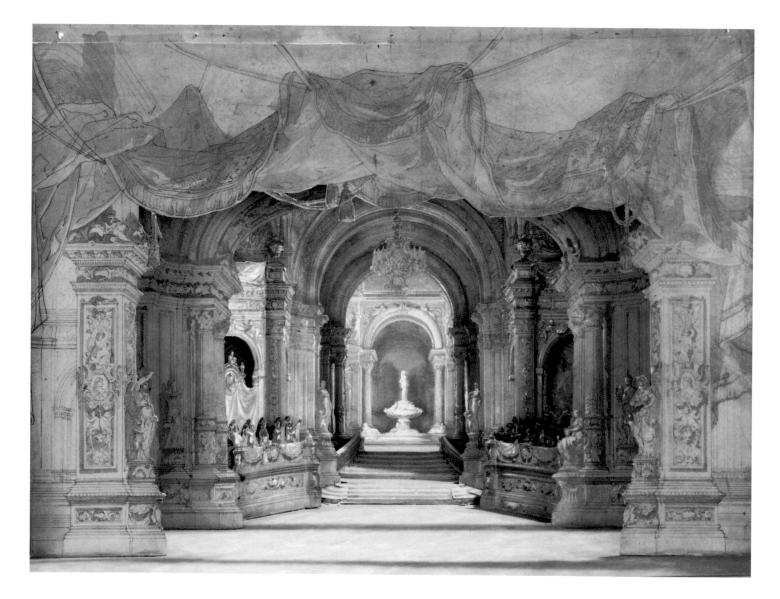

tumes, the movement of the listeners and a kind of magnetic quivering in the crowd, who observe and sense that they are observed."[26]

While he is speaking as an architect and not as a painter, Garnier might be said to espouse the post-Romantic view of theatrical consumption, acknowledging the claims of display and sensory indulgence alongside his more lofty aspirations for the spectacle itself. In this he sided with the writings of Edmond de Goncourt, Ludovic Halévy, Emile Zola and Maxime du Camp, as well as with artists like Daumier, Menzel, and the Degas of *The Ballet from "Robert le Diable."* Garnier's vocabulary is instructive, dense with words such as "perceive," "see," "observe," "sense," and "glimpse," and offering further parallels to the recorded notes and conversations of Degas at this time. Struggling to come to terms with his damaged eyesight, Degas had developed an acute awareness of the functioning of vision that often became a central theme in his theatrical art.[27] In *Ballet from an Opera Box*, for example, he looked down at a seated woman who has recently peered through a pair of opera glasses, glancing at her "glistening" gown and the "brilliance" of her accessories, and following her gaze toward a dancer who in turn averts her eyes.

Like Degas, Garnier was preoccupied with the structural and perceptual anomalies that threatened the suspension of disbelief, though where the artist relished their consequences, the practical designer sought ways to eliminate them. As we have seen, Garnier opposed the introduction of *avant-scène* boxes: "the stage is less defined, attention is distracted by the sight of occupants in these loges," he wrote, devoting an entire section of his *Le Théâtre* to their amelioration or suppression.[28] In many of Degas' auditorium scenes, however, the artist explicitly chose the viewpoint of these very occupants, located in boxes very close to the performance and necessarily in sight of much

98. *Ground plan of the Opéra (Palais Garnier), 1875. Bibliothèque nationale de France*

From their ultimately very different perspectives, Degas and Garnier shared a fascination with at least one aspect of the Opéra: the complexities and contradictions of the audience's visual experience. Though music and drama dominated Garnier's thinking, his concern with the interaction of sight, color, lighting, and movement in the modern theater, and their relationship to the practicalities of spectatorship, often overlapped with Degas' own. Garnier's published texts explained that all such encounters derived from ancient social ritual, while continuing to reflect the larger issues of human existence: "everything that happens in the world is essentially theater and performance."[25] Vision could be directed and enriched, he believed, especially in those theatrical interiors favored by the French, where "even as they perceive the stage" the visitors "see the auditorium equally well." He continually stressed the role of the audience, who could "study at leisure the physiognomies of those present, the glistening of their gowns, the brilliance of their jewellery...this assembly is by no means a minor decorative element, along with the variety of cos-

99. *The foyer of the Opéra (Palais Garnier). Bibliothèque nationale de France*

100. Edgar Degas, At the Theater, Woman with a Fan, c. 1880. Lithograph, 9⅛ x 7⅞ in. (23.2 x 20 cm). Museum of Fine Arts, Boston; Bequest of W.G. Russell Allen (60.260)

of the audience. Among other qualities in the lithograph *At the Theater, Woman with a Fan* (plate 100), Degas found humor in Garnier's "disagreeable" juxtaposition of spectator and production, seeming to balance a dancer's foot on the edge of the young woman's fan and to maximize the confusion of scales, meanings and visual registers. Similarly, in discussing the mechanisms of perspective and the creation of illusion on the stage, Garnier noted the "considerable inconvenience" of concealing the view into the wings for those observers close to the proscenium.[29] Yet again, Degas inverted the older man's priorities, probing the gaps between scenery flats and revealing their sometimes haphazard occupants. In a pastel such as *L'Etoile* (plate 180), the artist evidently found a weak spot in Garnier's defenses, celebrating the failures rather than the strengths of his fabled edifice.

Finally referring in some detail to the subject of dance in his chapter on lighting, Garnier argued that the power of direct electric light can produce "strange effects" and that diffuse illumination is more appropriate in certain circumstances: "it is the light of fairy tales, it is not that of human life; it has its place in ballets, which are just a kind of dream."[30] Garnier reflects on the use of footlights, overhead lights, and lighting from the wings, acknowledging that each has its advan-

tages and drawbacks, especially when employed to pick out individual actors or dancers. He defended the conventional distortion of low-level lighting on performers at the front of the stage, a phenomenon that fascinated Degas over many years in both his cabaret and theater images. But Garnier criticized attempts to "spotlight" the principals, pointing to the disruption of facial features and arguing that "teeth are left in the shadows and do not present those sparkling highlights which brighten the smiles of dancers," adding that the same practice obscured their legs "in the shadow of their skirts."[31] Several of these qualities were seized on in Degas' pictures, notably in *Ballet from an Opera Box* (plate 94) and *The Star* (plate 103), which could almost serve as illustrations of Garnier's direst warnings. On one or two issues, however, the two men might have found agreement: toward the end of his treatise Garnier declared that in the theater "all is convention," concluding that "the stage is finally nothing but a large painting, a living painting, a moving painting."[32]

The pictorial attractions of the Opéra and other Paris theaters engaged a number of Degas' immediate contemporaries, though rarely with such ingeniously subversive results. By the late 1870s, scenes of the wings, the audience, and backstage life had become a staple of the wider Impressionist circle, embracing the prints and drawings of Jean-Louis Forain and Paul Renouard, Renoir's delicate oil on canvas *The First Outing*, and several variations on the elegant and thoughtful female spectator by Mary Cassatt. Her *Woman with a Pearl Necklace* of 1879 (plate 101) might be a preview of the figure in Degas' *Ballet from*

101. Mary Cassatt, Woman with a Pearl Necklace, 1879. Oil on canvas, 31⅝ x 23 in. (80.3 x 58.4 cm). Philadelphia Museum of Art; Bequest of Charlotte Dorrance Wright, 1978 (1978.1.5)

102. Marcelin, The Public in the Loges, *from* L'Illustration, *August 11, 1860. Literature Department, Free Library of Philadelphia*

Degas' principal subject in Garnier's new auditorium was neither the audience nor the ballet, but the perceptual and psychological territory where they met. A persistent spectator himself, he made almost no portraits of those around him after his early orchestra and perform-ance pictures, confining the rare exceptions to anonymous silhouettes or shadowy human foils for the action on stage.[35] In their absence, Degas used a wide repertoire of devices to signify that he—and by extension, we—are situated at a certain level in the theater and at a measurable angle to the performance, and not like the dancers of Gar-nier's imagination, "in a kind of dream." Typically, the velvet-covered front of a *loge*, the curve of a double bass, a prompter's box, or—most often—the floorboards on stage, define our lines of sight and our place in the physical scheme of things. In the scintillating *The Star* (plate 103) for example, the sense of limbs and fabric materializing in a cloud of pastel immediately beneath us is explicit, as we peer down at the dancer's chest and at the upper surface of her spotlit pink tutu. Yet this vision is anchored by the diagonal striations on the stage floor to the palpable geography of the Opéra, locating the viewer toward the side of the theater rather than in seats opposite the proscenium. Behind the ballerina, we also orient ourselves with respect to the wings and see the kind of half-hidden figures who distracted Charles Garnier, here so fragmentary as to suggest the excitement of the moment.

In more sedate compositions from these years, Degas continued to follow the pattern established in such earlier works as *Orchestra of the Opera* and *Ballet from "Robert le Diable,"* presenting a relatively broad aspect of the performance as seen from the main body of the Opéra. Both *Ballet at the Paris Opéra* (plate 183) and *Dancer on the Stage* (plate 187), for example, offer the near-horizontal visual experience of the *parterre*, a fact underlined in the former by the inclusion of a vestigial orchestra and a defined stage perimeter. In each work, the parallel alignment of the footlights and the lower edge of the backdrop with the picture rectangle tells us that we occupy central seats, looking directly at the stage. In *Dancer with a Bouquet, Bowing* (plate 104), Degas had already begun to vary this conceit, still situating the viewer in front of the proscenium but now looking down from a second- or third-level balcony. Such central *loges* were much sought-after among Opéra regulars, allowing them to enjoy the full sweep of the pano-rama at a height appropriate to their status, while enabling them to pick out details of the production at will. It was here that some of the grandest families in Paris retained their boxes and where visiting heads of state and their retinues were enthroned on formal occa-sions. Degas never belonged to this superior class and would only have shared their viewpoint—if at all—in his imagination or as an occasional guest. But his art shows that he participated in almost every aspect of a theatrical ritual that was both architecturally and socially stratified.

As Degas accustomed himself to the new auditorium and acquired greater confidence in depicting the stage, his pictures of the ballet

an Opera Box, here brightly lit and seen from the facing balcony, and even more highly charged with Garnier's "magnetic quivering." Cas-satt plays knowingly with a deep-rooted graphic stereotype, typified in the illustration by Ludovic Halévy's friend Marcelin (plate 102). Unusually, in creating her painting a female artist has looked away from the stage in order to "study at leisure the physiognomies of those present," in a part of the theater where seating restrictions brought together members of her own sex. Notoriously, however, it was the male habitués who specialized in this recreation and provided the subject for one of the most persistent graphic and literary clichés of the century. In 1879, the year Cassatt's picture was shown at the fourth Impressionist exhibition, Maxime du Camp announced that certain productions were "best seen in reverse: you should turn your back on the stage and look at the auditorium. The audience offers a more curious spectacle than the painted women among the card-board architecture." Du Camp admitted that the sight of his female neighbors was a significant distraction at the theater, along with their revealing dresses and a rare glimpse, in these censorious times, of "arms, legs and shoulders." Placing such "décolletés" before the pub-lic, he declared, was like "a fairy tale, where fresh meat was thrown to an ogre to satisfy his hunger."[33] There could also be open disapproval of such practices, as in the objections of Alphonse Karr to the "almost naked" bodies he encountered at the theater, or in a story recounted by Degas that concerned an overweight woman who revealed too much of herself to the Opéra crowd, and withdrew in shame when she was jeered at.[34]

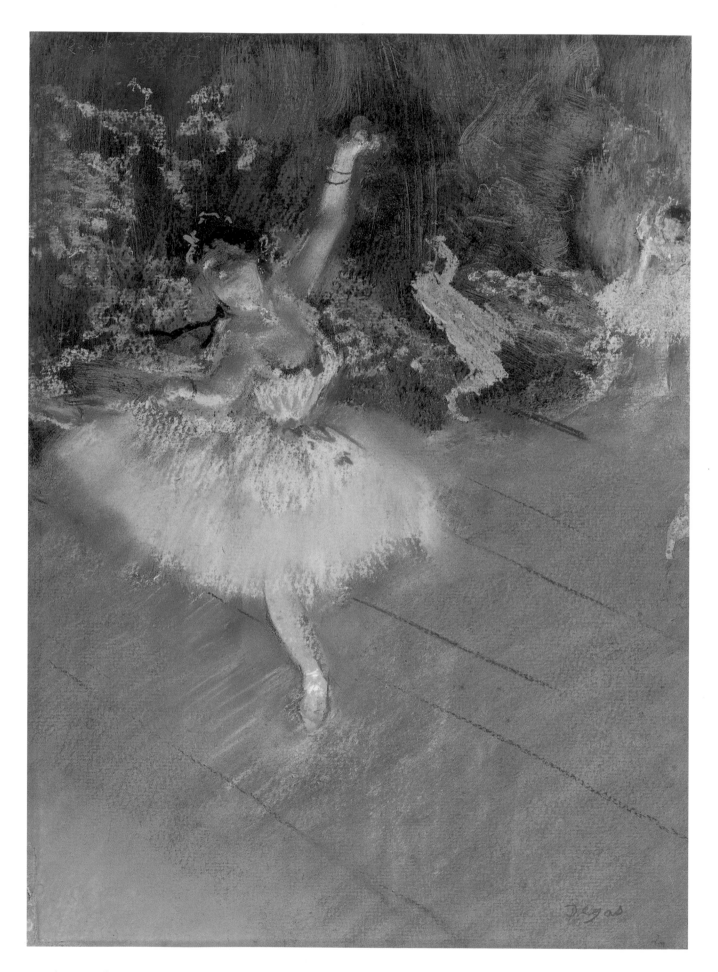

103. Edgar Degas, The Star, c. 1878. Pastel over monotype on paper, 17⅜ x 13½ in. (44.3 x 34.3 cm). Philadelphia Museum of Art; Bequest of Charlotte Dorrance Wright, 1978 (1978-1-50)

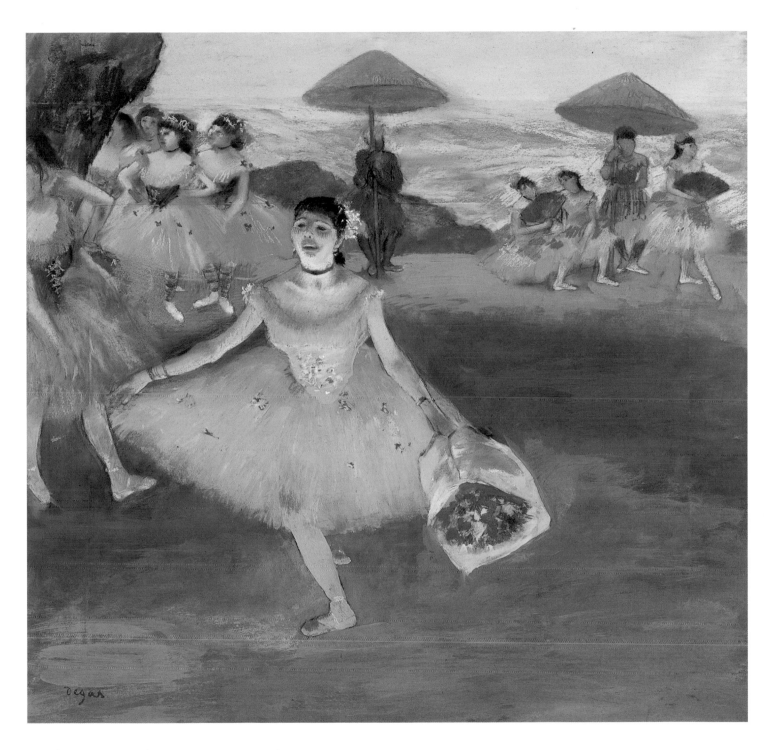

104. Edgar Degas, *Dancer with a Bouquet, Bowing*, 1877. *Pastel on paper, 28³⁄₈ x 30½ in.*
(72 x 77.5 cm). Musée du Louvre, Departement des arts graphiques, fonds Orsuy (RF 4039)

became progressively more audacious, not just as compositions but as conceptualizations of individual experience. Between 1875 and 1885 we can trace his increased mobility within the theater, moving from one level of seats to another, approaching and retreating from the stage, and investigating extreme and previously unexplored angles of view. In one variant of *Dancer with a Bouquet, Bowing*, for example, Degas experimented with a tightly cropped and implicitly closer glimpse of the same *étoile*, who is seen in yet another study on a wide span of stage complete with footlights, spacious box, and fan-wielding observer.[36] Elsewhere, he carries us to the highest seats in the house and to viewpoints immediately over the stage, leaving the more reassuring and impersonal vision of the majority of the audience far behind. At their most exhilarating, these works take the observer beyond the public spectacle to a heightened, visceral encounter with fragments, colors, and bodies in advanced states of exertion. In *The Star*, we are pulled sharply to the flanks of the theater and thrust up against a single dancer, now detached from her companions and from the narrative that once linked them. *Ballet from an Opera Box* is even more hazardous, suspending us above a radically truncated figure and almost within reach of her flame-tinted costume. By this date, too, Degas had transformed his visual vocabulary to respond to this new challenge: planes tilt, alarming spaces open up and any practical relationship to the *parterre* or *loges* becomes tenuous, as the artist's eye sweeps over his seated companions at the Palais Garnier and into the great cube of the stage itself.

Nuitter, the Opéra archivist and one of the librettists for *La Source*, *Coppélia*, and *Namouna*, tells us that the stage of the new Opéra was the largest in existence, "not just in its depth, but above all in its width and height," a claim graphically supported in a contemporary print (plate 105).[37] Armed with this information and using scale plans of the theater, we can make other important deductions about Degas' per-

formance pictures. In literal terms, the dancer emerging from the scenery in *The Star*, for example, was at least sixty-five feet from the nearest *avant-scène* box, and almost a hundred feet from the first lateral *loges*. At such a distance, any figure on the Opéra stage would have been tiny in a normal field of vision, as countless illustrations of performances at the Palais Garnier show (plates 15 and 268). In devising his composition, the artist was thus obliged to enlarge the dancer many times, and correspondingly to modify and reduce the surrounding scene. Overwhelmingly, the resulting images look like part of a stage seen through magnifying apparatus, such as opera glasses, lorgnettes, binoculars, or the monocular preferred by some of Degas' contemporaries. Magnification of this kind automatically reduces the angle of the visual field and tends to flatten perceived space, as well as heightening effects of focus. As we have seen in images by Cham, Daumier, and Marcelin, and in Degas' *Ballet from an Opera Box*, optical aids were ubiquitous in the theaters of the day, intensifying the voyeuristic pleasure of those who "observe and sense that they are observed" and enhancing the nuances of the performance. In pictures such as *The Star*, therefore, Degas offered his viewers a simulacrum of their nightly experience, gently underscoring his strategy by introducing a pair of lorgnettes into the foreground of occasional works. Coincidentally or otherwise, the effect is again to disrupt the continuity of the shared ritual, individualizing consumption and transgressing Garnier's ideal of a production integrated with the decorative ensemble.

Certain theater pictures made between 1875 and 1885 seem to take obliqueness as their principal subject, exploring the far corners of the proscenium and the extreme edges of the stage. Like *The Star*, the abrasive *Three Dancers in the Wings* (plate 106) and the superbly complex *Ballet Dancers on the Stage* (plate 107) take us beyond conventional viewpoints, yet leave us near enough to the performers to study their faces and describe their costumes in minute detail. Opera glasses may again have compressed the intervening space in the Dallas pastel, but a position in a box beside the stage is surely implied by its angled, palpable confrontation. This is a bravura work that edges as close to visual mayhem as Degas ever allowed himself, yet triumphantly imposes a kind of linear order on the flailing arms and finds unity in the pervasive gold of the tutus. The proximity of the dancers to each other seems to preclude rapid movement, as if we glimpse a tableau at the end of a divertissement that only slowly reveals its symmetry. At the center are the two girls in turquoise and pink, posed identically in *plié*, flanked by symmetrical standing dancers with their arms outstretched. To our left is the glare of the footlights and the rapt audience, while the artist—as in *The Chorus* (plate 178)—hovers in fascination over the brandished limbs, intent expressions, and fragmented physiques of this brilliantly individualized cast.

Three Dancers in the Wings is less radical in its implied elevation but almost as shocking in its visual immediacy and facture. Few signed

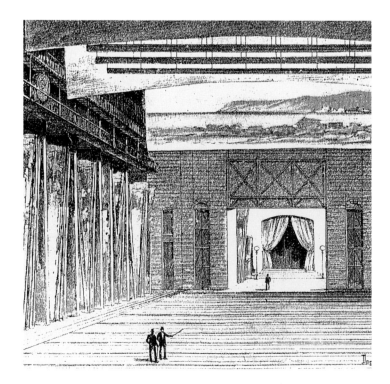

105. M. J. Moynet, The Stage of the Opéra, *from* La Machinerie théâtrale: Trucs et décors, *1893*

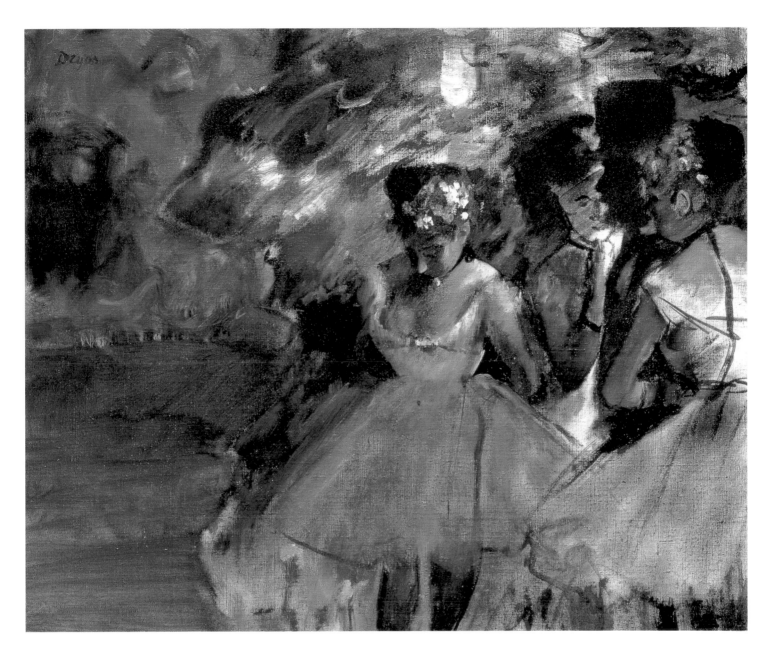

106. *Edgar Degas, Three Dancers in the Wings, c. 1880–85. Oil on canvas,*
21½ x 25½ in. (54.5 x 65 cm). Private collection, New York

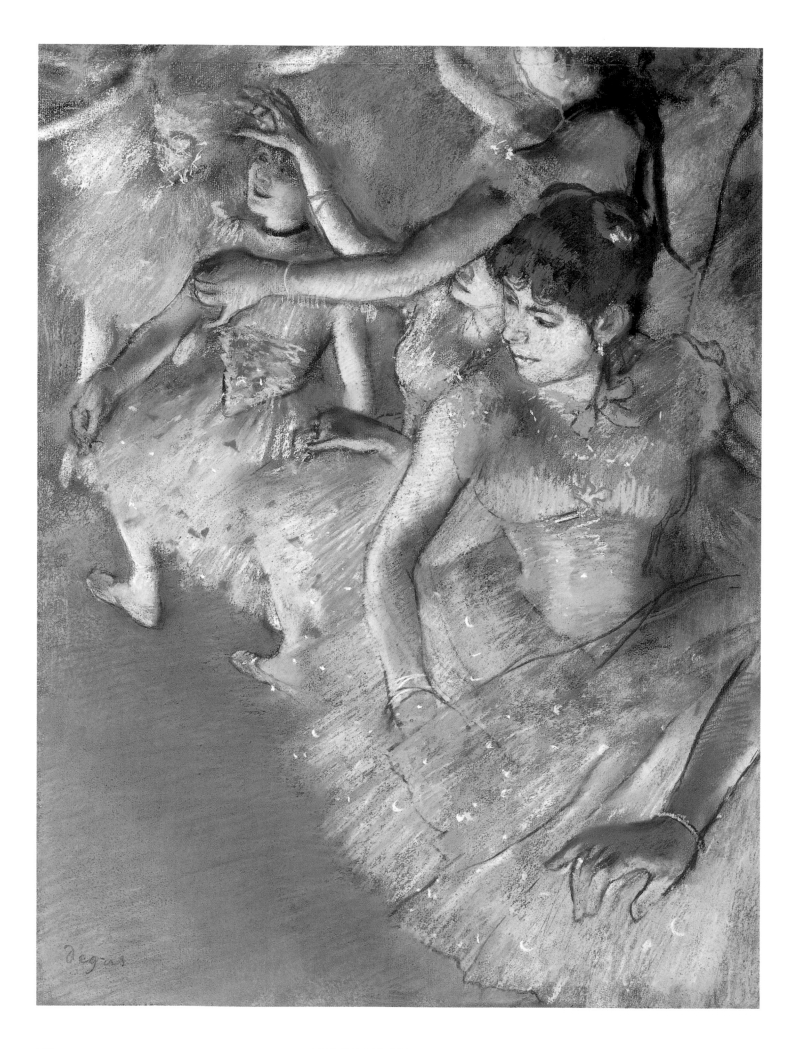

paintings by Degas are as raw in their impact, thrusting uncovered canvas and dark, calligraphic brushstrokes into the foreground space, while flurries of color indicate richness beyond. Recalling more labored variants of the same motif (plates 76 and 77) this abrasive image also comes surprisingly close to the atmosphere of a monotype such as *Ludovic Halévy Meeting Madame Cardinal Backstage* (plate 73), to the extent of including one of Degas' rare painted male figures beside the stage. *The Entrance of the Masked Dancers* (plate 108) is arresting in a subtly different way, the artist positioning himself as the backstage observer confronted by two brightly clad ballerinas who sweep past him into the wings. Crucial to our reading of this pastel is the back of a scenery flat behind the figure in green, indicating that the auditorium is immediately to the left; the minuscule, distant *abonné* above her, echoing Degas' own presence in the wings; and a mysterious patch of red-brown toward the edge of the picture in this same area. One of the most dynamic of all his stage creations, the Clark picture places us unforgettably among the corps de ballet itself, brushed by colored muslin, sharing "the smell of rice powder, hot wood, paint, sex" described by Félicien Champsaur, and poised to enter the pool of light beyond.[38]

Several years earlier, Degas had first explored such transverse views of the stage in two pastel-over-monotypes based on the rue Le Peletier building, both made around 1877 and therefore executed from memory. In *Dancers at the Old Opéra House* (plate 8) and *The Chorus* (plate 178), his line of sight is perpendicular to that of the audience at a point close to the footlights. Describing the view from the left and right wings respectively, Degas spelled out his location in a near-pedantic manner, as if to underline his knowledge of this restricted terrain. At the far side of the stage, for example, we see the white molded base and gilded pilaster of the proscenium surround in Debret's theater, familiar from engravings (plate 5) and from Degas' slightly earlier trio of *Rehearsal on the Stage* pictures (plates 61 and 62). Next to this pillar, but partially hidden from the audience, we also become aware of small, plainly decorated but distinctively red-hued boxes, each containing blurred figures who observe the action a few feet away. These discreet onstage *loges* were situated behind the curtain and were strictly private, reserved for the Opéra director and for senior individuals involved with the production, and for their personal guests. They are not marked on Debret's original designs and when they appear in later plans they seem to be insubstantial and perhaps improvised.[39] For all these reasons, the boxes in question were largely overlooked by contemporary commentators, though a colorful account in the Goncourt brothers' journal for 1862 describes an evening spent in distinguished company in the "loge du Directeur." From their unusual vantage point, the brothers were enthralled by the sight of the stage before the performance began, the technicians tense at their posts and a dancer beneath a lamp, whose light seemed to "caress her skin."[40]

In these two pastels, Degas clearly wished us to imagine ourselves in one of the red-brown onstage boxes, arguably the most privileged seats at the Paris Opéra. Their view of the stage was highly eccentric, combining a lateral vision of the performance and the opposite wings with extreme sensory immediacy. The vividness of Degas' images and the plausibility of their effects of light and perspective argue strongly for his firsthand experience of this location on at least one occasion, and perhaps many, conceivably through the intervention of Ludovic Halévy, who remembered being taken there himself by his celebrated uncle.[41] Though Degas' pictures are still the principal documents of his access to these *loges*, such compositions were to proliferate in the years immediately following the opening of the new Opéra. Garnier's design had allowed for a similar seating arrangement from the beginning, his plans indicating a suite of cubicle-like boxes on either flank of the stage just beyond the massive proscenium divide (plate 98). Also visible on the plans are the private staircases that linked the three-tiered private boxes to the stage and the doorways giving access to the *avant-scène*, which can only have added to their select appeal. Garnier's *loges du directeur* were as plain in appearance as Debret's, as an 1889 drawing of the stage with the lowered curtain in the background illustrates (plate 109). The drawing also reveals the remarkable height of the topmost *loge*, which is almost hidden in the flies, and prompts further speculation about the artist's most audacious stage scenes.

In the late 1870s, Degas created a series of fan-shaped paintings of the ballet that carried his research into new realms of theatrical and aesthetic sensation. Where his three fan designs of the previous decade (plate 46) had been self-consciously historical or Hispanic, the new sequence of some twenty works combined visual radicalism with the decorative genius of Japan, a pervasive influence on the sensibility of Degas' generation. Competition was also a factor: several members of the Impressionist group had agreed to show fans at their fourth exhibition in 1879, stimulating Degas to assert his authority as draftsman and technical innovator.[42] The unusual demands of the semicircular format and its associated media seem to have encouraged extreme license, prompting him to experiment with ink, gouache, pastel, watercolor, and metallic paint on paper and silk, and to pursue wild flights of compositional fancy. In *Fan: Dancers with a Double Bass* (plate 110), a rush of dancers enters from the wings to be confronted by unrelieved and unexplained emptiness. Rapid flicks with the tip of an oriental brush were used to fix the girls' bodies and strokes of pastel were applied beneath their limbs to suggest the effect of footlights, while a blur of white and vermilion gauze is almost left behind as they surge forward. Only the scrolls of the double basses and an ambiguous dark line at the lower margin, presumably indicating the edge of the stage, remind us of our place in a distant, apparently parallel, row of seats.

Other fan designs take the spectator to the side of the stage area, lifting us over the action while providing few other hints of our

107. Edgar Degas, Ballet Dancers on the Stage, *1883. Pastel on paper, 24½ x 18⅝ in. (62.2 x 47.3 cm). Dallas Museum of Art; Gift of Mr. and Mrs. Franklin B. Bartholow (1986.277)*

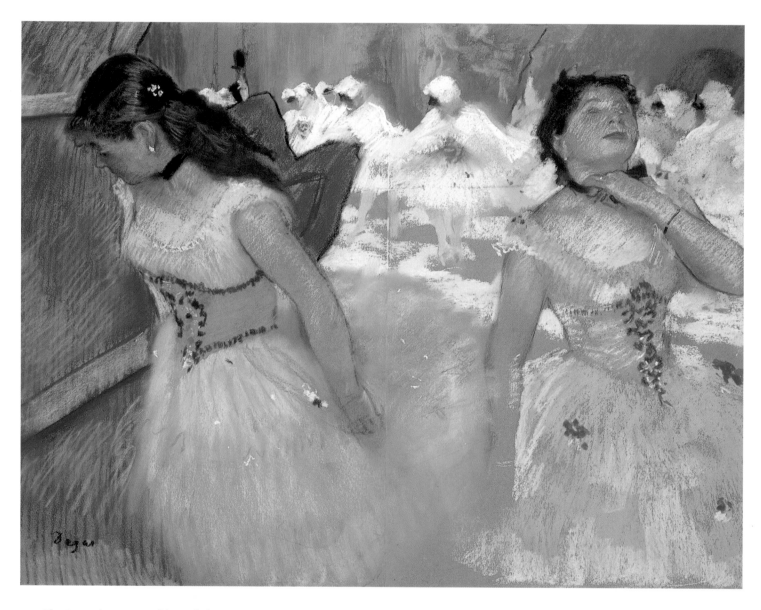

108. *Edgar Degas,* The Entrance of the Masked Dancers, *c. 1884. Pastel on paper,*
19³⁄₈ x 25¹⁄₂ in. (49 x 64.7 cm). Sterling and Francine Clark Art Institute, Williamstown,
Massachusetts (1955.559)

position. The painted surface of a large, amorphous piece of scenery dominates the foreground of *Fan: Dancers* (plate 111), as if we look out from the direction of the auditorium, but from an acute angle and from high above the stage. Our view in this spectacular, little-known fan can be compared to that of the 1889 illustration of Garnier's stage (plate 109), though in the fan we seem to look toward the backdrop, rather than in the direction of the curtain and the *loges du directeur*, as in the print. But common to both is the crucial fact that the events shown occur during an intermission, when the curtain would be down: in *Fan: Dancers* a knot of *abonnés* has drifted out from the wings while the ballerinas warm up for the performance, and in the illustration a larger male group in contemporary garb shares the boards with what appear to be female singers, again awaiting the raising of the curtain. Whoever created these images, they implicitly witnessed such scenes at first hand and were free to locate themselves at some height above the boards. This inevitably draws attention to the tier of onstage *loges* and the ability of their occupants, unique among visitors to the Opéra, to watch events unfolding between acts. The clear implication is that the perspective of the fan is shared with a viewer in one of these on-stage boxes, probably the uppermost one, who looks out over scenery flats and down on the gathering cast.

The same lofty viewing position within the stage is implied in around half this dazzling sequence of fan compositions. *Fan: Dancers and Stage Scenery* (plate 112) again allows a glimpse over high, stylized foliage, across the broad wooden floor and up to the distant backdrop, with deep *coulisses* visible at left. Now the performance is well underway, as one dancer hides from the public gaze and others form a line beneath a central group of coral-pink trees, while a solitary figure at

extreme right throws herself excitedly into her role. Clearly indicated are the painted canvas flats, the basic components of the Opéra décor that were often raised from below through slots in the stage. A diagram from Moynet's treatise on theater machinery (plate 113), first published in 1873 and revised in 1893, helps to explain this ingenious system and coincidentally replicates the angle of Degas' composition.[43] Similar structural elements presumably lie behind *Dancers (fan design)* (plate 114), where cascades of gold, fiery red, pink, and charcoal suggest a volcanic cataclysm. Even less explicit than previous examples, this proto-Symbolist scene includes a cluster of gesticulating coryphées who are caught up in some extreme but mysterious drama. But if they are performing and we are conventionally seated in Garnier's auditorium, it follows that our view of the proceedings must be seriously obstructed. Adding to the puzzle, the faint horizontal line at right appears to correspond to the lower edge of a backdrop, aligning the scene with the front of the stage and leaving us high to the left, perhaps among the stage apparatus or on one of the machinists' gantries.[44]

Degas' fan pictures on ballet themes, painted ten years after he first turned to this subject, reveal the continued capacity of the stage to excite him as a spectator and to stimulate him as an artist. By this date, he was so sure of his material and his dexterity that he was able to carry out these demanding designs with breathtaking ease. There are virtually no drawn studies for either the figures or their settings, which Degas must have improvised from his memories of recent performances, from his accumulated knowledge of poses and theatrical effects, and from an acquired skill in quasi-oriental brushwork. Made alongside much more pondered dance compositions, such as *Dancer with a Bouquet, Bowing* (plate 104), the fans oblige us to confront the wide range of the mature artist's responses to the ballet. His disciplined command of the figure in movement and in awkward repose was by now widely acknowledged, one critic claiming in 1879 that—alongside the varied talents of the Impressionists—he seemed like "a master" and another hailing him as an "erudite draftsman."[45] But the fan designs also revealed a witty, whimsical colorist and a fanciful inventor of spaces who now tested his followers to the limit. Most of the commentators at the 1879 exhibition hurried past them, one anonymous writer exclaiming, "The fans!!... Oh! The fans!!," and a colleague briefly noting "their very curious Japanese fantasy."[46] It was left to his more perceptive dealers and friends to acquire the first examples: Durand-Ruel bought *Fan: Dancers* (plate 111) and *Fan: Dancers and Stage Scenery* (plate 112), and brave purchases were made by Mary Cassatt, the writer and graphics expert Roger Marx, and Degas' companion in the Opéra *parterre*, Albert Hecht.[47]

The flurry of fan painting stopped almost as soon as it had begun, to be revived only once when Degas made two designs to commemorate his friend Ernest Reyer's opera *Sigurd* (plate 199). These pictures thus became part of an outstanding phase of experimentation in the

109. Emile Bayard, *The Wings of the Opéra, from* L'Illustration, *February 2, 1889. Free Library of Philadelphia, Literature Department*

110. Edgar Degas, Fan: Dancers with a Double Bass, c. 1879. Pastel, black chalk, and ink wash on paper, 14⅛ x 25½ in. (36 x 65 cm). Private collection, Dallas

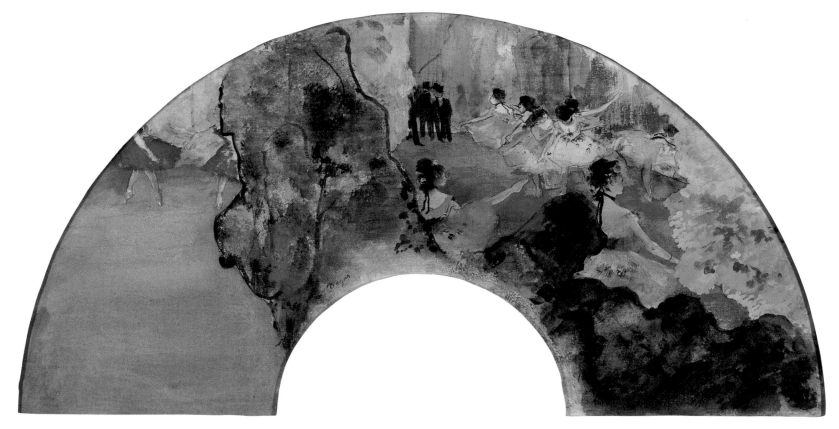

111. Edgar Degas, Fan: Dancers, c. 1879. Gouache, pastel, and essence on silk, 12 x 23½ in. (30.5 x 59.7 cm). Tacoma Art Museum; Gift of Mr. and Mrs. W. Hilding Lindberg (1983.001.008)

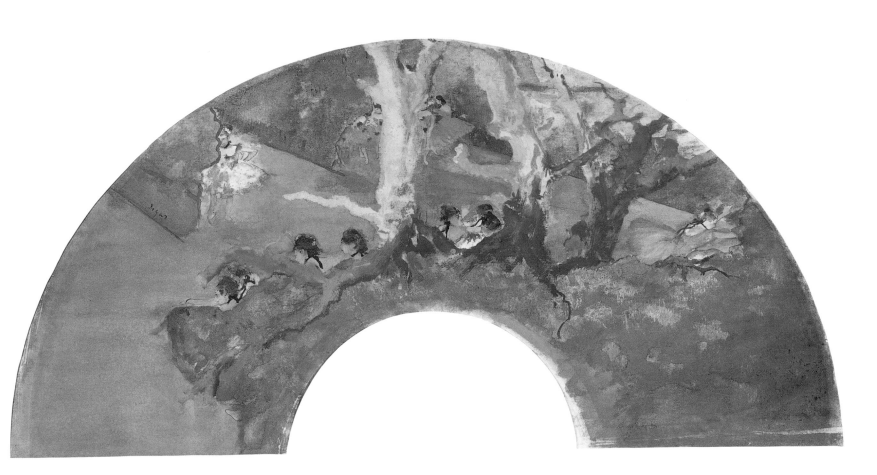

112. Edgar Degas, Fan: Dancers and Stage Scenery, c. 1878–80. Gouache with gold high lights on silk, mounted on card, 12¼ x 24 in. (31 x 61 cm). Private collection, Switzerland

years around 1880, when the artist's technical and pictorial originality reached a dazzling new peak. Few of his achievements in etching, lithography, monotype, and various hybrid print-and-pastel processes at this time were to be surpassed, and the excursion into large-scale, hyper-realistic sculpture exemplified by the *Little Dancer, Aged Fourteen* marked a similar watershed. Now approaching fifty, Degas could count on brisk sales and a widening reputation, with significant groups of his pictures gathered in contemporary collections, such as those of Jean-Baptiste Faure, Ernest May, Gustave Caillebotte, and Henri Rouart, and interest in his work growing in London, New York, and elsewhere. Ballet subjects were the clear favorites among his clientele, accounting for more than half his submissions to the Impressionist exhibitions at this date and remaining at the center of Degas' output for the rest of his career. By this time, sentimentalized versions of some of his staple themes had established a firm foothold in the market, as in Houry's *In the Wings* from the Salon of 1883 (plate 115). As Degas advanced into the next decade, we can trace a lessening of bravura display, as if the attention-seeking, self-conscious innovation of earlier years was now tempered by other concerns. Unconventional media lost ground to a vigorously personal pastel technique, while his bird's-eye stage views, acrobatic structures, and violently cropped dancers grad-

113. M. J. Moynet, The Opéra Stage and Its Subdivisions, *from La Machinerie théâtrale: Trucs et décors, 1893*

ually gave way to level, symmetrical encounters with entire figures or discrete groups, such as those in *Dancer with Bouquets* (plate 214) and *Ballet Dancer on Stage* (plate 312).

BEHIND THE SCENES IN THE GARNIER ERA

Where Degas' pictorial involvement with the stage at the Palais Garnier was overt, original, and highly productive, his relationship with the world beyond the scenery was defined by withdrawal and paradox. By the late 1870s, his prints, pastels, and fan paintings had already demonstrated an acute knowledge of the intermediate areas between

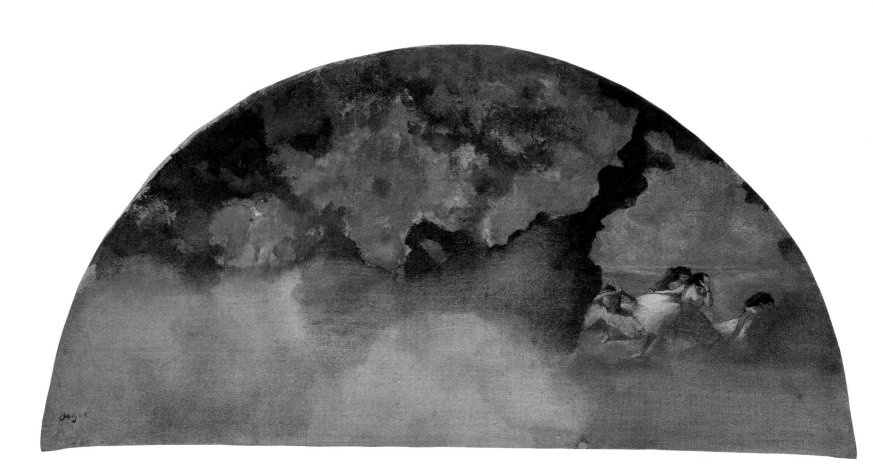

114. *Edgar Degas, Dancers (fan design), c. 1879. Gouache (or distemper) with gold and charcoal on silk, 13⅛ x 24¾ in. (33.3 x 62.9 cm). The Baltimore Museum of Art; Fanny B. Thalheimer Memorial Fund (BMA 1963.009)*

public and private experience: the arena of the stage, in works like *Fan: Dancers* (plate 111); and the spaces behind the flats, in images such as *In the Wings* (plate 78). As his reputation spread and his personal connections among the Opéra's employees and administrators reached to the highest and lowest levels, we find Degas increasingly regarded as "one of the family" backstage. The visual and documentary records locate him among the parents and jury at a dance examination, for example, held in private at the new Opéra, and at several ballet rehearsals, which took place on the Palais Garnier stage; there are sketchbook drawings of young pupils in class and other sheets apparently made while tuition was in progress; and a mysterious painting of Garnier's principal dance exercise room. So familiar was he with such locations that they deserved only the most casual mention: before discussing the fortunes of the dancer Joséphine Chabot in a letter to Ludovic Halévy in 1882, Degas noted in passing that "the rehearsal was hot."[48] By this date, if not before, Degas had become formally attached to the Opéra as a one-night-per-week subscriber, and was better placed than ever to exploit his circle of acquaintances and the chance invitation to go beyond the proscenium. Three years later, as a full *abonné*, he could proceed at will to the stage, the *foyer de la danse*, and other restricted areas.

Yet the specific, localized representation of the sequestered world of the ballet, so memorably begun by Degas at the rue Le Peletier, did not materialize in the new premises. Apart from his fan pictures, he showed even less interest in the pandemonium of Garnier's stage than

115. *After Houry, In the Wings, exhibited at the Salon of 1883, from L'Illustration, April 28, 1883. Free Library of Philadelphia, Literature Department*

Debret's, and it was left to a younger generation of his admirers and to mediocre illustrators like Valnay (plate 71) to satisfy the public appetite for such scenes. Sadly, therefore, there are no equivalents of the *Famille Cardinal* monotypes set in the new theater, where Degas left the brightly lit and now hygienically maintained accommodation for the performers largely unrecorded. There is no implication, however, that Degas had chosen to compromise his incisive vision. His intransigence is summed up in an exchange recorded in January 1882 by Ludovic Halévy, in which Degas accused his friend of "abandoning the theater" in order to publish sentimental novels, like his recent and largely escapist *L'Abbé Constantin*. "He is disgusted by all this virtue, all this elegance.... I should always produce *Madame Cardinal*, little things that are dry, satirical, skeptical, ironic," Halévy complained in his journal.[49]

Garnier's purpose-built classrooms equally failed to inspire a fresh cycle of canvases from Degas, such as those initiated in the *foyer de jour* at the Hôtel de Choiseul. This baffling situation is further complicated by our knowledge that it was in precisely the years after the opening of the new Opéra that some of these works—notably the *famille Cardinal* prints and the rue Le Peletier classroom paintings—were begun or completed. Clinging to the past, capitalizing on nostalgia, or indulging in bravura exercises of memory, Degas worked on the monotype sequence around 1876 and exhibited some of them in 1877, and showed the Frick Collection's *Rehearsal* (plate 84) as late as 1879. Though these projects may have offered the artist and his public a bridge between the old and the new, they leave us to confront Degas' resistance to the private life of the "greatest theater in the world," now resplendent at the center of the recently remodeled city. We are denied not only identifiable images of Garnier's dressing rooms, instruction spaces, and staircases busy with coryphées, but even depictions of those subjects—such as the foyer and the ballet examination—that were unquestionably known to Degas at first hand.

Degas' inquiries about one of the latter occasions have often been cited, but can now be fixed to a three-year period. In a note to Albert Hecht, who was portrayed by Degas in *The Ballet from "Robert le Diable"* and later purchased a fan painting, the artist wrote, "Have you the power to get the Opéra to give me a pass for the day of the dance examination, which, so I have been told, is to be on Thursday? I have done so many of these dance examinations without having seen them that I am a little ashamed of it," adding in a message sent before 1882 that Hecht planned to lead him "in person to the feet of M. Vaucorbeil," the director appointed in 1879.[50] There has been a curious reluctance to link this brief correspondence with a longer but less well-known text, consisting of notes made by Degas at just such an event where he records the presence of the *régisseur générale*, Adolphe Meyer; the *régisseur*, Edouard Pluque; the dance teachers Mme Mérante and Mme Théodore; and the ballet master and choreographer of *Sylvia*, Louis Mérante ("very familiar," he observed).[51] Degas' eager description of this ordeal for the young dancers and his delight in their efforts is consistent with the novelty of the scene. After explaining how he had

joined the adults on stage, the artist observed "the whole hall in darkness, large green-gray cloths covering the boxes and stalls. Six big gas lights on stands with large reflectors in the orchestra pit." Following the examination itself, he remarked, "It is the age when dancing is pretty, it is naïve, primitive, firm," before returning to his visual impressions: "curious silhouettes around me, in front of me."

But where similar experiences at the rue Le Peletier had resulted in scribbled notes, sketches, and then a major picture, such as *Ballet Rehearsal on the Stage* (plate 61) or the work exhibited by Degas in 1876 as "Dance Examination," *The Dance Class* (plate 127), this vivid encounter produced neither drawings nor paintings. Within a year or two of 1880 he made a cluster of chalk and charcoal sketches of child-dancers and some grander pastels of young ballerinas, but they were all concerned with the quite specific routines of training at the barre in a dance classroom. What is distinctive—and somewhat disconcerting—about all these pictures, and about most of the exercise and rehearsal scenes of the late 1870s and beyond, is that they take place in anonymous spaces with no resemblance to the Palais Garnier classrooms. In contrast to the particularized *faux-marbre* décor and richly molded doorways of the Hôtel de Choiseul, an otherwise highly refined pastel such as *Dancers Practicing at the Barre* in the Metropolitan Museum of Art might be set against almost any wall in Paris.[52] Ironically for us, of course, this is also the time when the exact shape, size, and design of the rooms at the Opéra are fully documented, not just in the surviving theater but in records of their original appearance. Garnier himself explained in his lavish 1878–81 publication, *Le Nouvel Opéra*, that two such areas were included in the upper levels of the building: "one for the exercises of the dancers of the corps-de-ballet, the other for the teaching of young children who are destined for the theater. The first is a vast circular room, situated in the story above the rotunda of the west pavilion. The other is an immense rectangular room, placed beneath the secondary stairs in the same west wing."[53]

The exception to the rule is the incorrectly titled but hauntingly beautiful painting in the Norton Simon Museum, *Dance Rehearsal in the Foyer of the Opéra* (plate 116), which unquestionably shows one of these classrooms. Unique in Degas' oeuvre, this picture features the round windows and curved walls of the "vast circular room," which is recognizable in one of Renouard's etchings (plate 117) and is still in use today. Technical study of the painting has helped to explain the unusual combination of deep, descriptive space—normally associated with the artist's earlier ballet compositions—with the broad brushwork and smoldering color of his final years. As with the similarly mislabeled *Dancers Practicing in the Foyer* (plate 91), it is now clear that the elderly Degas took up a canvas begun in the 1870s and radically reworked both its color harmonies and elements of its structure. At some point around 1895 the original canvas was extended by several inches at the top, bottom and right side, and this enlarged surface was then energetically repainted in contrasted autumnal tones. X rays show that Degas not only changed the poses of most of the figures while leaving the room design intact, but obliterated the form of a spiral staircase at

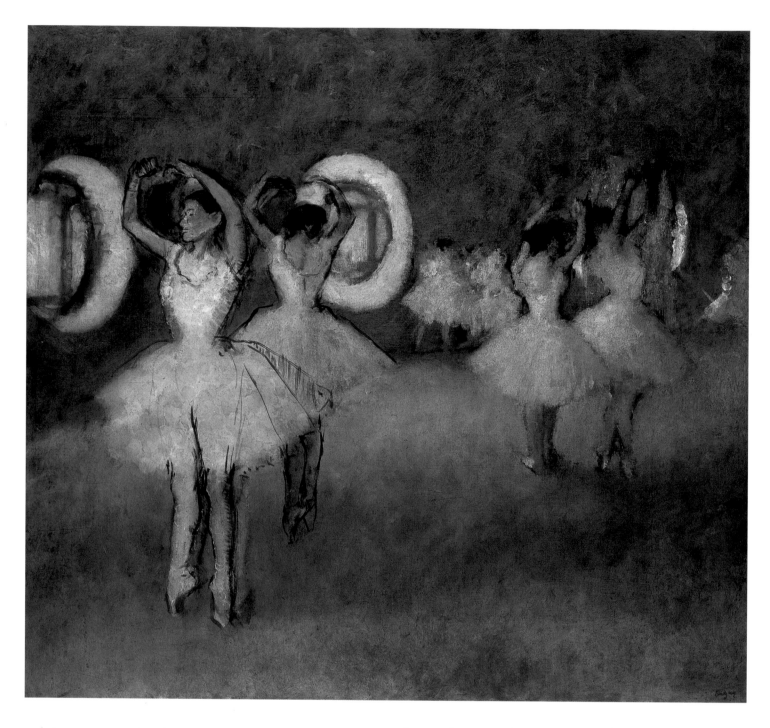

116. *Edgar Degas, Dance Rehearsal in the Foyer of the Opéra, 1895. Oil on canvas, 34⅞ x 37¾ in. (88.6 x 95.9 cm). The Norton Simon Art Foundation, Pasadena, California (M.1968.25.P)*

left, roughly where the principal dancer now stands.[54] This staircase is an extraordinary discovery, suggesting that Degas once went to considerable lengths to link the Garnier classroom with his earlier scenes of the Hôtel de Choiseul, such as *The Rehearsal* (plate 165) and *The School of Ballet* (plate 146), despite the apparent absence of such a structure in either space. Announcing his knowledge of the new Opéra's private facilities, Degas simultaneously asserted his right to intervene in the brute facts of iron and stone, not just once, but twice in the history of a single canvas.

Some light is shed on Degas' conflicted response to such backstage motifs by the work of Paul Renouard, a printmaker and illustrator who was eleven years his junior. As a pupil of Isidore Pils, the young Renouard helped to complete the ceiling paintings over Garnier's Grand Staircase, soon acquiring a reputation for his own "powerfully rendered scenes of everyday life," such as those in the Opéra wings admired by the ubiquitous Jules Claretie.[55] By 1878, Renouard had published several studies of young Opéra dancers in *L'Illustration* and embarked on a suite of etchings of their daytime and nighttime activities, including some lively and charming scenes in stairwells (plate 118), at rehearsals, and in their new classrooms (plate 117).[56] These describe in rather clumsy detail the "rectangular" and "circular" space designed by Garnier, where the bulk of training for dancers of all ages took place. Claretie was frank about Renouard's limitations, immediately acknowledging Degas' precedence as an artist of the "seductive oddities" of the ballet. Degas is said to have encouraged his disciple,

but he must also have felt Renouard snapping—however bluntly—at his heels, less than a decade after he himself had pioneered many of these themes.[57] If an agile young draftsman such as Renouard could roam behind the scenes at the new theater, recording characters from *Sylvia*, showing Madame Mérante instructing a young dancer, and sketching off-stage events during *Don Juan*, Degas had more reason than ever to reconsider his artistic priorities.[58]

The thirty-year-old Renouard's free access to the Palais Garnier in the late 1870s suggests that Degas' growing antipathy to such documentary projects was a matter of choice as much as opportunity. Renouard was not alone in his mobility or his willingness to capitalize on this terrain. Over the years, we meet a growing catalogue of artists who trailed meekly or brazenly in Degas' footsteps, making drawings in the *foyer* and occasional or interminable paintings and pastels of the *coulisses*, and publishing lavish portfolios of etchings and lithographs on backstage themes, such as Renouard's *L'Opéra* of 1892 and Legrand's *La Petite Classe* of 1908. The list embraced established figures in Degas'

117. *Paul Renouard,* Classe de Danse (Classe du Ier Quadrille), *from* Le Nouvel Opéra, *1881. Etching and aquatint, 9 x 11 in. (22.8 x 27.8 cm). Baltimore Museum of Art; George A. Lucas Collection (BMA 1996.48.8371)*

118. *Paul Renouard,* Escalier des Classes, *from* Le Nouvel Opéra, *1881. Etching and aquatint, 12³⁄₈ x 9⁵⁄₈ in. (31.5 x 24.4 cm). Baltimore Museum of Art; George A. Lucas Collection (BMA 1996.48.8405)*

wider circle, like Zandomeneghi, Béraud, and Toulouse-Lautrec; close friends whose plagiarism was apparently forgiven, among them Forain (plate 119) and Jeanniot; the suave opportunist, Carrière-Belleuse, who showed coy, saccharine pastels of ballerinas at the Salon; and a generation of younger printmakers and draftsmen, including Henri Boutet, Gustave Leheutre, Charles Léandre, Louis Legrand (plate 120), and Paul Seguin-Bertault. Much of their imagery had distant roots in the graphic tradition, but was now designed to ingratiate as much as to satirize. Even as they built on Degas' example ("he flies with our own wings," Degas is said to have remarked of one painter) these individuals exploited the appetite for illustrative detail, heightened innuendo, and shameless flourishes of style that ensured ready sales.[59]

The commercialization of the realist theater vocabulary that had been so fundamental to Degas' early years was a sign of both his success and the limited grasp of his followers. By the early 1880s Degas himself had already moved on, shedding themes from the pioneering Impressionist period, the self-consciously novel techniques that

informed them, and the abrasive assumptions that lay behind much of his urban imagery. Subjects such as the brothel, the cabaret, and the café had either disappeared or were losing ground, to be replaced over the decade by less contextualized depictions of his principal motifs. Never a systematic individual, Degas continued to take practical excursions and to retrace his steps on occasion, but this was increasingly a period of deepening engagement with the theme that was to consume his art: the female figure, as nude or as dancer.

THE FRIEZE PAINTINGS

The most sustained expression of Degas' artistic distance from the Palais Garnier was his series of frieze-like classroom paintings, among them, *The Dance Lesson* (plate 121), *The Dancing Lesson* (plate 168), and *Dancers in the Green Room* (plate 125). Light-filled or broodingly atmospheric, delicate or encrusted to the limits of coherence, this engrossing suite of canvases was begun in the late 1870s and was still subject to extension or revision a quarter of a century later. There are ten such compositions in oil, most of them measuring approximately fifteen by

119. *Jean-Louis Forain, Dancer in Her Dressing Room, c. 1890. Oil on panel, 11 x 13¾ in. (28 x 35 cm). Sterling and Francine Clark Art Institute, Williamstown, Massachusetts (1955.738)*

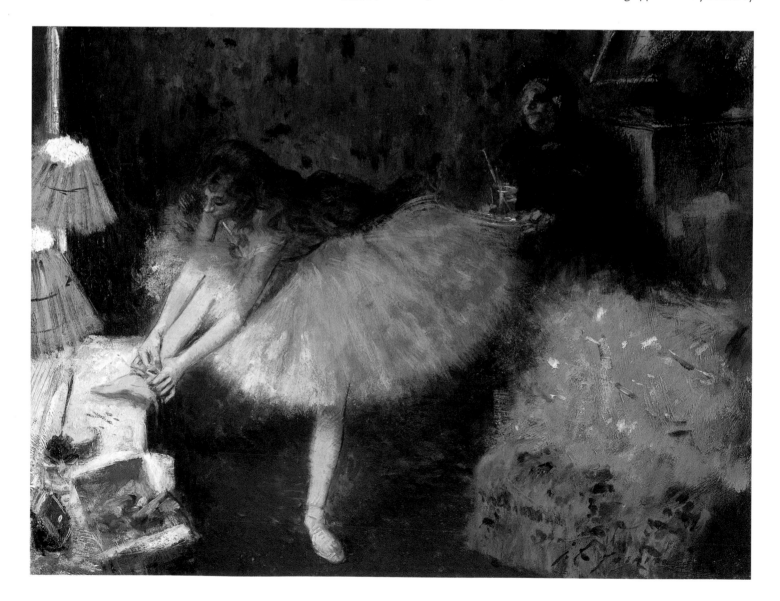

120. *Louis Legrand*, La Rampe S'allume, *from* Le Courrier Français, *September 21, 1890. Private collection*

thirty-five inches, and a similar number in charcoal or pastel, accompanied by well over a hundred preparatory drawings for individual figures.[60] Like the earlier paintings based on the lofty *foyer de jour* at the rue Le Peletier Opéra, this sequence relies on permutations of a single architectural space, here a wide, relatively shallow room. These new paintings, therefore, might be said to constitute the second movement of a larger orchestral work, taking up familiar motifs and themes but transposing them into a new key. The links between the two cycles are unmistakable: both present us with nuanced variations on the motif of the exercising or resting ballerina, disposed in space like musical notes on an improbable three-dimensional stave; as with the scenes at the Hôtel de Choiseul, the frieze cycle occupied the artist out of all proportion to its scale or market significance, demanding intensive labor in drafting, much revision of detail, and wholesale stylistic and technical transformation of certain images; and even more than the earlier group, these new pictures maintained an elusive relationship with their apparent subjects, seeming to represent—yet failing to correspond to—Garnier's documented ballet classrooms.

Several of the frieze paintings have been discussed with great eloquence, notably by George Shackelford, Jean Sutherland Boggs, Michael Pantazzi, and Gary Tinterow. Though the story of the sequence remains to be fully told, especially in its later phases, there is now

general agreement that the first work, *The Dance Lesson* (plate 121), was begun around 1879 and shown at the 1880 Impressionist exhibition, and that its successor, *The Dancing Lesson* (plate 168), was probably completed about this time.[61] Most of the other canvases followed rapidly, the majority perhaps within two or three years, but the substantial reworking over time of up to half this remaining group makes their genesis a matter of continued speculation. Stylistic and other factors suggest that two of these pictures reached their final state during the mid or late 1880s, two others were repainted in the following decade, and the rest were finished or abandoned in the complex period around 1900.[62] Together, therefore, the succession of frieze paintings forms an erratic but vital thread running through Degas' maturity, consistent in direction yet responsive to the twists and turns of his technique and his changing engagement with dance itself. "More than any other group in the artist's oeuvre," writes Tinterow, "the frieze-format rehearsals constitute a genuine series. For over twenty years, Degas elaborated—in a style gradually evolving from a precise rendering of observed detail to an expressive notation of linear rhythm and suffused color—a fixed set of dancers placed in an oblong rehearsal room, who appear, disappear, or are reproduced in reverse images of themselves in an unending stream of contrapuntal variation."[63]

As well as being the earliest of the group, *The Dance Lesson* (plate 121) is one of the most limpid, describing the long, corridor-like chamber that was so often revisited and modified in subsequent works, and introducing some of the rules of this prolonged pictorial engagement. Throughout the series, Shackelford points out, "The space portrayed is usually divided into two distinct zones. In the foreground, situated either at right or left of the picture space, there is a group of dancers, sometimes surrounded by musical instruments. They are usually grouped against a wall that seems to end, turning sharply back into space about halfway across the canvas. In the background, greatly diminished in scale, other dancers perform exercises or rest."[64] Only in the Washington canvas, however, is this dominant wall painted an unbroken celadon green, creating a bold trapezium of color that defines and balances the busy activity elsewhere. Establishing the gentle diagonal that runs through every picture in the sequence, this audacious device also underlines the play of geometry and animal mass—so evocatively explored by Mari Kálmán Mellor—that animates each of these scenes.[65] The frieze in the Metropolitan Museum might be the same scene a few moments later, complete with double bass and seated and standing figures, scarcely moved from their previous positions but now plunged into golden shadow by a passing cloud. [66]

If the gamelike principle remains the same, the shift from the high-windowed room of *The Rehearsal* (plate 88) or *The Dance School* (plate 93) to the horizontal frame of *The Dance Lesson* (plate 121) imposed new constraints and opened up new panoramic possibilities. Degas' choice of this highly unusual frieze-form rectangle, which he also explored in a concurrent family of racecourse pictures, can be linked to the wide format of certain early monotypes, such as *Ballet at the Paris Opéra* (plate 183) and *Three Ballet Dancers* (plate 34); to some of

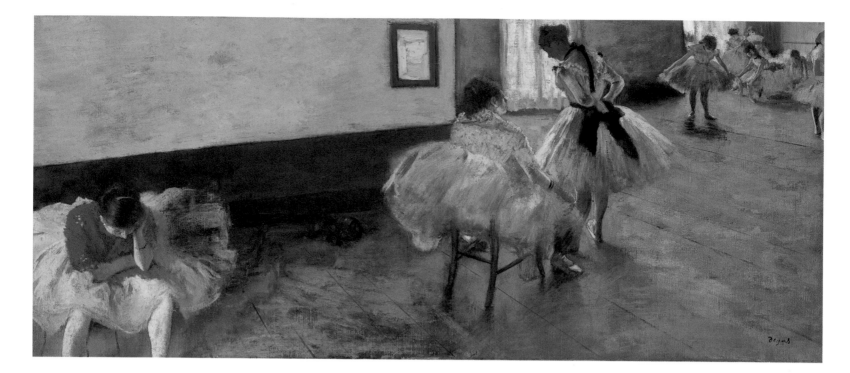

121. Edgar Degas, The Dance Lesson, c. 1879. Oil on canvas, 14⅞ x 34⅝ in. (38 x 88 cm). *National Gallery of Art, Washington; Collection of Mr. and Mrs. Paul Mellon (1995.47.6)*

Daumier's innovative designs (plate 33); and to examples of contemporary illustration (plate 122). Underlying all these precedents, however, is the historical dimension, fixed in Degas' well-educated memory by the carved entablatures and narrative wall paintings that are a fundamental part of the European tradition, and already influential in some of his youthful compositions (plates 37, 39, and 43). The frieze paintings represent one of his most deliberate attempts to create a heroic cycle of semi-public statements of this kind, where thoroughly modern *dramatis personae* occupy palazzo-like vistas based on informal Renaissance perspectives. Richard Thomson has shown how Degas remembered for almost two decades the structure of a Benozzo Gozzoli fresco, only to re-use it in a jockey picture of the late 1870s, and the artist himself chatted to Edmond de Goncourt about Mantegna in the same breath as his recent ballet paintings.[67] Regularly exposed

to the mediocre murals of his contemporaries at the Palais Garnier and elsewhere, Degas later confessed, "It has been my lifelong dream to paint walls."[68] But it is misleading to see his frieze canvases as modern wall panels in the literal sense: they are too refined, spatially complex, and un-patterned to compete with the bourgeois salon decorations made by Monet and Renoir at this period, and would have seemed absurdly small in any grander location. Only once in his maturity did Degas come close to such a project, painting the monumental, almost seven-feet-wide *Frieze of Dancers* (plate 278) in unknown circumstances in the mid-1890s, but soon selling it as an independent work of art. Enthralling though it is to imagine Degas' ballet classrooms enlarged to life-size and installed in a public library or stairway, his miniature friezes are better understood as the wistful, thwarted schemes of an institutional outsider.

122. *Anonymous*, Aida, View of the Wings at the Opéra. The Egyptian Warriors at Rest, *from* L'Illustration, *October 30, 1880. Free Library of Philadelphia, Literature Department*

Whether Degas' ambitions for these works were modest or grand, he characteristically chose moments of extreme informality for each of the paintings in question. Significant though this is for his maturing relationship with the dance, their identity in ballet terms has never been critically assessed and continues to be misrepresented. In almost every case, the current titles of the frieze pictures offer a distorted view of their subjects and thus of the artist's purposes, defining these scenes as organized classes, ballet rehearsals and—most irrelevantly—the Opéra foyer.[69] In the Washington *Dance Lesson* and the similarly titled *Dancing Lesson* at the Clark Art Institute, for instance, there are none of the distinctive signs of ballet instruction taking place that distinguish the entire series of rue Le Peletier classroom pictures. All of the earlier works include a musician, a dance teacher, or both, and members of the class respond singly or in regimented groups to their presence. Not one of the friezes includes a male figure, and we search in vain for the kind of directed or coordinated activity that signifies either class exercise or the study of choreography. Apart from the occasional cluster warming at the barre, these new dancers make a virtue of their separateness, absorbing themselves in their individual concerns, facing in a dozen different directions and addressing neither each other nor the artist-visitor. Denying coherence and avoiding a singular identity, these vague classroom gatherings seem designed to resist the order we attempt to impose upon them.

If there are unifying themes in the Washington and Clark paintings that continue into the remainder of the group, they are diffuse concerns with indolence, private preparation, and time suspended. Dancers tie their sashes and smooth the wrinkles in a stocking, work on their turnout, or stretch muscles in advance of rigors to come, like the young aspirant in *Dancer at the Barre* (plate 167). This simple yet wonderfully powerful drawing has been related to one of the more remote figures in *The Dancing Lesson* (plate 168) who practices her *battement à la seconde*. But for every such figure, there are two or three who prefer idleness or wait in undisguised boredom, surely the most plausible reading of *A Coryphée Resting* (plate 123). Here Degas shows us a slight, fine-limbed pupil who has abandoned all pretence at decorum, serving as an early model for the rather vacant right-hand figure in the same painted frieze.[70] The attention Degas insisted on paying to such inert and unglamorous individuals can be seen as part of his larger oppositional project, in which he insistently turned away from the titillating elegance of the ballerinas to the monotony of their routines and to their unstable patterns of behavior and display. Writing at length about *The Dance Lesson* (plate 121) in 1880, the novelist Joris-Karl Huysmans enthused over precisely these qualities in perhaps the most brilliant account of the artist's dance imagery published by this date. Choosing to see the character at left as "a statue of cares and weariness," he nevertheless felt that Degas' picture was concerned with anticipation, sensing the moment when "the period of rest is over, the music grinds out again, the torture of limbs recommences." For Huysmans, who shows considerable first-hand knowledge of such circumstances, all was "illusion" and "metamorphosis," a mysterious

process that would soon transform "nervous, thin" girls with "muscles protruding under their tights" into dancers with a "specially charming beauty," who would finally "pirouette, leap, advance and retreat on their pointes, on the stage."[71]

A number of superb drawings from this period serve as reminders of Degas' accumulated authority in such matters. Remarkably, studies can be found for almost every dancer in the frieze cycle, however small or distant in their respective compositions, and sometimes varied by just a slight adjustment to a limb from one sheet to another. *Sketchbook Page with Studies of a Female Head and Dancer* (plate 124) retains the freshness of the direct encounter between artist and model, as if Degas worked in his studio with unusual rapidity to capture effects of light and fleeting expressions and only later integrated them into the larger scene. Here he abbreviated the wayward muslin of a tutu in swift strokes of pastel, then paused delicately over the highlights in the model's hair and ear against her shadowed face. All these elements became part of the Washington *Dance Lesson*, where another drawing identified by Shackelford tells us that the obscure English ballerina Nelly Franklin may have modeled for three or four of the larger figures.[72] The seriousness with which Degas approached his draftsmanship is emphasized in the often overlooked fact that these studies are almost invariably several times larger than their painted counterparts and were sometimes signed and sold by him as independent works of art. By 1891, for instance, *A Coryphée Resting* had already passed to van Wisselingh of The Hague and then to John G. Johnson of Philadelphia, and a very similar work was acquired by the acquaintance of Degas' later years, the composer Ernest Chausson.[73]

The dialogue between the thing observed and the thing made, between observation and drawing, knowledge and creative invention, haunts this series. As with most of his interior subjects, Degas did not make sketchbook studies of the room on which the frieze paintings were based, which recent commentators have assumed to be "imaginary," "a world totally inhabited by creatures of one man's imagination."[74] But the more closely we have examined Degas' earlier ballet paintings, the more they emerge as precisely situated scenes or as somewhat eccentric combinations of features from existing buildings. The beginning of his new sequence coincided with the high point of Degas' friendship with the writer and critic Edmond Duranty, who famously urged his painter friends to locate their figures in authentic, contemporary contexts. In his 1876 essay, *The New Painting*, Duranty observed "our lives take place in rooms and streets, and rooms and streets have their own special laws of light and visual language," proceeding to dispense highly specific advice for rendering modern space; "Our vantage point is not always located in the center of a room whose two side walls converge toward the back wall ... nor does our point of view always exclude the large expanse of ground or floor in the immediate foreground. Sometimes our viewpoint is very high, sometimes very low; as a result we lose sight of the ceiling, and everything crowds into our immediate field of vision."[75] Degas' own voice has plausibly been heard behind this text, which seems to map out with extraordinary vividness some of the formal

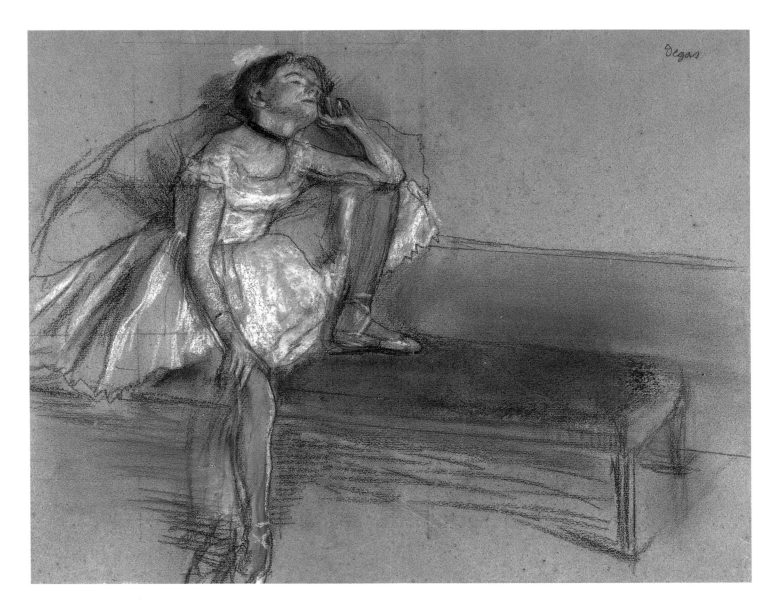

123. *Edgar Degas, A Coryphée Resting, c. 1880–82. Pastel on paper, 18⅞ x 24½ in.*
(47.9 x 62.2 cm). Philadelphia Museum of Art; The John G. Johnson Collection (J 970)

and perceptual issues of the larger classroom project. But whatever the source of its ideas, the essay encourages us to believe that Degas—who completed a magisterial portrait of Duranty posed in his book-lined study in 1879—was actively concerned with the experience of real structures and surroundings at this historical moment.

Our attempt to test the verisimilitude of the frieze classroom is complicated by a number of factors, not least Degas' by-now-familiar delight in rearranging the evidence of his senses to suit his pictorial needs. Most obviously, he reversed or mirrored the basic architectural pattern in about half the sequence of works, one subgroup following the Clark painting in having its windows at left, the other corresponding to the Washington work with windows at right. Other physical variations recall the inconsistencies of the *foyer de jour* paintings, in shifting window numbers and shapes, and in the sudden appearance of a solitary column and then a Mantegna-like flight of stairs in the foreground of certain frieze pictures, while one canvas boasts a door in the otherwise blank central wall.[76] Behind all these permutations, how-

ever, the character of the space remains emphatic and the artist's lingering concern with details suggests observation as much as invention. Two such examples can be found in the Clark canvas: the first is the fragmented but suggestive view through the windows, situating us high above a confusion of rooftops, chimneys, and apartment buildings. Again recalling the rue Le Peletier classroom, the effect is to isolate the events within even more markedly from the surrounding city and simultaneously to hint at the precariousness of all such endeavors.[77] The second clue lies in the nature of these windows themselves, which are less deeply set than those in the Hôtel de Choiseul and enhanced on their exteriors by wrought-iron grilles. The serpentine curls of these grilles are common in French domestic architecture of the early and middle years of the century, adding a further touch of individuality to Degas' carefully described scene.

Perplexingly, however, all these features tend to steer us away from the new Opéra rather than toward it. None of the broad spaces

124. *Edgar Degas, Sketchbook Page with Studies of a Female Head and Dancer, c. 1878.*
Black, white, violet, and green chalks on paper, 18½ x 11¾ in. (47.8 x 31.3 cm). Private collection,
courtesy R. M. Thune

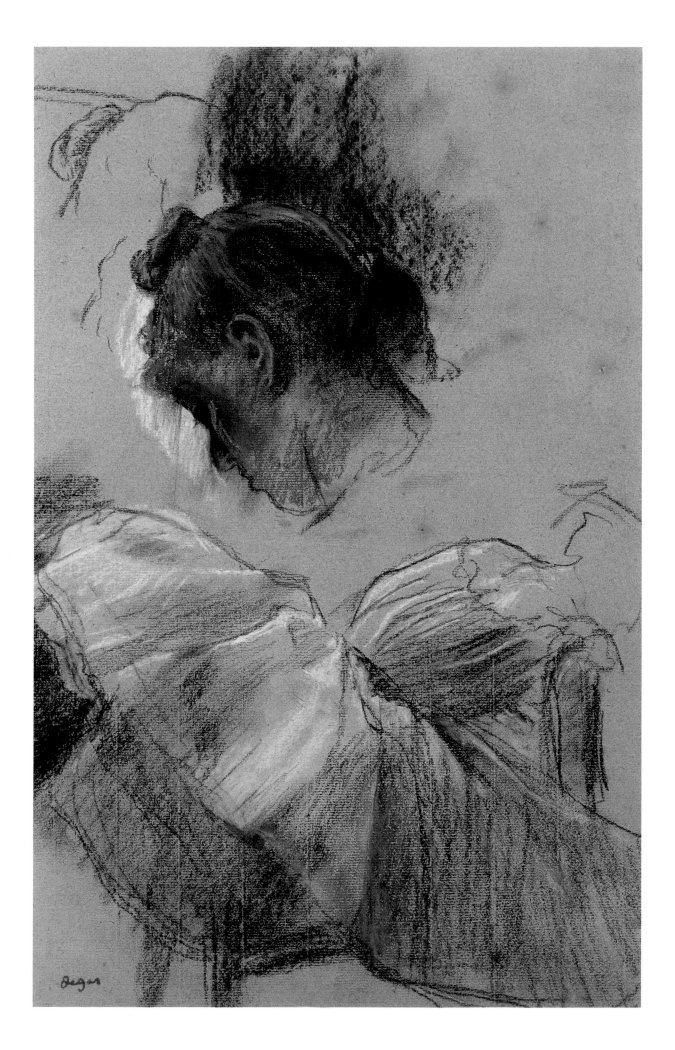

in the frieze pictures resembles in any way the "vast circular room" at the Palais Garnier, previously identified in the Norton Simon painting, while prints and photographs show that the "immense rectangular room" nearby has always been windowless. The possibility that the friezes represent other areas in Garnier's theater that were temporarily commandeered for the use of dancers is no more convincing, undermined as it is by the domestic style of the painted windows and their ironwork, which have no counterpart in the new structure. Having drawn a blank at the Opéra, we are obliged to look elsewhere and perhaps to accept that our room no longer exists in its original form: could Degas' idiosyncratic classroom have been yet another, even more distant memory of the rue Le Peletier, a space high up under the roof of the Hôtel de Choiseul? Or did he simply paint a dance class in another tall building?[78]

For many years, it now appears, the Opéra had maintained premises on a site separate from both the rue Le Peletier and the Palais Garnier that have not yet featured in the Degas literature. This was a purpose-built *Ecole de danse* or *Conservatoire* at no. 6, rue Richer, immediately adjacent to the Opéra's scenery painting workshops and about half a mile east of the rue Le Peletier itself, which functioned until the late 1870s but has long since disappeared.[79] Surviving plans show that dance education took place in two plain, street-level classrooms without large windows, where generations of beginners were supervised by the long-serving Opéra teacher, Madame Dominique.[80] Léontine Beaugrand, the *première danseuse* hailed as a homegrown star in her early career, began her studies at the rue Richer at the age of eight, while the Italian star Amina Boschetti came here in her maturity to receive a final "polish" before being presented to the Opéra audience.[81] While it is possible that Degas had some access to the Conser-

vatoire, a room in the six-story block next door, at no. 4, rue Richer, is perhaps a better focus of attention. Private coaching had been given here for many years by Jean Baptiste Barrez and others, and one of the topmost apartments with its row of traditional windows and iron grilles may conceivably have provided the elusive starting point for Degas' frieze cycle.

Degas' restless manipulation of his chosen dancers, their accessories, and their long, low room would frequently leave traces on the painted canvas. Prompted by a thumbnail sketch in a Degas notebook of this time, George Shackelford was able to identify the ghost of a subsequently over-painted violin and its open case in the foreground of *The Dance Lesson*.[82] An X ray made in 1996 has also revealed an ornamental bracket and traces of a window or niche at upper left in the same work, while confirming that the original figures were largely unmodified in the revision that took place.[83] Sparkling though it appears today, the Clark *Dancing Lesson* was even more thoroughly transformed when Degas removed the painting from its stretchers and remounted it on the slightly enlarged frame, adding a small extension to his composition at the top and bottom edges.[84] Fundamental alterations were made to the two foreground ballerinas, not just once but seemingly on several related occasions, involving the gradual raising of the outstretched leg and the transformation of the pose that formerly resembled *A Coryphée Resting* (plate 123). At this date Degas still attempted to disguise most of these interventions, encouraging the eye to move smoothly from form to form and space to space, here following the zigzag of the seated dancer's legs through her standing companion

125. Edgar Degas, Dancers in the Green Room, *c. 1880–94. Oil on canvas, 16¼ x 34½ in. (41.3 x 87.6 cm). The Detroit Institute of Arts; City of Detroit Purchase (21.5)*

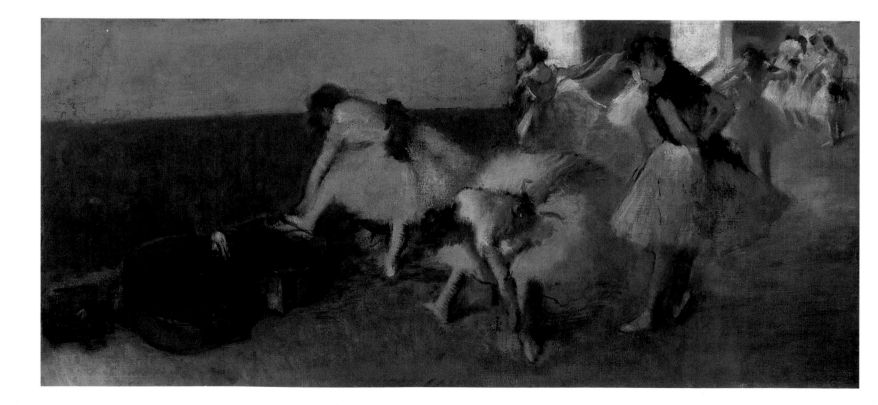

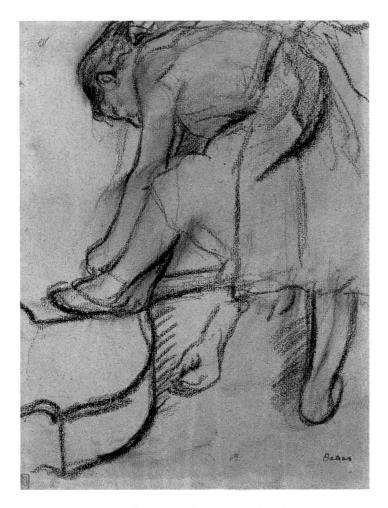

126. *Edgar Degas,* Dancer Adjusting Her Slipper, *c. 1879. Charcoal on tan paper, 12 x 8⅞ in. (30.5 x 22.5 cm). The Detroit Institute of Arts; Founders Society Purchase, Elizabeth Allan and Warren Shelden Fund (67.273)*

early friezes and, most tellingly, our attention is now arrested by simmering color and dense textures. This was the period when the aging Degas turned back longingly to the Venetian tradition, experimenting with warm painted grounds, scumbled brushwork, and the complementary mineral greens and earth reds that dominate the Detroit canvas today. He could be reckless as well as inventive, to the extent of superimposing such hues on existing limbs and faces, as he appears to have done in figures at the center and right of this scene.[85]

Almost certainly begun around 1880 and unquestionably reworked in the 1890s, the complex surface of *Dancers in the Green Room* has revealed under X ray the presence of obliterated forms and suppressed detail, while the naked eye can detect a canvas extension at the upper edge and brushmarks from more than one period.[86] It remains a difficult image to decipher historically, however, and may have been revisited by the artist more than once. The dozen or so drawings related to its human participants have been dated over two decades, while the rich, broad paint handling would have been inconceivable before the end of the century. A spirited charcoal study also in the Detroit Institute of Arts summarizes the quandary (plate 126), seeming to tease us with qualities from all these phases, though some finely scrutinized passages in the head and arm identify it as a rapid sketch for the first design.[87] But, crucially, our absorption in the expressive physical character of *Dancers in the Green Room* is suggestive of a deep shift in Degas' ballet art: in effect, the loss of precision in the painting coincides with a final loss of contact with the practicalities of the dance. This magnificent late frieze tells us nothing about the "nervous, thin girls" described by Huysmans, but everything about an aging artist reflecting on painting, on his distant memories of dancers in class, and on his strange identification with their laborious, thrilling profession.

and beyond, into the diminished cadence of their colleagues at the barre. In both this work and the Washington *Dance Class*, it seems, the artist felt that coarse textures or half-concealed marks would disrupt such a progression into depth and draw unwelcome attention to painterly battles fought and won.

The poignant and forceful finale to this lifelong saga is represented by *Dancers in the Green Room* (plate 125), still recognizably related to the early backstage scenes but—in its present form—completed some fifteen or twenty years later, when the artist was in his midsixties. In this magnificent deep gold, plum, and copper–colored vision of the classroom, Degas repeated the layout of the room, the double bass placed beneath a two-toned wall, the seated dance pupil in a cloud of muslin and her friend tying a blue sash, all following the Washington *Dance Lesson* like hallucinatory echoes. And yet the two pictures might be by a different hand, so contrasted are their palettes, their repertoires of touch, and their grave, internal music. After the midday clarity of the National Gallery canvas, the blurred contours of its successor in Detroit seem dreamlike and the distinctions between masses imponderable, as if the weight of the dancers rather than the artist's quick perception has brought them to a standstill. Nothing remains of the "Florentine" draftsmanship admired by critics in his

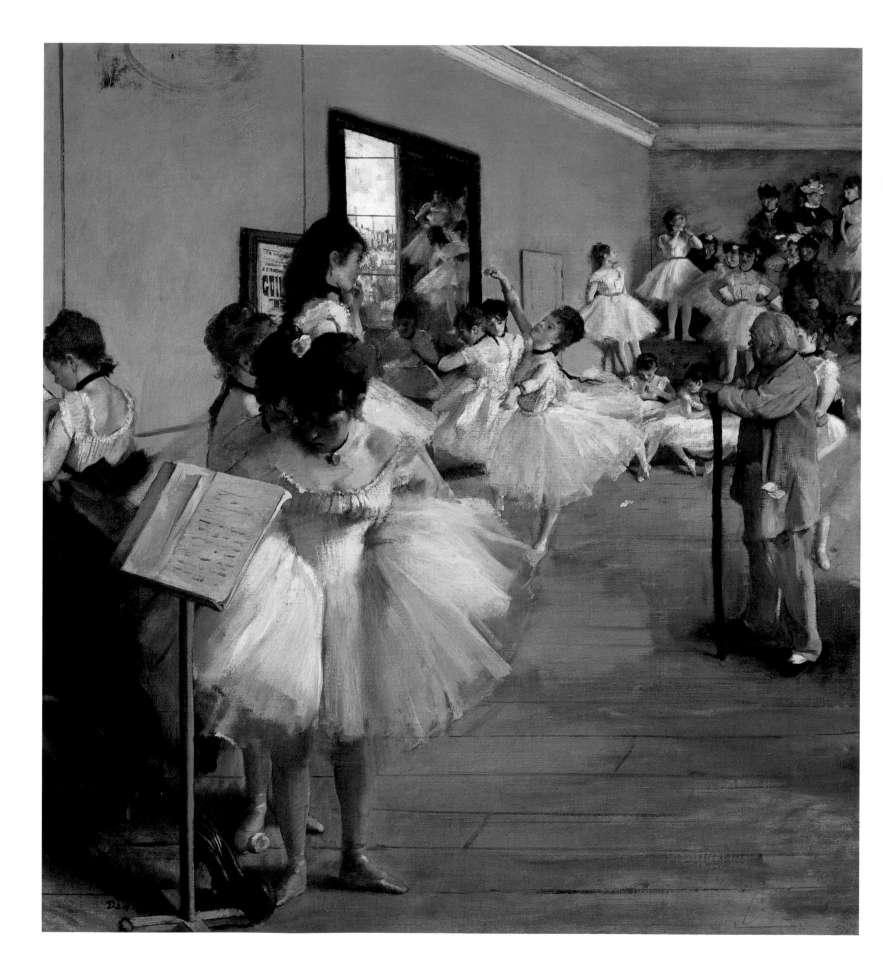

5. The Making of a Dancer

*Experience proves Degas right: he showed
what dancers are—creatures in pursuit of a craft.*

—TONI BENTLEY, FORMER DANCER
WITH THE NEW YORK CITY BALLET[1]

The professional lives of the dancers of Degas' era have almost disappeared beneath a century of accumulated legend, innuendo, and selective emphasis, some of it of the artist's own making. In his early masterpiece *The Dance Class* (plate 127), for example, almost twenty of the Opéra's dancers appear to adopt characteristic roles, from the idle young girls and their chaperones in the distance who watch and wait, to the energetic soloist demonstrating her *piqué attitude*, while somewhat older ballerinas in the foreground adjust their costumes as they prepare for action. Seemingly transparent in significance, these individuals and the pictures they inhabit have been overlaid with violently opposing assumptions from the beginning. Mary Cassatt proclaimed that *The Dance Class* was "more beautiful than any Vermeer I ever saw," speaking for several generations who have found in the work the charm and innocent vitality of the ballet itself.[2] But the same gathering of dancers, and their colleagues in the Musée d'Orsay's version of the subject (plate 229), have been seen quite differently. A writer in 1876 noticed only "a thick-set ballet master" and "an ugly dancing girl scratching her shoulder," while a recent critic believes that they "verge on caricature," "objects of sexual gratification and purchasable pleasure" who "slide uncontrollably about."[3]

The rival qualities of Vermeer-like calm and caricatural instability, of glamour and vice, indolence and labor, can all be shown to have some basis in the documented circumstances of the ballerinas at the Paris Opéra. Details of the girls and women who posed for paintings like *The Dance Class* were carefully recorded in the institution's archives, along with their contracts, records of their promotion and dismissal, and their final claims for pensions.[4] In the published literature, the arrangements for the dancers' training and their progression through the hierarchies of status and salary were explained, and several dancers and theorists attached to the Opéra wrote teaching manuals.[5] Outside the Opéra, photographs of its personalities were circulated in the tens of thousands, and their stage performances were dissected by scores of newspaper critics, while a sub-genre of gossip columns, "coulisses" journalism, and scurrilous memoirs fed a public appetite for scandal and rags-to-riches success within this world.

127. *Edgar Degas, The Dance Class, 1874.
Oil on canvas, 32¾ x 30¼ in. (83.2 x 76.8 cm).
The Metropolitan Museum of Art; Bequest of
Mrs. Harry Payne Bingham, 1986 (1987.47.1)*

Several volumes published around the time of *The Dance Class* help to fill out the details of the Opéra performers' existence. In Georges d'Heylli's *Foyers et Coulisses* of 1875, for example, we are offered a complete register of the theater's artistic staff, beginning with its directors and stage supervisors, proceeding to its singers, and then listing the names of 111 full-time dancers and their teachers.[6] From d'Heylli we learn that the current company of female dancers was divided into four principal strata, among which—incidentally—we find around a dozen individuals with whom Degas already had some familiarity. At their head were the twenty-eight *sujets*, including several who had either posed for the artist or been referred to in his letters; then a list of eighteen coryphées, which mentions Mlle Simon, with whom Degas had corresponded; they were followed by nineteen girls in the *premier quadrille* and eighteen in the *deuxième quadrille*, where the name of the young Alice Biot appears.[7] Degas' models in successive years were consistently chosen from the groups outlined by d'Heylli, as they progressed from category to category according to skill, experience, and influence in high places. Rigorous annual and bi-annual examinations were held to determine this advancement, followed by appropriate adjustments to the dancers' levels of pay. Paul Mahalin tells us that in 1869 *premier* and *deuxième quadrille* members received between 700 and 900 francs a year, coryphées advanced to 1,000 to 1,200 francs; and *petits sujets* earned 3,000 to 6,000 francs. From other sources we discover that *premiers sujets* were contracted at an annual salary of 6,800 francs or more, and that *étoiles*, then as now, negotiated their own terms, which could exceed 30,000 francs in the 1880s.[8]

Degas' attentiveness to the dancers' working lives took many forms, ranging across the youngest recruits and the veterans, the stars as well as the failures, and extending to their progress through the Opéra system. In the late 1870s he made several images of child-ballerinas and attended one of their examinations, while at the 1880 Impressionist exhibition he used the title *Dance Examination* for the much-admired pastel now in Denver (plate 128).[9] In this forcefully constructed composition, Degas thrust his contemporaries into the tense preparations of two young dancers awaiting their turn before the Opéra jury, when they presumably hoped to elevate themselves from the *quadrilles* to the rank of coryphée. His approach is both starkly descriptive and personally engaging, with crisp pastel lines and bold colors setting the scene in a bare corridor at the Palais Garnier and dense textures bringing to life its nervous occupants. Vividly characterizing each of the distracted ballerinas and their family supporters, Degas lingered over the freshly laundered practice clothes of the girls and the ribbons and bows with which they have been enlivened. Both candidates avert their faces, heightening the restlessness of the moment and adding them to the scores of dancers of unknown name, age, and social status who also populate Degas' art. Huysmans was in no doubt about their type: reviewing *Dance Examination* in 1880, he noted beside the figure in the foreground her "friend in street clothes, in the vulgar manner…and a nondescript mother in her bonnet in a floral shawl, with the mug of an old concierge."[10]

The critic and his peers knew that many of the Opéra recruits came from poor homes, submitting themselves to years of intensive training for small rewards, as they aspired to achieve the fame and fortune of popular romance. In the confused, quasi-scientific manner of the day, Huysmans believed that members of this class would necessarily appear "vulgar" and ill-formed, but his assumptions about the ballet dancers' economic origins were crudely correct. Other writers confirmed that the majority "were daughters of the common people, of hired hands from the workshop, the shop or the office, retired or humble performers, concierges," a view supported by modern research in the Opéra's records and elsewhere.[11] The register of new arrivals at the Opéra in mid-century reveals, according to Martine Kahane, that "more than half" came from fatherless families and from "mothers who were doorkeepers, laundresses," a situation that slowly improved after 1870 as "the dance was recognized as an art and a vocation" and "rules concerning compulsory education and the employment of children became stricter."[12]

It was also understood that a number of dancers supplemented their meager incomes and achieved advancement at the Opéra by offering sexual favors to *abonnés*, establishing settled liaisons with wealthy "protectors," or resorting to "occasional prostitution" simply to feed their families.[13] Examples from every level can be cited: the girls driven to suicide; the lifelong relationships between several leading dancers and their married companions; the ballerinas who were courted by financiers and diplomats with jewels, carriages, and sumptuous apartments; and the rare few who landed aristocratic husbands, dutifully listed by Mahalin.[14] This was the stuff of contemporary legend, immortalized in visual form in countless cheap prints of backstage dishabille (plate 129), in scenes of overt titillation (plate 115), and even in semi-erotic photography.[15] Several opportunistic novels exploited the theme: Ludovic Halévy's tales of two amorous young Opéra pupils—one of whom married the fictitious Marquis Cavalcanti, the other becoming "*une grande cocotte*"—helped his *La famille Cardinal* become a bestseller, while Félicien Champsaur's *L'amant des danseuses* carried the image of the promiscuous ballerina into frankly pornographic territory.[16] Following his Degas-like hero to the theater ("a harem"), into the wings ("an intense sexual and pecuniary melee") and finally into the bed of an *étoile* he hoped to paint, Champsaur evoked the "artistic and sensual fever" experienced by "Decroix" in the dancer's company.[17]

As we return to the documented events of the dancers' lives, we discover that contemporary writers repeatedly stressed the ballerinas' diversity of background, character, and motivation, though this has rarely been acknowledged in the Degas literature.[18] Nestor Roqueplan stated that it was "incorrect to compare the wings to a seraglio" and stressed the "tendency of women of the theater to find husbands among fellow professionals," an assertion borne out by recent studies.[19]

128. Edgar Degas, Dance Examination, 1880. Pastel and charcoal on paper, 25⅝ x 18⅝ in. (63.4 x 48.2 cm). Denver Art Museum; Anonymous gift (1941.6)

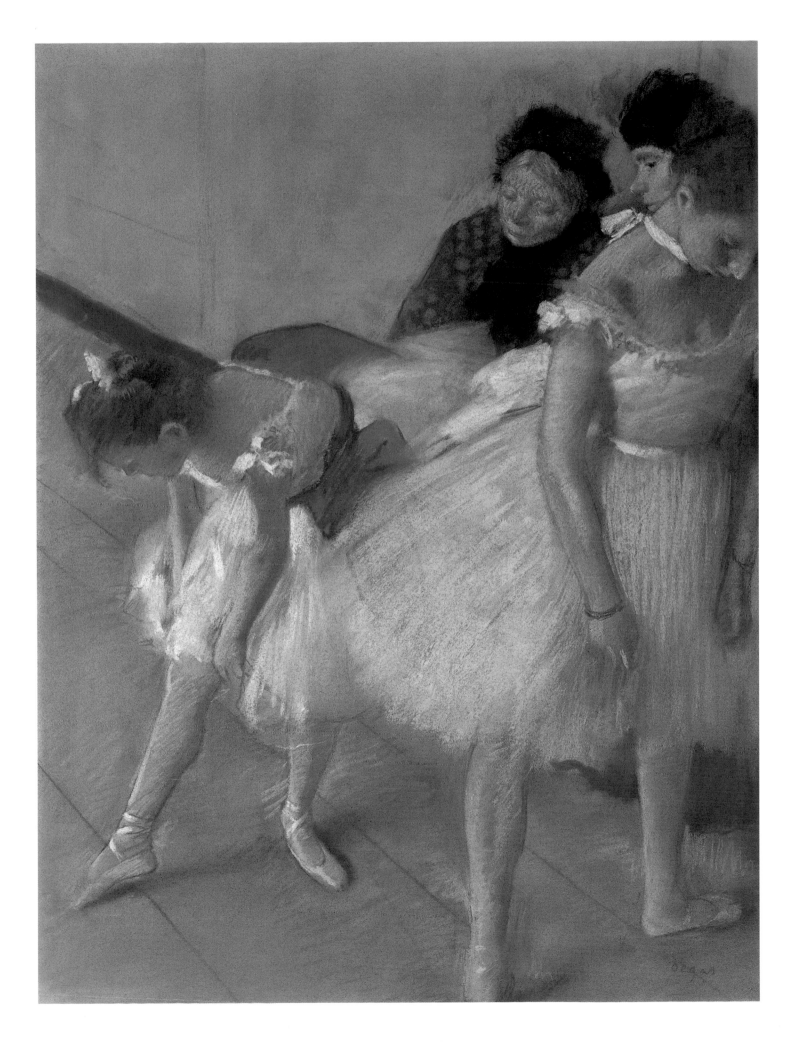

129. Paul Renouard, from The Dance, Twenty Drawings by Paul Renouard, 1892. Jerome Robbins Dance Division, The New York Public Library for the Performing Arts, Astor, Lenox and Tilden Foundations

In the late 1860s, the salacious Vizentini admitted that, in reality, most ballerinas were "too absorbed by their daily gymnastics" for other pleasures, a sentiment echoed by Théophile Gautier, while Paul Mahalin acknowledged in 1887 that there were "no more Babylonian orgies" at the Opéra.[20] One view offered by these witnesses opens up an important new perspective on a poorly understood situation, insisting that the Opéra's ballerinas could be more practically separated into two broad types: the sexual adventurers and the committed professionals. On the one hand were the girls with "the lightest of morals... especially those in the corps de ballet" and on the other "the true dancer," who is "passionate about her art and sacrifices everything to it."[21] Mahalin—hardly a moral judge—arrived at a similar conclusion, distinguishing between "the young ones, who search for wealth" and what he called the "serious dancers."[22]

This "highly nuanced terrain," as Kahane describes it, has been insufficiently explored by students of Degas' dance art.[23] It is now clear that he knew both the Opéra and its recent history in some detail, and that his acquaintances among its personnel came from every rank and with every reputation, from the dignified Jules Perrot, to the members of the semi-criminal van Goethem family. The acutely class-conscious Degas would have been aware that, alongside the many

girls from working-class homes, there was a steady stream of young women from "privileged" backgrounds, such as a certain Anna Rust, who was treated with politeness "even by the machinists."[24] Similarly, though the majority were young and single, some were already married and many others found partners among the Opéra employees, who in turn frequently put their offspring on the stage.[25] Personal reputations also soared from the lowest to the highest: the great Taglioni herself was remembered by Véron as indifferent to wealthy suitors, "a good and honest person" who helped her less fortunate colleagues; Adèle Grantzow was known for her simple tastes and Lutheran beliefs; and the prodigious Emma Livry lived out her short existence with her mother and refused all gifts from her admirers.[26] Among those known to Degas, certain models returned to the obscurity from which they had emerged, while the Mante sisters (plate 237) came from a sheltered bourgeois family and enjoyed long, impeccable careers at the Palais Garnier.[27] Rosita Mauri, who may be the subject of Degas' magnificent pastel portrait (plate 244), was celebrated for the strictness of her regime, denying to journalists that her private life involved even "the smallest little adventure," while the authentically aristocratic Cléo de Mérode was famed for both her beauty and her virginity.[28]

A single case history brings the story into focus in the context of Degas' most ambitious ballet sculpture, Little Dancer, Aged Fourteen (plate 130). The model for this unusually well-documented work was Marie van Goethem, one of three sisters who attended the Opéra dance school in the 1870s and who all appear to have posed for Degas, their near-neighbor during this decade.[29] Investigation by Martine Kahane has uncovered the girls' precarious circumstances, dependent on their mother's income as a laundress and their own from the Opéra.[30] A year after enrolling at the Opéra in 1878 at the age of thirteen, Marie modeled both clothed and naked for a series of superb drawings made by Degas in preparation for his famous wax statuette.[31] By 1882 there is evidence that the eldest girl, Antoinette, and possibly the mother had engaged in prostitution and criminal theft, while Marie was acquiring a reputation as a dancer "with the lightest of morals": "she poses for painters and consequently frequents the brasserie des Martyrs and the Rat Mort," one newspaper reported suggestively.[32] When she failed to attend eleven ballet classes in April of that year Marie was dismissed from the Opéra. In complete contrast was the career of her younger sister Louise, who emerged from this same harsh background to become a model student at the Palais Garnier. She gradually progressed through the system of examinations and promotions, advanced to the quadrille in 1883, to coryphée in 1887 and to sujet in 1889. Louise, in other words, was the exemplar of the "serious dancer," developing into a performer of some distinction in the 1890s and achieving the ultimate in respectability as an Opéra teacher after her retirement from the stage in 1907.[33]

130. Edgar Degas, Little Dancer, Aged Fourteen, 1878–81. Bronze and fabric, 39 in. (99 cm). Philadelphia Museum of Art; The Henry P. McIlhenny Collection in memory of Frances P. McIlhenny, 1986 (1986-26-11)

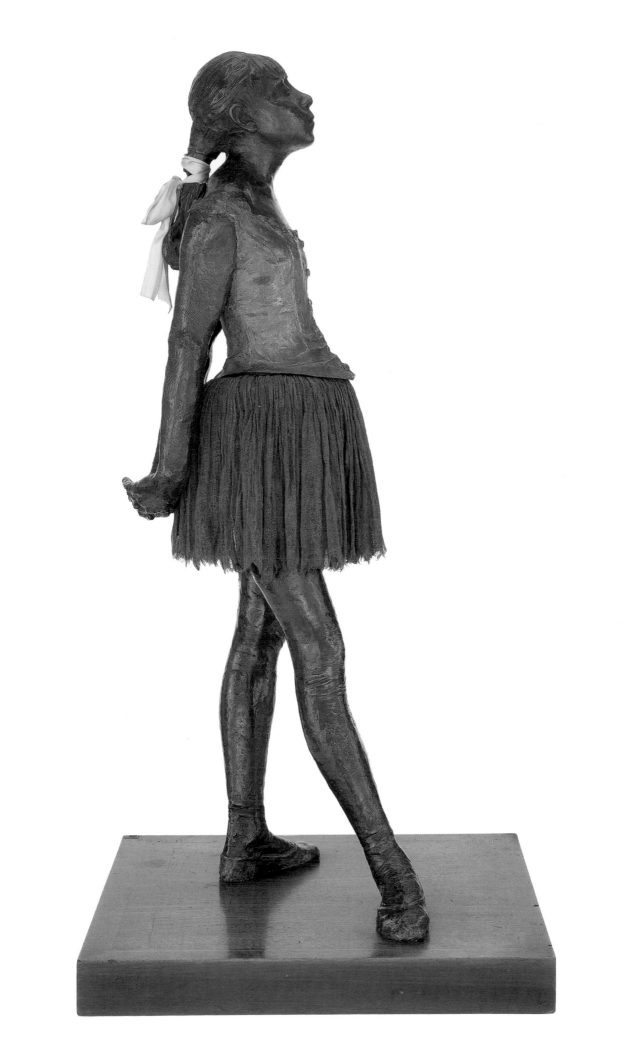

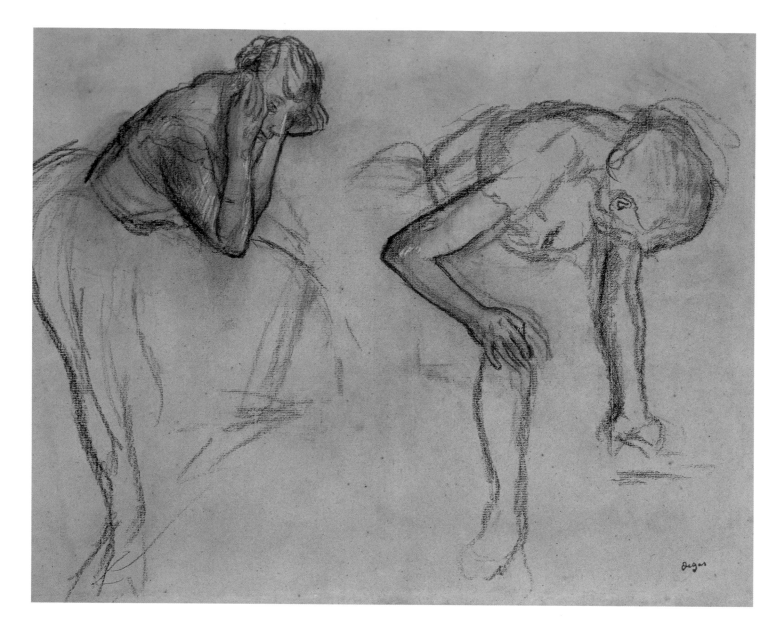

131. *Edgar Degas,* Study of Two Dancers, *c. 1885. Charcoal and chalk on paper, 18¼ x 24 in. (46.4 x 61 cm). High Museum of Art, Atlanta, Georgia; Anonymous gift (1979.4)*

Degas' negotiation of these extremes of professional behavior, and the many shades in between, offers another inflected approach to his many hundreds of ballet subjects. Some performance scenes, such as *The Star* (plate 103) and *Orchestra Musicians* (plate 1), revolve around young women who project their skills and their physical charms at the Opéra's largely male audience; "make them want to sleep with you," Vestris had advised an earlier generation.[34] Approximately half his suite of *Famille Cardinal* monotypes refer to the backstage encounters of Halévy's heroines and a small number of pastels and paintings, such as *Three Dancers in the Wings* (plate 106), incorporate figures who might be either predatory *abonnés* or Opéra officials. But statistically the dominant group in his ballet oeuvre is concerned with dancers "absorbed by their daily gymnastics," the hard-working beginners at the barre, the tired corps members behind the scenery, and the individuals— some of them presumably "serious dancers"—who endlessly practice their steps. In comparison with the most banal ballet imagery of the

day, including both titillating photographs and Salon paintings, most of his depictions of dancers are almost asexual, avoiding the exaggerated bodily attributes and the gratuitous exposure of flesh that characterized the prints of Legrand or the pastels of Carrière-Belleuse, and the suggestive eye contact and obscene gestures of Lautrec or Forain. Though he was neither naïve nor innocent as a dance artist, and while we should not overlook the erotic potential of lightly clad and muscularly engaged women for certain tastes, Degas' distance from the voyeuristic ballet vocabulary of his day remains a defining characteristic.

Physical exertion and its aftermath, on the other hand, became one of Degas' obsessive themes, exemplified in the austere lines of *Study of Two Dancers* (plate 131) and the desolate pastel *Dancer Stretching* (plate 132). In the former, a single figure responds to two of the most familiar consequences of ballet exercise, bending over to nurse an aching limb and struggling to support a weary body. Economical

132. *Edgar Degas,* Dancer Stretching, *c. 1882–85. Pastel on paper, 18⅜ x 11¾ in. (46.7 x 29.7 cm). Kimbell Art Museum, Fort Worth, Texas (PA 1968. 04)*

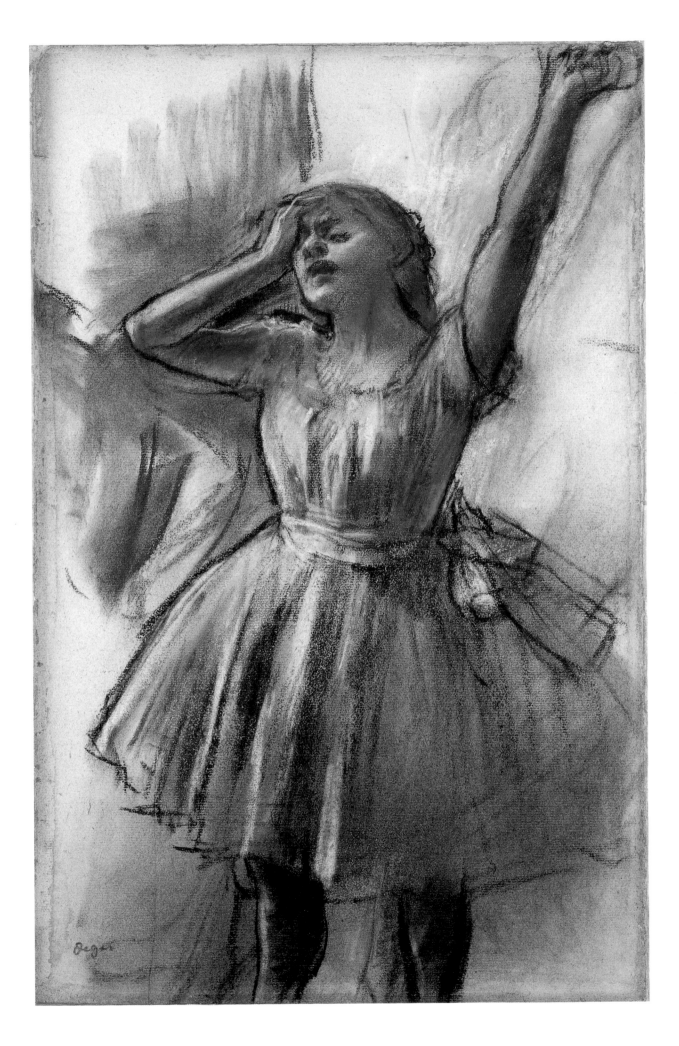

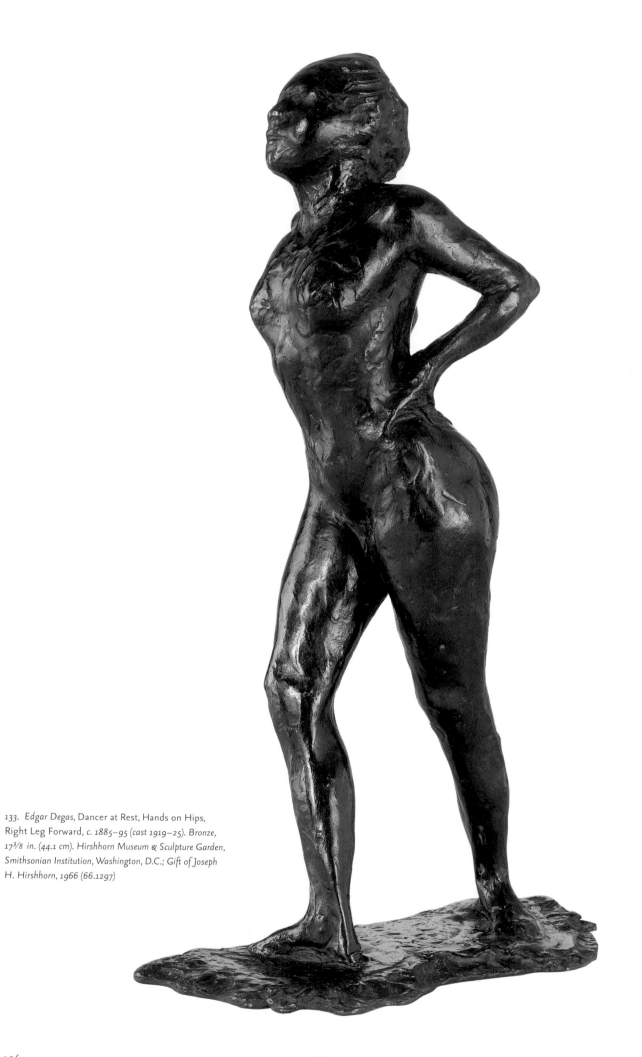

133. *Edgar Degas, Dancer at Rest, Hands on Hips,*
Right Leg Forward, c. 1885–95 (cast 1919–25). Bronze,
17³⁄₈ in. (44.1 cm). Hirshhorn Museum & Sculpture Garden,
Smithsonian Institution, Washington, D.C.; Gift of Joseph
H. Hirshhorn, 1966 (66.1297)

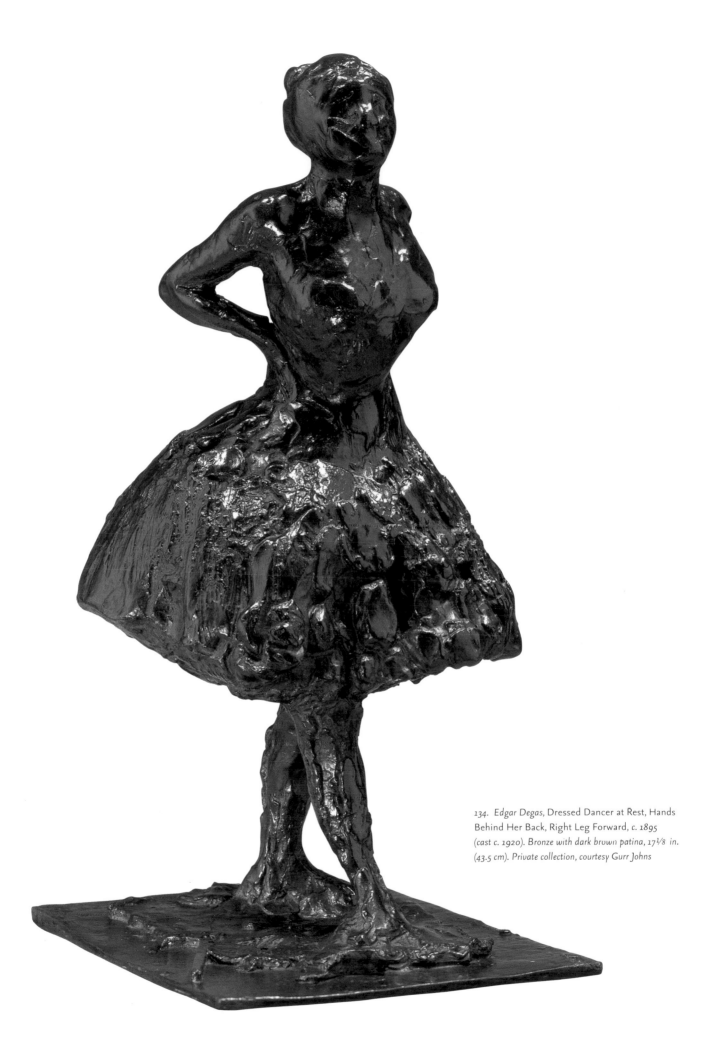

134. *Edgar Degas, Dressed Dancer at Rest, Hands Behind Her Back, Right Leg Forward, c. 1895 (cast c. 1920). Bronze with dark brown patina, 17⅛ in. (43.5 cm). Private collection, courtesy Gurr Johns*

yet intensely focused, this moving sheet isolates just those features—the splayed fingers, pointed elbow and slit-like mouth and eyes—that most effectively convey strain, without introducing a hint of glamorous self-awareness. Begun as drafts for more extensive compositions, variants of these images acted as reminders of daily fatigue in classrooms scenes from the 1870s to the 1890s.[35] The most exhausted of all Degas' ballerinas may be that in *Dancer Stretching*, whose tiredness has crossed over into pain and whose gesture seems to be that of despair. The rigors of the dancers' exercises formed a constant refrain in the Opéra literature, from Roqueplan's account of the "hideous contortions, such as *pliés* and *battements,* which weaken them, stifle them, drown them in sweat," to a description written about the time *Dancer Stretching* was created: "some groan or moan, others gasp and cough," we are told, and yet others "can barely support themselves, overcome, crushed, almost dead."[36] Degas rose to this challenge in his monumental design, placing the model centrally and frontally while reducing her legs to near-ciphers, and allowing no distraction from the anguish expressed in her face and upper body. Even the untypically cool, acidic colors add to the harshness, suggesting the hard lines of a marble relief and perhaps alluding to mourning figures from the Christian or classical vocabulary. Strangely, Degas used this bold form for a tiny coryphée at the back of a classroom frieze, "with an almost perverse twist"—as Gary Tinterow has observed—relegating "to a secondary position one of his most expressive figures."[37]

The demands placed upon the dancer's body became a particular concern of Degas' manipulations in wax and clay. In *Dancer at Rest, Hands on Hips* (plate 133), a strongly built nude woman displays her muscular limbs and torso, arching her back in preparation for the "gymnastics" to come or recuperating after class. Here she is presented in her physical rather than her sexual glory, an athlete who has trained at the Opéra's barres and now confidently balances the diagonal forces of legs and arms, boldly thrust neck, and firmly planted feet. The energetic containment of this figure, too, haunted Degas in dozens of two- and three-dimensional works of art, most of them made in the last twenty years of his working life.[38] It has often been suggested that he found an equivalent for his own discipline in the dancers' ritualized labors, identifying more closely with their weariness as he grew older. The exceptional clothed version of the same posture, *Dressed Dancer at Rest, Hands Behind Her Back, Right Leg Forward* (plate 134) was probably modeled in the mid-1890s when the artist was in his sixties and already complaining of indifferent health. The only sculpture in which Degas translated the fabric tutu into the same dark wax as the dancer's body, it is also one of his few statuettes with a low center of gravity and a corresponding massiveness. Still tensing her spine and supporting it with bent elbows, this dancer seems fragile under the weight of her skirt, even oppressed by her craft and at the limits of her endurance. The same clothed performer recurs in a dated pastel of 1894, while at least one charcoal study reveals a woman dressed only in bodice and tights, reminding us of the practical origins of this remarkable image in Degas' studio.[39]

It is in the nature of such drawings and sculptures that Degas depicts the dancer off guard, neither showing herself to the best advantage nor acknowledging the artist's presence. As with the backstage narratives by Halévy, Vizentini, Champsaur, and their peers, we are encouraged to believe that Degas has seen these sights and learned something of their significance, sharing their exceptional frankness about the working circumstances and physical attributes of these girls. Gautier shamelessly admired the "charming body" and "sexless beauty" of the teenage Eugénie Fiocre, "vaguely glimpsed through flimsy gauzes," after defining another type—that of the young Caterina Beretta—as "small, and with a body developed by the violent gymnastics of ballet training."[40] This phrase could almost have been written for the slender figure in Degas' *Coryphée Resting* (plate 123), whose limbs are those of a youth or perhaps a sufferer from the "original anemia" resulting from a diet "of Italian cheese and wine by the liter," as Huysmans claimed of the poorer dancers.[41] Backstage gossips like Mahalin easily dismissed the attenuated members of the corps—such as "Mlles Barratte and Lamy"—as merely "skinny," then brazenly preferred the "superb chest" of Rita Sangalli, while imagining "beneath the dress" of Rosita Mauri her "blooming bosom, her amply proportioned thighs."[42] Contemporary images of some of these stars, such as Sangalli (plate 96) and Julie Subra (plate 135), show them to have been heavily built by today's standards, but it was not unknown for a dancer of "enormous girth," such as Amina Boschetti, to fall from favor, or for excessive "embonpoint" to threaten a career.[43]

Degas' knowledge of the dancers' way of life extended to their behavioral idiosyncrasies and their attentions to comfort, appearance, and clothing. *Dancer with Red Stockings* (plate 137) combines two such studies in a modest progression, from the introverted and apparently cold girl at left to the suddenly active figure slipping on her tomato-hued leg warmers. The context is slightly puzzling, since similarly huddled ballerinas appear in drawings for the classroom scene, *The Dance Lesson* (plate 121), while the more lively character is dressed for the stage in a dramatic costume of black trimmed with white. But Degas' sympathetic response to their predicament is far from documentary, setting the hunched shoulders and tightly compressed body of one young woman against the open manner of the other, and highlighting such carefully observed minutiae as the thumbs slipped between the latter's red and black garments. No doubt first noted in the classroom or backstage, most of these inglorious moments from the dancer's toilette must have been recreated by ballerina-models in his studio, then patiently translated into charcoal, pastel, or wax. *Dancer Fastening the String of Her Tights* (plate 138) represents just such a fleeting moment in three dimensions, an extraordinary spiraling action that catches the human animal at its most supple, arms twisted in one direction and left leg in another. The subject raises questions about Degas' close scrutiny of a private act and his decision to show the figure illogically and unhistorically naked, which will be considered in a later chapter. It also belongs to a significant group of his sculptures that are notionally based on the dance, yet have little relationship to the stage or the formal class.

135. *Julie Subra, photograph from* Le Théâtre, *December 1898. Bibliothèque nationale de France*

In *Dancer Adjusting Her Slipper, Bust of Pierrette* (plate 136), a similar alertness to the intricacies of apparel led Degas to a ballerina easing on her slipper, inserting her fingers around her ankle as she prepared for a performance or dress rehearsal. Nuitter describes these final touches in the wings: "At the last moment before going on stage, the dancer puts on new shoes…makes a few pirouettes in front of the mirror…strikes some poses to check that her skirts are not creased… puts a little white on her arms, on her hands…grinds a small piece of resin under the foot to prevent slipping, and then sets out."[44] Though rapidly executed, Degas' pencil sketch seizes the lithe form of the young woman and her improvised position, while taking in the half-concealed hand in her muslin skirts and the elegance of her well-groomed head. The dark hue of the bodice is distinct from plain practice dress, leaving no doubt that this was a formal stage ensemble, while the enigmatic study of a figure with a kerchief tied in a bow and a skullcap at lower left hints at a more complex sequence of events. If this shows a second ballerina, she is presumably dressed for one of the "travesty" roles that commonly featured in the Opéra's divertissements, which became a specialty of stars like Eugénie Fiocre

and Alice Biot. If it is the principal figure in a different guise, however, we may glimpse a rare reflection by Degas on the shifting nature of theatrical identity and the camouflage of costume.

Scattered throughout Degas' career, these intimate images amount to an informal narrative of the ballerina's grueling day. "After having been at class from nine o'clock in the morning until one, then from one until four," Vizentini tells us, they returned for the evening spectacle with "a smile on their lips, to play the sylphide as if nothing had happened."[45] Classes took place six days a week, with afternoons and sometimes evenings occupied by rehearsals for forthcoming productions.[46] Though public performances during much of this period were confined to Monday, Wednesday, and Saturday, they typically lasted for several hours and frequently ended well after midnight, adding to the burdens of the younger contributors.[47] Several of Degas' pictures show these trainee dancers and their chaperones in street clothes (plates 127, 128, and 164), linking us to their lives outside the building and their journeys back and forth to the Opéra from the poorer quarters of the city.[48] Lateness and other minor infractions were punished by a strictly implemented system of fines and—as in the case of Marie van Goethem—dismissal followed a certain number of absences.[49]

The life of the young dancer was examined at length in a long, witty, but ultimately sympathetic essay published in 1856 by Théophile Gautier, entitled *Le Rat*.[50] Though some of the rituals he describes were outmoded by Degas' day, the gist of his account was still vividly

136. *Edgar Degas,* Dancer Adjusting Her Slipper, Bust of Pierrette, *c. 1880. Pencil and gouache on paper, 16¾ x 12¼ in. (42.6 x 31.2 cm). Private collection, United Kingdom, courtesy Frost & Reed, London*

137. *Edgar Degas, Dancer with Red Stockings, c. 1884. Pastel on pink laid paper, 29⅞ x 23⅛ in. (75.9 x 58.7 cm). The Hyde Collection Art Museum, Glens Falls, New York (1971.65)*

138. *Edgar Degas, Dancer Fastening the String of Her Tights, c. 1885–90. Bronze, 16¾ in. (42.5 cm). Cincinnati Art Museum; Gift of Ethan Emery, Irene Emery Goodale, Melissa Emery Lanier, and Lela Emery Steele in honor of John F. Steele's election as President of the Board of Trustees of the Cincinnati Museum Association (1992.138)*

139. Edgar Degas, Ballet Dancers Rehearsing, *from* An Album of Pencil Sketches, *c. 1877. Page 23 from Notebook 28. Pencil on wove paper, 9⁷⁄₈ x 13³⁄₈ in. (25 x 34 cm). The J. Paul Getty Museum, Los Angeles (95.GD.35.12)*

appropriate. After rising at eight and eating almost nothing, Gautier explained, the children left home with their mothers and walked to the Opéra, to begin the first of many changes of clothing, footwear, and demeanor that might continue into the night. Performance shoes were provided by the management, to be used "six times if they are white, ten times if they are pink," while cast-offs were employed for daily classes. These took place in a vast room, "severe and mournful," where from the age of seven or eight the pupils undertook their exercises in order to "relax the joints and extend the muscles" (the apparatus resembling "instruments of torture" used in Gautier's time was to gradually disappear); "to dance passably, ten years of uninterrupted work are needed," the author noted.[51] After their classes, rehearsals were held in the unheated auditorium, followed by a brief return home for another meager meal. Around six, they traveled once more to the Opéra to prepare for the stage and another sequence of costumes, the younger dancers often standing in as extras or in largely decorative roles for which they were paid a small fee. Gautier was

frank about the amorous advances once made to the teenage *rats*, adding that such practices were in decline; "the wild, crazy life has given way to domestic life, the working life," he wrote, a view endorsed in the subsequent accounts by Berthe Bernay and Cléo de Mérode.[52]

Within five years of Gautier's death in 1872, Degas had embarked on a group of pictures of the Opéra's younger *rats* that included several drawings in pencil, substantial works in pastel (plate 237), and two crowded pages of a current notebook (plates 139 and 140). The exertions undertaken by these children could be strenuous, a fact acknowledged in the Opéra's insistence that applicants be examined by the company's official doctor and their physical progress monitored, while from at least mid-century dancers had been taught to "warm up" before classes and performances to lessen the chance of "accidents."[53] As in Gautier's day, a new recruit would also abandon any chance of a school education on entering the Opéra: "Erudition is not their strong point," he wrote dryly. "It is quite something if they can read and their handwriting is very like hieroglyphics...they would do better if they wrote with their feet." Some pupils were more fortunate, as Degas' circle of acquaintance shows, growing into literate and multilingual individuals who held their own in sophisticated society.[54]

140. Edgar Degas, Ballet Dancers Rehearsing, from An Album of Pencil Sketches, c. 1877. Page 25 from Notebook 28. Pencil on wove paper, 9⅞ x 13⅜ in. (25 x 34 cm). The J. Paul Getty Museum, Los Angeles (95.GD.35.13)

The all-absorbing instruction of the young dancer is cleverly suggested in Degas' encounter with a roomful of *rats*, recorded in two sheets from a notebook he used around 1877 (plates 139 and 140). These drawings are especially remarkable for being carried out from memory at the home of the Halévys, where the book was kept, testifying to his formidable powers of recall, as well as his observant presence in the Opéra classroom. Though classes were strictly formal and—as Gautier and Cléo de Mérode both tell us—conducted in silence, we almost sense the noise and energy for which these girls were notorious at other times, as they test out their steps or gather round their seated teacher before the day's work begins.[55] Two distant figures sway at their hips, others stretch in *attitude* or practice a moment from a stage role, while the largest figure nurses a sore arm or simply waits abstractedly. Most of the teachers for the female students were women, led by the legendary Mmes Dominique and Théodore, one of whom may be shown here in an unusual vignette of social contact with the girls in her charge. There is implicit camaraderie in many such cloistered scenes, helping to sustain "these frail creatures offered as sacrifices to the Parisian Minotaur," as Gautier phrased it. At this age, he claimed, "the world does not exist for them. Talk to them about the simplest things, they will be ignorant of them; they know only the theater and the dance class; the spectacle of nature is closed to them; they barely know if there is a sun, and see it only rarely…they can't tell the difference between a beetroot and an oak tree; they only see trees that are painted, unlucky things!"[56]

IN THE CLASSROOM

To ballet dancers in the twenty-first century, Degas' classroom scenes seem strikingly familiar: his spacious interiors fitted with barres resemble the studios in which they train, and much of what happens in them corresponds to their own learning experience. An analysis of the ballerinas in Degas' compositions reveals that they practiced a codified body of steps that has remained remarkably unchanged since the late nineteenth century.[57] In *Dancers in Plié at the Barre*, for example (plate 141), we see two young girls engaged in a routine that is still part of every ballet dancer's daily conditioning. The pose of the figure in the

foreground is nearly identical to that in a technique manual written in 1890 by the former Opéra dancer and teacher Berthe Bernay (plate 142), but in his wry treatment of the scene Degas uses two variations of the position to suggest the movements involved, evoking the falling action of the torso as the knees bend.[58] Scores of similar cases can be found in the artist's two- and three-dimensional oeuvre, where we see dancers working at the barre, in groups in the center of the room, or warming up in much the same way as the dancers of our own era. So continuous has the classical dance tradition been, as it is passed down from one generation to another, that a student today can identify almost every step and exercise depicted by Degas. His realism is never less than complex, but his engagement with the formalized tradition of the ballet offers a unique opportunity to assess the accuracy of these representations of dancers, using benchmarks and terms of reference that are largely unavailable in discussions of his other subject matter.

This is not to say that ballet practice has remained stagnant over the last one hundred and twenty years. Different schools and styles have evolved, notably in Russia, England, and America, and new steps and exercises have been introduced into the classical repertory.[59] The technical proficiency of dancers has continued to rise, progress has been made in the scientific understanding of the body, and modern

142. Plié in Second Position, *from Berthe Bernay,* La Danse au Théâtre, *1890*

dance forms and their postmodern progeny have had their invigorating impact. But despite this broadening of the dancer's experience, the training of ballet pupils is still largely based on principles first formalized in 1820 by the Italian dancer and instructor Carlo Blasis, in his seminal treatise *Traité élémentaire, théorique et practique de l'art de la danse.*[60] Blasis's teachings were further developed during the Romantic era by Filippo Taglioni and François Albert, and by ballet masters

141. Edgar Degas, Dancers in Plié at the Barre, *c. 1880. Pastel on paper, 13 x 20 in. (32 x 52 cm). Collection Janet Traeger Salz, New York*

THE MAKING OF A DANCER

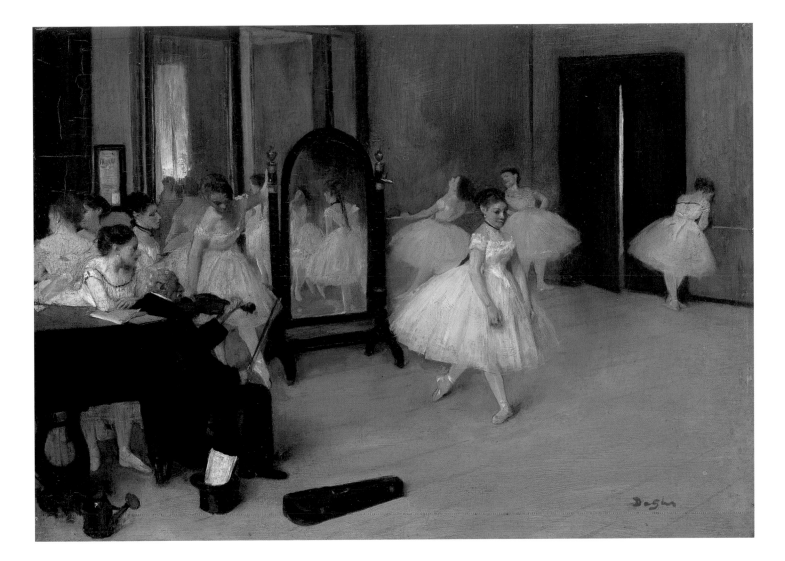

143. Edgar Degas, The Dancing Class, c. 1871–72. Oil on panel, 7¾ x 10⅝ in.
(19.7 x 27 cm). The Metropolitan Museum of Art; H.O. Havemeyer Collection, Bequest of
Mrs. H.O. Havemeyer, 1929 (29.100.184)

still active in Degas' day such as Arthur Saint-Léon, resulting in methods of training and a dance vocabulary that was even closer to that of classical practice today.[61]

In Degas' first classroom paintings, completed shortly after 1870, the dancers hold themselves decorously and self consciously, as if in response to an unfamiliar visitor in their midst. As his ballet imagery evolved and his knowledge of their activities deepened, and perhaps because they had become accustomed to his presence, such formalities were gradually abandoned. The earliest of such pictures (plates 143 and 19) might be described as serene: the dancers are sedate, the colors are subdued, and the light filters evenly throughout the space and across the figures. The miniature scale of both works invites close scrutiny, encouraging us to admire the artist's refined brushwork and his meticulous description of these variously clustered and solitary ballerinas. In the Musée d'Orsay canvas (plate 19), the gesture of the white-clad instructor—who has been identified as the Opéra's ballet master, Louis Mérante—seems to have suspended much of the classroom's activity, allowing him to address the dancer standing opposite.[62]

Like the principal ballerina in the New York panel, the subject of Mérante's interest assumes a preparatory position, as both she and the violinist wait for the signal for her variation to begin. Other dancers in the two works are shown stretching at the barre, pointing their feet, or watching the figure under instruction—all commonplace occupations in the classrooms of today—but most are attractively posed, in contrast to the lively and often uninhibited characters who populate the practice scenes that followed. Within a short period of time, Degas appears to have become invisible, as irrelevant to their self-awareness as the humble male instrumentalists who provided music for their classes.

Degas' inexperience of the classroom may also be reflected in the numerous preparatory studies he made for these pictures, including a vigorous essence (oil paint thinned with turpentine) on paper sketch showing two dancers relaxing by the barre (plate 144). Though the sheet was rapidly executed and lacks detail, the figure at left was clearly the starting point for the background dancer to the right of the doorway in the Paris painting (plate 19), while the pose of her companion resembles that of the ballerina beside the door in the New York panel (plate 143). As a study of dancers at rest, the drawing is respectful and already remarkably well informed, focusing on their actions rather than their features. Degas' description of these bodies

144. *Edgar Degas, Two Dancers at the Barre, 1871–72. Essence on pink paper, 8¾ x 11⅛ in. (22.3 x 28.3 cm). Museum Boijmans Van Beuningen, Rotterdam (F II 54)*

evokes the many hundreds of hours they have spent training at the Opéra: both ballerinas display the flexibility in the hip sockets that allows them to rotate their legs and feet outward, a crucial requirement for classical dancing; the figure with her back to the barre possesses the developed musculature of an experienced dancer and the confident bearing that accompanies it; and the young woman turning toward us is exploiting a relaxed moment to point and stretch her right foot. The universality of their actions is vividly brought home in a photograph of members of the American Ballet Theatre standing by the barre a century later (plate 145), their feet similarly crossed or splayed, their bodies in comparable stances. Such responsiveness has always endeared Degas to those close to the ballet, from the erudite

Lillian Browse to the more recent Toni Bentley, who asserts that his "dance scenes convey an entire world, the one dancers inhabit— unique, specialized, insulated, and dedicated to the perfection of an ideal."[63]

Soon after returning from New Orleans in 1873, Degas began work on *The School of Ballet* (plate 146), a larger, more intricate, and

145. *Eve Arnold, Deanne Albert, Cynthia Balfour, Cynthia Anderson, Cheryl Yeager, Alessandra Ferri, from John Fraser, Private View: Inside Baryshnikov's American Ballet Theatre, 1988*

THE MAKING OF A DANCER

much more candid image than his two earlier paintings on this theme.[64] The trio in the foreground of this work tell us that any sense of decorum has been abandoned: at center, a dancer bends over to tie her shoe; the ballerina in a red shawl sits with legs apart and feet turned out; and a colleague at far right turns awkwardly to tie her sash, allowing a glimpse of her barely covered chest. Immodest as these actions seem, they would hardly be inappropriate in a dance classroom: ballerinas habitually fasten their shoes from a standing position without bending their knees because it stretches their hamstrings and they still take advantage of restful moments to splay their legs in order to engage their inner thigh muscles.[65] Even the pose of the figure at right would hardly be noticed in such circumstances, where revealing clothing and bodily display are the norm. However innocent or commonplace these actions might be in class, of course, in Degas' paintings they were effectively made available for public consumption. Some of the appeal of such works unquestionably derived from glimpses of partly clad and indiscreetly poised girls and women, just as much of it depended on his inventive response to that world.

Degas' critics frequently remarked on the ungainliness of the models in his ballet pictures, describing them as "bizarre and ugly rather than graceful," or as "skinny girls with uncertain shapes and repulsive features, whose movements lack harmony."[66] Much of this resentment can be traced to the disparity between public image and private reality, between the dancers whom Degas most often represented—those engaged in "bizarre and ugly" classroom activities—and idealized notions of the "graceful" ballerina. As in his other studies of the working women of Paris, from laundresses to prostitutes, Degas was evidently committed to making art for his fellow citizens out of the raw material that nourished their luxury and pleasure. At the Opéra, this necessarily involved what Eunice Lipton has called the "demystification of the dance," a matter-of-fact engagement with long hours in class and rehearsal rooms, where youthful physiques were tuned for their fleeting roles in the footlights.[67] In this important sense, the large number of Degas' pictures devoted to backstage subjects is proportional to the experience of ballerinas everywhere. The arduous training methods of Taglioni and his successors were conceived to build muscles, increase flexibility, and acquire control over the body,

146. Edgar Degas, The School of Ballet, c. 1873. Oil on canvas, 18¾ x 24½ in. (47.6 x 62.2 cm). The Corcoran Gallery of Art, Washington, D.C.; William A. Clark Collection (26.74)

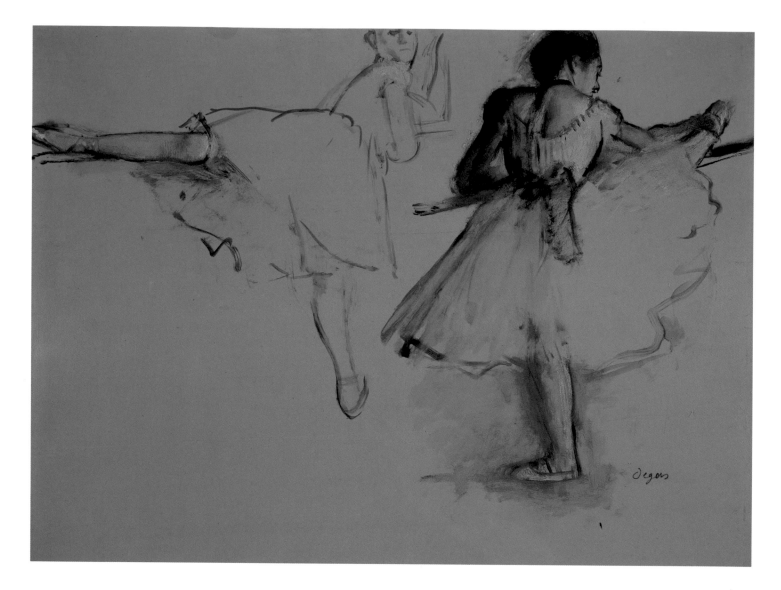

147. Edgar Degas, *Dancers at the Barre, c. 1873. Oil paint, thinned with turpentine on green paper, 18⅞ x 24⅝ in. (47.9 x 62.5 cm). Trustees of The British Museum, London (1968-2-10-25)*

148. *The Dance Class of Madame Théodore, from Le Figaro Illustré, February 1895. Bibliothèque nationale de France*

in order to attain the gracefulness that performance demands.[68] On stage, the dancer was required to maintain a continuous illusion of effortlessness, as if her turns, leaps, and extensions were achieved without strain. Transcendence and practicality thus became interdependent, as they were in Degas' formulation of his own craft: "Art is the same as artifice, that is to say something deceptive," he told Henri Hertz. "It is necessary to give the impression of nature by false means, but it must appear true."[69]

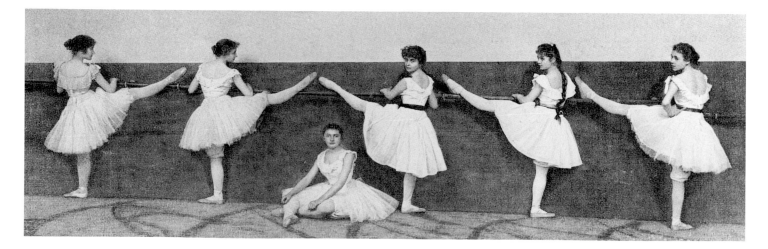

THE MAKING OF A DANCER

One of the most common classroom sights is that of a figure stretching at the barre, an action listed by Paul Mahalin as among the "various tortures" endured by the dancer.[70] Part of a standard limbering-up process, this exercise was represented by Degas in several of his pioneering ballet pictures and continued to engage him until his old age (plates 19, 168, and 320). Among the earliest is a dramatic study in essence on green paper made around 1873 (plate 147), where one ballerina is positioned with her back foot on the barre and a companion extends her front leg.[71] The artist's relatively cursory execution of the left-hand figure corresponds to the relaxed attitude with which she approaches her task, in contrast to the more laborious description of her stalwart colleague, whose hunched upper body appears strained. Despite Degas' improvised manner, the dynamic arrangement and echoing forms of the pair provided the starting point for one of his most admired ballet images, *Dancers Practicing at the Barre*, realized some three or four years later.[72] In this large, mixed-media painting, the two figures appear in an empty, light-filled space whose unrelieved plainness sets the scene for their labors, the wall behind them transformed into a heavily textured pale ochre.

As today, ballet lessons in the late nineteenth century began with a series of barre exercises that included extending the raised leg in three directions—to the front, side, and back, two of which were depicted in the essence sheet.[73] An 1895 photograph (plate 148) shows Opéra students demonstrating these stretches, though their winsome poses say little about the physical rigor and mental absorption that real class work demands. Nonetheless, the aspiring ballerinas use the barre for support as they would in their daily exercises, many of which are still practiced in varied sequences and sometimes under different names. *Pliés* (plate 141), *ronds de jambes*, and *grands battements* (plate 167) were standard parts of the barre warm-up, as were *tendus*, which were then called *dégagés à terre* (see figure at upper left in plate 140). After half an hour of barre work, the students proceeded to the center of the room, where they executed adagio routines involving slow leg lifts and corresponding arm movements, such as *dévelopé à la seconde* (plate 234).[74] Degas repeatedly referred to this position, exploiting it as a dramatic focus for a series of classroom canvases of the 1870s, where several dancers hold the pose in unison at the prescribed ninety-degree angle (plates 84, 88, and 93).[75]

Following thirty minutes of these adagio combinations, the last half hour of class was devoted to jumps and turns, highly mobile steps that were largely beyond Degas' rapid observation and formidable recall. He did, however, make a number of superb studies of the

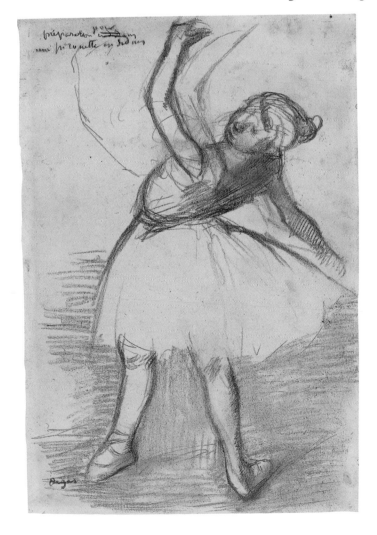

149. *Edgar Degas*, Preparation for an Inside Pirouette, *c. 1880. Charcoal and black crayon on paper, 13¼ x 10⅝ in. (33.6 x 22.7 cm). The National Museum, Belgrade (217)*

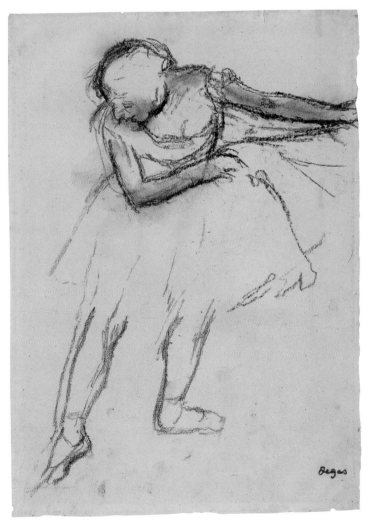

150. *Edgar Degas*, Dancer Executing Tendu à la Seconde, *c. 1885. Dark brown chalk on paper, 13 x 9 in. (32.9 x 23.1 cm). Museum Boijmans Van Beuningen, Rotterdam (F II 131)*

moments that preceded and followed these actions, including a dynamic drawing of a dancer in fourth position with her torso arched dramatically backward (plate 149).[76] The artist's inscription—"preparation for an inside pirouette"—and the linear evidence of his struggle to follow her shifting form allow those familiar with ballet not only to identify the step depicted but also to decipher the sequence of the model's actions: standing vertically, she reached toward the back; from her current pose she will return to the vertical and place her arms for a pirouette to the left.[77] The emphatic contours of her lower limbs evoke the stability of her stance—which is essential when the weight of the upper body is transferred from one direction to another—while traces of her changed arm positions suggest the motion of her backward bend.

Many steps practiced at the barre are incorporated into center-floor combinations, as we see in an even more rapidly executed charcoal drawing of a dancer executing a stylized *tendu* (plate 150). Here Degas' model extends her right leg to the side as she bends slightly forward to look at her pointed foot, lifting her skirt with one hand and holding the opposite arm across her chest in a typically nineteenth-century manner. The same movement drawn from behind appears on another sheet, where Degas noted that his subject had just completed a series of steps in the "Spanish" style, ending "in second position."[78] A similarly stylized pose deriving from the folk tradition is found in *Spanish Dancer* (plate 151), a brilliantly observed study of a young woman—presumably a product of the Opéra's classrooms—whose physique is entirely consistent with modern expectations of ballerinas. Unusual as a depiction of a character role in Degas' sculptural repertoire of classical dancers, the extreme torsion of this figure is more often associated with his statuettes of bathers and nudes. It remains, however, a masterful achievement, both as an acute record of a superbly trained professional with elegantly pointed foot and turned-out leg, and as a thrilling conjunction of rippling surfaces and taut, resilient forms.

In *Dancers in Blue* (plate 152), a haunting image of a classroom where three girls appear to be rehearsing, Degas portrays each of them standing with arms uplifted and one leg extended to the front. Though movement is implicit, the room and its inhabitants seem eerily still, the dancers sylph-like in their languor, and their mentor fading out of—or just coming into—being. Even the ballerina adjusting her skirt is frozen in time, staring beyond the canvas and as inaccessible to us as to her companions. Undated but probably completed around 1890, the scene shares its dreamlike quality with the roughly contemporary classroom painting in the Norton Simon Museum (plate 116), where another warm, light-dappled room is occupied by not-quite-corporeal women who hover in cool-hued tutus.[79] Like them, the figures in *Dancers in Blue* show signs of having been developed by Degas years after he began the picture, which was probably in the early 1880s: a drawing of the ballerina second from left can be located in this period,

151. *Edgar Degas, Spanish Dancer, c. 1890. Bronze, 17 in. (43.2 cm). The Detroit Institute of Arts; Gift of Robert H. Tannahill (69.302)*

152. *Edgar Degas,* Dancers in Blue, *c. 1882–90. Oil on canvas, 20 x 24⅛ in. (50.8 x 61.3 cm). Private collection, New York*

as can his fascination with trios of figures in such pastels as the luminous *Green Dancers* (plate 197).[80]

The violin in the foreground of *Dancers in Blue* reminds us that many nineteenth-century ballet instructors played these instruments as they taught.[81] The short, slightly built figure in his distinctive fez-like cap is easily recognized in several of Degas' paintings and pastels ranging from the mid-1870s to the mid-1890s, where he sometimes wields a long staff like that used by Jules Perrot (plates 127 and 229), which was traditionally banged on the floor to reinforce the tempo of the music.[82] All the male teachers depicted by Degas are shown standing, but Renouard's print of the Opéra's main classroom (plate 118) illustrates that others—mainly women—could be seated.[83] Only two pictures by Degas portray teachers in balletic poses: *The Dance Rehearsal* (plate 87), which reveals a male figure demonstrating a movement, and a later painting showing a female instructor with her arms

raised *en couronne,* presumably correcting her pupils' attempts at the same position.[84]

Cléo de Mérode reported that when she first attended the Opéra conservatory in the late 1880s, Madame Théodore was able to convey to the children exactly what to do "with just a few words and gestures."[85] In all probability, these gestures included a sequence of finger movements, a mnemonic device still employed by dancers: "The teacher indicates the steps with her hands while naming them, and then the students imitate her," noted Gaston Vuillier in 1898, adding, "This language somewhat recalls that of the deaf."[86] The wonderfully delicate drawing *Seated Dancer* (plate 153) captures a young woman "marking" a combination with her fingers in this way, as she sits with the soles of her feet touching, to stretch her thigh muscles.[87] Here the quality of Degas' observation is extraordinary, encompassing the porcelain-like delicacy of the dancer's face and hands, the transparency of her voluminous tutu—draped over the chair to avoid creasing—and the shapes of her legs underneath defined by a few dark contours. Relating loosely to a distant figure in the two variants of *The Dance Class* (plates 127

153. Edgar Degas, Seated Dancer, c. 1873–74. Charcoal, heightened with white and squared
for transfer, on pink paper, 16³⁄₈ x 12⁷⁄₈ in. (41.7 x 32.7 cm). The Metropolitan Museum of Art;
H.O. Havemeyer Collection, Bequest of Mrs. H.O. Havemeyer, 1929 (29.100.942)

THE MAKING OF A DANCER

154. Edgar Degas, *Study of Legs*, c. 1873. *Black chalk heightened with white on blue paper,* *17¾ x 11⁷⁄₁₆ in. (45 x 29 cm). Private collection, New York, courtesy W. M. Brady & Co., New York*

155. Disdéri, *The Legs of the Opéra*, c. 1870. *Carte-de-visite, 4 x 2½ in. (10.1 x 6.2 cm).* *Collection Julie Saul*

and 229), though not used for a more ambitious composition in its own right, the precision and intimacy of this squared-up study underscore Degas' firsthand acquaintance with such scenes. Contemporary technique manuals illustrated only standard positions, and in his early years there were no informal photographs to augment the visual repertoire, while popular imagery idealized or caricatured ballerinas and sensationalized their backstage lives, overlooking just those mundane events that became central to Degas' dance oeuvre. As Toni Bentley has observed: "For every figure actually portrayed executing steps there are ten who are waiting—tying a *pointe*-shoe ribbon, rubbing an ankle, stretching a leg, adjusting a costume.... It is here that Degas captured with unerring truth a dancer's existence."[88]

The turned-out legs and pointed feet of *Seated Dancer* reappear at lower right in a witty and unusual drawn arrangement (plate 154), where they join several other pairs of limbs related to major paintings and pastels made by Degas in 1873 or soon after. Some effort is required to disentangle them: the uppermost, central sketch corresponds to the young woman sitting next to this splayed-leg figure in both versions

of *The Dance Class* (plates 127 and 229); the rather pedestrian stance at the bottom of the page refers to a foreground dancer in the Metropolitan Museum's canvas (plate 127); the legs viewed from the back at upper right are linked to those of a tiny background ballerina in the Corcoran's classroom painting (plate 146); and the preparatory pose at lower left is found in Degas' celebrated trio of stage rehearsal scenes (plates 61, 62, and 176). Resembling a page of working drawings, the sheet also has a refined and deliberate quality that suggests a number of historical precedents, from the fragmentary studies of Watteau and of Hokusai's *Manga*, to such contemporary images as *The Legs of the Opéra* (plate 155), a Disdéri *carte-de-visite* of around 1870.

If proof is needed of Degas' seriousness as a student of the ballet, it can be found in his mastery of the dancer's foot. A little-discussed sequence of drawings in a notebook from the mid-1880s (plate 156) follows a single pair of feet and legs over twenty enthralling studies, often recording the finest nuances of position and the most intimate physical details.[89] Tight ribbons can be seen biting into ankles, downward pressure forces flesh into ridges against the shoe, and variations

in toe and heel are noted as the foot rolls or tenses. Exceptionally, Degas chose to work in a sketchbook with pages made of tracing paper, allowing him to superimpose certain of his drawings and to create a primitive cinematic progression from image to image. A similar obsession with the language of feet is apparent throughout much of his middle career, resurfacing in an account by Georges Jeanniot of an occasion when Degas himself turned teacher:

> He discussed the shape of the satin shoes held on by silk cords which lace up the ankles, using terms that revealed long study: suddenly he snatched up a piece of charcoal and in the margin of my sheet drew the structure of the model's foot with a few strong black lines: then with one finger he added a few shadows and half-tones: the foot was alive, perfectly modeled.[90]

156. *Edgar Degas, Studies of Legs, from An Album of Drawings, 1882–85. Page 5 from Notebook 36. Graphite on tracing paper, 10 9/16 x 8 5/8 in. (26.7 x 21.9 cm). The Metropolitan Museum of Art; Fletcher Fund, 1973 (1973.9, pl. 38)*

157. *Edgar Degas, The Foyer of the Dance, c. 1880. Watercolor and monotype on paper, 18 x 20 in. (45.7 x 50.8 cm). Philadelphia Museum of Art; The Henry P. McIlhenny Collection in memory of Frances P. McIlhenny, 1986 (1986-26-12)*

The seated dancer is ubiquitous in Degas' ballet oeuvre, her pose variously one of weariness, pain, or simply relaxation put to good use. Another such character is found at the center of *The Dance Lesson* (plate 121), shoulders slightly hunched and feet flat on the floor, the only figure taking notice of her companions who are engrossed in adjusting their costumes, examining their bodies, or pondering their boredom. The preoccupied nature of dancers is especially apparent in the frieze compositions, where empty spaces and distances between individuals heighten their detachment. In the technically and thematically curious fan picture *The Foyer of the Dance* (plate 157), Degas created a scattering of such psychologically isolated dancers in a vast but ill-defined interior, leaving one side of his composition virtually

empty. Painted on paper with watercolor that has partially faded, this work was formerly owned by Léon-Marie Clapisson, an Opéra *abonné* who may well have seen such backstage gatherings for himself.[91] Also the purchaser of Degas' celebrated ballet pastel *Waiting*, Clapisson would surely have recognized some of the poses in this fan from Degas' established vocabulary and might have been familiar with a more unexpected dance presence in this scene.[92] The carved bust at left is undoubtedly that of the legendary eighteenth-century ballerina La Guimard, which had graced the foyer of the rue Le Peletier opera house for many years (plate 80).

But even the melee in *The Foyer of the Dance* has no figure to rival that of the endearing *Dancer Resting* (plate 158), a unique depiction by Degas of a ballet pupil seated on the floor. Her position is again far from arbitrary, a variant of a turn-out stretch still employed by young ballerinas who bend their knees and turn them outward, while holding their ankles and applying gentle downward pressure with their elbows. One of many methods to encourage rotation in the hip sockets, it further illustrates the dancers' remorseless efforts to hone their bodies, as well as the artist's insight into their moments of seeming idleness. This is the kind of small, spontaneous drawing that Degas may have begun during class, here combining the intense scrutiny of an unconventional pose with real tenderness, in a way that pleased

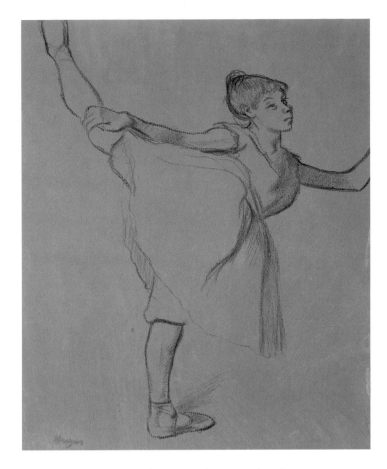

158. *Edgar Degas, Dancer Resting, c. 1879. Charcoal and pastel on brown paper, 9 x 14 1/8 in. (23 x 35.8 cm). Courtesy Colnaghi, London*

159. *Edgar Degas, Dancer Stretching in Attitude, c. 1880. Charcoal on paper, 11 5/8 x 9 in. (29.5 x 23 cm). Hamburger Kunsthalle; Hegewisch Collection*

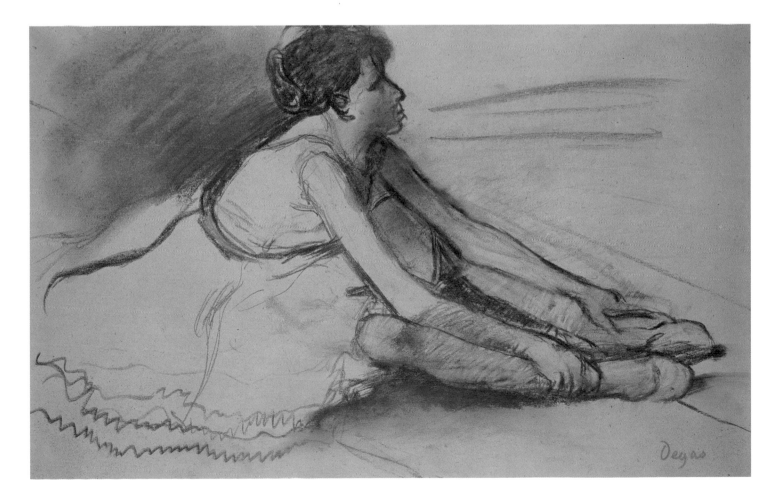

him sufficiently to warrant a flourishing red signature at lower right.[93] Virtually all such casual exercises continue in use today, including that shown in *Dancer Stretching in Attitude* (plate 159), which is commonly employed to warm up for back leg extensions. This finely controlled study is based on another pose unrecorded in the imagery of Degas' day, testifying to his presence on the most informal occasions and his curiosity about less than perfect practitioners. Although the model's hips and shoulders should be "squarer," or facing equally toward the front, the height of her lifted leg and its fluid, arcing line suggest that she had distinct promise. Several other drawings of this position exist, but as with the earlier *Dancer Resting* and scores of dance studies from the 1880s, it was never introduced into a finished work by the artist.[94]

Such drawings were perhaps made in preparation for more ambitious compositions, then set aside, but a substantial number seem to have been carried out as part of Degas' own dance education, contributing to a personal lexicon of ballet exercises and steps. Support for this notion comes from nearly one hundred sheets carrying inscriptions in Degas' hand, covering such matters as color and effects of light, details of costume, and technical ballet concerns. On *Dancer Adjusting*

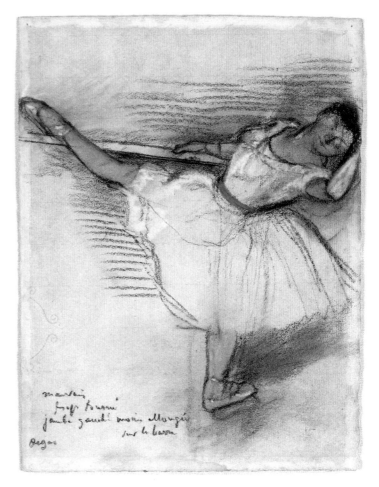

161. Edgar Degas, Dancer at the Barre, c. 1885. *Charcoal and pastel on cream paper, 12¼ x 9 in. (31.1 x 22.9 cm). Private collection*

Her Slipper (plate 227), for instance, he wrote "the arm sinks slightly into the muslin," articulating a feature that was lacking in clarity and implying a need to recall this effect at a later date.[95] On many of these drawings Degas identified the step in question, noting "fifth position" on a sensitive, muted study (plate 160), for example, and "preparation for an inside turn" on the charcoal sketch in Belgrade (plate 149). The significance of his annotations has been the subject of speculation: on *Dancer at the Barre* (plate 161), we read "Bad, too twisted, left leg less lengthened on the barre," which Lillian Browse sees as a comment on the model's technical weaknesses.[96] But redrawn contours around the dancer's elbow and legs suggest that Degas himself struggled with this pose, supporting Theodore Reff's contention that such notes served as criticisms of his own draftsmanship.[97]

Several inscriptions reveal Degas' fluency in the finer points of ballet terminology, among them the distinctive phrase "*mauvais épaulement*." Linda Muehlig first pointed out that *épaulement* is a dance term that refers to the placement of the shoulders (its nearest English equivalent is "shouldering"); if Degas were commenting on his drawing, the words *mauvais épaules* would have been more appropriate.[98] According to the journalist-critic François Thiébault Sisson, Degas

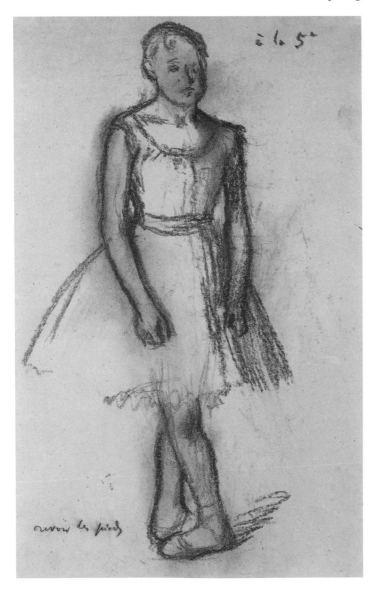

160. Edgar Degas, Dancer in Fifth Position, c. 1885. *Charcoal on light brown paper, 14 x 9 in. (35.5 x 22.5 cm). Collection Janet Traeger Salz, New York*

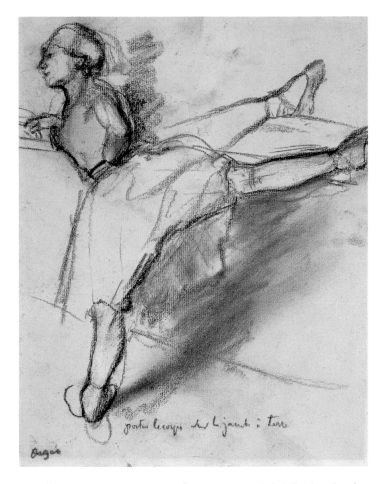

162. Edgar Degas, Dancer Exercising at the Barre, c. 1885. Black chalk with touches of pink and white on paper, 12⅜ x 9⅜ in. (31.2 x 23.7 cm). Cincinnati Art Museum; Annual Membership Fund (1920.40)

could sometimes be observed in the Opéra's classrooms with a sketchbook on his knees: "He comes here in the morning," related a companion, "He watches all the exercises in which the movements are analyzed, and... nothing in the most complicated step escapes his gaze."[99] Though the extent of Degas' drawing in these circumstances has probably been exaggerated, some of his inscribed sheets offer the clearest evidence of his sharp eye and acute ear during class. Alongside a rapid study of a dancer who was feebly posed in *attitude*, he recorded an unflattering remark on her position, presumably overheard on the spot: " 'She looks like a dog urinating,' said Madame Théodore," referring to the long-serving teacher of the children's classes.[100]

Other annotated drawings demonstrate Degas' understanding of a specific pose or exercise, among them, *Dancer Exercising at the Barre* (plate 162), a slightly oblique view of a young woman stretching that bears the inscription "carry the body over the standing leg."[101] As Lillian Browse suggests, here it is Degas who notes that the ballerina's torso should be placed more directly over her supporting limb, since her pelvis and upper body have been pulled too far back by her extended leg.[102]

163. Eve Arnold, Bonnie Moore and Jurgen Schneider, from John Fraser, Private View: Inside Barysnikov's American Ballet Theatre, 1988

Like the drawings of casual exercises, these inscribed sheets are doubly significant: they deepen our insight into Degas' knowledge of classical dance and they provide us with incomparable information about ballet practice in the late nineteenth century. The proficiency of ballerinas in Degas' day was a topic of lively and often negative comment: several of his contemporaries asserted that they were not as skillful as their Romantic predecessors, too often sacrificing artistry for crowd-pleasing, acrobatic effects.[103] In 1859 the Opéra instructor Leopold Adice lamented that the French school had not "produced an eminent dancer in twenty years," a sentiment echoed by Paul Mahalin in 1887 when he wrote, "It is true that the stars of today are hardly the nebulae of yesteryear."[104] Difficult though it is to assess the standards of another era, some sense of the dancers' competence can be deduced from the technical writings of the day and—once again—from the resource of Degas' art. Of overwhelming importance in this context is his *Little Dancer, Aged Fourteen* (plate 130), a scrupulously detailed, two-thirds life-size model of the ballet student Marie van Goethem.[105] Before she registered at the Opéra at the age of thirteen, Marie must have been encouraged and trained elsewhere: in Degas' portrait, she already shows an impressive command of her body and a physique with many of the attributes sought in promising young performers. Her figure appears well proportioned with a slight sway in the lower back, denoting a suppleness that becomes advantageous as the muscles are strengthened; her legs, splayed outward, show her ability to rotate her lower limbs in the hip sockets; and the flexibility apparent in her ankles would have enabled her to achieve graceful lines when her legs were extended.

Marie's gifts are attested to by her progress at the Opéra, where she soon joined the corps de ballet and evidently responded to current

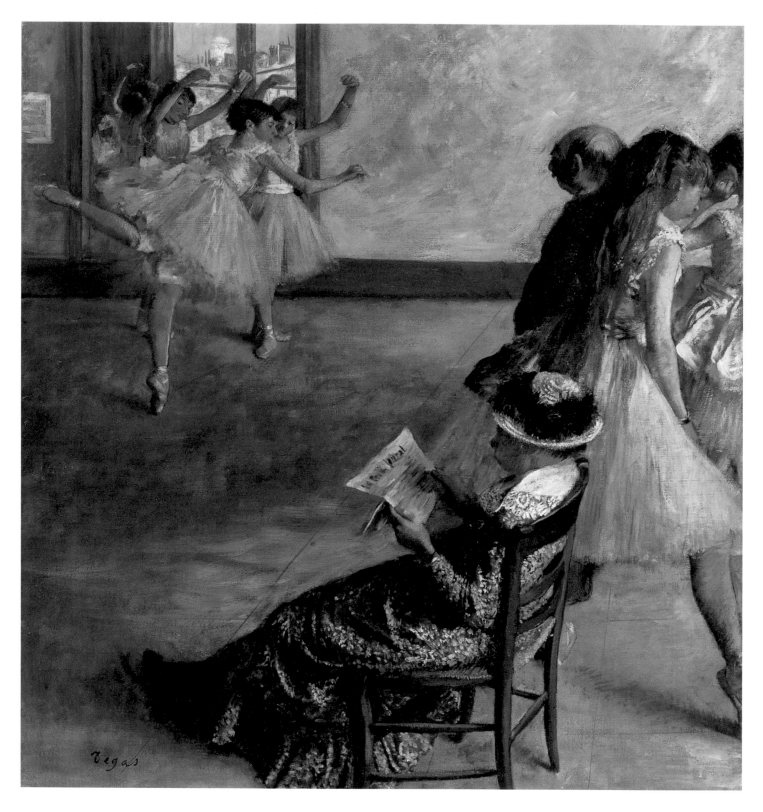

164. *Edgar Degas, The Ballet Class, c. 1878–80. Oil on canvas, 32⅛ x 30⅛ in.*
(81.6 x 76.5 cm). Philadelphia Museum of Art; Purchased with the W.P. Wilstach Fund,
1937 (W1937-2-1)

THE MAKING OF A DANCER

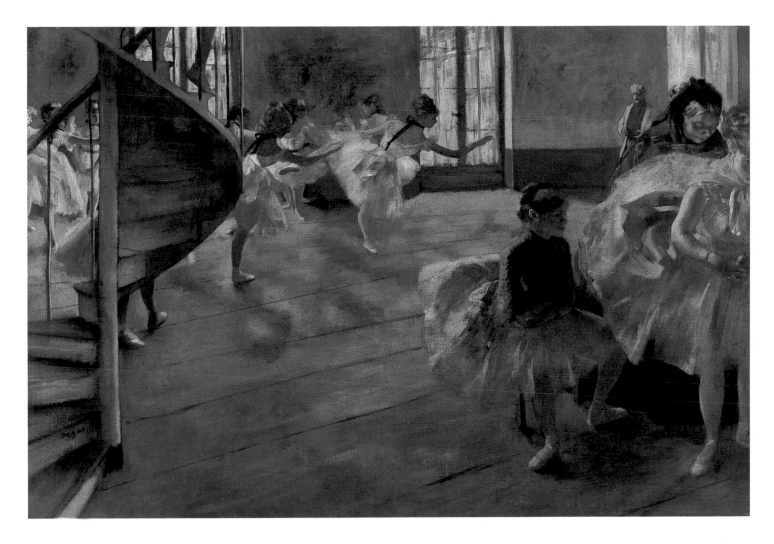

165. *Edgar Degas, The Rehearsal, c. 1874. Oil on canvas, 23 x 33 in. (58.4 x 83.8 cm). Glasgow Museums, The Burrell Collection (35/246)*

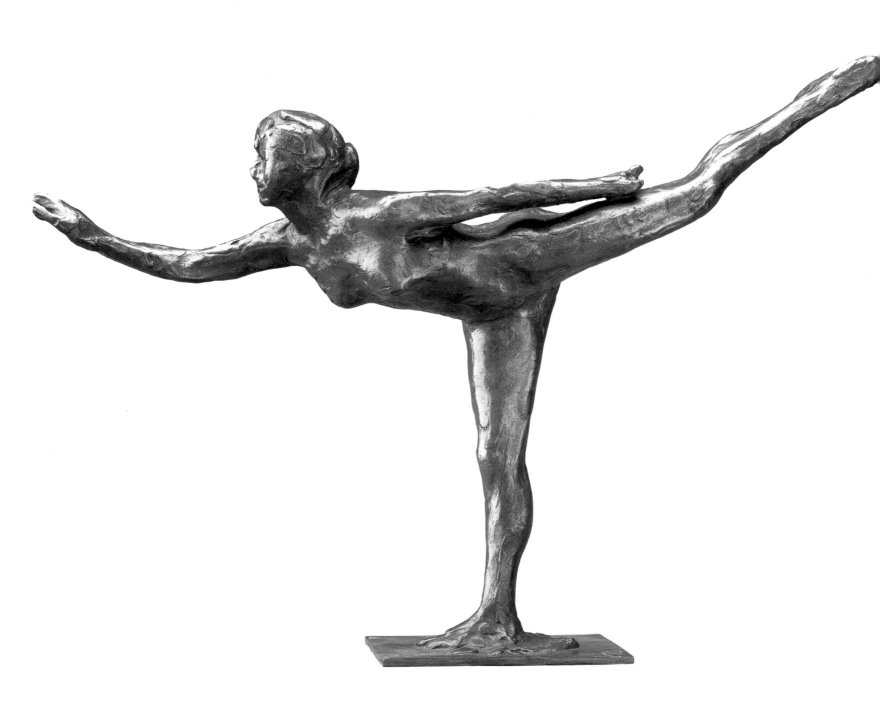

166. *Edgar Degas,* Arabesque Over the Right Leg, *1919–21. Bronze, 11¾ in. (29.9 cm).*
Collection Charles and Jane Cahn, New Jersey

THE MAKING OF A DANCER

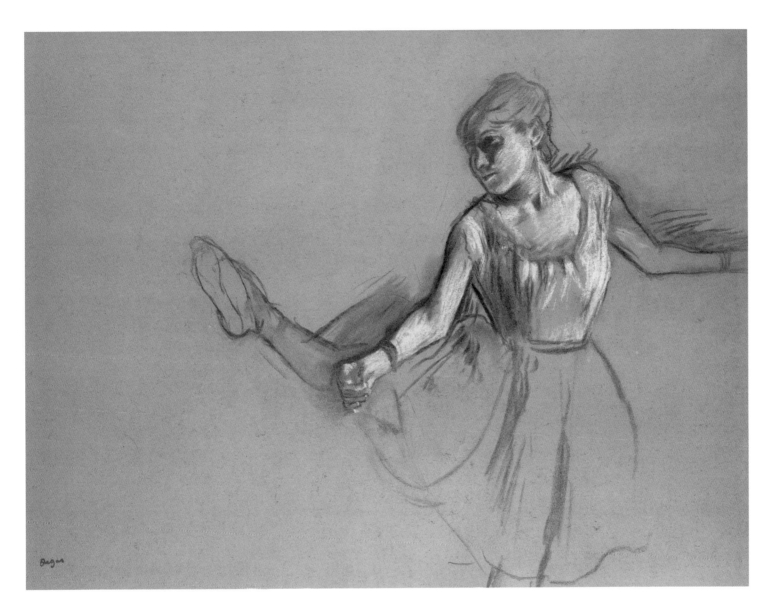

167. Edgar Degas, Dancer at the Barre, c. 1880. Charcoal heightened with white on paper,
18¾ x 23⅞ in. (47.5 x 60.5 cm). Private collection, courtesy Galerie Jan Krugier, Ditesheim
and Cie, Geneva

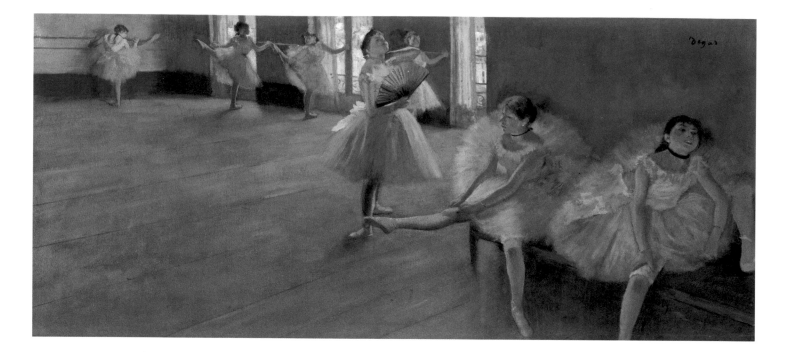

168. Edgar Degas, The Dancing Lesson, c. 1880. Oil on canvas, 15½ x 34⅜ in. (39.4 x 88.4 cm). Sterling and Francine Clark Art Institute, Williamstown, Massachusetts (1955.562)

teaching. The critic Georges Duval had stressed in his technique manual of 1875 that "the shoulders must be held low and the head lifted ... a lofty bearing is one of the essential qualities of an artist."[106] This carriage is apparent in images of Marie Taglioni (plate 16) and in the torso and upraised chin of *Little Dancer, Aged Fourteen*, and still survives, as seen in a photograph of a dancer from the American Ballet Theatre (plate 163). Crucially, however, Marie van Goethem is shown by Degas in an off-duty moment, adopting a stance known as "casual fourth position" that dancers continue to assume when they are at ease (plate 145). Few of Degas' peers seem to have understood this when the original wax sculpture was included in the 1881 Impressionist exhibition. Perhaps shocked to find themselves face to face with an image of an adolescent dressed for class, rather than a distant nymph

on the stage, Charles Ephrussi noted that "she presents herself half-naked, in her work clothes, weary and fatigued," while Elie de Mont asked, "Have you ever encountered a model so horrible and repulsive?" adding that she looked like a "a puny specimen."[107] But two writers were informed enough to identify her abilities, Paul de Charry asserting that Degas' "model is perfect" and Nina de Villars foreseeing for the young girl a "royal future."[108]

Mary Cassatt believed that the figure seated in the foreground of *The Ballet Class* (plate 164) was modeled by Marie van Goethem, who has also been recognized in the young woman standing at right.[109] A more complete pastel study of this ballerina shows her breaking in her pointe shoe and arching her foot, which has clearly been shaped and strengthened by many hours of training.[110] In *The Ballet Class*, her distant colleagues appear to be rehearsing for a performance, though certain aspects of their technique reflect ballet practices that are now outmoded. The girls with their arms raised *en couronne* for example, affect a rather squat, round shape that was then current, where dancers in the modern classroom are advised to lengthen their limbs above their heads to soften the bend in their elbows. Similarly, the pose of the ballerina on pointe, in *piqué attitude*, would be regarded as seriously flawed today, since her knee is dropped below the horizontal and her torso pitched a long way forward. But this was specifically advocated in late-nineteenth-century teaching manuals such as Charbonnel's *La Danse*, where students were instructed to raise the foot higher than the knee when executing *attitude*.[111]

Both *attitude* and the related pose, *arabesque*, were among Degas' particular favorites, occurring in pastels, paintings, and sculptures throughout much of his working life.[112] With *arabesques*, we again find that allowance must be made for the established style and practical

169. Carlo Blasis, The Code of Terpsichore, detail of plate II, 1828. Jerome Robbins Dance Division, The New York Public Library for the Performing Arts, Astor, Lenox and Tilden Foundations

170. Edgar Degas, Fourth Position Front, on the Left Leg, 1880s. Bronze, 22⅝ in. (57.4 cm). Sterling and Francine Clark Art Institute, Williamstown, Massachusetts (1955.49)

constraints of the era. It is easily forgotten that every ballerina in Degas' pictures wore a waist-pinching corset under her bodice, both in the classroom and on the stage, inevitably restricting the range of her movements.[113] This effect can be seen in the curvaceous body and slightly angled, rigid back of the central dancer in *The Rehearsal* (plate 165), whose posture—elegant though it seemed to Degas' peers—is too stiff for today's tastes. Such mannerisms were central to the Romantic repertoire and are frequently seen in prints of the period, as well as in reconstructions of ballets such as *La Sylphide*.[114] In Degas' *Arabesque Over the Right Leg* (plate 166), we encounter an almost flat back once again, while the bent left knee represents a further departure from the current practice of keeping the extended leg completely straight. An unpublished treatise written between 1868 and 1871 by the Opéra instructor Leopold Adice, *Grammaire et Théorie chorégraphique...*, makes it clear that the bent knee was actively promoted. Adice's manuscript was extensively illustrated by himself, and as Sandra Noll Hammond has noted, in his drawings of high *arabesques* "the raised leg is always shown as though with a slightly relaxed knee."[115] In this context, we should note that Degas' sensitively modeled, lyrical figure is repre-

sented in the nude, allowing him to give full articulation to the currently preferred pose and, incidentally, to reveal the true shape of his uncorseted model.

By contrast, the *grand battement* in second position of the young ballerina in *Dancer at the Barre* (plate 167) can hardly be distinguished from that of pupils today, who are also taught to point their toes, rotate their legs, and keep their pelvis facing front. As much a portrait of a dogged, strongly built individual as a balletic study, this masterful drawing emphasizes Degas' continuing engagement with his models as personalities. Probably made in preparation for *The Dancing Lesson* (plate 168), it invites comparison with the row of three ballerinas executing the same movement, one almost hidden by their fan-wielding companion. Both drawing and painting show the broad continuity in dance training over the half-century since Blasis's *Code of Terpsichore* appeared, as well as the evolving stylizations of this period.[116] The solemn male dancer at right in Blasis' illustration (plate 169) demonstrates the *battement*, with the author specifying that the leg should only be raised to ninety degrees while the students in Degas' pictures approach the higher leg extensions of their modern counterparts.[117] In

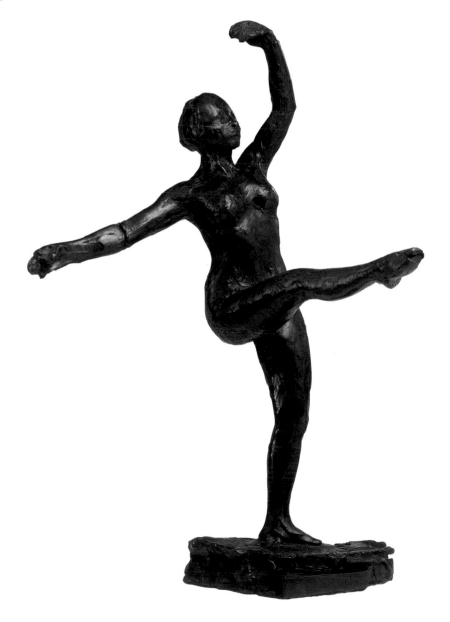

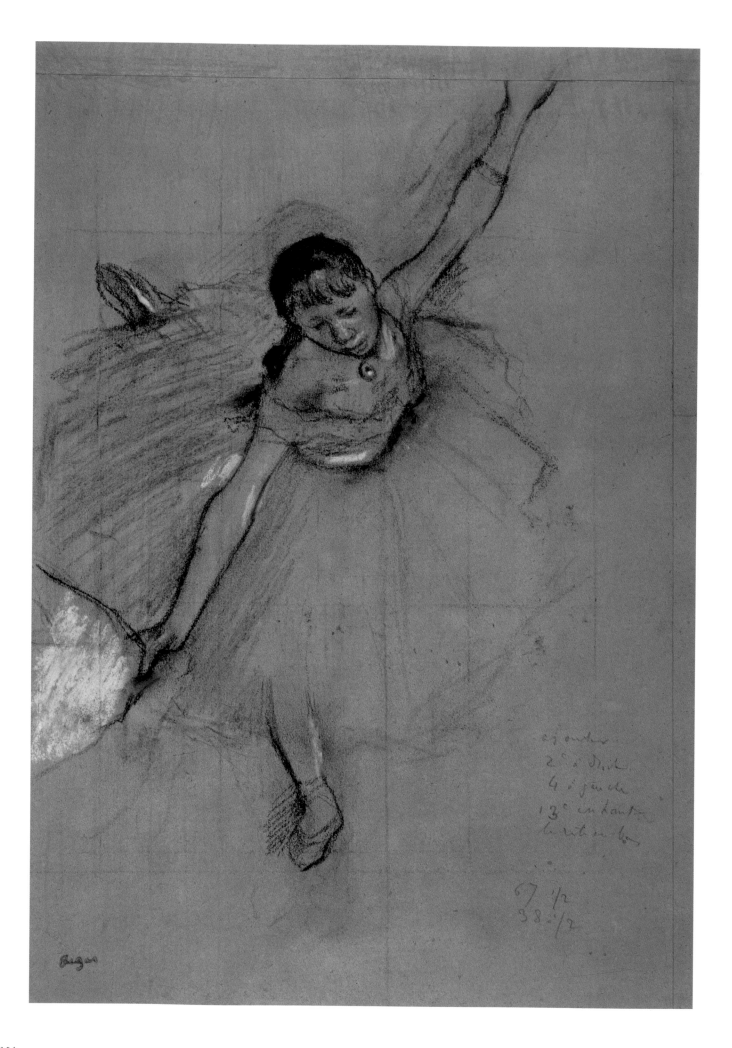

THE MAKING OF A DANCER

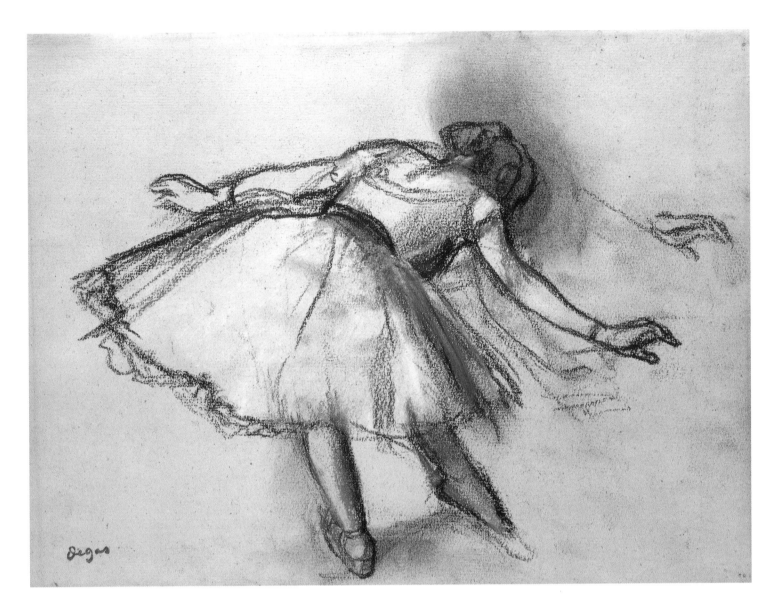

172. *Edgar Degas, Dancer Executing Port de Bras, c. 1880. Black chalk and pastel on paper, 8⅞ x 9¾ in. (24.7 x 32 cm). Private collection*

his *Fourth Position Front, on the Left Leg* (plate 170), a *battement* is again the subject, now with the leg kicked to the front rather than the side. Apparently more mature than the figures in his two-dimensional works, the model in Degas' sculpture displays a command over her physique that rivals that of professionals today. Her firm musculature enables her to hold a precarious stance with great poise; the confident "centering" of her body weight gives the impression of effortlessness even though she stands on a single leg.

At their finest, the dancers in Degas' pictures suggest a high level of accomplishment, by the standards of his day but also of our own. Even the adolescent in *Dancer with a Bouquet, Bowing* (plate 171) has transcended the purely technical considerations of her profession, finding fluidity and grace in her stage persona. This dynamic *attitude*,

a variant of the central pose in the Burrell Collection's *Rehearsal* (plate 165), is transformed into a bow as she accepts a bouquet from the audience, while maintaining her balance and the perfect alignment of her arms. Emerging from the exercises of the Opéra classrooms, this difficult position challenges the dancer to appear natural and secure even as she twists her body and hovers on her right foot.[118] In one of the most sensitively rendered studies in Degas' ballet oeuvre, *Dancer Executing Port de Bras* (plate 172), an equally fine-limbed dancer is shown in mid-*révérence*, another form of bow performed on stage, which is also traditionally executed at the end of each dance class. Here Degas' skills as a draftsman and his informed feeling for the ballet meet the artistry of an exquisite, expressive performer, his study in the classroom matching her years of application. While the dancer is trained to conceal her exertions, Degas has characteristically left traces of earlier drafts, hinting at his model's gentle movements as she salutes the audience or takes leave of her teacher.[119]

171. *Edgar Degas, Dancer with a Bouquet, Bowing, c. 1876–78. Charcoal heightened with white, gray chalk, and brown pastel on paper, 20⅝ x 14⅝ in. (52.5 x 36 cm). Private collection*

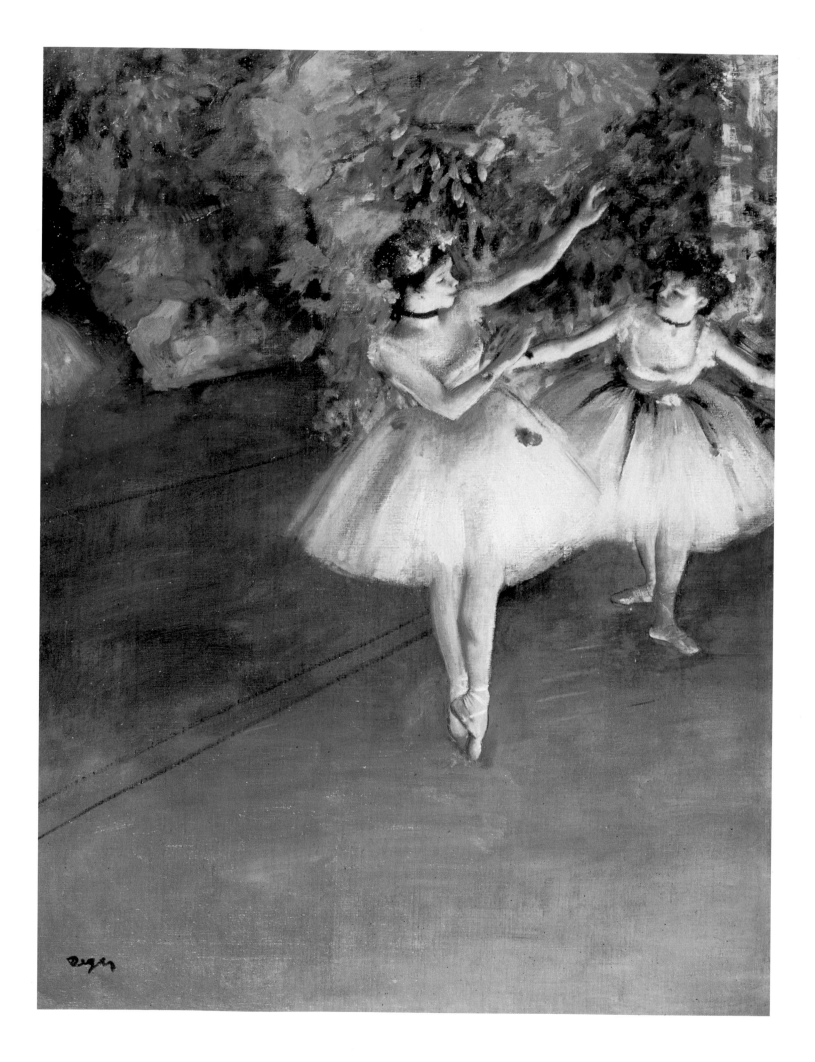

6. Picturing the Performance

Go forth, without the help of useless beauty
My little darlings, with your common face.
Leap shamelessly, you priestesses of grace!

The dance instills in you something that sets you apart,
Something heroic and remote. One knows that in your world
Queens are made of distance and greasepaint.

—DEGAS, SONNET V, C. 1889[1]

No one observed more closely than Degas, who wrote these verses in the late 1880s, the process by which "common" Opéra dancers were transformed—through makeup, stylized costumes, and the distance between the proscenium and the audience—into "priestesses of grace."[2] Much of his own art was concerned with this metamorphosis: research has increasingly revealed the extent to which his performance images were rooted in firsthand experience of the stage rather than in his painterly imagination. But the opposite belief—that his theater pictures were fanciful inventions—remains deeply ingrained in the modern literature on the artist, as summarized by one art historian's claim that "very few of Degas' dance scenes represented identifiable ballets: indeed, many of the seemingly most spontaneous depictions are actually deliberate creations, constructed of poses and settings combined and reconstructed at will."[3]

The aim of the present chapter is to re-examine this conviction in the light of both earlier documentation and a substantial quantity of new evidence. In a limited number of cases, Degas' performance pictures were associated with ballets of the day by the artist himself or by his immediate contemporaries, and other candidates have been proposed by art historians in subsequent years, notably by Lillian Browse in her 1949 *Degas Dancers* and later by Theodore Reff.[4] To this catalogue a significant number of new pairings can be added, derived from an analysis of Degas' works of art and a parallel study of period photographs, journal illustrations, contemporary prints, and original production designs in the Bibliothèque de l'Opéra in Paris. Together this material encourages us to step back from the received wisdom and to re-evaluate, even to invert, the artist's relationship with the stage. If his pastels and oil paintings of the dance can still be seen as "deliberate creations," we must now consider the possibility that the majority owe their origin, and

173. Edgar Degas, Two Dancers on a Stage, 1874. Oil on canvas, 24½ x 18⅛ in. (62 x 46 cm). Courtauld Institute Gallery, Somerset House, London

much of their final appearance, to a precise moment of contact between Degas and the contemporary ballet.

In launching his career as the "painter of dancers," Degas initially aligned himself with the tradition that representations of the ballet— be they paintings, journal illustrations, or mass-produced sculptures and prints—were accompanied by titles and captions that spelled out the names of the productions, the roles the stars appeared in, and the scenes depicted.[5] All three of Degas' earliest performance-centered paintings were orthodox in this respect: *Mlle Fiocre in the Ballet "La Source"* (plate 49) and the two variants of *The Ballet from "Robert le Diable"* (plates 53 and 58) announced in their titles their link to the Opéra repertoire and each was based on a celebrated scene from the ballet or opera in question.[6] In these formative cases, Degas chose to define his visual territory in a way that was immediately legible, establishing a topicality of reference that has often been underestimated. When the Salon-going public of 1868 was confronted by his picture of *La Source* and when his two paintings of *Robert le Diable* were sold, both productions were currently playing on the Opéra stage.

The literal, almost pedantic nature of the relationship between these paintings and the contemporary events at the Opéra seems even more remarkable in retrospect. After the early 1870s, Degas never again included the name of a ballet in the titles of his performance images, listing them in exhibitions under generic phrases such as *"Ballet,"* *"Dancer with a Bouquet,"* and *"Ballet Scene."*[7] This taxonomic shift coincided with a marked departure from other pictorial and presentational modes, and from existing assumptions about the representation of the dance. At its simplest, Degas turned his back on illustration, denying the role of his pictures as mere records of a performance or as souvenirs of personal glamour. By abandoning the practice of specific titling, he could assert the distinct claims of art and his right to be inventive and perhaps arbitrary as occasion demanded. To assume that this development forever separated Degas from the quotidian world of the stage, however, is to misunderstand the complexity of his realist project. By the early 1870s, he would have been aware that his patrons were a small and often informed group, including many individuals who shared his evenings at the Opéra and bought his pictures because they knew this world, enjoying the frisson of identifying a favorite dancer or a moment from a recent production. Some of the collectors were also followers of the latest developments in painting, who delighted in the novelty of Degas' perceptions, and that combination of ambiguity and precision that was to become his hallmark.[8]

DEGAS AND DON GIOVANNI

In his recollections of the artist, Daniel Halévy tells of an occasion when a friend played a Beethoven sonata for Degas. As the musician finished, the painter turned to him and said: "When I am listening to Beethoven, it seems as if I am walking through a forest, burdened with all my troubles. Play me something by Mozart or by Gluck."[9] Degas' fondness for these two eighteenth-century composers is again alluded to by Halévy when he describes one of the artist's ballet pictures in which "a dancer, elevated on *pointe*, with open arms, slips away in the distance, her movements calling forth a song by Gluck or Mozart."[10] Halévy's words take on additional significance with the discovery that a substantial cluster of pictures by Degas from the 1870s can now be linked with Mozart's music. At least two of these associations can be traced back to the artist's lifetime, but seven additional paintings and pastels have revealed more subtly coded connections with Mozart's opera *Don Giovanni*, specifically with the ballet divertissements that were a popular feature of the Opéra production in Degas' day. One of the works in question, *Two Dancers on a Stage* (plate 173), where a ballerina performs on *pointe* and her companion poses "with open arms," even suggests itself as the subject of Halévy's reminiscence.

Don Giovanni—or in the French usage, *Don Juan*—was the only major vocal work by Mozart presented at the Paris Opera during the late nineteenth century.[11] It was performed on more than two hundred occasions from the 1860s to early 1880s, enjoying two revivals during Degas' formative years: the first in 1866 at the rue Le Peletier theater (where it had first appeared thirty years earlier), and the second in 1875, at the Palais Garnier. The most noteworthy feature of the 1866 revival was the insertion of a new ballet, involving the augmentation of the opera's original score with instrumental pieces by Mozart. Although critics like Albert de Lasalle complained that the additional music "felt exactly as if it had been *added*" and made the opera boringly long, this feature proved to be an enduring success.[12] According to the opera historian Charles Dupêchez, the ballet became so popular that it "constituted the highpoint of the evening," to such an extent that "one went to see *Don Juan* for the dance."[13]

Originally choreographed by Saint-Léon, the new divertissement in *Don Juan* was called the *Ballet des Roses* and revolved around a frivolous story of the romantic pursuit of flowers by butterflies. The majority of dancers were dressed as roses, wearing bell-shaped tutus enhanced with sepal-like decorations that fell from the waist, over the skirt. Although the original costume designs for the 1866 production no longer exist, we get a glimpse of them in an illustration from *Le Charivari*, where several dresses look like upside-down rose blossoms (plate 174).[14] It is startling to find that virtually the same tutu has remained unremarked in a well-known painting by Degas for over a century: in *Two Dancers on a Stage* (plate 173), the costume of the figure at right shows the unmistakable arrangement of attached sepals, confirming that this flower-decked pair appear in the divertissement from Mozart's opera.

Further supportive evidence can be found in a photograph of Marie Sanlaville (plate 175), where she is undoubtedly dressed for her role in the *Ballet des Roses* and resembles the dancer at right in Degas' painting in several key respects: both figures wear outfits with a band

174. Hadol, Scenes from Don Juan, from Le Charivari, 1866. Engraving. Bibliothèque
nationale de France

of darker fabric covering the midriff, with sepals draped over their
skirts, and have flowers in their hair.[15] Strikingly, in the photograph
Sanlaville also extends her arms in a manner that recalls the leading
dancer in the picture, suggesting that her action may have prompted
Degas' image or—conceivably—that he used such a photograph in
his creative process. Though the costumes in Degas' painting lack the
many overlapping muslin petals of Sanlaville's, it seems that he fol-
lowed the illustrator of Le Charivari in simplifying his representation
of the multi-layered skirt.

The reappearance of a similarly posed duo of dancers in other
stage images by Degas suggests that these pictures, too, were associ-
ated with Don Juan. The pair is portrayed, for example, in the three
versions of the Ballet Rehearsal on the Stage (plates 61, 62, and 176),
where they alone are practicing their steps amid a scattering of more
leisurely companions. In the essence and pastel variants of this com-
position (plates 62 and 176), the position of the right-hand ballerina
is slightly altered, but there can be no doubt that her actions derive
from essentially the same choreographed moment.[16] It should also
be noted that all figures in the three pictures are wearing simple white
tutus rather than ornamented skirts: then as now, dancers adopted
plain classroom attire for practice sessions and saved their stage cos-

tumes for dress rehearsals and performances.[17] Previously unrelated
to any specific ballet production, the poses and apparel in this cele-
brated triad of rehearsal scenes, as well as an analysis of the scenery
yet to come, indicate that these young soloists are practicing a varia-
tion from the Ballet des Roses.

The Ballet Rehearsal on the Stage pictures are all set in the interior
of the Opéra house on the rue Le Peletier and were probably begun
before the building burned down in 1873.[18] Don Juan featured nearly
fifty times in the Opéra program between 1872 and 1874, with the title
role sung by Jean-Baptiste Faure. In the spring of 1873 Faure pur-
chased three works by Degas and soon ordered two more; compli-
cations over these and other commissions eventually soured their
relationship.[19] But painter and singer were evidently on good terms
in the early 1870s, and it may be that their connection influenced
Degas' choice of rehearsal subjects and facilitated his access to the
stage during preparations for the opera. Such sustained contact
would also explain Degas' attention to the painted settings in all four
pictures, where loosely brushed foliage and a succession of tree-like
flats indicate a wood or parkland scene. The scenery at the far side
of the stage varies in prominence from one work to another, amount-
ing to a succession from a barely dressed set to a partially completed
one, and culminating in the complete décor of Two Dancers on a
Stage.[20] Though seeming rather scant, this leafy context is entirely
appropriate to Act One, Scene Two, of Mozart's opera, "The garden

175. *Photograph of Marie Sanlaville in costume for Don Juan. Bibliothèque nationale de France*

century outfit used in *Don Juan*, as recorded in the *Le Charivari* illustration (plate 174), and whose ingratiating actions suggest the Don's servant, Leporello. This subtle humor is raised to the level of high comedy in *The Chorus* (plate 178), where a disorderly line-up of singers in period costumes spans the stage, creating an uncharacteristic moment of operatic pageantry in Degas' oeuvre. *The Chorus* is one of the handful of performance scenes to have been associated with a named production by the artist himself, who confirmed the link in a conversation with Daniel Halévy when he referred to his "choristes de Don Juan," which by then had passed with the Caillebotte collection to the Musée de Luxembourg.[23]

When it was shown in the 1877 Impressionist exhibition, *The Chorus* attracted considerable attention: one unidentified journalist included it among several of Degas' pictures described as "masterpieces of satire and truth," asserting that "No one, not even Gavarni or Grévin, has so humorously depicted backstage life at the theater, or the world of the café-concert."[24] The reference to these two illustrators is doubly significant in the context of *The Chorus*, where Degas has chosen to highlight the comic relief in a fundamentally tragic opera, prompting other observers to associate the work with the theater paintings and prints of Daumier.[25] A more exact source can be found in the 1866 illustration from *Le Charivari* (plate 174), where the vignette of singing heads unquestionably provided a starting point for Degas' mannered picture. Once again, the use of a popular model enabled him to sharpen the directness and topicality of his image, relying on a lucid graphic mode to present a much-loved scene from a current production. But the claim that *The Chorus* reflected the "truth" conceals the contradictory nature of Degas' procedures. What appears to be a forceful record of the Opéra stage turns out to be a conflation of temporally disparate sources: a decade-old illustration, recollections of a theater that no longer existed, and a revival of Mozart's eighteenth-century masterpiece. Further, the absence of any drawings or sketchbook studies for Degas' image indicates that it was almost certainly made from memory. Begun as a monotype, the print must have been executed in the studio where the necessary plate, ink, and press were on hand, rather than from his implied vantage point in the Opéra wings. Perhaps improvised soon after a performance, this image is among Degas' densest and most vivid theatrical inventions.

When *The Entrance of the Masked Dancers* (plate 108) was identified with *Don Juan* in George Lecomte's 1892 catalogue of the Durand-Ruel collection, the connection between the pastel and a second divertissement—in this case, performed during the masked ball in Act Two—would have been widely understood.[26] In his crisply detailed composition, Degas spelled out with unusual care the hooded yellow cloaks of the corps de ballet and their darkly concealed faces, as they move en masse through the brightly lit middle distance.[27] Surprisingly, the divertissement is not shown in the palatial marble interior of the Opéra staging (plate 97), but in an outdoor setting dominated by autumnal hues and flourishes of foliage. The artist evidently allowed

of Don Juan's chateau," where the wicked Don attempts to seduce the maid Zerlina on the grounds of his country estate, and thus provides a suitable pretext for a dance of birds and bees. A colored print of the period situates the ballet among overarching trees, shrubbery, and a distant pergola-like structure, while—contrarily—one contemporary reviewer locates it in the ballroom of the Don's chateau (plate 97).[21] If Degas did whimsically relocate the *Ballet des Roses*, it would not be the last time that he took such a liberty in this same series, as we shall see in our examination of his *Entrance of the Masked Dancers* (plate 108).

The solemnity of the *Rehearsal on the Stage* pictures is vividly contrasted in three smaller works made in response to *Don Juan*.[22] In a diminutive canvas titled *Ballet Scene* (plate 177), whose first owner was the art and theater critic Jules Clarétie, an indignant ballerina caught mid-mime is sporting a tutu with ribbon-like decorations that recalls the rose costumes. She is accompanied by one of the rare male characters in Degas' dance art, who wears the kind of seventeenth-

176. *Edgar Degas, The Rehearsal on the Stage, 1874(?). Pastel over brush-and-ink drawing on thin, cream-colored wove paper laid on Bristol board, mounted on canvas, 21 x 28½ in. (53.3 x 72.3 cm). The Metropolitan Museum of Art; H.O. Havemeyer Collection, Bequest of Mrs. H.O. Havemeyer, 1929 (29.100.39)*

himself considerable latitude, departing from the production even as he recorded some of its details with precision in a way that would become habitual in his performance pictures. *The Entrance of the Masked Dancers* adds its considerable weight to a growing body of images centered on Mozart's opera, including several of Degas' major public statements of this period.[28] Spread over a decade, they amount to a sustained engagement with an Opéra success seen in rehearsal, performance, and from the wings. Characteristically, he emphasized the ballet interludes at the expense of the broader spectacle of singers and extras, the unfolding tragedy, and historical setting, but this feat of combined observation and accumulated memory can be seen as a benchmark for his later enterprises.

177. *Edgar Degas, Ballet Scene, c. 1874–75. Oil on canvas, 10¼ x 8¼ in. (26 x 21 cm). Location unknown*

178. Edgar Degas, The Chorus, 1877. Pastel over monotype on laid paper, 10.6 x 12.6 in. (27 x 32 cm). Musée du Louvre, fonds Orsay, D.A.G. (RF 12259)

THEMES AND VARIATIONS

Against the verdant backdrop of *On the Stage* (plate 179), four dancers stand with arms uplifted, bathed in a pool of light as pale as their ghostly figures. In the foreground another group of ballerinas dash about in close proximity to one another, in a frenzy of turquoise tutus, criss-crossed limbs, and streaming hair. At their center is a single dancer who gestures toward the audience, hovering in a technically flawless and gracefully executed *piqué arabesque*. This vaporous scene bears all the hallmarks of the nineteenth-century ballet of legend, complete with sylvan landscape, sprightly nymphs, and disembodied sylphs. But *On the Stage* is also compelling as a record of a theatrical experience, an encounter with a live performance perhaps seen through a pair of lorgnettes from the balcony. Many aspects of the picture's credibility are shaken, however, when we compare it to another work with an equally

vertiginous view and an identically posed dancer, now shown in an entirely different production. In what is arguably Degas' most widely known ballet picture, *L'Etoile* (plate 180), the ballerina in question is alone on the floor boards, wearing a flax-colored rather than a sea-green costume and with her hair neatly pinned up, here in a spare autumnal setting against barren hills and distant blue sky. The presence of the same dancer in two such contrasted contexts suggests an arbitrariness in their location, undermining the plausibility of both images and even the integrity of the artist's realist project. Adding to this uncertainty, we discover that at least three further works—two pastels and one painting—feature the increasingly familiar dancer, in each case wearing a distinctive outfit and appearing in transformed surroundings.[29]

The existence of such variations has been taken as evidence of the distance between Degas' pictures and the Opéra repertoire, reflected

179. Edgar Degas, On the Stage, c. 1876–77. Pastel and essence over monotype on cream laid paper, laid down on board, 24¼ x 16¾ in. (59.2 x 42.8 cm). The Art Institute of Chicago; Potter Palmer Collection (1922.423)

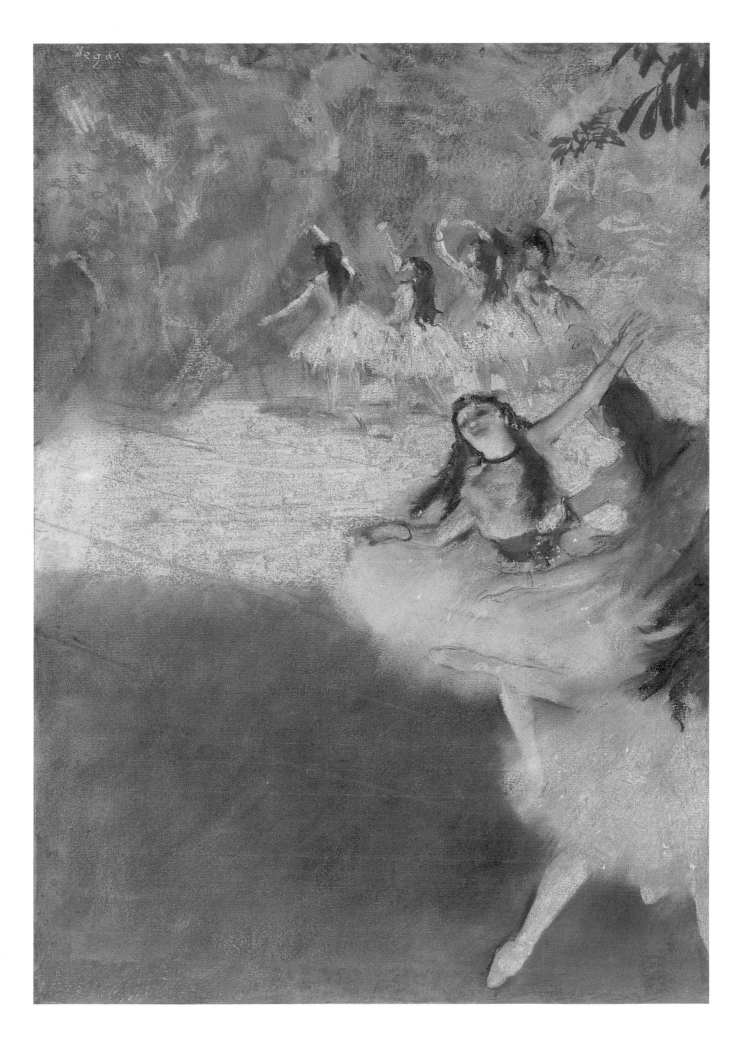

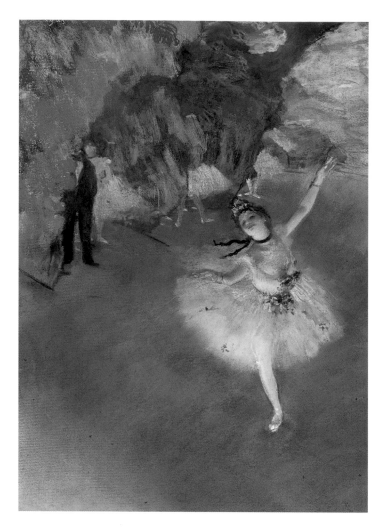

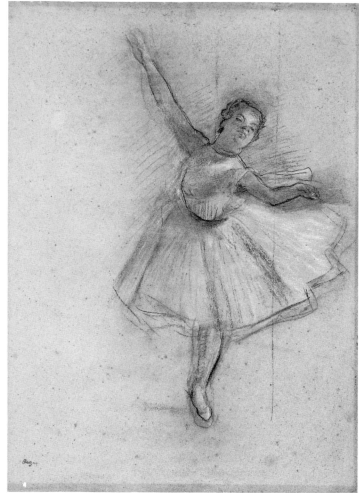

180. Edgar Degas, L'Etoile, c. 1876–77. Pastel over monotype, 23 x 16⅝ in. (58 x 42 cm). Musée du Louvre, Departement des arts graphiques, fonds Orsay (RF 12258)

181. Edgar Degas, Dancer, c. 1876. Charcoal heightened with white chalk with stumping on pinkish-gray laid paper with blue fibers, 23⅞ x 17⅝ in. (60.7 x 44.8 cm). The Art Institute of Chicago; Bequest of John J. Ireland (1968.82)

in the belief that his "use of the same figure indicates that he seldom followed literally the actual production of a ballet, even if on occasion he borrowed elements from it."[30] A careful examination of these works as both technical objects and as informed depictions of dancers and known productions, however, helps to illuminate this critical question. As Eugenia Parry Janis was the first to discover, the similarities between *On the Stage* and *L'Etoile* are not coincidental: they began life as monotypes pulled from the same plate and were subsequently differentiated by the application of pastel.[31] *The Star* (plate 103) belongs to another such pairing, based on a smaller monotype plate and also developed with color into a strikingly different performance scene.[32] In *The Star*, the ballerina reappears in a pink tutu and is situated closer to the wings than in the two larger works, while only a hint of pastel enlivens the gray monotype ink in the flats behind her.

Analysis of these images from a dance perspective also sheds light on the intricacies of Degas' approach. The dancer's position in *The Star* is subtly distinct from that of her close cousin in *L'Etoile*: the placement of her left foot (partially hidden behind her tutu) shows that the back leg is bent rather than straight, indicating a balance in *attitude*, rather than *arabesque*. A more significant modification of the pose occurs

in the work paired with *The Star*, where the dancer is portrayed *standing* on her back leg with no weight placed on the right foot, which is pointed toward the front, an extraordinary adjustment in ballet terms: Degas has effectively transformed a dancer who strikes a precarious balance into a stable figure with both feet touching the ground.[33] Behind these nuanced changes, all the principal characters in this series appear to derive from the same carefully executed charcoal drawing, *Dancer* (plate 181), which shows a ballerina in practice attire rather than stage apparel.[34] Almost certainly drawn from life, the model is a mirror image of her counterparts in the pastel-over-monotypes, her figure having been reversed by the printing process. By the same logic, in the only oil painting in the series, *Entrance onto the Stage*, the dancer is standing on her left leg, as in the drawing.[35]

This detailed case study reveals the lengths to which the technically capricious Degas was willing to go to generate not just visual variants, but knowledgably inflected interpretations of ballet practice. While we cannot preclude the possibility that one or more works in such a group was freely invented or created from memory, many of his performance pictures are more specific in the character of their costumes and décor than has previously been realized. The example of the leafy

landscape is a case in point: though far from invariable in Opéra productions at the time, similar settings could be found in such lyric dramas as *Romeo et Juliette*, *La Juive*, and *Hamlet*, sometimes with scenery elements recycled from one opera to another.[36] *On the Stage* (plate 179) stands out for its exotic, lush vegetation and wild rock-like forms, suggesting a shadowy swamp or jungle where the light falls only in a clearing. Comparable scenes occurred in three successful operas with Eastern or tropical themes when Degas was working on his pastel: Meyerbeer's *L'Africaine*, Massenet's *Le Roi de Lahore*, and Donizetti's *La Favorite*. As we shall discover, several images by Degas from this period can be linked to these works, some through a telling detail, others through wider effects of context or design.

Meyerbeer's *L'Africaine* was as popular with Opéra audiences as Mozart's *Don Juan*, from its premiere at the rue Le Peletier in 1865 to long after its three-hundredth performance in 1879; Degas himself saw it at least nine times in the 1880s.[37] Jean-Baptiste Faure sang a leading role, and Louis Mérante, who appears in *Dance Class at the Opéra* (plate 19), choreographed the ballet divertissement. When it was revived in 1877 at the Palais Garnier, a group of temple dancers was led by Marie Sanlaville in the fourth act, in a scene dominated by a large palace and a Hindu sanctuary.[38] More appropriate to the setting of *On the Stage*, however, was the location of the next act in a tropical garden (plate 182), where the combination of dense undergrowth and tall trees corresponds loosely to the vegetation in Degas' pastel. Intriguingly, however, there are no records of dancing in this sequence, again leaving us to speculate—as with *The Entrance of the Masked Dancers*—about the coincidence. In both cases, we are reminded of Degas' aversion to the grandiose architectural sets so beloved of the Opéra's critics and audiences (plate 17) and are perhaps offered further proof of his willingness to transpose events on the stage to suit his artistic needs.[39]

A larger and even more luxuriant pastel over monotype, *Ballet at the Paris Opéra* (plate 183), which shares many features with *On the Stage*, also displays a resemblance to the tropical sequence in *L'Africaine*, though again without offering a definitive link to Meyerbeer's opera. The painted flats at far left in this emphatically horizontal image have much the same character as the verdant, rugged shapes in the background of the smaller picture: the foreground in each work remains in shadow, while the middle ground is flooded with light; and in both, several ballerinas clad in white tutus decorated with coral roses allow their long dark hair to flow freely. Unlike *On the Stage*, however, we are now offered a partial view of the musicians at the bottom of the sheet, locating the viewer among the *abonnés* nearest the stage where Degas had painted the first owner of this pastel, Albert Hecht, in his *Ballet from "Robert le Diable."* (plates 53 and 58). By virtue of its lower viewpoint and broader span, *Ballet at the Paris Opéra* provides more information about its setting: here we see a panorama of dense

182. *Maquette for L'Africaine, Act V, Scene 1, Paris Opéra, 1877. Designed by Joseph Chéret.*
Bibliothèque nationale de France

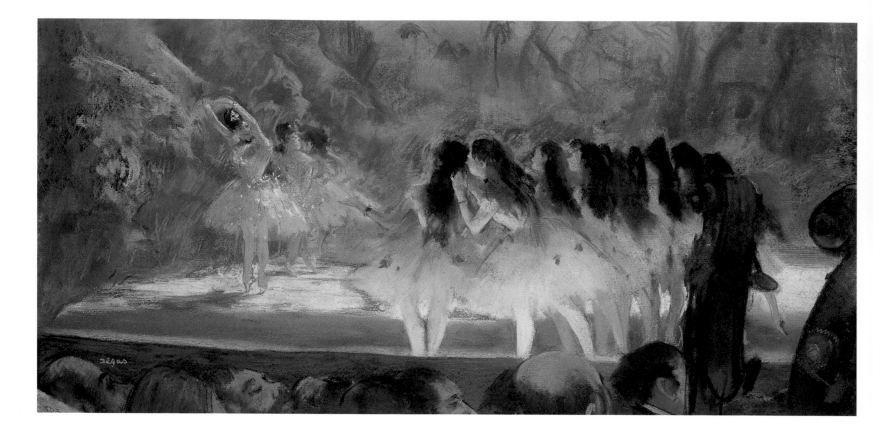

undergrowth, tall trees, and overgrown landscape forms at left, with the small but unmistakable silhouettes of two coconut palms in the center distance.[40] While there is nothing comparable in Degas' picture to the monumental structures visible in *L'Africaine*, we can make out the tips of a pair of roof-like structures nestled between the palms.

A similar suggestion of tropical flora can be discovered in the etching *On Stage III* (plate 184), a composition with unusual historical links to *Ballet at the Paris Opéra*.[41] Although squarer in format and more cursorily executed, this tiny image mirrors many of the features of *Ballet at the Paris Opéra*, including the cropped heads of the musicians in the foreground, the stems of two double basses invading the stage, and the general disposition of the dancers; there is even a lightly drawn palm tree among its loosely sketched foliage. The etching appeared in the catalogue for an 1877 exhibition in the southern French town of Pau, where Sue Welsh Reed and Barbara Shapiro believe it was introduced "to reflect a work that was part of the exhibition," the pastel *Ballet at the Paris Opéra*, remaining "not a slavish copy but a creative variant" of the larger scene.[42]

The second contemporary opera with a jungle-like setting, Massenet's *Le Roi de Lahore*, was widely acclaimed at its premiere in 1877 and drew praise for its "stunning costumes and luxurious décor."[43]

Set among the plains, forests, and temples of India, it was first proposed as the subject of Degas' radiantly colored *Dancer with a Bouquet, Bowing* (plate 104) by Lillian Browse, a suggestion endorsed by the surviving set and costume designs.[44] In addition, scrutiny of a contemporary engraving that includes five vignettes of the production (plate 185), reveals the figure of a uniformed Indian attendant in the fourth act carrying a large sunshade similar to those in Degas' picture.[45] Another vignette shows that the sweeping background vista in the Paris pastel corresponds with the arid landscape of the second act, in which a ballet divertissement was performed.[46]

Such cases add to the emerging pattern of Degas' teasing manipulation of theatrical subjects, along with his disregard for entire

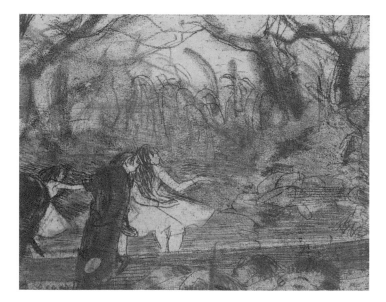

183. *Edgar Degas, Ballet at the Paris Opéra, 1877. Pastel over monotype on cream laid paper, 13⅞ x 27¹³⁄₁₆ in. (35.2 x 70.6 cm). The Art Institute of Chicago; Gift of Mary and Leigh Block (1981.12)*

184. *Edgar Degas, On Stage III, 1876–77. Softground etching, drypoint, and roulette (red-brown ink) on cream to buff paper, 5¾ x 6¾ in. (14.6 x 17.1 cm). Philadelphia Museum of Art; Purchased with the John D. McIlhenny Fund, 1941 (1941-008-33)*

185. *Scenes from Le Roi de Lahore, Paris Opéra, from L'Univers Illustré, 1877.*
Bibliothèque nationale de France

armies, palaces, and spectacular effects that failed to engage him. In *The Curtain* (plate 72), a roughly contemporary pastel not previously linked to *Dancer with a Bouquet, Bowing*, we find ourselves on the stage during an intermission, where a number of bodiless legs are visible below a descending or rising backdrop. Among these are several wearing black tights, golden knee-length garments, and similarly colored shoes with turned-up, pointed toes. Almost identical costumes are worn by the sunshade holders in Degas' larger pastel, who can again be discerned in the tiny engraved figures from the fourth act of *Le Roi de Lahore* (plate 185). Degas' more astute admirers must have been gratified and amused by such details, which would also have flattered the vanity of such Opéra regulars as Isaac de Camondo, who later presented *Dancer with a Bouquet, Bowing* to the nation.

When we return to *On the Stage* and *Ballet at the Paris Opéra*, however, it seems that the most probable source of their exotic settings is Donizetti's *La Favorite*. First staged in 1840, this enduring classic was revived with new costumes, sets, and choreography in 1875, shortly before the two pictures were made. The setting for the ballet divertissement was an island paradise off the coast of Spain (plate 186), for which the leading dancers were dressed in elaborate harem-like outfits and the supporting cast in more conventional tutus. The anonymous author of an undated, handwritten mise-en-scène tells us

that "the young ladies in the corps de ballet" appeared in "flesh-colored tights, short white dresses made of gauze, gold waist bands, and bare arms," as well as headbands allowing their "long hair to hang down their backs."[47] This description is remarkably suited to the distant ballerinas in *On the Stage* and those in the foreground of *Ballet at the Paris Opéra*, where each plays a subsidiary role appropriate to a member of the corps.

A costume design for the 1875 revival of *La Favorite* (plate 188) brings us even closer to a little-studied Degas canvas, *Dancer on the Stage* (plate 187). Among the largest and most unusual of all the artist's performance pictures, it belongs to a select group of works that portray dancers in detailed, exotic apparel, here against a backdrop that—while far from lucid—could come from only a few productions. This loosely brushed, untamed vegetation is not unlike that already encountered in *L'Africaine* (plate 182) and *Le Roi de Lahore* (plate 185), but the costume in Degas' painting is clearly diagnostic. The design for *La Favorite* shows a richly ornamented ensemble, with a pillbox hat, a jeweled belt across the hips, and a short decorated bodice that leaves the midriff lightly covered. Refinements were apparently introduced as the outfit was fitted and made, but there can be little doubt that this sheet records the origin of the costume worn by Degas' ballerina. Annotations indicate that two versions were envisioned, one pink and the other blue, the latter intended for Alice Biot, who somewhat resembled the performer. Degas' picture may have been conceived as a celebratory onstage portrait of Biot, who became

186. *Maquette of set for La Favorite, Act I, Scene 2, Paris Opéra, 1875. Designed by Joseph Chéret. Bibliothèque nationale de France*

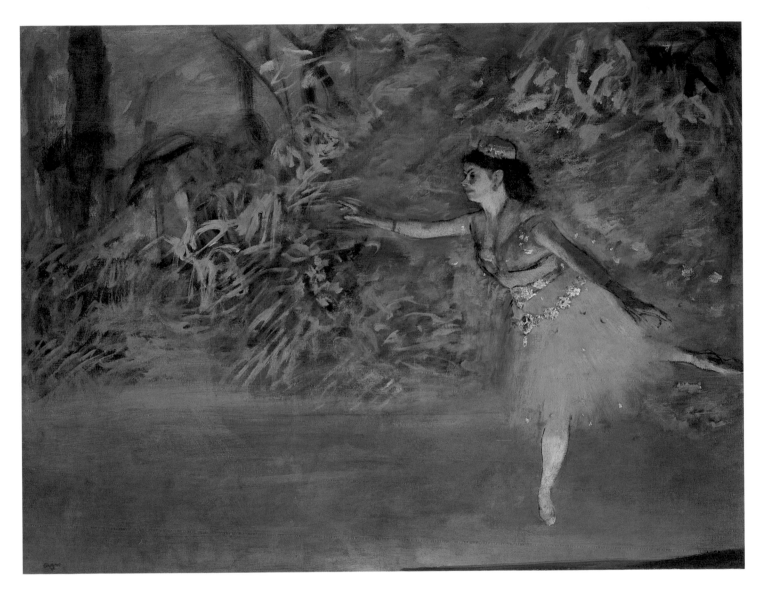

187. *Edgar Degas, Dancer on the Stage, c. 1877–80. Oil on canvas, 36 x 46½ in.*
(91.4 x 118.1 cm). Smith College Museum of Art, Northampton, Massachusetts; Gift of Paul
Rosenberg and Company, 1955 (1955:14)

188. *Costume design for La Favorite, Act I, Scene 2, Paris Opéra, 1875. Designed by Alfred Albert. Bibliothèque nationale de France*

terpart in the pastel and could hardly have been recorded in mid-action from a theater seat, unlike his tiny notebook sketches from the beginning of the decade (plate 3), while in the studio such a pose could easily have been sustained by a dancer-model. Variants of the ballerina's distinctive supplicating gesture occur in the contemporary lithograph *At the Theater, Woman with a Fan* (plate 100), in the reworked oil painting *Ballet Scene* (plate 316) and, more surprisingly, in at least two pastels made around 1890.[51] Degas' practice of "recycling" figures in this way may have been pragmatic or sentimental, but it could also reflect the longevity of the production from which it derives: *La Favorite* was performed virtually every year throughout Degas' adult career, until well into the twentieth century.[52]

CRYPTIC ALLUSIONS AND TELLING DETAILS

References in Degas' performance imagery to productions at the Opéra may seem elusive to his admirers today, but many were undoubtedly intelligible to the habitués who followed the slowly changing repertoire year after year. While a telling detail in a costume, like the sepals in *Two Dancers on a Stage* (plate 173) or a distinctive stretch of scenery,

a *petit sujet* in 1877, reviving his ambitions of the 1868 Salon canvas of Eugénie Fiocre and forming the center of another *Don Juan*–like cluster of performance works from the latter 1870s.[48]

Such explicit responses to Opéra productions raise important questions about the practical genesis of Degas' stage images. While it appears that he occasionally drew dancers in class and perhaps in rehearsal, the accounts of his contemporaries and an analysis of the drawings themselves indicate that he rarely made studies while a performance was in progress.[49] The artist himself insisted that his pictures were typically created in the studio, a practice that placed him at a physical and temporal remove from his theatrical subjects, heightening the roles of memory, the posed model, and such materials as photographs, prints, and his own earlier studies. A drawing for the figure in the central foreground of *Ballet at the Paris Opéra* offers some insights into this process. In *Dancer in Walking Position with Arms Stretched Forward* (plate 189) the girl leans forward with arms extended and back foot pointed in *tendu*, making an imploring gesture that is not part of the standard balletic vocabulary.[50] This must therefore be a mimed or choreographed movement, presumably a step from the dance interlude of *La Favorite*. The drawn form is much larger than its coun-

189. *Edgar Degas, Dancer in Walking Position with Arms Stretched Forward, c. 1877. Charcoal on blue-gray wove paper, 18¾ x 12¼ in. (47.7 x 31 cm). Statens Museum for Kunst, Copenhagen (KKS8527)*

such as the arid backdrop in *Dancer with a Bouquet, Bowing* (plate 104), would have enabled an *abonné* to identify the opera or ballet in question, a number of signature steps, decorative touches, or briefly famous incidents may have lost their significance forever. Such might have been the case with the frenetic movements of the tiny ballerinas in his fan design *Dancers* (plate 114), one of the wildest evocations of a stage event Degas ever painted: the eruption of Vesuvius in the last act of *La Muette de Portici*.[53] What at first appears to be an abstract pattern of splashes of color and amorphous shadows is actually a fiery, smoke-filled sky from which the dancers retreat in panic. The links between artist and opera were significant: Eugénie Fiocre played the mute heroine in the 1860s, a role later assumed by Rosita Mauri when the work was first presented in full-length at the Palais Garnier in 1879, a revival that coincided with Degas' creation of a group of painted fans, such as *Dancers*.[54]

A suggestive element of another kind appears in a diverse group of dance scenes in a wide variety of media and dating over a period of about fifteen years: the cavern or grotto, often with a bordering stretch of water.[55] This motif seems to have first occurred in a tiny etching of 1879 or 1880, *Dancers in the Wings* (plate 190), where four ballerinas are surrounded by shadowy stalactites and cave-like forms, with curious haloes of light in the distance. A concurrent work, *The Rehearsal for the Ballet*, was executed in ink and watercolor on silk—evidently once part of a fan—and shows dancers scattered among underground rocks and encircled by a lake or stream.[56] In his print, Degas employed a

191. *Maquette for Sylvia, Act II, Scene I, Paris Opéra, 1876. Designed by Joseph Chéret. Bibliothèque nationale de France*

range of grainy and striated textures to evoke the performers' subterranean context, while in the watercolor, washes of green, blue, and burgundy suggest mysterious minerals and dank vegetation. Similar rock formations and tunnel-like openings occur in the background of the richly developed *Ballet Dancer on Stage* (plate 312), a pastel whose present appearance was arrived at a decade or more later, arguably as the result of reworking an earlier sheet.[57]

Caverns were encountered in several late-nineteenth-century Opéra productions, though only one seems to have been in the repertory when Degas' fan and etching were made: the ballet *Sylvia*.[58] The second act of *Sylvia* followed the capture of the heroine by a hunter and her detainment in a grotto, a setting preserved in the original card-and-paper maquette for the stage design (plate 191). Here we see the rocky archways and outcrops, the smooth, reflective floor, and the burst of light emanating from an aperture in the ceiling, all of which have their equivalents in Degas' pictures. Though he took accustomed liberties with the details, we can hardly doubt the relation of his earlier works to the picturesque Opéra set, which was regularly visible as he worked at these very images. By the time he completed the late *Dancer on the Stage*, however, *Sylvia* had fallen out of favor for several years, to be revived for only six performances — one attended by the artist—in 1892. Degas' return to its grotto-like setting may have been prompted by its short-lived reappearance, or by the premiere of another ballet with a similarly appointed cavern: *La Tempête*, performed at the Palais Garnier between 1889 and 1892.[59] Degas was present at the Opéra during at least three performances of *La Tempête*, where the second scene in the first act took place on a wooded beach with a cave entrance, an unusual combination that perhaps informed the even later pastel, *Two Dancers* (plate 314).[60]

190. *Edgar Degas,* Dancers in the Wings, *1879–80. Etching, aquatint, and drypoint on buff wove paper, 9⅜ x 7¾ in. (23.6 x 19.7 cm). Philadelphia Museum of Art; Purchased with the Joseph E. Temple Fund, 1949 (1949-089-004)*

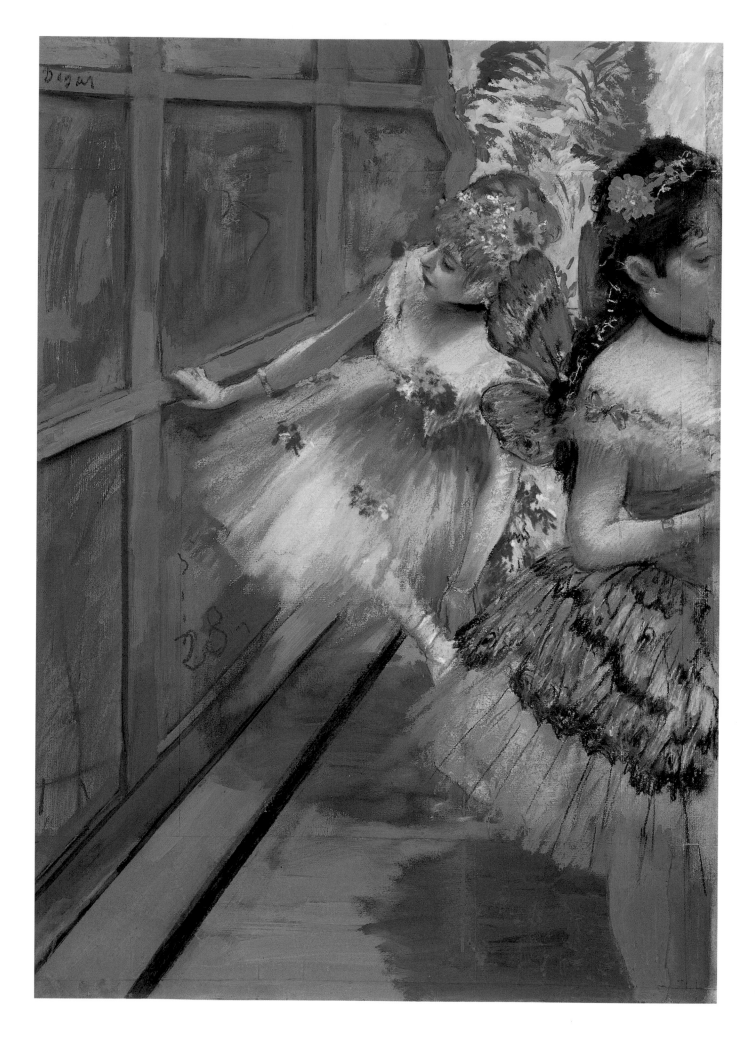

PICTURING THE PERFORMANCE

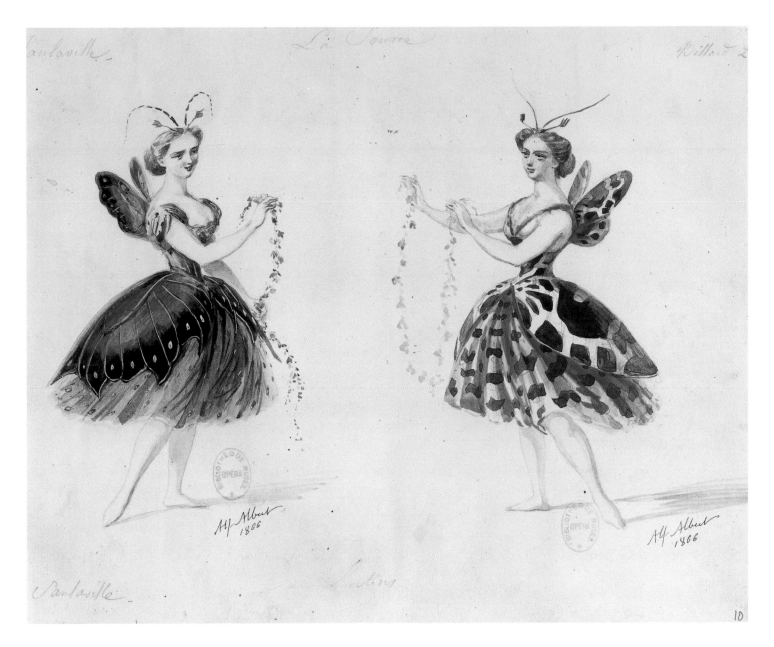

193. *Alfred Albert, Costume designs for La Source, 1866, Paris Opéra. Bibliothèque nationale de France*

192. *Edgar Degas, Dancers in the Wings, 1880. Pastel and tempera on paper, mounted on paperboard, 27¼ x 19¾ in. (69.2 x 50.2 cm). Norton Simon Art Foundation, Pasadena, California (M.1977.06.P)*

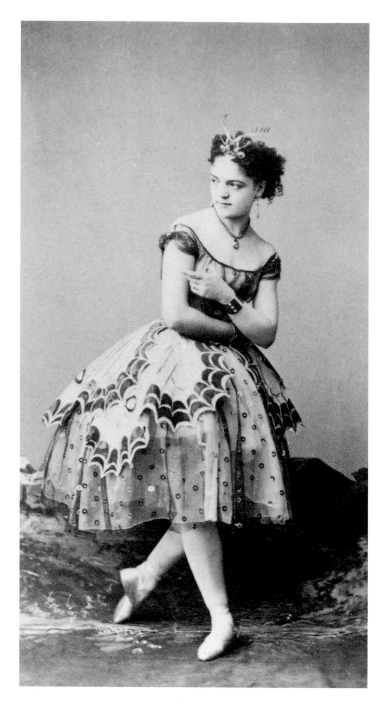

194. *Photograph of Marie Sanlaville in costume for* La Source. *Bibliothèque nationale de France*

drawing is a blue-toned dress envisioned for the young Marie Sanlaville, while the one in autumnal hues comes closer to the colors of Degas' pastel. Though the original design from the 1860s is dominated by irregular spots, it corresponds to the overall form of Degas' creation, which may reflect the final version of the butterfly outfit used on the rue Le Peletier stage or a refreshed version for the Palais Garnier.[63] Changes made while such costumes were in preparation can be seen by comparing Albert's sketch for Sanlaville's skirt with a photograph of the tutu she actually wore (plate 194) and similar alterations may have been made to his second butterfly design. In the pastel, Degas portrays an insect with irregular "veins," smudged "eyes," and ragged wing edges much like a spotted fritillary, a naturalistic shift appropriate to the artist and his amateur scientist friends.[64] Rarely has the clichéd association between pastels and the "powder of butterfly wings"—repeated in 1881 by Degas' admirer, Jules Clarétie—been so apt.[65]

Degas lavished attention on another striking tutu during these years, delighting in its transposition from one context to another. Its principal elements remain the same: a wide, fan-shaped, pale skirt; a girdle-like band covering the midriff with a V-shaped peplum; and long black, gold, and red or pink ribbons draped around the waist in an angular pattern. These festive colors are evident in a work such as *Dancer with a Tambourine* (plate 195) but its form is also visible in the monochromatic lithograph *Program for the Soirée Artistique* (plate 196).[66] Despite its emphatic visual character and Mediterranean aura, the precise role of this costume in the Opéra's activities is frustratingly undocumented. The 1884 program implicitly links the outfit to the ballet *Fandango*, written by Ludovic Halévy and Henri Meilhac, that premiered at the Palais Garnier in 1877, but the ribboned skirt depicted does not resemble any of those inspired by Spanish national dress worn in this production. Degas gave a prominent role to the multicolored tutu in several performance scenes and at least two intimate backstage pastels, implying some personal identification with the production and perhaps the wearer.[67] Before leaving the subject we should note that there is a curious lack of designs for simple tutus worn in late-nineteenth-century Opéra productions, while national, exotic, and historical costumes are recorded in great numbers. The absence of such designs is largely accounted for by the tutu's standardized form, which was simply dyed or otherwise modified with colored overskirts and trimmings as required, perhaps following the kind of handwritten notes found in the mise-en-scène for *La Favorite*. The scarcity of this information for the bulk of productions is especially unfortunate in any approach to Degas'

As well as distinctive settings, the character of a single costume might have been sufficient to characterize one of Degas' compositions for his contemporaries. Surprisingly, one of the most detailed and colorful outfits he depicted has failed to attract the attention it surely demands: that of the figure at right in *Dancers in the Wings* (plate 192). Winged ballerinas are remarkably rare in Degas' oeuvre, but here he seems to have compensated by rendering the varied fabrics, degrees of translucency and bloom, and refinements of ornament in the right-hand dancer's apparel with hypnotic intensity.[61] Alfred Albert designed a similarly themed ensemble for the first act of *La Source* (plate 193), where two ballerinas dressed as butterflies danced with eight of their colleagues disguised as flowers.[62] At left in Albert's

195. *Edgar Degas,* Sheet of Studies: Dancer with a Tambourine *or* Spanish Dance, *c. 1882. Pastel with pencil on paper, 18⅛ x 22⅞ in. (46 x 58 cm). Musée du Louvre, Department des arts graphiques, fonds Orsay (RF 4534).*

196. *Edgar Degas,* Program for the Soirée Artistique, *1884. Lithograph, 9⅞ x 12⅝ in. (27.5 x 38.8 cm). S.P. Avery Collection, Miriam and Ira D. Wallach Division of Art, Prints and Photographs, The New York Public Library, Astor, Lenox and Tilden Foundations*

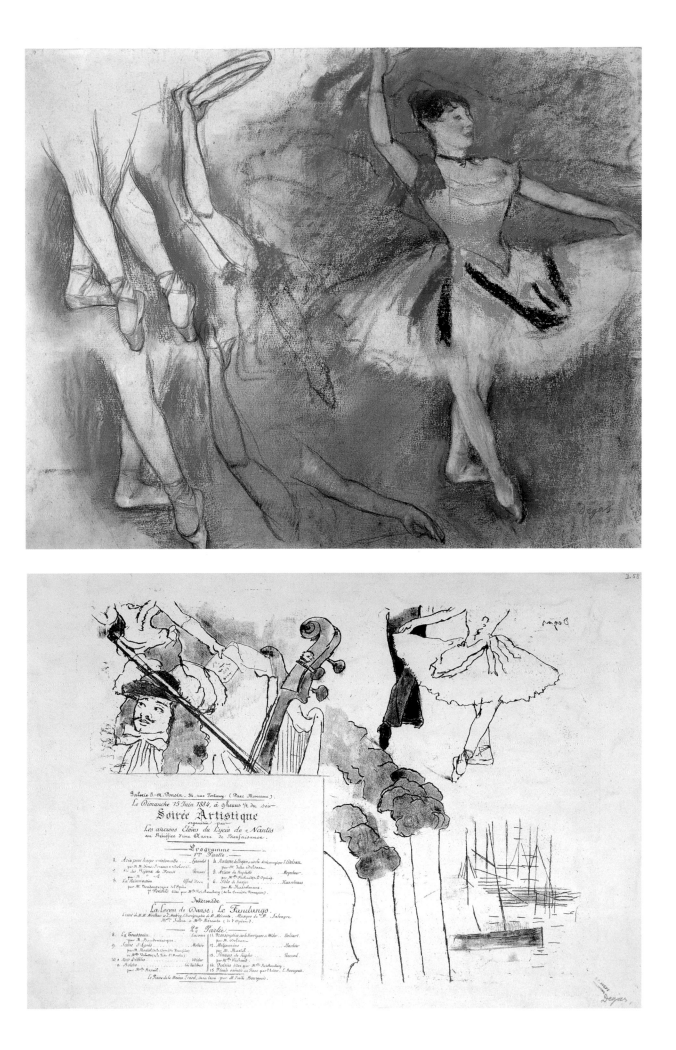

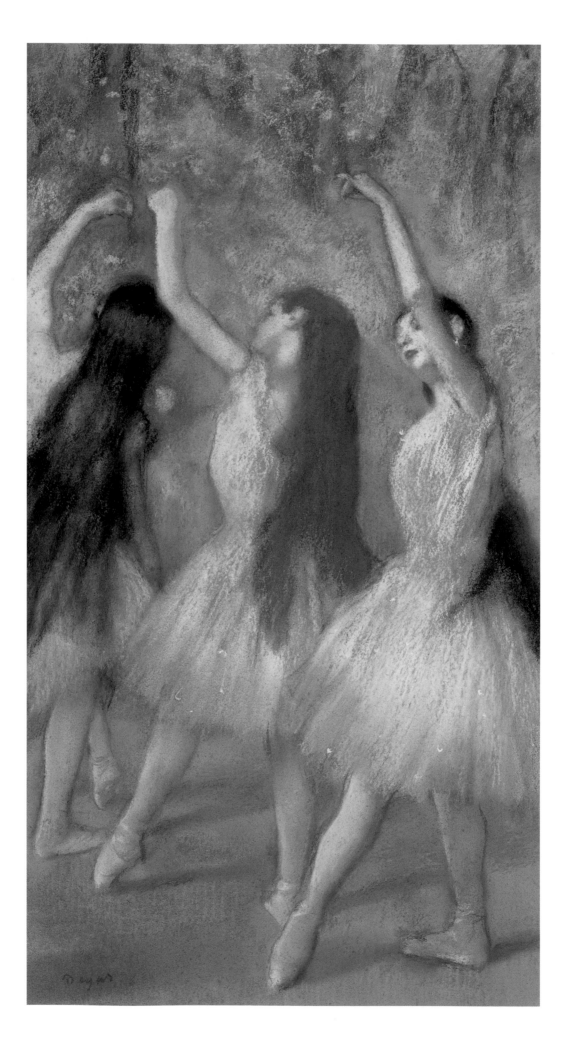

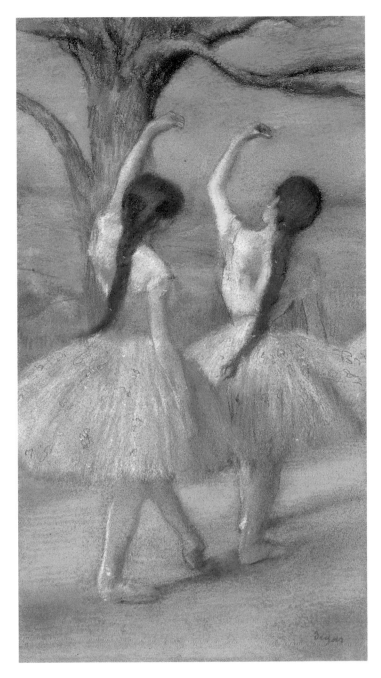

198. Edgar Degas, Dancers in Pink, c. 1885. Pastel on cardboard, 28¾ x 15¾ in. (73 x 40 cm). The Norton Simon Museum, Pasadena, California (F.1969.05.1.P)

performance œuvre, where most of the dancers are attired in conventional tulle skirts.[68]

While the documentation of costumes is imperfect, records of the choreography for almost every ballet that Degas saw or responded to artistically are nonexistent. Engravings, press reviews, and verbal descriptions fill some of these gaps, but the limitations of contemporary photography and the lack of an effective notation system mean that reliable accounts of dance sequences are rare. This is another sense in which Degas' art takes on unexpected significance as a visual archive: while his approach was far from systematic, his erudite and

197. Edgar Degas, Green Dancers, c. 1885. Pastel on wove paper, 28½ x 15½ in. (72.4 x 39.4 cm). Private collection, Chicago

precisely inscribed studies of ballet steps, arm and hand movements, and the role of mime have few historical rivals. So acute were his observations of the classical ballet and—in the words of the ex-dancer and ballet critic Lillian Browse—so absolute his "faithfulness to its laws and conventions," that many of his pictures can be productively analyzed in strictly technical terms.[69] In the exquisitely detailed Green Dancers (plate 197), for example, the luminous color and delicate pastel textures evoke an otherworldly scene, but Degas' scrupulous placement of the dancers' feet and legs must be grounded in close attention to events on the Opéra stage. Scrupulous also in his account of their rhythmically inclined bodies and delicately raised arms and fingers, the artist was surely reflecting a choreographed moment in a divertissement he had studied at length. A directly comparable work, Dancers in Pink (plate 198), also made in pastel in the mid-1880s, carries our three-dimensional grasp of this same configuration further, as we follow from behind a succession of young ballerinas performing their variations on a tendu theme in wooded surroundings. Again choosing the vertical format of a decorative panel or scroll, Degas defines the gently repeated intervals, echoing limbs, and artful pattern of costumes that allow us to visualize their musical and spatial progression.[70]

LATER DEPICTIONS OF DANCERS IN PERFORMANCE

During the late 1870s, Degas produced nearly half of the approximately one hundred performance pictures of his career.[71] The following decade represented a period of transition in his ballet art generally: after 1880, single figures rather than groups began to dominate his performance compositions; frontal, horizontal perspectives were favored over the oblique and vertiginous; and greater stress was placed on the concentrated, personal moment than on the unfolding narrative. Some of these changes are apparent in Fan: Personnages de l'Opéra (plate 199), for which Degas chose to revive the fan format of the previous decade (plates 110, 111, and 112). The exceptional dynamism of his earlier fan designs here gives way to dignified near-stasis, in a frieze-like presentation that seems to suspend his figures in time and space.

Theodore Reff has demonstrated that this haunting image portrays the opening of the second act of Sigurd, a solemn but remarkably popular opera by Degas' friend Ernest Reyer that opened at the Palais Garnier in 1885.[72] Degas attended a rehearsal and at least thirty-seven performances, and developed a passion for the leading soprano, Rose Caron, whose "thin and divine arms" are recorded in his design.[73] Events of the second act take place in an ancient Icelandic forest, as Norse priests and their mournful followers prepare to sacrifice the maiden Brunehilde to the god Odin. A photograph of the original set designer's maquette (plate 200) illustrates the cluster of huge trees that occupied center stage, clearly repeated in Degas' watercolor and subtly punctuating his procession of women. A rare example of his

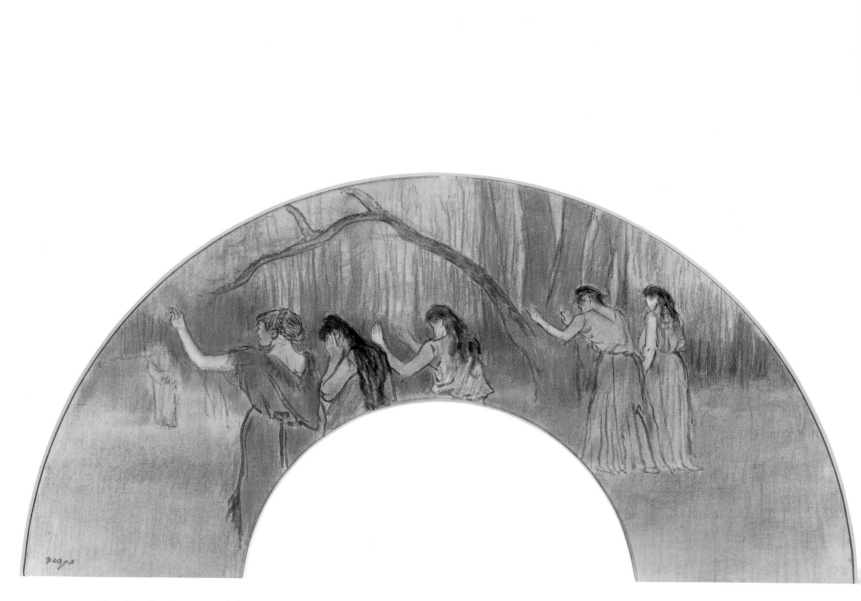

*199. Edgar Degas, Fan: Personnages de l'Opéra, c. 1885. Watercolor and pastel on silk
laid on paper; 12 ¼ x 25 ½ in. (31 x 64.8 cm). Private collection, U.S.*

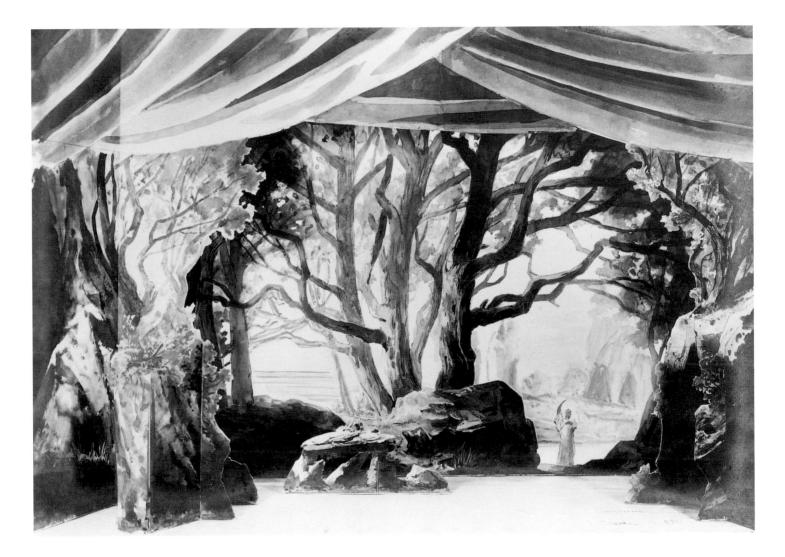

200. *Maquette of set for Sigurd, Act II, Scene I, Paris Opéra, 1885. Designed by Jean-Baptiste Lavastre. Bibliothèque nationale de France*

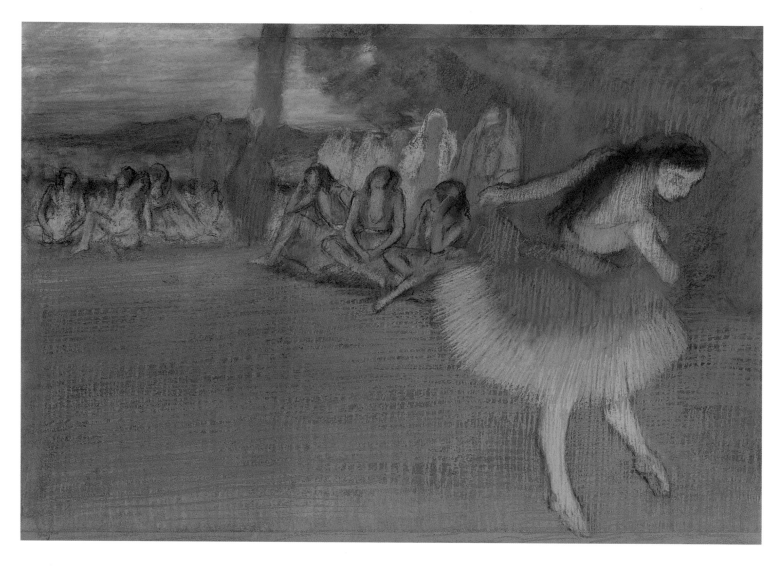

201. *Edgar Degas, Ballet Scene, c. 1887–90. Pastel on paper, 26 x 37 in. (66 x 94 cm).*
Tel Aviv Museum of Art; Moshe and Sara Mayer Collection

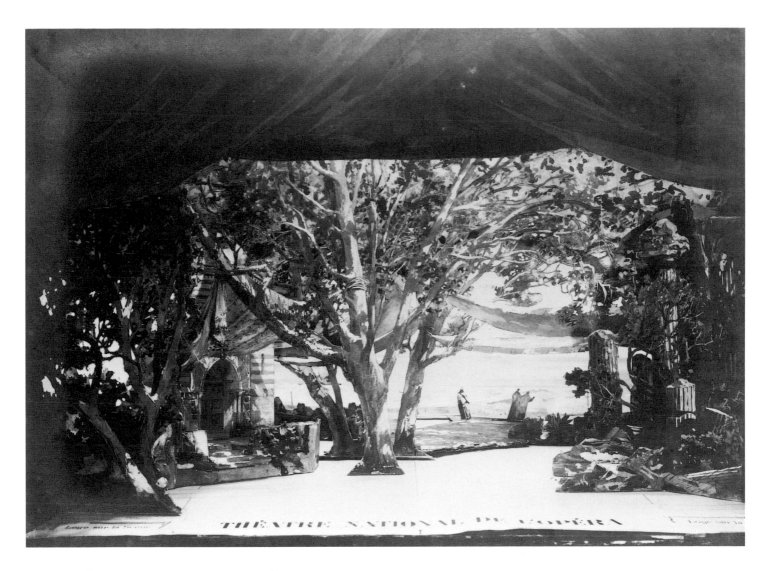

202. *Maquette for Namouna, Act II, Paris Opéra, 1882. Designed by Jean-Baptiste Lavastre.*
Bibliothèque nationale de France

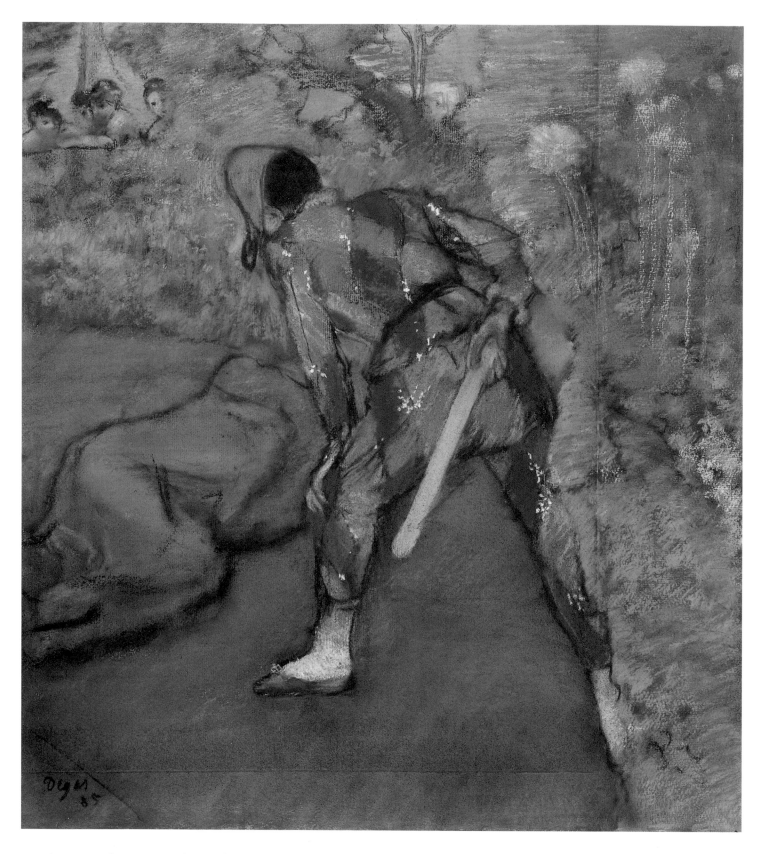

203. *Edgar Degas, Harlequin, 1885. Pastel on cream laid paper, 22.6 x 25.5 in.*
(57.3 x 64.8 cm). The Art Institute of Chicago; Bequest of Loula D. Lasker (1962.74)

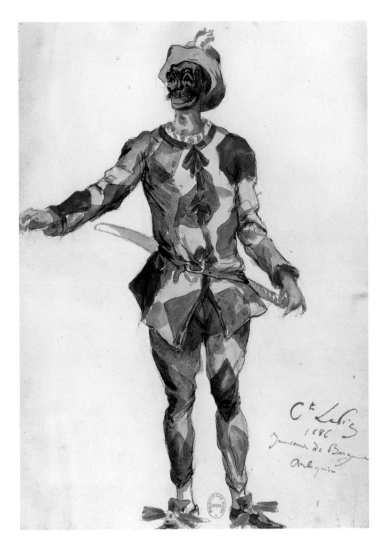

204. Count Ludovic Lepic, Costume design for Les Jumeaux de Bergame, 1886. Bibliothèque nationale de France

depiction of figures in historical dress, it represents an even rarer emphasis on singers rather than dancers.[74]

Characters and a setting of a quite different kind occur in *Ballet Scene* (plate 201), a large, brilliantly colored and rarely reproduced pastel of the late 1880s. Degas used all his technical resources to evoke the principal dancer's energy, encapsulating her nimble footwork in quivering strokes and broken contours. Dense applications of pastel can be found throughout this thrillingly asymmetrical composition, in which the costumes of the subsidiary figures, as well as the background scenery, are unusually specific. In a broad, tree-lined landscape, a group of seated attendants are dressed in sheer blue or flesh-tinted tunics with open necklines, while their standing companions wear shifts or veiled garments in white, lilac, scarlet, and lemon. This ensemble recalls the second-act tableau from Lalo's ballet *Namouna*, where slave girls of diverse nationalities reclined on carpets under a giant tree, a scene certainly known to Degas. As Linda Muehlig discovered, the artist and "the composer, Camille Saint-Saëns broke the silence of the bored *abonnés*" during the second act of one performance "by applauding vociferously for Mlle. Subra's mazurka."[75] The maquette for the Opéra production (plate 202) suggests that the incident in *Ballet Scene* took

place at extreme right of the stage, against overhanging foliage and a glimpse of broken columns, and a view of open terrain beyond. Although surviving designs show that most costumes were decorated with embroidery, patterning, and jewels, several included veils, one blue outfit had a plunging neckline, and another resembled the fiery tutu of Degas' foreground ballerina.[76]

When Degas unexpectedly turned to poetry in the late 1880s he wrote several sonnets on ballet themes, including one referring to Marie Sanlaville as a "masked and restless harlequin."[77] Sanlaville had created this role in the ballet *Les Jumeaux de Bergame*, a commedia-dell'arte–type farce with music by Théodore de Lajarte, choreography by Degas' long-standing acquaintance Louis Mérante, and costumes by Sanlaville's lover, Ludovic Lepic.[78] Seven major pastels have been associated with this production, though their historical links prove to be contentious and complex.[79] Degas was present at a rehearsal in July 1885 and at a performance several weeks later, when the ballet had a trial run in the small Breton resort of Paramé prior to its Opéra premiere the following January.[80] But research by Gary Tinterow has shown that two of Degas' harlequin pastels were completed months before the ballet's staging in Brittany.[81] In addition, one of Lepic's designs (plate 204) is dated 1886, indicating that the costumes were finished after Degas' first harlequin pictures. Nevertheless, the connections between Lepic's drawings and such images as *Harlequin* (plate 203) still remain highly suggestive. It is easier to believe that *Les Jumeaux de Bergame* was a long time in the making, with Degas' pictures growing out of its earlier phases, than to explain how he executed several works on an identical theme without reference to a current Opéra production that featured two dancers known to him and costumes designed by a good friend.[82]

The harlequin theme pervades a lyrical and less-familiar sequence of works that preoccupied Degas in later life. At their center is the small, bewitching oil on panel in the Musée d'Orsay, *Harlequin and Columbine* (plate 205), which depicts a figure in male costume kneeling beside a ballerina in a mysteriously deserted landscape. Their flirtatious encounter again brings to mind the antics of the commedia dell'arte, but the scene is now wistful and calm in a Rococo manner that is underscored by tapestry-like colors and an ornate male outfit, with knee-length pantaloons, short jacket, and soft hat. Overwhelmingly, we are reminded of Watteau's idyllic garden settings, reticent women, and plaintive lovers, the latter often adopting the same downward spiraling pose.[83] It is unclear whether Degas' picture reflects a specific production and its designs or was part of an exercise in free improvisation on an eighteenth-century motif, following his known taste for the art of that era and perhaps his delight in current revivals of its dances.[84]

The painting and the dozen or so highly varied pictures to which it is related range across Degas' favored media, into three dimensions—two studies showing the figure group from behind as if rotated—and through time, in both early and late stage scenes.[85] Some variants reveal the protagonists in costume, others in body stockings, or even naked, while another work on panel surrounds them with

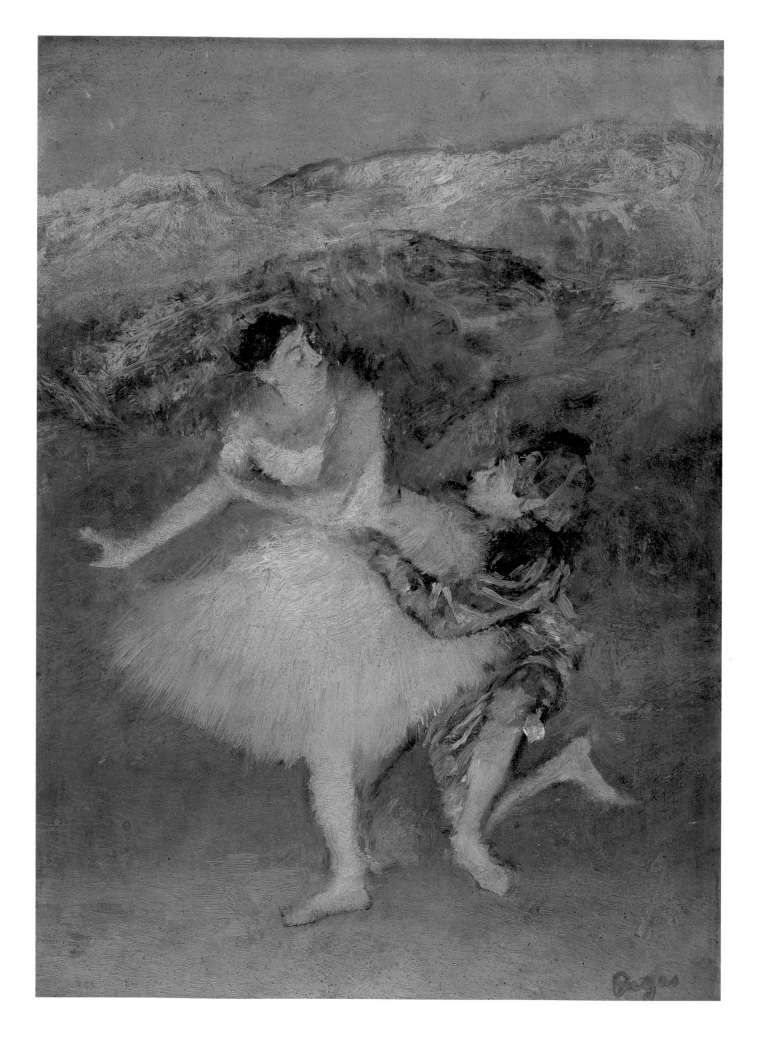

PICTURING THE PERFORMANCE

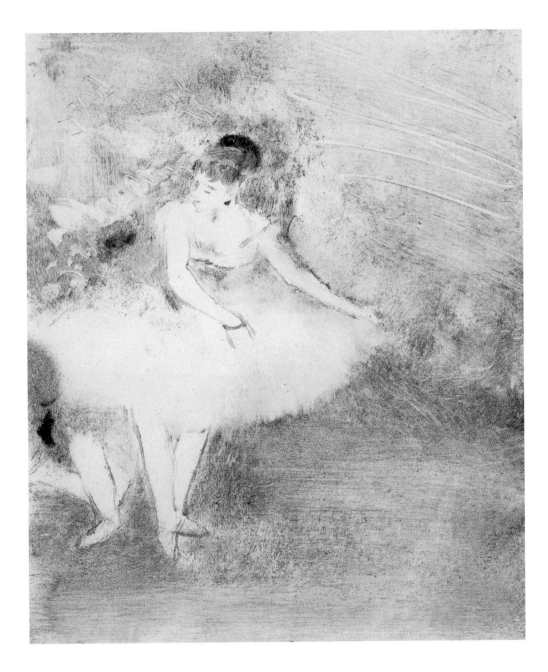

206. *Edgar Degas, Dancer on the Stage, c. 1875. Monotype on wove paper, 9¾ x 8⅛ in.*
(24.8 x 20.6 cm). Statens Museum for Kunst, Copenhagen (KKS 9158)

205. *Edgar Degas, Harlequin and Columbine, c. 1900. Oil on panel, 13 x 9¼ in.*
(33 x 23.5 cm). Musée d'Orsay, Paris (RF1961-28)

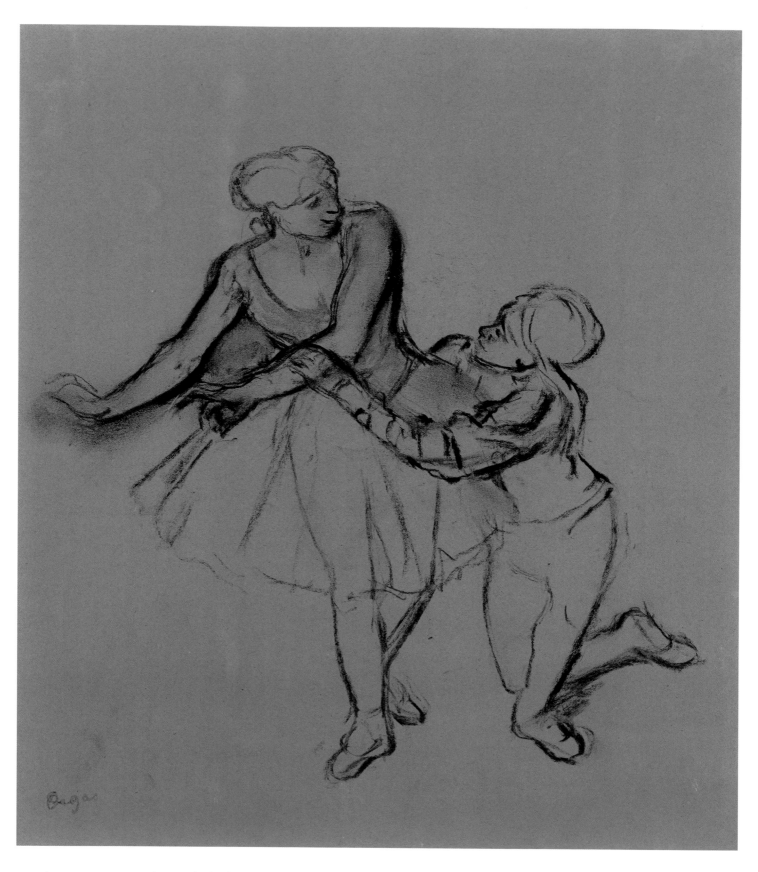

207. *Edgar Degas, Dancers as Harlequin and Columbine, c. 1890. Charcoal and pastel
on paper, 14½ x 12⅝ in. (37 x 32 cm). Private collection*

208. *Edgar Degas, Harlequin and Columbine (Two Dancers in Body Stockings),
c. 1890–95. Charcoal on tracing paper, 12½ x 9 in. (31.7 x 23.1 cm). Museum Boijmans Van
Beuningen, Rotterdam (F II 217 [PK])*

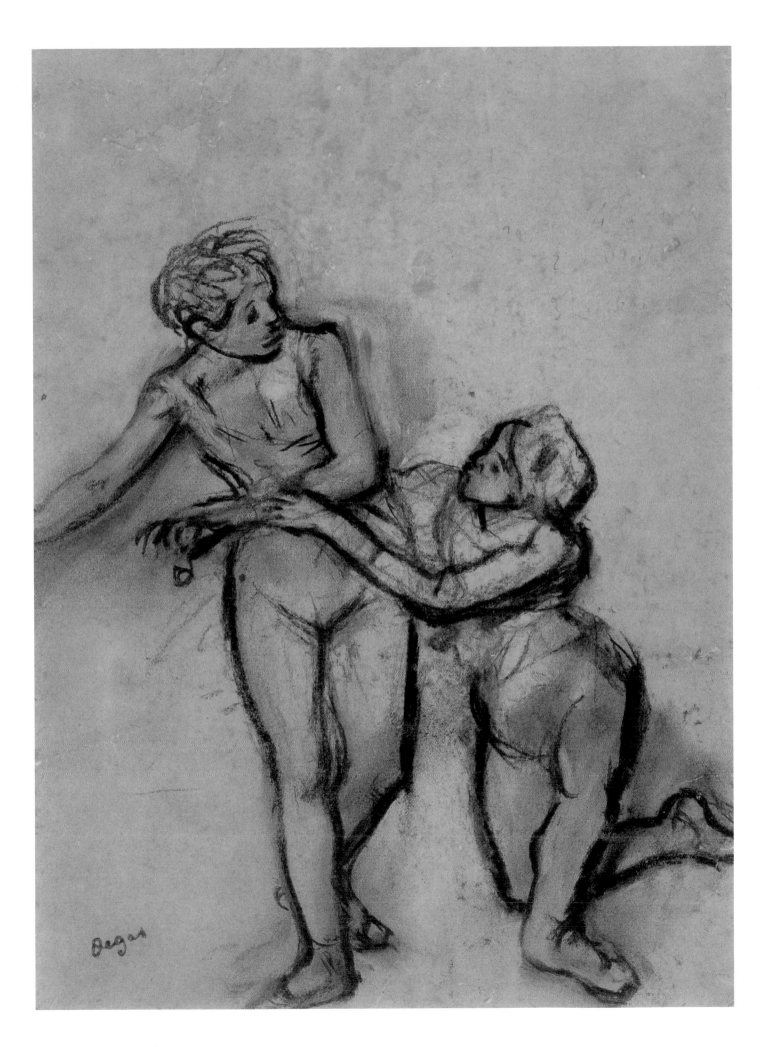

209. Edgar Degas. Aria After the Ballet, 1879. Pastel and gouache over monotype mounted on board, 23½ x 29½ in. (59.7 x 75 cm). Dallas Museum of Art; The Wendy and Emery Reves Collection (1985.R.26)

dancers, musical instruments, and foliage, like one of Degas' stage paintings of the 1870s. One of the first appearances of the pair was in a monotype of around 1875, *Dancer on the Stage* (plate 206), where the gestures of the ballerina who was to recur twenty years later in the Musée d'Orsay painting are already—uncannily—in place, albeit reversed by the printing process. In the monotype, her crouching companion is largely obscured, but a pencil drawing of the same date fixes both figures in the positions they retained.[86] Closer in time to the Paris picture is *Dancers as Harlequin and Columbine* (plate 207), whose energetic charcoal and pastel lines are arguably consistent with Degas' draftsmanship of the earlier decade. Now we have hints in the male costume—which would have been worn by a female dancer in travesty—of the Rococo accessories to come, though the relationship between the two dancers remains robust rather than ethereal. A later charcoal study of the pair (plate 208) reiterates their flowing, inter-

laced contact, here stripped down to their body stockings and appearing both vulnerable and tender. The smudged, heavy contours in this deeply affecting sheet belong with the artist's finest drawings of the fin-de-siècle, when he could still find satisfaction in revisiting themes of entreaty and rejection.

Bridging the heyday of Degas' stage pictures in the mid-1870s and the last of his performance images from the 1890s is the subject of *Aria After the Ballet* (plate 209), an image shot through with visual and thematic contradictions. It was initiated as a monotype—the largest Degas ever attempted—but was so overlaid with pastel and gouache that the monochrome print is now almost invisible. In its upper half we see a delightful alpine landscape, complete with cloud-topped mountains and pine trees, but we discover that the lower register is improbably crowded with pink-clad ballerinas, two gigantic double basses, and a solitary singer. Finally, having identified its Northern European locale, we find that the soloist is dressed for the Mediterranean, in a classical toga. The only operatic candidate for this strange juxtaposition is surely Gounod's *Faust*, the most performed work at the Paris Opéra in Degas' lifetime, one that he saw regularly until at

210. *Engraving of set for Faust, Act IV, Scene 1, Paris Opéra, 1869. Bibliothèque nationale de France*

least 1892.[87] One of the climaxes of Gounod's dramatization was set in the Harz Mountains on Walpurgis night (plate 210), where Faust has a vision of the most beautiful women of antiquity at a banquet: the Greek courtesan Phryné, the Trojan queen Helen, and the Egyptian empress Cleopatra. The details of this complex episode are not easily recovered, but it clearly brought together singers and dancers—the latter playing the legendary beauties and their retinues in appropriately ancient garb—in a mountainside setting, in a way that comes remarkably close to Degas' pastel.[88]

Aria After the Ballet was listed in the catalogue of the 1879 Impressionist exhibition, but attracted no critical attention and may not have been actually shown.[89] As in a number of Degas' works intended for public display, a witty acknowledgment of his debt to caricature was woven into the scene, here in a reference to a print by Daumier (plate 211). Most of the costume designs have disappeared, but a study for an attendant at the banquet (plate 212) offers a fascinating link with

211. *Honoré Daumier, Le Régisseur, 1856. Lithograph 8¼ x 10⅜ in. (21.1 x 26.7 cm). Private collection*

Faust. Valpurgis

Figurantes
non dansant

Faust

Lotus

5

212. *Paul Lormier, Costume design for figurantes in* Faust, *1869, Paris Opéra. Bibliothèque*
nationale de France

PICTURING THE PERFORMANCE

213. *Edgar Degas, Dancer in Egyptian Dress, Turned Toward the Right, c. 1890.*
Pastel on paper, 12¼ x 9½ in. (31.1 x 24.3 cm). The National Museum, Belgrade (218)

214. Edgar Degas, Dancer with Bouquets, 1890–1900. Oil on canvas, 71 x 60 in.
(180 x 151 cm). Chrysler Museum of Art, Norfolk, Virginia; Gift of Walter P. Chrysler Jr., in
memory of Della Viola Forker Chrysler (71.507)

215. *Maquette for* Guillaume Tell, *Act IV, Scene 2, Paris Opéra, 1875. Designed by Joseph Chéret, 1875. Bibliothèque nationale de France*

both the opera's and the artist's later years.[90] At some point in the 1890s, Degas made a group of broadly executed sketches of female characters in long robes and richly colored accessories (plate 213), on one of which he wrote a rare note: "ballet de Faust, Egyptiennes."[91] The wide-striped sashes, decorated collars, and heavy head ornaments of Degas' subjects clearly read back to the Opéra's production as reflected in the detailed design and suggest a nostalgic project to make another, very different image of its exotic plot. Gounod's drama was revived in 1893 at the Palais Garnier, and Rose Caron sang the leading female role when the opera celebrated its thousandth performance the following year.[92]

Almost all Degas' later stage pictures are elliptical in theme or diffuse in their range of historical reference, as if the artist were following his poetic instincts and leaving the prose of realism behind. Some, like *Before the Performance* (plate 319), aspire to remake a subject of the 1870s in the dense colors and wild handling of the fin-de-siècle, while others—among them, *Dancer with Bouquets* (plate 214)—bring together themes, techniques, and aspirations from every phase of his career. The latter is the kind of large canvas that Degas once submit-

ted to the Salon, taller even than his dancer-in-a-landscape portrait of Eugénie Fiocre and even more self-conscious as an assertion of modern painting on the scale of the old masters. Emerging from a characteristic series of drawings, earlier pastels, and even a small wax sculpture, the figure in *Dancer with Bouquets* has the combination of awkwardness and utter plausibility of Degas' greatest ballet heroines.[93] As she takes her bow on the Opéra stage, we recall almost identical young women curtseying in front of grottoes (plate 312) or surrounded by Eastern slaves, and again find ourselves wondering about her place in the Palais Garnier repertoire.[94] The alpine pasture, blue lake, and peaks beyond might be those of *Faust* or possibly *Guillaume Tell* (plate 215), but now it is the dense textures of Degas' paint and the drifts of lavender, rose, green, and peach making up the dancer and her surroundings that monopolize our sensations. Some of these finger marks and layerings must postdate his 1892 landscape monotypes, and the stark handling of the ballerina's body comes close to that of the turn-of-the-century *Four Dancers* in Washington.[95] By a strange coincidence, *Dancer with Bouquets* was the very first of hundreds of paintings, pastels, and drawings to be sold in the auctions that followed Degas' death, but it may also have been among his last deeply felt and truly grand statements about a ballerina in the footlights.

7. Degas and the Dancers

…even this heart of mine has something artificial.
The dancers have sewn it into a bag of pink satin,
pink satin slightly faded like their dancing shoes.
—DEGAS IN A LETTER TO BARTHOLOMÉ, JAN. 17, 1886[1]

After two decades of drawing and painting dancers, a lonely fifty-one-year-old Degas confessed to his sculptor-friend that his heart had been stolen, not by any one dancer in particular, but by a collective of the hard-working, gravity-defying, and sometimes socially questionable women who dominated his art. By this date, Degas had come to know many of the dancers at the Opéra intimately: he had devoted nearly half his professional life to an extended study of their daily routines and to putting what he observed onto paper and canvas, or into wax and clay. Their work sustained a great deal of his own, a dependence noted in reviews of the Impressionist exhibitions, where one critic suggested in 1879 that Degas had himself become "one of those remarkable coryphées," and another hailed him the following year, possibly for the first time, as "the painter of dancers."[2] In later life, the artist would be resentful about this simplistic association: "They call me the painter of dancers," he complained to the dealer Vollard, "not understanding that for me the dance is a pretext for painting pretty costumes and rendering movement."[3]

Degas was to find "pretexts" for painting dancers for nearly half a century, developing a wide variety of relationships with scores of ballerinas in the process. As we have seen, several of these young women played an important role at the very beginning of his dance art: both the renowned Eugénie Fiocre and the otherwise invisible Joséphine Gaujelin sat for portraits that featured among his first images to be exhibited publicly (plates 48 and 49). Around 1870, he was friendly enough with several other dancers to fraternize and correspond with them, among them, the coryphée Mlle Simon (plate 217), to whom he wrote a letter in 1872, and the dancer Mlle Malot, the mistress of his brother, Achille.[4] Over subsequent decades Degas would encounter ballerinas on a regular basis, as they came to his studio to model, met with him socially, and became familiar to him in dance classes, the Opéra *foyer*, and at the occasional rehearsal. The names and addresses of corps members who posed for him—such as Mlle Hughes, Antoinette van Goethem, Nelly Franklin, and Melina Darde (plate 216)—can be found scribbled on drawings or in his notebooks, and his contacts with both fledgling and accomplished stage personalities can be traced through his letters

216. *Melina Darde and companion, undated carte-de-visite. Bibliothèque nationale de France*

217. *Mlle Simon in* L'Etoile de Messine. *Bibliothèque nationale de France*

Halévy's help to secure a better contract for Joséphine Chabot (plate 249), and years later paid several visits to a ballerina-model who had fallen ill.[7] Although such attentiveness might suggest a certain intimacy, there is no indication that Degas was ever amorously engaged with a dancer, unlike his brother Achille or his friend Ludovic Lepic, who both had ballerinas as lovers.

EARLY PORTRAITS OF DANCERS

Degas' public career as "painter of dancers" began in the company of one of the Opéra's most glamorous stars of the 1860s, Eugénie Fiocre. His first major dance picture, *Mlle Fiocre in the Ballet "La Source"* (plate 49), shows the ballerina in a role that confirmed her status as a leading box-office attraction, though the work attracted little critical attention when it was exhibited at the Salon of 1868. The nineteen-year-old Fiocre had made a sensational debut on July 11, 1864, performing the role of Cupid in a new full-length ballet, *Néméa,* written by Ludovic Halévy and Henri Meilhac and choreographed by Arthur Saint-Léon.[8] In the words of the eminent dance historian Ivor Guest, Fiocre was an immediate "*succès de beauté,*" causing "a spontaneous gasp of admiration to ripple throughout the house" when the curtain lifted to reveal her on a pedestal posing as a statue of the winged god. Cupid was "never portrayed in a more beautiful, graceful, or more charming body," wrote Théophile Gautier in his review, "What splendid legs! They would be the envy of Diana."[9] Shortly before the premiere of *Néméa,* Fiocre had been elevated to the level of *sujet,* yet the consensus was that her lively persona and good looks were largely responsible for this promotion. Her allure was such that she was given important new roles each year between 1864 and 1870, the most historically significant being that of Franz in *Coppelia,* one of several travesty parts for which she became celebrated.[10]

After her triumph in *Néméa,* Fiocre was sought after by wealthy suitors, including such men of title as the Baron Soubeyran, and influential financiers, like the banker Salamanca, and is recorded by Ludovic Halévy at a dinner for Opéra dignitaries in 1865.[11] She was also courted by artists of renown, among them, the fashionable portraitist the sculptor Jean-Baptiste Carpeaux, who portrayed her in a marble bust, in a statuette titled *Cupid Disarmed* (plate 51), and—according to family legend—amid the monumental figures in *La Danse* on the Opéra façade.[12] In 1866, the year before Degas began his canvas of Fiocre, Franz Xaver Winterhalter completed his highly finished painting of the dancer in an extravagant and revealing gown, looking directly out at the viewer with exquisite self-possession (plate 218). Winterhalter makes no reference to Fiocre's humble origins or to her questionable profession; here she appears to be as refined as the royal or noble personages whose portraits brought him such acclaim.

Against this background, the approach of the virtually unknown Degas to the Opéra celebrity and the radical portrayal of her that resulted seem all the more puzzling, and perhaps even impertinent.

and pictures, and the memoirs of friends.[5] Though he undoubtedly encountered many more, it is now possible to document Degas' acquaintance with almost fifty dancers.

The broad spectrum of Degas' contact with individual ballerinas offers a range of insights into his relationship with the Opéra, his working practices, and ultimately into the genesis of his ballet art. Lillian Browse's pioneering study *Degas Dancers* of 1949 has provided an inspirational basis for this inquiry and established some of its themes. As we build on Browse's research, it becomes even clearer that Degas knew dancers from all levels of the Opéra hierarchy, from the lowliest corps members to the most famed *étoiles;* that his associations with some ballerinas lasted for a brief period, while others extended over the course of many years; and that he developed close, mutually respectful relationships with some of the individuals in question. Although his dealings with many of them were purely professional, as in his hiring of the young Melina Darde (plate 216) to model for him, we know of such social engagements as a "lunch with the Italian and French dancers," and of instances in which Degas took an active interest in the welfare of specific performers.[6] In 1883 he enlisted Ludovic

218. *Franz Xaver Winterhalter, Portrait of Eugénie Fiocre, 1866. Oil on canvas. Private collection*

The studies made for his Salon canvas indicate that Fiocre modeled for him on at least one occasion, while an analysis of a less well-known group of works may shed light on the circumstances surrounding their first encounter.[13] These suggest an earlier phase to the project, conceivably begun at a distance from the star as a "warming-up" exercise or as a means of gaining access to her. In the early 1860s Winterhalter had also painted a portrait of the Princess de Metternich, a distinguished figure in Second Empire society, who presumably sat for him in the traditional manner. Around the same time, Degas made his subtle oil study *Princess Pauline de Metternich* (plate 219) but was obliged to work from a *carte-de-visite* of the vivacious princess with her ambassador-husband.[14] The artist used photographs of Fiocre in much the same way, including a *carte-de-visite* by Nadar that provided a model for a small bust of the dancer in oil on cardboard (plate 221).[15] Closely following the pose and tonal structure of Nadar's print—despite its tiny scale and monochromatic character—Degas was able to evoke the ballerina's schoolgirl demeanor and adolescent charm. His modest painting bears a close resemblance to another *carte-de-visite* of Fiocre as Fenella in *La Muette de Portici* (plate 220), a role she assumed in 1865. Further support for Degas' use of such commercially available photographs for these trial likenesses comes from a charcoal drawing of the dancer, which shows her hair gathered elegantly above her

219. *Edgar Degas, Princess Pauline de Metternich, early 1860s. Oil on canvas,* 15¾ x 11⅜ in. (40 x 28.8 cm). The National Gallery, London (NG3337)

brow and crowned with a giant bow, exactly as she appears in photographs of her costumed for *Néméa*.[16]

The Fiocre and Metternich studies were among Degas' first attempts to make paintings of individuals outside his immediate family and social circle, beginning a long history of ballet portraiture and of sporadic recourse to photography. Photography often allowed for vicarious contact with inaccessible models and proposed alternative modes of depiction, as it did for many of his colleagues, as different as Edouard Manet and Paul Cézanne during these same years.[17] Both Eugénie Fiocre and the Princesse de Metternich moved in a much-photographed milieu, their lives overlapping at least once in the glittering—and for the young Degas, still remote—world of the Paris Opéra. Richard de Metternich was not only a member of the exclusive Jockey Club, a powerful force at the Opéra, but also an accomplished musician who co-wrote the score for the 1865 ballet *Le Roi d'Yvetôt*, which starred Eugénie Fiocre.[18] The event and the glamour of the celebrities involved may have prompted both of Degas' portrait efforts, though neither seems to have brought him the attention he hoped for. But Degas and Fiocre remained in contact, the dancer accepting two of the 1867 drawings as a gift, giving him a signed *carte-de-visite* in 1888, and apparently posing again for a tiny oil on canvas, *Head of a Woman* (plate 222).[19] Not previously associated with Fiocre, *Head of a Woman* clearly mirrors the painted study made after Nadar's

220. *Eugénie Fiocre in La Muette de Portici. Bibliothèque nationale de France*

221. *Edgar Degas, Portrait of Eugénie Fiocre, c. 1865. Oil on cardboard, 13³/₈ x 10⁵/₈ in. (34 x 27 cm). Private collection, Paris*

photograph (plate 221), the two figures displaying almost identical profiles, similarly styled hair, and inclining their heads in much the same manner. The Tate picture is noticeably more melancholy, its drab colors and coarser surface showing an older individual who has lost the naïve beauty that brought her early fame. As such, it can be associated with a group of canvases of mature women from the early and mid-1870s, in which the artist explored their moods, psychological states, and symptoms of illness.[20] Here Degas extends his concern to his seemingly troubled sitter, looking behind the public mask of the once-idealized dancer who retired from the stage in 1875 and lived on her accumulated earnings out of the spotlight.[21]

The second ballerina who featured prominently in Degas' early dance oeuvre, Joséphine Gaujelin, was as obscure as Fiocre was famous. Gaujelin was so undistinguished as an Opéra corps member that not a single photograph of her has been found, when even modestly accomplished dancers appeared in mass-produced *cartes-de-visite* (plates 216, 249, and 253). Like Fiocre, however, Gaujelin became the subject of an elaborately studied portrait that Degas submitted to the Salon, where it was received with a similarly muted response in 1869 (plate 48).[22] Though linked in time and theme, there are significant contrasts between the two works: *Mlle Fiocre in the Ballet "La Source"* is a complex and seemingly candid image of several exotically dressed performers, while *Madame Gaujelin* is a small, restrained composition showing a woman in street clothes. The former might be described as a modern

genre scene, presenting its subject in her professional capacity; the latter is an intimate image of its subject seated in a plain interior, which only after careful scrutiny turns out to be a boudoir or dressing room.[23] These images summarize Degas' principal approaches to portraits of dancers as the decades passed, though coincidentally Gaujelin and Fiocre were among the few ballerinas to appear in both portraits and genre pictures.

Some insight into Degas' Salon painting of Gaujelin is offered by a previously unpublished pastel study for the canvas, where his sitter seems considerably more at ease (plate 223)[24] and he seems more willing to be explicit about her bodily forms, open expression, and the details of her dress and hairstyle. Degas' handling of his media underscores the differences between the study and the painting: the muted palette of the pastel allows the contours to dissolve and the forms to breathe, suggesting a more relaxed and accessible character than that in the tonally severe oil painting. Had Degas persisted with his casual approach, the Gardner picture would have perhaps come closer to his slightly earlier and more freely brushed canvas of Victoria Dubourg— an audaciously candid study of a woman painter—and to other informal portraits by Degas' colleagues, such as Manet and Fantin-Latour. For his Salon canvas, however, it was the coolness and technical control of Ingres that triumphed, presenting the former dancer in all her propriety. When it appeared in the 1869 exhibition, Berthe Morisot caustically described the painting as "a very pretty little portrait of a

222. *Edgar Degas, Head of a Woman, c. 1875. Oil on canvas, 6⅞ x 7¾ in. (17.5 x 19.7 cm). Tate London; Presented by A. E. Anderson through the National Art Collections Fund 1924 (NO3833)*

very ugly woman in black," perhaps in one of her moments of misunderstanding with Degas, or even in a minor spate of jealousy.[25] Presumably Morisot's response would have been kinder to the smaller and significantly contrasted portrait in Hamburg (plate 224), where Gaujelin appears against a bright blue sky and more open to psychological engagement. In this snapshot-like image, Gaujelin is shown as neither a patient accomplice nor an anonymous model, but as a Parisian woman who evidently intrigued the artist outside the context of her profession.

Several years later, Gaujelin again modeled for Degas, this time in the unequivocal role of a dancer. Although a number of ballet paint-

ings and drawings have been plausibly associated with her, she can be definitively identified in only three: a drawing in black pencil and chalk now in Rotterdam (plate 225) and an essence study on paper, both inscribed with her name and the date 1873; and a small oil on canvas.[26] Unusually for this period, the Rotterdam drawing is not related to a finished composition, a fact that may be explained by the artist's dissatisfaction with his own efforts or by a perceived lack of proficiency on his model's part. Hinting at the latter, Degas wrote at the bottom of the sheet: "1873/ Joséphine Gaujelin / once a dancer at the Opéra / later an actress at the Gymnase."[27] The former ballerina had left the Opéra in 1865 for a theater known for its comedies and dramas rather than its ballets; therefore, when Degas made his drawing, it may have been eight years since Gaujelin had danced professionally, accounting for some of the awkwardness evident in her posture.[28] Although her legs and feet are correctly placed in a standard preparatory position,

DEGAS AND THE DANCERS

her bearing is almost pedestrian, with her upper body tensed, shoulders slouched, and arms hanging limply at her sides.

Curiously, the dancer in the annotated Rotterdam study hardly resembles the Gaujelin of the earlier portraits, while the model in the uninscribed *Ballet Dancer in Position Facing Three-Quarters Front* in the Fogg Art Museum (plate 226)—with her heart-shaped face, almond eyes, and sensuous half-smile—strongly recalls the image of Gaujelin in the Hamburg painting (plate 224). This teasing uncertainty of identification continues in an intricately linked series of drawings, all executed in graphite and white chalk on various shades of pink paper in 1872 or

1873, and each portraying a dancer wearing a scoop-necked bodice over a ruffled camisole and a straight-waisted practice skirt. In the Fogg's exquisite work, the figure exhibits great poise and technical facility: her arms are held effortlessly in place, her shoulders are erect, and her right foot is fully pointed behind her, creating a balletic line as fluid as Degas' pencil rendering. This sheet was also used as a study for several paintings and pastels, including the Musée d'Orsay's *Dance Class* (plate 229) and the three versions of *The Rehearsal on the Stage* (plates 61, 62, and 176).[29] The gracefulness of the model is equally apparent in what may be Degas' most titillating picture of a ballerina, *Dancer Adjusting Her Slipper* (plate 227), where a barely concealed chest and supple body were spelled out with unusual candor. Despite her charms, George Shackelford has demonstrated that this same ballerina was painted out of the foreground of the Musée d'Orsay's *Dance Class* (plate 229) and replaced by another individual who stands with her back to the viewer.[30]

223. *Edgar Degas, Portrait of Madame Gaujelin, 1867. Pastel and pencil on paper, 17¾ x 13 in. (45 x 33 cm). Private collection, United States*

224. *Edgar Degas, Madame Gaujelin, 1867. Oil on mahogany, 13⅞ x 10½ in. (35 x 26.5 cm). Hamburger Kunsthalle, Hamburg*

225. *Edgar Degas, Joséphine Gaujelin, 1873. Pencil and black chalk on paper, 12 x 7¾ in. (30.7 x 19.7 cm). Museum Boijmans Van Beuningen, Rotterdam (F II 169 [PK])*

226. *Edgar Degas, Ballet Dancer in Position Facing Three-Quarters Front, c. 1872–73. Graphite, touches of black crayon, and white chalk on pink wove paper, squared, 16⅛ x 11¼ in. (41 x 28.4 cm). The Fogg Art Museum, Harvard University Art Museums; Bequest of Meta and Paul J. Sachs (1965.263)*

The third example in this remarkable trio of studies, *Dancer Adjusting Her Costume* (plate 228), shows once again Degas' scrupulous and informed description of pose and costume. Contrasting a delicate line with a suggestive lack of finish, he now presents his model fussing with the front of her bodice and rearranging the layers of her tutu, just like a distant ballerina, partially hidden by the dance master, in the Musée d'Orsay's *Dance Class* (plate 229). Intriguingly, therefore, the three drawings modeled by a single individual were used as the basis for a trio of quite separate characters who all appear in one painting.[31] Other clues to Degas' manipulation of his dancer-models can be found here: in the Paris painting, the dancer's hair color is lighter and differently styled from the figure in the Detroit drawing, and her facial features are markedly less distinctive. It is also clear that the artist was prepared to alter a ballerina's status, presenting an obscure ex-dancer like Gaujelin as a star in the pictorial narrative of a classroom scene or posing as a soloist in a rehearsal (plates 61, 62, and 176). The artist's willingness to modify the attributes and roles of the women who posed for him, even to transpose their heads and bodies in certain circumstances, was part of the wider functioning of artifice in his working practice.[32] Whether it is Joséphine Gaujelin or another model who features in every one of this complex group of studies, we

again find Degas tracing the nuanced appearance and shifting presentation of dancers, some known to him over a period of time, as both skilled and fallible practitioners of a physically demanding art.

Fortunately, there is no doubt about the identity of the silver-haired teacher at the center of the Musée d'Orsay's *Dance Class* (plate 229), the legendary dancer and choreographer Jules Perrot (plate 231).[33] In this and the Metropolitan Museum's variant of the scene (plate 127), the maestro presides over his pupils with a casual air that belies his spectacular achievements. Engaged by the Paris Opéra at the age of twenty in 1830, Perrot was highly praised by critics during the golden age of the Romantic ballet, and extolled by Gautier—who openly disdained male dancers—as "the aerial Perrot, Perrot the sylph, the male Taglioni."[34] Yet the Opéra did not renew his contract in 1835; for the next three decades he traveled throughout Europe, performing and staging dance productions for some of the world's leading opera houses, and becoming ballet master at the Imperial Theaters in Saint Petersburg from 1849 to 1860.[35] When Perrot returned to Paris in 1861, he lived in an apartment within walking distance of the Opéra and the dance conservatory on the rue Richer, harboring dreams of a new professional life at the Opéra that were never realized.[36] Although not formally employed at the rue Le Peletier theater, it seems that Perrot

227. *Edgar Degas, Dancer Adjusting Her Slipper, c. 1872–73. Graphite heightened with white chalk on paper, 12⅞ x 9⅝ in. (32.7 x 24.4 cm). The Metropolitan Museum of Art; H.O. Havemeyer Collection, Bequest of Mrs. H.O. Havemeyer, 1929 (29.100.941)*

228. *Edgar Degas, Ballet Dancer Adjusting Her Costume, c. 1872–73. Graphite heightened with white chalk on pink paper, 23⅝ x 18⅝ in. (60 x 47.3 cm). The Detroit Institute of Arts; Bequest of John S. Newberry (65.145)*

often taught classes there during this last phase of his career—and privately coached principal ballerinas—after his friend Louis Mérante became ballet master in 1869.[37] This then was the historically and personally weighted context for the group of three major pictures made by Degas between 1873 and 1876 (plates 127, 165, and 229), showing Perrot giving lessons in the former Hôtel de Choiseul, where we see a presence from another era training the corps de ballet of the modern age.

The circumstances in which Degas met Perrot and painted these pictures are unknown, but from the beginning the artist seems to have revered him and felt impelled to restate his authority. The first work in which Perrot appears is *The Rehearsal* (plate 165), where the former ballet dancer is depicted as a distant and somewhat detached instructor in a busy classroom.[38] As with Degas' early pictures of Fiocre, it has been shown that this miniature portrait was based on a daguerreotype taken nearly fifteen years before when Perrot was still working at the Imperial Theaters.[39] The use of a photograph may suggest that Degas had yet to become acquainted with his model, though a group of drawings made around this time indicate that Perrot began to pose for him soon after. One of these studies (plate 230) was used to insert the figure of the retired ballet master into another imaginative composition, the Musée d'Orsay's *The Dance Class* (plate 229). In

his landmark study of this sequence of works, George Shackelford has demonstrated that the Paris canvas was well underway before Perrot was introduced, indicating a change of heart on the artist's part.[40] An X ray of the picture reveals that Perrot was painted over another male teacher thought to be the Opéra's ballet master, Louis Mérante, who had already been portrayed in one of Degas' earliest ballet paintings, *Dance Class at the Opéra* (plate 19).

In contrast to Mérante, whose extended acquaintance with the artist is attested to in several letters, no written record of Degas' contact with Perrot survives, except for a note of his address in a sketchbook.[41] However, the dozen works of art depicting the retired ballet master suggest sustained contact between them and considerable sympathy for Perrot on Degas' part.[42] One characteristic charcoal and chalk study, representing Perrot leaning on his staff in the pose of the Musée d'Orsay's *Dance Class*, displays all the immediacy of a figure drawn from life.[43] Probably executed in 1874, the drawing shows Perrot gesturing to a hastily sketched ballerina behind him, implying that his placement in the Paris canvas was already largely determined. Soon afterward, Degas must have begun the loosely brushed essence painting now in the Philadelphia Museum of Art, signed and dated 1875 (plate 230) which was almost certainly developed from the earlier

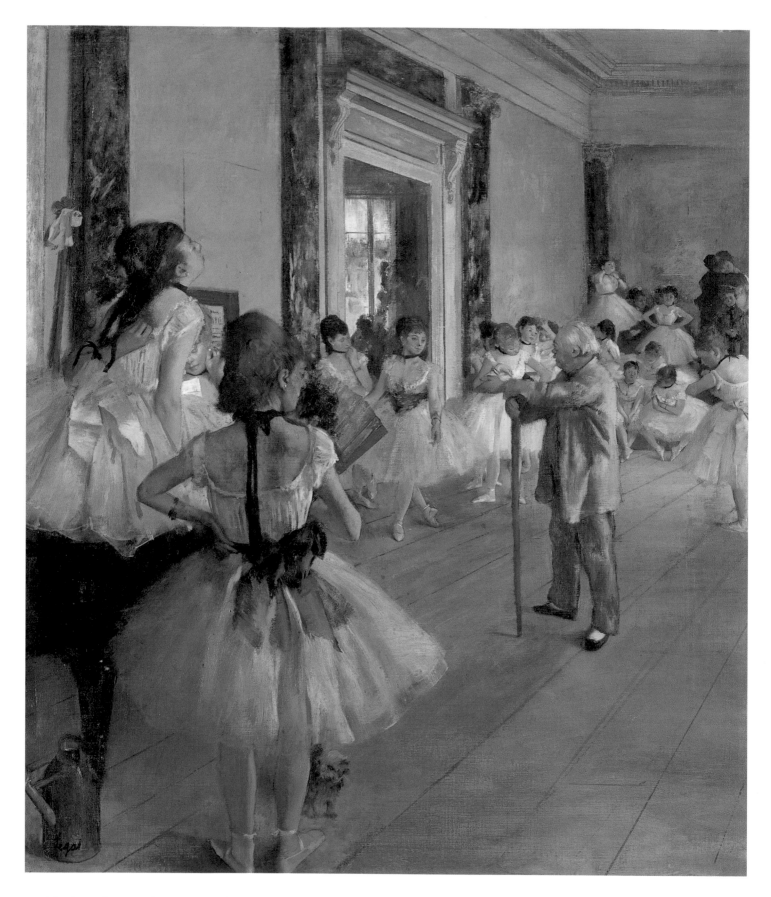

229. Edgar Degas, The Dance Class, c. 1873–76. Oil on canvas, 33½ x 29⅝ in.
(85 x 75 cm). Musée d'Orsay, Paris (RF 1976)

230. Edgar Degas, The Ballet Master, Jules Perrot, 1875. Oil sketch on brown paper,
18⅞ x 11¾ in. (47.9 x 29.8 cm). Philadelphia Museum of Art; The Henry P. McIlhenny
Collection in memory of Frances P. McIlhenny, 1986 (1986-26-15)

Degas
1875

231. *The ballet master Jules Perrot. Bibliothèque nationale de France*

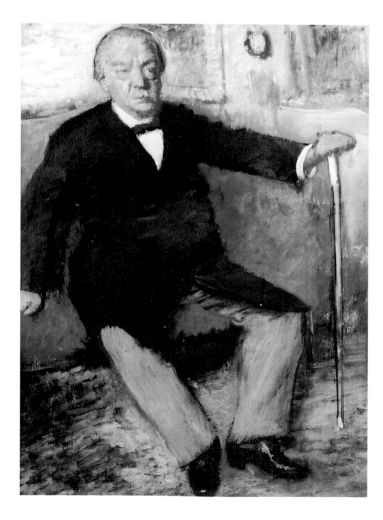

sketch rather than from life: not only are the two figures nearly identical, but certain features of the essence picture—such as the velvety texture of Perrot's flannel suit and the red reflections on his face—correspond to the inscriptions on the charcoal study.[44]

Perrot's iconic significance for Degas as a representative of the Romantic ballet deserves serious consideration in any approach to his dance art. Several of Degas' images of the former star indicate not just wide-eyed fascination for a personal idol, but an identification with his cause. In the slightly earlier *Rehearsal* (plate 165), Degas had created a vision of a much younger Perrot at work in the rue Le Peletier *foyer du jour*, and in a succession of pictures he celebrated the ex-dancer's role in the present and followed him into dignified old age. A small oil painting of uncertain date depicts Perrot in decline (plate 232), now using a walking stick rather his teacher's staff, and seated instead of standing, perhaps because those "soft and pliable, elegant and supple" legs once praised by Gautier could no longer support him.[45]

The Philadelphia essence painting may have had an even more pointed meaning. The magisterial pose adopted by Perrot seems to have been associated with *maîtres de ballet* in general, as suggested in an 1864 illustration of the rehearsal *Néméa* (plate 64). In the lengthy caption—purportedly written by Ludovic Halévy—it is explained that the figure directing the action is choreographer Arthur Saint-Léon, who had taken over Perrot's position in Saint Petersburg.[46] Ten years later, Degas echoed this image in two major dance class pictures and in a visionary scene made around 1875, *Rehearsal of the Ballet* (plate 233), where Perrot conducts a practice session on a fully dressed stage. By this time, it had been ten years since he had mounted a ballet, and though there was a rumor in 1874 that Perrot might produce *Esmeralda* at the soon-to-be completed Palais Garnier, the story was refuted by the Opéra.[47] The event depicted, in other words, could never have taken place, a fact underscored by the ghostly illumination, the weightlessness of the figures, and their detachment from the practicalities of the surrounding theater. While one dancer bends away from us into shadow and another floats in spectral light, the gaunt Perrot retains his statuesque authority.[48]

DEGAS AND THE CORPS DE BALLET

Unlike the venerated Perrot, or Fiocre the seductive star, most of the dancers who appear in Degas' ballet pictures were unexceptional or unseasoned members of the corps de ballet. Inscriptions on drawings and notes in his sketchbooks reveal that dozens of these young women came to Degas' studio to model, where they would dress in classroom attire and re-create poses typically assumed during practice sessions and performances, or in moments of preparation and relaxation.[49] They appear in hundreds of drawings dating to the 1870s and 1880s—

232. *Edgar Degas, Jules Perrot, Seated, c. 1875–92. Oil on panel, 13¾ x 10¼ in. (34.9 x 26 cm). Private collection*

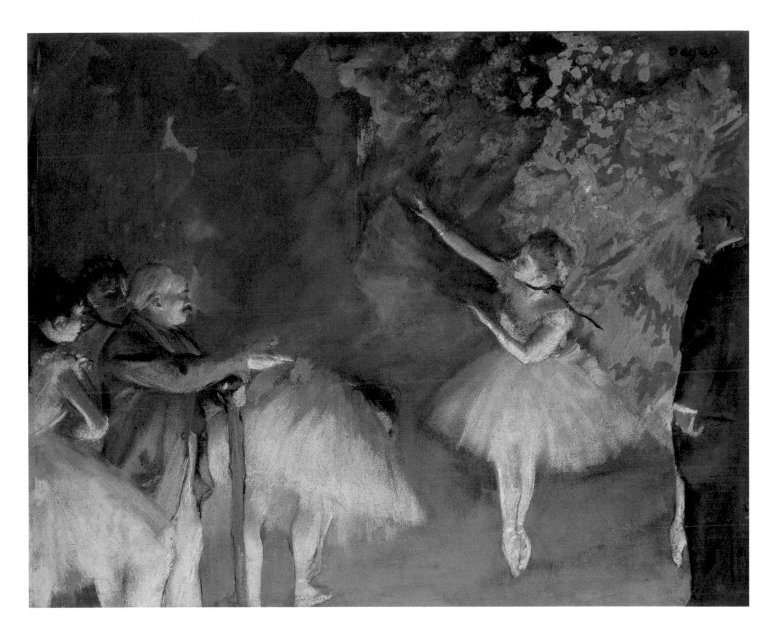

233. Edgar Degas, Rehearsal of the Ballet, c. 1876. Gouache and pastel over monotype on paper, 21¾ x 26¾ in. (55.2 x 67.9 cm). The Nelson-Atkins Museum of Art, Kansas City, Missouri; Purchase of the Kenneth A. and Helen F. Spencer Foundation Acquisition Fund (F73-30)

many painstakingly observed, most rapidly executed—including those used as studies for finished works, others made simply as drafting exercises, and examples that contributed to the artist's personal "dictionary" of classical dance steps. Preparatory drawings and finished portraits bearing names, dates, and even addresses help us to recognize several of these personalities, and to reconstruct something of their professional history, yet scores of these ballerinas—some distinctly familiar from Degas' drawings, pastels, and paintings—still remain anonymous.

All of the known dancers who appear in Degas' works were affiliated with the Paris Opéra at some point in their careers, and while most were company members throughout their professional lives, some performed at other theaters either before or after joining the Opéra.[50] In two instances, the artist himself provided information about a model's professional history: the study of Gaujelin on which he noted her move to the Gymnase (plate 225), and a delicate pencil drawing of a much younger ballerina executed several years later bearing a partly illegible inscription that includes "Melina Darde / 15

years old / at the Gaîté / Dec. 78."[51] Not long after Degas made this drawing, Darde must have left the Gaîté, as we learn from Opéra records that she started performing at the Palais Garnier around 1880. In an equally exquisite drawing in charcoal heightened with white, *Dancer* (plate 234), which also includes Darde's name and notes regarding color and lighting effects, the ballerina is engaged in a difficult exercise without a trace of strain in her face or in her upper body. The manner of Degas' drawing is judiciously appropriate to his model: both achieve precision without appearing stilted, and both display ease and control in pursuing their respective activities.

In an undated photograph in the Bibliothèque de l'Opéra, Darde poses with a companion (plate 216), her slender limbs displayed to full advantage and the cheerful assurance conveyed in *Dancer* again in evidence. The drawing was employed as a study for the ballerina at left in *The Rehearsal* (plate 84), presenting the teenager taking class at the old Opéra house, which she could not possibly have known since it was destroyed by fire when she was just ten years of age. This incongruity not only adds to the reinventions surrounding Perrot, it underscores the broader freedoms Degas allowed himself in his ballet pictures, once again emphasizing his willingness to redefine the professional identities and histories of his models. Melina Darde's

234. Edgar Degas, Dancer (Battement in Second Position), *1878. Charcoal heightened with white on tan paper, 12¼ x 22⅞ in. (31.1 x 58.1 cm). Private collection, Massachusetts*

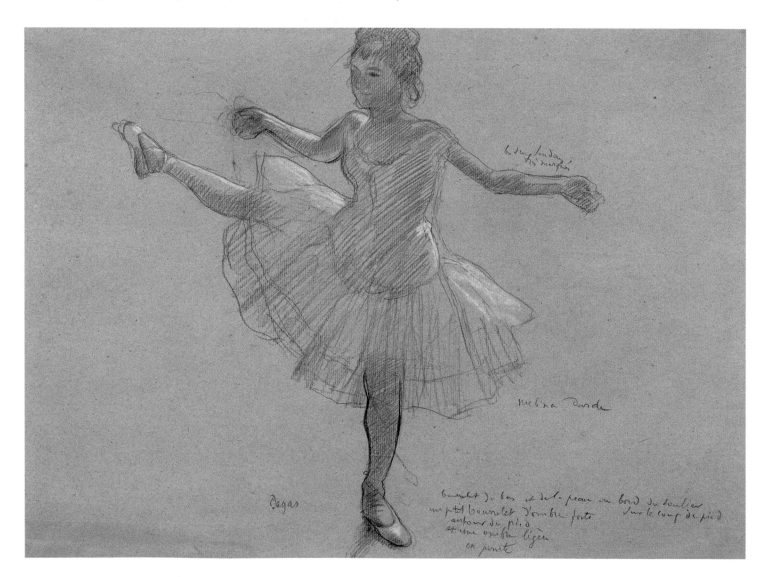

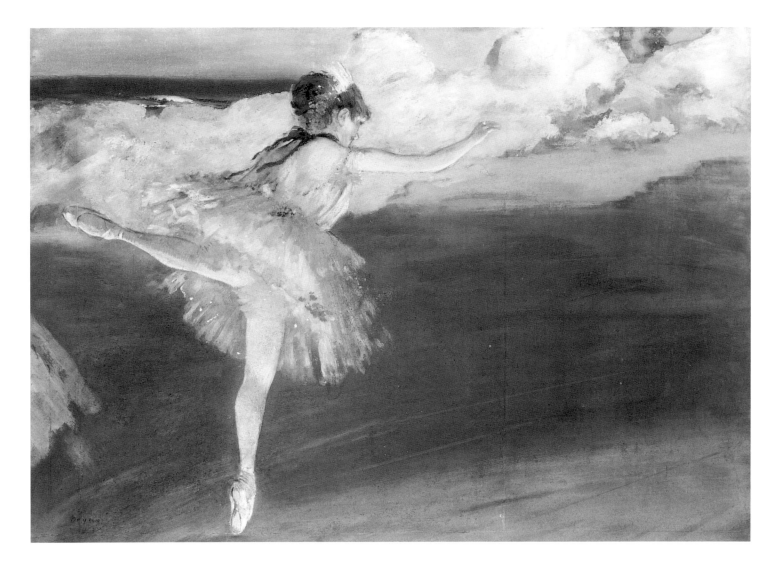

235. *Edgar Degas,* Dancer on Pointe: The Star, *c. 1878. Gouache and pastel on paper, 22¼ x 29¾ in. (56.5 x 75.6 cm). The Norton Simon Art Foundation, Pasadena, California (F.1969.40.P)*

presence in *The Rehearsal* may be doubly anomalous: as well as being too young to have trained in this classroom, it seems she had barely emerged at the Palais Garnier when she modeled for *Dancer*. Her name first emerges among those of the corps de ballet around 1880, in *livrets* for such works as *Korrigane*, which premiered eighteen months after *The Rehearsal* was displayed in the fourth Impressionist exhibition.[52] For unknown reasons, Degas chose to flatter the child-dancer by portraying her in the historic surroundings of the rue Le Peletier Opéra, and again by representing her as an improbable soloist in the roughly contemporary *Dancer on Pointe: The Star* (plate 235).[53] In this sparklingly fresh work in gouache and pastel, he captures the ballerina in mid-flight as she steps out from the wings. Her audaciously viewed figure is based on several studies from a third sheet inscribed with Darde's name, depicting her in the same pose and dressed in practice attire, rather than in the costume of the final painting.[54] Glamorously attired and technically adept, Melina Darde has been promoted by the artist to the level of *sujet* or *étoile*, a highly unusual distinction for a young dancer—and one she never attained.[55]

A surprising feature of most of Degas' images of Melina Darde is that her facial features are either averted or lost in shadow; had her name not been inscribed on his drawings, her identity would probably be unknown.[56] Such is the case with the figure shown practicing behind her in *The Rehearsal* (plate 84), whose reddish hair is tied back with a large blue bow. This short-necked, pale young woman might be taken for a caricature of a ballerina, until we consider another representation of her, *Study for Bust of a Dancer* (plate 236), a pastel in the Musée d'Orsay. In this unusual, near life-size work the young woman's coloring, pose, and the wide ribbon in her hair are identical to those in the Frick canvas, though here she appears only from the waist up. The pastel has been seen as a preparatory work for *The Rehearsal*, but its size suggests otherwise: Degas rarely—if ever—made figure drawings that were four times larger than their counterparts in a finished picture.

Little celebrated, *Study for Bust of a Dancer* is exceptional among Degas' representations of ballerinas on a number of counts. With the scale and personal emphasis of a traditional portrait, it also overlaps with the distinctive genre works that Degas was showing to some acclaim at the time, such as the pastel *Singer with a Glove* included in the Impressionist exhibition of 1879, where the Frick painting was also shown.[57] For all its sketchiness, the Musée d'Orsay sheet is a signed

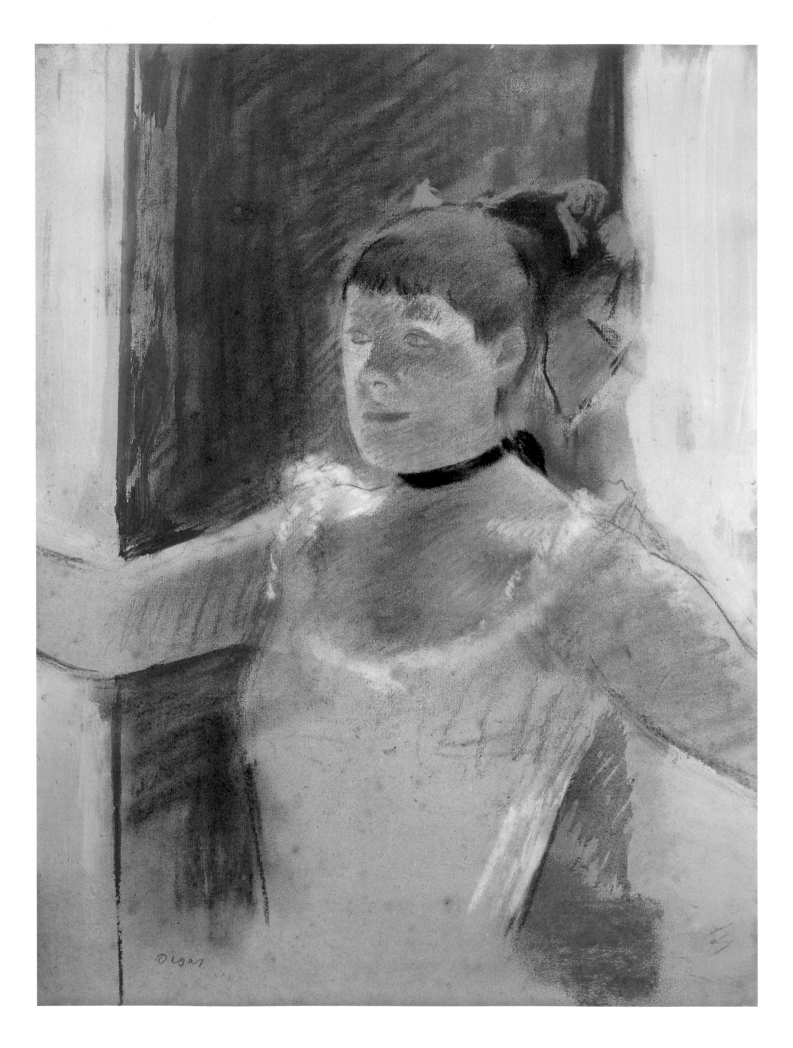

DEGAS AND THE DANCERS

work that might conceivably have been included in the same installation under one of Degas' vaguer catalogue titles; it was acquired by Gustave Caillebotte, who frequently bought from exhibitions.[58] While the identity of the pastel as a study, recapitulation, or enlarged detail of the Frick canvas remains unclear, there is some evidence that Degas fabricated the figure in the painting from more than one dancer, attaching the head from this pastel to a body drawn from a separate model.[59]

A FAMILY OF YOUNG BALLERINAS

The majority of Degas' dancer-models were old enough to perform with the corps de ballet, but on a few memorable occasions during the late 1870s and mid-1880s, he portrayed the children from the *classe des petites*, always in works on paper rather than oil paintings. Two such *rats* are featured with their attentive mother in *The Mante Family* (plate 237), a simply composed yet richly worked pastel that is unique in the artist's oeuvre for its personal significance and documented history. The family in question was well known to Degas, both through the father—who was a double-bass player in the Opéra orchestra— and through their residence in the same Montmartre neighborhood as the artist.[60] All three of the Mante daughters—Suzanne (born in 1871), Louise (born in 1875), and Blanche (born in 1877)—attended the Opéra's ballet school, and all went on to perform on the Palais Garnier stage.[61]

Executed around 1884, Degas' picture poignantly recalls a group portrait he painted nearly a quarter-century earlier, showing his Aunt Laura standing behind two young female cousins with their father seated to one side: *The Bellelli Family*.[62] In both works, the attentive gestures of the mothers are directed toward the more retiring of two siblings, who seem to welcome their parent's touch. Similarly, the mother-figures echo and envelop the forms of these daughters, establishing an emotional triangle with the more distant, independent-seeming girls. Degas had been charmed and exasperated by the experience of painting his psychologically contrasted Italian cousins, and a similar engagement is hinted at in the pastel.[63] The response of the socially conscious Degas to the Mante family is doubly significant: by acknowledging his intimacy with the Mantes he signals their membership in his own bourgeois caste and vividly reminds us that dancers at the Opéra could come from many levels of Parisian society.

Unexpectedly in such an ambitious work, and unlike most of Degas' ballet images from this period, there are no surviving drawings for *The Mante Family*.[64] While Degas may have contrived the composition directly on the present sheet, an alternative origin is suggested in the accomplishments of the missing father, Louis-Amédée Mante. As well as being an experienced musician, Mante was also an innovative photographer who had worked professionally in Paris since the late 1840s, contributing significantly to the development of color photography and making historically critical records of the rue Le Peletier Opéra in its last hours (plate 85).[65] If this imaginative practitioner had taken pictures of his wife with their daughters dressed for class, the results might well have resembled the candid family group of Degas' pastel, and perhaps provided the artist with his starting point. Given his penchant for making portraits from existing photographs, Degas must have been drawn to Mante's experiments. We can also assume that he would have preferred them to the contrived studio shots of Opéra dancers that proliferated during these years (plates 243 and 253), which appear to have played little role in his later dance art.

The Mante Family subtly illuminates the early stages of the young dancers' apprenticeship, as they gained the necessary confidence and skill to step into a demanding adult world. Jean Sutherland Boggs has argued convincingly that the girls depicted are the two youngest, Louise and Blanche, who would have been around eight and ten years old in 1884.[66] At this age, ballet pupils still depended on the practical help of their mothers or chaperones, who were a ubiquitous presence at the Opéra and sometimes a feature of Degas' classroom and backstage scenes (plates 127, 128, and 146). As a seasoned observer of such gatherings, he astutely recorded the attention of Madame Mante to her daughter's hair, the self-conscious pointing of the tutu-ed girl's foot, and the splayed legs of the formally attired sister, whose "turned-out" stance indicates that she too is an aspiring ballerina. Eventually the eldest and most successful sister, Suzanne, rose to the level of *premier sujet* at the Palais Garnier, and both she and Blanche continued their Opéra careers by becoming instructors.[67] They appear together in a photograph that contrasts gloriously with Degas' pastel, dressed in classical garb and bearing garlands (plate 238), where Blanche is shown pointing her foot like the young girl in the Philadelphia picture. In 1947, Lillian Browse interviewed the elderly Suzanne Mante, and thus established a precious link with a ballerina once known to the artist. Looking back to the previous century, Mlle Mante recalled Degas as a "kind old man who wore blue spectacles to protect his eyes," and claimed that he "used to stand at the top or bottom of the many staircases in the [Palais Garnier], drawing the dancers as they rushed up and down," asking them "to pause for a moment, just as they stood, in order that he could make some quick sketches of them."[68]

In similar circumstances Degas met the van Goethems, a slightly older trio of sisters who attended the Opéra ballet school in the 1870s. They too lived near Degas—on the rue Douai, the same street as the Halévys—and it seems that at least two of the three girls modeled for the artist.[69] Marie van Goethem was the focus of a large group of drawings and possibly a number of pastels, as well as Degas' most notorious and celebrated sculpture, *The Little Dancer, Aged Fourteen* (plate 130).[70] As we have seen, the van Goethems' social and personal history was crucially different from that of the Mantes, as were Degas' images of their respective family members, illustrating again

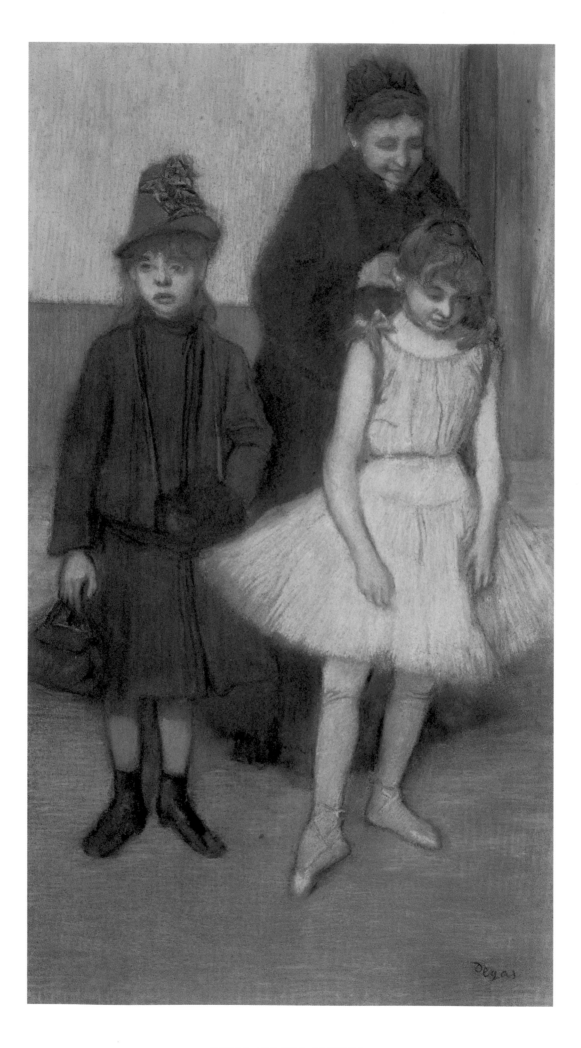

DEGAS AND THE DANCERS

238. *Suzanne and Blanche Mante, petits sujets, c. 1910. Bibliothèque nationale de France*

the broad spectrum of individuals within the Opéra's walls and the artist's responsiveness to this socially stratified world.

FAMED DANCERS AND OTHER FRIENDS

Shortly after arriving in New Orleans in November 1872, Degas wrote to Désiré Dihau to gossip about their mutual acquaintances, including no less than four Opéra ballerinas: he confided that he had already written to "the good Simon" (plate 217) and was waiting for her reply, and that his brother and traveling partner, René, was corresponding with "Mlle Malot," a corps member who sat for several of his portraits. Degas' letter is familiar and even suggestive, such as his exclamation about a *sujet* whose name was new to him, "What you tell me about Vittoq (?) delights me," and an allusion to a famed Italian ballerina who had recently arrived at the Opéra: "Mlle Sangalli will doubtless remain all winter. I shall thus be able to enjoy her upon my return."[71] This letter not only reveals his personal interest in the Opéra personnel at a

237. *Edgar Degas, The Mante Family, c. 1884. Pastel on paper, 35⅜ x 19¾ in. (89.9 x 50.2 cm). Philadelphia Museum of Art; Given by Mrs. John Wintersteen, 1948 (1948-31-1)*

remarkably early date, but also his involvement with a specific generation of performers. Two of the ballerinas mentioned were colleagues of Eugénie Fiocre's during the 1860s, when Degas first turned his artistic attentions to the dance, and all four would have been in or nearing their twenties in the early 1870s. Sangalli had been a world-renowned star for several years; Simon and Malot had been with the Opéra since at least 1860; and though little is known about Amélie Vitcoq, she was talented enough to have become a *sujet* by 1874, a position rarely attained by adolescent ballerinas.[72]

While all the dancers referred to in Degas' 1872 letter may have posed for him at some time, only one has been firmly identified as a model: Mlle Malot. In each of the portraits associated with her (plates 239, 240, and 241), Malot is shown seated and attired in street clothes as Degas' social equal, with no visible reference to her stage profession.[73] In the largest, a canvas in the National Gallery of Art in Washington, D.C. (plate 240), she is posed rather formally in a high-backed armchair against a meticulously painted arrangement of flowers, recalling both the setting of *Woman with Chrysanthemums*, dated 1865, and the severity of his Salon portrait of Joséphine Gaujelin (plate 48).[74] These similarities indicate that the Washington picture was executed earlier than has been previously assumed, perhaps in the late 1860s, when Thérèse Malot apparently became the mistress of Degas' brother Achille.[75] Malot had appeared in the premieres of *Pierre de Medicis* and *La Source*, alongside Gaujelin and Fiocre, and would thus join them as one of the first dancers to model for Degas and—as his 1872 letter and pictures imply—to mix in his social circle.

The Malot portraits take on additional resonance when two complicating factors are taken into account: first, that the woman portrayed in Degas' pictures might be Thérèse or Augustine Malot, both of whom danced at the Opéra; and second, that Thérèse's affair with Degas' brother erupted in a violent public scene. The photographic and documentary evidence about the two sisters does little to clarify the identity of Degas' model, though the family link with Thérèse must favor her candidacy. Thérèse's appearance among the corps de ballet at the beginning of the 1860s would place her at least in her mid-twenties around 1870, which is consistent with the appearance of the sitter in the Washington canvas, as well as with a spirited pastel study in the Barber Institute traditionally dated to the late 1870s (plate 239). Yet another image of a dancer as a fashionable Parisian—like the painting of Gaujelin in Hamburg (plate 224)—the Barber picture joins a precocious group of portraits of women made at this time, linking family, friends, and professional acquaintances from the dance world.

The second factor concerns the confrontation between Achille and Thérèse's new husband in front of the Bourse in 1875, resulting in a scandal that shocked the artist's family.[76] There are no further traces of Degas' contact with Thérèse until 1893, when Degas sent a poignant note to her on the occasion of his brother's death, acknowledging how good she had been for Achille "in his moments of need."[77] It is possible that this late contact explains a puzzling second version of the Washington *Portrait of a Woman (Mlle Malot?)*, now in Detroit (plate 241), a

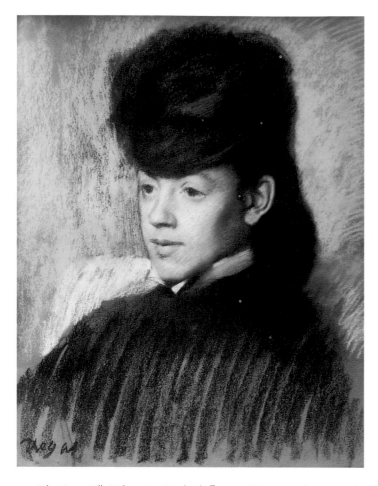

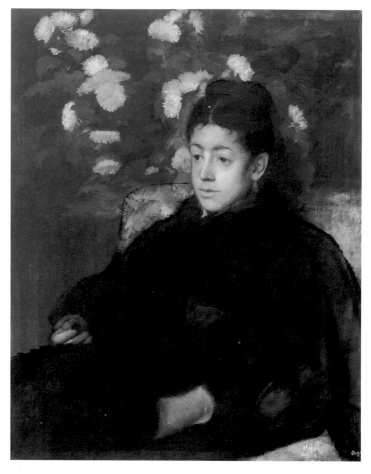

239. *Edgar Degas, Mlle Malo, c. 1870. Pastel on buff paper, 20⁹⁄₁₆ x 15⅛ in. (52.2 x 41.1 cm).*
The Barber Institute of Fine Arts, The University of Birmingham (49.12)

240. *Edgar Degas, Mlle Malo, c. 1868–70. Oil on canvas, 31⅞ x 25⅝ in. (81.1 x 65.1 cm).*
National Gallery of Art, Washington; Chester Dale Collection (1963.10.18)

canvas manifestly reworked by Degas in his late career. Originally very close in composition and tonality—and almost certainly in date—to the earlier picture, parts of the Detroit painting have been broadly brushed over to conceal some delicate white and lavender chrysanthemums, and to transform a slender young woman into a fuller-figured matron.[78] Consistent with the phase of repainting in the 1890s that produced *Dancers Practicing in the Foyer* (plate 91) and *Ballet Scene* (plate 316), this extraordinary act of reinvention may also have been part of Degas' difficult leave-taking of his turbulent sibling.

The images of Mlle Malot further exemplify Degas' interest in dancers as private individuals, rather than as mere representatives of their calling. Subsequent portraits of ballerinas present them in domestic interiors or against neutral grounds, where their off-stage personalities seem to emerge: some appear friendly and casual (plate 244), others inscrutable and self-consciously posed (plate 246), their respective demeanors perhaps reflecting their relationship to the artist. It is clear that a number of ballerinas mixed with Degas outside the Opéra and a few were closely involved with his friends and family. As a general rule, it was these individuals and their illustrious colleagues who tended to feature in his formal dance portraits. An intriguing aspect of the circle of ballerinas that Degas knew—some of whom appear in genre pictures, several in portraits—is that many began to realize

their professional potential during the same years that the artist came into his own, including Mlles Simon and Perrot, who are referred to in letters and notebooks; Mlle Parent, who appears in his two earliest performance canvases (plate 1); Fiocre, Gaujelin, and Malot, who are all depicted in multiple portraits (plates 48, 49, and 239); and Marie Sanlaville (plate 175), who seems to be the subject of a group of harlequin pictures and an informal pastel portrait (plate 242).[79]

Never famed for her beauty or lauded as an extraordinary dancer, Marie Sanlaville was among the most popular and accomplished performers of Degas' era. Born in 1847, Sanlaville rose through the Opéra hierarchy to become a *premier sujet* known for her spirited performances and her intelligence; according to one contemporary "she could dance a role after a single rehearsal."[80] Encounters between Sanlaville and Degas seem to have been relaxed affairs, among them, an afternoon spent in Lepic's studio that was recorded by Georges Jeanniot, and a curious outing when the artist escorted Marie and her sister to an "elocution contest," described in one of his letters.[81]

A pastel previously known as *Mlle S., Première Danseuse à l'Opéra* (plate 242), can now be securely identified with Sanlaville through a

241. *Edgar Degas, Portrait of a Woman (Mlle Malo?), c. 1868–93. Oil on canvas, 25½ x 21 in. (64.8 x 53.3 cm). The Detroit Institute of Arts; Gift of Ralph Harman Booth (21.8)*

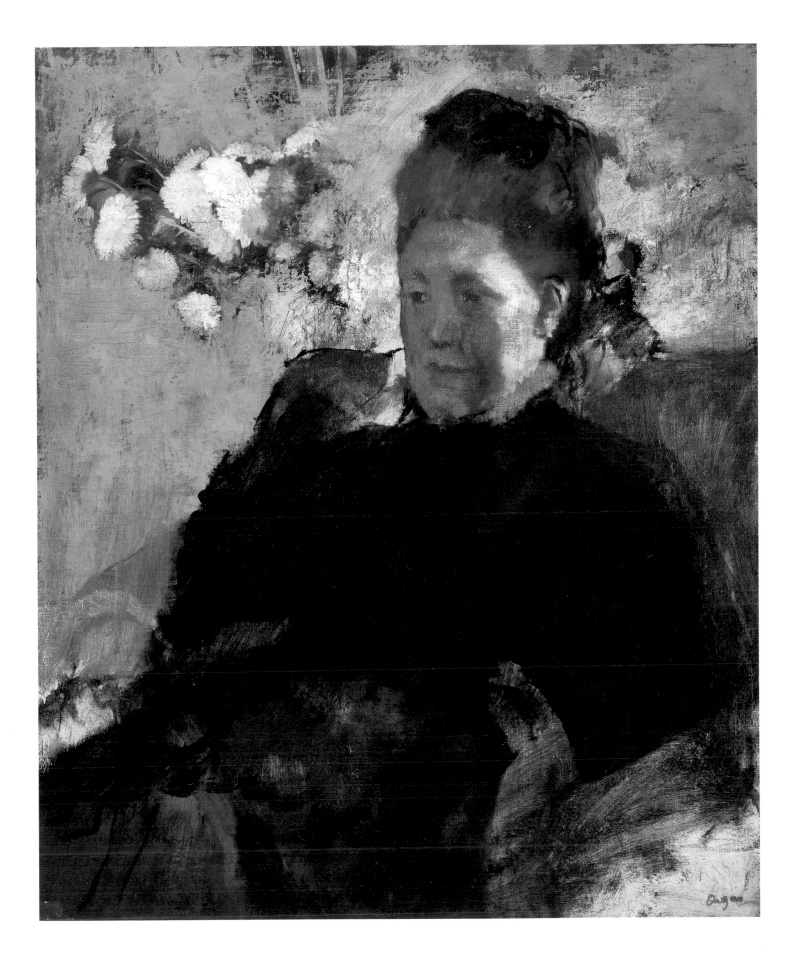

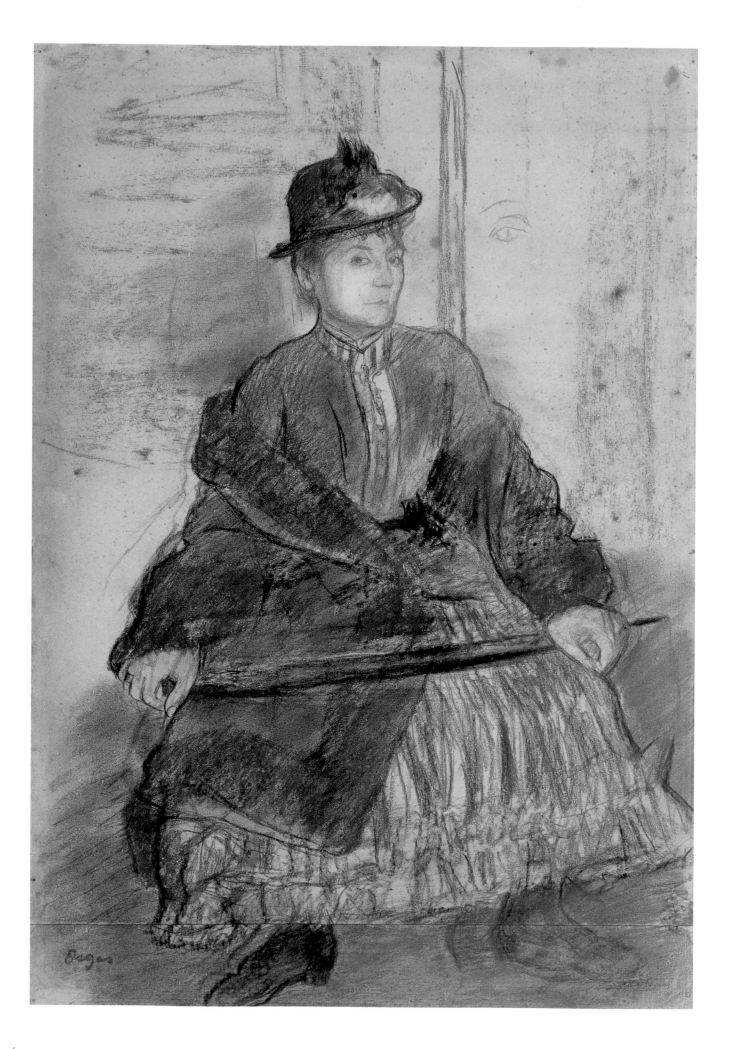

photograph of the dancer that shows her with similarly fine lips, a square jaw, and pronounced chin, and even a feathered hat.[82] Like the photograph, the portrait seems to date to the period just before her retirement in 1889, when Sanlaville was approaching forty years of age.[83] Seated on an invisible chair with an umbrella across her lap, her feet inelegantly splayed in the manner of resting dancers, this leading figure from the Opéra stage is portrayed in the plainest and most anonymous of settings, perhaps in the studio of Lepic or Degas. The informality of Sanlaville's pose and the disorderliness of her attire suggest considerable ease in the artist's company, while her glance might be wary—or teasingly disapproving—of the liberties he is taking. Made around the time of her success in *Les Deux Pigeons*, a ballet that premiered at the Opéra in November 1886, this relaxed portrait is a testimony to their friendship, to which the artist paid further homage during these years in a touching four-verse sonnet dedicated to Sanlaville.[84] Degas' dense poem alludes to the travesty roles for which the ballerina was acclaimed and to the illusory nature of her art. Influenced by Heredia and Mallarmé, the latter among his confidants at this time, Degas concludes his verses with a subtle reference to the ballet's ancient beginnings and to his own susceptibility to its pleasures, in spite of his advanced age:

> In the obscure grove, your infinite art keeps watch:
> When in doubt or forgetful of a step, I think of you,
> And you come to the old faun, reprimanding him.[85]

The same poem conjures up the image of a "masked and restless harlequin," a character created by Sanlaville in the ballet *Les Jumeaux de Bergame*. Degas expressed his interest in this production by attending a rehearsal and one of the first performances, and arguably in an enigmatic series of works—six pastels and a sculpture—based on a harlequin theme. Though the definitive association of this series with *Les Jumeaux de Bergame* has proved elusive, we may still see in them the figure of Sanlaville in her checkered costume as the baton-wielding Harlequin (plate 203), far removed from Degas' portrayal of her seated in street clothes with an umbrella across her knees (plate 242).[86]

According to Jeanniot, on the day Degas visited Lepic's studio, Sanlaville was accompanied by the most celebrated Opéra dancer of the 1880s, Rosita Mauri.[87] A fiery and technically brilliant performer, Mauri has been tentatively identified in a portrait by the artist, dated 1887, a richly worked pastel in hues of copper, gold, and pewter (plate 244).[88] The association finds some support in contemporary images of the dancer, such as a photograph of her in costume for *Korrigane* (plate 243), a ballet Degas saw at least six times between 1885 and 1889.[89] Here the profile of her right cheekbone, the shape of her lips, and her cleft chin are similar to the features of the figure in the pastel, though it has been pointed out that the latter does not show "the magnificent black tresses" for which Mauri was famous, an attribute

243. Rosita Mauri in La Korrigane. *Bibliothèque nationale de France*

Degas would hardly have overlooked or modified in such a finished portrait.[90] Our inquiry is given a new twist by the discovery that the half-smiling woman in the pastel also bears a strong resemblance to Marie Sanlaville, as she appears in a small engraving in *Le Journal Illustré* (plate 245), from an 1885 issue devoted to the Paris Opéra.[91] Though it may not be possible to resolve the issue definitively—in the *Journal Illustré* engravings, the two women look rather alike—the association of this pastel with Sanlaville assumes somewhat greater weight when it is compared with the less-finished *Mlle Sanlaville (or Mlle S., Première Danseuse à l'Opéra)* (plate 242): the two figures share many facial characteristics, both wear tall feathered hats, and both exhibit a somewhat jaunty manner.[92] Regardless of which dancer modeled for the *Portrait of a Woman*, it remains significant as a portrayal of a dancer as a confident bourgeois woman rather than a working-class professional. At ease in the situation and even a little flirtatious, her rakish pose reminds us of something Degas had written a decade earlier: "Make portraits of people in familiar and typical attitudes, but above all, be sure to give the same expression to the face that one gives to the body."[93]

Around 1880, a new generation of corps members was rising through the ranks at the Opéra: ballerinas who had been mere children—or in the case of Julie Subra, newly born—when Degas made

242. Edgar Degas, *Mlle Sanlaville (or Mlle S., Première Danseuse à l'Opéra)*, c. 1886. Pastel on paper, 15⅜ x 10⅝ in. (39 x 27 cm). *Private collection*

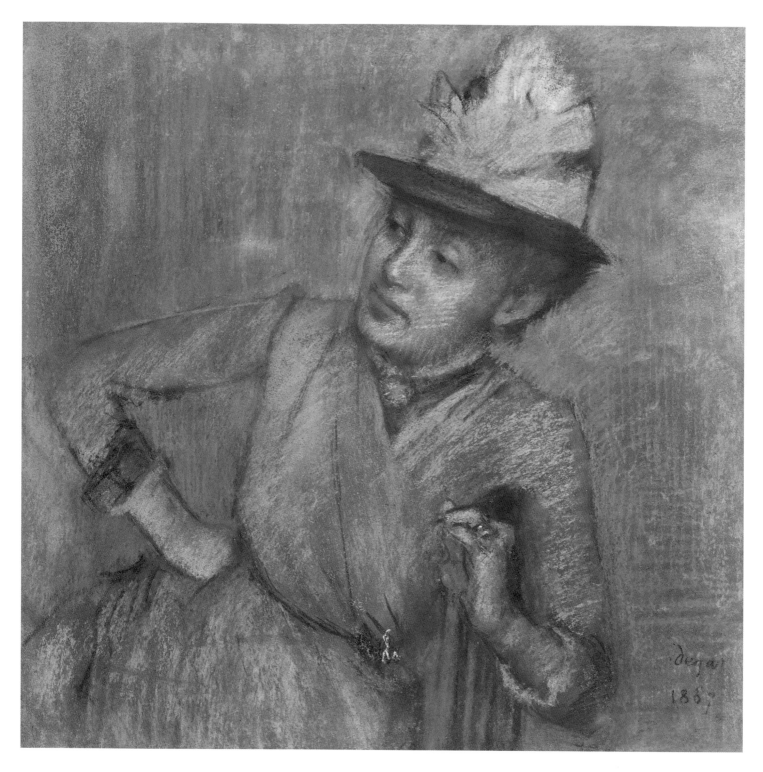

244. Edgar Degas, Portrait of a Woman, 1887. Pastel on wove paper, affixed to original
pulpboard, 19¾ x 19¾ in. (50 x 50 cm). Collection Gregory Callimanopulos

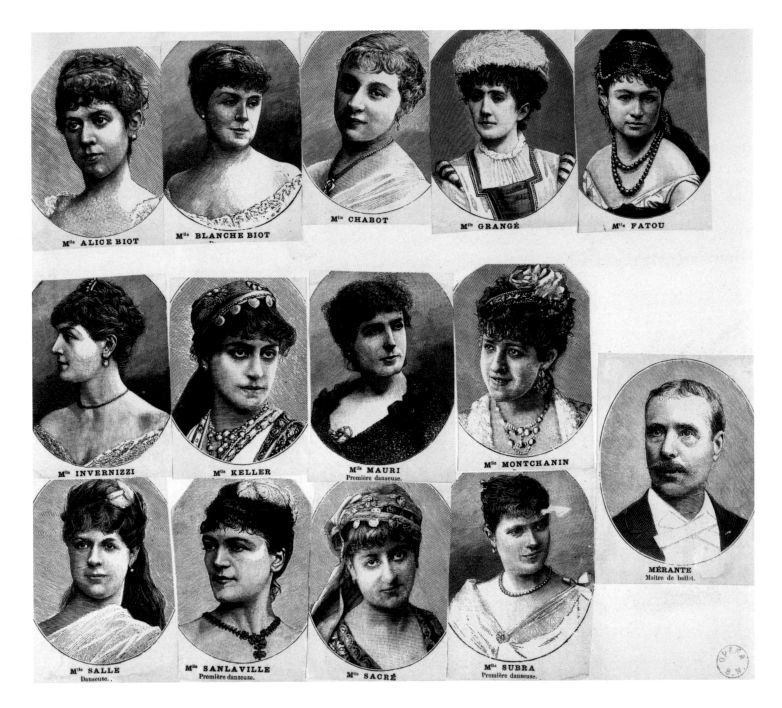

Mᶦˡᵉ ALICE BIOT Mᶦˡᵉ BLANCHE BIOT Mᶦˡᵉ CHABOT Mᶦˡᵉ GRANGÉ Mᶦˡᵉ FATOU

Mᶦˡᵉ INVERNIZZI Mᶦˡᵉ KELLER Mᶦˡᵉ MAURI
Première danseuse. Mᶦˡᵉ MONTCHANIN

Mᶦˡᵉ SALLE
Danseuse. Mᶦˡᵉ SANLAVILLE
Première danseuse. Mᶦˡᵉ SACRÉ Mᶦˡᵉ SUBRA
Première danseuse.

MÉRANTE
Maître de ballet.

245. Stars of the Paris Opéra, collage of details, from Le Journal Illustré, *December 17, 1885. Bibliothèque nationale de France*

his first painting of Eugénie Fiocre (plate 49). At least a dozen of these youngsters were well enough known to the artist to pose for him, but very few seem to have featured in his social life. Among the new talents were Mathilde Salle, who appears in two strikingly different portraits (plates 246 and 247); Alice Biot, who made a great "impression" on the artist in the summer of 1885; a Mlle Sacré, whose contract renewal was mentioned in a letter to Ludovic Halévy; Mlle Grangé, whose address is recorded in a notebook; Julie Subra, one of two dancers who performed at a "soirée," for which Degas designed the program (plate 196); and Joséphine Chabot, the proposed model for *Seated Woman in a Yellow Dress* (plate 250).[94] Each of these ballerinas made her debut sometime between 1877 and 1880, and all had become

premiers sujets by December 1885, when their images were highlighted in the Opéra issue of *Le Journal Illustré* (plate 245).[95] It is a telling insight into Degas' close affiliations with the Opéra that he had contact with at least eight of the thirteen dancers featured in this publication.

The dancers most often noted in Degas' sketchbooks tend to be those who were inexperienced or obscure—such as Mlles Blanc, Carpentier, and the Prince sisters—and were presumably anxious to augment their salaries by modeling for him.[96] Only one among these dancers is known to have posed for a formal portrait, an otherwise almost undocumented British girl named Nelly Franklin, who also appears as the seated ballerina at center in *The Dance Lesson* (plate 121).[97] This pastel likeness shows her in everyday clothes in an upholstered chair, wearing a forlorn expression that seems to extend throughout her body. The artist took the unusual step of acknowledging her sadness by writing on the sheet in English "unhappy Nelly,"

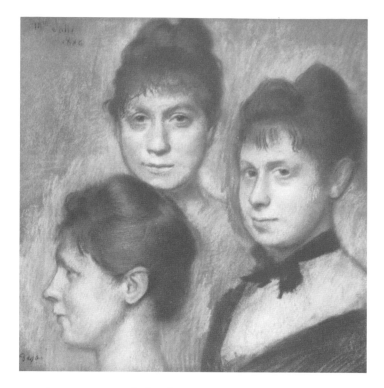

246. *Edgar Degas, Portrait of Mlle Salle, 1886. Pastel on blue paper, 19¾ x 19¾ in. (50 x 50 cm). Location unknown*

followed by a second phrase in French, "Ça m'est égal" (It doesn't matter either way). Selecting an unexceptional coryphée to be the subject of a considered portrait, Degas thus set up a cryptic narrative to record their brief acquaintance and something of Franklin's private self. This distinctly modern gambit contrasts with a later sheet of three pastel studies of the dancer Mathilde Salle (plate 246), which achieves intimacy through more traditional means. In three highly finished images of her profile, full face, and three-quarter view, dated by the artist 1886, Degas seems to look back to such Rococo predecessors as Lancret and Watteau, and specifically to their drawings of figures observed from several different angles that were often carried out in pastel or chalk on tinted papers.

Only nineteen when she sat for Degas, Salle was rarely singled out in contemporary reviews, and though she may have advanced on her own merits, she also enjoyed the attentions of two influential "protectors": she had a child by the famously lecherous *abonné* Henri Vever, and later became the mistress of Comte Isaac de Camondo, a fanatical Opéra devotee and major art collector.[98] Though Camondo did not begin acquiring contemporary works until the early 1890s, his relationship with Salle may have been taken into account by Degas when he made his uncommonly decorous and historically redolent pastel. Several eighteenth-century French masters featured in Camondo's eclectic collection, including Boucher, de La Tour, Fragonard, and—most significantly—Watteau.[99]

Like his multiple drawings for the *Little Dancer, Aged Fourteen* (plate 130), Degas' triple portrait has been linked to a sculpture, in this case a bust of Salle that apparently was not pursued until the early 1890s.[100] In three letters to Bartholomé, one dated August 16, 1892, Degas alludes to his "clay" likeness of the ballerina, as well as to Bartholomé's own marble figure of Salle that was completed by 1893. In one of his letters Degas complained, "And Salle, you are going to finish with her and she won't want to come back to me," while in another he grumbled, "You don't mention Salle to me? Have you gone on with the bust? And my poor clay?"[101] Two unfinished sculptures of the dancer in clay-like materials were found in Degas' studio after his death: one small and smoothly rendered, the other a heavily worked, larger variant (plate 247).[102] Untrained in the medium, Degas already had a history of practical problems with his sculpture, which were often improvised, left incomplete, and allowed to deteriorate.[103] A posthumous bronze cast of the larger bust of Salle tells a familiar story, a crack under the chin suggesting the premature drying of the original model and a damaged or partially repaired left eye indicating successive phases of work. The varying textures in the ballerina's right cheek and hair also reveal that at least one side of the head had been brought to the level of finish we might expect for a portrait of such a glamorous figure. Compelling though it is to audiences accustomed to the abrasive busts of Rosso, Rodin, and their successors, it is not difficult to understand why Salle might have been reluctant to return to Degas' studio to model for his "poor clay."

Although Mlle Salle and the celebrated mime Mlle Sallandry have been linked with a study of a vivacious ballerina dated 1885 (plate 248), the subject can now be firmly identified as Joséphine Chabot, a dancer

247. *Edgar Degas, Head of a Woman (Mlle Salle), modeled 1892, cast after 1919. Bronze, 16 in. (40.6 cm). Museum of Fine Arts, Boston; Bequest of Margarett Sargent McKean (1979.509)*

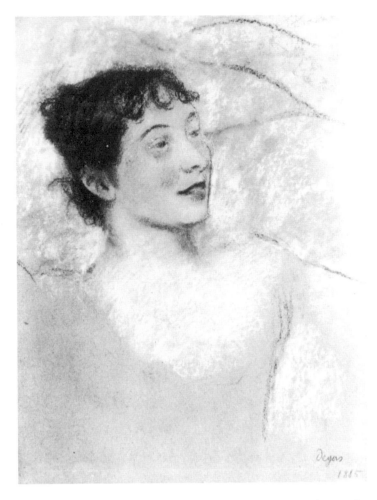

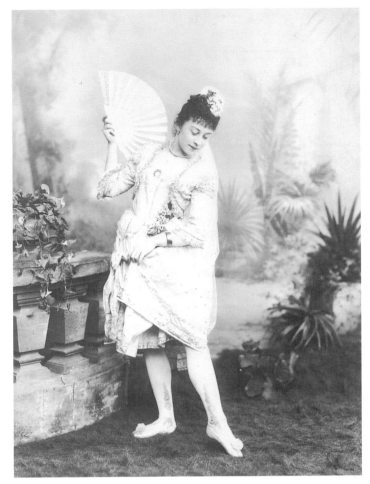

248. Edgar Degas, Bust of a Woman, 1885. Pastel on paper, 29½ x 23⅝ in. (75 x 60 cm). Location unknown

249. Joséphine Chabot. Bibliothèque nationale de France

not previously associated with Degas' paintings and pastels.[104] An undated photograph of this ballerina (plate 249) helps us to define her distinctive features: curly hair with wavy bangs, high cheekbones, a finely chiseled nose, shapely mouth, and almond eyes with slender arched eyebrows. All these characteristics are evident in the carefully observed portrait and in several other images to which this picture is related, including the spectacular pastel *Dancer with a Tambourine* (plate 195), where Chabot wears a white tutu ornamented with black, gold, and reddish ribbons and holds a pose associated with folk dances such as the fandango.[105] The connection between these two sheets is apparent in the profiles of the performers, in the tilt of their heads and shoulders, and in the contours sketched in the background, denoting a landscape setting.

Chabot seems to have endeared herself to Degas, and if she was as lively as she appears in these images—and as persistent as suggested in several of Degas' letters—it is little wonder that the artist agreed on no less than three occasions to persuade Ludovic Halévy to intercede on her behalf at the Opéra. In one note written in 1882, Degas urged Halévy to encourage the director, Vaucorbeil, to "turn his eyes from music to the dance," and particularly to the dancer Chabot; and in another he solicited Halévy's assistance to secure the "little Chabot" a better contract.[106] Yet another request appears in a letter sent while Degas was vacationing in the country in 1884, in which

Degas asked his friend Paul Paulin to send Chabot fifty francs, perhaps money owed for modeling sessions.[107] In conjunction with Degas' pictures of Chabot, these letters demonstrate the remarkable extent of the fifty-year-old artist's support for this young ballerina, for whom he effectively acted as patron or protector. Chabot's willful and teasing ways, conveyed in one of Degas' messages to Halévy, evidently charmed him into action: "You must know what a dancer is like who wants you to put in a word for her.... I had no idea.... And she wants it done at once. And if she could, she would to take you in her arms wrapped in a blanket and carry you to the Opéra!"[108]

Degas' pleasure in Chabot's company may have found expression in one of his most sensuous pastel portraits, *Seated Woman in a Yellow Dress* (plate 250). The model's "elegant features, so white against the auburn head of hair"—in Jean Boggs' words—have much in common with Chabot's, while her lithe, confident body and the self-conscious arrangement of her limbs and hands are surely consistent with those of a dancer.[109] Though the sitter has previously been anonymous, and the work is neither signed nor dated, the technique used in this striking image links it to a group of pastel nudes and portraits made in the years around 1890, when Chabot would have been twenty-six.[110] The vivid mesh of horizontal and vertical pastel strokes, for example, was often employed by Degas during this period to

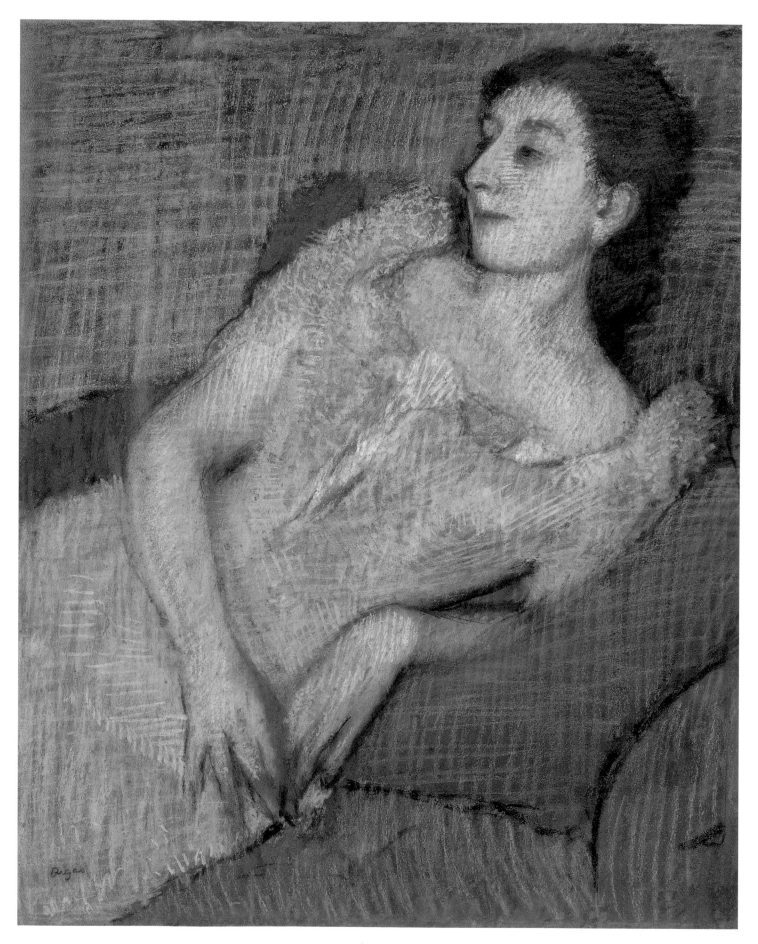

250. *Edgar Degas, Seated Woman in a Yellow Dress, early 1890s. Pastel on buff paper mounted on board, 28 x 22⅞ in. (71 x 58 cm). Collection Andrea Woodner and Dian Woodner, New York (WO-6)*

enrich surfaces or energize forms, and was sometimes superimposed on a previously established image.[111] In *Seated Woman in a Yellow Dress,* there are hints that these vigorous strokes were drawn over a more precisely defined figure and costume, perhaps begun around 1886 or 1887 when Degas made several other studies of ballerinas, such as *Portrait of a Woman* (plate 244) and the triple bust *Portrait of Mlle Salle* (plate 246). If this is indeed a picture of Chabot, it ranks among Degas' most sophisticated celebrations of a ballerina, a scintillating composition in green, gold, and lemon with a Matisse-like rigor, suggesting a perfect fusion of poise and social animation.

DANCERS AS MODELS IN LATER YEARS

Degas' energetic contact with dancers in the 1880s—as recorded in letters, notebooks, and other contemporary accounts—stands in marked contrast to the near silence about these individuals during the following decade. Though records of Degas' daily life are sparser during the 1890s, there are signs of a gradual withdrawal from the social world of the Opéra and from some of the pictorial projects associated with it. The casual series of portraits of ballerinas—such as Marie Sanlaville, Nelly Franklin, Mathilde Salle, and Joséphine Chabot—came to an end, and other shifts in his artistic priorities left fewer traces of young apprentices posing in his studio for classroom and performance scenes. Only two student models are known from these years, one of them the internationally admired Cléo de Mérode (plate 251), who claimed in her autobiography to have worked with Degas on a regular basis.[112] Born in 1875, she presumably modeled while in her teens before achieving the exceptional renown of her turn-of-the-century career, and though Cléo's dark eyes, full mouth, and long wavy hair were the subject of a thousand contemporary photographs, they have proved elusive in Degas' pastels and oils. An exception may be a densely worked canvas from the mid-1890s, *Dancers in Blue,* where the handsome young brunette at right displays several of Cléo's features.[113] Though this elegant corps member would soon be lauded as "the most beautiful woman in the world," Degas the portraitist does not seem to have been tempted by her classical proportions or prettiness.[114] Cléo candidly reported that she would not be recognized in any of the artist's drawings because he made her look "like all his other 'Dancers.'" According to the ballerina, Degas "was not concerned with the [details] of the figure, it was the movement he was after," expressed in his requests "to lift the arms, to bend a leg, to get up on her *pointes,* and to assume all kinds of dance positions that interested him."[115]

Years later, Degas asked another dancer to "get up on her *pointes*" to pose for him, but we cannot be certain of her name, her age, or her status as a performer. In the ghosted, anecdotal memoirs of a professional model who is given the name "Pauline," we hear of this dancer's employment by Degas around 1910, when he was working on several

of his wax statuettes. Though not a ballerina herself, Pauline refers to a colleague called "Yvonne" who posed on the "tips of her toes" for a "figurine" that was on a turntable in Degas' studio.[116] The work in question may well have been *Dancer Moving Forward, Arms Raised, Right Leg Forward* (plate 273), the only surviving three-dimensional work by Degas of a figure on "tiptoe." The same source implies that Yvonne modeled frequently for the artist around this time, raising the possibility that she appears in several late sculptures and in such drawings as *Nude Dancer* (plate 294).[117] We should also note that Pauline, who describes posing for sculptures like *Dancer Holding Her Right Foot in Her Right Hand* (plate 281), makes it clear that she was not a trained ballerina.

By far the most dramatic recent discovery from this period derives from a charcoal study in the National Museum of Belgrade, *Dancer with Raised Arms, Seen from the Back* (plate 252), which carries the simple inscription: "Bouissavin, June '94." Closely related to at least six drawings and an equal number of paintings and pastels from the mid-1890s, this tall, slender figure was a minor employee at the Opéra who captured Degas' attention, as Marie van Goethem and Joséphine Chabot had done in previous decades.[118] Little personal information about Mlle Bouissavin has come to light, but her less than willowy

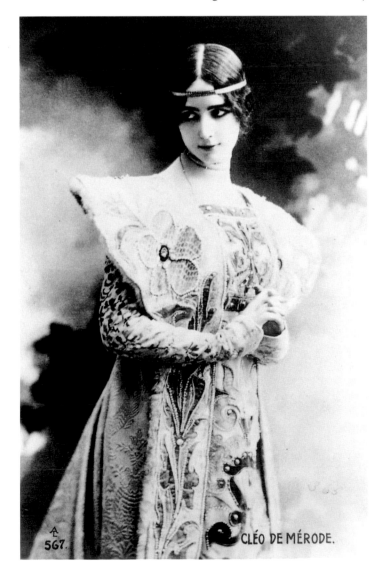

251. Cléo de Mérode. Carte-de-visite. Private collection

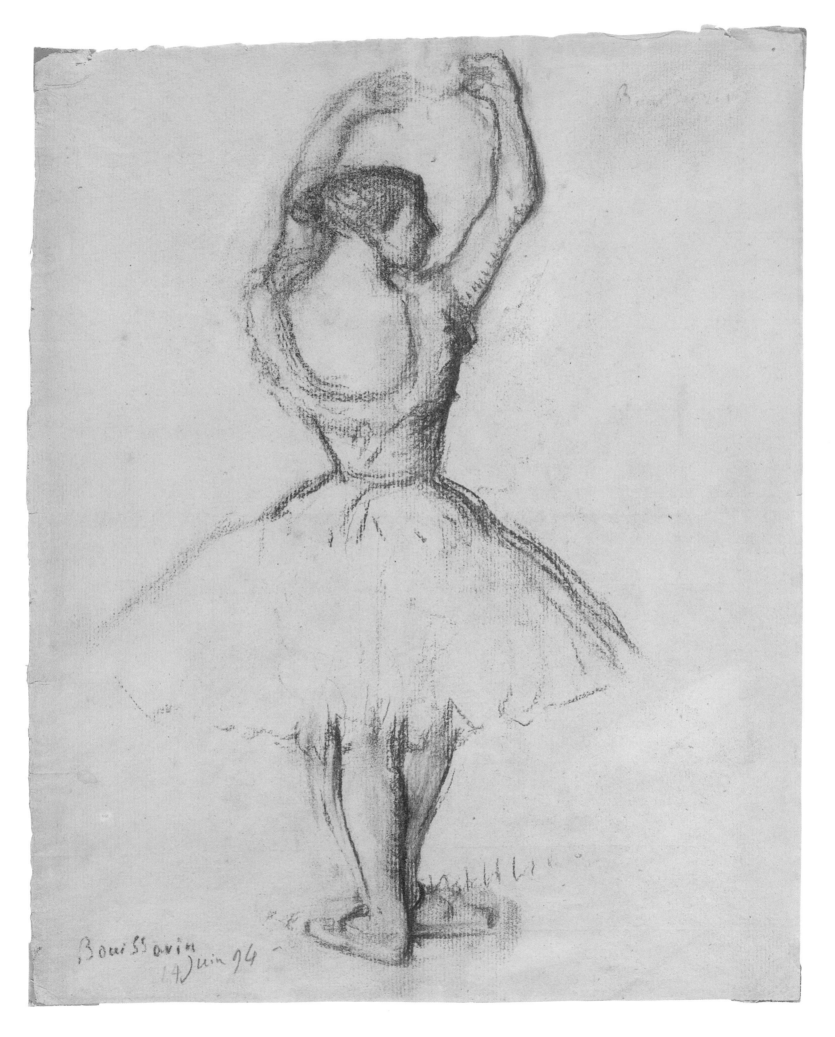

Boussarin
14 Juin 94

254. *Edgar Degas, Dancer with Raised Arms, Seen from the Front, 1894. Charcoal on paper, 12⅛ x 9⅝ in. (30.8 x 24.5 cm). The National Museum, Belgrade (1627)*

253. *Mlle Bouissavin, Bibliothèque nationale de France*

physique was immortalized in an undated photograph (plate 253) and we know that her promotion to *petit sujet* at the Opéra occurred in 1900.[119] A male relative is also listed among contemporary Opéra singers and Bouissavin herself had important roles in the ballet *Danses Grecques* in 1901 and in the lyric drama *Ariane* in 1907.[120] She was therefore still young and in training when Degas made the 1894 drawing, presumably the date of another, very similar sheet in Belgrade, *Dancer with Raised Arms, Seen from the Front* (plate 254), showing Bouissavin standing in *quatrième devant*. In this study her stance recalls that of a ballerina painted by Degas twenty years earlier, in *Dancer Posing for a Photograph*, where an equally commanding performer practices before a cheval glass in a shadowy, modern interior.[121] Few examples so vividly summarize Degas' development over the decades as the settings into which he now introduced Bouissavin, ranging from a fanciful seashore to an arcadian hillside, and only once barely touching on an explicitly urban scene.

The two Belgrade drawings are so alike in scale, technique, and detail that they were probably made during the same modeling ses-

252. *Edgar Degas, Dancer with Raised Arms, Seen from the Back, 1894. Charcoal on paper, 12¼ x 9⅝ in. (31 x 24.5 cm). The National Museum, Belgrade (215)*

sion, when Degas focused on the dancer's pinched waist and elegantly lifted arms. He was also able to persuade the young Bouissavin—as he had the fourteen-year-old Marie van Goethem—to model in the nude (plate 255), repeating the pose of *Dancer with Raised Arms, Seen from the Front* (plate 254) as if to study her physique more completely. Again echoing the upper limbs on a larger scale, the artist seems to announce the features that attracted him, while simultaneously defining a motif he would pursue in a group of oils and pastels. Degas had once waxed lyrical about the arms of the singer Rose Caron, and he now extended this affection to Bouissavin's in a strange variety of contexts.[122] Repeating her pose as she performs alone or leading a group of ballerinas on stage (plates 256, 257, and 271), Degas represented her as a soloist or even as a *première danseuse*, which would have promoted her—as he had done decades earlier with Joséphine Gaujelin and Melina Darde—to a status she failed to attain before disappearing from the Opéra cast after 1906.

Though only modestly accomplished professionally, Bouissavin seems to have inspired Degas to revive a practice he had virtually abandoned after the 1880s: the pictures in which she appears are among the most contextually specific performance images of the artist's last decades. In *Dancer on Stage* (plate 256), we gaze through a stone archway

255. *Edgar Degas, Nude Dancer, 1894. Charcoal on paper, 12½ x 9 in. (31 x 23 cm).*
Courtesy Galerie Berès, Paris

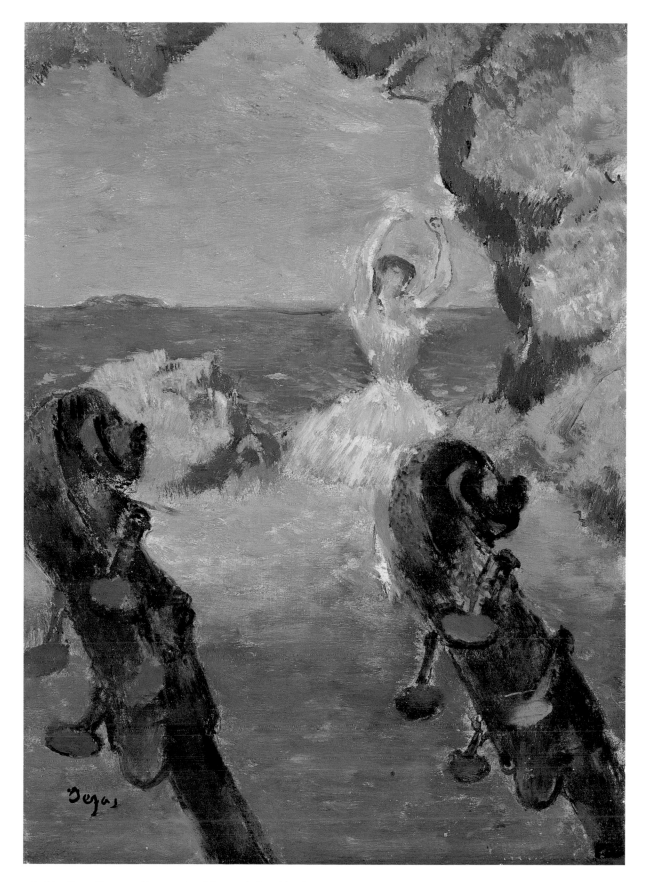

256. Edgar Degas, Dancer on Stage, c. 1894. Oil on wood, 8¾ x 6¼ in. (22 x 15.8 cm).
Hamburger Kunsthalle, Hamburg

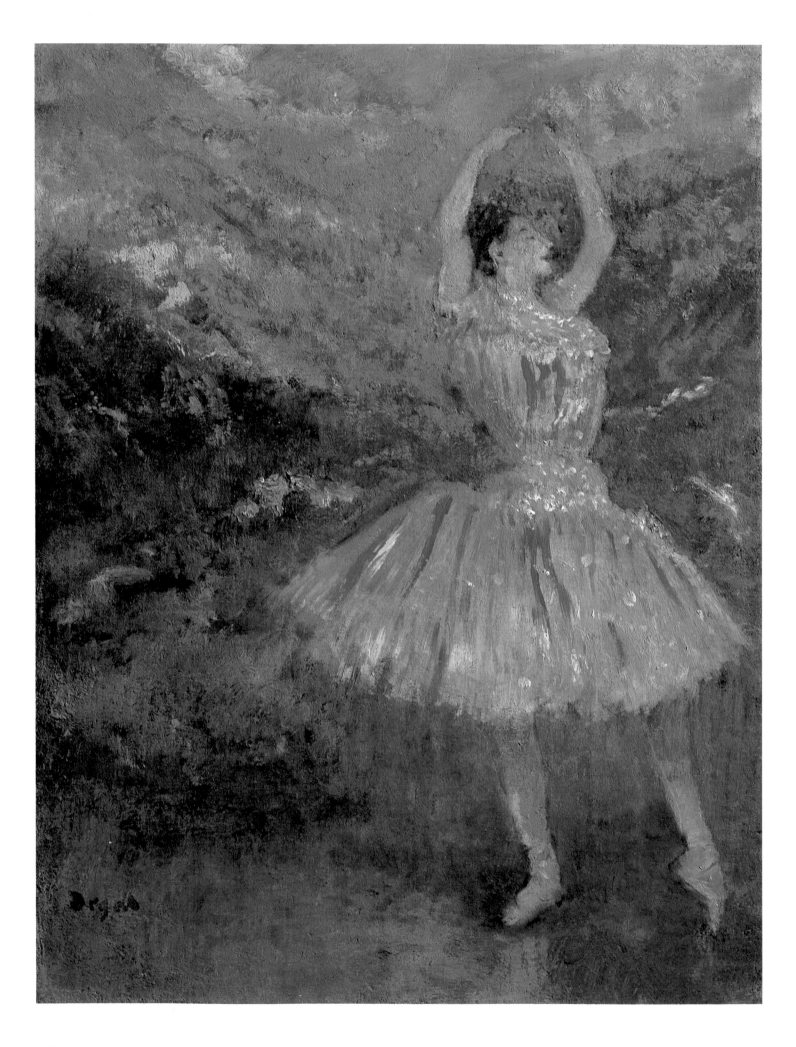

DEGAS AND THE DANCERS

to a sun-drenched beach by the sea, to where Bouissavin balances on pointe with her arms—as always—uplifted, here against a brilliant cerulean sky. Both the rocky coastline and her figure are partially obscured by the stems of two double basses looming impossibly large in the foreground, a compositional device dating back to Degas' first performance pictures, such as *Orchestra Musicians* (plate 1). It is hard to fathom this deliberated act of revivalism, with its conjunction of nervously brushed stage set, frighteningly animated instruments, and serenely posed dancer. Though somewhat similar in handling, the contrasting cool and earthy tones of *Blue Dancer* (plate 257) describe an autumnal mountainside, a smoldering background for the ballerina's glittering tutu. Dramatically asymmetrical and dedicated to the fusion of color, atmosphere, and the touch of brush on canvas, this image also shows how far Degas was willing to go in stylizing the physical attributes of his tiny-headed, buxom model.

Other variants of Bouissavin's figure can be found in a painting in the Norton Simon Museum (plate 116), where the scene is unmistakably that of the main classroom at the Palais Garnier. While the figure facing away from us in fifth position was undoubtedly based on the inscribed Belgrade sheet (plate 252), Bouissavin may well have posed for the three other main characters, who hold their arms above their heads as effortlessly as they balance on their perfectly pointed feet. A similarly repositioned model was probably responsible for all five performers in *Group of Dancers* (plate 271), where Degas transports his new idol to a craggy, treeless landscape with a ruined classical temple in the distance. This dream-like pastel on panel was prepared in several studies of naked and clothed Bouissavin-like ballerinas, and its implications are arguably the grandest of this extensive sequence of works.[123] Now Bouissavin leads four of her colleagues in an idyllic tableau that resonates back through Degas' career, recalling his life-long engagement with classical art, his numerous depictions of events on the Opéra stage, and most intriguingly, a painting he made more than thirty years earlier: *Young Spartans Exercising* (plate 270).[124] At once a survey of his own past and a gesture toward a young charismatic beginner, this complex cluster of pictures also marks his last documented contact with a named dancer.

257. Edgar Degas, Blue Dancer, c. 1894. *Oil on canvas, 13 x 9⅞ in. (33 x 25 cm). Private collection, Connecticut*

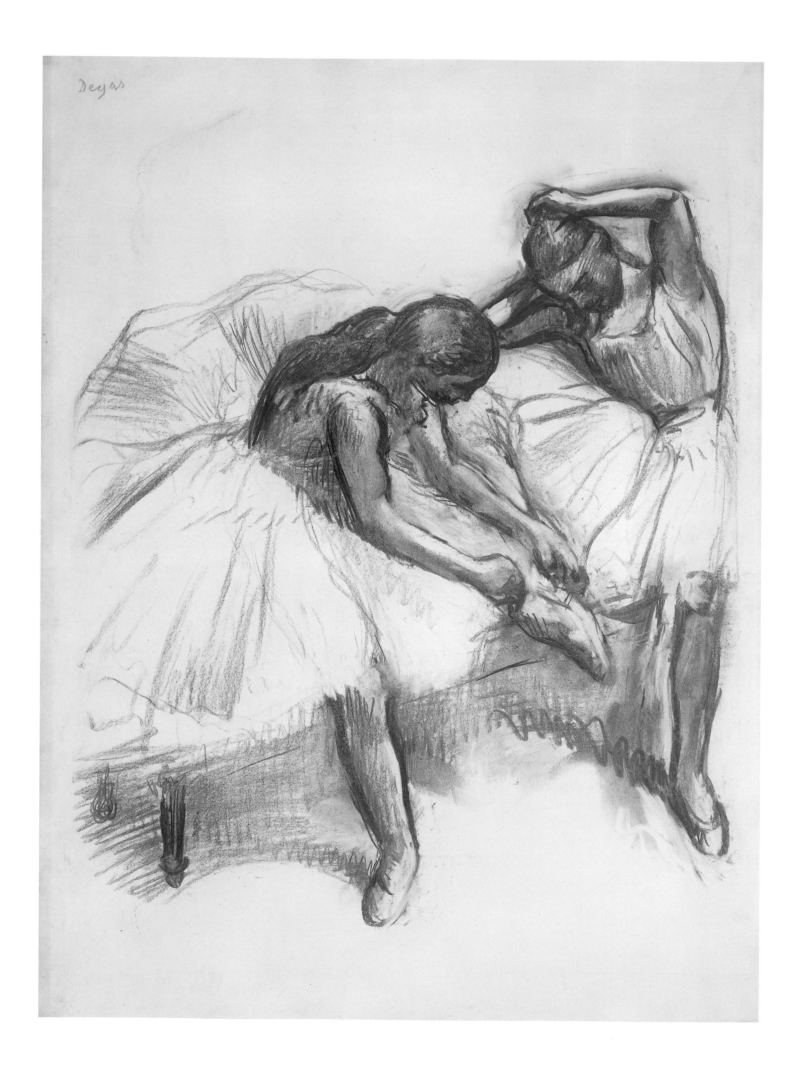

8. The Last Dancers

I am a colorist with line.

—DEGAS, TO HENRI HERTZ [1]

Degas' preoccupation with dancers increased inexorably in the course of his long working life, until it almost overwhelmed the art of his old age. Some three-quarters of his total output of pictures in the 1890s and early 1900s were concerned with ballet themes, only his images of the female bather approaching them in sustained originality and commitment. Often this distinction became blurred, in a strange transitional world of nude women who executed arabesques and adjusted their imaginary tights, and naked ballerinas who attended to their bodies rather than to the performance. Dancers also pervaded Degas' mysteriously poetic photographs (plate 262) and some unexpected poems written around 1889, while a visit to friends in the country resulted in an al fresco ballet performance, with Degas starring as the dark-suited coryphée (plate 259). And we know that dancers from the Opéra still visited his apartment and studio until at least 1910, to pose both unclothed and in the dusty tutus kept there for the purpose. [2]

There is a high degree of continuity and of profound innovation in Degas' final dance images. One of the grandest of all his late ballet paintings, *Dancers at the Barre* (plate 320), could almost be a reworking of a background detail from one of his earliest, *Dance Class at the Opéra* (plate 19), now enlarged to giant scale and translated into the language of color and bodily equilibrium. Other subjects reasserted themselves in changed circumstances: the young coryphées lurking backstage in *In the Wings* (plate 78) became, twenty years or more later, senior members of the corps de ballet arranged in the monumental pastel *Dancers* (plate 264), while the idle pupils on the bench in *The Dancing Lesson* of around 1880 (plate 168) have been rotated, tilted upward, and expanded to fill the majestic late drawing *Two Dancers* (plate 258). Entirely new figures appear, among them a reiterated woman with arched back and hands on hips (plate 133), perhaps a distant descendant of the *Little Dancer, Aged Fourteen*, but now shown exhausted, matronly, and approaching retirement. The physicality of these individuals increasingly engaged him, expressed in their massively stated anatomy, in the dense textures of their clothing and surroundings, and in the vividness of striated primary hues. Less concerned with technical experiment for its own sake, during the 1890s Degas abandoned printmaking and the mixed-media experiments that had once intrigued his contemporaries, revisiting the skills of his youth

258. Edgar Degas, Two Dancers, c. 1900–1905. Charcoal and pastel on tracing paper, mounted on wove paper, 43 x 32 in. (109.3 x 81.2 cm). The Museum of Modern Art, New York; The William S. Paley Collection (SPC 65.90)

259. *Anonymous (Edgar Degas?), Degas with Monsieur and Madame Fourchy at Ménil-Hubert (detail), c. 1895. Bibliothèque nationale de France*

and repeatedly drawing his dancer-models in charcoal, before translating them into pastel and oil paint on canvas.[3]

The principal obsession of Degas' last years was with the dancer rather than the dance. Images of performers on the Palais Garnier stage dwindled to a mere handful, along with recognizable sets and costumes, rehearsal scenes, identifiable stars, and localized views of theater boxes and audiences. Where exceptions occur, such as *Ballet Dancer on Stage* (plate 312) and *Dancers, Entrance on Stage* (plate 310), his ballerina-subjects are typically earthbound and fixed before the public gaze, far removed from the leaping nymphs, pirouetting *étoiles*, and scurrying corps de ballet of earlier decades. His turn-of-the-century dancers prop themselves against walls and huddle in endless permutations in the wings or on convenient banquettes, persuasive as bored or tired human beings but hardly as celebrities at the nation's leading theater. Where their multicolored flesh and costumes reflect the patterns of the scenery and the tinted stage lights, as in the exquisite *Dancers* (plate 306), the dancers are invariably waiting offstage, caught in eternal anticipation of the spectacle to come. Just as frequently their setting is blank or uninformative: the bare walls of *Dancers at the Barre* (plate 320) and the minimal furnishings of *Two Dancers* (plate 258) locate the figures in space but offer no clues as to their whereabouts in the classrooms of Paris, which appear to have lost their fascination for Degas as a pictorial challenge. The physiognomies of these "huskily broad-shouldered dancers"—in Jean Sutherland Boggs' phrase—can

be equally anonymous, lacking the distinctive facial features, idiosyncratic hairstyles, and items of jewelry that had captivated the forty-year-old artist.[4]

This partial retreat from the stage and from the particularity of the ballet coincided with several changes in Degas' professional existence. In the late 1880s and early 1890s, a number of showings of his recent work confirmed Degas' place among the era's leading artists, presenting him as "perhaps the most original, the most personal in the second half of the nineteenth century," as Gustave Geffroy claimed.[5] He could now command high prices and the widespread respect of his colleagues in France, and progressively in England, Germany, America, and elsewhere, yet was still able to surprise them with new sequences of pictures, such as the "suite of nudes" shown in 1886 or the color landscape monotypes in 1892. Buoyed by his success, in January 1890 Degas took over a large fifth-story studio at 37, rue Victor Massé in lower Montmartre, where for more than two decades he was to produce all his drawings, prints, pastels, sculptures, and oil paintings, and was soon to establish an apartment on adjoining floors. Legend has it that he retreated from the public eye in his "fortified enclosure," leading the life "of a recluse, shut away with his models and his sketches, intent upon conjunctions of tone and lines" as Geffroy reported in 1890, apparently oblivious to the artist's relentless myth-making: "I want people to believe me wicked," Degas confided to his niece.[6]

Other accounts tell how Degas' friends found him in a dirty smock (plate 260) or "shuffling around in slippers" in "the indescribable disorder" of this last studio.[7] Here Paul Lafond saw "numerous

260. *Edgar Degas, Self-Portrait in the Studio, c. 1895–96. Bibliothèque nationale de France*

THE LAST DANCERS

261. *Pink satin ballet slipper, once owned by Edgar Degas. Musée d'Orsay, Paris*

easels, laden with canvases or pastels in the process of execution; other paintings, turned to face the entire length of the walls, one against the other; sculptor's turntables, tables covered with lumps of clay, with unfinished waxes already half-collapsed; lithographic and etching presses, aquatint boxes; objects that had served the artist as accessories collided with each other on all sides: double basses, violins, baths, tubs, the skirts and shoes of dancers, a cast of a woman, a conductor's rostrum, a piano, even a theatrical spiral staircase"[8] In this creative mayhem, Degas made the many hundreds of two- and three-dimensional images of dancers that—alongside his late bathers—defined his final achievement, working in a bizarre combination of storehouse and life-study room, workshop, and imaginative playground. Here, we learn from his visitors, he would arrange some "skirts and shoes of dancers," such as the ballet slipper found among his possessions (plate 261); a soiled, velvet-covered bench; the scenery-like screens glimpsed in Degas' own studio photographs (plate 262); and perhaps a rudimentary barre, to recreate the corner of a ballet classroom or the edge of a stage.[9] Like primitive film sets, these improvised environments allowed Degas to control not only the outcome of his pictorial explorations, but also the choice of dramatic personae and the narratives they followed. In effect, he could recreate on his own territory those dance activities at the Palais Garnier that were still of pictorial interest to him, appointing himself set designer, choreographer, and director in one.

Around 1890, Degas still maintained something of the vital connection with the Paris Opéra that had invigorated his early decades. The records of the *porte de communication* at the Palais Garnier show that he took sporadic advantage of the *abonné*'s right to pass behind the proscenium, even though backstage subjects—apart from scenes in the wings—had faded from his concerns. These same documents, which do not record Degas' name when he simply visited the auditorium, tell us that he was on the Opéra premises for a notably wide range of productions, including such standard items of the ballet reper-

toire as *Coppélia* and *Sylvia*, and a variety of old and very new operas, most with dance divertissements. Favorites from his early career included *L'Africaine*, *Faust*, *Guillaume Tell*, *La Favorite*, and the seemingly inexhaustible *Robert le Diable*, while among more recent arrivals on the Garnier stage were *Aida* and *Rigoletto*. Catholic in his taste, he was present in 1891 at the premieres of Wagner's *Lohengrin* and Massenet's *Le Mage*, and in 1892 at his friend Ernest Reyer's *Salammbô*, watching the same composer's *Sigurd* at least nine times in a period of three years.[10] In 1893, Degas' name disappeared from the lists of those going backstage and his *abonnement* is assumed to have lapsed, though he remained as free as any other prosperous citizen to enjoy performances and accept invitations from subscriber-friends. Cost is unlikely to have been a factor by this date, though an anecdote reported by Lafond suggests an inclination to prolong the arrangement: on being approached by a government minister who wanted to honor him, Degas replied, "If you wish to decorate me…give me free entry to the Opéra for the rest of my life!"[11]

Given his previous quarter-century of regular attendance and the purposeful nature of recent visits, it would be surprising to find that Degas' interest in the ballet and the musical offerings of the Opéra had evaporated overnight. From friends we learn of his occasional attendance at the theater, at two Gluck operas toward the end of the 1890s, for example, in the company of young admirers.[12] It is equally misleading to suggest that he vanished from the social and

262. *Edgar Degas*, Dancer from the Corps de Ballet, *c. 1896. Modern print from a glass negative. Bibliothèque nationale de France*

artistic circuits of Paris around the same time, despite the hermit-like reputation fostered by Geffroy and apparently by Degas himself. A broad spectrum of sources show that in this decade he dined regularly with friends like the Rouarts and the Halévys and enjoyed the company of the poet Stephane Mallarmé, the Opéra singer Jeanne Raunay, the composers Claude Debussy, Ernest Chausson, and Ernst Reyer, and many other writers, painters, and sculptors.[13] He visited exhibitions with Mary Cassatt and Berthe Morisot, and claimed to make regular tours of the galleries on the rue Laffitte "when he had finished work for the day," releasing to the dealer Vollard such pastels and drawings as *Dancers* (plate 264) and *Dancers, Nude Study* (plate 292), or to Durand-Ruel the oil painting *Frieze of Dancers* (plate 278).[14]

During these same years, Degas' letters became shorter, more sporadic, and considerably less informative on the subject of his daily regime. He had abandoned the use of notebooks around 1886, leaving us to rely on his highly literate and largely reliable younger acquaintances to flesh out the record of his existence. Despite his attachment to Gluck and a scattering of late pictures that seem to record productions he saw, such as *Group of Dancers* (plate 271) and *Before the Performance* (plate 319), the story is one of gradual withdrawal from public spectacles as his indifferent health and diminishing morale left their mark. He refused to visit the Bal Tabarin, for example, a celebrated nightclub opposite his studio, claiming that the "violent lighting" would hurt his enfeebled eyes.[15] There can be no doubt that declining sight affected his mobility, reduced his social pleasures, and affected his art in many different ways, presumably contributing to his eventual abandonment of the Opéra. In 1892 or 1893, around the time he gave up his *abonnement*, Degas wrote to the painter Evariste de Valernes, "My sight too is changing, for the worse. With regard to writing, ah! my friends can scarcely count on me. Just imagine that to re-read, re-read what I write to you, would present such difficulty, even with the magnifying glass, that I should give it up after the first lines."[16]

We should not overlook, therefore, the complexity of the aging Degas' perceptual and psychological circumstances, nor should we underestimate the fact that he was to work stubbornly and fruitfully for almost another two decades, until some five years before his death in 1917. He was astonishingly productive, investigating entirely new variants of ballet themes and revisiting several of the obsessions of his youth. An endless dialogue between line and color linked him to the past, with the Renaissance and Classical forebears he persistently cited, and with such personal idols as Ingres and Delacroix, Rubens and Poussin, Veronese and Mantegna. "We are *tradition*, one can't say it often enough," he told Daniel Halévy.[17] But the image of the dancer also gave him license to explore the monumental, decorative, and dynamic potential of the human figure, in ways that resonated with his senior and junior contemporaries. Rodin, Gauguin, Lautrec, Maillol, and Denis all turned to the subject in these years, while a younger breed of artists passing through Montmartre found a new stimulus in his obsessive vocabulary. Rouault, Valadon, Denis, Rothenstein, and Sickert all visited his studio and carried word to their colleagues, and

263. *Ernst Ludwig Kirchner, Dance Training, 1910–11, altered 1920. Oil on canvas, 47 x 35¼ in. (119.4 x 89.5 cm). Minneapolis Institute of Arts; Gift of Mrs. Charles Meech (80.27)*

Everett Shinn from New York, Ernst Ludwig Kirchner from Dresden (plate 263), Pablo Picasso from Barcelona, and the native Henri Matisse watched from a distance as they reinvented the dance in the language of their own century.[18]

"THE MOVEMENT OF THE GREEKS"

In 1903, the energetic American collector Louisine Havemeyer, who already owned more than a dozen of Degas' ballet drawings and pastels, ventured into the "indescribable disorder" of the sixty-nine-year-old artist's studio to inquire about the purchase of the *Little Dancer, Aged Fourteen*. She later recalled part of their conversation: "I asked Degas the question—I blush to record it—a question that had often been asked me: 'Why, monsieur, do you always do ballet dancers?' The quick reply was: 'Because, madame, it is all that is left us of the combined movements of the Greeks.' It was so kindly said, I felt he forgave me the silly question and for not understanding him better."[19] Degas' puzzling response, one of the very few explanations he offered for his most famous preoccupation, has not been given the attention it deserves. Its implications are profound: even as the artist and his visitors examined the wax statuette that had once shocked their con-

temporaries with its "horror and bestiality" and its "exact science," Degas insisted on the association of his ballet subjects with the serene, timeless values of classical civilization.[20] The disjunction between the two epochs and their languages of art remains almost violent, and were it not for a number of corroborating observations from Degas' circle we might still be tempted to doubt Mrs. Havemeyer's recollection. But the writer Henri Hertz reported Degas as saying that his dancers "followed the Greek tradition purely and simply, almost all antique statues representing the movement and balance of rhythmic dance"; the English painter William Rothenstein, who went to the rue Victor Massé studio, recalled that the ballet allowed Degas "the color and movement of romantic art, yet provided the clear form dear to the classical spirit"; and Paul Gsell compared Degas' "last groups of dancers executed in pastel" to "bas-reliefs," while his crumbling sculp-

tures resembled "antique figurines from Tanagra or Myrina, when archaeologists remove them from tombs."[21]

Part of our challenge, then, is to look again at Degas' later images of the dance as incarnations of antiquity, as they were perceived by his contemporaries. The magnificent pastel *Dancers* (plate 264), one of the pictures acquired by Vollard in the early twentieth century and presumably shown at his rue Laffitte gallery, is a case in point.[22] It remains an extraordinary image, its subtly modulated strokes of blue, violet, green, and pink juxtaposed with raw charcoal and passages of uncovered paper, yet carrying the artist's signature as a finished composition. Our study of earlier decades has surveyed the roots of these scenes, in a casual grouping at the edge of *Ballet Rehearsal on the Stage* (plate 61) of the early 1870s, or in a pair of tired coryphées on a bench from *The Dancing Lesson* (plate 168) of around 1880. Something of the day-to-day world behind the scenery still clings to the Vollard *Dancers*, but much has changed: where we once looked into the depths of the theater or across an airy classroom, the surroundings of these women

264. Edgar Degas, Dancers, c. 1897–1901. Pastel and charcoal on tracing paper, 23¾ x 30⅝ in. (65.1 x 77.8 cm). Collection Mr. and Mrs. A. Alfred Taubman

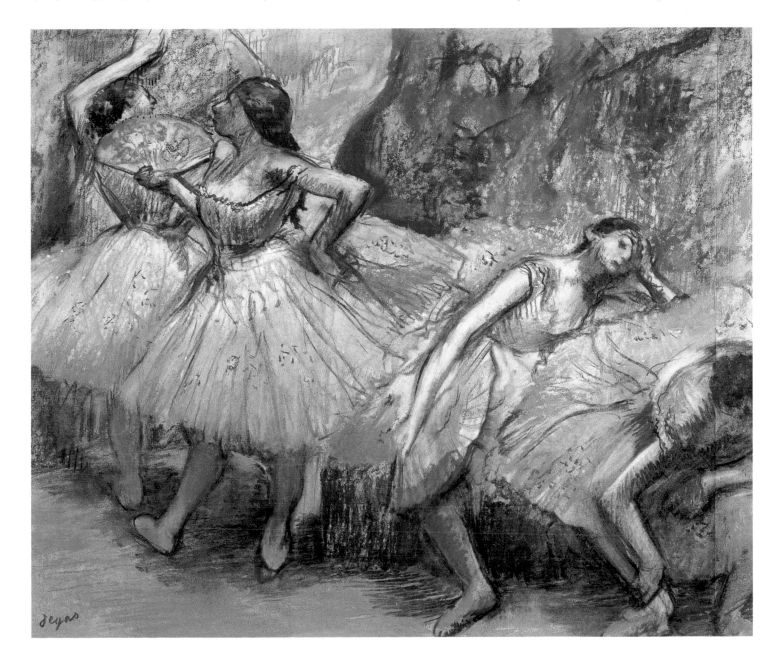

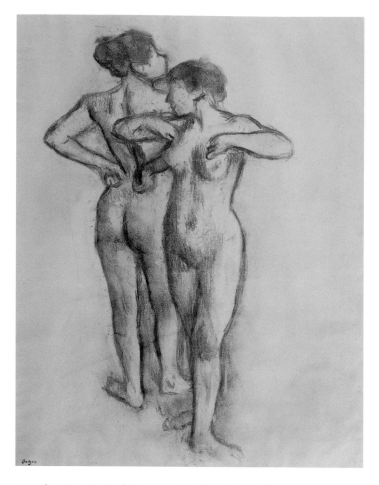

265. Edgar Degas, Two Nude Dancers, c. 1895. Charcoal and pastel on paper, 24¾ x 18¾ in. (62.9 x 47.6 cm). Collection Janet Traeger Salz, New York

266), where the stylized affectations of "antique dance" are mockingly compared to the rude Gallic tradition. Common to all these forms was the principle that modern ballet had descended from modes of dancing in former centuries and earlier cultures, in an unbroken succession that reached back to the beginnings of human society. "The history of the dance is also that of civilization and morals," wrote Gaston Vuillier in 1898. "More durable than the stone of monuments, light and diaphanous, dance has passed down to us through every people, every custom, every religion."[23] Vuillier's lavishly illustrated publication La Danse surveyed the field in eleven chapters, from "Sacred Dances among the Egyptians and the Greeks," "Dance in the Middle Ages," and "Dance Under Louis XV," to reach the achievements of "The Great Modern Ballets" only in its culminating section, its sentiments echoing those of several more modestly produced texts.[24]

"Dancing and music were more particularly cultivated by the Greeks than by the rest of the ancients," pointed out Carlo Blasis, whose 1828 Code of Terpsichore was the single most influential treatise on dance technique in the nineteenth century (plate 169).[25] The great teacher of the pre-Romantic era Auguste Vestris required the Opéra company to "dance as they did at Athens, as bacchantes or courtesans" and even at the height of Romanticism, Théophile Gautier could describe Fanny Elssler (plate 267) as "a completely pagan dancer. She recalls the muse Terpsichore with her tambourine and her tunic slit to reveal her thigh…she evokes a vision of those beautiful figures from Herculaneum or Pompeii standing out in white relief against a black

now seem compressed and subsidiary to their bodily drama, locking them in the downward diagonal of their fading energy. Rothenstein was surely perceptive in seeing both romantic color and classical form in such works, and Paul Gsell equally acute in identifying these densely crafted, shallow spaces as bas-reliefs in some imprecise antique manner. Even a drawing as straightforward as Two Nude Dancers (plate 265), with its echoes of exercising gymnasts and naked nymphs or goddesses, lends itself to Hertz's claims for the importance of the Greek tradition in late Degas, however much we have tended to link such studies with the ballet class or with the decontextualized nudity of early modernism.

If Degas' statement to Mrs. Havemeyer still disconcerts us today, it seems to have been far less surprising to his contemporaries. In two senses—one far-ranging, the other specific to the last years of his career—the affinity between ballet and the ancient world was a truism of the age. It touched on French pride in their choreographic heritage and found expression in Degas' world at the grandest as well as the most commonplace levels: inescapable in the decoration of both the rue Le Peletier and Garnier theaters, the notion pervaded dance theory and criticism, popular novels and satires, and caricatures from Daumier to his fin-de-siècle successors in the magazine Le Rire (plate

266. L'Antiquité, L'Esprit Gaulois, from Le Rire, c. 1896. Bibliothèque nationale de France

background."[26] Gautier continued his theme into Degas' formative years, arguing in 1855 that "ballet must be a kind of painted bas-relief," and claiming of Eugénie Fiocre in the 1864 premier of *Néméa* that "she might have been hewn from a block of Paros marble by a Greek sculptor."[27] Critics at the Palais Garnier repeated the litany, Georges Duval confessing that the dancing of Rita Sangalli (plate 96) in 1875 made his mind wander to "palaces of marble bathed in sunshine against a deep blue sky, like the friezes of the Parthenon."[28] And a decade later, as we have seen, Jules Claretie noted that Maurice Magnier's book *La Danseuse* ranged from "the antique dance…to the little modern chorus-girl, the little Cardinal of Ludovic Halévy, the little turned-up face of Degas' Parisienne."[29]

A conspicuous aspect of this heritage in Degas' lifetime, of course, was the tradition of operas, ballets, and divertissements on Greek and Roman themes, several of which emphasized the natural place of dance in ancient society. When he returned from Italy in the early 1860s, Degas would have found Félicien David's *Herculanum* playing on the Opéra stage, followed by the historically somewhat vague *Néméa*, which featured nymphs, fauns, and the young Fiocre as a statue of Cupid. In 1871, Reyer's opera *Erostrate* lasted at the rue Le Peletier for only two performances, but its tale of love and despair surrounding

268. H. Toussaint, *Scenes from* Sapho, *Acts I and IV, Paris Opéra, 1884, from L'Illustration, April 5, 1884. Bibliothèque nationale de France*

the creation of the *Venus de Milo* added another sculptural variation to the story. Three further classical productions, Delibes' ballet *Sylvia* and Gounod's two operas *Polyeucte* and *Sapho*, appeared in 1876, 1878, and 1884 respectively, and in the next decade Henri Maréchal's tale of the Trojan wars, *Déidame*, opened in 1893. Though the solemnity of these works varied widely, several boasted a scholarly basis in ancient culture and research among the collections of the Louvre. The much-admired set by Rubé and Chaperon for Act Three, Scene Two of *Sylvia* (plate 269), for example, was considered architecturally irreproachable, as were Eugène Lacoste's authentic costumes for the rustic or tunic-clad principals. [30]

This diversity of visual and verbal allusion to antiquity helps to recreate the context of Degas' reply to his American patron; at the same time, it reminds us of the artist's unrelenting aversion to the spectacular historicism that was so popular on the Opéra stage. When Degas saw these "classical" performances, they may have inspired a drawing of one of the dancers in a conventional tutu who featured in even the most elaborate productions, as an engraving of *Sapho* illustrates (plate 268). But the larger scene never attracted him: it was Greek "movement" and the "balance of rhythmic dance" that Degas placed at the center of his vision, not its ornamental trappings. Apart

267. Jean Auguste Barre, Fanny Elssler (Le Diable Boiteux), *nineteenth century. Silvered bronze, 16½ in. (42.9 cm). Fine Arts Museums of San Francisco; Gift of Mrs. Alma de Bretteville Spreckels (T&D 1962.134)*

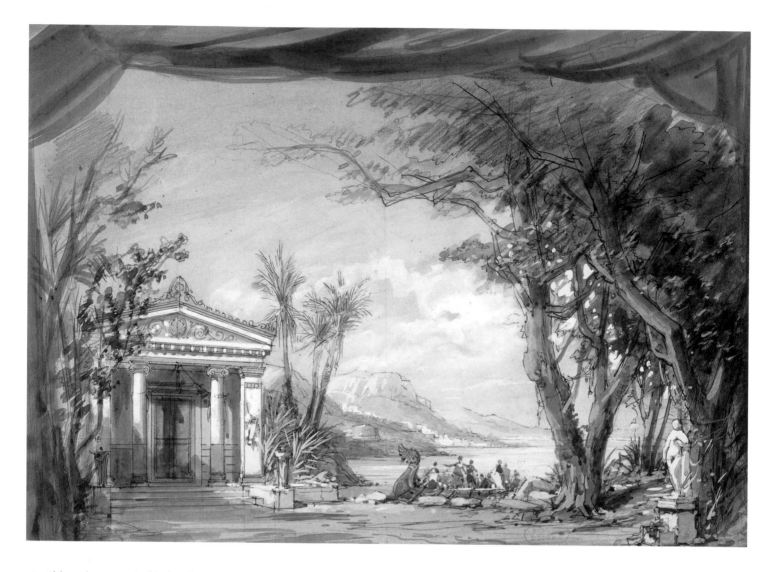

269. *Philippe Chaperon, Study of the décor for Sylvia, Act III, Scene 2, Paris Opéra, 1877. Pen, pencil, watercolor, and gouache, 9½ x 12⅝ in. (24.2 x 32.2 cm). Bibliothèque nationale de France*

from the distant temple in *Group of Dancers* (plate 271) and the toga-clad singer in *Aria After the Ballet* (plate 209), Degas showed no more interest in antique settings at the Palais Garnier than in its gothic cathedrals, Indian temples, or baroque palaces.

Two exceptional pictures from opposite ends of Degas' career offer their separate insights into his Hellenism. Though he painted the enigmatic *Young Spartans Exercising* around 1860 (plate 270), Degas remained sufficiently fond of the canvas to consider it for submission to the 1880 Impressionist exhibition and to display it in his apartment in later life.[31] He told Daniel Halévy that the scene followed an account in Plutarch's *Life of Lycurgus* of "young Spartan girls challenging the young boys to combat," a narrative repeated by Ludovic Halévy's friend, Hippolyte Taine, in his lectures at the Ecole des Beaux-Arts, where he described how Greek youths typically appeared naked "at the baths, at the gymnasium, in sacred dances and in public games."[32] The role of dance in Degas' Spartan picture has been largely overlooked, but in Desrat's *Traité de la danse* it was explained that the Spartan ruler Lycurgus—who stands in the center distance in the

painting—was known for instituting a regime of both dancing and athletics for young people: "dance was the source of health, of vigor," he declared.[33] This story was echoed by Vuillier, De Soria, and others, the latter adding that Spartan girls—as well as boys—practiced "dancing and wrestling, absolutely naked and in the presence of magistrates and citizens."[34] Once *Young Spartans Exercising* is seen as a picture on these twin themes we better understand Degas' plan to display it in 1880, where—in his original scheme—its frieze-like structure would have hung so suggestively beside the Washington *Dance Lesson* (plate 121) and the Denver *Dance Examination* (plate 128), as well as the provocatively adolescent *Little Dancer, Aged Fourteen*.[35]

Jeanne Fevre, the artist's niece, tells us that Degas read Greek authors in the original and was "passionate about the world of antiquity," a claim supported in his extensive notebook studies of classical objects from museums in Italy and France.[36] Theodore Reff has shown that several of the figures in *Young Spartans Exercising*, such as that of Lycurgus and the taunting girl at left, were derived from Greek

270. *Edgar Degas, Young Spartans Exercising, c. 1860. Oil on canvas, 43 x 60¾ in. (109.2 x 154.3 cm). The National Gallery, London*

271. *Edgar Degas, Group of Dancers, c. 1894. Pastel and gouache on panel, 12 x 16⅛ in. (31.7 x 40.6 cm). Dallas Museum of Art; The Wendy and Emery Reves Collection (1985.R.25)*

sculptures and reliefs in the classical holdings of the Louvre, which were already among the finest in the world.[37] As with Degas' concurrent, equally theatrical *Sémiramis Building Babylon* (plate 43), many of these specifically archaeological features were suppressed as the work advanced, and the extensive over-painting of *Young Spartans Exercising* before the 1880 exhibition covered further detail.[38] In this single work, therefore, described by Lincoln Kirstein as "the best of all ballet pictures," we follow Degas' trajectory from the museological to the proto-modern, and finally leave behind the touristic manner of Rubé and Chaperon.[39]

A brief lapse in this progress is represented in a smaller, less well-known ballet image from the early 1890s, *Group of Dancers* (plate 271). This translucent pastel on panel, signed by Degas and therefore considered a completed work, shows a cluster of ballerinas against a rocky landscape with an Acropolis-like edifice looming on the horizon. Neither the costumes nor the figures are remotely Greek, but their subtly interwoven bodies and the unifying tones of the scene evoke the bas-relief envisaged by Gautier and later described by Gsell. The picture can be dated with some accuracy through a drawing for the principal performer (plate 252), where Degas' inscription "Bouissavin, June 1894" refers to a young Opéra hopeful who seems to have posed for several of the dancers. So specific are the setting and the choreography that we instinctively turn to the Palais Garnier for their source: the strongest candidate at this date was Maréchal's opera *Déidamie*, which survived for just twelve nights between September 1893 and May 1894, and is thus poorly documented, but its second act opened with a ballet choreographed by Joseph Hansen in a "picturesque site on the island of Scyros."[40] One of the leading dancers in the divertissement was Mathilde Salle, a favorite subject in Degas' pastels of the late 1880s, and a prominent singer in the cast was a certain Monsieur Bouissavin.[41]

Group of Dancers may be a "dream or memory, a visual evocation" of ancient Greece, in Richard Brettell's phrase, as well as a free interpretation of an Opéra episode pieced together with the help of Mlle Bouissavin.[42] Full of yearning for a golden past, it was also an elegiac counterpart to the *Young Spartans Exercising* then on view at the rue Victor Massé. Aside from the Greek theme and the Mediterranean setting, the high horizon and rocky prominence, and the warm tonality of the picture, several of its figures clearly reverberate with the earlier work.[43] From the advancing, lightly clad female trio at left in *Group of Dancers*, one stretching her arm to the center of the composition like her Spartan cousin, we find that Degas also mirrored the crouching Spartan boy in the attitude of the later kneeling ballerina. The pivotal elements in both pictures, however, are the individuals toward the right with arms raised; the leading male in one, the dominant female in the other. When we recall that Degas first drafted Bouissavin as a nude with lifted arms (plate 255) and repeated the pose in other current drawings of naked dancers, the echo becomes resounding. The wonderfully unforced line in *Nude Dancer with Arms Raised* (plate 272) captures both the idealism and the practicality of the situa-

272. Edgar Degas, *Nude Dancer with Arms Raised*, c. 1890. *Black chalk on wove paper, 12⁷⁄₈ x 9³⁄₈ in. (32.7 x 24 cm). Statens Museum for Kunst, Copenhagen (KKS8524)*

tion, as it follows the tremulousness of the model's naked torso and uplifted arms, while noting her ballet tights below the waist. Reminding us how frankly sensuous Degas' later dance drawings can be, despite their formidable freight of historical and technical significance, this superb study records his loyalty to a pair of twinned, airborne limbs over three decades, to be rediscovered in a group of around fifteen works based on the teenage Bouissavin (plates 252, 254, and 257).

As Degas made such studies in his last studio, he could move not just from medium to medium, but from two dimensions to three and back again. He explained to the journalist François Thiébault-Sisson in 1897 that his sculptures were intended "to give my paintings and drawings greater expression, greater ardor and more life," a number becoming substitute models for his dance and bather scenes.[44] Most of the waxes are undated, but the testimony of Lafond, Thiébault-Sisson, and many others indicates that the years between 1890 and 1910 were highly productive for this cross-fertilization. About half a dozen statuettes, for example, have an affinity with *Group of Dancers* and were probably made around the same moment, one of them— *Grand Arabesque, First Time*—showing a similar bend in the knee, tilt of the head, and oppositional arm movements to the left-hand pair of

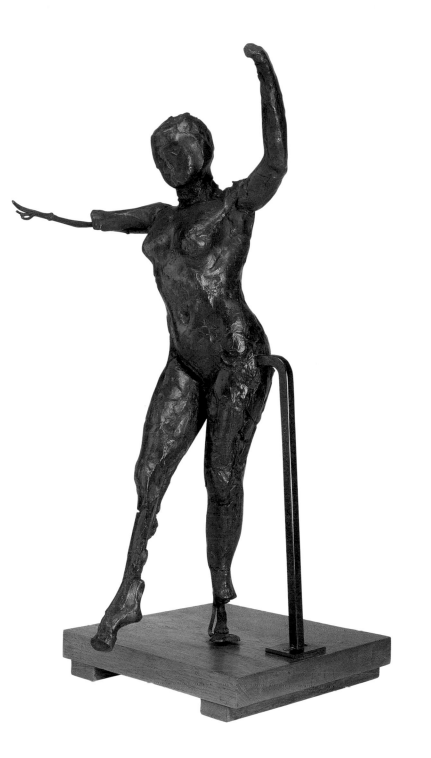

273. *Edgar Degas,* Dancer Moving Forward, Arms Raised, Right Leg Forward,
*c. 1882 95. Bronze, 27¼ in. (69.2 cm) Hirshhorn Museum and Sculpture Garden,
Smithsonian Institution, Washington, D.C.; Gift of Joseph H. Hirshhorn, 1966 (66.1298)*

ballerinas.[45] Tellingly, two further sculptures from this group offer vari-
ations on the motif of the symmetrically lifted arms, with *Dancer Mov-
ing Forward, Arms Raised, Right Leg Forward* (plate 273) coming closest
to the central figure in the pastel and participating in her sprightli-
ness and symmetry. *Dancer Moving Forward, Arms Raised* (plate 274)
belongs to the same family, but she is squatter and more earthbound,
her forward-facing hands now suggesting a choreographed act of sup-
plication rather than routine buoyancy.

This reading of the dancer's hieratic pose was favored by Degas
at the turn of the century, in a richly varied series of drawings and

pastels that includes the sinuous, almost ethereal charcoal *Three Dancers
Seen from the Back with Arms Raised* (plate 275). By repeating the figure
several times, perhaps using a sculpture such as *Dancer Moving For-
ward, Arms Raised* and drawing it from slightly differing angles, he set
up a wave-like motion across the entire scene. Seen from behind
and—as is more apparent in the pastels—from a notional position in
the wings, the understated motion of Degas' willowy skyward-stretching
ballerinas seems to have entranced him. While the physiques of the
dancers in his two sculptures could not be confused with the tall,
wasp-waisted Bouissavin, the models in all these works are united in
their simple dignity and the suggestion of action gently held in check.
Each figure has at least one foot partially off the ground, and the high
center of gravity created by their elevated arms increases the sugges-
tion of weightlessness. The effect is stately, a truly rhythmic procession

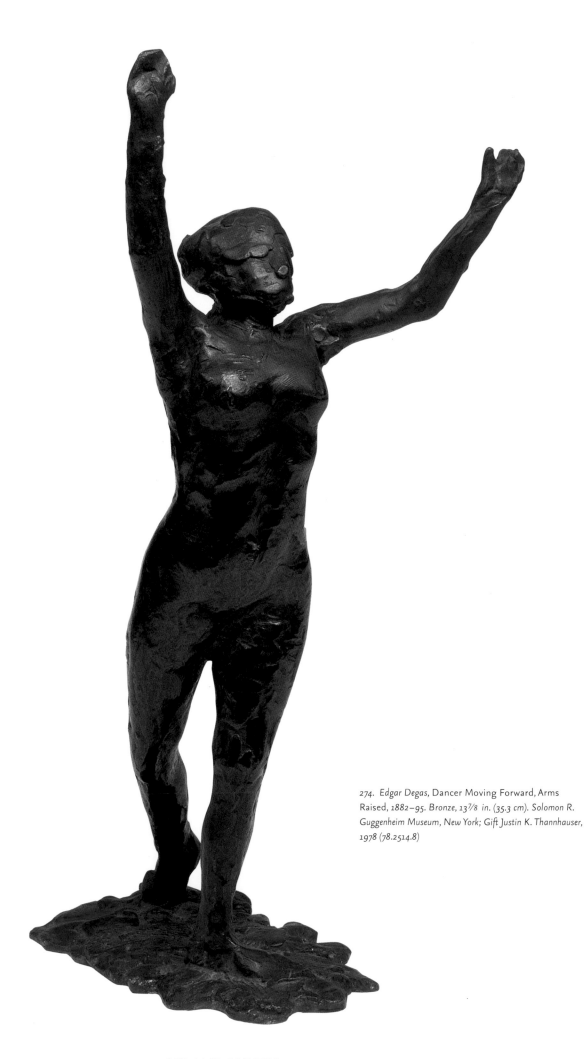

274. Edgar Degas, Dancer Moving Forward, Arms
Raised, 1882–95. Bronze, 13⅞ in. (35.3 cm). Solomon R.
Guggenheim Museum, New York; Gift Justin K. Thannhauser,
1978 (78.2514.8)

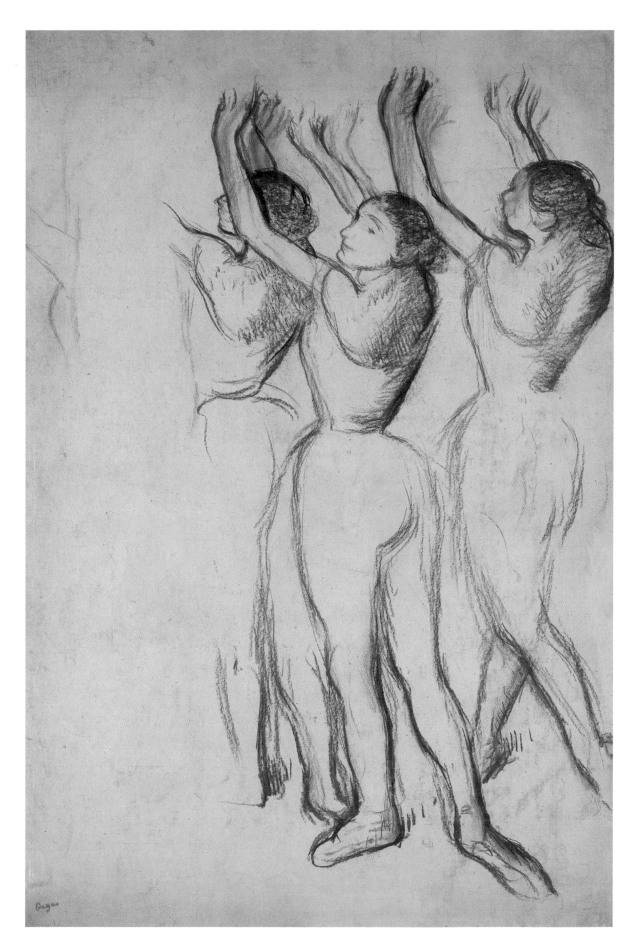

275. *Edgar Degas, Three Dancers Seen from the Back with Arms Raised, c. 1898.*
Charcoal and pastel on paper, 35 x 23¼ in. (88.9 x 59 cm). Private collection, courtesy Browse
& Darby, London

out forcing the comparison, we can find a similarly contained energy in his monumental painting of these years, *Frieze of Dancers* (plate 278), one of Degas' most self-consciously historic works. Like a panel from some latter-day temple to elegance and vitality, its blunt brush-marks gouging into the shallow space of the canvas, this celebration of past forms is also miraculously modern, energized by an awareness of the photographic sequences of Muybridge and Marey, and by a spatial mobility that was to erupt, within a decade, into cubism.

The drawings made by Degas for the *Frieze of Dancers* are eloquent of his complex historicism in other ways. Ballerinas on flimsy chairs had first featured in his art around 1878, in paintings such as *The Dance Lesson* (plate 121), where they shared the open space of a classroom with a dozen companions who variously stretch and preen. Making occasional appearances in the next decade, they became more solitary and detached from their locations, while generally remaining engulfed in their gauzy petticoats. The *Frieze* itself has a complex technical history and may have been drafted during this period, perhaps as a loosely brushed composition that was then set aside, to be densely reworked and signed in the mid-1890s. It is clear from the drawings for this painting, however, among them, *Nude Dancer Adjusting Her Shoe* (plate 279) and *Seated Nude Dancer Tying Her Shoe* (plate 280), that all the figures were begun as nudes, allowing the artist to explore minor variations in their poses as he integrated them into the larger structure. Returning to the academic practices of his youth and his early experience of copying past art, Degas used simple lines and

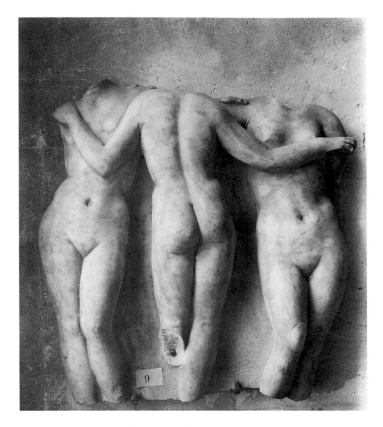

276. Late nineteenth-century photograph of The Three Graces, *marble. Musée du Louvre*

in two dimensions that is remote from the acrobatics of his fan paintings or the anxious darting of his earlier *rats*. Looking for analogies we turn easily to the art of antiquity, to the painted vases that often represent solemn, frieze-like dancers, or to a carved Greek relief, such as the Louvre's *Three Graces* (plate 276).

DEGAS AT THE LOUVRE

As much as any of his aging Impressionist colleagues, Degas was conscious of his place in history, urging his followers to study the traditional skills of draftsmanship ("draw lots of lines," Ingres had once advised him) while persisting with his attentions to the paintings and sculptures in the Louvre.[46] On one occasion he explained to Georges Jeanniot in front of the *Venus de Milo* that, by introducing a slight imbalance into the work, "the Greek sculptor gave his figure a splendid movement, while still retaining the calm that characterizes masterpieces."[47] Degas' visits to the classical galleries brought him into contact with Greek art from the monumental to the miniature, from entire temple friezes (plate 277), to such celebrated marble fragments as *The Three Graces*. In the latter, both the form and the subject—the Graces were the daughters of Zeus who danced at the gatherings of the Gods—offered him an unusually appropriate model, fusing "movement" with "calm" in a lyrically symmetrical composition. With-

277. Late-nineteenth-century photograph of marble relief panels from the Temple of Artemis Leucophryne. Musée du Louvre

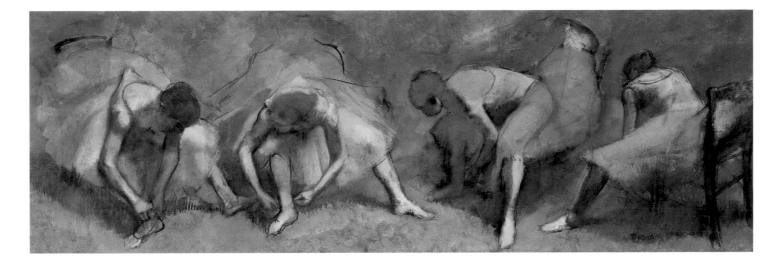

278. Edgar Degas, *Frieze of Dancers*, c. 1895. Oil on canvas, 27⅝ x 79 in. (70 x 200.5 cm). *The Cleveland Museum of Art; Bequest of Leonard C. Hanna, Jr. (1946.83)*

softly rubbed modeling to articulate the dancers' serpentine limbs, adding white pastel in a way that recalls highlights on marble. But he also went further, hinting that his models are as much like young athletes or Spartan youths attending to their ankles as ballerinas fussing with their slippers, and distantly invoked such canonical images as the Greek *Spinario*. The drama of his conception, audaciously built around the idea of four simultaneous views of a single rotated body, would surely have been overwhelming when these magnificent studies were first transferred to canvas. Examination of the surface shows that the dancers were originally painted as pale, naked figures, and only in the final stages had their skirts and bodices, as well as the brilliant swathes of orange and green, superimposed.[48]

Degas only once attempted a modeled relief of his own, in the early 1880s, but his late sculptures of dancers suggest a number of intense, and sometimes witty or paradoxical engagements with both the past and the unresolved present.[49] These original wax and mixed-media figures were emphatically the products of their time, made from everyday materials in his squalid Montmartre studio and frequently posed by girls from the Paris Opéra. Though none were exhibited in public after the unveiling of the *Little Dancer, Aged Fourteen* in 1881, they were regularly seen by Degas' visitors and fellow sculptors and participated in some sense in the radical sculptural events of the fin-de-siècle.[50] The challenge of a work such as *Dancer Holding Her Right Foot in Her Right Hand* (plate 281) is self-evident, appearing brazenly unfinished and unbeautiful by the standards of almost all his contemporaries. Clay models or sketches had a long history, but Degas showed little inclination to refine his late creations and typically energized

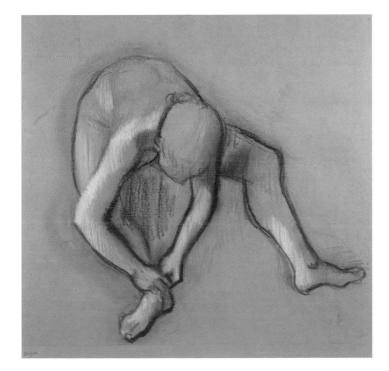

279. Edgar Degas, *Nude Dancer Adjusting Her Shoe*, c. 1885–95. *Charcoal heightened with white on paper, 21⅝ x 22 in. (55 x 56 cm). Private collection, New York*

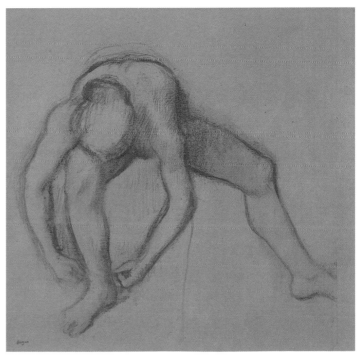

280. Edgar Degas, *Seated Nude Dancer Tying Her Shoe*, c. 1893–98. *Charcoal on buff paper, 22⅜ x 23½ in. (56.7 x 59.7 cm). Collection Mr. and Mrs. Nico Delaive, Amsterdam*

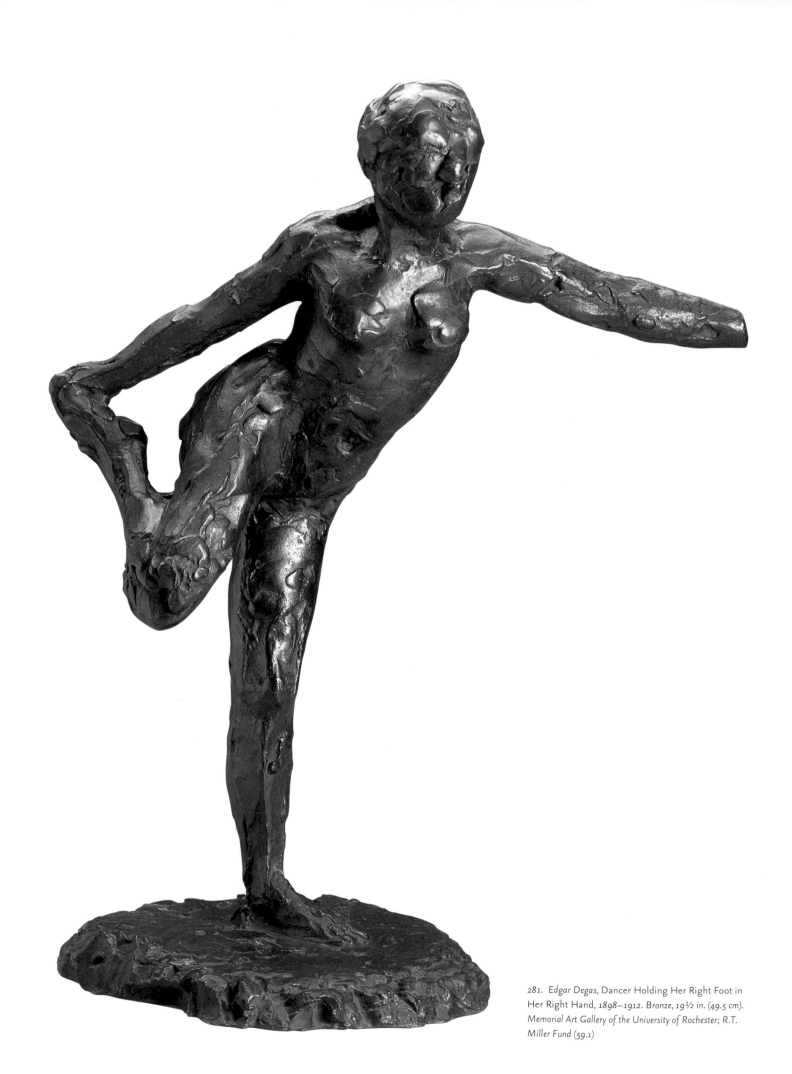

281. *Edgar Degas, Dancer Holding Her Right Foot in Her Right Hand, 1898–1912. Bronze, 19½ in. (49.5 cm). Memorial Art Gallery of the University of Rochester; R.T. Miller Fund (59.1)*

their surfaces with knives, spatulas, finger-marks, and accidental effects. In many cases, their abrasiveness was heightened by their ungainly classroom subjects, contrasting with the exquisite moment in performance preferred by an earlier generation of sculptors, such as Barre (plate 267). The modernity of Degas' figures has been compromised by several factors, among them the damage that occurred to his waxes in the artist's last years and their posthumous translation into bronze. Ironically, both factors tend to create a falsely antiquarian aura: today, the cast of *Dancer Holding Her Right Foot in Her Right Hand*, with its featureless face, broken arm, and rough-hewn textures, would hardly seem out of place in a vitrine of corroded classical bronzes.

The possibility that Degas pursued a dialogue between his statuettes and the sculptural tradition of Greece and Rome has been most thoroughly explored by Charles Millard. In *The Sculpture of Edgar Degas*, Millard stressed the artist's deep grounding in the subject from his early years and the accessibility of appropriate models in his adult milieu.[51] By comparing astutely chosen historical objects with certain of Degas' waxes, Millard argued persuasively that the artist followed their heroic or lyrical forms in a purposeful way, while relocating them among plausible modern activities. *Dancer Moving Forward, Arms Raised* (plate 274), for example, is described as "very nearly a copy" of a classical *Dancing Faun* that was commonly available as a plaster cast, while a relief of a male figure tying his sandal from the Parthenon frieze, drawn by Degas in a youthful notebook, becomes the ancestor of the bronze *Dancer Putting on Her Stocking* (plate 282).[52] But this cast also emphasizes the distance the artist might travel from his putative source, leaving behind the stable and barely three-dimensional form of his antique prototype to arrive at a wax dancer who totters awkwardly and largely in space. While Degas' well-stocked memory provided many starting points for his figurative repertoire, he was equally inclined to regard such models as precedents to be superseded, not complacently echoed.

When Degas pointed out that "almost all antique statues" represented "the movement and balance of rhythmic dance," he was reflecting both a general belief among his peers and something of his own practice. There was also a more topical element in the artist's remarks, apparently reflecting the latest thinking on the subject. Alongside the broad surveys of De Soria, Vuillier, and others, there was a marked increase in the 1890s in academic, archaeological, and literary concern with early dance, some of which found immediate popular expression. The notion that Degas was alert to such scholarly developments is not outlandish: described as "an artist of rare intelligence, preoccupied with *ideas*" in an earlier decade, Degas had made a note of the journal *La Nature* when an article on the chronophotographs of Marey appeared, and in 1891 had cited a paper by the British ophthalmologist Leibriech.[53] In his immediate circle, both Mallarmé and the young Paul Valéry interested themselves in ancient and contemporary dance, while his patron and fellow ballet-enthusiast Charles Ephrussi may have indirectly introduced him to another recent theory. As editor of the *Gazette des Beaux-Arts*, Ephrussi published in 1896 a long essay by

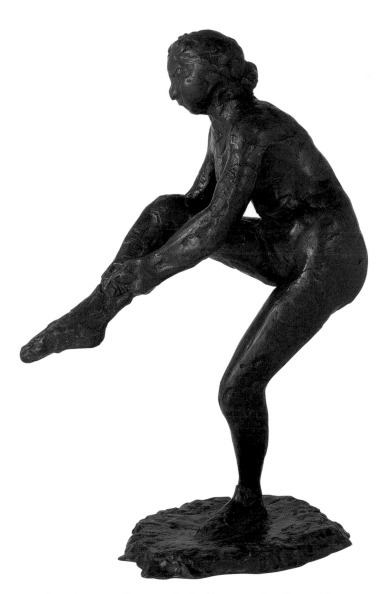

282. *Edgar Degas, Dancer Putting on Her Stocking, c. 1900 (cast after 1922). Bronze, 18 3/8 in. (46.5 cm). The Museum of Fine Arts, Houston; Museum purchase with funds provided by the Estate of Mrs. Harry C. Wiess, the Vale-Asche Foundation, and Mr. and Mrs. Lloyd Smith in memory of Mrs. Harry C. Wiess (80.43)*

Maurice Emmanuel entitled "La danse Grecque antique," which coincided with Emmanuel's new book on the same theme.[54]

Both of Emmanuel's texts were dedicated to a simple, dramatic thesis, developed at considerable length with the aid of hundreds of engravings and diagrams (plate 283). This was his belief that in all societies the "movement of the body is the essence of the dance," a principle that was evident throughout Greek culture and still emphatically visible in its painted vases and sculpture.[55] For Emmanuel, these objects showed the existence of stylized bodily actions in ancient Greek dance that were directly comparable to those of the modern ballet: "dancers of antiquity and modern dancers do not differ at all in their gymnastic activity: the laws which govern the working of the organism have not changed in 2000 years."[56] Acknowledging the advice of experts from the Paris Opéra, Emmanuel used objects chosen largely from the Louvre to show that Greek dancers had their equivalents of the "five positions" of modern ballet, turning out their

135. A la figure 98 correspondent les figures 142, 143, 144, 208.

Fig. 140. Fig. 141. Fig. 142. Fig. 143. Fig. 144. Fig. 145. Fig. 146.

qui révèlent, de la part du peintre à qui elles sont dues, une véritable intention d'analyse, indéniable. L'exemple suivant est plus remarquable encore.

290. Les trois Satyres à pieds de bouc, de la fig. 386, sont empruntés à un même vase. Malgré la déformation de leurs mem-

Fig. 386.

bres inférieurs, ils sont facilement comparables aux images de la série chronophotographique ¹ qui commence à la figure 387 et finit

Fig. 387. Fig. 388. Fig. 389. Fig. 390. Fig. 391. Fig. 392.

à la figure 398. Cette série est l'analyse d'une des innombrables formes du saut dans notre danse : le *Saut de Chat*, exécuté latéra-

283. Dancing figures from Greek terra-cottas and vase paintings, from Maurice Emmanuel, La danse Grecque antique d'après les monuments figurés, 1896

284. Dancing satyr on a Greek vase and sketches of a modern dancer executing a saut de chat, from Maurice Emmanuel, La danse Grecque antique d'après les monuments figurés, 1896

feet and using such steps as *plié, fouetté, jeté,* and *ballonné,* as well as performing "sur les pointes."[57] Evidence was also offered of the expressive use of light, veil-like clothing, such as the short skirt visible in a marble relief in the Louvre (plate 289).[58] By juxtaposing these classical images with high-speed photographs of a modern ballerina in action, taken—coincidentally—by the same Jules-Etienne Marey, Emmanuel made his argument even more explicit (plate 285). In drawings made from one of these sequences (plate 284), he explained that the *saut de chat* had clear antecedents in the painted satyrs on a fourth-century B.C. red figure vase, a demonstration that "greatly surprised" Joseph Hansen, "the knowledgeable ballet master at the Opéra."[59]

Whether we accept such analogies at face value or not, the dissemination of ideas like those of Emmanuel's at the fin-de-siècle contributed to a sustained re-examination of Greek dance in a wide variety of forms, both reactionary and forward looking. A surprising number overlap with Degas' own preoccupations, among them the passion for Tanagra figurines, many of which were understood to be dancing, however sedately.[60] Discovered only in the 1870s, these delicate and animated objects were already represented in the Louvre (plate 286) and had a marked effect on contemporary sculpture, painting, and dance, providing a flimsy vehicle for performances by Cléo de Mérode, for example, in the 1905 ballet *Tanagra.*[61] The same resurgence lay behind a fashion for historic and ethnic dancing, from displays by Opéra stars in eighteenth-century costumes and Asian dancers at the Paris Inter-

national Exhibitions to a revival of interest in the operas—with their appropriately antique ballets—of the great classicist Gluck. After many decades of neglect, several works by Gluck—Degas' idol—returned to the Paris theater, when both *Orfeo* and *Iphigénie en Tauride* were seen by the artist, the latter starring his friend Jeanne Raunay (plate 287).[62] Joseph Hansen evidently specialized in these events, choreographing *Fête Russe* in 1893, a short-lived entertainment entitled *Danses Grecques* in 1901 (which featured Mlle Boussavin) and a new production of Gluck's *Armide* in 1905.[63] This was fertile ground for the dance, breeding not just Degas' pastels of *Russian Dancers* (plate 315) and the debut of the sensational "Greek" performer Isadora Duncan in the same year, 1899, but a blossoming of many inventive forms in the early twentieth century.

A distinctive feature of this revived classicism—and again a feature of Degas' later dance art—is the issue of nudity. Though conspicuous in a large number of his ballet images of these years, the implicit paradox of the nude dancer has rarely been acknowledged. With only two exceptions, Degas' sculptures of ballerinas show their subjects completely naked, while several hundreds of his charcoal drawings depict these individuals nude or in extreme states of undress. In the late nineteenth century there were no circumstances in which such dancers would appear in public without full costumes or conventional tutus, and it was still normal practice for their limbs to be entirely covered.[64] There can be no question that the figures in the nude studies by Degas are members of the corps de ballet and not women con-

285. *Sequence of a dancer in motion by Jules-Etienne Marey, from Maurice Emmanuel, La danse Grecque antique d'après les monuments figurés, 1896*

286. *Early-nineteenth-century photographs of terra-cotta statuettes from Myrina. Musée du Louvre*

287. *Jeanne Raunay in the role of Iphigénie, 1899*

cerned with their private toilette. many of his models, like the subject of *Study of a Nude Dancer* (plate 288), have the athletic body, bunched hair, and tell-tale features—such as turned-out feet—that identify them as dancers; some, as in *Three Dancers* (plate 291), are shown among companions in ballet skirts and tights; a large number, among them, *Nude Dancer* (plate 294) and *Study of a Nude* (plate 293), adopt positions already familiar to us from waxes, pastels, and paintings of conventional dance subjects; while others are drawn, sometimes disconcertingly, in the act of tying a non-existent ballet slipper or adjusting an invisible tutu, as in *Seated Nude Dancer Tying Her Shoe* (plate 280) and *Two Nude Dancers* (plate 265).

Degas' identification of such images with the "movement of the Greeks" may well have been informed by a sense of their historic nakedness. Contemporary authorities asserted that ancient dancers of both sexes were often partly clothed or nude, though Greek female figures tend to wear flimsy shifts or the longer, enveloping gowns of certain vase paintings and Tanagra figurines (plate 286). Academic painters and sculptors—such as Carpeaux and Boulanger in their decorations for the Opéra—had exploited these possibilities for some time, but Degas was at pains to separate himself from their opportunism, his own undressed dancers neither flaunting themselves nor showing embarrassment. This blurred boundary was exemplified in the person

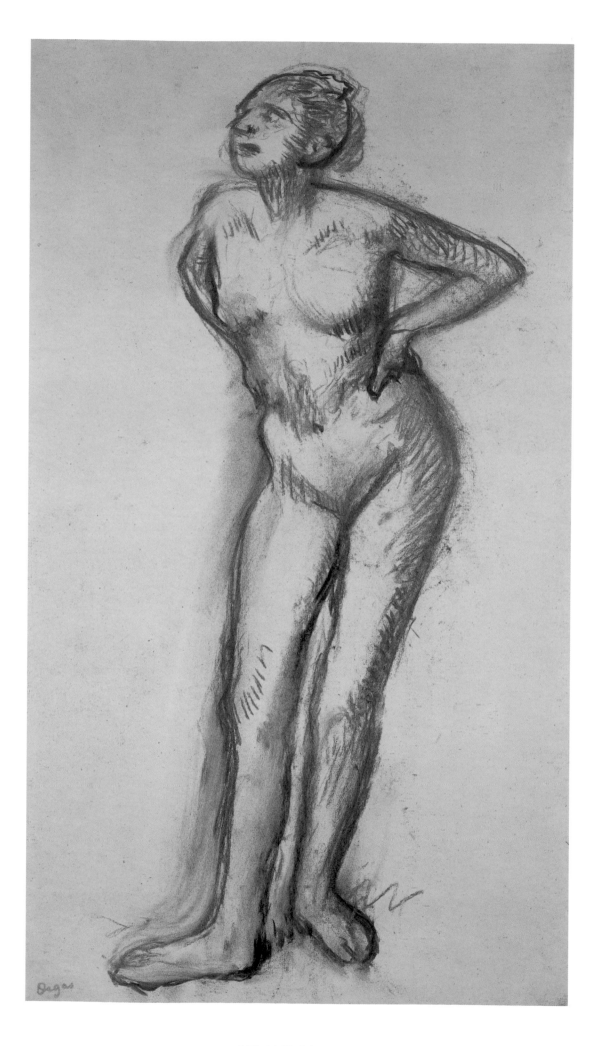

THE LAST DANCERS

of the glamorous and reputedly chaste Cléo de Mérode (plate 251), who reports that she sometimes modeled for Degas "several afternoons a week," though without revealing whether she joined the dancers Marie van Goethem, Mlle Bouissavin, and "Yvonne" by posing naked.[65] But Cléo famously contributed to the cultural—and sculptural—confusion when she appeared as the classical beauty in a production of *Phryné* at Rohan in 1896, performing in nothing but a pale pink body stocking, lightly veiled, so that her "feminine, flesh-colored silhouette would create the illusion of a naked body."[66] This sensation was soon exploited by the sculptor Falguière, who caused another minor scandal by exhibiting a life-size nude plaster of Cléo at the Salon, called simply *Dancer*, bringing further delight to the cartoonist of *Le Rire* (plates 266 and 290).

The assumption remains that Degas' nude studies were produced in the time-honored process of drawing from a naked model, prior to the incorporation of the figure—now fully or partly clothed—into a finished composition. Raised in the shadow of Ingres and the Renaissance masters, the young Degas had become adept in this procedure and exploited it skillfully in such works as *Sémiramis Building Babylon*, persisting as late as the drafts for his 1867 portrait of Eugénie Fiocre.[67] But these studies for his first dance canvas were also among the last of their kind: at almost exactly this moment, the use of the nude drawing disappeared from Degas' habitual practice. Now mixing in the company of Manet, Renoir, Morisot, and their peers, he abandoned a number of traditional techniques along with his former historical themes, adopting a more direct, improvised approach to the modern figure. Significantly, Degas made no studies from the unclothed model for his urban repertoire of laundresses, milliners, jockeys, cabaret artistes, musicians, or bourgeois pleasure-seekers, and the merest handful for the hordes of ballerinas who populated his dance pictures in the Impressionist years. This situation continued throughout the 1870s and 1880s, a period in which almost all Degas' drawings of the naked body were confined to scenes of bathing and the toilette.

Around 1890, this emphasis changed yet again, so completely that Degas was to make nude studies—almost as a matter of course—for all the principal figure subjects of his last two working decades. By far the largest group were depictions of naked and semi-naked dancers, though some surprising sheets of undressed maids carrying coffee and stripped jockeys on horseback reveal the extent of his transformation.[68] This previously uncharted shift in Degas' procedures is not easily explained: he surely had no need to re-educate himself as a draftsman and there is little suggestion of a commercial motive, the bulk of these drawings remaining in his possession until the end. Those that relate most directly to his paintings and sculptures may seem most comprehensible. *Three Dancers* (plate 291), for example, is like an artistic performance frozen in mid-action, with the slim, androgynous left-hand figure superbly established in its nakedness, appar-

289. *Late-nineteenth-century photograph of marble relief with dancer. Musée du Louvre*

ently awaiting the arrival of a diaphanous costume like that of her colleague. Scrutiny of such drawings, including the much larger *Dancers, Entrance on Stage* (plate 310), shows that these ballerinas were sometimes "dressed" by the artist in an item-by-item manner on the sheet itself, a sequence only complete when a tissue of multi-colored pastel was draped across players and setting. Later variants of *Three Dancers* show the once-nude athlete in her decorous costume, while the plainly clothed dancers in the Pittsburgh sheet appear dazzlingly appareled in the *Ballet Scene* of around 1900.[69] Other cases raise larger questions: the striking *Study of a Nude Dancer* (plate 288) is complete in itself, yet it also belongs to a sprawling tribe of single and multiple studies of near-identical figures, two sculptures (plate 133), and a large subgroup of pastels. Whether it preceded this throng as a preparatory sheet or emerged partway through, or was even drawn *after* one of Degas' own waxes, is far from clear. And having created so many of these finely observed studies, we find ourselves asking why the artist continued to draw and re-draw the same pose, as if life drawing had again become a private discipline or a nostalgic routine. Was there a suppressed eroticism in his manipulations of bodies and clothing? Or were there yet other meanings within the redefined nature of his procedures?

An important clue is the discovery that a number of the drawings in question were signed by the artist and sold through his dealers

288. Edgar Degas, Study of a Nude Dancer, c. 1895–1900. Charcoal on paper, 23 x 13 in. (58.4 x 33 cm). Collection James and Katherine Goodman, New York

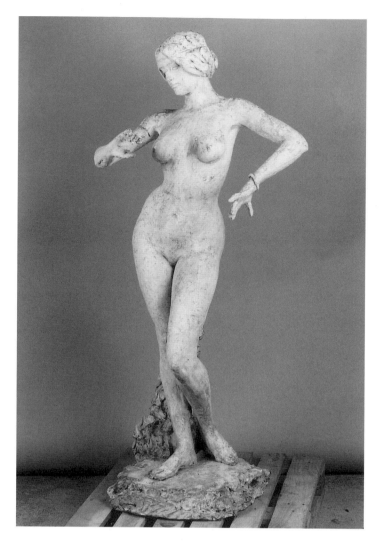

290. Alexandre Falguière, The Dancer: Cléo de Mérode, c. 1896. Plaster model. Musée d'Orsay, Paris

around the turn of the century, effectively transforming them from studio drafts to public works of art. The exceptionally vibrant *Dancers, Nude Study* (plate 292), for example, was one of no less than seven signed compositions of unclothed ballerinas illustrated in a catalogue of Vollard's stock in 1914, which ranged from large, multifigure compositions of naked figures to an almost shocking study of a naked girl, legs akimbo, on a banquette.[70] *Dancers, Nude Study* is almost as provocative in its clustered, naked arms, shoulders and hips, which are scarcely contained by the splintered and smudged charcoal lines around them. Some touches of pastel in their tightly pulled-back hair help to identify these women as dancers, but the vivid thrust and counter-thrust of flesh and muscle makes few other concessions to balletic or artistic orthodoxy. Degas' endorsement for the Paris market of such works, which would certainly have been regarded as preliminary studies in an earlier generation, can be linked to his current activities as a collector of drawings and a promotor of his own graphic output; but most crucially, it expresses a conviction that such studies

291. Edgar Degas, Three Dancers, c. 1900. Charcoal and pastel on wove paper, 15⅜ x 15⅜ in. (39 x 39 cm). Collection Dr. Morton and Toby Mower

of naked dancers were rational, exhibitable images with their own historic resonance.[71]

Some of Degas' final drawings must be considered among his most powerful and touching representations of dancers, though their relationships to events on the Opéra stage, to the art of the Louvre and even to the practice of the ballet has now become enigmatic and perhaps irrelevant. *Study of a Nude* (plate 293) may once have participated in the drafting process for a larger pastel, but it remains an exemplary, economical statement about the structure and muscular suspension of a human body.[72] We are again reminded of the admiration for Degas' late art of Matisse, Picasso, and their generation, who at this moment were stripping down their own resources and refining their visual means, sometimes in the context of the dance and increasingly in three dimensions. In March 1910, the seventy-five-year-old Degas could still write to his collector-friend Alexis Rouart, "I do not finish with my damned sculpture," and it was perhaps at this time that the tremulous *Nude Dancer* (plate 294) was made, either from one of his accustomed ballerina-models like "Yvonne," or from a wax figure in his studio.[73] Especially poignant is the ruled plumb line down the woman's back, a vestige of his brief academic tuition in the 1850s and remotely linked to his observations of a "slight imbalance" in the *Venus de Milo*. But the *Study of a Dancer in Tights* (plate 295) leaves us in no doubt that the elderly Degas' artistic powers could rise magnificently to the occasion. Rich in echoes of his own earlier drawings, prints, pastels, and sculptures of Spanish dancers (plates 150, 151, 195, and 196), and of the dynamic silhouettes of Greek vase painting (plate 296), the palpable forms of this deeply moving sheet are now their own justification. Tense and supple, yet perfectly controlled by an understated symmetry, these dancers belong with the greatest art of the early twentieth century.

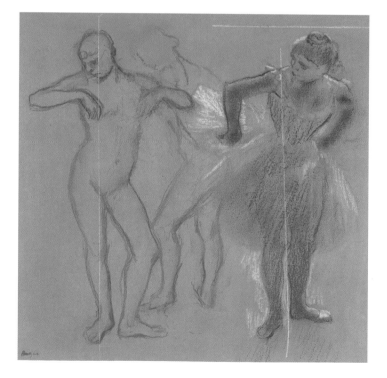

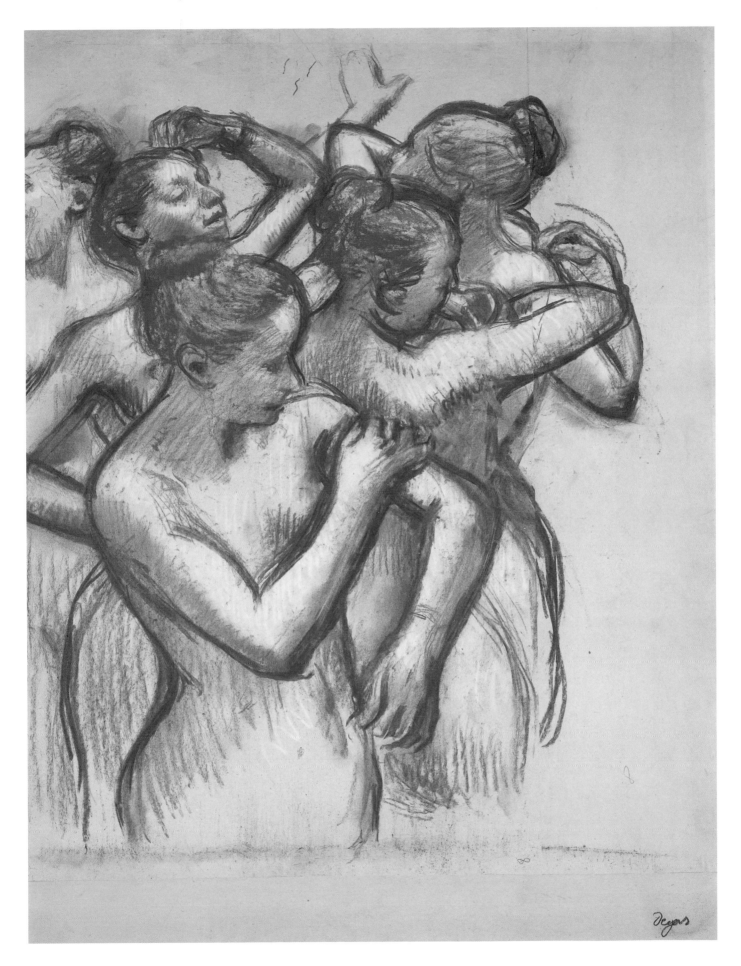

292. *Edgar Degas, Dancers, Nude Study, 1899. Charcoal and red-brown pastel on cream-colored wove paper, 30¾ x 22⅞ in. (78.1 x 58.1 cm). Private collection*

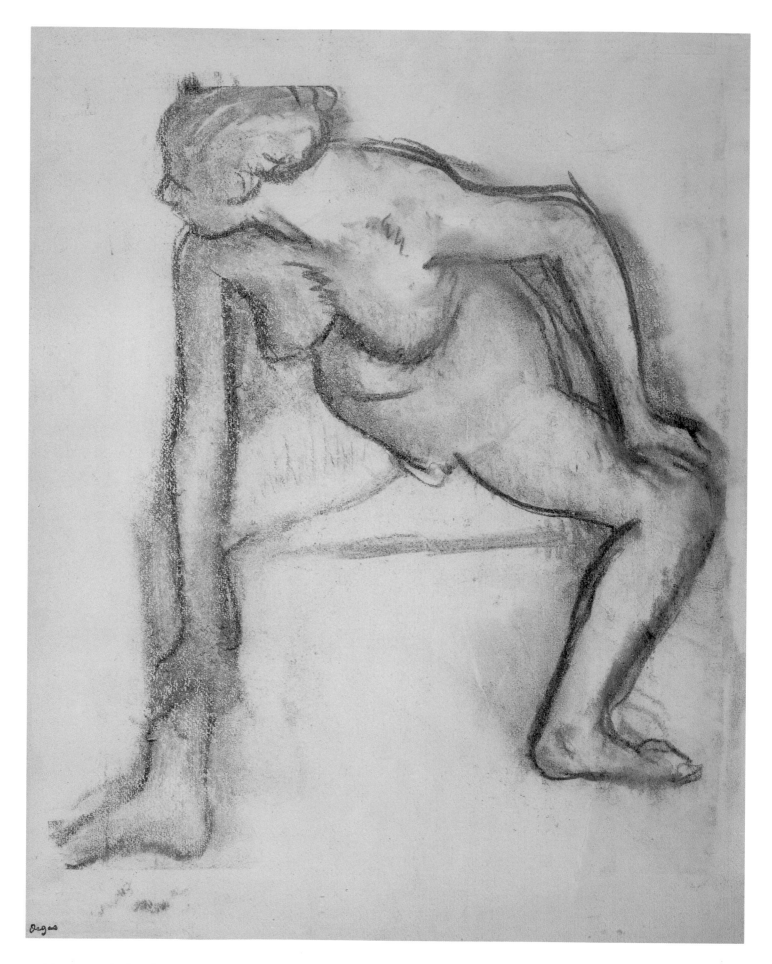

293. *Edgar Degas, Study of a Nude, c. 1895. Charcoal on paper, 16⅝ x 19⅝ in. (65 x 50 cm).*
Collection J. Kasmin, London

THE LAST DANCERS

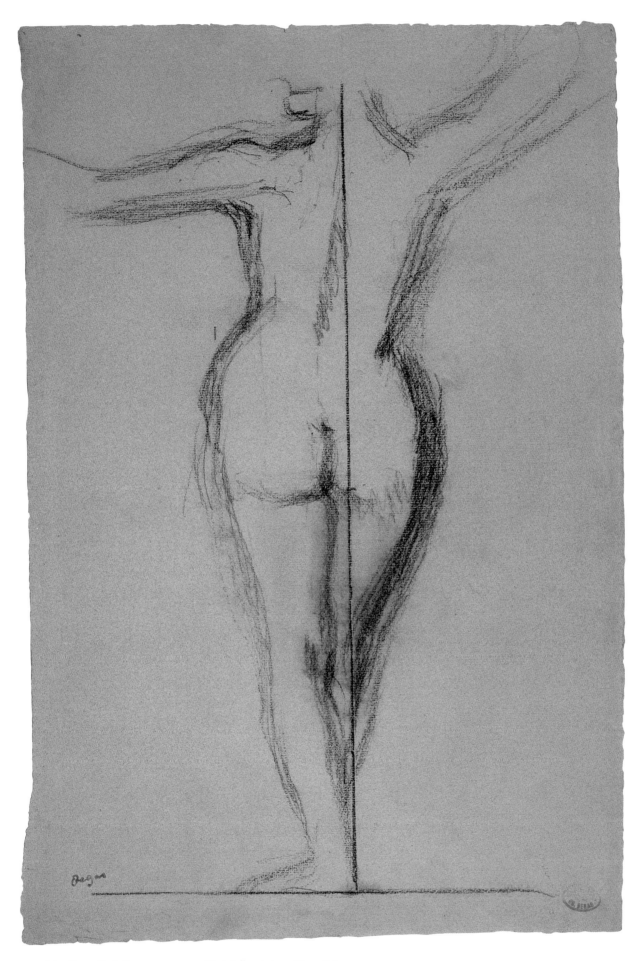

294. *Edgar Degas, Nude Dancer, c. 1905–10. Black chalk on paper, 19³⁄₈ x 12³⁄₄ in.*
(49.3 x 32.3 cm). Nasjonalgalleriet, Oslo (NG.K & H.B.15575)

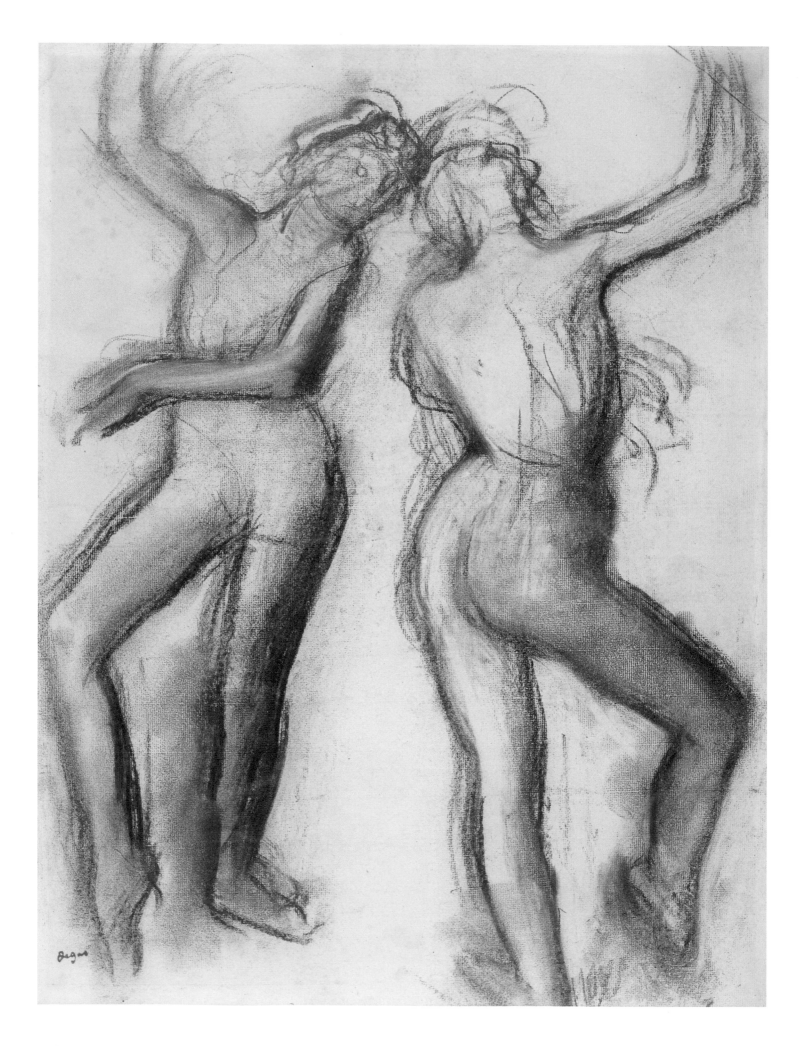

THE LAST DANCERS

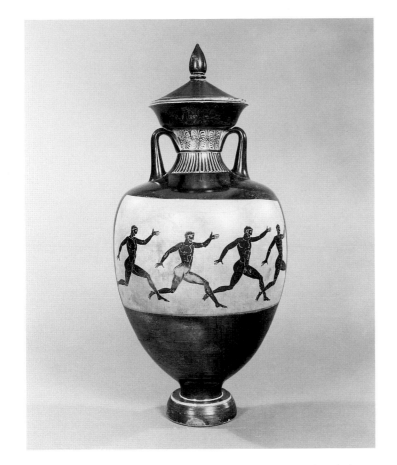

296. Greek Attic Panathenaic Amphora, 375–370 B.C. Ceramic, 27½ in. (70 cm). The Detroit Institute of Arts; Founders Society Purchase, General Membership Fund (50.193.A)

"THE MARRIAGE AND ADULTERY OF COLORS"

"I am a colorist with line," the elderly Degas proclaimed, wittily acknowledging one of the creative tensions that persisted through his long career. His divided loyalties to draftsmanship on the one hand, and to the sensuous, painterly tradition of Veronese, Titian, Rubens, and Delacroix on the other, were evident in the private artistic dialogue of his youth and were to be gradually recognized by supporters and critics across the decades. In the Impressionist years it became almost routine to admire his linear mastery, Huysmans noting at the 1880 group exhibition several "superb drawings" by Degas, among them, "a female head that is entirely worthy of being hung beside the drawings of the French School in the Louvre." But Huysmans also detected the increasing role of color in Degas' latest offerings, especially in his pastels, writing of *Dance Examination* (plate 128) that the "redhead" had a "neck shaded in green and the hollows of her calves shadowed in violet: from close to, her tights are like crushed pink crayon," and memorably summarizing this new departure as the "marriage and adultery of colors."[74] Characteristically, Degas chafed against his new reputation, while progressively extending his use of pastel and ranging wider and more recklessly across his palette, yet

295. Edgar Degas, Study of a Dancer in Tights, c. 1900. Black crayon on paper, 23⅝ x 18 in. (60 x 45.5 cm). The National Museum, Belgrade (291)

he could still tease Sickert by remarking, "I always tried to urge my colleagues to seek for new combinations along the path of draftsmanship, which I consider a more fruitful field than that of color."[75]

Two Dancers in the Wings (plate 297), a pastel of the early 1890s, shows the extent to which Degas found a constructive equilibrium between his "superb" drawing and his variously espoused colors. The monumental central ballerina, for example, emerged from repeated charcoal studies of the nude and from tracings of previous drawings, and was perhaps reinforced by observations of his own sculptures, such as *Dancer at Rest, Hands on Hips, Right Leg Forward* (plate 133) and *Dressed Dancer at Rest, Hands Behind Her Back, Right Leg Forward* (plate 134). His original drafting lines are still visible in the contours of the arms and the facial profile of the Boston figure, but throughout there is a modulated interweaving of pastel that breathes life into its varied forms. Feathery strokes of gray and pinpoints of lemon, for example, conjure up the insubstantial tutu, while dense touches of russet and black heighten the tension of the upper body, leaving a range of firmly blended, shadowed tones to suggest the hidden strength of the legs. In her turn, this slender-waisted young woman appears to have inspired the more rugged individual at left in *Dancers* (plate 264), though the Boston sheet was also signed and released onto the market as a finished picture.[76] Rather than categorize such works as a sequence or hierarchy, we might see them as participants in a protracted conversation, a debate between equals that flowed from line and color to modeled form, from observation to past precedent.

The role of sculpture in this exchange is perhaps the most surprising. But when we learn that Degas used some of his statuettes as the starting points for his pictures, it becomes difficult to look at a pastel like *Three Dancers* (plate 298) without seeing a wax figure rotating in front of us. This thrillingly energized work recreates a moment from a traditional Mediterranean dance, such as a Spanish fandango or an Italian tarantella, which were popular elements of many operas and ballets at this time and already featured in an early Degas fan painting (plate 46), a lithograph (plate 196), and a number of pastels of the 1880s (plate 195). Here the elegant bodies of the performers and their glittering surroundings match the extraversion of the theme, as the dancers absorb the bright stage lights and follow their precisely choreographed moves along a rising diagonal. Three sculptures by Degas of similar figures survive (plate 151), none in identical positions but all close enough to assist him in recreating the curve of a back or in tracking the spatial shifts of legs and arms. Finer detail in the pastel must surely have come from sessions with a model—perhaps the tall, slim Mlle Bouissavin—but we may also sense a loosening of his ties with exactitude and theatrical description. Unlike the comparable *Green Dancers* of several years earlier (plate 197), Degas has sacrificed shoe ribbons, the delicate edge of a bodice or the definition of a nostril to the eruption of rainbow-like hues throughout his vivacious scene. Though charcoal and tonal structure played their preparatory roles in *Three Dancers*, it was the "marriage and adultery of colors" that triumphed.

297. Edgar Degas, Two Dancers in the Wings, c. 1880–95. Pastel on paper mounted on cardboard, 23¼ x 18¼ in. (59. 5 x 46.5 cm). Museum of Fine Arts, Boston; Given by Mrs. Robert B. Osgood in memory of Horace D. Chapin (38.890)

In her memoirs of working with Degas around 1910, the model Pauline relates how she watched his wax and plasticene figures take shape in front of her, as she struggled "to hold her raised right foot behind her with her right hand."[77] She also noted that the artist had been making sculptures of this same position for at least a decade, and might also have recognized her tilted, spiraling pose in drawings and paintings from as early as the 1870s.[78] In the energetic study *Three Dancers* (plate 299), Degas used charcoal to revive this same character in the company of two resting companions, one of whom is again similar to the wax *Dressed Dancer at Rest, Hands Behind Her Back*. This sheet has the qualities of a true working drawing, in which the artist labored to define the intervals between his living or sculptural models, to find answering echoes in their limbs, and to erase and redraw a foreground leg. Parallel strokes were employed to establish dominant planes in tutus and shoulders, while touches of pastel recall the sculptural highlights on the drawings for *Frieze of Dancers*. Millard has made a vigorous case for the origins of Pauline's stance in classical prototypes and, once again, it is possible to discover kindred forms in the popular imagery of Degas' own day.[79] Resolving these and many other issues into a single, complex design, Degas transferred it to the foreground of a canvas as he began the little-known *Dancers on the Stage* (plate 309), where no less than four of the five performers have a

close resemblance to his sculpted figures. As oil paint was applied to this canvas in successive stages, disciplined line was blended with rich brushwork, "the clear form dear to the classical spirit"—in Rothenstein's words—with the "color and movement of romantic art."

The cyclical nature of Degas' obsession is further exemplified in *Ballet Dancers* (plate 300), an unusually tactile, vibrant painting from the turn of the century that again looks back to the Impressionist era; both the offstage setting and the blur of muslin-clad pupils in the background can be found, for example, in *The Ballet Class* of c. 1878–80 (plate 164). The London canvas is as bewitching in its complementary red-browns and mineral greens as it is puzzling in technical terms, emerging from Degas' experiments in under-painting and scumbling as he attempted to learn from the revered Venetian tradition.[80] As with many of these trials, his procedures owed more to enthusiasm than to historical knowledge, but this improvisation on unprimed linen retains much of its energy, undimmed by excessive finish or reworking. What is also unmistakable is that his classroom scene still engaged the artist twenty years after its inception, the dainty pupils in arabesque counterbalancing the mundane foreground event, the tall windows opposing a flutter of diagonals and curves. Most persistent of all was the kneeling dancer, whose pose accounted for no less than six sculptures in Degas' final decades, from relatively polished and naturalistic examples to such uncompromising late works as *Dancer Holding Her Right Foot in Her Right Hand* (plate 281).[81] Descended from a long line of drawn and painted ballerinas, these surprisingly naked figures have lost all contact with dance steps and exercise routines, as Degas himself recognized when he relocated some of them, without a hint of irony, to his pastels of the bath and the bedroom.[82]

"I am hoping to do a suite of lithographs, a first series on nude women at their toilet and a second one on nude dancers," Degas wrote to a friend in 1891.[83] Such migrations of form between one subject and another, between different media and between successive works of art, became his preferred mode of operation. When he told Barthölomé, "It is essential to do the same subject over again, ten times, a hundred times," Degas might have been describing the two- and three-dimensional techniques of his own studio, as he continued to develop means appropriate to his new themes.[84] The procedure that proved most enduring was tracing, where he began a charcoal drawing on translucent paper and then copied it on to other sheets, some of which were reversed and extended by adding other pieces. From this growing family of interrelated images, he retained some as monochrome drawings and chose others to be gradually developed in pastel. Degas must have thrilled to the sense that this process of repetition and variation so visibly rhymed with the dancing practices it depicted, and that both drawing and ballet exploited the mirroring of actions and the progression from spare, colorless exercises to multi-hued brilliance.

Several of his studio visitors reported how Degas would arrange such sequences of pictures on a row of easels: Pauline noted that one drawing of "a dancer at the barre reappeared in a number of pastels. In one, she was dressed in green and stood out against a background

298. Edgar Degas, Three Dancers, c. 1888–93. Pastel on paper laid down on board,
18½ x 12⅛ in. (47 x 30.8 cm). Private collection, Florida

299. *Edgar Degas, Three Dancers, c. 1889–1905. Charcoal and pastel drawing on blue-gray paper, sheet 23¼ x 17⅞ in. (59 x 45 cm). Museum of Fine Arts, Boston; Bequest of John T. Spaulding (48.872)*

of violet: in another, the background was yellow and the costume red, and in a third she appeared in a pink tutu against a ground of green."[85] The strikingly cropped and unexpectedly overlapped pair of figures in *Two Dancers Resting* (plate 303) was once the starting point for one of these cycles, their rigorously redrawn charcoal outlines ideal for subsequent tracing and their densely hatched forms a perfect foundation for chromatic extravagance. Three pastels are known to have emerged from this sequence, one of them a brilliant copper-green and salmon-pink confection in the National Gallery of Canada, but their varied formats and finishes emphasize the latitude the artist gave himself in this unfolding research.[86] Unusually for this period, Degas' successive designs also seem to encourage a range of anecdote, the dancers appearing conspiratorial in the Philadelphia drawing and variously distracted and intimate in the other variants.

Perhaps the grandest of all these tonal beginnings, however, is *Two Dancers* (plate 258), a large charcoal drawing on tracing paper that was signed by Degas and included in Vollard's 1914 album.[87] By the standards of Degas' own generation or even the tumultuous decade in which Vollard published it, this was a tour-de-force of draftsmanship and an

uncompromising statement about human physicality, expressed in the simplest of means. Broad veils and sweeps of charcoal were employed to indicate the weightless, billowing skirts, one of them opening like a flower while the other is crushed against the picture edge. Where the first dancer is energetic and expansive, the second is almost agonized, grappling with the knot of her hair and heavily supporting her dark, mask-like head. Elsewhere, pleats of modeling undulate across the surface, tightening around an arm or plunging between a shadowed bodice and the surrounding mass of light. Only the lightest touches of color were chosen to enhance this monochromatic masterpiece, but it is intriguing to find a near-identical counterpart that Degas recast in thick encrustations of pastel. The little-known *Two Dancers* in the Saint Louis Art Museum (plate 302) is ablaze with fiery contrasted hues, a Mephistophelian alternative to the drawing's austerity.

What is most at issue in these late images is the transformed nature of Degas' dance project and the function of color in its realization. Color allowed him to manufacture variation after variation on a single scene, yet he showed little interest in exhibiting them in the manner of Monet's current "series" pictures, and almost no cynicism in their production. Twinned works were never left as an identical pair, but typically cropped and extended, their details suppressed or their characters modified as he contrived new pictorial identities for each emerging composition. Critically, also, the majority of these pictures were never released for sale, but retained in the countless portfolios of his studio. By repeating his subjects, on the contrary, Degas seemed to deepen the game he had created, pursuing new expressive permutations that had previously been beyond his self-imposed brief. The workings of color at a modest level can be reconstructed by following the progress of *Two Dancers Resting* (plate 301) and its later offspring. Starting with a study in line and tone, drawn either directly from the model or traced from such a drawing, Degas laid out another scene

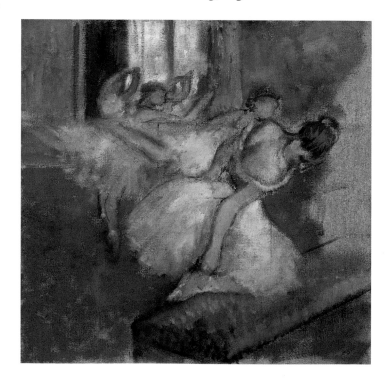

300. *Edgar Degas, Ballet Dancers, c. 1890–1900. Oil on canvas, 28⅜ x 28¾ in. (72.4 x 73 cm). National Gallery, London (NG 4168)*

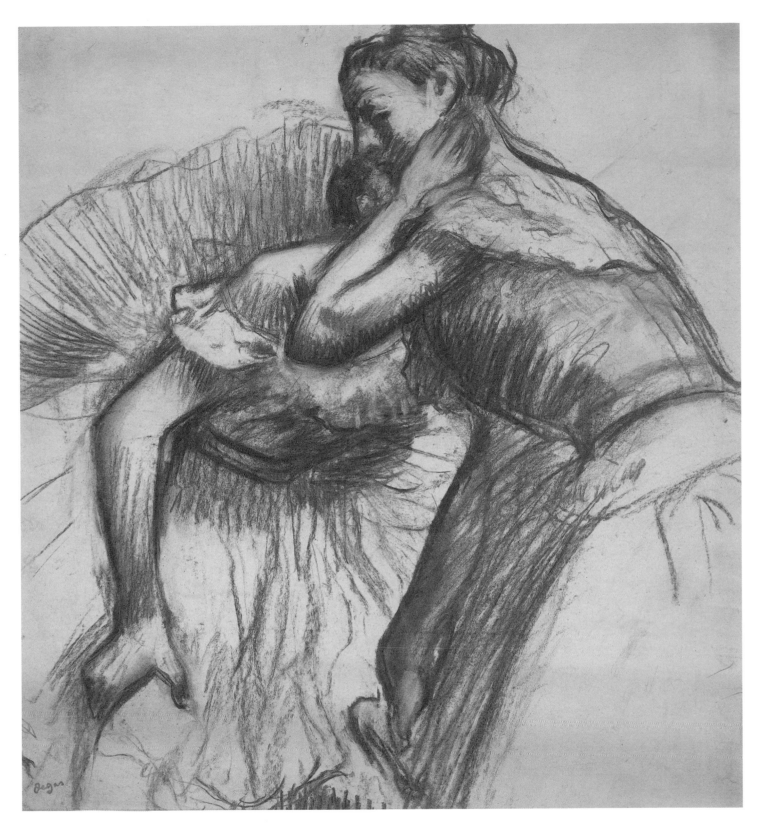

301. *Edgar Degas, Two Dancers Resting, c. 1895. Charcoal on tracing paper mounted on cardboard, 20⅛ x 18¹¹⁄₁₆ in. (51.4 x 47.5 cm). Philadelphia Museum of Art; The Louis E. Stern Collection, 1963 (1963-181-144)*

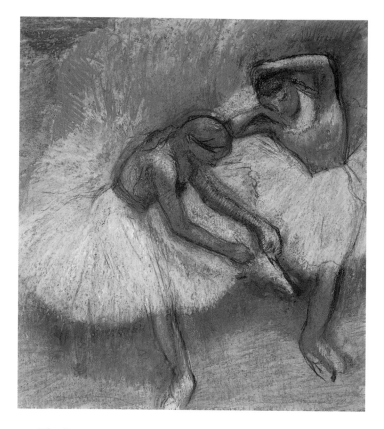

302. *Edgar Degas, Two Dancers, c. 1898–1905. Pastel on paper, 33⅜ x 30⅜ in. (84.8 x 77.2 cm). The Saint Louis Art Museum; Funds given by Mrs. Mark Steinberg (1:1953)*

of inertia and melancholy that was gently warmed with touches of orange brown. Its theme is unashamedly nostalgic for his earlier groups of tired coryphées huddled on benches, such as *The Dancing Lesson* (plate 168), though now their spacious, illusionistic surroundings are contracted into a low relief. After further revisions of this initial design, and a definitive reversal on a separate sheet, Degas applied the first delicate strokes of the favorite red-green harmony of these years, to produce *Dancers in Repose* (plate 304).[88] Though essentially similar in structure, this version is altogether less formal, inviting us to believe in a backstage moment when a young performer in a frail pink costume took refuge beside a friend, while averting her face to concentrate on a strained or tired foot.

The emotional and practical challenges of this pairing evidently gripped the artist, who made larger and smaller alternatives in square, vertical, and horizontal patterns that covered the psychological spectrum from serenity to near-hysteria. A more neutral juxtaposition formed the starting point for two pastels entitled simply *Dancers*, now in museums in Detroit (plate 305) and Princeton (plate 306). Very close in size and self-evidently descended from the same master drawing, these works exhibit minor differences in their background detail and subsidiary cast but none in their bold, centralized motif. Changing

dramatically from sheet to sheet, however, is what might be called the sensual temperature, which is diffuse and coolly autumnal in the Detroit pastel, and almost volcanic in the Princeton sheet. With the former, Degas continued the pale angularity of the ballerinas' arms into the tree trunks and branches behind them, creating his own sympathetic choreography of limbs and rugged textures, and hinting at a quasi-Symbolist fusion of figures and landscape. The second picture was probably completed some time later, around 1899, when the artist was able to exploit a greatly extended repertoire of rubbed color, steamed and dampened surfaces, and successive layers of hot and cold pastel repeatedly secured with fixative. Here, at last, Degas achieved a visual intensity that approached the partly mythical enrichment of the old masters, now translated into dense chemical hues and indescribable superimpositions of complementary pinks and greens, ochres and blues. The effect is hallucinatory, a barrage of sensation that might dissolve the dancers altogether were it not for their massively modeled torsos and their pitted, ancient faces. If we think of stage productions at all, it is of fragments seen under blazing lights, distorted by heat and shimmering movement, and by the selectivity of memory.

The subject chosen by Degas for these two *Dancers*, and many pastels and paintings from his late decades, is tellingly neutral in ballet terms. His models are now far too occupied with their hair, their clothing, and their bodies to be part of a performance, and their gestures have no place in the choreography of the day. Yet they are dressed in gorgeously colored costumes and stand against lushly painted

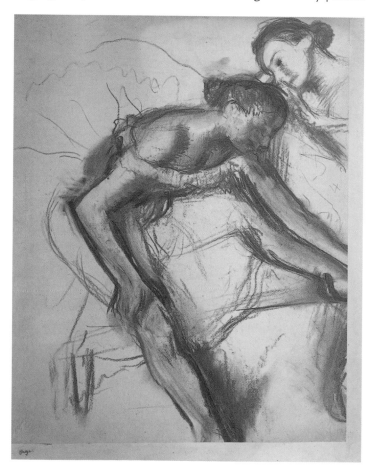

303. *Edgar Degas, Two Dancers Resting, c. 1890–1900. Charcoal and colored chalk or pastel on paper, 24¹⁵⁄₁₆ x 22¾ in. (63.2 x 57.8 cm). Philadelphia Museum of Art; The Samuel S. White, 3rd and Vera White Collection, 1967 (1967-30-20)*

THE LAST DANCERS

304. Edgar Degas, Dancers in Repose, c. 1898. Pastel and charcoal on thin wove paper,
fully attached to a thin supporting sheet, 34 x 27¾ in. (86.4 x 70.5 cm). The Detroit Institute of
Arts; Gift of Edward E. Rothman (72.441)

305. *Edgar Degas, Dancers, c. 1897. Pastel with charcoal on heavy wove paper, 35½ x 30 in.*
(90.2 x 76.2 cm). The Detroit Institute of Arts; City of Detroit Purchase (21.6)

306. *Edgar Degas, Dancers, c. 1899. Pastel on tracing paper mounted on wove paper,*
23¼ x 18¼ in. (58.8 x 46.3 cm). The Art Museum, Princeton University; Bequest of
Henry K. Dick, Class of 1909 (x1954-13)

THE LAST DANCERS

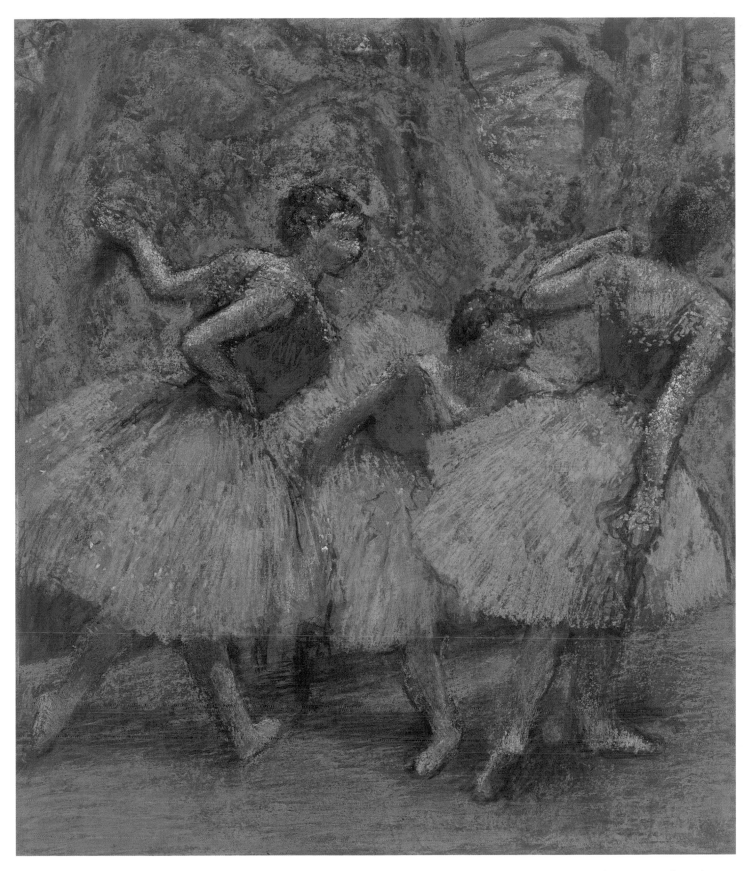

308. Edgar Degas, Three Dancers, c. 1900–1903. Pastel on paper mounted on card,
37 x 31½ in. (94 x 81 cm). Fondation Beyeler, Riehen/Basel (20)

307. Edgar Degas, Dancers, c. 1900. Pastel on paper, 37⅝ x 26¾ in. (95.6 x 68 cm).
Memorial Art Gallery of the University of Rochester; Gift of Mrs. Charles H. Babcock (31.21)

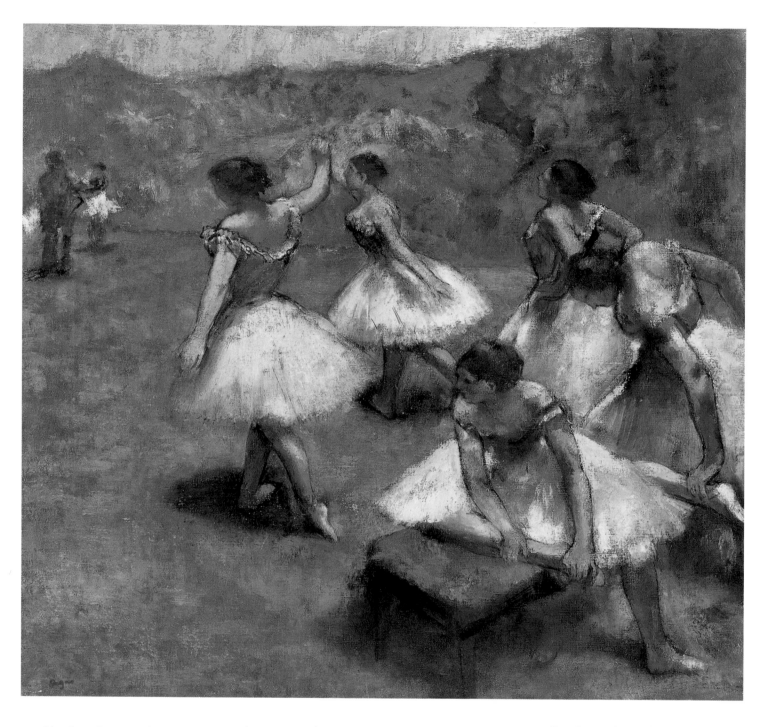

309. *Edgar Degas, Dancers on the Stage, c. 1889–94. Oil on canvas, 30 x 31⅞ in. (76 x 81 cm). Musée des Beaux-Arts, Lyon*

vegetation, evidently on or near the edge of a stage. Another work known as *Dancers* (plate 307), a pastel with the scale and the aspirations of a major oil painting, shows the advantages of this space for an artist with Degas' old masterly preoccupations. Such an indeterminate context allowed him to manipulate the human body at will, contrasting the superb contrapposto figure at right against her seated colleague, and abruptly introducing a third presence to provide new dynamism. Here he chose an uncharacteristic ochre and olive key, but in *Three Dancers* (plate 308) he dressed a similar ensemble according to a new, exotically complex harmony. This broader composition was carried to even greater extremes of luxuriance, its increased spaciousness

encouraging an entire gamut of hatchings, dots and dashes, and accumulations of color that were rarely surpassed in his last years. Again the play of serpentine stretched arms in these two effulgent works dominates the rhythms of the scene, their vitality reaching through the picture space and offering the most direct identification with our own corporal experience.

If a rational context is needed for such haunting inventions, the one that most closely matches them is the rehearsal on stage, when

310. *Edgar Degas, Dancers, Entrance on Stage, c. 1898–1905. Charcoal and pastel on tracing paper, 29 x 41½ in. (73.7 x 102.9 cm). Carnegie Museum of Art, Pittsburgh; Acquired through the generosity of the Sarah Mellon Scaife family (66.24.1)*

311. *Edgar Degas, Dancers on the Stage, c. 1900–1905. Charcoal and pastel on tracing paper, 25½ x 27½ in. (65 x 70 cm). Von der Heydt-Museum, Wuppertal (KK 1961/64)*

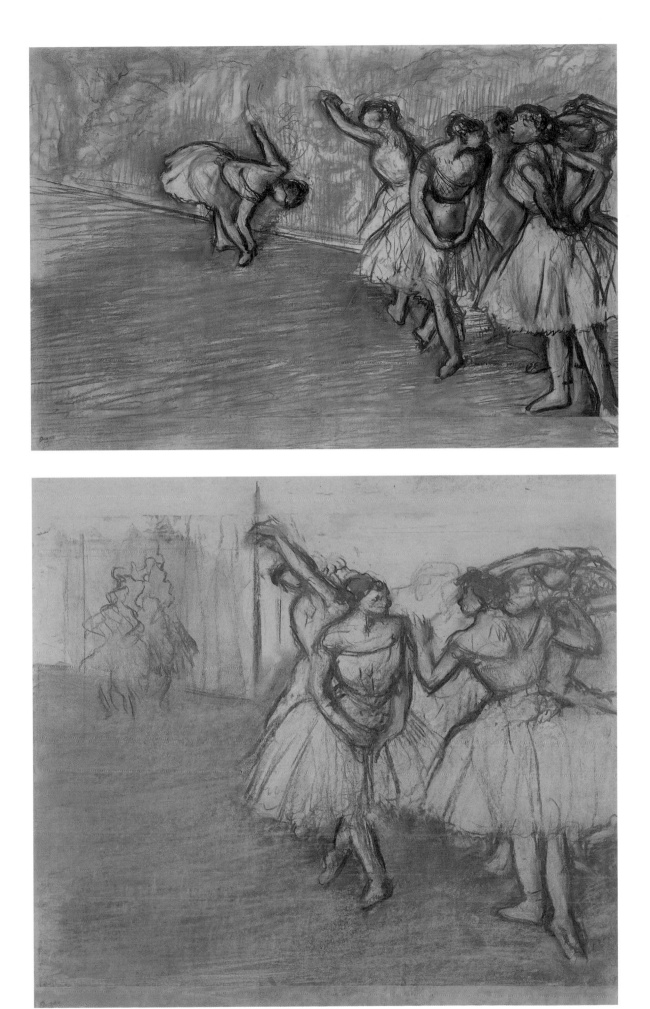

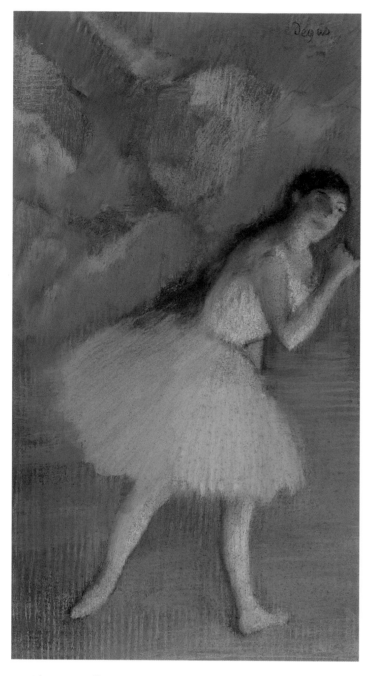

ingly observed. Degas established a base of naturalistic flesh, leaf green, and cream, then—apparently some time later—stressed the deep bronze tonality and added the final gestural strokes, both reminiscent of his color monotype landscapes of the early 1890s.[89]

The leap from this canvas to the charcoal and pastel *Dancers, Entrance on Stage* of around 1898–1905 in Pittsburgh (plate 310) is conceptually enormous, despite remarkable resemblances in their subject matter, in their orange-hued backgrounds sloping up toward blue skies, and in two similar, sculpture-related participants. Conceived as a study for the heavily worked *Ballet Scene* in Washington, one of Degas' largest pastels, *Dancers, Entrance on Stage* is itself suspended between preparatory drawing and colored exposition. By this date, however, we are overwhelmingly aware of the statuesque nature of these solemn figures, who contribute less plausibly to a dance rehearsal and now belong to a larger human rhythm. Degas' ambitions for such works are still palpable in their grand dimensions, in their stately, relief-like compositions and in his determined return to this theme. *Dancers on the Stage* in Wuppertal (plate 311) gives greater prominence to the right-hand dancers and subtly rearranges certain poses, while defiantly maintaining the asymmetry of the scene. Perhaps executed as late as 1905, Degas' charcoal lines are now emphatic rather than refined and almost indifferent to the niceties of anatomy. Where once the feet and hands would have been minutely studied, they are now suppressed in favor of the massively stated musculature of these Amazons, with their small, bird-like heads. But these women still occupy the edges of a stage of some kind, hazily recalling the coulisses of thirty years previously and even certain gestures—the hands sinking into muslin, the arm stretched skyward—of that period.

True performance pictures are a rarity in Degas' late career, when he preferred the tension or the uncertainty of the stage or wings just before curtain call, rather than its opulent aftermath. *Ballet Dancer on Stage* (plate 312) of around 1890 is an under-celebrated exception, a late blossoming of a strain rooted in the distant ballerinas of his *Orchestra*

312. Edgar Degas, Ballet Dancer on Stage, c. 1885–90. Pastel on paper, 31 x 20 in. (78.7 x 50.8 cm). Private collection, Chicago

dancers wore full or partial costume, some scenery and lighting was in place, and a measure of informality was still permitted. As we have seen, this was the setting for some of Degas' first dance pictures and one that he experienced personally in the 1880s. *Dancers on the Stage* (plate 309) belongs to one of an extraordinary group of revisitations of such pioneering subjects from his later years, featuring a dark, blurred figure at left who is arguably the last dancing master in Degas' oeuvre. The handling of this picture—a transitional statement in many ways—is broad and tactile, yet its spaces echo the airy classrooms and friezes of a previous era, and the sense of everyday Opéra activities is know-

313. Edgar Degas, Dancer Adjusting Her Shoulder Strap (detail), c. 1895–96. Modern photograph made after a glass negative. Bibliothèque nationale de France

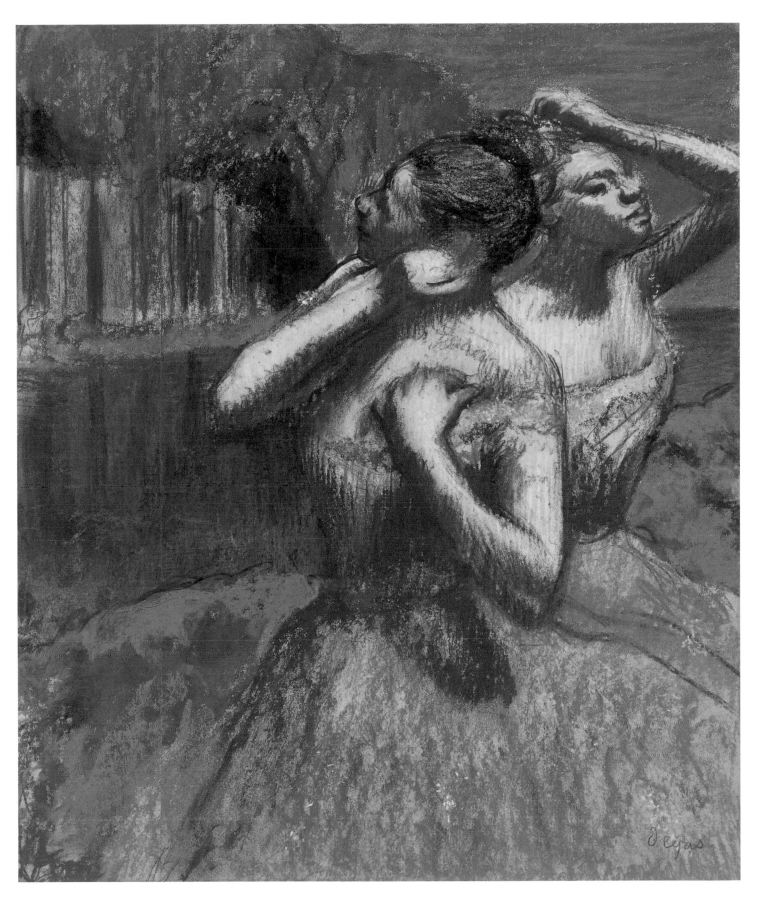

314. *Edgar Degas, Two Dancers, c. 1895–97. Pastel on paper, 24¾ x 21¼ in. (62.9 x 54 cm). The National Museum of Fine Arts, Stockholm (345)*

Musicians (plate 1) and *Ballet Scene from Meyerbeer's Opera "Robert le Diable"* (plate 58). The link is surprisingly apt: after two decades of resourcefulness in which Degas experimented with "drawing things from above and below," as well as from the sides and corners of the theater, he returned in this pastel to a simple, frontal view of his subject. Drama is now to be found in less oblique qualities, in the pose of the dancer and in the vividness of her illumination, and above all in the luminous color of Degas' pastel palette. His masterstroke was to plunge the entire stage into a warm half-shadow, subdued and gently rippling through a hundred shifting, moistened, and rubbed tones until it merged with the grotto-like forms in the background.[90] This setting provides a muted foil for the brilliantly lit ballerina, whose white tutu is magically infused with a green and pink phosphorescence. In other hands such a scene might have been merely pretty, but Degas characteristically fixes our attention on an unbeautiful, angled figure caught between a curtsy and an awkward salute to her audience. Clearly satisfied with this unflinching image, he signed the sheet and passed it to Durand-Ruel, adding to a sequence of variations of this pose that fascinated him in drawings, oil paintings, and sculptures.

At first glance, both *Two Dancers* (plate 314) and *Before the Performance* (plate 319) seem to represent the public face of the ballet, but each turns out to be deceptive. Voluminous dresses and complex scenery take up much of the former, where two artistes are putting the final touches to their earrings and hair as they prepare themselves for an audience they cannot yet see. This elegiac work from the closing years of the century has remained almost unknown outside Scandinavia, but presents a rare late image of a specific—but still uncertainly identified—production featuring a dark lake in front of a distant forest or grotto.[91] It is also an unusual exploration by Degas of a single dominant hue, a rich coral pink that pervades figures and landscape, and even the depths of sky and water. As in the Detroit *Dancers* (plate 305), we see these strongly sculpted women as part of nature, their costumes growing like coral itself from the surrounding rock and their bodies blending with the remoter landscape. By a strange paradox, Degas' pantheistic scene is closely related to one of his most unnatural sources of imagery, the photographs of dancers taken around this date (plate 313). Imperfectly made in his rue Victor Massé studio on gelatin dry plates, but leaving a unique record of one of his dancer-models in her bodice and tutu, the negatives acquired an untypical orange-russet tint that may lie behind the haunting tonality of *Two Dancers*.[92] Experimentally audacious and offering a unexpected late link to the Opéra, this pastel was sold to Durand-Ruel in 1900 and bravely accepted by the National Museum in Stockholm in 1913.[93]

One of Degas' rare recorded comments about his own pictures in these late years concerns a group of pastels on the theme of the Russian dancer. Julie Manet tells us that he met her in the street in July of 1899, urging her to come to his studio to see a new series that he described—in an unforgettable phrase—as "orgies of color."[94] Around a dozen compositions resulted, some of them as brilliant in their patterns of primary and secondary hues as any works from his entire career. In the vibrant *Russian Dancers* (plate 315), for example, saturated yellow, red, and lilac are counterpoised by the white of the blouses and the blue trim, while a foreground figure bursts away from her companions in a blaze of gold. The vividness of the scene is overwhelming, yet the existence of another pastel with an almost identical design, now dominated by browns and greens, reminds us of the element of control in the artist's inventiveness.[95] Charcoal drawings for all these figures suggest that they, too, originated as studio studies that were gradually developed into a multi-hued sequence, though nothing further is known about their subjects. It would be a decade before Diaghilev's Ballet Russes ballet company took Paris by storm, and Degas' models most probably came from one of the traveling troupes of ethnic dancers recorded in cabarets and vaudevilles before the turn of the century.[96] Surprising though it may seem, central European folk traditions were frequently cited among the survivors of ancient dancing, perhaps attracting Degas as he increasingly turned to the ballet's historical roots.[97]

Given Degas' working practices, a successful color departure in one medium would often flow into another, especially when the subject of the ballet was common to both. Many of Degas' oil paintings in the 1890s aim at the breadth of his latest pastels, borrowing their intensity of juxtaposed hues and emulating their granular touch on the coarse surface of canvas. Along with several of his colleagues, Degas had come to regret his own meager technical training, exclaiming to Vollard, "What a cursed medium oil is anyway!" as he struggled with preparatory grounds, the build-up of paint layers, and the traditional processes of glazing.[98] His contact with younger artists and their theories, from Gauguin and Seurat to Denis and Rouault, undoubtedly encouraged him to greater boldness as a colorist and may have prompted a strange late phase in which he reworked some of his own earlier pictures. The decision to partially paint over a substantial number of canvases—most of them ballet scenes—from the Impressionist years, typically retaining their subject while transforming color and facture, is as puzzling as it is sometimes exhilarating.[99] Few artists have reinvented their formative oeuvre as violently, and few had so little obvious need to do so, whether to eradicate failures, engage in self-promotion or seek financial gain.

Ballet Scene (plate 316) is a prime example of this rejuvenation, combining the deep, intricate spaces of the 1870s, when Degas was in the habit of contrasting foreground forms with distant, finely detailed dancers, and late color and facture. Some of his original refinement can still be glimpsed beneath the present paint surface, which now presents a rich mosaic of texture and revision, older sobriety and fresh glamour. More monochromatic in its first state, it was transformed around the turn of the century with sweeping textures of emerald, cerise, and amber, vigorously applied over and across his previous forms. A modern X ray (plate 317) reveals how Degas remained faithful to the structure of the first composition, but boldly restated the ballerina at left who once stood beside a sloping stage flat and reanimated the entire image in the idiom of a new generation.[100] Copenhagen's *Dancers*

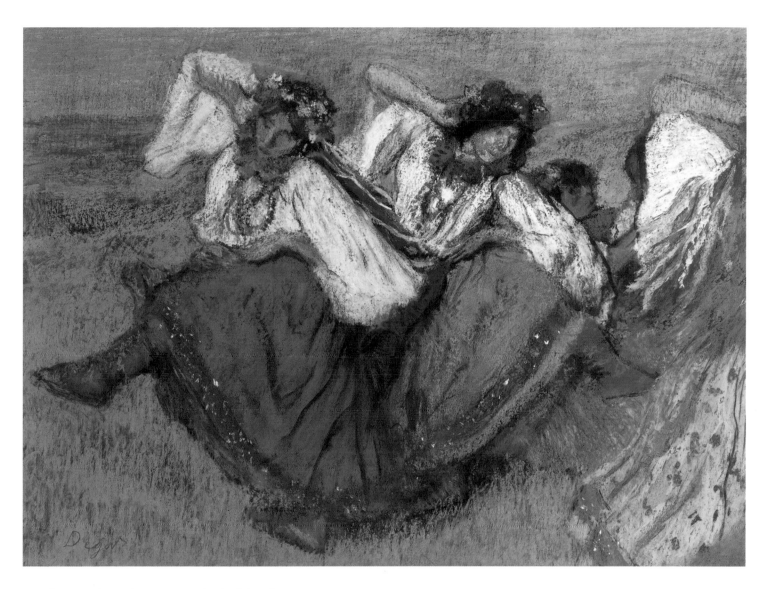

315. Edgar Degas, Russian Dancers, c. 1899. Pastel and charcoal on tracing paper,
18 7/8 x 26 3/8 in. (48 x 67 cm). Private collection, courtesy Gurr Johns

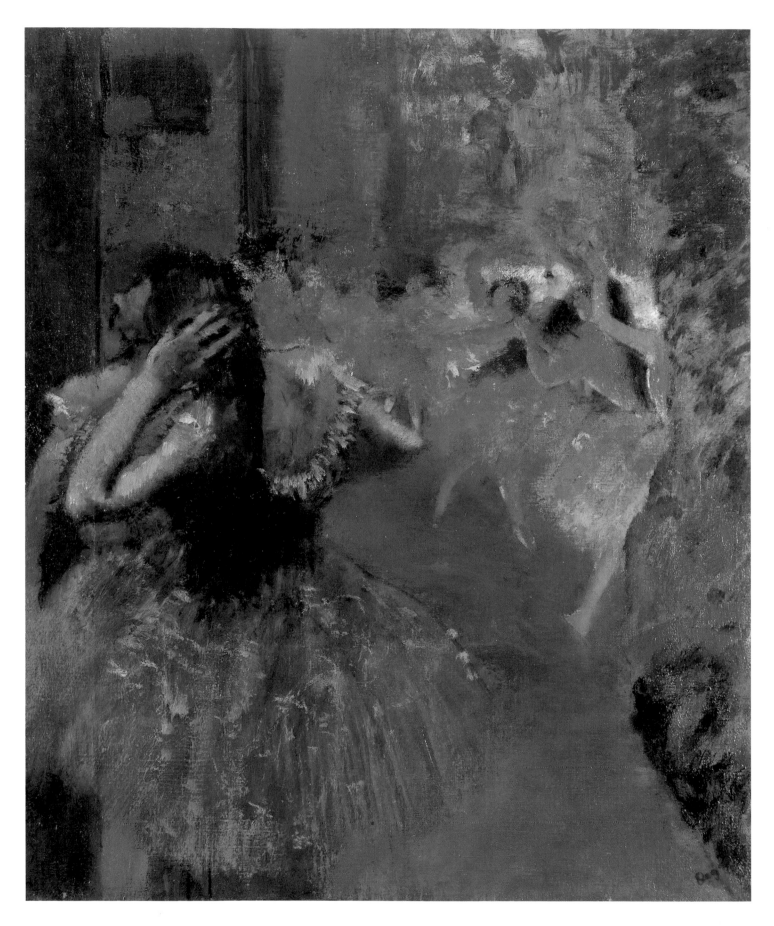

316. *Edgar Degas, Ballet Scene, c. 1878, 1893. Oil on canvas, 23¼ x 19⅝ in.*
(59 x 49.8 cm). Private collection

317. *X ray of Edgar Degas,* Ballet Scene *(plate 316)*

Practicing in the Foyer (plate 91) was an even more extreme case, where an early classroom scene was brushed over from side to side in fin-de-siècle greens and oranges, and figures were both obliterated and newly introduced. But these daring excursions clearly invigorated Degas' craft, teaching him much about successive veils, hatchings, and patinations of paint, and—coincidentally—providing us with an insight into his evolving vision of the dance.

When he embarked on an entirely fresh canvas, as in *Three Dancers in Yellow Skirts* (plate 318), many of these acquired skills were brought to a long-familiar subject, here the desultory gathering in the wings. First defined twenty or more years earlier in his prints and paintings (plates 75, 77, and 78), the theme now took on greater amplitude and surface richness, while the suggestive possibilities of the distant *abonné* in an image like *Yellow Dancers (In the Wings)* (plate 76) have long been rejected. Just as radically, *Three Dancers in Yellow Skirts* is transposed into one of the hottest, near-tropical keys of Degas' late phase. Though a rock- or bush-like form behind the dancers and a glimpse of the land-scape setting beyond recalls the roughly contemporary *Four Dancers* in the National Gallery of Art, the artists' concerns were far from the-

atrical.[101] Now the proud owner of intensely colored paintings by Cézanne, Van Gogh, and Gauguin, Degas has unmistakably responded to their challenge in this smoldering fusion of golds, sienas, green-pinks, and blue-browns, largely applied as fresh paint on an already wet surface. As much a Symbolist reverie as any of Degas' late works, this canvas is exceptional in the sensual traces of the artist's presence, which range from loaded brush marks and richly blurred contours, to crusts of contrasted hue and repeated discs of color applied with his fingers.[102] At the heart of this painterliness, it comes as a surprise to discover a pair of dancer's hands adjusting a garland, while another raises a flower—or perhaps a drink—to her face, adding tokens of touch, taste, and smell to a glorious celebration of the senses.

Before the Performance (plate 319) is another rare survival, a directly executed oil painting from Degas' last years that shows a fully cos-tumed ballet troupe on stage. As with the Stockholm *Two Dancers* (plate 314), these sparkling figures make their final preparations before the dancing begins, though now we see a near-frontal panorama of scenery and performers from a height and at a distance, presumably from the main body of the theater with the curtain raised. Logically, this could only happen at a dress rehearsal, an almost unprecedented occasion in Degas' art that further extends our sense of his late inventiveness,

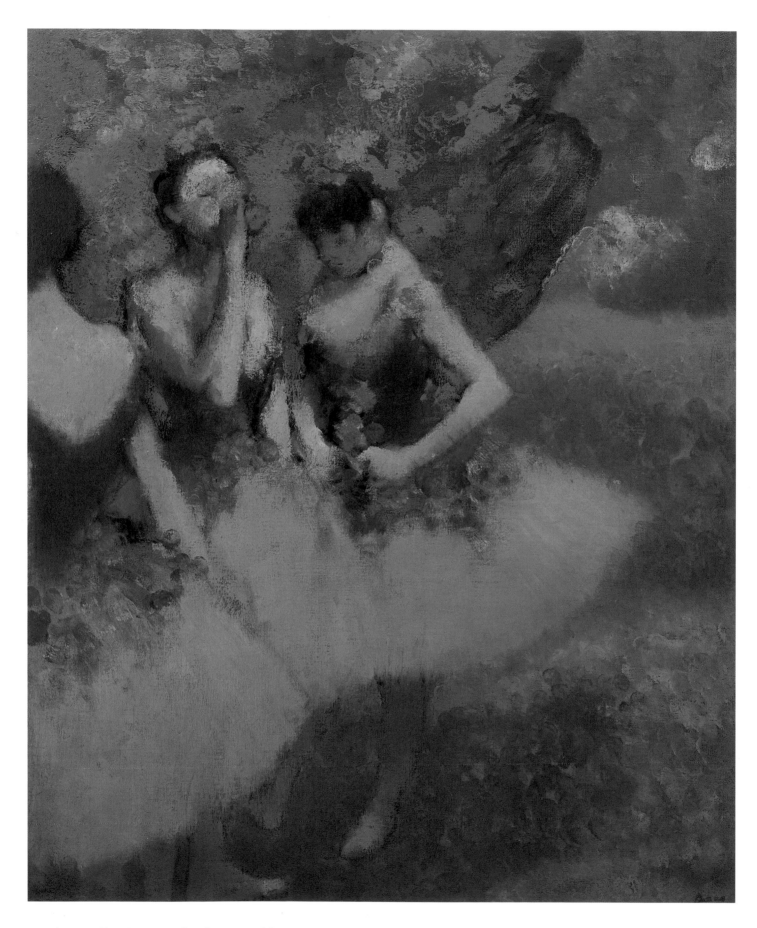

318. Edgar Degas, Three Dancers in Yellow Skirts, c. 1899. Oil on canvas, 32 x 25⅝ in.
(81.3 x 65.1 cm). UCLA Hammer Museum, Los Angeles; The Armand Hammer Collection, Gift
of the Armand Hammer Foundation (AH 90.20)

THE LAST DANCERS

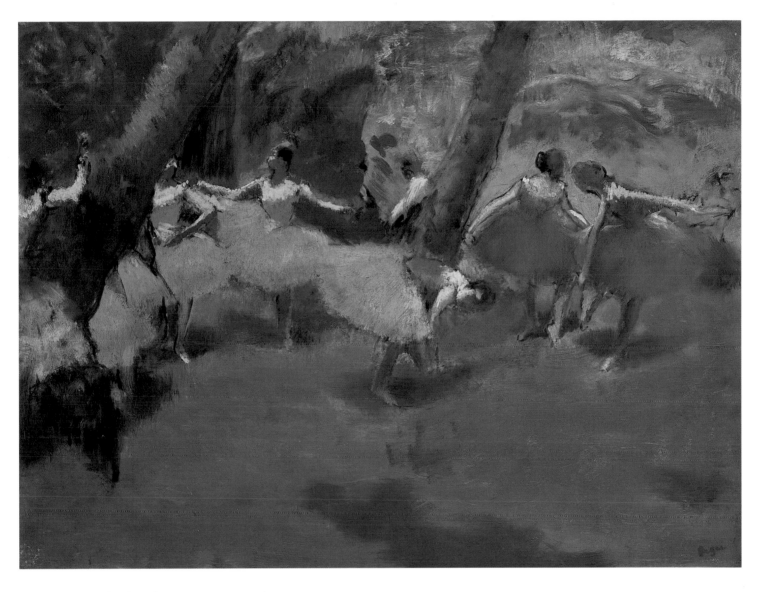

319. *Edgar Degas, Before the Performance, c. 1895–1900. Oil on paper, 18⅞ x 24¾ in.*
(48 x 63 cm). National Gallery of Scotland, Edinburgh (NG 2224)

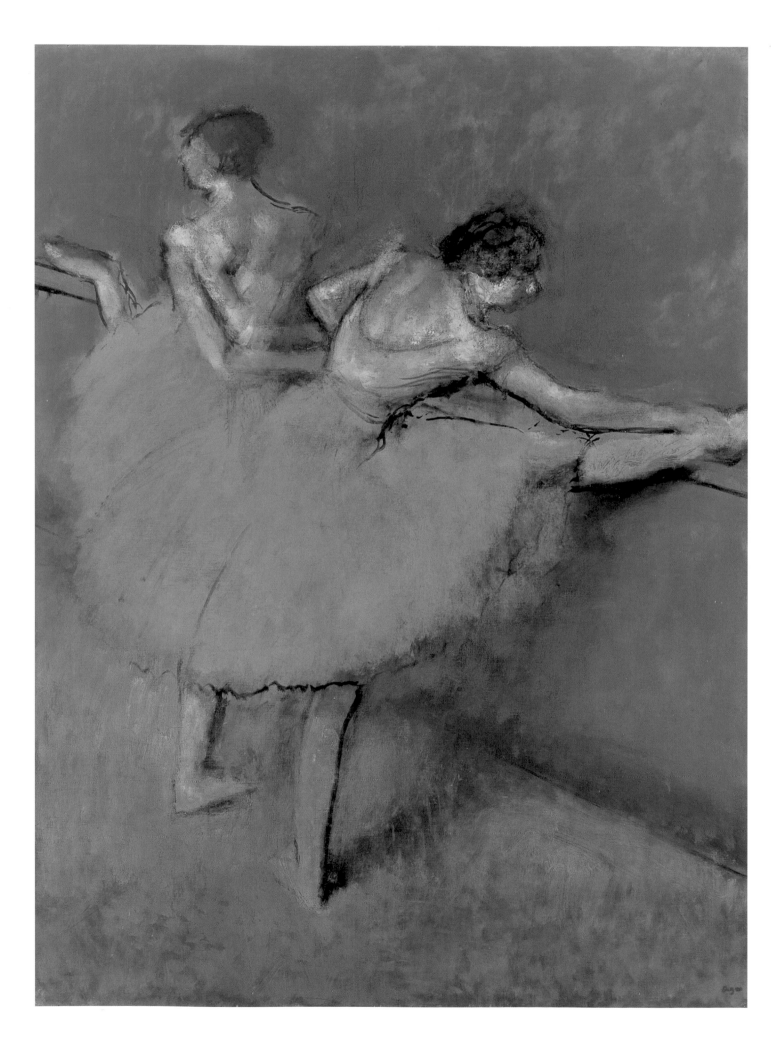

THE LAST DANCERS

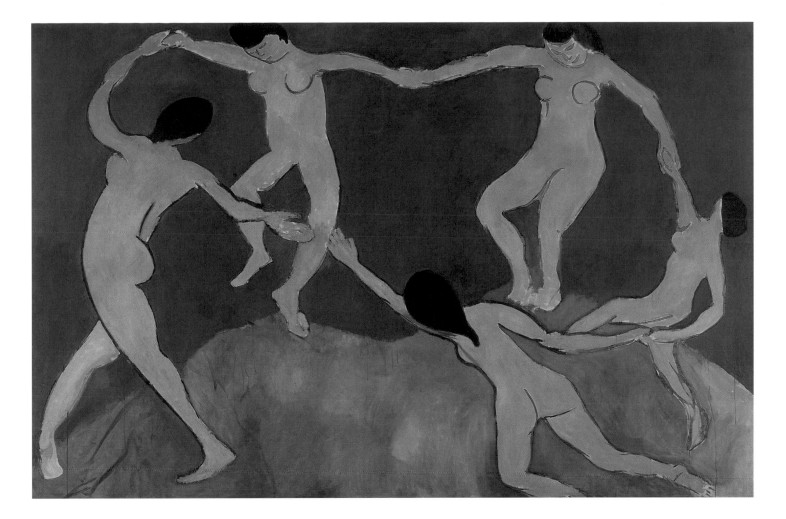

321. *Henri Matisse,* Dance (First Version), *1909. Oil on canvas, 8 ft. 6½ in. x 12 ft. 9½ in. (2.6 x 3.9 m). The Museum of Modern Art, New York; Gift of Nelson A. Rockefeller in honor of Alfred H. Barr, Jr. (201.63)*

or perhaps his final liberation from practical constraint. Using a fluid oil procedure that matched the brilliance of his subject, he first applied a patchwork of strong colors that was allowed to dry, ultimately providing a contrast for the hues that would dominate the scene; the luminous yellows and oranges of the tutus, for example, were painted over a dense green. The life of the resulting scene pervades both the vivacious brushwork and the dancers defined by it, suggesting direct comparison with the art of such younger contemporaries as the Nabis or even the Fauves. On a much larger scale, a comparable radicalism informs the epic *Dancers at the Barre* (plate 320), as well as a similar dialogue between intensely drawn figures and the saturated colors that create them. Executed in the early twentieth century, just a few years before Matisse's *Dance* (plate 321), this great canvas pulls together many of the strands of Degas' long career as "the painter of dancers," while offering few signs of their final or complacent resolution.

The subject of *Dancers at the Barre* takes us back to the gray and umber classrooms of the rue Le Peletier, where tiny, exquisite-featured

320. *Edgar Degas,* Dancers at the Barre, *c. 1900. Oil on canvas, 51¼ x 38½ in. (130.2 x 97.8 cm). The Phillips Collection, Washington, D.C.; Acquired 1944 (0479)*

ballerinas once exercised against high-windowed walls. Central to his early achievement, the convincingly active dancer had almost vanished from Degas' late oeuvre, and it is difficult not to see this grand, relief-like image made around 1900 as both redemptive and valedictory. More than any other theme, that of the ballet dancer illustrates the profound role of retrospect in Degas' art, allowing him to plunder the past and to re-create the compositions of early adulthood through the insights of age. Now approaching his seventies, he was able to draw upon four decades of close scrutiny of ballerinas encountered on the stage, in his studio, and as private individuals, as well as his expert knowledge of their acrobatic and expressive bodies. But the spareness of *Dancers at the Barre* is also eloquent of his lifelong resistance to the merely illustrative. Figures and setting have been stripped to their essentials along with the mechanisms of their portrayal, here reduced to wiped and abraded swathes of color, and dark, surgical incisions of line. To twenty-first-century eyes this suppression of depth and accentuation of gesture are immediately familiar, while the insistence on the centrality of the human figure strikes another, equally deep chord. It was perhaps this, more than any other concern, that sustained and unified Degas' dance art: a yearning for emblems of vitality, for the lyrical and erotic and rapturous, that was at the same time rooted in the commonplace. Often melancholy at the end, the elderly painter exclaimed to a friend, "The Gods are dead, poetry alone is left to us, the last star in the night of chaos."[103]

Notes

In the notes, the following abbreviations for the standard catalogues of Degas' works are used:

BR: Brame and Reff 1984.
J: Janis 1968.
L: Lemoisne 1946-49.
Nb.: Reff 1976, *The Notebooks of Edgar Degas*.
R: Rewald 1944.
RS: Reed and Shapiro 1984.
I, II, III, and IV: Degas studio sales; see Vente Atelier Edgar Degas 1918–19.

CHAPTER 1 DEGAS AT THE PARIS OPERA

1. Letter from Manet to Fantin-Latour, August 26, 1868; see Courthion 1953, p. 50.
2. *Orchestra Musicians* was reworked by Degas at an early date, and its composition significantly changed, notably in an extension of several inches to the upper register of the canvas—which must originally have lacked the dancers we see today—and the introduction of the painted scenery: see Städelschen Kunstinstitut 1999, pp. 62–64.
3. Chesneau in Berson 1996, vol. 1, pp. 19–20; Burty in Berson 1996, vol. 1, pp. 36–38.
4. Boggs 1988, p. 161.
5. D'Heylli 1875, pp. 378–81.
6. Parent's participation in *La Source* is recorded on a poster for the ballet; for her role in *Robert le Diable*, see Kahane, 1985, p. 104, and in *The Orchestra of the Opéra*, see Boggs, 1988, p. 161.
7. Loyrette 1996, pp. 68–79.
8. Halévy 1933, p. 764; Buchanan 1997, p. 45.
9. Nb. 24, pp. 9–11, and 1, 3, 26, 27; Nb. 22, p. 135.
10. Guérin 1947, p. 44.
11. Ibid., p. 66.
12. Ibid., p. 111. This letter was found among Degas' papers, and it is unclear if a copy was sent.
13. Guérin 1947, pp. 14–16.
14. Jeanniot 1933, pp. 153–55.
15. Guérin 1947, pp. 74–75; Michel 1919, p. 476.
16. Patureau 1991, pp. 325, 339, 348, 352; see also Loyrette 1989, pp. 52–55.
17. In the brief period before the opening of the Palais Garnier, Opéra productions were held at the Salle Ventadour: see Gourret 1985, pp. 163–70.
18. For evidence of Degas' pictorial response to Opéra productions in the 1870s, see Chapter 6.
19. For the date of the first monotypes, see Boggs 1988, pp. 257–59.
20. Much documentary material is housed in the Archives Nationales; see Labat-Poussin 1977.
21. Véron 1854, p. 307; Dubor 1899, p. 493.
22. Beauvoir 1854, p. 5.
23. I. Guest, 1953, p. 101; *Le Monde Illustré*, July 31, 1875, p. 77, and January 16, 1875, p. 44.
24. For Lully, see Royer 1875, pp. 10–36; Vuillier 1898, p. 349.
25. *Le Monde Illustré*, May 5, 1860, p. 303.
26. Gautier 1986, pp. 250–51.
27. Lasalle 1875, p. 260.
28. Guérin 1947, pp. 27, 145.
29. His dislike of Wagner is noted in Halévy 1960, p. 74. In Loyrette 1989, p. 63, Degas is recorded at productions of *Lohengrin* in 1891 and 1892.

30. Loyrette 1989, pp. 55–63.
31. The Caron portrait is L 862.
32. Dumas 1988, p. 11; Patureau 1991, p. 305.
33. Loyrette 1989, p. 61.
34. Patureau 1991, p. 307.
35. Ibid., p. 336.
36. Ibid., pp. 318–27.
37. Ibid., p. 307.
38. For the list of *abonnés* in 1859, which includes Lepic's father and Halévy's uncle, see Kahane 1988, pp. 38–40. Paul Valpinçon and Emmanuel Chabrier are mentioned in Loyrette 1989, pp. 50, 53. In Buchanan 1997, p. 45, it is noted that Ludovic Lepic "became a regular opera-goer in 1859" with access to the family box.
39. See Loyrette 1991, pp. 316–17.
40. Guérin 1947, pp. 68–69.
41. Loyrette 1989, pp. 50–55; Patureau 1991, p. 308.
42. Guérin 1947, p. 68.
43. Patureau 1991, p. 348.
44. Patureau 1991, p. 354; Terrier 2000, p. 3; Kahane 1988, pp. 37–38.
45. See Dubor 1899, p. 492; and Patureau 1991, p. 299; see also Terrier 2000.
46. I. Guest 1953, pp. 41–42.
47. Prevost 1866, p. 1; *Le Monde Illustré*, February 27, 1864, pp. 142–43.
48. *Le Monde Illustré*, June 4, 1870, p. 366.
49. Loyrette 1989, pp. 59–63.
50. Ibid.
51. Ballets were presented at such theaters as the Variétés, Gaîté, Italien, Bouffes-Parisien, and Porte-Saint-Martin; for a fuller account, see I. Guest 1953, pp. 136–40.
52. For Gaujelin and Darde, see Chapters 2 and 7; for Hughes, see Boggs 1988, p. 176.
53. Dupêchez 1984, p. 129.
54. See Kendall 1996, pp. 17–18, and Guérin 1947, p. 76.
55. Guérin 1947, p. 16; Nb. 27, pp. 100–102.
56. Champsaur 1888, p. 10.
57. I. Guest 1976, p. 92.
58. For the full repertoire, see Chouquet 1873, pp. 387–425.
59. I. Guest 1976, p. 82.
60. Castil-Blaze 1855, p. 193.
61. Véron 1854, p. 255; I. Guest 1953, p. 59; Desarbres 1864, p. 45.
62. Castil-Blaze 1855, p. 202.
63. *Le Monde Illustré*, March 18, 1862, p. 159.
64. Du Camp 1879, vol. 6, p. 185.
65. *Le Monde Illustré*, May 12, 1860, p. 314.
66. For Emma Livry, see I. Guest 1953, pp. 1–19, 21–38.
67. Fourcaud 1881, p. 5.
68. Gautier 1986, p. 307.
69. De Lassalle 1875, p. 260.
70. For the Opéra's designers, see Join-Diéterle 1988.
71. *Le Monde Illustré*, July 14, 1860, p. 30. Flandin was a pupil of Horace Vernet.
72. *Le Monde Illustré*, July 21, 1860, p. 38.
73. *Le Monde Illustré*, March 3, 1860, p. 192.
74. I. Guest 1953, pp. 77, 105.
75. *Daily Telegraph*, April 28, 1877.
76. *Le Monde Illustré*, May 12, 1860, p. 311.
77. I. Guest 1976, p. 136.

CHAPTER 2 THE RUE LE PELETIER OPERA

1. Chesneau, in Berson 1996, vol. 1, p. 19.
2. See Kendall 1989, pp. 6–7.
3. For Mlle Hughes, see Boggs 1988, pp. 176–77; for Mérante, see Browse 1949, pp. 53–54.
4. See Fevre 1949, p. 56; D. Halévy 1960, p. 30. The likelihood of Degas having occasional access to the Opéra from the early 1860s through the *loge* of the Lepic family is noted in Buchanan 1993, p. 45.
5. L 256; for Pagans, see Boggs 1988, pp. 169–71, and McMullen 1985, p. 173. A letter of 1872 from the artist's brother, René, which describes how Pagans "sang to guitar accompaniment" in Degas' own apartment, suggests that the latter might be the setting of the painting: see Lemoisne 1946–49, vol. 1, p. 70.
6. McMullen 1984, pp. 25, 172; Loyrette 1991, p. 179.
7. Michel 1919, p. 468; D. Halévy, 1960, p. 46.
8. Nb. 22, p. 216; Boggs 1988, p. 161.
9. Reff 1976, pp. 120–25.
10. For Degas' beginnings in the area, see Lemoisne 1946–49, vol. 1, p. 8; for the later period, see Kendall 1996, pp. 20–22.
11. Vollard 1936, p. 70.
12. Boggs 1988, p. 162; see Berson 1996; Kendall 1996, pp. 40–44.
13. Loyrette 1996, p. 20.
14. Reff 1976, pp. 244–45.
15. Millet 1979, p. 109; the location cited, however, does not seem to correspond to any known address of Degas'. See also Chapter 7, n. 60.
16. I. Guest 1953, pp. 3, 128; Boggs 1988, p. 161.
17. Wolff 1962, pp. 84–85.
18. Nb. 24, p. 7; *Le Monde Illustré*, March 20, 1869, p. 191.
19. L. Halévy 1933–34, March 15, 1934, p. 373; L. Halévy 1883, p. 1.
20. Donnet 1840–57, p. 284; Touchard-Lafosse, 1846, vol. 4, p. 302.
21. Gourret 1985, pp. 141–62.
22. Hautecoeur 1952, pp. 145, 174, 289. Debret is otherwise barely mentioned in this six-volume survey.
23. Hervey 1847, p. 23.
24. Touchard-Lafosse 1846, p. 302.
25. For these refurbishments, which account for some of the changes in interior design visible in contemporary engravings, see Join-Diéterle 1988, p. 71; Gourret 1985, p. 144; Wild 1987, p. 227; *Le Monde Illustré*, January 5, 1861, p. 2. Garnier's own role in this process from 1863 is mentioned in Mead 1991, p. 261.
26. For lighting, see Castil-Blaze 1855, p. 174; the claim is from Beauvoir 1854, p. 5.
27. Second 1844, p. 228; Véron 1854, p. 331.
28. Garnier 1871, p. 227.
29. The emperor is shown in his *loge* in *Gazette des Abonnés*, October 20, 1864, p. 1 (see plate 13); for the dancers' *loge*, see Mahalin 1887, p. 192.
30. Houssaye 1885–91, vol. 2, pp. 271–72; Join-Diéterle 1988, p. 76.
31. Donnet 1840–57, p. 289; Véron 1854, p. 181.
32. Garnier 1871, pp. 227–300.
33. Donnet 1840–57, p. 287.

34. See also Terrier 2000, pp. 42–45.

35. Join-Diéterle 1988, p. 74.

36. Patureau 1991, p. 298.

37. Hervey 1847, p. 22; Desarbres 1864, p. 28.

38. For the survival of these practices in the Palais Garnier, see Patureau 1991, pp. 299–302.

39. Terrier 2000, p. 14.

40. Castil-Blaze 1847, p. 62.

41. A protest against this situation is found in *Le Monde Illustré*, March 19, 1867, pp. 178–79.

42. Objection to the exclusion of women was made in *Le Monde Illustré*, December 17, 1867, p. 279. For tickets, see Terrier 2000, p. 34.

43. Montfaud, in Berson vol. 1, p. 29.

44. Nb. 4, pp. 25–33.

45. Pickvance 1963, p. 259.

46. See Kendall 1996, p. 91. For La Tour's links with ballet, see Vuillier 1898, pp. 126–27.

47. Delacroix 1937, p. 214.

48. Among others, Delacroix admired Cimarosa's *Mariage Secret*, Mozart's *Don Juan*, and Rossini's *Sémiramis*; see Delacroix 1937, pp. 150, 160, 289. His drawings of *Robert le Diable* are in Sérullaz et al. 1984, vol. 1, pp. 528–30.

49. For Taglioni, see de Beauvoir 1854, pp. 85–86; Houssaye 1885–91, vol. 4, p. 310. Delacroix was recorded in a ballet audience in Second 1844, p. 297. His paintings of M. and Mme Simon are in Robaut 1885, nos. 555, 556.

50. Johnson 1981–89, nos. 244, 248, 589.

51. Courbet's painting (Metropolitan Museum of Art, acc. 19.84) was shown at the Salon of 1857. Lepaulle's pictures of dancers are noted in Second 1844, p. 182, I. Guest 1966, p. ii, and Bénézit, vol. 4, p. 591. His *Trio from "Robert le Diable"* of 1835 is in the collection of the Paris Opéra (MUS. 520); see also Kahane 1985.

52. Wissman 1989, vol. 2, pp. 122, 126. Our thanks are due to Fronia Wissman for generously drawing this link to our attention.

53. Wissman 1998, pp. 260–62. Forty-five of the sketchbooks catalogued in Robaut 1905, vol. 4, include studies of theater, opera, and dance, the last one (no. 3117) dated 1870–74.

54. Alexandre 1888, p. 168.

55. See, for example, Maison 1968, nos. 187, 188, 503; Loyrette et al. 1999, pp. 418–20.

56. Jeanniot 1933, p. 171.

57. A retrospective of Daumier's paintings and drawings was held in the Durand-Ruel galleries in Paris in 1878.

58. Manet's figure was originally shown against an empty ground and the Daumier-like glimpse of scenery and auditorium added later; see Cachin and Moffett 1983, pp. 146–48. For Menzel's painting, see Keisch and Riemann-Reyher 1996, pp. 278–80, and Boggs 1988, p. 270. Menzel's address on a later visit to Paris appears in a Degas notebook (Nb. 24, p. 116), and it is claimed, without documentary evidence, that the two artists met frequently between 1867 and 1868: See Lemoisne 1946–49, vol. 1, p. 95.

59. Delteil 1925–30, vol. 7, no. 2243.

60. See Ives et al. 1997, nos. 19–84, 505–87.

61. I. Guest 1966, pp. 20–22.

62. Isaacson 1982, p. 102.

63. Ibid., p. 106.

64. Nb. 3, pp. 87, 96; Nb. 6, pp. 5–14; Nb. 8, p. 28.

65. Boggs 1958, p. 165.

66. Nb. 3, p. 96; Nb. 6, p. 9.

67. Nb. 3, p. 87.

68. Nb. 6, pp. 5–14.

69. Nb. 8, p. 28.

70. See, for example, Ristori 1907, pp. 132, 175, 182. Some of the resemblances between these images and Degas' drawings suggest that he may have used similar works as *aides-mémoire*.

71. Nb. 6, pp. 73, 75; Nb. 8, pp. 29v–31, 51v; Nb. 9, p. 4; Nb. 10, pp. 38, 41; Nb. 12, pp. 77–79; Nb. 13, p. 106.

72. Nb. 8, pp. 6v, 26v; Nb. 10, p. 27A; Nb. 13, p. 106.

73. Nb. 13, pp. 28, 91; Nb. 18, pp. 67, 69, 72, 119, 137, 153, 191, 256.

74. Nb. 13, p. 4; Nb. 20, pp. 8–14.

75. Nb. 13, pp. 77A, 77B; Nb. 14A, pp. 2–3; Nb. 17, p. 16; Nb. 18, pp. 67, 153, 185, 191; Nb. 19, p. 43.

76. Nb. 14A, p. 599; Nb. 18, pp. 68–69, 187–91, 193–94; Nb. 19, pp. 98–102.

77. Nb. 18, pp. 35, 181, 191, 193.

78. See I. Guest 1953, pp. 46–49; *La France Musicale*, June 2, 1861, p. 169.

79. For *Pierre de Medicis* see I. Guest 1953, pp. 40–41; *La France Musicale*, March 11, 1860, pp. 121–22, and March 18, 1860, pp. 133–35; Pitou 1990, pp. 1056–60. *Don Juan* premiered at the Opéra in 1834 and was still playing in the 1860s. *Faust* opened at the Théâtre Lyrique in 1859.

80. Full casts are listed in the opera *livrets* in the Bibliothèque de l'Opéra.

81. Nb. 18, p. 223.

82. For *L'Etoile de Messine*, see I. Guest 1953, pp. 49–54; *La France Musicale*, November 24, 1861, pp. 369–71; *Le Monde Illustré*, 1861, pp. 763–65; Pitou 1990, pp. 432–36. A wood engraving of Act One, Scene Three, in the collection of the Bibliothèque de l'Opéra shows the view in question.

83. For example, Nb. 18, pp. 140, 173, 221.

84. Grove 1992, vol. 4, p. 308.

85. The ballet is mentioned in *Le Monde Illustré*, July 14, 1860, p. 30, and in *La France Musicale*, July 15, 1860, p. 297. The opinions are cited in Browse 1949, p. 334, and Boggs 1988, p. 90.

86. Boggs 1988, p. 90. Prints of the sets of several acts are preserved in the Bibliothèque de l'Opéra.

87. See Monnier 1978. An X ray of the painting shows that it, too, originally included extensive, high vegetation; see Couëssin 1989, p. 146.

88. The study is in the Louvre, Cabinet des dessins, RF 15533; it is reproduced in Boggs 1988, fig. 42.

89. The date, when Degas was certainly close to Morisot, was proposed in Orangerie des Tuileries 1937, p. 125. For the three early fans, see also Gerstein 1982, pp. 105–6.

90. Orangerie des Tuileries 1937, p. 125.

91. Nb. 14, pp. 20, 35, 37. The figure playing a guitar has been identified as Alfred de Musset, whom Degas considered portraying in an "epic portrait" in 1859 or 1860; see Nb. 16, pp. 6–7 and Reff 1976, pp. 156–58.

92. The Manet, now in the Phillips Collection, Washington, D.C., was prompted by a performance at the Paris Hippodrome: see Cachin and Moffett 1983, pp. 144–45.

93. Browse 1949, p. 60.

94. Joséphine Gaujelin is listed as "Gaujelin" in the opera *livret*; in *Le Monde Illustré*, October 28, 1865, p. 275, her name appears as "Gaugelin."

95. See Chapter 7.

96. For the brief reference to the painting in *Le Monde Illustré*, July 24, 1869, p. 58, see Chapter 7, n. 22.

97. A marble bust of Fiocre is in a French private collection, and a plaster version is in the Musée d'Orsay (RF 930).

98. See Dumas 1988, p. 15. In I. Guest 1953, p. 41, it is noted that Saint-Léon introduced Fiocre to the ballet. Both Saint-Léon and Degas lived on the rue de Laval.

99. Buchanan 1997, p. 54.

100. Ibid., pp. 46–50, 63–64; on p. 64, Sanlaville is identified with the "lutist" in Degas' portrait, though she is recorded as the imp Zaël in the 1866 *livret*.

101. See *Le Ménestrel*, November 18, 1866, p. 403.

102. *L'Epoque*, November 20, 1866. The story is summarized in Pitou 1990, pp. 1251–54.

103. *Le Ménestrel*, November 18, 1866, p. 403; *Le Globe Artiste*, November 18, 1866, p. 1.

104. *La France politique, scientifique et littéraire*, November 18, 1866, p. 1.

105. *Le Monde Artiste*, November 17, 1866, p.1; Gautier 1986, p. 323; *Gazette des Etrangers*, November 14, 1866.

106. Gautier 1986, p. 323; *La France politique, scientifique et littéraire*, November 18, 1866, p.1; *La Presse*, October 9, 1872; *L'International*, November 18, 1866.

107. IV:96.b; the second, uncatalogued, drawing (dated "August 1867") is fig. 72 in Boggs 1988.

108. Nb. 21, p. 12; other studies are on pp. 12v, 13, 32, and Nb. 20, pp. 20–21. Additional drawings are IV:107.b; L 149; and fig. 71 in Boggs 1988.

109. Zacharie Astruc, *L'Etendard*, July 30, 1868, p. 1; Louis Leroy, *Le Charivari*, May 20, 1868, p. 2; Emile Zola, *L'Evénement*, June 9, 1868, pp. 2–3.

110. Kendall 1993, pp. 77–79.

111. The print reproduced in Dumas 1988, p. 11, appears to represent the 1872 reprise.

112. Browse 1949, p. 51; Dumas 1988, p. 24.

113. Gautier 1986, p. 330.

114. See also Mayne 1966 and Kahane 1985.

115. Pitou 1990, p. 1123.

116. Gautier 1986, pp. 330–31.

117. For Parent, see Kahane 1985, p. 104; in Boggs 1988, p. 172, it is incorrectly stated that this role was continuously played by Fonta.

118. Nb. 24, p. 7.

119. See *Le Monde Illustré*, September 16, 1871, p. 187, and November 25, p. 342.

120. Boggs 1988, pp. 171–73.

121. The history of both works is summarized in Boggs 1988, pp. 171–74, 269–70.

122. The X ray also appears to indicate that the edges of the work were redefined and the canvas restretched at some point.

123. Musée d'Orsay 1989, p. 362, n. 10. We are indebted to Theodore Reff for further elucidation of this event.

124. For the 1874 exhibition, see Berson 1996, vol. 1, p. 5, and vol. 2, pp. 7–8; Carjat, in Berson 1996, vol. 1, p. 14; Montfaud, in Berson 1996, vol. 1, p. 29.

125. Chesneau, in Berson 1996, vol. 1, p. 19.

126. See Nb. 22, p. 204 for some of the pictures he planned to include.

127. Guérin 1945, p. 12; for Degas' eyesight, see Kendall 1988.

128. Lemoisne 1946–49, vol. 2, p. 98; Guérin 1947, p. 12; Boggs 1988, p. 162.

129. Guérin 1947, p. 12; Boggs 1988, p. 173.

130. Lemoisne 1946–49, vol. 1, p. 71.

131. Guérin 1947, p. 22; see also pp. 16, 32.

132. L. Halévy 1937, February 1, p. 542.

133. Goncourt 1956, vol. 2, pp. 967–68.

134. Nb. 24, pp. 1, 3, 27.

135. Berson 1996, vol. 1, p. 35.

136. Pickvance 1963, p. 260.

137. The ink lines originally showed little but bare branches, not leafage.

138. The audacity of adopting such a viewpoint at this date has been overlooked, but it is vividly reflected in Ludovic Halévy's shock when he found that the emperor's *loge* was so quickly offered for hire after the war: L. Halévy 1889, p. 181.

139. Gantès, in Berson 1996, vol. 1, p. 23.

140. Pothey, in Berson 1996, vol. 1, p. 104, and Zola, in Berson 1996, vol. 1, p. 108.

141. Castagnary, in Berson 1996, vol. 1, p. 17, and Chesneau, in Berson 1966, vol. 1, p. 19.

142. Véron 1854, p. 297; M. J. Moynet 1873, p. 143; Mahalin 1887, p. 24.

143. Véron 1854, p. 298.

144. Vizentini 1868, pp. 26–29. Vizentini was the director of the Gaîté theater in the 1870s. L. Halévy 1889, pp. 107–8.

145. M. J. Moynet 1873, p. 143.

146. Mahalin 1887, pp. 29–31.

147. Accounts of *répétitions générales* are in Véron 1854, p. 229; Duval 1875–77, vol. 2, pp. 36–38 and vol. 3, p. 302; Moynet 1873, p. 143; Mahalin 1887, p. 271.

148. See Couëssin 1989, p. 153. Pluque was made *régisseur de la danse* in 1870, but the figure in question also resembles Saint-Léon; see I. Guest 1953, p. 132, and the photograph opposite p. 100.

149. See Chapter 6. The fact that the resting dancers are not wearing shawls or cloaks in an unheated auditorium suggests that this is a summer scene, perhaps mid-1873.

150. See Boggs 1988, pp. 228, 230.

CHAPTER 3 DEGAS BACKSTAGE

1. Claretie, in Berson 1996, vol. 1, p. 141.

2. Claretie wrote the preface to Magnier's *La danseuse* in 1885 and owned the painting *Ballet Scene* (plate 177).

3. We are greatly indebted to Martine Kahane, former chief librarian at the Bibliothèque de l'Opéra, for guiding us through the public and private spaces of the building.

4. L. Halévy 1937, p. 547.

5. Loyrette 1996, pp. 162–77.

6. L. Halévy 1933–34, December 15, 1933, p. 772.

7. L. Halévy 1883; for their publication history, see Loyrette 1996, pp. 178–93.

8. L. Halévy 1883, pp. 1–34.

9. See J 195–231. Some unused printing plates linked to certain of these images are in the documentation of the Musée d'Orsay.

10. Magnier 1885, p. 1.

11. L. Halévy 1883, p. 69.

12. Claretie, in Berson 1996, vol. 1, p. 141.

13. Second 1844, p. 116; Mahalin 1887, p. 190.

14. Véron 1854, p. 330, explains that the relevant door at the rue Le Peletier Opéra was to the right of the auditorium. The corresponding door at the Palais Garnier is at the left, near the stairway to the Bibliothèque.

15. See Patureau 1991, pp. 360, 364; Labat-Poussin 1977, pp. 301 and 304. See Kahane 1988.

16. Boigne 1857, p. 33.

17. Garnier 1878–81, vol. 1, p. 53.

18. Second 1844, p. 175; Véron 1854, pp. 297, 301; M. J. Moynet 1873, p. 141.

19. Second 1844, pp. 189–202. See also Roqueplan 1855, pp. 62–63.

20. Vizentini 1868, p. 25.

21. A small engraving of the subject is included in M. J. Moynet 1873, p. 183.

22. Mahalin 1887, p. 41; Hervey 1847, p. 25; Roqueplan 1855, p. 62.

23. J 186; RS 50.

24. L. Halévy 1883, pp. 35–61; see J 212–15.

25. L. Halévy 1883, p. 32.

26. Goncourt 1956, vol. 1, p. 885.

27. The picture appears to show the same model as a painting by his friend de Valernes, which can be dated to 1872; see Reff 1981, pp. 126–27. It is equally possible that Degas reused the painted sketch he himself executed on this occasion (L 1025) as the starting point for the slightly later Washington picture.

28. Precedents for the line of legs are in Isaacson 1982, p. 102. The X ray reveals a complex story of repainting that left few areas unchanged and a somewhat congested surface. Both the left-hand and central dancers once faced the viewer more symmetrically, the latter perhaps covering the right-hand figure (not vice versa, as at present) and appearing more in profile. Some of these earlier poses may be preserved in such works as L 617, L 783, and L 1003. Our thanks to Gloria Groom and Timothy Lennon for arranging for this X ray to be made.

29. See, for example, L 617 and L 783.

30. Porcheron, in Berson 1996, vol. 1, p. 103, and Huysmans, in Berson 1996, vol. 1, p. 86.

31. See Lemoisne 1946–49, vol. 3, no. 782; Munk 1993, pp. 16–17.

32. Both the pattern of streets and some of their names were changed in the early part of the nineteenth century. While the façade of the theater always faced the rue Le Peletier (sometimes Pelletier), it was formerly bounded on the north by the rue Pinon (now the rue Rossini) and on the east by the rue Grange-Batelière (roughly corresponding to the present rue Drouot). Maps of the area from the late eighteenth and early nineteenth centuries are preserved in the Bibliothèque Historique de la Ville de France.

33. Grasset 1874, p. 214; Maugras 1903, p. 323.

34. Grasset 1874, p. 213.

35. A number of engraved plans of different periods and designs with hand-drawn alterations are in the Bibliothèque de l'Opéra.

36. The use of the building during the revolutionary period is described in Pessard 1904, p. 843. For a detailed account of the new and old structures, see Donnet 1840–57, vol. 1, pp. 271–96.

37. See the entries in Lemoisne 1946–49, vol. 2, for nos. 297, 298, 362, 375, 403.

38. Véron 1854, p. 297. For Lami's annotated watercolor, see Lemoisne 1912 (ii), opposite p. 96.

39. Donnet 1840–57, vol. 1, p. 296.

40. Arago 1841, p. 17; Vizentini 1868, p. 23; the bust, lights, and benches are also visible in Lami's print.

41. Roqueplan 1855, p. 57; Vizentini 1868, p. 24.

42. Mahalin 1887, p. 270.

43. The bust of Guimard appears in one painting, BR 86 (plate 157).

44. J 227 and 230.

45. J 217; see also J 231 and Adhémar and Cachin 1974, no. 7.

46. Second 1844, p. 116; Roqueplan 1855, p. 55; Véron 1854, p. 329. In Guérin 1949, p. 69, Degas suggests that Blanche can demand entry as a "right," even without formal permission.

47. Magnier 1885, p. 1.

48. Mahalin 1887, p. 270; L. Halévy 1883, p. 69; Wagner 1986, pp. 227, 253.

49. See Véron 1854, p. 329. The composer Auber made visits to watch the dance class; see Guest 1953, p. 86.

50. Loyrette 1996, p. 189. McMullen's claim that Degas "had held a season ticket since he was twenty" is not substantiated; McMullen 1985, p. 172.

51. Degas' acquaintance with the photographer and Opéra cellist Mante, discussed below, raises the possibility that photographs of the interior of the building were used by the artist to paint its rooms.

52. The two principal "families" are the works reflecting the high-windowed practice room and the group of frieze pictures.

53. On stylistic grounds, several of these works have been dated to 1873 or soon after; see, for example, Brame and Reff 1984, p. 64. The resemblance between L 362 of 1872 and a work such as L 298 also support this early date.

54. The Frick *Rehearsal* was exhibited in 1879; see Berson 1996, vol. 2, p. 110.

55. Donnet 1840–57, vol. 1, p. 293. See also the cross section of the building in Contant 1859, pl. 30.

56. A small chamber to the left of the principal foyer, marked "Chant" in a plan of 1839, is designated as an additional *foyer de la danse* in Debret's original usage.

57. Donnet 1840–57, vol. 1, pl. 20.

58. These schemes are recorded in hand-drawn plans in the Bibliothèque de l'Opéra, but it is not clear if they were carried out: Vizentini 1868, p. 11.

59. See, for example, *Le Monde Illustré*, November 8, 1873, front cover; *Le Journal Illustré*, November 1873.

60. See Millet 1979.

61. Some of the photographs have Mante's name printed on them, but this example is unattributed. There is no evidence here of the damage to roof and chimneys visible in other photographs taken after the fire.

62. Mahalin 1887, p. 190. In Browse 1949, p. 250, this view is identified in BR 60.

63. See Dax, in Berson 1996, vol. 1, p. 70. Degas' inclusion of photographs in an early exhibition is noted in Pickvance 1963, p. 265.

64. Zola, in Berson 1996, vol. 1, p. 108.

65. Guérin, 1949, p. 183.

66. This discovery would not have been possible without the support of James Cuno and Ivan Gaskell, and the patient and protracted collaboration of Teri Hensick at the Fogg Art Museum, to whom we are also indebted for the X ray, IR, and graphic images. Several other detailed changes in the figures and building can be identified, possibly made in more than one phase of reworking.

67. These drawings include L 279; II:232 and 247; II:326.2, 343.2, 359; IV:284.a; and Nb. 30, p. 17.

68. For Thornley, see Kendall 1996, pp. 41, 49; Musée Goupil, Bordeaux 1997, pp. 88–96. The classroom print was not included in Thornley's album of Degas' work in 1889.

69. We are most grateful to Flemming Friborg of the Ny Carlsberg Glyptotek for his help in arranging for this X ray to be made. The last figure to the left is clearly visible in the X ray and partially so with the naked eye.

70. See L 396; L 399 and L 537; L 430 and L 398.

71. Goncourt 1956, p. 967.

72. Wells 1964. The staircase model is recorded in Lafond 1918–19, vol. 1, p. 114. Note that the structures of the staircases are different.

73. Examination of the surface suggests that it was painted in an egg tempera or distemper-like medium.

74. Brandon owned L 341, Blanche L 430, Rouart L 537, and Manzi L 398 and BR 60.

75. See Berson 1996, vol. 1, p. 48 and vol 2, p. 35, nos. II-44, II-45.

76. For 1877, see Berson 1996, vol. 2, p. 118, and vol. 2, p. 72, no. III-38. For 1879, see Berson 1996, vol. 1, pp. 204–5, and vol. 2, p. 110, nos. IV-65, IV-66.

77. Sivestre, in Berson 1996, vol. 1, p. 240.

78. Gérôme, in Berson 1996, vol. 1, p. 222.

79. Burty, in Berson 1996, vol. 1, p. 210.

CHAPTER 4 THE PALAIS GARNIER YEARS

1. Garnier 1871, p. 52.

2. Guérin 1947, pp. 53, 85, 98–99; for Les Jumeaux de Bergame, see Boggs 1988, pp. 431–32.

3. Garnier 1871, pp. 50–52.

4. Ibid., p. 215.

5. Castil-Blaze 1855, p. 210.

6. Le Monde Illustré, September 5, 1868, p. 146.

7. Le Monde Illustré, November 17, 1866, p. 322.

8. Delaborde 1870, pp. 377–78.

9. Pitou 1990, p. 1284.

10. Journal des Débats, June 19, 1876; Tribune, June 17, 1876; L'Opinion, June 17, 1876.

11. Le Français, June 19, 1876; Le Gaulois, June 16, 1876.

12. Le XIXe Siècle, June 20, 1876.

13. L'Opinion, June 17, 1876.

14. Degas was at the Opéra on June 29, 1892, when Rigoletto and Sylvia were playing; see Loyrette 1989, p. 63.

15. Guérin 1947, p. 111.

16. Ephrussi, in Berson 1996, vol. 1, p. 278.

17. Mead 1991, pp. 21–33.

18. Had it been exhibited at the Salon, Sémiramis Building Babylon would arguably have become Degas' first theater-related picture shown in public.

19. Wagner 1986, pp. 3, 134. For the commissioning of the paintings, see Mead 1991, pp. 176–77.

20. Nuitter 1875, pp. 1, 140–42, 248–49.

21. Ibid., p. 248.

22. Mead 1991, p. 6.

23. Nuitter 1875, p. i; d'Heylli 1875, p. 404.

24. Mead 1991, p. 196.

25. Garnier 1871, p. 41.

26. Ibid., p. 144.

27. See Kendall 1987.

28. Garnier 1871, pp. 227–35.

29. Ibid., pp. 221–22.

30. Ibid., p. 239.

31. Ibid., pp. 238–42.

32. Ibid., pp. 240, 243.

33. Du Camp 1879, vol. 6, pp. 178–79.

34. Karr 1879, p. 144; D. Halévy 1960, pp. 52–53.

35. Some exceptions are J 55–57; L 577, L 584, L 586, L 737, L 829, and L 873.

36. L 476 and L 515.

37. Nuitter 1875, p. 157.

38. Champsaur 1888, p. 20.

39. See, for example, the plan illustrated in Kahane 1988, p. 16.

40. Goncourt 1956, vol. 1, p. 1036. In a notebook drawing of the stage, Degas marked this area "loge du Directeur"; see Nb. 24, pp. 26–27.

41. L. Halévy 1933–34, December 15, 1933, p. 764.

42. Gerstein 1982, p. 108.

43. M. J. Moynet 1873; G. Moynet 1893.

44. For these gantries, see G. Moynet 1893, pp. 43, 165, 197, 201.

45. Rolland, in Berson 1996, vol. 1, p. 238, and "X," in Berson 1996, vol. 1, p. 251.

46. "X," in Berson 1996, vol. 1, p. 252, and Sébillot, in Berson 1996, vol. 1, p. 238.

47. See provenances in Lemoisne 1946–49, vol. 2, for L 556, L 564, L 566, L 562; and Brame and Reff 1984, no. 74. See also Gerstein 1982, p. 110.

48. Reff 1969, p. 287.

49. L. Halévy 1938, p. 399.

50. Guérin 1947, p. 66. Degas left his apartment on the rue Fontaine–St. Georges, specified in the first of these letters, in 1882.

51. Lemoisne 1946–49, vol. 1, p. 115. Vaucorbeil, who is mentioned in the text, became director in 1879, so Degas' visit must have taken place between 1879 and 1882. We are grateful to Theodore Reff for helping us confirm these events. For dance examinations, see Mahalin 1887, p. 267; Mérode 1985, pp. 61–63; and Browse 1949, pp. 58–59.

52. L 408.

53. Garnier 1878–81, p. 233.

54. The examination of this picture was made possible by Sarah Campbell, and assisted by Rosamond Westmoreland, to whom we are deeply grateful. Very little of the earlier brushwork is still visible.

55. Claretie 1881, p. 436.

56. See L'Illustration, March 16, 1878, pp. 172–76.

57. See D. Halévy 1960, p. 135.

58. See Claretie 1881, pp. 441, 445, 447.

59. Valéry 1960, p. 73.

60. The oil paintings are L 625, L 820, L 894, L 900, L 902, L 905, L 941, L 996, L 1107, and L 1394. The canvas on which the pastel Dancer in Her Dressing Room (plate 70) was created has similar dimensions and may once have been destined for this cycle.

61. The crucial link between L 625 and the drawings on p. 70 in Notebook 31 (datable 1878–79) was first made in Reff 1974, p. 74, n. 44. See also Shackelford 1984, chap. 4, and Boggs 1988, pp. 339–41.

62. L 905 and L 1107 appear to have been completed in the 1880s; L 900 and L 941 in the 1890s; and L 996, L 1394, and other related works thereafter.

63. Boggs 1988, p. 405.

64. Shackelford 1984, p. 85.

65. Meller 1988, p. 201.

66. L 905.

67. Thomson 1987, pp. 93 98; for the friezes as decoration, see Shackelford 1984, pp. 85–86, and Meller 1990. For Mantegna, see Meller 1988, p. 199, and Goncourt 1956, vol. 2, p. 968.

68. Vollard 1937, pp. 77–78.

69. None of Degas' own titles for works in this series are known with certainty.

70. The X ray of the Clark frieze shows that the relevant figure originally looked very like this study.

71. Huysmans, in Berson, vol. 1, p. 291.

72. Shackelford 1984, p. 86.

73. Boggs 1985, p. 45; L 822.

74. Shackelford 1984, p. 85; Boggs 1988, p. 405.

75. Moffett 1986, pp. 44–45.

76. The column is present in L 1107 and L 1394; stairs in L 894; and a door in L 996. Degas had copied Mantegna's Calvary, with its soldiers descending into a stairwell-like foreground space, in the late 1860s; see L 194.

77. The psychological significance of their elevation is spelled out clearly in L 700.

78. The fragmentary view corresponds quite closely to that surrounding the rue Le Peletier courtyard, but the dormer story had an angled exterior, which does not appear in the paintings.

79. For the rue Richer establishment, see A.M., L'Illustration, March 16, 1878, pp. 172–74; Constant 1894;

Labat-Poussin 1977, p. 304; and Guest 1966, p. 23–24. It was twice destroyed by fire, in 1861 and 1894.

80. See Constant 1894, p. 17; I. Guest 1853, p. 109.

81. Fourcaud 1881, p. 14; I. Guest 1953, p. 67.

82. Shackelford 1984, p. 86.

83. We are most grateful to Ann Hoenigswald for her assistance with this examination.

84. See Fernandez and Murphy 1987, p. 61. The extension was achieved by including the original tacking edge within the visible rectangle. The X ray of the picture reveals extensive modification to most of the figures; our thanks to Richard Rand and Sandy Webber for making the examination possible.

85. For Degas' late repaintings and experiments in technique, see Kendall 1996, pp. 106–23.

86. While the disposition of the architecture and most of the figures appears to be largely unchanged, the X ray indicates significant alterations to areas of shadow, dancers' tutus, and perhaps legs.

87. A very similar drawing is III:86.3. See also Reff 1974, pp. 36–37.

CHAPTER 5 THE MAKING OF A DANCER

1. Bentley 1987, p. 126.

2. Weitzenhoffer 1986, p. 126.

3. Review in The Echo, April 22, 1876, cited in Pickvance 1963, p. 259; Lipton 1986, p. 115.

4. See Labat-Poussin 1977.

5. See Adice 1859 and 1868–71; Bernay 1890; Blasis 1820 and 1828; Charbonnel 1899; and Duval 1875.

6. D'Heylli 1875, pp. 372–81.

7. For Degas' relationships with these dancers, see Chapter 7.

8. Mahalin 1887, pp. 5–7; Bernay 1890, p. 16; Giraudet 1900, p. 453; Vizentini 1868, pp. 26–27. See also I. Guest 1953, pp. 16, 26, 54, 55, 66, 67, 74, 92, 126; Kahane 1988, p. 12; and Lipton 1986, pp. 88–91.

9. For drawings of the youngest students, see III:109.3 and two uncatalogued studies reproduced in Kendall 1998, nos. 11, 12. For the Denver picture, see Berson 1996, vol. 2, p. 148, no. V-40.

10. Huysmans, in Berson 1996, vol. 1, p. 291. When The Dance Class (L 397) was exhibited in 1876, it was also titled Examen de Danse; see Berson 1996, vol. 2, p. 34, no. II-37.

11. Mahalin 1887, p. 15; see also Gautier 1840, p. 463; Robin-Challan 1992, pp. 20–28; and Kahane 1988, pp. 7–8.

12. Kahane 1988, p. 13

13. Véron 1854, p. 289; see also Kahane 1988, p. 8.

14. Mahalin 1887, pp. 284–86; see also Vizentini 1868, p. 26.

15. Such photographs can be found in Baschet undated (c. 1890s).

16. L. Halévy 1883.

17. Champsaur 1888, pp. 4, 6, 9.

18. One notable exception is Lipton 1986.

19. Roqueplan 1855, p. 35; see Robin-Challon 1992, p. 27, and Kahane 1988, p. 8.

20. Vizentini 1868, p. v; Gautier 1986, p. 273; Mahalin 1887, p. 284.

21. Véron 1854, p. 306; Vizentini 1868, p. 27.

22. Mahalin 1887, p. 273.

23. Kahane 1988, p. 8.

24. Mahalin 1887, p. 191.

25. Mahalin 1887, p. 191; Kahane 1988, p. 8.

26. Véron 1854, p. 302; I. Guest 1953, pp. 93, 97.

27. See Chapter 7.

28. Mahalin 1887, p. 219; Mérode 1985, pp. 122–24, 161–62.

29. For an extended bibliography, see Kendall 1998; see also Kahane 1998, pp. 48–71.

30. Kahane 1998, p. 51.

31. L 586/bis, L 586/ter, L 599, III:149.1, 277, 341.2, 370, 386; IV:287a.

32. Panserose in L'Evénement, February 10, 1882, cited in Kahane 1998, p. 57. Mahalin 1887, p. 265, cites this article but does not give a reference.

33. Kahane 1998, p. 62.

34. Véron 1854, p. 304.

35. See, for example, L 658 and L 1107, and Rouart 1964, nos. 11, 15.

36. Roqueplan 1855, p. 7; Mahalin 1887, pp. 28–29.

37. Tinterow, in Boggs 1988, p. 409.

38. See Kendall 1996, pp. 82–83, 262–67.

39. L 1149 and IV:161.

40. Gautier 1986, pp. 305, 323, 277.

41. Huysmans, in Berson 1996, vol. 1, p. 291.

42. Mahalin 1887, pp. 198, 216.

43. I. Guest 1953, pp. 67–68; Mahalin 1887, p. 195.

44. Nuitter 1875, p. 182

45. Vizentini 1868, p. 27.

46. Nuitter 1875, p. 192.

47. Duval 1875–77, vol. 3, p. 69, mentions a ballet continuing until 12:30 A.M.; see also Bernay 1890, pp. 13–14.

48. Bernay 1890, pp. 12–14.

49. Mahalin 1887, p. 9; Kahane 1998, p. 58.

50. Gautier 1840.

51. Gautier 1840, pp. 467–69.

52. Ibid., pp. 472–73; Bernay 1890, pp. 11–14; Mérode 1985, pp. 85, 100–101, 107; see also Robin-Challan 1992, pp. 20–21.

53. Véron 1854, pp. 300, 366; Castil-Blaze 1855, pp. 319–30; Mérode 1985, p. 54.

54. Gautier 1840, p. 466. During the 1850s, it became obligatory for dancers to be educated until the age of twelve; see Robin-Challan 1992, p. 23.

55. Gautier 1840, p. 469; Mérode 1985, p. 58.

56. Gautier 1840, p. 465.

57. Such is apparent in a comparison of nineteenth-century technique manuals and those of our own era; see Adice 1859 and 1968–71; Bernay 1890; Charbonnel 1899; Duval 1875; Giraudet 1900; and Kirstein and Stuart 1980. For in-depth analyses of technical similarities, see Hammond 1982, pp. 148–54, and Hammond 1993, pp. 33–58.

58. Bernay joined the Opéra company in 1869 after studying at the conservatory; she became a sujet in 1876 and a teacher upon her retirement. In 1885 Degas attended a rehearsal in which she participated; see Boggs 1988, p. 432, n. 6.

59. By this time the French, Italian, and Danish schools were already well established; at the turn of the twentieth century, the Russian school would eclipse all others.

60. See Haskell 1954, p. 14; I. Guest 1961, pp. 26–37, and I. Guest 1966, p. 16.

61. See I. Guest 1966, p. 16, and Hammond 1982, p. 154.

62. The teacher was first identified as Mérante in Browse 1949, p. 53.

63. Browse 1949, p. 59; Bentley 1987, p. 75.

64. For the date of this painting, see Pickvance 1963, p. 259.

65. A recent X ray shows that this picture was extensively repainted and once even more crowded with figures, including a male teacher standing in the middle distance at extreme right. Our thanks to Laura Coyle and Dare Hartwell for making this examination possible.

66. Bigot and Ephrussi, in Berson 1996, vol. 1, pp. 60 and 278; see also Bernadille, in Berson 1996, vol. 1, p. 130; Mantz, in Berson 1996, vol. 1, p. 167; Anonymous in L'Illustration, in Berson 1996, vol. 1, p. 225; Burty, p. 269; and Huysmans, p. 291.

67. Lipton 1986, p. 102.

68. See I. Guest 1966, p. 16, and Hammond 1995, p. 40.

69. Hertz 1920, p. 20.

70. Mahalin 1887, p. 26.

71. For the dating of this sheet, see Boggs 1988, p. 226.

72. L 408.

73. See A. M. 1878, p. 174; Mahalin 1887, pp. 26–27 and Mérode 1985, p. 60.

74. See A. M. 1878, p. 174; Mérode 1985, p. 60, and Hammond 1984, pp. 54–55.

75. See also L 460; L 820, L 941, and L 1107.

76. Only three images by Degas capture a dancer in midair: Three Ballet Dancers (plate 34) and the related drawings in Nb. 26, pp. 6, 7.

77. The annotation reads: "préparation pour [word crossed out] / une pirouette en dedans."

78. See III:102.4. The inscription reads: "à l'espagnole / pas de bourré / fini (or fait?) à la seconde."

79. Before the Ballet (L 941), another reworked canvas, displays similar qualities.

80. Two studies of c. 1882–85 appear in Nb. 36, pp. 4, 56; a third related drawing is III:136.4.

81. Several teachers were violinists: see Beaumont 1949, pp. 402–3, and I. Guest 1976, p. 111. Pitou 1990, vol. 1, p. 338, notes that Les Deux Pigeons (1886) was the first Opéra ballet to be rehearsed to piano accompaniment. By the late 1880s, piano music was regularly played in classrooms; see Mérode 1985, p. 60.

82. This male figure appears in L 396, L 399, L 703, and L 987. An older man in a similar cap depicted in L 403 has been identified in Browse 1949, p. 365 (no. 82) as Eugène Coralli, a régisseur de la danse at the Opéra who retired in 1870.

83. At one time, a chair was formally presented to the teacher before class began; see Bernay 1890, p. 180.

84. L 1004; this is the only painting or pastel by Degas depicting a female ballet instructor.

85. Mérode 1985, p. 60.

86. Vuiller 1898, p. 367; see also Mahalin 1887, p. 38, and Giraudet 1900, p. 455.

87. The significance of the dancer's hand movements was first noted by Browse 1949, p. 341, no. 18.

88. Bentley 1987, p. 126.

89. Nb. 36, pp. 5–10, 36.

90. Jeanniot 1933, p. 153.

91. See Patureau 1991, p. 348, and Thomson 1995, pp. 43–48.

92. The figures at left, on the bench, are identical to those in L 599; the ballerina on the chair in the foreground also appears in J 20; the two at the barre recall the dancers in L 409 (plate 147); and the dancer with arms extended has counterparts in several works, including III: 276 (plate 172), L 418, L 490, and L 591. See Brame and Reff 1984, p. 92 (no. 86), and Gerstein 1982, p. 109, n. 33.

93. This uncatalogued drawing was published for the first time in Pickvance 1993, p. 73, no. 36.

94. Other studies of this exercise include: II:228.1; III:146.1, 121.1; IV:340.b; J 22; and Adriani 1985, no. 169.

95. The drawing is inscribed: "le bras est enfoncé un / peu dans la mousseline." The figure reappears in L 343, L 481, and L 585, as demonstrated in Shackelford 1984, pp. 45–48, 61.

96. The annotation reads: "mauvais / trop tourné / jambe gauche moins allongée / sur la barre." See Browse 1949, p. 387 (no. 151).

97. Reff 1967, p. 260.

98. Muehlig 1979, p. 9.

99. Thiébault-Sisson 1921, p. 3.

100. The annotation on this drawing, III:146.1, reads: "jambe plus croisée / Elle est comme un / chien qui pisse / dit Mme Théodore." This analogy is still used to describe a poorly executed attitude.

101. This sheet is inscribed: "porter le corps sur la jambe à terre."

102. Browse 1947, p. 386, no. 149.

103. See Vizentini 1868, p. 30; Duval 1875, pp. 7–15 (preface by Rita Sangalli); Royer 1875, pp. 206–7; and Fokine, cited in Hammond 1989, p. 7.

104. Adice 1859, p. 10; Mahalin 1887, pp. 7, 267–68.

105. See Kendall 1998 for an extended bibliography; see also Kahane 1998.

106. Duval 1875, p. 65; the same advice was given in Blasis 1828, p. 65.

107. Ephrussi and Mont, in Berson 1996, vol. 1, pp. 337, 361.

108. Charry and Villars, in Berson 1996, vol. 1, pp. 333, 371.

109. Cassatt cited in Boggs 1988, p. 337; Kendall 1998, p. 15.

110. L 408.

111. Charbonnel 1890, p. 408. See also Blasis 1820, plate VIII, and Adice, as summarized in Hammond 1995, p. 52.

112. In arabesque, the leg is extended straight to the back; in attitude the knee of this leg is bent so that the lower part of the limb crosses behind the dancer's torso.

113. This was first brought to the authors' attention by Sandra Noll Hammond, to whom we are greatly indebted for sharing her knowledge of nineteenth-century ballet practice. The effects of the corset are also noted in Hutchinson Guest 1997, p. 823.

114. La Sylphide, which premiered at the Opéra in 1832, had fallen out of the repertoire by the 1860s. A historical re-creation was mounted at the Palais Garnier in 1972. See Opéra National de Paris 1998.

115. Hammond 1995, p. 47. Illustrations of arabesque with a slightly bent knee also appear in Blasis 1820, plate XI; Blasis 1828, plates X, XI; and Charbonnel 1899, pp. 408–9. For an analysis of the development of arabesque, see Falcone 1999, pp. 71–117.

116. Blasis' 1828 The Code of Terpsichore reiterates much of his 1820 Traité élémentaire théorique et practique de l'art de la danse.

117. Blasis 1828, p. 100, and plate II, fig. 5.

118. The pose reappears in several finished works, including L 418, L 490, L 591, L 735, L 736, L 775, and BR 86.

119. See Bernay 1890, p. 180, and Mérode 1985, p. 61.

CHAPTER 6 PICTURING THE PERFORMANCE

1. Degas 1946, Sonnet V, p. 34. For the dating of Degas' sonnets, see Boggs 1988, p. 290, and Loyrette 1991, pp. 547–52.

2. The artifice inherent in ballet practice and performance, and its appeal to Degas, are discussed in Reff 1978.

3. Fernandez and Murphy 1987, p. 70. See also Boggs 1988, p. 272; Boggs and Maheux 1992, pp. 74, 78; McMullen 1984, p. 227; Muehlig 1979, p. 13; and Pickvance 1979, p. 17.

4. Browse was the first to link Degas' harlequin pastels with the ballet *Les Jumeaux de Bergame* and to associate *Dancer Bowing with a Bouquet* (L 474) with *Le Roi de Lahore*; see Browse 1949, pp. 56–58. In Reff 1976 *Notebooks*, two fans (L 594 and 595) and numerous sketchbook studies are associated with the opera *Sigurd* (see entries and images for Nb. 36, pp. 17, 19, 21–32, 34, 46–49), and other drawings are related to *L'Africaine* (see entries and images for Nb. 36, pp. 35–36, 38, 40, 42). *Danseuse à la rampe* was first identified as a scene from *Yedda* in Brame and Reff 1984, pp. 82–83 (BR 77).

5. See Chapter 2.

6. Degas' portrait of Eugénie Fiocre was exhibited at the Salon in 1868 under the title cited here. In a letter to Tissot of 1872, Degas referred to the first version of *The Ballet from "Robert le Diable"* (plate 53) as his *Orchestre*, but when it was exhibited in London that same year, it was listed in the accompanying catalogue as *Robert le Diable*; see Guérin 1947, p. 34, and Cooper 1954, p. 22. In a later letter to Faure, the artist called the second variant *Robert le Diable* (plate 58); see: Guérin 1947, p. 45.

7. At the third Impressionist exhibition of 1877, Degas listed two works simply as *Ballet* and one as *Danseuse, un bouquet à la main*; see Berson 1996, vol. 1, p. 118, nos. 39, 57, 40. The painting in the Courtauld Collection, *Two Dancers on a Stage* (plate 173) was originally shown as *Scène de Ballet*, as noted by Pickvance, 1963, p. 263.

8. For early collectors of Degas' ballet pictures, see Chapters 3 and 4. For *abonnés* who bought Degas' ballet pictures, see Chapter 1.

9. D. Halévy 1995, pp. 223–24.

10. Ibid., p. 227.

11. First performed at the Paris Opéra in 1834, *Don Juan* was the only work by Mozart in the repertory from 1850 to 1900; see Chouquet 1873, pp. 411–23; d'Heylli, 1875, 319–73; and Wolff 1962, pp. 73–75, 555–56.

12. Lassalle 1866, p. 95.

13. Dupêchez, 1984, p. 70. See also Vaillat, 1947, p. 50.

14. The illustration by Hadol clearly shows the 1866 revival, as it refers to Emile Perrin, the Opéra director from 1866 to 1870.

15. Sanlaville is mentioned as playing a "rose" in a *Le Monde Artistique* review of August 4, 1866. The costumes for the 1866 revival, including that worn by Sanlaville in the photograph, remained in use until *Don Juan* was again refreshed in 1875; see Wild 1987, pp. 81–85. The costumes for the latter staging, recorded in designs at the Bibliothèque de l'Opéra, bear no resemblance to those of the 1866 production.

16. For studies, see: L 426–L 428; II:313; III:115.1; and IV:280b. Other related works include L 365, L 429, L 613 bis; and J 1.

17. Costumes were worn only for performances and dress rehearsals. For use of stage costumes, see Moynet 1873, p. 143, and Mahalin 1887, p. 29.

18. Two of the rehearsal pictures are documented in 1874, and the closely related *Two Dancers on the Stage* was sold to a British collector in January of that year; see Boggs 1988, pp. 225–30, and Pickvance 1963, pp. 259–63.

19. See Boggs 1988, pp. 221–23.

20. No scenery is visible at right in the grisaille (plate 61), tall treelike elements appear in the pastel (plate 176), and bushy, irregularly shaped flats have been added to the essence variant (plate 62). The leafy background in the Courtauld painting mirrors the verdant flat at left in all three rehearsal images.

21. The *livrets* and the mise-en-scène of 1866 do not specify in which act the *Ballet des Roses* was inserted. The print referred to is *Le Pas des Roses* by Belin and Charpentier, from the series *Musée de Moeurs en Actions* of the 1860s; the contemporary review by Hippolyte Prevost is in *La France*, April 8, 1866.

22. The two other pictures, both in the Musée d'Orsay, are linked by their male costumes: *The Chorus* (plate 178) and *Les Pointes* (L 454).

23. D. Halévy 1995, p. 160. *The Chorus* was purchased by Caillebotte in 1877 and bequeathed to the French nation in 1894.

24. Anon. in *La Petite République Française*, in Berson 1996, vol. 1, p. 176.

25. See Boggs 1988, p. 271.

26. Lecomte 1892, plate following p. 62, titled *Ballet de Don Juan*. An 1873 *livret* situates this *divertissement* during the masked ball in Act II. The pastel was mistakenly identified in Fernandez and Murphy, 1987, p. 70, as the "Trio des Masques" at "the close of the first act" which involves three singers, not dancers (coincidentally, a painting of this trio by Paul Rouffio was shown at the Salon of 1878).

27. Although no costume designs for the 1866 production of *Don Juan* survive, the blue and yellow cloaks worn in *Entrance of the Masked Dancers* are nearly identical to gray hooded capes designed for *La Maschera* of 1864, which may have provided the pattern for the cloaks in *Don Juan*.

28. The poses of the two dancing figures in *Rehearsal of the Ballet* (plate 233) suggest that it, too, may be related to *Don Juan*.

29. The three pictures include *The Star* (L 492, J 7, discussed below); its cognate, also titled *L'Etoile* (L 628, J 8); and the painting *Entrance onto the Stage* (L 453).

30. Boggs 1988, p. 272.

31. Janis 1968, nos. 5, 6.

32. Ibid., nos. 7, 8.

33. The features of the principal ballerina in J 8 are remarkably similar to those of the central figure in *On the Stage* (plate 179).

34. Known as *Dancer Turning* since Degas' studio sales of 1918–19, this work has recently been retitled; the position shown does not necessarily involve turning.

35. In Brettell and McCullagh 1984, p. 93, it is noted that a tracing of the Chicago drawing, III:166.3, suggests Degas' wish to study the effects of reversal in a print; see also III:151.2. The painting here referred to is L 453.

36. *La Juive* was a staple of the Opéra's repertory from its creation in 1835; *Hamlet* was also consistently performed after its 1868 premiere, as was Gounod's *Romeo et Juliette*, first presented by the Opéra in 1888. Among the numerous productions that featured recycled scenery are *Don Juan* (1866 staging), *Sigurd* (1885), *Les Deux Pigeons* (1886), and *Les Jumeaux de Bergame* (1886); see Wild 1987, pp. 83, 72, 158, 251.

37. The success of *L'Africaine*, noted in Dupêchez 1984, p. 66, is documented by Soubies 1893 and Wolff 1962, pp. 25–26. For Degas' presence, see Loyrette 1989, pp. 59–63. In an undated letter, Degas mentions plans to attend a performance of this opera; see Guérin 1947, pp. 85–86.

38. See the *livret* and mise-en-scène for the 1877 production of *L'Africaine*; see also Pitou 1990, pp. 13–16; Wild 1987, pp. 23–24; and Wolff 1962, p. 25.

39. The mise-en-scène and *livrets* for *L'Africaine* indicate that ballerinas were present in several scenes, but only danced in Act IV, Scene 1.

40. The original image may have contained even more telling details: the monotype, printed from one of the largest plates Degas ever used, was cut at the top; see Brettell and McCullagh 1984, p. 73.

41. For a full discussion of this and related prints, see Reed and Shapiro 1984, pp. 62–72.

42. Ibid., p. 68.

43. Jules Guillemot, *Le Soleil*, April 30, 1877. Similarly enthusiastic responses to the costumes and sets can be found in *La Défense*, May 2, 1877; *L'Entracte*, May 5, 1877; *Le Ménestrel*, April 29, 1877; *L'Ordre*, May 9, 1877; and *Le Peuple*, May 8, 1877.

44. Browse 1949, pp. 56–57. See also Boggs 1988, pp. 272–74.

45. Engraving of 1877 from *L'Univers Illustré*, preserved in the Bibliothèque de l'Opéra.

46. The *livrets* and mise-en-scène for *Le Roi de Lahore* indicate that a short dance was performed in the desert encampment scene at the beginning of Act II; a more extensive ballet was presented in Act III, the paradise of Indra.

47. Among dozens of late-nineteenth-century mises-en-scène in the Bibliothèque de l'Opéra, which principally record stage directions, that for *La Favorite* is unusual in including costume descriptions.

48. In 1885 Biot made an "impression" on Degas, when he encountered her at a seaside resort, where she performed in *Les Jumeaux de Bergame*; see Guérin 1947, p. 104. A small engraved portrait of Biot bears some resemblance to the ballerina in *Dancer on the Stage*; see Bernay 1890, p. 141. The date of Biot's debut as a *sujet* is noted in Wolff 1962, p. 529.

49. For Degas' drawings of dancers during class or rehearsal, see Chapter 5, and for his early sketches of the Opéra auditorium, see Chapter 2.

50. In the drawing, the dancer's left leg is extended behind her, but in *Ballet at the Paris Opéra*, the right leg of the corresponding figure is extended back.

51. The pastels are L 838 and 840; the pose is also present in another late, reworked oil painting, L 839.

52. For the performance history of *La Favorite*, see Soubies 1893 and Wolff 1962, pp. 89–90.

53. See Pitou 1990, vol. 2, pp. 905–7; Wild 1987, pp. 186–89; and Wolff 1962, pp. 152–53.

54. For the date and cast of the 1879 revival, see Wolff 1962, p. 152.

55. These include BR 75 and BR 84; L 485, L 1123, L 1296; and RS 47.

56. See Brame and Reff 1984, p. 80, and Gerstein 1982, p. 105, n. 1.

57. For further discussion of *Dancer on the Stage*, see Chapter 8.

58. Productions featuring similar caverns include *Le Corsaire* (1856–68), *Don Carlos* (1867), *Françoise de Rimini* (1882–84), *La Maladetta* (1893–1922), *Tannhauser* (1861 and 1895), and *La Tempête* (1889).

59. For performance histories of *Sylvia* and *La Tempête*, see Soubies 1893 and Wolff 1962, pp. 329, 331. For further discussion of *Sylvia*, see Chapter 8.

60. For Degas' presence at the Opéra during performances of *Sylvia* and *La Tempête*, see Loyrette 1989, pp. 62–63.

61. Winged costumes also appear in a fan design, *Dancers* (L 566).

62. The butterfly costumes in *La Source* included tutus, in contrast to those in *Don Juan*, which consisted of short pantaloons and tights. Degas'

pairing of one dancer dressed as a butterfly and another decorated with flowers also points to a connection with *La Source*. This latter figure is a composite of two others, both uncatalogued drawings: one is at the Metropolitan Museum of Art (plate 227), and the other is reproduced in Adriani 1985, no. 95.

63. As no costumes were designed for the 1875 revival of *La Source*, we can assume that the old ones were used or remade.

64. For Degas' interest in science, see Druick and Zegers, in Boggs 1988, pp. 197–211.

65. Claretie 1881 (ii), p. 218.

66. For the print, see Reed and Shapiro 1984, pp. 203–4.

67. The same tutu, worn by identically posed figures in two related pastels, L 690 and 691, is also visible in the backgrounds of L 800 and BR 89. Although Mlles Subra and Mérante are listed among the performers on the *Soirée Artistique* program, the model for the figure in Degas' pictures appears to have been Joséphine Chabot, a ballerina close to the artist at the time. See Chapter 7.

68. The predominance of plain tutus in Degas' performance works was noted in Browse 1949, p. 56, n. 1. Though Degas typically avoided the prevalent ethnic and period costumes of the day, exceptions include: the exotic garb worn by background figures in L 471, L 474 (plate A10), L 483, and L 937; the harem-like outfit in L 469 (plate A7); the oriental attire shown in Nb. 36, pp. 35, 36, 38, 40, 42; the Egyptian costumes for *Faust* depicted in L 863, Rouart 1964, no. 16 (plate 212), and an uncatalogued work sold at Cornette de Saint-Cyr, June 18, 1998, lot 16; and the robes worn for *Sigurd* in L 594 (plate 199), L 595, L 975, Adriani 1985, no. 158, and Nb. 36, pp. 17, 19, 21–32, 34, and 46–49.

69. Browse 1949, p. 46.

70. Studies include IV:271.b and a drawing once owned by the artist's niece, Jeanne Fevre (Vente: Paris, Galerie Jean Charpentier, June 12, 1934, no. 99). Similarly posed figures appear in III:136.4 and in Nb. 36, p. 4.

71. Among the approximately one hundred stage images by Degas, nearly forty can be dated to the late 1870s.

72. See Reff 1976 *Notebooks*, entries and images for Nb. 36, pp. 17, 19, 21–32, 34, 46–49. *Sigurd* had its world premiere in Brussels in 1884; see Wolff 1962, pp. 202–3.

73. Degas' visit to a "general rehearsal" is recorded in a letter; see Guérin, 1947, p. 105. For his attendance at *Sigurd*, see Loyrette 1989, pp. 59–63. His admiration for Caron is expressed in several letters and a poem; see Guérin 1947, pp. 107 (cited here), 109, 145, and Degas 1946, Sonnet VII, pp. 37–38.

74. According to the *livret*, dancers did not appear in this scene but in the following one, where they were dressed as Valkyries, nixes, and elves. *The Chorus* (plate 178) and *Aria After the Ballet* (plate 209) are the only other finished pictures featuring Opéra singers.

75. Muehlig 1979, p. 6.

76. The costume design resembling the tutu in *Ballet Scene* is in pink and white rather than shades of orange; a red flower is worn in the hair in both cases.

77. Degas 1946, Sonnet VI, pp. 35–36.

78. See Pitou 1990, pp. 709–10, and Wild 1987, p. 158.

79. The seven pastels are L 771, L 806, L 817, L 818, L 1032 bis, L 1033, and BR 123. The sculpture R XLVIII has also been associated with this ballet; see Boggs 1988, pp. 433–34.

80. A note written on Opéra stationery documents his attendance at a rehearsal; see Boggs 1988, p. 432, n. 6. A pastel at the National Gallery of Ireland (BR 123) showing dancers in harlequin costumes practicing in a room, rather than performing on stage, may be linked to this event. Degas' visit to Paramé in the summer of 1885 is documented in Guérin 1947, p. 101.

81. See Tinterow, in Boggs 1988, pp. 431–32, where it is also noted that harlequin characters were common in operas and ballets at the time, in productions mounted at the Opéra and other theaters. See also Brettell and McCullagh 1984, p. 159.

82. Alice Biot, a dancer in whom Degas expressed a special interest, played Sanlaville's younger harlequin brother in *Les Jumeaux de Bergame*. See Pitou 1990, vol. 1, pp. 709–10, and Wolff 1962, p. 291; see also Guérin 1947, p. 104.

83. Thomson 1987, p. 60, notes the "Watteau-esque" qualities of this painting.

84. For Degas' historicism in later years, see Kendall 1996, pp.63–64, and Chapter 8.

85. These works include: L 1112 and L 1113; BR 85; J 4; II:340; III:179, 265, 323, 395.1; and IV:155, 263.b, 281.b.

86. Although the print (J 4) and the drawing (IV:281.b) resemble other works executed in 1874 (L 425, II:313, IV:280.b), Degas' first monotypes were made in 1875; see Pickvance, 1963, pp. 263–64, and Boggs 1988, pp. 257–59.

87. *Faust* was presented at the Opéra on more than twelve hundred occasions between 1869 and 1916; see Wolff 1962, pp. 85–87. Degas is known to have been present during ten performances between 1885 and 1892; see Loyrette 1989, pp. 59–63.

88. According to contemporary *livrets* and the mise-en-scène, the action in Act V began in the Harz Mountains, which opened up to reveal a grotto-like palace where a banquet takes place. See also Pitou 1990, pp. 465–66; for a description of the dances, see I. Guest 1953, p. 105, and Vaillat 1947, pp. 24–29, 69.

89. See Berson 1996, vol. 2, p. 111, no. IV-73.

90. Only thirteen costume designs for the 1869 production survive and no new ones were created for the 1875 revival; see Wild 1987, pp. 102–4. The design reproduced here is for a minor character who is not a singer or a dancer.

91. For the drawings, see note 68 above. The inscription on the study (L 863) is legible in Browse 1949, plate 124.

92. Ludovic Lepic designed costumes for this revival, but they were never realized; see Wild 1987, p. 106. The thousandth performance of *Faust* occurred at the Palais Garnier in 1905; see Wolff 1962, p. 85.

93. Works referred to include L 471, L 472, L 483, L 484, L 485, L 1264, L 1265, L 1266; III:227, III:326; Nb. 36, p. 52; and R LIII. See also R XXXII and R XXXIII.

94. See L 471, L 472, L 483, L 485.

95. See Kendall 1993, pp. 213–14.

CHAPTER 7 DEGAS AND THE DANCERS

1. Guérin 1947. p. 116.

2. Bertall and Paul de Charry, in Berson 1996, vol. 1, pp. 212, 273.

3. Vollard 1924, pp. 109–10 (authors' translation).

4. Guérin 1947, p. 14.

5. For Hughes, see L 300 and Nb. 25, p. A; for van Goethem, see Nb. 22, p. 211; for Franklin, see BR 107, II:354, and Nb. 30, p. A; for Darde, see II:

230.1, III:359.1, and IV:181. For contemporary accounts, see D. Halévy 1995, pp. 120, 209; Jeanniot 1933, pp. 153, 155; Mérode 1985, p. 86; Michel 1919; and Thiebault-Sisson 1921.

6. Guérin 1947, p. 72.

7. Ibid., pp. 74, 75; Reff 1969, p. 267; Michel 1919, p. 476.

8. The choreographer Saint-Léon is said to have been a neighbor of the Fiocre family's and to have encouraged Eugénie and Louise to attend the Opéra's dancing school; see I. Guest 1953, p. 41.

9. I. Guest 1953, p. 78; Gautier 1986, p. 305.

10. See Vizentini 1868, p. 34, and I. Guest 1953, pp. 79, 97. Fiocre was given leading roles in *La Muette de Portici* (1865), *Le Roi d'Yvetot* (1865), *La Source* (1866), *Don Juan* (1866), *Hamlet* (1868), *Faust* (1869), and *Coppelia* (1870).

11. I. Guest 1953, p. 79; L. Halévy 1933, p. 772.

12. We are deeply indebted to the Marquise de Lillers, granddaughter of Eugénie Fiocre, for information about the dancer's personal history and the stories surrounding her.

13. For studies for the Salon canvas, see Dumas 1988, pp. 24–34, and Boggs 1988, pp. 133–36. The less-known works are L 129, IV:96.b, and an uncatalogued drawing. The latter two are reproduced in Dumas 1988, p. 27.

14. See Rewald 1937.

15. See Lassaigne and Minervino 1974, p. 95, nos. 212, 212a.

16. The drawing and a photograph are reproduced in Dumas 1988, pp. 18, 27.

17. For the most recent bibliography on the subject of Degas and photography, see Daniel, Parry, and Reff 1998, pp. 140–41. For Manet's and Cézanne's use of the medium, see Scharf 1974, pp. 62–75, 351.

18. I. Guest 1953, p. 85; Pitou 1990, vol. 2, pp. 1132–35.

19. The drawings, both signed and dated "August 3, 1867," are reproduced in Dumas 1988, pp. 27, 28, as is the *carte-de-visite*, which appears on p. 15.

20. See Kendall and Pollock 1992, p. 26.

21. See I. Guest 1953, pp. 79–80, and Dumas 1988, pp. 19–22. According to her descendants, Fiocre's search for a wealthy husband misfired. Her marriage to the Marquis de Courtivron ended in divorce when she discovered that he was a spendthrift in need of her money.

22. For the critical response to Fiocre's portrait, see Loyrette and Tinterow 1994, pp. 373–74. In Oliver Merson's review in *Le Monde Illustré*, July 24, 1869, p. 58, the picture of Gaujelin was described as "a good little piece of painting…that drew the attention of connoisseurs." When shown in the 1877 Impressionist exhibition, the portrait was remarked on by Leroy, Mantz, and Rivière; see Berson 1998, vol. 1, pp. 160, 167, 181.

23. When Morisot saw the painting in 1869, she mistook the dressing table for a mantelpiece; see Adler and Garb 1986, p. 37.

24. Other figure studies include III:405.1 and III:405.2; IV:89.c; and Nb. 22, p. 29.

25. See Adler and Garb 1986, p. 37, and pp. 31–33, 36–43.

26. The essence sheet (L 325), which is a study for the oil painting (L 324), is inscribed "d'après Gaujelin / 1873." Gaujelin's name and address also appear in Nb. 22, p. 207.

27. The annotation reads: "1873 / Joséphine Gaujelin / autrefois danseuse à l'Opéra / puis actrice au Gymnase." According to Castil-Blaze 1856, p. 445, Gaujelin was already an Opéra coryphée in 1855.

28. For Gaujelin's departure from the Opéra, see Chapter 2.

29. A similarly posed dancer appears in *The Dancing Class* (plate 143).

30. See Shackelford 1984, pp. 43–52.

31. Shackelford has suggested that the drawings were made while Degas was working on the three versions of *The Rehearsal on the Stage* (plates 61, 62, and 176).

32. According to Jeanniot 1933, p. 153, Degas was present at a modeling session in Lepic's studio, where two corps members "posed for the movements" and two stars "for the heads."

33. The figure was first identified as Perrot in Browse 1949, p. 54.

34. Gautier 1986, p. 87.

35. See I. Guest 1984, pp. 28–29, 30–319.

36. Ibid., pp. 320–28. Perrot lived on the rue des Martyrs, not far from Degas; see Loyrette 1991, p. 362.

37. I. Guest 1984, pp. 326–28, 333–34, 335, 337. See also I. Guest 1953, p. 132.

38. As shown in Roberts 1963, pp. 280–81, this painting can be dated to early 1874 based on its description in the Goncourt journals. See Goncourt 1956, vol. 2, pp. 967–68.

39. The photograph was first associated with the painting in I. Guest 1984, p. 336.

40. See Shackelford 1984, pp. 43–58; see also Boggs 1988, pp. 234–36.

41. Three letters mention Mérante or his wife; one refers to a birthday party for the latter, which Degas attended. See Guérin 1947, pp. 44, 109–10, and Musée d'Orsay 1989, p. 401. Perrot's address appears in Nb. 22, p. 210. (This sketchbook has been dated to 1867–74, but Perrot did not live at the address noted until 1879; see I. Guest 1984, p. 337.)

42. The works are L 341, L 364-66, L 397, L 430; III:67, III:157.2, III:157.3; J 1; and Nb. 28, p. 41.

43. III:157.2. The drawing is inscribed: "reflets rouge de la / chemise dans le cou / pantalon bleu / flanelle / tête rose."

44. For the dating of both works, see Shackelford 1984, pp. 50–52, 56–58, Boggs 1988, pp. 239–40.

45. Gautier 1986, pp. 86–87.

46. In I. Guest 1953, p. 75, it is proposed that Halévy is the author.

47. I. Guest 1984, p. 336.

48. The monotype is clearly a composite image, based on studies for such paintings and pastels as L 340, L 341, L 397, L 398, L 400, L 425, and L 498.

49. The names of several dancers inscribed in Degas' sketchbooks are noted in Kahane 1998, p. 53. Others include (the spellings vary) the following: Anna Jousset (Nb. 22, p. 209), Augustine Malot (Nb. 27, p. 8), Mlle Mércèdes (Nb. 22, p. 222), Mlle Pallier (Nb. 22, p. 216), Marie van Goethem (Nb. 34, p. 4), and Mlle Vitcoq (Nb. 22, p. 220). For drawings with dancers' names on them, see the following: Gaujelin (L 325 and III:156.1), Mathilde Salle (L 868), and Mlle Bouissavin (an uncatalogued drawing, plate 252). See also the studies listed in note 5 above.

50. Melina Darde, Rosita Mauri, Rita Sangalli, and Marie Sanlaville had performed with other companies; Joséphine Gaujelin and Mlle Hughes left the Opéra for other theaters.

51. The inscription on the drawing, II:230.1, reads: "Melina Darde / 15 ans / [term unclear, possibly "danseuse" or "d'aujourd'hui"] / à la Gaîté / Dec. 78."

52. The exhibition was held during April and May 1879, and *Korrigane* did not premiere until December 1880. Darde's name also appears in an 1882 *livret* for *Françoise de Rimini*.

53. The painting, now at the Norton Simon Museum, once belonged to Alexis Rouart, Degas' friend.

54. IV:181; see also IV:180.

55. Darde's name does not appear on the list of those who rose to the level of *petit sujet* in Wolff 1962, pp. 529–33.

56. In Browse 1949, p. 60, Darde is identified in three other drawings: II:350; III:357.2; and an uncatalogued study (Browse no. 67).

57. For *Singer with a Glove*, see Berson 1996, vol. 2, p. 111, no. IV-70. *Study for "Bust of a Dancer"* recalls such genre pictures so strongly that it was formerly taken for an image of a singer; see Orangerie des Tuileries 1969, p. 36, no. 160, where it is titled *La Chanteuse*.

58. See Distel 1990, pp. 252–56.

59. The body derives from III:336.

60. For the Mantes' residence near Degas, see Boggs, in Baumann and Karabelnik 1994, pp. 69, 84 n. 37.

61. See Browse 1949, p. 60, and Millet 1979, p. 105.

62. L 79.

63. See Reff 1969, p. 283.

64. Related works include a variant of this portrait (L 972) and two pastels of the girl in a tutu (L 969, L 970).

65. See Millet 1979.

66. Although Suzanne Mante claimed that she and Blanche modeled for Degas' portrait, the apparent age difference of his models makes this unlikely. See Browse 1949, p. 60, and Boggs, in Baumann and Karabelnik 1994, p. 69.

67. Browse 1947, p. 61.

68. Ibid., p. 60.

69. The rue de Douai address and Marie's name are noted on a drawing (III:341.2) and in Nb. 34, p. 4; Antoinette's name and current address appear in Nb. 22, p. 211. It is unclear if Louise ever posed for Degas; see Coquiot 1924, p. 81; Browse 1949, p. 62; and Kahane 1998, p. 62.

70. For studies of the sculpture and other works associated with Marie, see Kendall 1998; Boggs 1988, pp. 331, 337, 355, 356, 399, 435; and Browse 1949, pp. 62, 389–91. On the basis of these pictures, Marie may also be proposed as the subject of *Head Resting on One Hand* (R XXIX). This identification is further supported by Cassatt's reference to a bust of the girl who modeled for the *Little Dancer, Aged Fourteen*; see Boggs 1988, p. 337.

71. Guérin 1947, pp. 13–16, 20. Degas was evidently unsure of the spelling of "Vittoq" (actually Vitcoq), and yet another variant, "Vilcoq," occurs in Nb. 22, p. 220. The spelling of "Malot" varies, depending on the source.

72. For Simon and Malot, see the *livret* for *Pierre de Medicis*; for Vitcoq, see d'Heylli 1875, p. 379.

73. See also L 443, a fourth portrait of the dancer. L 441 (plate 239) was reproduced in Degas' lifetime, when it was owned by his friend Jacques-Emile Blanche, as *Portrait of Mlle Malot*; see Du Bois 1906, p. 351.

74. For the date and title of *Woman with Chrysanthemums* (L 125), see Boggs 1988, pp. 114–16.

75. See Pickvance 1993, p. 20.

76. In a fit of jealousy Malot's husband attacked Achille, who responded by wounding him with a revolver. The event was reported in the press, and both men spent a month in jail; see McMullen 1984, p. 251, and Loyrette 1991, pp. 320–23.

77. Musée d'Orsay 1989, p. 421.

78. Many of these changes are apparent to the naked eye and are confirmed in an X ray of the painting.

79. See Chapter 6, note 79, for the harlequin works.

80. X. Y. Z. 1875, p. 332. See also Vizentini 1868, p. 35; Mahalin 1887, p. 228; and Dupêchez 1984, p. 133.

81. See Jeanniot 1933, p. 153, and Reff 1969, p. 287.

82. The photograph is reproduced in Buchanan 1997, p. 100. The subject is tentatively identified as Sanlaville in Boggs 1962, p. 65, and Boggs 1967, p. 194.

83. See Buchanan 1997, p. 98.

84. Dressed in travesty, Sanlaville played the lead "male" role in *Les Deux Pigeons*. See Pitou 1990, vol. 1, pp. 337–38.

85. Degas 1946, Sonnet VI, pp. 35–36 (authors' translation).

86. For further discussion of Degas' harlequin pastels and *Les Jumeaux de Bergame*, see Chapter 6.

87. Jeanniot 1933, pp. 152–53.

88. See Boggs 1988, p. 457.

89. Choreographed by Mérante, *Korrigane* premiered at the Opéra in 1880; for Degas' attendance, see Loyrette 1989, pp. 59–63.

90. See Tinterow, in Boggs 1988, p. 457.

91. *Le Journal Illustré*, Dec. 27, 1885.

92. This was first noted in Boggs 1962, p. 130.

93. Nb. 23, pp. 46–47.

94. For Biot and Sacré, see Guérin 1947, pp. 104, 73; for Grangé, see Nb. 22, p. 22; for Subra, see Muehlig 1979, p. 6; Salle and Chabot are discussed below.

95. For the debuts of these dancers, see Wolff 1962, pp. 529–34.

96. For Blanc, see Nb. 22, p. 206; for Carpentier, see Nb. 26, p. 92; and for the Prince sisters, see Nb. 22, p. 209, and Nb. 26, p. 88. These individuals were first identified as dancers in Kahane 1998, p. 53.

97. Franklin was identified as a dancer in Brame and Reff 1984, p. 116 (no. 107), and in Shackelford 1984, p. 88. She appears in a study for *The Dance Lesson* (II:354, inscribed with her name) and possibly in an uncatalogued drawing in the Louvre (RF. 30013).

98. See Mahalin 1887, p. 242; Mérode 1985, p. 107; and Loyrette 1991, p. 541.

99. Camondo's collection is described in Loyrette 1991, p. 605. If Degas hoped to appeal to Camondo's historical tastes, he appears to have failed; the portrait of Salle was not among the nearly two dozen works by Degas that Camondo acquired.

100. In Millard 1979, pp. 10–11, the sculpture is dated to 1892, based on correspondence between Degas and Bartholomé.

101. For the two letters cited, see Millard 1979, p. 10. The third letter is in Reff 1968, pp. 92–93, where it is dated July 1890; it has since been redated to Aug. 19, 1892. We are most grateful to Theodore Reff for this information.

102. R XXX and R XXXI. The medium for both works has been variously described as "clay" and "undefinable matter containing plaster"; see Millard 1979, pp. 10–11, and Rewald 1944, pp. 98, 100.

103. See Millard 1979, pp. 35–39.

104. The picture was exhibited as *Portrait of Mlle Sallandry* in Galerie Georges Petit 1924 (no. 172) and in Orangerie des Tuileries 1931 (no. 143), and titled thus by Lemoisne 1946 (L 813). In Boggs 1962, p. 65, the subject is tentatively identified as Mlle Salle.

105. See L 690, L 691, and Nb. 37, p. 5. Chabot may also be recognized in L 804, L 838, and L 882.

106. See Reff 1969, p. 287, and Guérin 1947, pp. 74–75. In recent correspondence, Theodore Reff has helpfully indicated that these letters should be dated between June 1882 and November 1883.

107. Musée d'Orsay 1989, p. 401.
108. Guérin 1947, p. 74.
109. Boggs and Maheux 1992, p. 140. For a related drawing, see III:302.
110. Chabot was nineteen in 1883; see Browse 1949, p. 61.
111. See L 847, L 855, L 873, L 876, L 897, and BR 115.
112. Mérode 1985, p. 86.
113. L 1014.
114. Mérode 1985, p. 122.
115. Ibid., p. 86.
116. Michel 1919, p. 476.
117. Ibid., p. 638.
118. For the drawings, see III:122.1 and III:180; IV:263 and IV:268; an uncatalogued study in Belgrade (plate 254); and an uncatalogued sheet at the Baltimore Museum of Art (50.12.658). For the paintings and pastels, see L 819, L 1087, L 1087 bis, L 1093, L 1094, L 1097, and an uncatalogued pastel at the Dallas Museum of Art, *Group of Dancers* (plate 271).
119. See Wolff 1962, p. 529.
120. Ibid., p. 450; see also pp. 39, 264.
121. L 447.
122. For Degas' obsession with Caron, see Chapter 6.
123. For the drawings in question, see note 118 above.
124. See Chapter 8.

CHAPTER 8 THE LAST DANCERS

1. Hertz 1920, p. 55.
2. Michel 1919, pp. 464, 637.
3. See Kendall 1996, chaps. 3–5.
4. Boggs 1988, p. 574.
5. For exhibitions during these years, see Kendall 1996, pp. 39–51, 294–95; Berson 1996, vol. 1, p. 451.
6. Geffroy 1894, p. 175; Fevre 1949, p. 14.
7. Valéry 1960, p. 22; Lafond 1918–19, vol. 1, p. 114.
8. Lafond 1918–19, vol. 1, p. 114.
9. See also Michel 1919, pp. 457–59.
10. Loyrette 1989, p. 63.
11. Lafond 1918–19, vol. 1, p. 89.
12. See note 62 below.
13. See Kendall 1996, pp. 16–17; and Raunay 1931.
14. See Kendall 1996, pp. 16, 159.
15. Michel 1919, p. 470.
16. Guérin 1947, p. 184.
17. D. Halévy 1960, p. 40.
18. See Kendall 1996, chap. 6.
19. Havemeyer 1961, p. 256.
20. Ephrussi, in Berson 1996, vol. 1, p. 337, and Trianon, in Berson 1996, vol. 1, p. 368. See Reff 1978, p. 149, and Kendall 1998, pp. 45–51.
21. Hertz 1919, p. 37; Rothenstein 1931–32, p. 104; Gsell 1918, p. 373.
22. See Vollard 1914, pl. XIV.
23. Vuillier 1898, p. viii.
24. See, for example, Lajarte 1883, Magnier 1885, Desrat 1885–88, and Soria 1897.
25. Blasis 1828, p. 9.
26. Véron 1854, p. 304; Gautier 1986, p. 16.
27. Gautier 1986, pp. 275, 305.
28. Duval 1875–77, vol. 3, p. 69.
29. Magnier 1885, p. 1.

30. For these classical productions, see the appropriate entries in Pitou 1990 and Wolff 1962.
31. See Berson 1996, vol. 1, p. 260, and vol. 2, p. 147; and D. Halévy 1960, pp. 183–84.
32. Taine 1985, pp. 58–59.
33. Desrat, 1885–88, p. 19.
34. Vuillier 1898, pp. 4, 11, 14; Soria 1897, p. 70. See also Druick 1989, pp. 244–45.
35. Though both were listed in the catalogue, the *Little Dancer, Aged Fourteen* was not ready in time for the exhibition, and perhaps because of its exclusion, *Young Spartans Exercising* was also withheld.
36. Fevre 1949, p. 50.
37. Reff 1964, p. 257.
38. The studies for *Young Spartans Exercising* are in Burnell 1969.
39. Bentley 1988.
40. See Pitou 1990, pp. 312–14.
41. Wolff 1962, p. 70.
42. Brettell 1995, p. 121.
43. In Thomson 1987, p. 37, the resemblance between *Young Spartans Exercising* and a preparatory drawing for *Group of Dancers* is noted.
44. Thiébault-Sisson 1923, p. 3. See also Kendall 1996, pp. 254–75.
45. Certain examples, such as R XXXII, R XXXIII, and R XLVI, also show a similar physique and a comparable surface finish, and are perhaps based on the same model.
46. Valéry 1960, p. 35.
47. Jeanniot 1933, pp. 158–59.
48. For the X ray of this picture and a further discussion of its history, see Kendall 1996, pp. 121–22.
49. The relief is *Apple Pickers*, R I.
50. See Kendall 1995.
51. Millard 1976, chap. 5.
52. Ibid., p. 69.
53. Duranty 1881, p. 335; Nb. 31, p. 81; D. Halévy 1960, p. 68.
54. Emmanuel 1896 (i); Emmanuel 1896 (ii).
55. Emmanuel 1896 (i), p. 291.
56. Ibid., p. 294.
57. Emmanuel 1896 (ii), pp. 144–45, 150–51.
58. Ibid., pp. 82–83.
59. Emmanuel 1896 (i), p. 298.
60. For Degas and Tanagra sculpture, see Kendall 1996, pp. 136–37.
61. See Mérode 1985, p. 86.
62. For the Gluck revival, see Pitou 1985, p. 248; Degas' visit to *Orfeo* is recorded in Baudot 1949, p. 103, and to *Iphigénie en Tauride* in Manet 1979, p. 189.
63. See Wolff 1962, pp. 279, 264, 41–42.
64. In Mérode 1985, pp. 168–69, the dancer tells how she normally wore tinted covering on all her limbs and was considered daring for exposing her arms in 1897.
65. Mérode 1985, p. 86.
66. Ibid., pp. 143–45.
67. See L 148.
68. See, for example, L 725 and III:131.2.

69. L 998, L 999 bis, L 1459.
70. Vollard 1914, plates III, XXXVIII, XLII, LXVII, LXXIII, LXXV, XCI.
71. For his collecting, see Dumas et al. 1997, and Ives et al. 1997. For Degas' promotion of his drawings, see Kendall 1996, pp. 50–51.
72. It is related to, but not identical with, figures in L 1254-9.
73. Guérin 1947, p. 229. The resemblance between the Oslo drawing and R XLVI is noted in Camesasca 1986, p. 203.
74. Huysmans, in Berson 1996, vol. 1, pp. 291–92.
75. Sickert 1917, pp. 184–85.
76. For its history, see Lemoisne 1946–49, vol. 3, p. 548.
77. Michel 1919, p. 457.
78. See, for example, L 388 and L 587.
79. Millard 1976, p. 71 and plates 99–100. Similar poses can also be found in erotic photographs and illustrations; see, for example, Richter 1989, pp. 82–83.
80. The technical history of this painting is discussed in Kendall 1996, pp. 114, 118, 256.
81. See R XLV, R XLIX, R LX, R LXI, R LXII, R LXV.
82. See, for example, Kendall 1996, pp. 270–71.
83. Guérin 1947, p. 174; the works that resulted appear to be RS 59–66.
84. Guérin 1947, p. 117.
85. Michel 1919, p. 631.
86. See L 1103, L 1101-2. The Philadelphia picture appears to have been cropped at the lower edge as part of the artist's rearrangement of the composition. See also Boggs 1985, pp. 36–39.
87. Vollard 1914, plate XCVIII.
88. For this sequence, see Boggs 1985, pp. 36–39, and Reff 1974, p. 42.
89. The dense surface of this painting suggests a complex technical history, perhaps beginning in the early 1880s but followed by at least one phase of repainting as much as a decade later.
90. We are most grateful to Anne Maheux for her help in examining this pastel and to Harriet Stratis for making this possible.
91. For a proposed subject, see Chapter 6.
92. See Daniel 1999, nos. 42–44.
93. The sale of this pastel appears to coincide with a letter from the artist to Durand-Ruel in February 1900, though the gallery record of its title is inaccurate; see Musée d'Orsay 1989, p. 479.
94. Manet 1979, p. 238.
95. See L 1187.
96. Kendall 1996, pp. 276–87.
97. See Vuillier 1898, pp. 199–210, and Soria 1897, pp. 253–55.
98. Vollard 1937, p. 69.
99. For this phenomenon, see Kendall 1996, pp. 120–23.
100. Crucially, a very closely related work (L 841) that had been similarly repainted was sold by Degas to Vollard; see Vollard 1914, plate IX.
101. L 1267.
102. There are some indications that this picture was partially reworked by the artist, but the existing paint surface appears to be largely continuous.
103. Fevre 1949, p. 115.

Checklist of the Exhibition

The checklist is organized chronologically by medium. A variety of contextual materials, not listed below, are also included in the exhibition.

The number in parentheses that precedes the plate number is the one assigned to those works in Brame and Reff 1984 (abbreviated as BR); Janis 1968 (J); Lemoisne 1946–49 (L); Reff 1976 (Nb); Rewald 1944 (R); Reed and Shapiro 1984 (RS); and in the Degas studio sales (I, II, III, and IV)—see Vente Atelier Edgar Degas 1918–19.

PAINTINGS

Madame Gaujelin, 1867
Oil on canvas, 24⅛ x 18 in. (61.2 x 45.7 cm)
Isabella Stewart Gardner Museum, Boston (P1e4)
(L 165)
Plate 48, page 49
(Philadephia only)

Madame Gaujelin, 1867
Oil on mahogany, 13⅞ x 10½ in. (35 x 26.5 cm)
Hamburger Kunsthalle, Hamburg
(L 166)
Plate 224, page 201
(Philadelphia only)

Mlle Fiocre in the Ballet "La Source," 1867–68
Oil on canvas, 51½ x 57⅛ in. (130.8 x 145 cm)
Brooklyn Museum of Art; Gift of James H. Post, A. Augustus Healy and John T. Underwood (21.111)
(L 146)
Plate 49, page 50
(Philadelphia only)

Portrait of a Woman (Mlle Malo?), c. 1868–93
Oil on canvas, 25½ x 21 in. (64.8 x 53.3 cm)
The Detroit Institute of Arts; Gift of Ralph Harman Booth (21.8)
(L 442)
Plate 241, page 215

Orchestra Musicians, c. 1870–71
Oil on canvas, 27⅛ x 19¼ in. (69 x 49 cm)
Städtische Galerie im Städelschen Kunstinstitut, Frankfurt am Main (SG237)
(L 295)
Plate 1, page 12

The Ballet from "Robert le Diable," 1872
Oil on canvas, 26 x 21⅜ in. (66 x 54.3 cm)
The Metropolitan Museum of Art; H.O. Havemeyer Collection, Bequest of Mrs. H.O. Havemeyer, 1929 (29.100.552)
(L 294)
Plate 53, page 53

The School of Ballet, c. 1873
Oil on canvas, 18¾ x 24½ in. (47.6 x 62.2 cm)
The Corcoran Gallery of Art, Washington, D.C.; William A. Clark Collection (26.74)
(L 398)
Plate 146, page 137

The Dance Rehearsal, c. 1873
Oil on canvas, 16 x 21½ in. (40.6 x 54.6 cm)
Private collection, courtesy The Phillips Collection, Washington, D.C.
(L 362)
Plate 87, page 82

The Rehearsal, c. 1873–78
Oil on canvas, 18 x 23⅝ in. (45.7 x 60 cm)
The Fogg Art Museum, Harvard University Art Museums, Cambridge, Massachusetts; Bequest from the Collection of Maurice Wertheim, Class of 1906 (1951.47)
(BR 60)
Plate 88, page 84

The Dance Class, 1874
Oil on canvas, 32¾ x 30¼ in. (83.2 x 76.8 cm)
The Metropolitan Museum of Art; Bequest of Mrs. Harry Payne Bingham, 1986 (1987.47.1)
(L 397)
Plate 127, page 118

Ballet Rehearsal on the Stage, 1874
Oil on canvas, 25⅝ x 31⅞ in. (65 x 81 cm)
Musée d'Orsay, Paris (RF 1978)
(L 340)
Plate 61, page 59

Two Dancers on a Stage, 1874
Oil on canvas, 24½ x 18⅛ in. (62 x 46 cm)
Courtauld Institute Gallery, Somerset House, London
(L 425)
Plate 173, page 156
(Philadelphia only)

Yellow Dancers (In the Wings), 1874–76
Oil on canvas, 29 x 23⅜ in. (73.5 x 59.5 cm)
The Art Institute of Chicago; Gift of Mr. and Mrs. Gordon Palmer, Mr. and Mrs. Arthur M. Wood, and Mrs. Bertha P. Thorne (1963.923)
(L 512)
Plate 76, page 72

Head of a Woman, c. 1875
Oil on canvas, 6⅞ x 7¾ in. (17.5 x 19.7 cm)
Tate London; Presented by A.E. Anderson through the National Art Collections Fund 1924 (NO 3833)
(L 330)
Plate 222, page 199

Dancers Practicing in the Foyer, c. 1875–1900
Oil on canvas, 28 x 34⅝ in. (71 x 88 cm)
Ny Carlsberg Glyptotek, Copenhagen
(L 924)
Plate 91, page 86

Ballet Scene from Meyerbeer's Opera "Robert le Diable," 1876
Oil on canvas, 29¾ x 32 in. (76.6 x 81.3 cm)
Trustees of the Victoria & Albert Museum, London (CAI.19)
(L 391)
Plate 58, page 57

Dancers Backstage, 1876–83
Oil on canvas, 9½ x 7⅜ in. (24.2 x 18.8 cm)
National Gallery of Art, Washington; Ailsa Mellon Bruce Collection (1970.17.25)
(L 1024)
Plate 75, page 71

Dancer on the Stage, c. 1877–80
Oil on canvas, 36 x 46½ in. (91.4 x 118.1 cm)
Smith College Museum of Art, Northampton, Massachusetts; Gift of Paul Rosenberg and Company, 1955 (1955:14)
(L 469)
Plate 187, page 169
(Detroit only)

The Ballet Class, c. 1878–80
Oil on canvas, 32⅛ x 30⅛ in. (81.6 x 76.5 cm)
Philadelphia Museum of Art; Purchased with the W.P. Wilstach Fund, 1937 (W1937-2-1)
(L 479)
Plate 164, page 148

Fan: Dancers and Stage Scenery, c. 1878–80
Gouache with gold highlights on silk, mounted on card, 12¼ x 24 in. (31 x 61 cm)
Private collection, Switzerland
(L 556)
Plate 112, page 105

Ballet Scene, c. 1878, 1893
Oil on canvas, 23¼ x 19⅝ in. (59 x 49.8 cm)
Private collection
(L 843)
Plate 316, page 274

The Dance Lesson, c. 1879
Oil on canvas, 14⅞ x 34⅝ in. (38 x 88 cm)
National Gallery of Art, Washington; Collection of Mr. and Mrs. Paul Mellon (1995.47.6)
(L 625)
Plate 121, page 112

Dancers (fan design), c. 1879
Gouache (or distemper) with gold and charcoal on silk, 13⅛ x 24¾ in. (33.3 x 62.9 cm)
The Baltimore Museum of Art; Fanny B. Thalheimer Memorial Fund (1963.009)
(I 555)
Plate 114, page 106

Fan: Dancers, c. 1879
Gouache, pastel, and essence on silk, 12 x 23½ in. (30.5 x 59.7 cm)
Tacoma Art Museum; Gift of Mr. and Mrs. W. Hilding Lindberg (1983.001.008)
(L 564)
Plate 111, page 104

The Dancing Lesson, c. 1880
Oil on canvas, 15½ x 34⅜ in. (39.4 x 88.4 cm)
Sterling and Francine Clark Art Institute, Williamstown, Massachusetts (1955.562)
(L 820)
Plate 168, page 152

Three Dancers in the Wings, c. 1880–85
Oil on canvas, 21½ x 25½ in. (54.5 x 65 cm)
Private collection, New York
(BR 91)
Plate 106, page 99

Dancers in the Green Room, c. 1880–94
Oil on canvas, 16¼ x 34½ in. (41.3 x 87.6 cm)
The Detroit Institute of Arts; City of Detroit Purchase
 (21.5)
(L 900)
Plate 125, page 116

Dancers in Blue, c. 1882–90
Oil on canvas, 20 x 24⅛ in. (50.8 x 61.3 cm)
Private collection, New York
(L 704)
Plate 152, page 141

Dancers in Red Skirts, c. 1884
Oil on canvas, 15 x 18 in. (38 x 44.5 cm)
Ny Carlsberg Glyptotek, Copenhagen
(L 783)
Plate 77, page 73

Dancers on the Stage, c. 1889–94
Oil on canvas, 30 x 31⅞ in. (76 x 81 cm)
Musée des Beaux-Arts, Lyon
(L 987)
Plate 309, page 268

Ballet Dancers, c. 1890–1900
Oil on canvas, 28⅜ x 28¾ in. (72.4 x 73 cm)
National Gallery, London (NG 4168)
(L 588)
Plate 300, page 260

Dancer with Bouquets, 1890–1900
Oil on canvas, 71 x 60 in. (180 x 151 cm)
Chrysler Museum of Art, Norfolk, Virginia; Gift of
 Walter P. Chrysler Jr., in memory of Della Viola
 Forker Chrysler (71.507)
(L 1264)
Plate 214, page 192

Dancer on Stage, c. 1894
Oil on wood, 8¾ x 6¼ in. (22 x 15.8 cm)
Hamburger Kunsthalle, Hamburg
(L 1091)
Plate 256, page 227

Blue Dancer, c. 1894
Oil on canvas, 13 x 9⅞ in. (33 x 25 cm)
Private collection, Connecticut
(L 1093)
Plate 257, page 228

Three Dancers in Yellow Skirts, c. 1899
Oil on canvas, 32 x 25⅝ in. (81.3 x 65.1 cm)
UCLA Hammer Museum, Los Angeles; The Armand
 Hammer Collection, Gift of the Armand Hammer
 Foundation (AH 90.20)
(L 1100)
Plate 318, page 276

Dancers at the Barre, c. 1900
Oil on canvas, 51¼ x 38½ in. (130.2 x 97.8 cm)
The Phillips Collection, Washington, D.C.; Acquired
 1944 (0479)
(L 807)
Plate 320, page 278

Harlequin and Columbine, c. 1900
Oil on panel, 13 x 9¼ in. (33 x 23.5 cm)
Musée d'Orsay, Paris (RF1961-28)
(L 1111)
Plate 205, page 184

WORKS ON PAPER

Portrait of Madame Gaujelin, 1867
Pastel and pencil on paper, 17¾ x 13 in. (45 x 33 cm)
Private collection, United States
(Ex-Lemoisne/Vente)
Plate 223, page 200
(Philadelphia only)

Spanish Dancers and Musicians, c. 1868–69
Watercolor, pen, and black ink on wove paper, arched,
 20¼ x 10¼ in. (51.4 x 26 cm)
National Gallery of Art, Washington; Woodner
 Collection (2000.25.3)
(L 173)
Plate 46, page 48

*Nuns Dancing, Study for the Ballet from "Robert le
 Diable,"* 1871
Essence on buff laid paper, 22¾ x 31 in. (57.7 x 78.7 cm)
Trustees of the Victoria & Albert Museum, London
 (E3688-1919)
(III:364.1)
Plate 55, page 56

*Nuns Dancing, Study for the Ballet from "Robert le
 Diable,"* 1871
Essence on buff laid paper, 22¾ x 31 in. (57.7 x 78.7 cm)
Trustees of the Victoria & Albert Museum, London
 (E3687-1919)
(III:364.2)
Plate 56, page 56

*Nuns Dancing, Study for the Ballet from "Robert le
 Diable,"* 1871
Essence on buff laid paper, 22¾ x 31 in. (57.7 x 78.7 cm)
Trustees of the Victoria & Albert Museum, London
 (E3686-1919)
(III:363.2)
Plate 57, page 56

Two Dancers at the Barre, 1871–72
Essence on pink paper, 8¾ x 11⅛ in. (22.3 x 28.3 cm)
Museum Boijmans Van Beuningen, Rotterdam (F II 54)
(L 300 bis)
Plate 144, page 136

Dancer Adjusting Her Slipper, c. 1872–73
Graphite heightened with white chalk on paper, 12⅞ x
 9⅝ in. (32.7 x 24.4 cm)
The Metropolitan Museum of Art; H.O. Havemeyer
 Collection, Bequest of Mrs. H.O. Havemeyer, 1929
 (29.100.941)
(Ex-Lemoisne/Vente)
Plate 227, page 203

Ballet Dancer Adjusting Her Costume, c. 1872–73
Graphite heightened with white chalk on pink paper,
 23⅝ x 18⅝ in. (60 x 47.3 cm)
The Detroit Institute of Arts; Bequest of John S.
 Newberry (65.145)
(II:332)
Plate 228, page 203

Joséphine Gaujelin, 1873
Pencil and black chalk on paper, 12 x 7¾ in.
 (30.7 x 19.7 cm)
Museum Boijmans Van Beuningen, Rotterdam
 (F II 169 [PK])
(III:156.1)
Plate 225, page 202

Dancers at the Barre, c. 1873
Oil paint, thinned with turpentine on green paper,
 18⅞ x 24⅝ in. (47.9 x 62.5 cm)
Trustees of The British Museum (1968-2-10-25)
(L 409)
Plate 147, page 138
(Philadelphia only)

Study of Legs, c. 1873
Black chalk heightened with white on blue paper,
 17¾ x 11⁷/₁₆ in. (45 x 29 cm)
Private collection, New York, courtesy W. M. Brady &
 Co., New York
(IV:138.a)
Plate 154, page 143

Seated Dancer, c. 1873–74
Charcoal, heightened with white and squared for
 transfer, on pink paper, 16⅜ x 12⅞ in. (41.7 x 32.7 cm)
The Metropolitan Museum of Art; H.O. Havemeyer
 Collection, Bequest of Mrs. H. O. Havemeyer, 1929
 (29.100.942)
(Ex-Lemoisne/Vente)
Plate 153, page 142
(Detroit only)

The Ballet Master, Jules Perrot, 1875
Oil sketch on brown paper, 18⅞ x 11¾ in. (47.9 x 29.8 cm)
Philadelphia Museum of Art; The Henry P. McIlhenny
 Collection in memory of Frances P. McIlhenny, 1986
 (1986-26-15)
(L 364)
Plate 230, page 205

Dancer on the Stage, c. 1875
Monotype on wove paper, 9¾ x 8⅛ in. (24.8 x 20.6 cm)
Statens Museum for Kunst, Copenhagen (KKS 9158)
(J 4)
Plate 206, page 185

Study of a Ballerina, c. 1876
Charcoal heightened with white on buff paper,
 19¼ x 11¾ in. (48.9 x 29.8 cm)
Private collection
(II:326)
Plate 63, page 60

On Stage III, 1876–77
Softground etching, drypoint, and roulette (red-brown
 ink) on cream to buff paper, 5¾ x 6¾ in.
 (14.6 x 17.1 cm)
Philadelphia Museum of Art; Purchased with the John
 D. McIlhenny Fund, 1941
(1941-008-33)
(RS 24)
Plate 184, page 166

Ludovic Halévy Meeting Madame Cardinal Backstage,
 1876–77. Illustration for *La famille Cardinal*.
Monotype on paper, 6⅝ x 8⅜ in. (16 x 21.3 cm)
Collection André Bromberg
(J 197)
Plate 73, page 70

The Foyer, 1876–77. Illustration for *La famille Cardinal*.
Monotype in black ink on white laid paper, 6⅜ x 4⅝
 in. (16.2 x 11.9 cm)
Collection André Bromberg
(J 229)
Plate 81, page 77

In the Foyer: Men and Dancers, 1876–77. Illustration
for La Famille Cardinal.
Monotype in black ink on vellum, 8⅝ x 7⅜ in.
(21.9 x 18.7 cm)
Collection André Bromberg
(J 231)
Plate 82, page 78

On the Stage, c. 1876–77
Pastel and essence over monotype on cream laid paper,
laid down on board, 24¼ x 16¾ in. (59.2 x 42.8 cm)
The Art Institute of Chicago; Potter Palmer Collection
(1922.423)
(L 601)
Plate 179, page 163
(Detroit only)

Conversation: Ludovic Halévy Speaking with Madame
Cardinal, c. 1876–77. Illustration for La Famille Cardinal.
Monotype in black ink heightened with pastel on
paper, 8½ x 6¼ in. (21.6 x 15.9 cm)
Private collection, courtesy James Roundell, London
(J 199)
Plate 12, page 21

Group of Four Men and Two Dancers (The Cardinal
Sisters Talking to Admirers), c. 1876–77. Illustration
for La Famille Cardinal.
Monotype in black ink on white paper, 10⅜ x 7½ in.
(26.3 x 19.1 cm)
Musée du Louvre; Departement des arts graphiques,
fonds Orsay (RF 30021)
(J 226)
Plate 69, page 66
(Philadelphia only)

Dancer with a Bouquet, Bowing, c. 1876–78
Charcoal heightened with white, gray chalk, and brown
pastel on paper, 20⅝ x 14⅝ in. (52.5 x 36 cm)
Private collection
(III:276)
Plate 171, page 154

Pauline and Virginie Conversing with Admirers,
c. 1876–80. Illustration for La Famille Cardinal.
Monotype on paper, 11⅜ x 7½ in. (29 x 19 cm)
The Fogg Art Museum, Harvard University, Cam-
bridge, Massachusetts; Bequest of Meta and Paul J.
Sachs (M14295)
(J 218)
Plate 66, page 62

Ballet at the Paris Opéra, 1877
Pastel over monotype on cream laid paper, 13⅞ x
27¹³⁄₁₆ in. (35.2 x 70.6 cm)
The Art Institute of Chicago; Gift of Mary and Leigh
Block (1981.12)
(L 513)
Plate 183, page 166
(Detroit only)

An Album of Pencil Sketches, 1877
Book: 10¼ x 13¾ x ¾ in. (26 x 34.9 x 1.9 cm)
Pages: pencil on wove paper, 9⅞ x 13⅜ in.
(25 x 34 cm)
The J. Paul Getty Museum, Los Angeles (95.GD.35)
(Nb. 28)
Plate 139, page 132; plate 140, page 133

Dancer in Walking Position with Arms Stretched Forward,
c. 1877
Charcoal on blue-gray wove paper, 18¾ x 12¼ in.
(47.7 x 31 cm)
Statens Museum for Kunst, Copenhagen (KKS8527)
(IV:282b)
Plate 189, page 170

Dancer (Battement in Second Position), 1878
Charcoal heightened with white on tan paper,
12¼ x 22⅞ in. (31.1 x 58.1 cm)
Private collection, Massachusetts
(III:359)
Plate 234, page 208

Sketchbook Page with Studies of a Female Head and
Dancer, c. 1878
Black, white, violet, and green chalks on paper,
18½ x 11¾ in. (47.8 x 31.3 cm)
Private collection, courtesy R. M. Thune
(III:209a)
Plate 124, page 115

The Star, c. 1878
Pastel over monotype on paper, 17⅜ x 13½ in.
(44.3 x 34.3 cm)
Philadelphia Museum of Art; Bequest of Charlotte
Dorrance Wright, 1978 (1978-1-50)
(L 492)
Plate 103, page 96
(Philadelphia only)

Three Ballet Dancers, c. 1878–80
Monotype on paper, 14 x 19⅛ in. (35.6 x 48.6 cm)
Sterling and Francine Clark Art Institute, Williamstown,
Massachussetts (1955.1386)
(J 9)
Plate 34, page 41

Dancer Adjusting Her Slipper, c. 1879
Charcoal on tan paper, 12 x 8⅞ in. (30.5 x 22.5 cm)
The Detroit Institute of Arts; Founders Society Pur-
chase, Elizabeth Allan and Warren Shelden Fund
(67.273)
(III:137.1)
Plate 126, page 117

Dancer Resting, c. 1879
Charcoal and pastel on brown paper, 9 x 14⅛ in.
(23 x 35.8 cm)
Courtesy Colnaghi, London
(Ex-Lemoisne/Vente)
Plate 158, page 145

Fan: Dancers with a Double Bass, c. 1879
Pastel, black chalk, and ink wash on paper, 14⅛ x 25½
in. (36 x 65 cm)
Private collection, Dallas
(L 565)
Plate 110, page 104

Study for Bust of a Dancer, c. 1879
Pastel with highlights of gouache on gray paper,
24 x 18½ in. (61 x 47 cm)
Musée du Louvre; Departement des arts graphiques,
fonds Orsay (RF 12260)
(L 605)
Plate 236, page 210
(Philadelphia only)

Dancers in the Wings, 1879–80
Etching, aquatint, and drypoint on buff wove paper,
9⅜ x 7¾ in. (23.6 x 19.7 cm)
Philadelphia Museum of Art; Purchased with the
Joseph E. Temple Fund, 1949
(1949-089-004)
(RS 47)
Plate 190, page 171

In the Wings, c. 1879–80
Crayon lithograph (from transfer paper), 14 x 10 in.
(35.5 x 25.4 cm)
Private collection, courtesy Ruth Ziegler Fine Arts,
New York
(RS 38)
Plate 78, page 74

Dance Examination, 1880
Pastel and charcoal on paper, 25⅝ x 18⅝ in.
(63.4 x 48.2 cm)
Denver Art Museum; Anonymous gift (1941.6)
(L 576)
Plate 128, page 121

Dancer Adjusting Her Slipper, Bust of Pierrette, c. 1880
Pencil and gouache on paper, 16¾ x 12¼ in.
(42.6 x 31.2 cm)
Private collection, United Kingdom, courtesy Frost &
Reed, London
(IV:205a)
Plate 136, page 129

Dancers in Plié at the Barre, c. 1880
Pastel on paper, 13 x 20 in. (32 x 52 cm)
Collection Janet Traeger Salz, New York
(L 758)
Plate 141, page 134

Preparation for an Inside Pirouette, c. 1880
Charcoal and black crayon on paper, 13¼ x 10⅝ in.
(33.6 x 22.7 cm)
The National Museum, Belgrade (217)
(Ex-Lemoisne/Vente)
Plate 149, page 139

The Foyer of the Dance, c. 1880
Watercolor and monotype on paper, 18 x 20 in.
(45.7 x 50.8 cm)
Philadelphia Museum of Art; The Henry P. McIlhenny
Collection in memory of Frances P. McIlhenny, 1986
(1986-26-12)
(BR 86)
Plate 157, page 144

Dancer Stretching in Attitude, c. 1880
Charcoal on paper, 11⅝ x 9 in. (29.5 x 23 cm)
Hamburger Kunsthalle; Hegewisch Collection
(III:84.1)
Plate 159, page 145

Dancer Executing Port de Bras, c. 1880
Black chalk and pastel on paper, 8⅞ x 9¾ in.
(24.7 x 32 cm)
Private collection
(II:234.2)
Plate 172, page 155

At the Theater, Woman with a Fan, c. 1880
Lithograph, 9⅛ x 7⅞ in. (23.2 x 20 cm)
Museum of Fine Arts, Boston; Bequest of W.G. Russell
Allen (60.260)
(RS 37)
Plate 100, page 94

Dancer at the Barre, c. 1880
Charcoal heightened with white on paper, 18¾ x 23⅞ in.
(47.5 x 60.5 cm)
Private collection, courtesy Galerie Jan Krugier,
Ditesheim and Cie, Geneva
(III:372)
Plate 167, page 151

A Coryphée Resting, c. 1880–82
Pastel on paper, 18⅞ x 24½ in. (47.9 x 62.2 cm)
Philadelphia Museum of Art; The John G. Johnson
 Collection (J970)
(L 659)
Plate 123, page 114
(Philadelphia only)

An Album of Drawings, 1882–85
Book: 10⅞ x 8⅝ in. (27.6 x 22 cm)
Pages: graphite on tracing paper, 10⁹⁄₁₆ x 8⅝ in.
 (26.7 x 21. 9)
The Metropolitan Museum of Art; Fletcher Fund, 1973
 (1973.9)
(Nb. 36)
Plate 156, page 144

Dancer Stretching, c. 1882–85
Pastel on paper, 18⅜ x 11¾ in. (46.7 x 29.7 cm)
Kimbell Art Museum, Fort Worth, Texas (PA 1968.04)
(L 910)
Plate 132, page 125

Ballet Dancers on the Stage, 1883
Pastel on paper, 24½ x 18⅝ in. (62.2 x 47.3 cm)
Dallas Museum of Art; Gift of Mr. and Mrs. Franklin B.
 Bartholow (1986.277)
(L 720)
Plate 107, page 100

Program for the Soirée Artistique, 1884
Lithograph, 9⅞ x 12⅝ in. (27.5 x 38.8 cm)
S.P. Avery Collection, Miriam and Ira D. Wallach Divi-
 sion of Art, Prints and Photographs, The New York
 Public Library, Astor, Lenox and Tilden Foundations
(RS 54)
Plate 196, page 175

Dancer with Red Stockings, c. 1884
Pastel on pink laid paper, 29⅞ x 23⅛ in. (75.9 x 58.7 cm)
The Hyde Collection Art Museum, Glens Falls, New
 York (1971.65)
(L 760)
Plate 137, page 130

The Mante Family, c. 1884
Pastel on paper, 35⅜ x 19¾ in. (89.9 x 50.2 cm)
Philadelphia Museum of Art; Given by Mrs. John
 Wintersteen, 1948 (1948-31-1)
(L 972)
Plate 237, page 212
(Philadelphia only)

Ballet from an Opera Box, c. 1884
Pastel on paper, 26 x 20 in. (66 x 50.8 cm)
Philadelphia Museum of Art; John G. Johnson
 Collection (J969)
(L 828)
Plate 94, page 88
(Philadelphia only)

Study of Two Dancers, c. 1885
Charcoal and chalk on paper, 18¼ x 24 in. (46.4 x 61 cm)
High Museum of Art, Atlanta, Georgia; Anonymous
 gift (1979.4)
(III:223)
Plate 131, page 124

Dancer Exercising at the Barre, c. 1885
Black chalk with touches of pink and white on paper,
 12⅜ x 9⅜ in. (31.2 x 23.7 cm)
Cincinnati Art Museum; Annual Membership Fund
 (1920.40)
(II:125.4)
Plate 162, page 147

Dancer Executing Tendu à la Seconde, c. 1885
Dark brown chalk on paper, 13 x 9 in. (32.9 x 23.1 cm)
Museum Boijmans Van Beuningen, Rotterdam (F II
 131)
(III:81.3)
Plate 150, page 139

Green Dancers, c. 1885
Pastel on wove paper, 28½ x 15½ in. (72.4 x 39.4 cm)
Private collection, Chicago
(L 473)
Plate 197, page 176

Dancer in Fifth Position, c. 1885
Charcoal on light brown paper, 14 x 9 in. (35.5 x 22.5 cm)
Collection Janet Traeger Salz, New York
(Ex-Lemoisne/Vente)
Plate 160, page 146

Ballet Dancer on Stage, c. 1885–90
Pastel on paper, 31 x 20 in. (78.7 x 50.8 cm)
Private collection, Chicago
(L 485)
Plate 312, page 270
(Detroit only)

Nude Dancer Adjusting Her Shoe, c. 1885–95
Charcoal heightened with white on paper, 21⅝ x 22 in.
 (55 x 56 cm)
Private collection, New York
(II:272)
Plate 279, page 245

*Mlle Sanlaville (or Mlle S., Première Danseuse à
 l'Opéra)*, c. 1886
Pastel on paper, 15⅜ x 10⅝ in. (39 x 27 cm)
Private collection
(L 898)
Plate 242, page 216

Portrait of a Woman, 1887
Pastel on wove paper, affixed to original pulpboard,
 19¾ x 19¾ in. (50 x 50 cm)
Collection Gregory Callimanopulos
(L 897)
Plate 244, page 218

Three Dancers, c. 1888–93
Pastel on paper laid down on board, 18½ x 12⅛ in.
 (47 x 30.8 cm)
Private collection, Florida
(L 1208)
Plate 298, page 259

Three Dancers, c. 1889–1905
Charcoal and pastel on blue-gray paper, 23¼ x 17⅞ in.
 (59 x 45 cm)
Museum of Fine Arts, Boston; Bequest of John T.
 Spaulding (48.872)
(II:335)
Plate 299, page 260

Dancers as Harlequin and Columbine, c. 1890
Charcoal and pastel on paper, 14½ x 12⅝ in. (37 x 32 cm)
Private collection
(III:323)
Plate 207, page 186

Nude Dancer with Arms Raised, c. 1890
Black chalk on wove paper, 12⅞ x 9⅜ in. (32.7 x 24 cm)
Statens Museum for Kunst, Copenhagen (KKS8524)
(III:141b)
Plate 272, page 240

Dancer in Egyptian Dress, Turned Toward the Right,
 c. 1890
Pastel on paper, 12¼ x 9½ in. (31.1 x 24.3 cm)
The National Museum, Belgrade (218)
(Ex-Lemoisne/Vente)
Plate 213, page 191

Seated Woman in a Yellow Dress, early 1890s
Pastel on buff paper mounted on board, 28 x 22⅞ in.
 (71 x 58 cm)
Collection Andrea Woodner and Dian Woodner, New
 York (WO-6)
(L 1135)
Plate 250, page 222

Two Dancers in the Wings, c. 1890–95
Pastel on paper mounted on cardboard, 23¼ x 18¼ in.
 (59.5 x 46.5 cm)
Museum of Fine Arts, Boston; Given by Mrs. Robert B.
 Osgood in memory of Horace D. Chapin (38.890)
(L 944)
Plate 297, page 258

*Harlequin and Columbine (Two Dancers in Body
 Stockings)*, c. 1890–95
Charcoal on tracing paper, 12½ x 9 in. (31.7 x 23.1 cm)
Museum Boijmans Van Beuningen, Rotterdam (F II 217
 [PK])
(III:265)
Plate 208, page 187

Two Dancers Resting, c. 1890–1900
Charcoal and colored chalk or pastel on paper,
 24¹⁵⁄₁₆ x 22¾ in. (63.2 x 57.8 cm)
Philadelphia Museum of Art; The Samuel S. White, 3rd
 and Vera White Collection, 1967 (1967-30-20)
(II:294)
Plate 303, page 262

Seated Nude Dancer Tying Her Shoe, c. 1893–98
Charcoal on buff paper, 22⅜ x 23½ in. (56.7 x 59.7 cm)
Collection Mr. and Mrs. Nico Delaive, Amsterdam
(III:332)
Plate 280, page 245

Nude Dancer, 1894
Charcoal on paper, 12¼ x 9 in. (31 x 23 cm)
Courtesy Galerie Berès, Paris
(III:122a)
Plate 255, page 226

Dancer with Raised Arms, Seen from the Back, 1894
Charcoal on paper, 12¼ x 9⅝ in. (31 x 24.5 cm)
The National Museum, Belgrade (215)
(Ex-Lemoisne/Vente)
Plate 252, page 224

Two Nude Dancers, c. 1895
Charcoal and pastel on paper, 24¾ x 18¾ in.
 (62.9 x 47.6 cm)
Collection Janet Traeger Salz, New York
(II:277)
Plate 265, page 236

Two Dancers Resting, c. 1895
Charcoal on tracing paper mounted on cardboard,
 20⅛ x 18¹¹⁄₁₆ in. (51.4 x 47.5 cm)
Philadelphia Museum of Art; The Louis E. Stern
 Collection (1963-181-144)
(II:288)
Plate 301, page 261
(Philadelphia only)

Study of a Nude, c. 1895
Charcoal on paper, 16⅝ x 19⅝ in. (65 x 50 cm)
Collection J. Kasmin, London
(L 1260 bis)
Plate 293, page 254

Two Dancers, c. 1895–97
Pastel on paper, 24¾ x 21¼ in. (62.9 x 54 cm)
The National Museum of Fine Arts, Stockholm (345)
(L 1296)
Plate 314, page 271

Before the Performance, c. 1895–1900
Oil on paper, 18⅞ x 24¾ in. (48 x 63 cm)
National Gallery of Scotland, Edinburgh (NG 2224)
(L 1261)
Plate 319, page 277

Study of a Nude Dancer, c. 1895–1900
Charcoal on paper, 23 x 13 in. (58.4 x 33 cm)
Collection James and Katherine Goodman, New York
(III:256)
Plate 288, page 250

Dancers, c. 1897
Pastel with charcoal on heavy wove paper, 35½ x 30 in.
 (90.2 x 76.2 cm)
The Detroit Institute of Arts; City of Detroit Purchase (21.6)
(L 1311)
Plate 305, page 264
(Detroit only)

Dancers, c. 1897–1901
Pastel and charcoal on tracing paper, 23¾ x 30⅝ in.
 (65.1 x 77.8 cm)
Collection Mr. and Mrs. A. Alfred Taubman
(L 1223)
Plate 264, page 235

Dancers in Repose, c. 1898
Pastel and charcoal on thin wove paper, fully attached
 to a thin supporting sheet, 34 x 27¾ in. (86.4 x 70.5 cm)
The Detroit Institute of Arts; Gift of Edward E.
 Rothman (72.441)
(L 1243)
Plate 304, page 263
(Detroit only)

Three Dancers Seen from the Back with Arms Raised,
 c. 1898
Charcoal and pastel on paper, 35 x 23¼ in. (88.9 x 59 cm)
Private collection, courtesy Browse & Darby, London
(III:379)
Plate 275, page 243

Dancers, Nude Study, 1899
Charcoal and red-brown pastel on cream-colored wove
 paper, 30¾ x 22⅞ in. (78.1 x 58.1 cm)
Private collection
(L 1355)
Plate 292, page 253
(Philadelphia only)

Dancers, c. 1899
Pastel on tracing paper mounted on wove paper,
 23¼ x 18¼ in. (58.8 x 46.3 cm)
The Art Museum, Princeton University; Bequest of
 Henry K. Dick, Class of 1909 (x1954 13)
(L 1312)
Plate 306, page 265
(Philadelphia only)

Russian Dancers, c. 1899
Pastel and charcoal on tracing paper, 18⅞ x 26⅜ in.
 (48 x 67 cm)
Private collection, courtesy Gurr Johns
(L 1188)
Plate 315, page 273

Study of a Dancer in Tights, c. 1900
Black crayon on paper, 23⅝ x 18 in. (60 x 45.5 cm)
The National Museum, Belgrade (291)
(Ex-Lemoisne/Vente)
Plate 295, page 256

Dancers, c. 1900
Pastel on paper, 37⅝ x 26¾ in. (95.6 x 68 cm)
Memorial Art Gallery of the University of Rochester;
 Gift of Mrs. Charles H. Babcock (31.21)
(L 1430)
Plate 307, page 266
(Philadelphia only)

Three Dancers, c. 1900
Charcoal and pastel on wove paper, 15⅜ x 15⅜ in.
 (39 x 39 cm)
Collection Dr. Morton and Toby Mower
(III:214.2)
Plate 291, page 252

Three Dancers, c. 1900–1903
Pastel on paper mounted on card, 37 x 31½ in.
 (94 x 81 cm)
Fondation Beyeler, Riehen/Basel (20)
(L 1428)
Plate 308, page 267

Two Dancers, c. 1900–1905
Charcoal and pastel on tracing paper, mounted on
 wove paper, 43 x 32 in. (109.3 x 81.2 cm)
The Museum of Modern Art, New York; The William S.
 Paley Collection (SPC 65.90)
(BR 149)
Plate 258, page 230

Dancers on the Stage, c. 1900–1905
Charcoal and pastel on tracing paper, 25½ x 27½ in.
 (65 x 70 cm)
Von der Heydt-Museum, Wuppertal (KK 1961/64)
(L 1462)
Plate 311, page 269
(Philadelphia only)

Nude Dancer, c. 1905–10
Black chalk on paper, 19⅜ x 12¾ in. (49.3 x 32.3 cm)
Nasjonalgalleriet, Oslo (NG.K & H.B.15575)
(IV:287b)
Plate 294, page 255

SCULPTURE

Little Dancer, Aged Fourteen, 1878–81
Bronze and fabric, 39 in. (99 cm)
Philadelphia Museum of Art; The Henry P. McIlhenny
 Collection in memory of Frances P. McIlhenny
 (1986-26-11)
(R XX)
Plate 130, page 123

Fourth Position Front, on the Left Leg, 1880s
Bronze, 22⅝ in. (57.4 cm)
Sterling and Francine Clark Art Institute, Williamstown,
 Massachusetts (1955.49)
(R XLIII)
Plate 170, page 153

*Dancer Moving Forward, Arms Raised, Right Leg
 Forward*, c. 1882–95
Bronze, 27¼ in. (69.2 cm)
Hirshhorn Museum and Sculpture Garden, Smithson-
 ian Institution, Washington, D.C.; Gift of Joseph H.
 Hirshhorn, 1966 (66.1298)
(R XXVI)
Plate 273, page 241

Dancer Moving Forward, Arms Raised, 1882–95
Bronze, 13⅞ in. (35.3 cm)
Solomon R. Guggenheim Museum, New York; Gift
 Justin K. Thannhauser, 1978 (78.2514.8)
(R XXIV)
Plate 274, page 242

Dancer Fastening the String of Her Tights, c. 1885–90
Bronze, 16¾ in. (42.5 cm)
Cincinnati Art Museum; Gift of Ethan Emery, Irene
 Emery Goodale, Melissa Emery Lanier, and Lela
 Emery Steele in honor of John F. Steele's election as
 President of the Board of Trustees of the Cincinnati
 Museum Association (1992.138)
(R XXVIII)
Plate 138, page 131

Dancer at Rest, Hands on Hips, Right Leg Forward,
 c. 1885–95, cast 1919–25
Bronze, 17⅜ in. (44.1 cm)
Hirshhorn Museum & Sculpture Garden, Smithsonian
 Institution, Washington, D.C.; Gift of Joseph H. Hir-
 shhorn, 1966 (66.1297)
(R XXII)
Plate 133, page 126

Spanish Dancer, c. 1890
Bronze, 17 in. (43.2 cm)
The Detroit Institute of Arts; Gift of Robert H.
 Tannahill (69.302)
(R XLVII)
Plate 151, page 140

Head of a Woman (Mlle Salle), 1892, cast after 1919
Bronze, 16 in. (40.6 cm)
Museum of Fine Arts, Boston; Bequest of Margarett
 Sargent McKean (1979.509)
(R XXX)
Plate 247, page 220

*Dressed Dancer at Rest, Hands Behind Her Back,
 Right Leg Forward*, c. 1895, cast c. 1920
Bronze with dark brown patina, 17⅛ in. (43.5 cm)
Private collection, courtesy Gurr Johns
(R LII)
Plate 134, page 127

Dancer Holding Her Right Foot in Her Right Hand,
 1898–1912
Bronze, 19½ in. (49.5 cm)
Memorial Art Gallery of the University of Rochester;
 R.T. Miller Fund (59.1)
(R LXII)
Plate 281, page 246

Dancer Putting on Her Stocking, c. 1900, cast after 1922
Bronze, 18⅜ in. (46.5 cm)
The Museum of Fine Arts, Houston; Museum pur-
 chase with funds provided by the Estate of Mrs.
 Harry C. Wiess, the Vale-Asche Foundation, and Mr.
 and Mrs. Lloyd Smith in memory of Mrs. Harry C.
 Wiess (80.43)
(R LVI)
Plate 282, page 247

Arabesque Over the Right Leg, 1919–21
Bronze, 11¾ in. (29.9 cm)
Collection Charles and Jane Cahn, New Jersey
(R XLII)
Plate 166, page 150

Bibliography

Adhémar, Jean, and Françoise Cachin. 1974. *Degas: The Complete Etchings, Lithographs and Monotypes*. London.

Adice, Leopold. 1859. *Théorie de la gymnastique de la danse théâtrale*, Paris.

———. 1868–71. "Grammaire et théorie choré-graphique: Composition de la gymnastique de la danse théâtrale." Manuscript in the Bibliothèque de l'Opéra, Paris.

Adler, Kathleen, and Tamar Garb, eds. 1986. *The Correspondence of Berthe Morisot*. London.

Adriani, Götz. 1985. *Edgar Degas: Pastels, Oil Sketches, and Drawings*. New York.

Alexandre, Arsène. 1888. *Honoré Daumier*. Paris.

A. M. "L'Ecole de danse à l'académie de musique," *L'Illustration*, March 16, 1878, pp. 172–76.

Baschet, Ludovic, ed. c. 1890s. *Le Panorama. Paris s'amuse*. Paris.

Baudot, Jeanne. 1949. *Renoir: Ses amis, ses modèles*. Paris.

Baumann, Felix, and Marianne Karabelnik, eds. 1994. *Degas Portraits*. London and Zurich.

Beaumont, Cyril. 1947. *The Romantic Ballet as Seen by Théophile Gautier*. London.

———. 1949. *The Complete Book of Ballets*. London.

Beauvoir, Roger de. 1854. *L'Opéra*. Paris.

Bénézit, Emmanuel. 1976. *Dictionnaire critique et documentaire des peintres, sculpteurs, dessinateurs et graveurs.... 10 vols.* Paris.

Bentley, Toni. 1987. "What's Wrong with Degas." *Art and Antiques*, November, pp. 70–75, 126.

———. 1988. "Examination at the Barre." *Newsday*, December 29.

Bernay, Berthe. 1890. *La danse au théâtre*. Paris.

Berson, Ruth. 1996. *The New Painting: Impressionism 1874–1886.* 2 vols. San Francisco.

Blasis, Carlo. 1820. *Traité élémentaire, théorique et pratique de l'art de la danse*. Milan. Reprinted in English, New York: 1968.

———. 1828. *The Code of Terpsichore: a practical and historical treatise, on the ballet, dancing, and pantomime; with a complete theory of the art of dancing*. Translated by R. Barton. London. Reprinted, New York: 1976.

———. 1847. *Notes Upon Dancing, Historical and Practical*. Translated by R. Barton. London.

Bled, Victor S. 1921. "Le Ballet au XIXe siècle." *La Revue Musicale*, December 1, pp. 95–109.

Boigne, Charles de. 1857. *Petits mémoires de l'Opéra*. Paris.

Boggs, Jean Sutherland. 1958. "Degas Notebooks in the Bibliothèque Nationale." *The Burlington Magazine*, Group A (1853–58): May, pp. 163–71; Group B: (1858–61), June 1958, pp. 196–205; Group C: (1863–86), July, pp. 240–46.

———. 1962. *Portraits by Degas*. Berkeley.

———. 1967. *Drawings by Degas*. St. Louis.

———. 1985. "Degas at the Museum: Works in the Philadelphia Museum of Art and the John G. Johnson Collection." *Bulletin of the Philadelphia Museum of Art*, spring, pp. 2–48.

Boggs, Jean Sutherland, Douglas Druick, Henri Loyrette, Michael Pantazzi, and Gary Tinterow. *Degas*. 1988–89. Ottawa, Paris, and New York.

Boggs, Jean Sutherland, and Anne Maheux. 1992. *Degas Pastels*. New York.

Bouvet, Charles. 1924. *L'Opéra*. Paris.

Brame, Philippe, and Theodore Reff. 1984. *Degas et son oeuvre: A Supplement*. New York and London.

Brettell, Richard. 1995. *Impressionist Paintings, Drawings, and Sculpture from the Wendy and Emery Reves Collection*. Dallas.

Brettell, Richard R., and Susan Folds McCullagh. 1984. *Degas in the Art Institute of Chicago*. Chicago.

Browse, Lillian. 1949. *Degas Dancers*. London.

Buchanan, Harvey. 1997. "Edgar Degas and Ludovic Lepic: An Impressionist Friendship." *Cleveland Studies in the History of Art*, vol. 2, 1997. Cleveland.

Burnell, David. 1969. "Degas and His 'Young Spartans Exercising.'" *Art Institute of Chicago Museum Studies*, no. 4, pp. 49–65.

Cachin, Françoise, and Charles Moffett. 1983. *Manet 1832–1883*. Paris.

Camesasca, Ettore. 1986. *Degas scultore*. Florence.

Campbell, Sarah. 1995. "Degas' Bronzes." *Apollo*, August, pp. 11–48.

Castil-Blaze, François Henri Joseph. 1847. *Mémorial du Grand Opéra, épilogue de l'Académie Royale de Musique...de 1645 à 1847.* Paris.

———. 1855. *Théâtres lyriques de Paris. L'académie impériale de musique...1645–1855.* Paris.

———. 1856. *Théâtres lyriques de Paris. L'opéra-italien de 1548 à 1856.* Paris.

Champsaur, Félicien. 1888. *L'amant des danseuses*. Paris.

Charbonnel, Raoul. 1899. *La danse: comment on dansait, comment on danse*. Paris.

Chouquet, Gustave. 1873. *Histoire de la musique dramatique en France, depuis ses origins jusqu'à nos jours*. Paris.

Claretie, Jules. 1881. "M. Paul Renouard et l'Opéra." *Gazette des Beaux-Arts 23*, pp. 435–55.

———. 1881. *La vie à Paris*. Paris.

Cohen, Henry. 1876. *L'Opéra: eaux fortes et quatrains par un abonné*. Paris.

Cohen, H. Robert, compiler. 1982–83. *Les gravures musicales dans "L'Illustration," 1843–1899.* Québec.

Constant, Pierre. 1894. *Le magasin de décors de l'Opéra, rue Richer: son histoire (1781–1894).* Paris.

Contant, Clément. 1859. *Parallèle des principaux théâtres modernes de l'Europe et des machines théâtrales françaises, allemandes et anglaises*. Paris.

Cooper, Douglas. 1954. *The Courtauld Collection of Paintings, Drawings, Engravings, and Sculpture*. London.

Coquiot, Gustave. 1924. *Degas*. Paris.

Couëssin, Charles de. 1989. "Technique, transformations dans les toiles de Degas des collections du musée d'Orsay," in Musée d'Orsay, 1989, *Degas inédit*, pp. 144–58.

Daniel, Malcolm, Eugenia Parry, and Theodore Reff. *Edgar Degas, Photographer.* 1998. New York.

Degas, Edgar. 1946. Preface by Jean Nepveu-Degas. *Huit sonnets d'Edgar Degas*. Paris.

Delaborde, Henri. 1870. *Ingres: Sa vie, ses travaux, sa doctrine*. Paris.

Delacroix, Eugène. 1937. *The Journal of Eugène Delacroix*. New York.

Delteil, Loÿs. 1925–30. *Honoré Daumier*. 10 vols. Paris.

Desarbres, Nérée. 1864. *Sept ans à l'Opéra: souvenirs anecdotiques d'un secrétaire particulier*. Paris.

Desrat, G. 1885–88. *Traité de la danse. Contenant la théorie et l'histoire des danses anciennes et modernes*. Paris.

Distel, Anne. 1990. *Impressionism: The First Collectors*. New York.

Donnet, Alexis. 1821. *Architectonographie des théâtres de Paris mis en parallèle entr'eux*. 4 vols. Paris.

———. 1840–57. *Architectonographie des théâtres, ou, Parallèle historique et critique de ces edifices.... 4 vols.* Paris.

Druick, Douglas. 1989. "La petite danseuse et les criminels: Degas moraliste?" in Musée d'Orsay, 1989, *Degas inédit*, Paris, pp. 225–50.

Du Bois, Charles. 1906. Review of Julius Meier-Graefe's *Bibliographie: Histoire du développement de l'art moderne*. *Gazette des Beaux-Arts*, April, pp. 346–52.

Dubor, Georges de. 1899. "Le Théâtre de l'Opéra." *Monde moderne*, March, pp. 389–404.

Du Camp, Maxime. 1879. *Paris, ses organes, ses fonctions et sa vie dans la seconde moitié du XIX. siècle*. 6 vols. Paris.

Dumas, Alexandre, Théophile Gautier, Arsène Houssaye, Paul de Musset, Louis Enault, and G. du Fayl. 1856. *Paris et les Parisiens*. Paris.

Dumas, Ann. 1988. *Degas' Mlle. Fiocre in Context*. New York.

Dumas, Ann, Colta Ives, Susan Alyson Stein, Gary Tinterow, et al. 1997. *The Private Collection of Edgar Degas*. New York.

Dupêchez, Charles. 1984. *Histoire de l'Opéra de Paris: 1875–1980.* Paris.

Duranty, Edmond. 1876. *La nouvelle peinture à propos du groupe d'artistes qui expose dans les galeries Durand-Ruel*. Translated and reprinted in Charles Moffet, 1986, pp. 37–47.

———. 1881. *Le pays des arts*. Paris.

Duval, J. Georges [Claude Rieux, pseud.]. 1875. *Terpsichore, petit guide à l'usage des amateurs de ballet, par un abonné de l'Opéra*. Précédé d'une préface de Mlle Rita Sangalli. Paris.

———. 1875–77. *L'Année théâtrale: nouvelles, bruits de coulisses, indiscrétions, comptes rendus, racontars, etc.* 3 vols. Paris.

Emmanuel, Maurice. 1896 (i). "La danse Grecque antique." *Gazette des Beaux-Arts*, April, pp. 291–308.

———. 1896 (ii). *La danse Grecque antique, d'après les monuments figures*. Paris.

Falcone, Francesca. 1999. "The Evolution of the Arabesque in Dance." *Dance Chronicle 22*, no. 1, pp. 71–117.

Fayl, Ezvar du. 1878. *Académie Nationale de Musique, 1671–1877.... Paris.*

Fernandez, Rafael, and Alexandra Murphy. 1987. *Degas in the Clark Collection*. Williamstown.

Fevre, Jeanne. 1949. *Mon oncle Degas*. Geneva.

Forge, Andrew, and Robert Gordon. 1988. *Degas*. New York.

Fourcaud, Louis de. 1881. *Léontine Beaugrand*. Paris.

Fraser, John. 1988. *Private View: Inside Barishnikov's American Ballet Theater*. Photographs by Eve Arnold. New York.

Galerie Georges Petit. 1924. *Exposition Degas*. Paris.

Garafola, Lynn, ed. 1997. *Rethinking the Sylph: New Perspectives on the Romantic Ballet*. Hanover and London.

Garnier, Charles. 1878–81. *Le Nouvel Opéra de Paris*. 2 vols. Paris.

———. 1871. *Le théâtre*. Paris.

Gautier, Théophile. 1840. "Le Rat," in Claudine Lacoste-Veysseyre, ed. 1996. *Paris et les Parisiens*. Paris, pp. 463–73.

———. 1986. *Gautier on Dance*. Edited by Ivor Guest. London.

Geffroy, Gustave. 1894. *La vie artistique*. Paris.

Gerstein, Marc. 1982. "Degas's Fans." *Art Bulletin*, March, pp. 105–18.

Giraudet, Eugène. 1900. *Traité de la danse: Tome II, Grammaire de la danse et du bon ton....* Paris.

Goncourt, Edmond de, and Jules de Goncourt. 1956. *Journal: mémoires de la vie littéraire*. 4 vols. Paris.

Gourret, Jean. 1985. *Histoire des salles des l'Opéra de Paris*. Paris.

Grasset, Joseph. 1874. *Mme de Choiseul et son temps*. Paris.

Gsell, Paul. 1918. "Edgar Degas: statuaire." *La Renaissance de l'Art Française et industries du luxe*, December, pp. 373–8.

Guérin, Marcel, ed. 1947. *Degas Letters*. Oxford.

Guest, Ann Hutchinson. 1994. *La vivandière pas de six*. London.

———. 1997. "Saint-Léon, Bournonville and Cecchetti." *The Dancing Times* 87, no. 1041, June, pp. 822–23.

Guest, Ivor. 1953. *The Ballet of the Second Empire*. London.

———. 1961. *The Dancer's Heritage: A Short History of Ballet*. New York.

———. 1966. *The Romantic Ballet in Paris*. Middletown.

———. 1976. *Le ballet de l'Opéra de Paris*. Paris.

———. 1984. *Jules Perrot: Master of the Romantic Ballet*. London.

Halévy, Daniel. 1960. *Degas parle*. Paris.

———. 1995. *Degas parle*. Paris.

Halévy, Ludovic. 1883. *La famille Cardinal*. Paris.

———. 1889. *Notes et souvenirs, 1871–1872*. Paris.

———. 1933–34. "Les carnets de Ludovic Halévy." *Revue des deux mondes*, December 15, 1933, pp. 764–99; January 1, 1934, pp. 51–87; February 1, 1934, pp. 535–67; February 15, 1934, pp. 779–813; March 15, 1934, pp. 363–88; April 1, 1934, pp. 555–79; April 15, 1934, pp. 789–819.

———. 1937. "Nouveaux carnets." *Revue des deux-mondes*, January 15, pp. 296–323; February 1, 1937, pp. 560–65.

———. 1938. "Mes carnets." *Revue des deux-mondes*, January 1, pp. 95–126; January 8; January 15, pp. 375–40; February 1, pp. 589–613.

Hammond, Sandra Noll. 1982. "La Sténochorégraphie by Saint-Léon: A Link in Ballet's Technical History." *Dance History Scholars, Proceedings of Fifth Annual Conference*, Harvard University, Feb. 13–15, pp. 148–52.

———. 1984. "Clues to Ballet's Technical History from the Early Nineteenth-Century Ballet Lesson." *Dance Research* 3, no. 1, autumn, pp. 53–66.

———. 1987. "Early Nineteenth Century Ballet Technique from Léon Michel." *Society of Dance History Scholars, Proceedings of 10th Annual Conference*, Harvard University, Feb. 13–15, pp. 202–8.

———. 1989. "Technique and autonomy in the development of art: a case study in ballet." *Dance Research Journal*, vol. 21, no. 2, fall, pp. 15–24.

———. 1995. "Ballet's Technical Heritage: the Grammaire of Leopold Adice." *Dance Research* 13, no. 1, summer, pp. 33–58.

Haskell, Arnold. 1954. *A Picture History of the Ballet*. New York.

Hautecoeur, Louis. 1952. *Histoire de l'architecture classique en France*. 4 vols. Paris.

Havemeyer, Louisine. 1993. *Sixteen to Sixty, Memoirs of a Collector*. New York.

Hertz, Henri. 1920. *Degas*. Paris.

Hervey, Charles. 1847. *The Theaters of Paris*. London.

d'Heylli, Georges. 1875. *Foyers et coulisses: Histoire anecdotique de tous les théâtres de Paris*. Paris.

Houssaye, Arsène. 1885–91. *Les confessions; souvenirs d'un demi-siècle, 1830–1880 [1890]*. 6 vols. Paris.

Hugard, Jane. 1923. *Ces demoiselles de l'Opéra*. Paris.

Isaacson, Joel. 1982. "Impressionism and Journal Illustration." *Arts Magazine*, June, pp. 95–115.

Ives, Colta, and Susan Alyson Stein, Julie A. Steiner, Ann Dumas, Rebecca A. Rabinow, and Gary Tinterow. 1997. *The Private Collection of Edgar Degas: A Summary Catalogue*. New York.

Jamot, Paul. 1924. *Degas*. Paris.

Janis, Eugenia Parry. 1967. "The Role of the Monotype in the Working Method of Edgar Degas," *Burlington Magazine*; part 1: January, pp. 20–27; part 2: February, pp. 71–81.

———. 1968. *Degas Monotypes, Essay, Catalogue and Checklist*. Cambridge.

Jeanniot, Georges. 1933. "Souvenirs sur Degas." *Revue Universelle*; part 1: October 15, pp. 152–74; part 2: vol. 55, no. 14, November 1, pp. 280–304.

Johnson, Lee. 1981–89. *The Paintings of Eugène Delacroix*. 6 vols. Oxford.

Join-Diéterle, Catherine. 1988. *Les décors de scène de l'Opéra de Paris à l'époque romantique*. Paris.

Kahane, Martine. 1985. *Robert le Diable*. Paris.

———. 1986. *L'ouverture du nouvel Opéra: 5 janvier 1875*. Paris.

———. 1988. *Le foyer de la danse*. Paris.

———. 1998. "Enquête sur la 'Petite danseuse de quatorze ans' de Degas." *La Revue du Musée d'Orsay*, no. 7, fall, pp. 48–71.

Kahane, Martine, and Delphine Pinasa. 1997. *Le tutu*. Paris.

Karr, Alphonse. 1879. *Le livre de bord*. Paris.

Keisch, Claude, and Marie Ursula Riemann-Reyher. 1996. *Adolph Menzel 1815–1905: Between Romanticism and Impressionism*. New York and London.

Kendall, Richard. 1988. "Degas and the Contingency of Vision." *The Burlington Magazine*, March, pp. 180–97.

———. 1989. *Images of Women*. London.

———. 1993. *Degas Landscapes*. New Haven and London.

———. 1995. "Who Said Anything about Rodin?" *Apollo*, August, pp. 72–77.

———. 1996. *Degas: Beyond Impressionism*. London.

———. 1998. *Degas and the Little Dancer*. New Haven and London.

Kendall, Richard, and Griselda Pollock, eds. 1992. *Dealing with Degas*. London.

Kirstein, Lincoln, and Muriel Stuart. 1980. *The Classic Ballet: Basic Technique and Terminology*. New York.

Kochno, Boris. 1954. *Le ballet en France du quinzième siècle à nos jours*. Paris.

Koegler, Horst. 1977. *The Concise Oxford Dictionary of Ballet*. London.

Labat-Poussin, Brigitte. 1977. *Archives du Théâtre National de l'Opéra (AJ13 à 1466): Inventaire*. Paris.

Lafond, Paul. 1918–19. *Degas*. 2 vols. Paris.

Lajarte, Théodore de. 1883. *Curiosités de l'Opéra*. Paris.

———. 1890. *Les danses historiques*. Paris.

Lassaigne, Jacques, and Fiorella Minervino. 1974. *Tout l'oeuvre peint de Degas*. Paris.

Lasalle, Albert de. 1866. "Chronique musicale." *Le Monde Illustré*, August 11, pp. 94–96.

———. 1875. *Les treize salles de l'Opéra*. Paris.

Lecomte, Georges. 1892. *L'art impressioniste d'après la collection privée de M. Durand-Ruel*. Paris.

Lemoisne, Paul-André. 1912 (i). *L'art de notre temps: Degas*. Paris.

———. 1912 (ii). *Eugène Lami 1800–1890*. Paris.

———. 1946–49. *Degas et son oeuvre*. 4 vols. Paris.

Levinson, André. 1930. "Le ruban de velours noir ou Degas chorégraphe." *Le Figaro Artistique*, November, pp. 10–15.

Lipton, Eunice. 1986. *Looking Into Degas: Uneasy Images of Women and Modern Life*. Berkeley and Los Angeles.

Loyrette, Henri. 1989. "Degas à l'Opéra," in Musée d'Orsay, 1989, *Degas inédit*, Paris, pp. 47–63.

———. 1991. *Degas*. Paris.

———. 1996. *Entre le théâtre et l'histoire: La famille Halévy (1760–1960)*. Paris.

Loyrette, Henri, and Michele Melot, Ségolène le Men, Michael Pantazzi, and Edouard Papet. 1999. *Daumier 1808–1879*. Ottawa, Paris, and Washington, D.C.

Magnier, Maurice. 1885. *La danseuse*. Paris.

Mahalin, Paul. 1887. *Ces demoiselles de l'Opéra [par] un vieil abonné*. Paris.

Maison, Karl Eric. 1968. *Honoré Daumier: Catalogue Raisonné of the Paintings, Watercolors and Drawings*. 2 vols. New York.

Manet, Julie. 1987. *Growing Up with the Impressionists: The Diary of Julie Manet*. London.

Mathews, Nancy Mowll. 1984. *Cassatt and Her Circle: Selected Letters*. New York.

Maugny, Comte de. 1891. *Souvenirs of the Second Empire*. London.

Maugras, Gaston. 1903. *La disgrace du Duc et de la Duchesse de Choiseul: La vie à Chanteloup, le retour à Paris, la mort*. Paris.

Mayne, Jonathan. 1969. "Degas's Ballet Scene from Robert le Diable," *Bulletin of the Victoria and Albert Museum*, vol. 2, no. 4, pp. 148–56.

McMullen, Roy. 1984. *Degas: His Life, Times and Work*. Boston.

Mead, Christopher Curtis. 1991. *Charles Garnier's Paris Opéra, Architectural Empathy and the Renaissance of French Classicism*. New York.

Meller, Mari Kálmán. 1988–93. "Exercises in and Around Degas's Classrooms." *The Burlington Magazine*, part 1: March, pp. 198–215; part 2: April 1990, pp. 253–65; part 3: July 1993, pp. 452–62.

Mérode, Cléo de. 1985. *Le ballet de ma vie*. Paris.

Michel, Alice. 1919. "Degas et son modèle." *Mercure de France*, Feburary 16, pp. 457–78, 623–39.

Millard, Charles. 1979. *The Sculpture of Edgar Degas*. Princeton.

Millet, Jacqueline. 1979. "La famille Mante, une trichromie, Degas, l'Opéra." *Gazette des Beaux-Arts* 94, pp. 105–12.

Moffett, Charles S. 1986. *The New Painting: Impressionism, 1874–1886*. San Francisco and Washington, D.C.

Monnier, Geneviève. 1969. "La genèse d'une oeuvre de Degas: 'Sémiramis construisant une ville.'" *La Revue du Louvre et des Musées de France*, pp. 359–68.

Moore, George. 1918. "Memories of Degas." *The Burlington Magazine*; part 1: vol. 32, no. 178, pp. 22–29; part 2: vol. 32, no. 179, pp. 63–65.

Moore, Lillian. 1938. *Artists of the Dance*. New York.

Montorgueil, Georges. 1898. *Paris dansant*. Paris.

Moynet, Georges. 1893. *La machinerie théâtrale. Trucs et décors*. Paris. (Revised and more extensively illustrated edition of the volume listed directly below.)

Moynet, M. J. 1873. *L'envers du théâtre: machines et décorations*. Paris.

Muehlig, Linda D. 1979. *Degas and the Dance*. Northampton, Mass.

Munk, Jens Peters. 1993. *French Impressionism: Ny Carlsberg Glyptotek*. Copenhagen.

Musée Goupil. 1997. *Degas, Boldini, Toulouse-Lautrec...Portraits inédits par Michel Manzi*. Bordeaux.

Musée d'Orsay. 1989. *Degas inédit*. Paris.

Nuitter, Charles. 1875. *Le Nouvel Opéra (Garnier)*. Paris.

Opéra National de Paris. 1998. *La Sylphide*. Paris.

Orangerie des Tuileries. 1931. *Degas: Portraitiste, sculpteur*. Paris.

———. 1937. *Degas*. Paris.

———. 1969. *Degas: Oeuvres du Musée du Louvre*. Paris.

Patureau, Frédérique. 1991. *Le Palais Garnier dans la société Parisienne: 1875–1914*. Liège.

Pessard, Gustave. 1904. *Nouveau dictionnaire historique de Paris*. Paris.

Petit-Jean, Pierre. 1978. *Backstage with the Ballet*. Middlesex.

Pickvance, Ronald. 1963. "Degas's Dancers: 1872–1876." *The Burlington Magazine*, June, pp. 256–66.

———. 1979. *Degas: 1879*. Edinburgh.

———. 1993. *Degas*. Martigny.

Pingeot, Anne, and Frank Horvat. 1991. *Degas Sculptures*. Paris.

Pitou, Spire. 1985. *The Paris Opéra: An Encyclopedia of Operas, Ballets, Composers, and Performers: Rococo and Romantic, 1715–1815*. Westport.

———. 1990. *The Paris Opéra: An Encyclopedia of Operas, Ballets, Composers, and Performers: Growth and Grandeur, 1815–1914*. 2 vols. Westport.

Prevost, Hippolyte. 1866. "La Revue Musicale." *La France politique, scientifique et littéraire*, November 18, p. 1.

Prod'homme, J.-G. 1925. *L'Opéra 1669–1925*. Paris.

———. 1932. "Le ballet à l'Opéra." *Les spectacles à travers les ages: musique, danse*, Paris, pp. 167–92.

Randon, Gabrielle. 1885. *Mystères des coulisses d'Opéra, révélations*. Paris.

———. 1886. *Scènes comiques à l'Opéra*. Paris.

Raunay, J. 1931. "Degas, souvenirs anecdotiques." *La Revue de France*; part I: March 15, pp. 263–82; part 2: April 1, pp. 469–83; part 3: April 15, pp. 619–32.

Reed, Sue Welsh, and Barbara Stern Shapiro. 1984. *Edgar Degas: The Painter as Printmaker*. Boston.

Reff, Theodore. 1964. "New Light on Degas' Copies." *Burlington Magazine*, June, pp. 250–59.

———. 1967. "An Exhibition of Drawings by Degas." *The Art Quarterly* 30, nos. 3–4, pp. 252–63.

———. 1968. "Some Unpublished Letters of Degas." *The Art Bulletin* 50, no. 1, March, pp. 87–94.

———. 1969. "More Unpublished Letters of Degas." *The Art Bulletin* 51, no. 3, September, pp. 281–89.

———. 1974. "Works by Degas in the Detroit Institute of Arts." *Bulletin of the Detroit Institute of Arts* 53, no. 1, pp. 1–44.

———. 1976. *The Artist's Mind*. New York.

———. 1976. *The Notebooks of Edgar Degas: A Catalogue of the Thirty-Eight Notebooks in the Bibiliothèque Nationale and Other Collections*. 2 vols. New York.

———. 1978. "Edgar Degas and the Dance." *Arts Magazine* 53, no. 3, November, pp. 145–49.

———. 1981. "Degas and de Valernes in 1872." *Arts Magazine*, vol. 56, no. 1, Sept., pp. 126ff.

Rewald, John. 1937. "Le portrait de la princesse de Metternich par Degas." *L'Amour de l'Art*, March, pp. 89–90.

———. 1944. *Degas' Complete Sculpture*. London.

Richter, Stefan. 1989. *The Art of the Daguerrotype*. London.

Ristori, Adelaide. 1907. *Memoirs and Artistic Studies of Adelaide Ristori*. New York.

Robaut, Alfred. 1885. *L'oeuvre complete de Eugène Delacroix*. Paris.

———. 1905. *L'oeuvre de Corot: Catalogue raisonné et illustré*. 4 vols. Paris.

Roberts, Keith. 1963. "The Date of Degas's *The Rehearsal* in Glasgow." *Burlington Magazine* 105, no. 723, June, pp. 280–81.

Robin-Challan, Louise. 1992. "Social Conditions of Ballet Dancers at the Paris Opera in the 19th Century." *Choreography and Dance* 2, no. 1, pp. 17–28.

Roqueplan, Nestor. 1855. *Les coulisses de l'Opéra*. Paris.

Rothenstein, William. 1931–32. *Men and Memories*. 2 vols. London.

Rouart, Denis. 1964. *The Unknown Degas and Renoir in the National Museum of Belgrade*. New York, Toronto, and London.

Royer, Alphonse. 1875. *Histoire de l'Opéra*. Paris.

Sadie, Stanley, ed. 1992. *The New Grove Dictionary of Opera*. 4 vols. New York.

Scharf, Aaron. 1974. *Art and Photography*. Baltimore.

Second, Albéric. 1844. *Les petits mystères de l'Opéra*. Paris.

Sérullaz, Maurice, and Arlette Sérullaz, Louis-Antoine Prat, and Claudine Ganeval. 1984. *Dessins d'Eugène Delacroix, 1798–1863*. 2 vols. Paris.

Shackelford, George. 1984. *Degas: The Dancers*. Washington, D.C.

Sickert, Walter. 1917. "Degas." *The Burlington Magazine*, November, pp. 183–91.

Soria, Henri de. 1897. *Histoire pittoresque de la danse*. Paris.

Soubies, Albert. 1893. *Soixante-sept ans à l'Opéra en un page: du Siège de Corinthe à La Walkyrie: 1826–1893*. Paris.

Städelschen Kunstinstitut. 1999. *Impressionisten: 6 Französische Meisterwerke*. Frankfurt.

Taine, Hippolyte. 1985. *Philosophie de l'art*. Paris.

Terrasse, Antoine. 1983. *Edgar Degas et la photographie*. Paris.

Terrier, Agnès. 2000. *Le billet de l'Opéra*. Paris.

Thiébault-Sisson, François. 1921. "Degas sculpteur par lui-même." *Le Temps*, May 23, p. 3.

Thomson, Richard. 1987. *The Private Degas*. New York.

———. 1995. *Waiting*. Malibu.

Tinterow, Gary, and Henri Loyrette. 1994. *The Origins of Impressionism*. New York.

Touchard-Lafosse, Georges. 1846. *Chroniques secretes et galantes de l'Opéra, 1667–1845*. 4 vols. Paris.

Vaillat, Léandre. 1947. *Ballet de l'Opéra de Paris*. Paris.

Valéry, Paul. 1960. *Degas Manet Morisot*. New York.

Vente I. 1918. *Catalogue des tableaux, pastels et dessins par Edgar Degas. . . .* May. Paris.

Vente II. 1918. *Catalogue des tableaux, pastels et dessins par Edgar Degas. . . .* December. Paris.

Vente III. 1919. *Catalogue des tableaux, pastels et dessins par Edgar Degas. . . .* April. Paris.

Vente IV. 1919. *Catalogue des tableaux, pastels et dessins par Edgar Degas. . . .* July. Paris.

Véron, Louis. 1854. *Mémoires d'un bourgeois de Paris par le docteur L. Véron*. Paris.

Vizentini, Albert. 1868. *Derrière la toile (foyers, coulisses, comédiens)*. Paris.

Vollard, Ambroise. 1914. *Quatre-vingt-dix-huit reproductions signées par Degas*. Paris.

———. 1924. *Degas*. Paris.

———. 1936. *Recollections of a Picture Dealer*. London.

———. 1937. *Degas: An Intimate Portrait*. New York.

Vuillier, Gaston. 1898. *La danse*. Paris.

Wagner, Anne Middleton. 1986. *Jean-Baptiste Carpeaux: Sculptor of the Second Empire*. New Haven.

Weitzenhoffer, Frances. 1986. *The Havemeyers: Impressionism Comes to America*. New York.

Wells, William. 1964. "Degas' Staircase." *Scottish Art Review* 9, no. 3, pp. 14–17.

Wild, Nicole. 1987. *Décors et costumes du XIXe siècle: Tome I, Opéra de Paris*. Paris.

Wissman, Fronia. 1989. *Corot's Salon Paintings: Sources from French Classicism to Contemporary Theater Design*. 2 vols. New Haven.

———. 1998. "Arbres torturés, ailes de fées: Les sources des peintures du Salon de Corot," in Chiara Stefani, Vincent Pomarède, and Gérard de Wallens, 1998, *Corot, un artiste et son temps*. Paris.

Wolff, Stéphane. 1862. *L'Opéra au Palais Garnier (1875–1962)*. Paris.

X. Y. Z. 1875. *Le Nouvel Opéra*. Paris. London.

American Federation of Arts

Index

PHOTOGRAPH CREDITS

Photographs were in most cases provided by the institution or individual owning the works and are reproduced with permission. Additional information on photograph sources follows.

Plate 6: Photo courtesy Richard Kendall. Plate 19: Copyright Erich Lessing/Art Resource, NY. Photo Hervé Lewandowski. Plate 21: Copyright RMN. Photo Hervé Lewandowski. Plate 22: Copyright RMN. Photo Jean Schormans. Plate 28: Copyright Giraudon/Art Resource, NY. Plate 30: Photo courtesy Photothèque des musées de la ville de Paris/Briant. Plate 32: Photo Katya Kallsen. Plate 33: Photo Lynn Rosenthal, 2002. Plate 43: Copyright RMN. Photo Hervé Lewandowski. Plate 47: Copyright RMN. Photo Arnaudet. Plate 61: Copyright RMN. Photo Hervé Lewandowski. Plate 67: Copyright RMN. Photo C. Jean. Plate 69: Copyright RMN. Photo J.G. Berizzi. Plate 78: Photo courtesy Christie's Images, NY. Plate 92: Photo courtesy Christie's Images, NY. Plate 103: Photo Graydon Wood, 1993. Plate 104: Copyright RMN/Art Resource, NY. Photo Jean Schormans. Plate 121: Photo Bob Grove. Plate 123: Photo Graydon Wood, 1988. Plate 132: Photo Michael Bodycomb, 1997. Plate 141: Photo Robert Lorenzson. Plate 159: Photo Elke Walford. Plate 160: Photo Robert Lorenzson. Plate 161: Photo courtesy Christie's Images, NY. Plate 178: Copyright RMN. Plate 180: Copyright RMN/Art Resource, NY. Photo Jean Schormans. Plate 184: Photo Lynn Rosenthal. Plate 187: Photo Stephen Petegorsky. Plate 189: Photo DOWIC Fotografi. Plate 195: Copyright RMN. Photo Jean Schormans. Plate 205: Copyright RMN. Photo Arnaudet. Plate 222: Photo John Webb. Plate 223: Photo David Heald. Plate 224: Photo Elke Walford. Plate 229: Copyright RMN/Art Resource, NY. Photo Hervé Lewandowski. Plate 233: Copyright 1987 The Nelson Gallery Foundation. Photo E.G. Schempf. Plate 236: Copyright RMN. Photo Jean Schormans. Plate 237: Photo Eric Mitchell. Plate 256: Photo Elke Walford. Plate 261: Copyright RMN/Art Resource, NY. Plate 265: Photo Robert Lorenzson. Plate 281: Photo James Via. Plate 287: Photo courtesy Centre des Monuments Nationaux, Paris. Plate 290: Copyright RMN/Art Resource, NY. Photo Jean Schormans. Plate 292: Photo Robert Pettus. Plate 294: Photo J. Lathion. Plate 303: Photo Graydon Wood. Plate 306: Photo Bruce M. White. Plate 307: Photo James Via. Plate 309: Copyright RMN. Photo Ojéda/Le Mage. Plate 318: Photo Ed Cornachio.